The portraits speak: Chuck Close in conversation with 27 of his subjects

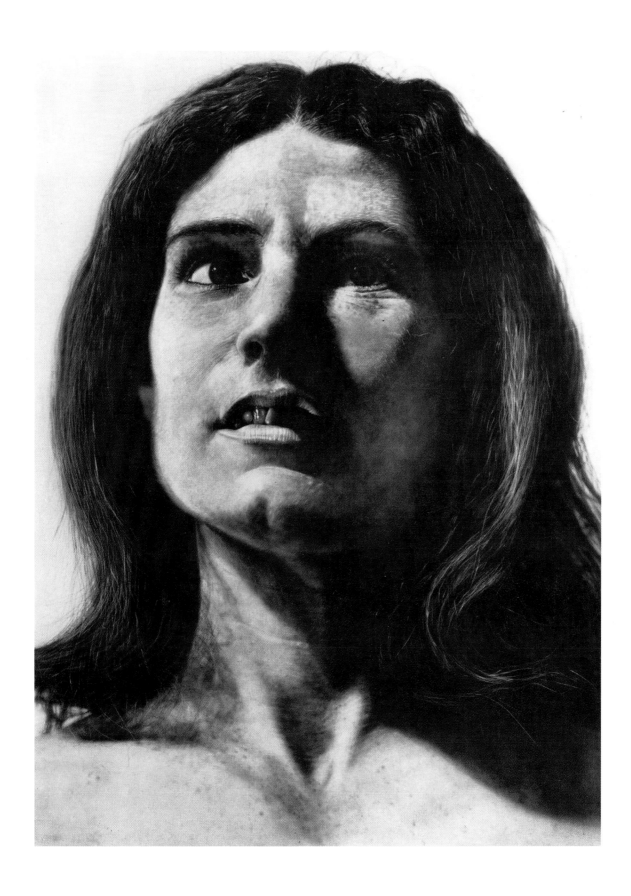

Nancy
1968, acrylic on canvas, 108 x 84 inches

Collection Milwaukee Art Museum, Milwaukee.

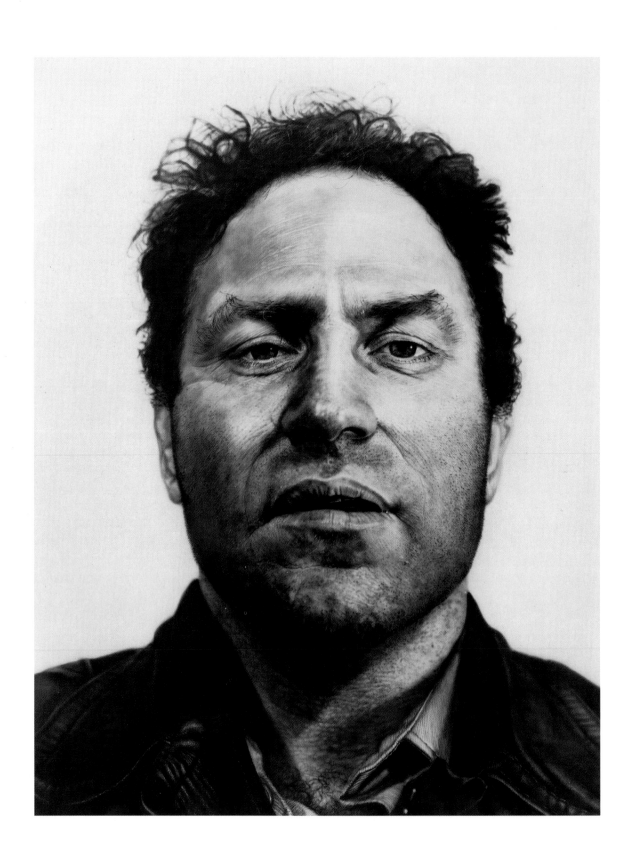

Richard
1969, acrylic on canvas, 108 x 84 inches

Ludwig Collection, Aachen, West Germany

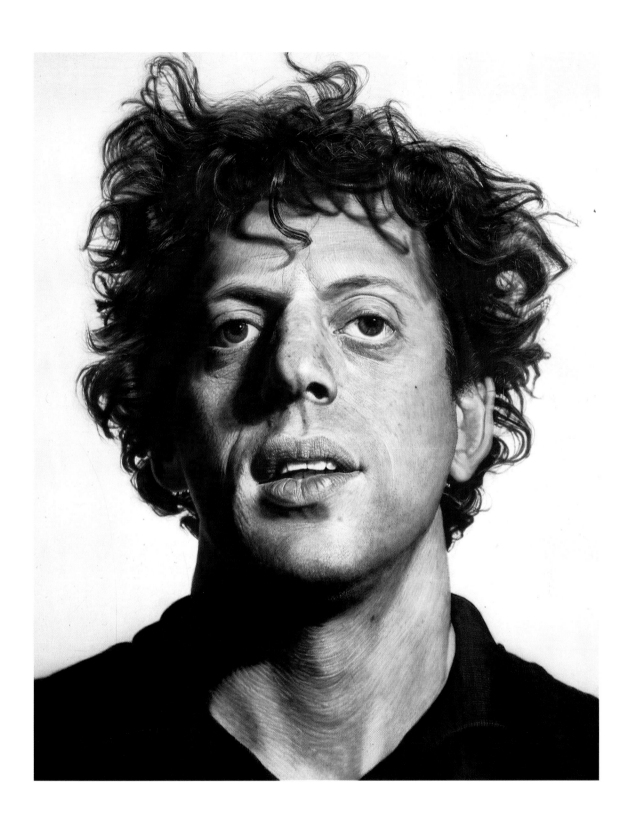

Phil
1969, acrylic on canvas, 108 x 84 inches

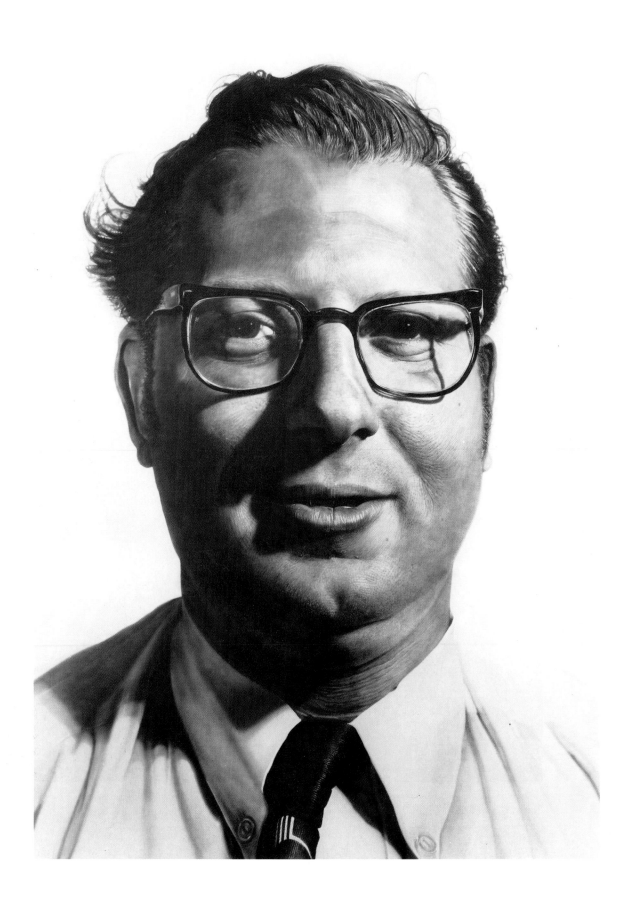

Joe
1969, acrylic on canvas, 108 x 84 inches

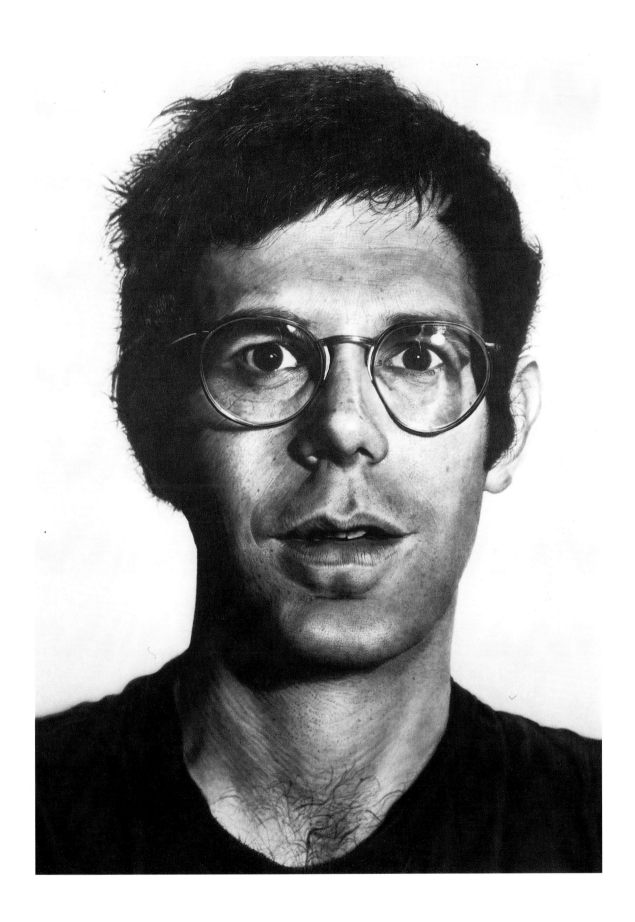

Bob
1970, acrylic on canvas, 108 x 84 inches

Collection of the Australian National Gallery, Canberra.

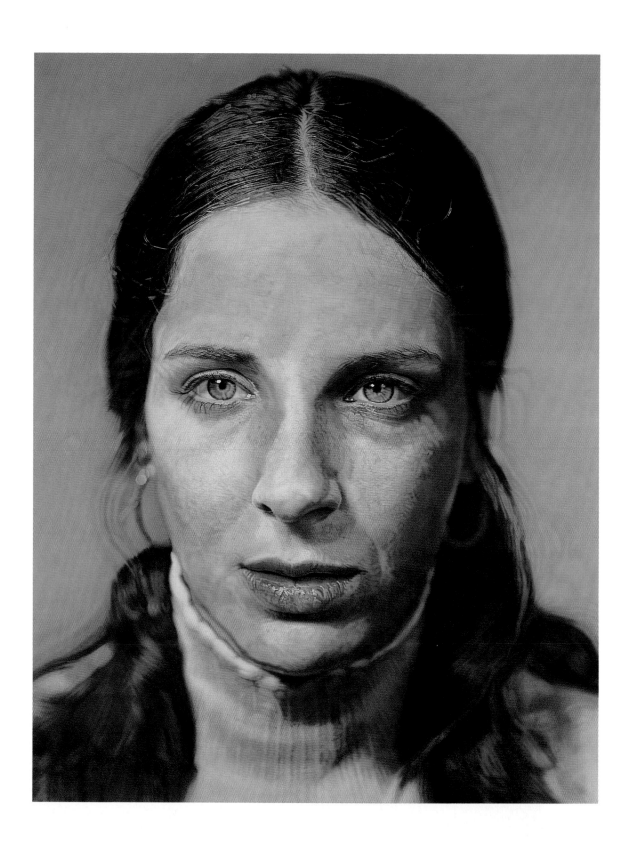

Leslie
1973, watercolor on paper on canvas, 72½ x 57 inches

Private Collection, New York

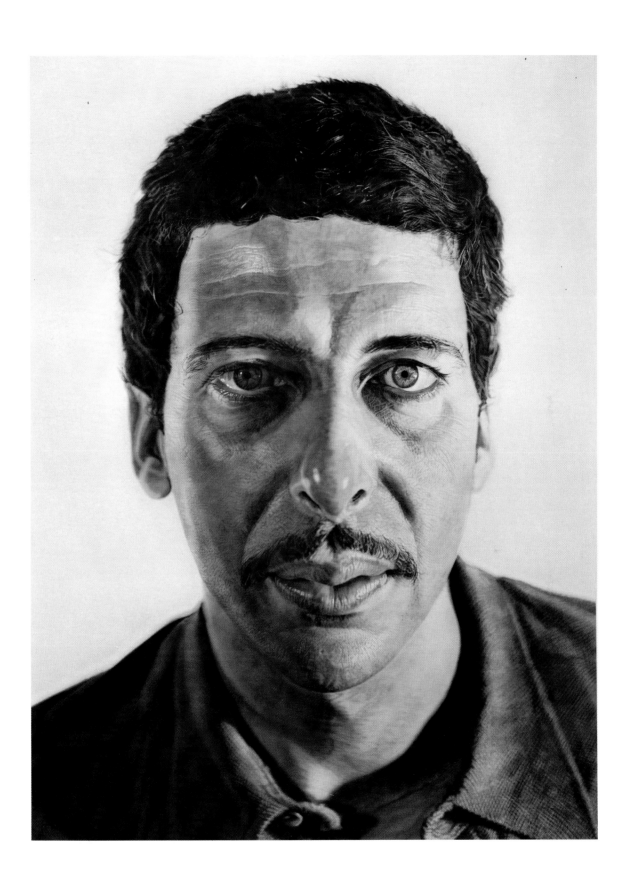

Klaus
1976, watercolor on paper, 80 x 58 inches

Collection Sydney and Frances Lewis, Richmond, Virginia

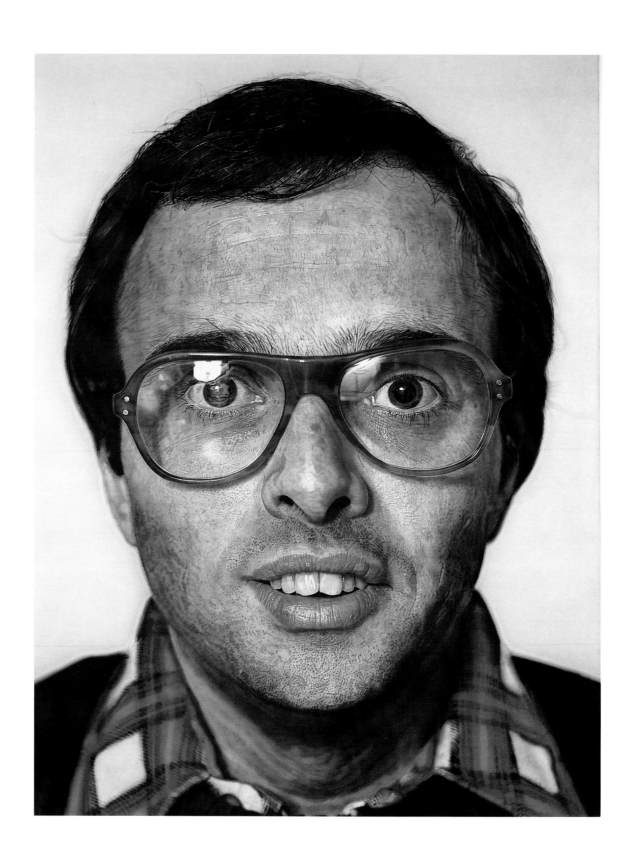

Mark
1979, acrylic on canvas, 108 x 84 inches

Private collection, New York

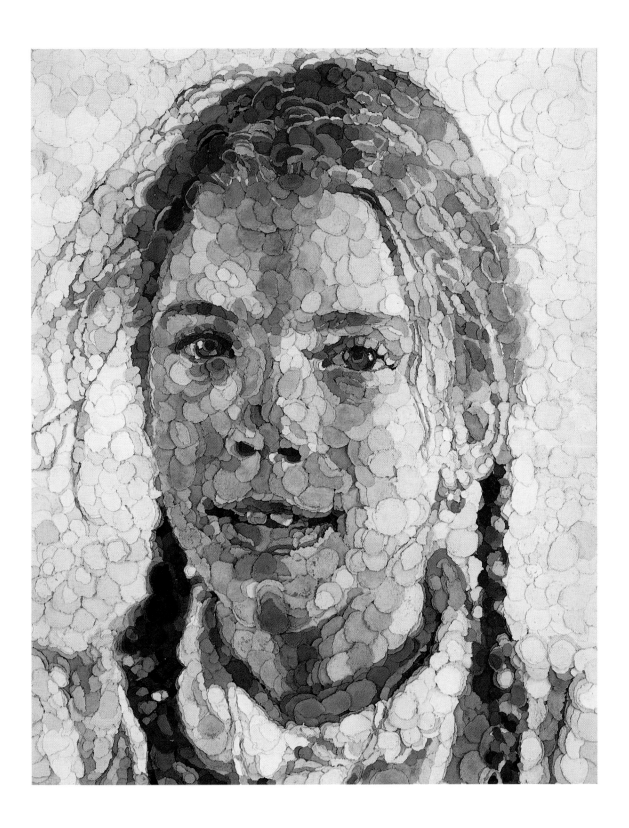

Georgia
1982, pulp paper collage on canvas, 48 x 38 inches
Private collection, New York

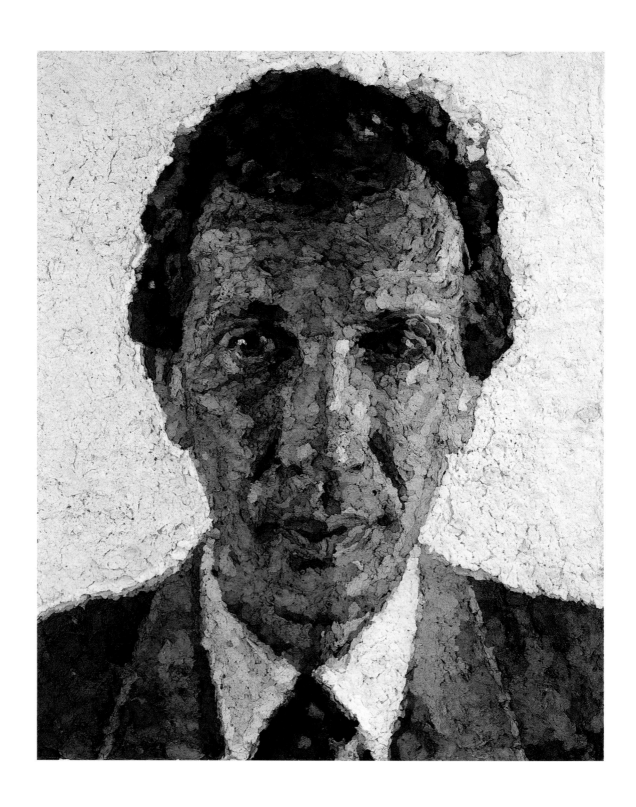

Arne
1983, pulp paper on canvas, 24¼ x 20¼ inches

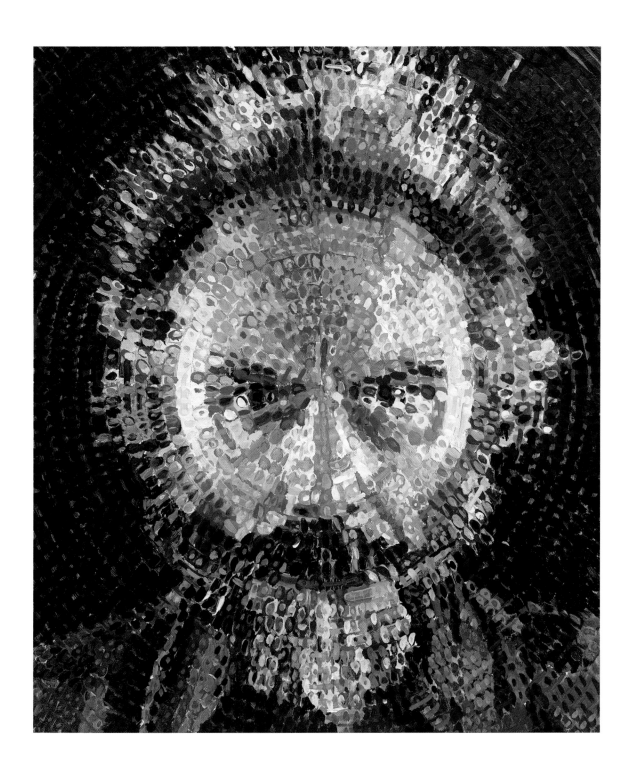

Lucas II
1987, oil on on canvas, 36 × 30 inches

Collection Jon and Mary Shirley, Seattle

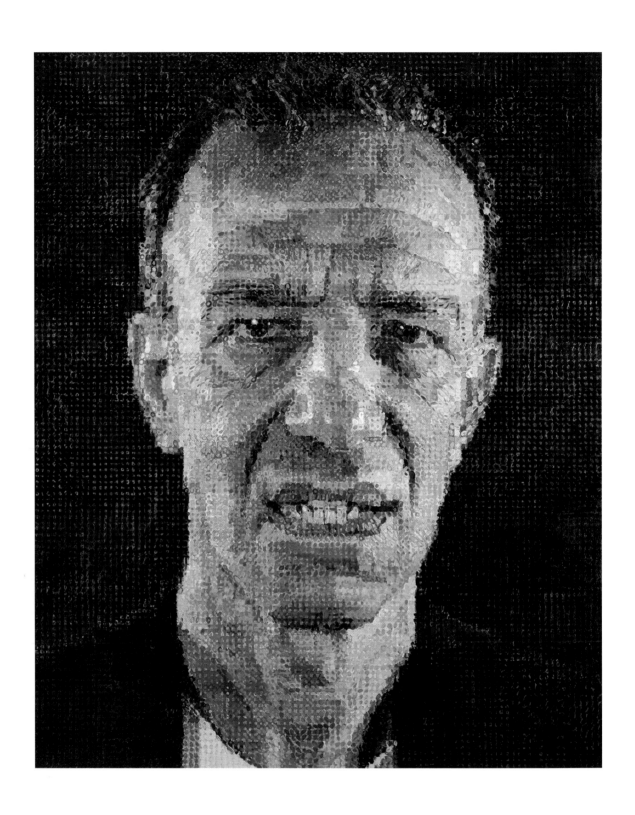

Alex
1987, oil on canvas, 100 x 84 inches

Collection of the Toledo Museum of Art, Toledo Art Museum

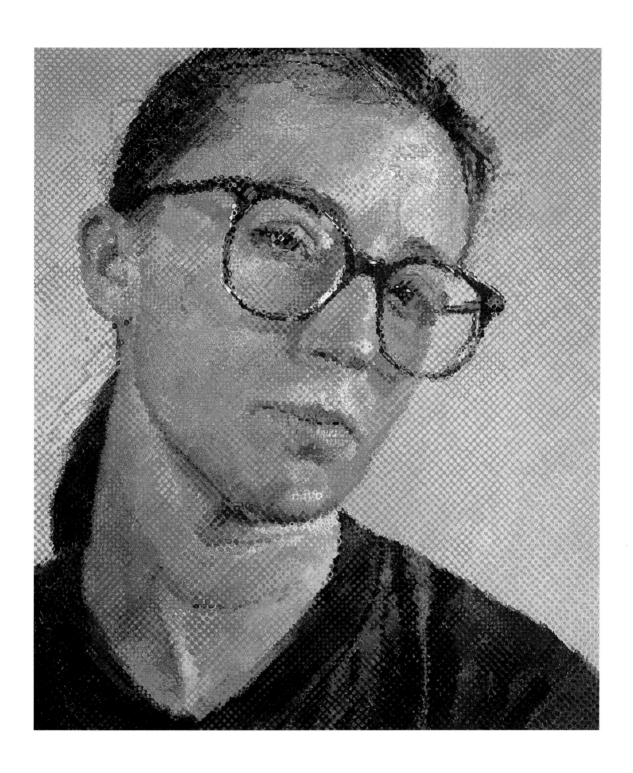

Cindy
1988, oil on canvas, 102 x 84 inches

Collection Camille and Paul Oliver-Hoffman

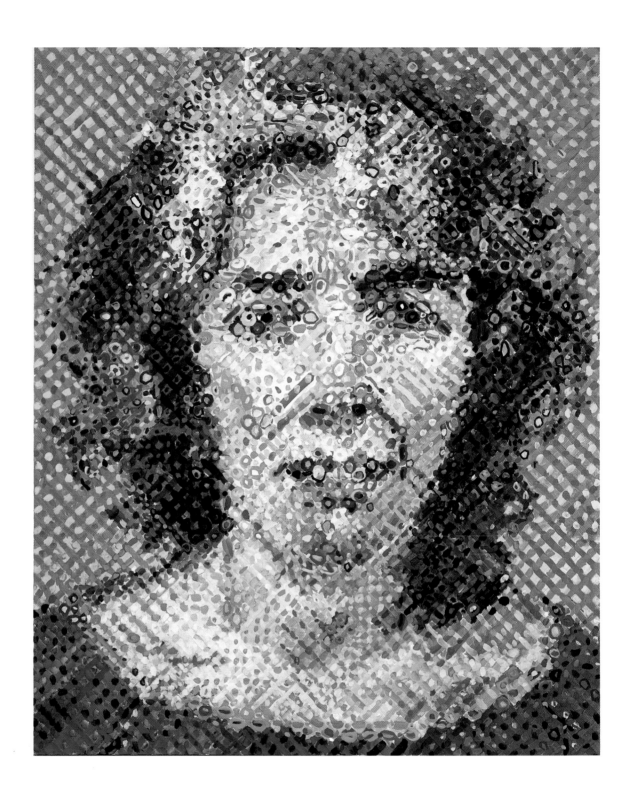

Elizabeth
1989, oil on canvas, 72 x 60 inches

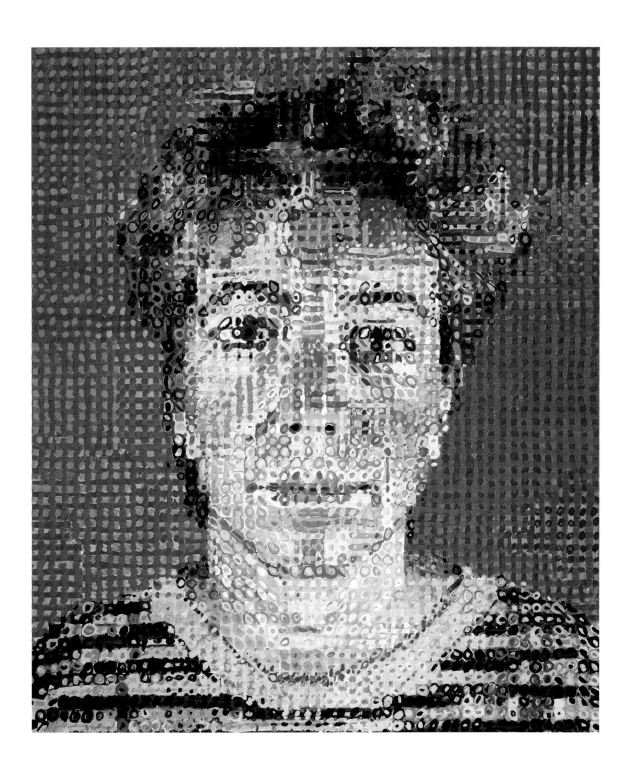

Judy
1989–90, oil on canvas, 72 x 60 inches

Collection Modern Art Museum of Fort Worth

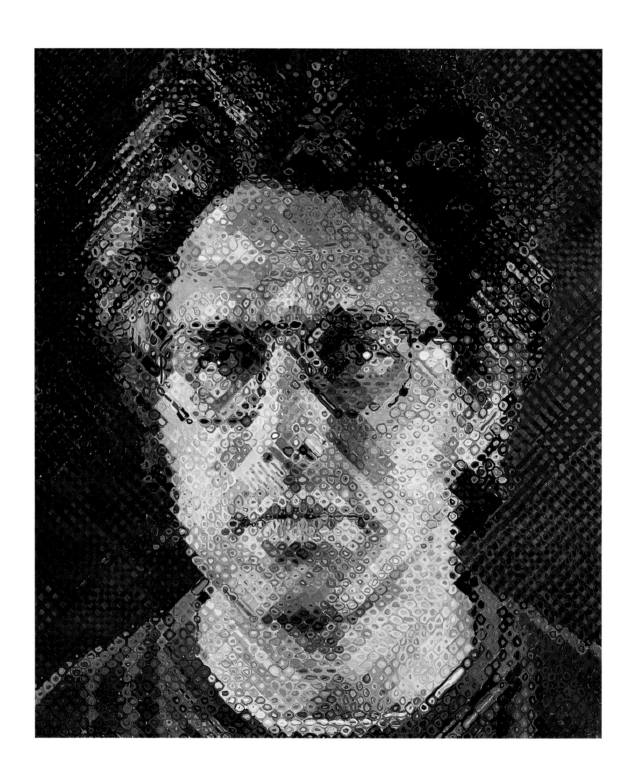

Eric
1990, oil on canvas, 100 x 84 inches
G.U.C. Collection, Deerfield Illinois

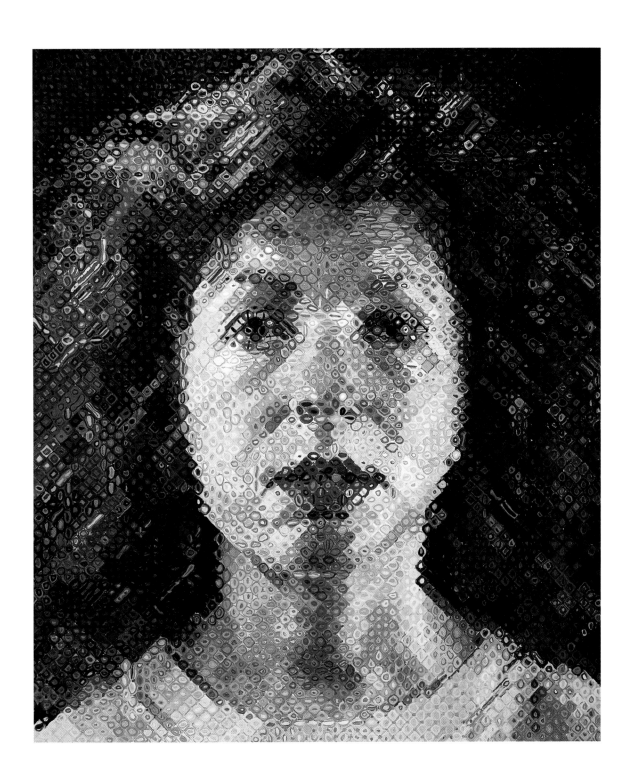

April
1990–91, oil on canvas, 100 x 84 inches

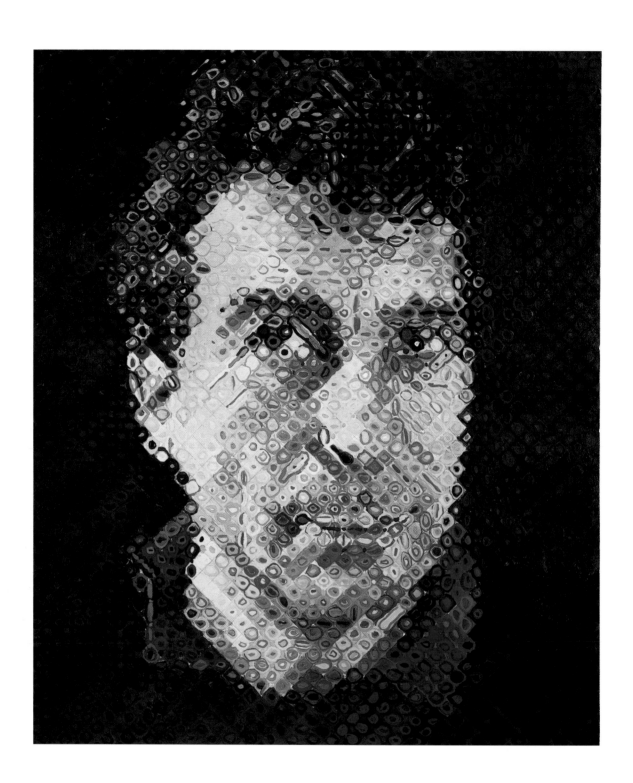

Bill
1990, oil on canvas, 72 x 60 inches
Private collection, New York

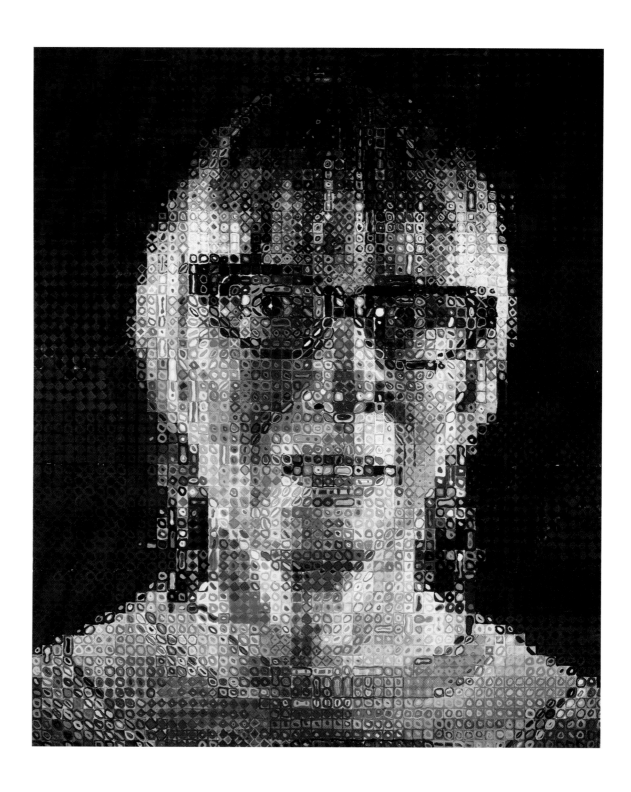

Janet
1992, oil on canvas, 100 x 84 inches

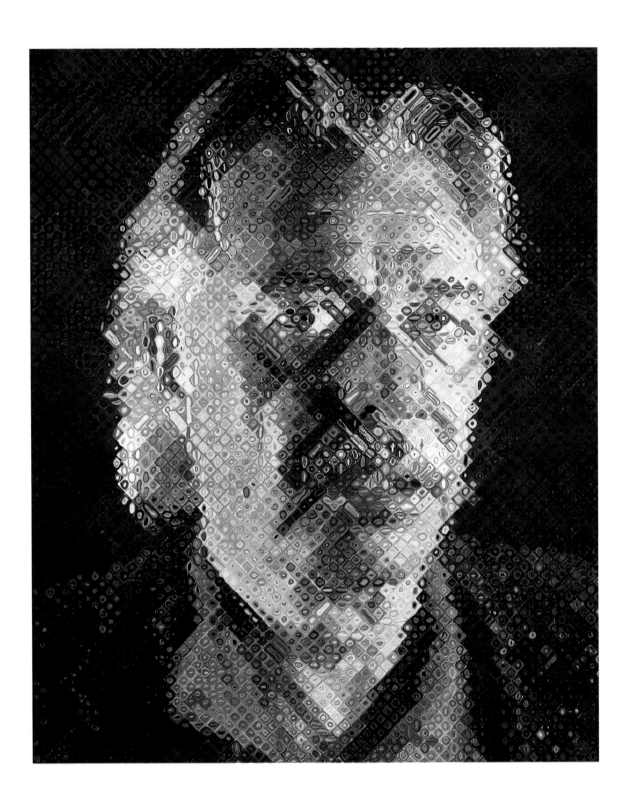

John
1992, oil on canvas, 100 x 84 inches

Collection of Michael and Judy Ovitz, Los Angeles

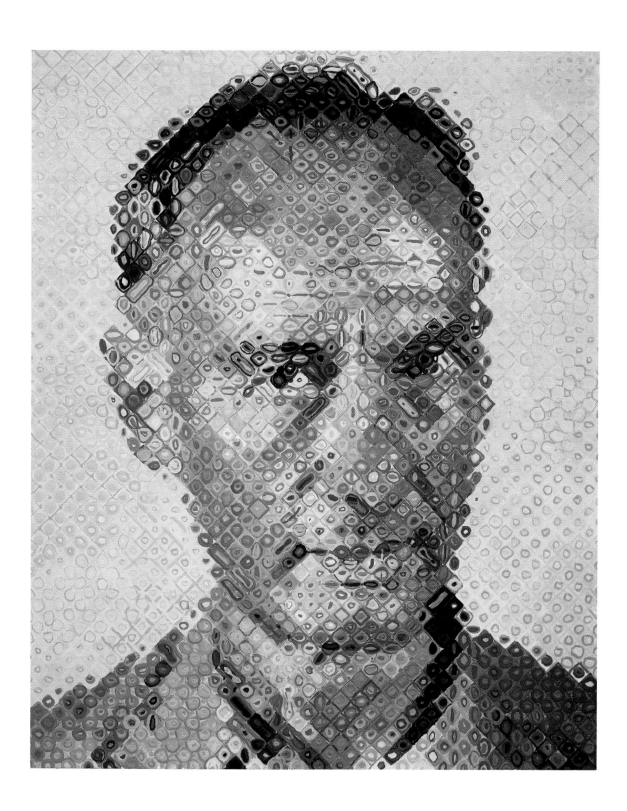

Richard (Artschwager)
1992, oil on canvas, 72 x 60 inches

Private collection, Los Angeles

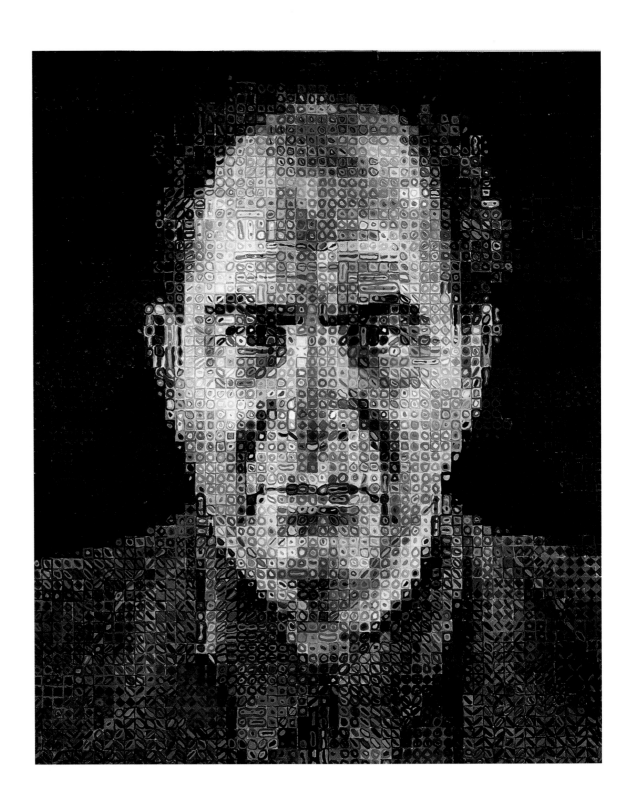

Joel
1993, oil on canvas, 102 x 84 inches

Private collection, New York

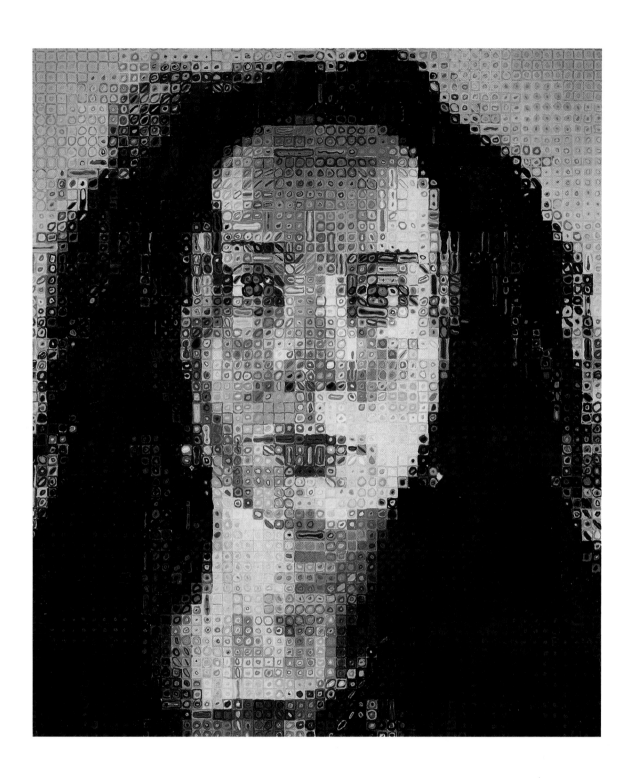

Kiki
1993, oil on canvas, 100 x 84 inches

Collection Walker Art Center, Minneapolis

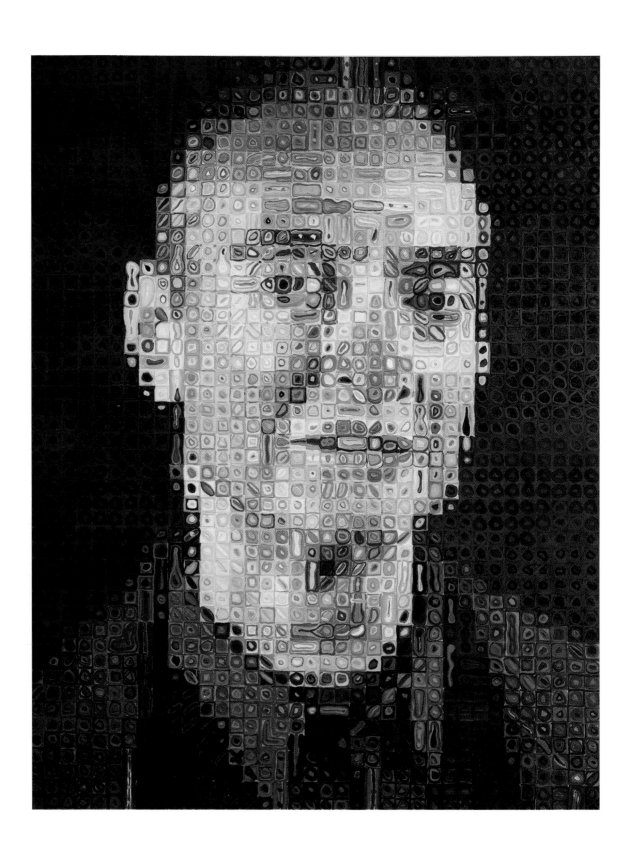

Roy I
1994, oil on canvas, 102 x 84 inches

Private collection, Los Angeles

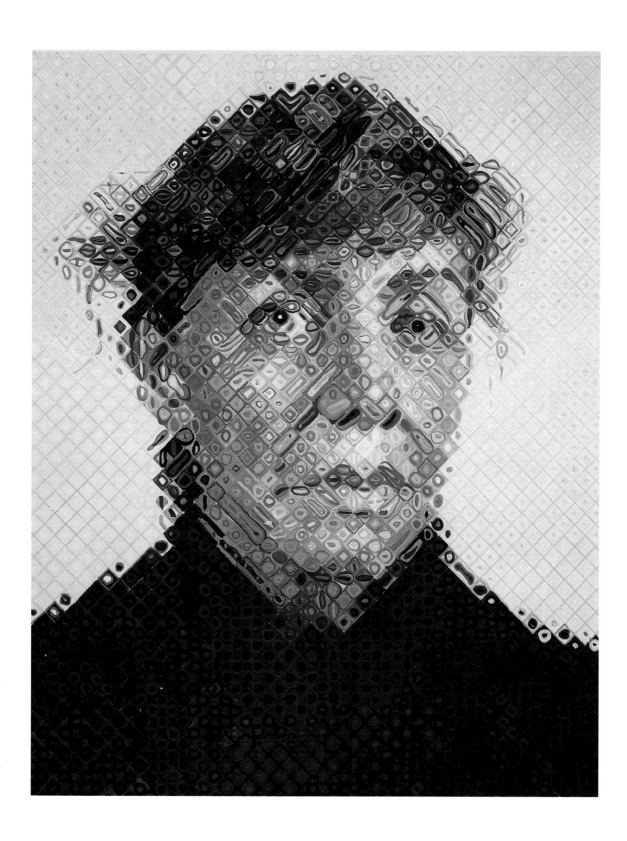

Dorothea
1995, oil on canvas, 102 x 84 inches

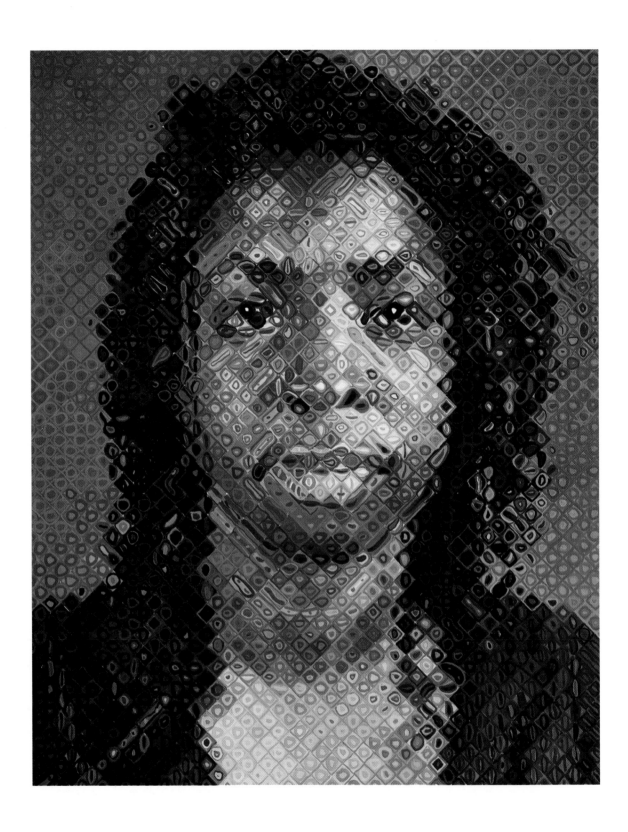

Lorna
1995, oil on canvas, 102 x 84 inches

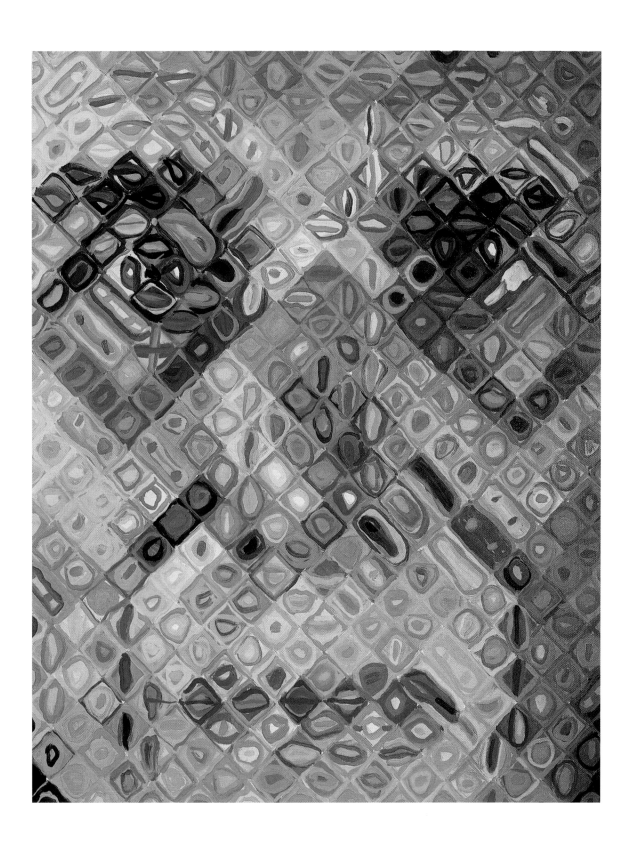

Paul II
1996, oil on canvas, 30 x 24 inches
Private collection Los Angeles

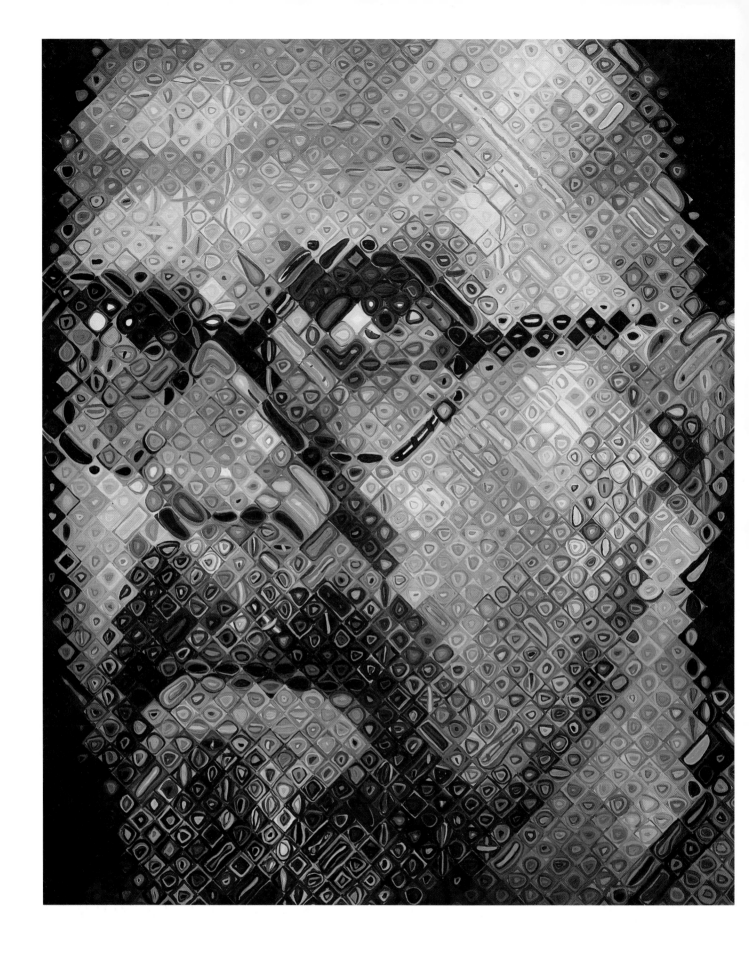

Self-Portrait
1997, oil on canvas, 102 x 84 inches

Private collection, New York

The portraits speak: Chuck Close in conversation with 27 of his subjects

Introduction by Dave Hickey

Edited by Joanne Kesten

Conceived, developed and produced by William Bartman

Designed by Judith Lausten and Renée Cossutta

A.R.T. Press, New York

The portraits speak: Chuck Close in conversation with 27 of his subjects
is dedicated to Jon and Mary Shirley

Editor: Joanne Kesten
Conversations organized and project supervised by William Bartman
Copy editor: Maggie Fogel
Design: Lausten/Cossutta Design, Los Angeles
Printing: Publishers Press, Salt Lake City

Special thanks to Bill Zules for his interview photographs

Distributed by:
Distributed Art Publishers (D.A.P.)
144 Sixth Avenue, 2nd Floor
New York, N.Y. 10013
1 800-338-Book

ISBN 0-923183-17-5 (Hard Cover)
ISBN 0-923183-18-3 (Soft Cover)

The publication of this book and its distribution through our D.U.C. Program
(Distribution to Underserved Communities) was made possible by a grant from the
Shirley Foundation, Bellevue, Washington.

Art Resources Transfer, Inc. was founded in 1987 in Los Angeles, California. Since its
inception it has been committed to documenting and supporting artists' voices and
work and making these voices accessible beyond conventional art spaces and out-
lets by establishing innovative methods of distribution and access. A.R.T. Press
books are based on an in-depth collaboration between artist, designer and editor.
Art Resources Transfer has recently relocated their programming to New York City.
and can be reached at:

504 West 22nd Street, 2nd Floor
New York, N.Y. 10011
tel: 212 691-5956 fax: 212 741-1356
e-mail: artresources@compuserve.com

Other A.R.T. Press books:
Kim Abeles
Between Artists
Vija Celmins
Jimmy De Sana
Judy Fiskin
Felix Gonzalez-Torres
Mike Kelley
Allan McCollum
Anne Scott Plummer
David Reed
Laurie Simmons
Pat Sparkuhl
Andrew Spence

Videotape *Film Strip* by Laurie Simmons

In memory of Nancy Graves and Roy Lichtenstein

Contents

Foreword

How does one describe five and a half years of one's life. Originally Chuck Close was to take part in conversations with three of the subjects of his paintings. The idea grew wildly until it included conversations with twenty six subjects and this project which started out as a conceit for creating a larger book than our normal A.R.T. Press publications which always contained only one conversation, had evolved into what now in many ways functions as an oral history of late twentieth century American art.

It took almost three years to complete all the conversations and another two and a half years to edit them. Early on I wondered if the original idea of our books, a conversation between two artists, could be extended to a longer format and still maintain a sense of intimacy in each conversation. Our compilation of the first twelve books, *Between Artists*, had not been published yet. So in addition to other concerns, there was no assurance that anyone would be interested in a collection of artist conversations.

As things progressed and the conversations seemed remarkably interesting to me, I remember often wishing that the conversations had been broadcast live on the radio so that I wasn't the only one who sat in on the complete sessions.

I remember repeatedly trying to schedule a conversation with Nancy Graves who enthusiastically scheduled dates and was forced by her illness to cancel them.

I remember meeting Paul Cadmus, and hearing him tell stories about his friend "Eddie," and discovering when I asked him "Eddie who?" that he was talking about "Eddie Hopper, of course."

I remember how the ritual of one or two conversations a month over lunch began to take its toll on both Chuck and myself as we both wondered if there was anything left to talak about and began actively recruiting the presence and participation of others who we hoped would add their two cents.

I remember listaening completely enchanted by Dorothea Rockburne as she explained to Chuck and myself the mysteries of the intersection between science, mathematics, and her art.

I remember the pleasure of sharing time with Alex Katz, Richard Artschwager, Roy Lichtenstein and all the others whose art had helped form the way that I looked at the world.

I remember how I, who could barely operate an electric can opener when we started this project, became almost uncomfortably dependent on the two intrepid tape recorders that were used for every one of these conversations. I found myself talking to them like old friends after each conversation, thanking them for making it through one more session and assuring them that when the last conversation was over they would be left in peace on a comfortable shelf and never be required to labor so intensively again.

I remember feeling completely spent and at the same time at loose ends when the long anticipated final conversation ended. It was with Leslie Close.

One of my most important memories in retrospect was the incredible commitment to life, the talent, and generosity that all participants exuded not only as artists but as full participants in the world that surrounded them. They had families, children, dogs, lovers, intense feelings about almost everything that one could imagine. I also remember how for the first time in what we call the mainstream "Art World" women artists were at last given an equal voice within, what to me, had always been uncomfortably a "man's club." It felt good that the world would see how many remarkable women artists were represented in this project. It would look more like the world that we all live in.

I remember elation, sadness, pain, love, anger, frustration and every other possible emotion that has passed through my life over the past five and a half years. But in spite of all the travails of life, I will always remember and treasure the journey that I was so fortunate to share with Chuck Close, Jon and Mary Shirley, Joanne Kesten, Bill Zules, and the wonderful cast of characters that are brought to life in these pages.

I feel totally and completely indebted in the most profound sense to everyone that participated in this book and only hope that in some small way this project will function as another step in the breaking down of the barriers between the perception of what an artist is and the discovery that all of us have so much more in common than our fears of each other allow us to see. We are in fact just a tiny moment of time as we all rocket through space and time in the ever expanding universe. We need to hold

on to each other for dear life and face the fact that we need each other in very profound ways and that art is something that belongs to everyone, not just those that can afford the high price of admission to our museums. That the barriers of prejudice by gender, race, physical appearance, sexual orientation or any other perceived or real difference, have no place amongst the true beauty, strength of ideas, and vulnerability that artists share with us when they turn over the results of their labor and creative process. And in spite of all the trappings of elitism in the art world, these artists desperately want to share this dialogue with everyone, with no one being left out in the cold to only look through the windows of our cultural institutions at the what they have created.

I would like to dedicate my work on this book to my dear friends, Jon and Mary Shirley who allowed this dream to come to fruition, to Chuck Close who allowed me into his life, to my dear friend Felix Gonzalez-Torres who continues to inspire me, to my friends, partners, and the designers of all fourteen of the A.R.T. Press books, Renée Cossutta and Judith Lausten, to all of the present generation of artists who I hope will find real inspiration and hope in the pages of this book as I have experienced in the making of it, and finally to my daughter Grace who I love more than anyone else in the world.

William Bartman
New York, November, 1997

Preface and Acknowledgements

While an art history student, my favorite activity was reading artist's words, whether in the form of unpublished correspondence in files at the Whitney Museum of American Art—I particularly loved Stuart Davis's letters—spending days with the materials at the Archives of American Art in Washington, DC, or reading the letters Chuck and other artists have written to me. Knowing that Chuck is a great conversationalist and a *raconteur*, I sensed that this project would be an exciting one. It has been an honor to contribute to the publication of this volume of artists' words, which will now be available to the public. The fact that *The Portraits Speak* will be distributed to public libraries across the country, free of charge, dramatically increases the potential number of readers. The range of the artists included in this book is a testament to Chuck's all-encompassing personality. The discussions were divergent—sometimes nostalgic, sometimes forward-looking, sometimes political, and sometimes downright gossipy. I did my best, with the help of my colleagues, to remain true to the spirit of each conversation. At least fifty percent of each conversation had to be edited so that the book would be manageable in size. Deciding what to keep and what to delete was sometimes agonizing, sometimes easy. Repetition exists in some stories, especially among Chuck's former classmates at Yale, but these redundancies remain only when I thought the retelling brought another point of view or dimension to the recollection of the time. My aim was to keep the spontaneity and intensity of each conversation. Since the thread of this book is Chuck's friendship with each sitter, the arrangement of the conversations posed a dilemma, but the framework emerged naturally—the conversations are arranged in chronological order based on when Chuck painted them. As a result, the first section of the book concentrates on the Yale, post-Yale days of the late sixties and early seventies and the emergence of SoHo. The conversations blend into one other as Chuck weaves his tale of the New York art world.

This book exists because of the determination of many people. Clearly the commitment of Bill Bartman, Chuck Close and the artists are at the center of this project, but it is the people behind the scenes who I would like to thank. First is Maggie Fogel, my copy editor *par excellence*. Without her persnickety attention to detail and love of the mechanics of the English language, the informal, chatty nature of the conversations would be lost to dangling participles and sentence fragments, not to mention "huhs," "likes" and "ehs." She made the endless stream of faxes, e-mails, and telephone conversations fun. Judith Lausten and Renée Cossutta designed this book. Their association with ART Press is longstanding, and we were pleased that they designed this book. Three wonderful research assistants, Amie Lam, Ana Picanco, and Mary Owen spent hours with microfilm and art indexes clarifying references and checking and investigating stories related in these conversations. Noelle Soper and all of her colleagues at PaceWildenstein Gallery were supportive of this project, and always eager to supply visual and biographical information whenever asked. Finally, my family needs to be thanked for their support of my work and their exceptional tolerance to living with piles and piles of paper and transparencies, slides, and books overflowing from the boundaries of my office into our lives. It was sometimes more than even I could live with. We can finally clean up!

Enjoy your eavesdropping on these conversations.

Joanne Kesten
Los Angeles, CA

Introduction

Dave Hickey

We must remember this: The handsome lines of type that march down the pages of this book do not represent writing. The sentences we read here were not written; they do not derive their authority from the domain of writing or aspire to its disembodied, infinitely regressive atmosphere of intertextuality. These texts are talk-in-type. They represent the oratorical world of vocal noise, facial expression and body language—the physical dance of conversation that may be inferred from the phonotext that, if we listen, we hear as we read—from the live sociability that we infer from the jolts and contingencies that tell us we are not reading writing.

More specifically, these texts represent talks between Chuck Close and some of the people whose portraits he has painted in the course of his long career—colleagues, contemporaries, family and friends—all of whom, in one way or another, inhabit Close's parish of the art world and share some aspect of his trajectory through time and space. So, like the portraits themselves, these conversations are occasions for remembering; they begin, in most cases, with some discussion of Close's portrait, the circumstances of its making and the consequences of its having been made, then circle out from there; as such, they are aural glosses on a visible event. Each conversation constitutes a tangible exchange of attitudes that is subsequent to, informed by and analogous with the tangible exchange of attitudes that inheres in the peculiar conversational logic of portrait-making itself.

In this sense, the conversations in this book and the photographs of the portraits that accompany them stand at a similar remove from their source. In both cases, there is an original in the realm of the senses, and what is represented, first and foremost, is that tangible, non-linear occasion. So these conversations, like Close's portraits, are

best viewed from a variety of distances. Their real interest lies less in what is said than in the way the painter and his sitters respond to one another (as the portrait and its subject respond to one another) the linear, discursive content of both the portraits and the interviews is only available at a distance. Only at a distance does the painting begin to look like a picture. Only at a distance, in footnotes, does the talk begin to sound like writing. At close range Chuck Close manufactures the least discursive of portraits and his sitters make the least pedantic brand of conversation.

• • • •

There are larger reasons to insist on the distinction between talk and writing here, however. Most critically, the talk in this book, might mark the resurgence of interest in the sustaining function of talk in the realm of art. After years of attributing art's validity and vitality to disembodied psychological and economic forces, the intricate filigree of attitudes and events that becomes perceptible as we read this book, along with the complex interaction of interest, desire, vanity, and aspiration that plays itself out on the pages, might encourage us to reconsider the function of art as a social artifact amidst the commerce of opinion. Or it might mark nothing more than a cultural moodswing, since the chasm that divides talk and writing in contemporary culture runs through the history of western art from classical antiquity up into the present. It emblematizes the ongoing, unreconcilable agon between the living domain of talk, paint and color and the discursive domain of writing, drawing and concept.

At any given moment in the history of art, the relative priority of talk and writing, of painting and drawing, of embodied color and disembodied concept, defines that moment and characterizes its discourse—but with this caveat: Art can live in the world without the adornment of writing; it cannot live without talk. Even in ages, like our own, that ignore talk's importance and deny the art's social nature, talk is indispensable. As Montesquieu remarked, the empire of climate is the empire of all empires, and talk constitutes the climate within which the objects of art have always flourished in the west. Talk's tangible ephemeral atmosphere provides the oxygen of art's social life.

The domain of writing, on the other hand, constitutes art's mausoleum. It preserves tangible, social objects of art at one remove, as names and lists of attributes, as representations absented from the present and located in the history of discourse with footnotes; it preserves the work as words but it does preserve the talk that gave it life. The talk is lost in physical memory, obliterated or changed utterly as it is recodified in

historical writing. Without talk, however, there would be no writing—as, without objects, there would be no representations—as, without society, there would be no culture. In the beginning, everything is social: talk in the presence of objects, in the memory of objects and in expectation of further objects. All works of art that enter the intricate, ephemeral domain of social esteem do so in the atmosphere of talk and are subject to its climate. They live and change in that atmosphere as it changes like the weather, as spoken words die into the air, only to be replaced by more words, until the words stop being spoken. At this point, the object stops being art and becomes a thing again, an historical artifact, as it was before the talk began.

So if we could somehow eavesdrop on the long, desultory, tangible babble of human beings talking about objects of art in their worldly presence, we would know the true, raggedy, contingent history of art.

But only if we could. Because, even though the edict came down from the bishop in writing, on behalf of the prince, ordering a work to be executed by Fra Angelico, outlining its materials and iconography—and even though the receipt for the work was signed by the artist himself—the documentation of that edict and that receipt, foot-noted in a written work of history, accompanied by a color representation of the object, tells us nothing about the textured circumstances of the work's creation or survival.

The single irrefutable, unprovable fact—the thing we know and cannot document—is that somewhere, in the beginning, in some withdrawing-room or cloister, two or more connoisseur priests, in conversation, decided that Fra Angelico rather than Fra Michael should paint Saint James. We know, as well, that subsequent to its making, faithful and the thoughtful observers, standing before Fra Angelico's creation, found it worthy and said so to one another—that young artist-priests, in the studio and in the refectory, decided in conversation, that what Fra Angelico had done was worth emulating, worth surpassing. We know, as well, that years later, after the bishop, the prince, the artists and all those other faithful and thoughtful conversants were dead and silent, subsequent conversationalists decided that Fra Angelico's work was well worth saving, and thus it was.

The difference between what we know and what we can document, unfortunately, divides the world of talk from the world of writing, and all those tangible utterances, with all their quirks, nuances, gestures, rituals, and power relations are lost to us. Today, only fugitive scraps of journal and scattered letters testify to the millions of conversations among the thousands of living constituencies that created and sustained western art from the fourteenth through the eighteenth centuries. With a few rare exceptions,

like the Carraccis' acerbic commentary in the margins of their copy of Vasari, the war between talk and writing has been won by writing.

Even so, we are still assured of talk's power and its primary hegemony by the continued existence of the objects as we stand before them in the Met or in the Louvre or in the Uffizi, and obsessively, relentlessly continue that conversation, reincarnating those lost social adjudications, extending their domain. We know the lost history of talk, because our own talk is unimaginable without it, and knowing the differences between our talk and the writing of our time, we can sense the difference in theirs. We also recognize the echoes of those lost, primary conversations about art in the language of Baudelaire, Wilde and especially Diderot, who invented art criticism by inventing occasional writing to communicate the ongoing talk about art in Paris to correspondents overseas. This written talk would enter the domain of occasional publications as a middle style: the epistilatory manner of periodical criticism, which aspires to the ebullient status of talk with a slightly longer shelf-life.

Today, of course, even that middle-style of written talk has fallen into disrepute and only a few aging adults of my own generation still practice it. Today, it is all writing and no talk; all representation and no incarnation; all culture and no society; all order and no contingency. So this is what this book offers us: a glimpse of the practice of art as participation in a social field, before it marks itself as culture, over the last thirty years. The ground charted here is only a part of the field, of course, but all this talk has ragged edges, as all talk does, tattered peninsulas of interest and enthusiasm from which we may infer the proliferating complexity of the rest.

So if we could supplement this book of talk from the people who populate Chuck Close's portraits—those denizens of Yale and the front-room of Max's Kansas City— with a book of talk from the denizen's of the Factory and the back-room at Max's who populate the portraits of Andy Warhol, with a book of talk from those more suburban glitterati who populate the portraits of Alex Katz, we would really have a sense of something—a sense of the enormous, disheveled, social complexity of American art as practiced during second half of the this century—and it would resemble nothing written in a book of art history. It would sound like the cruel, brilliant, happy, brave, stupid atmosphere in which art lives and dies.

◆

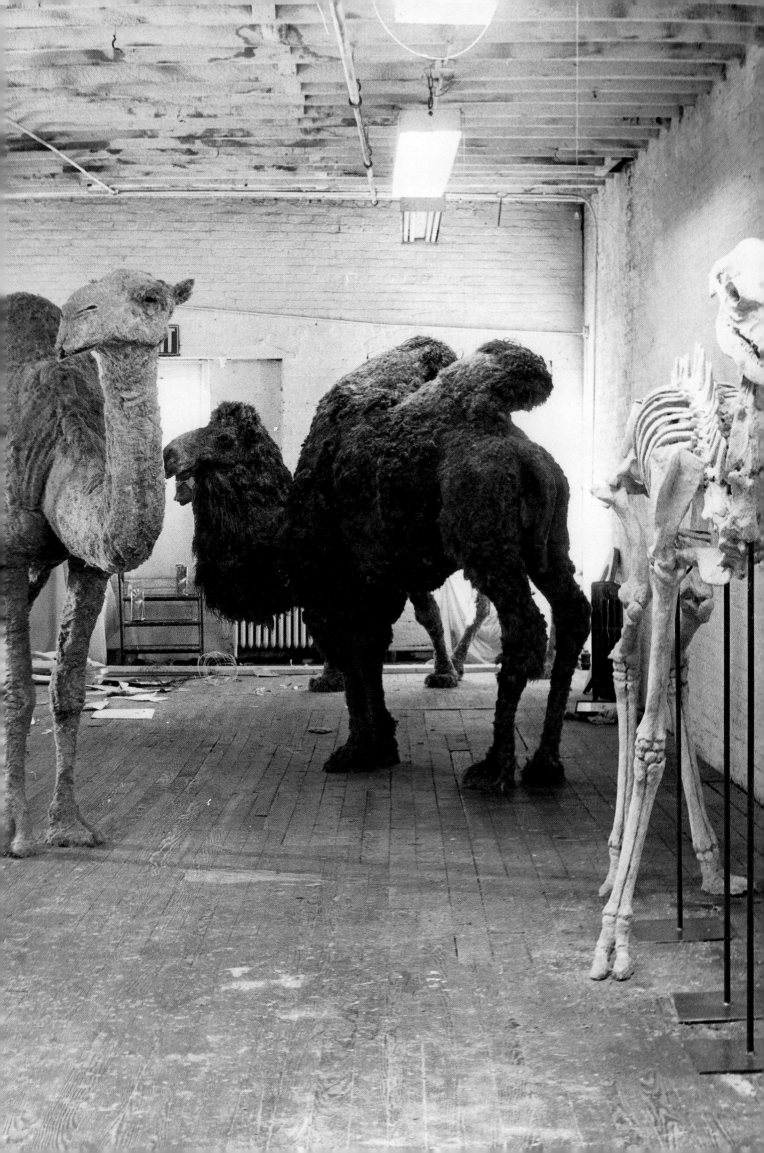

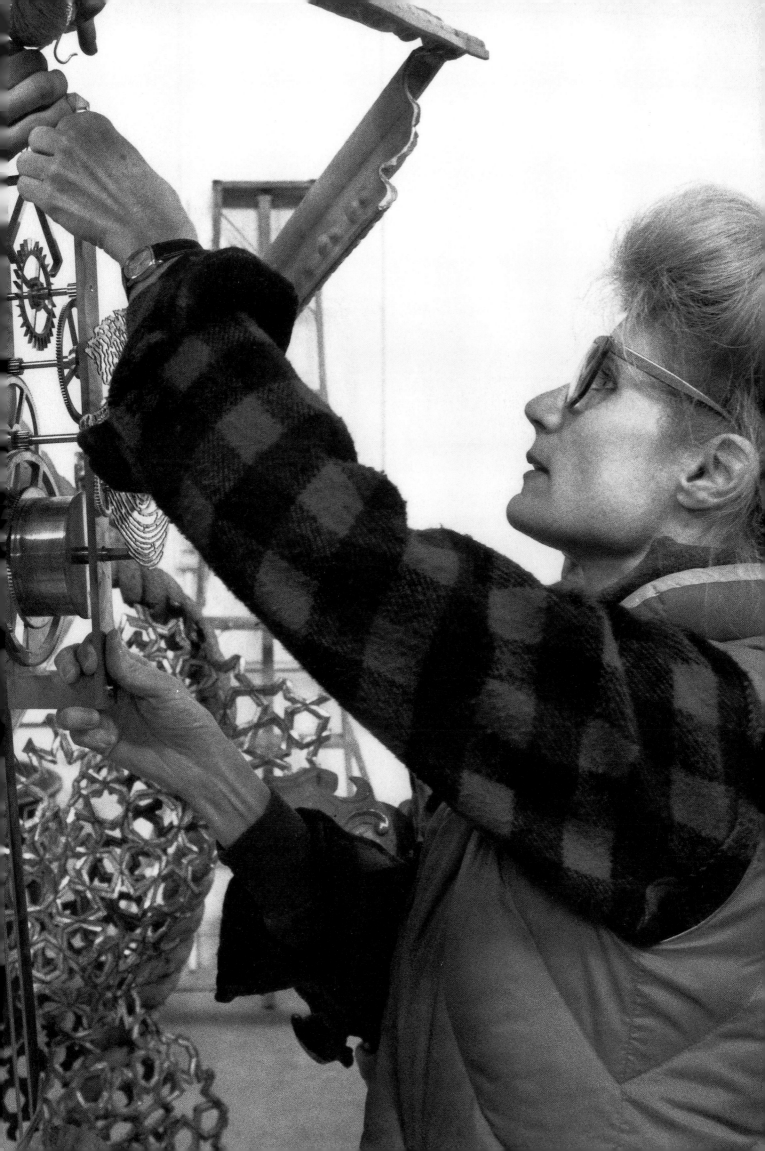

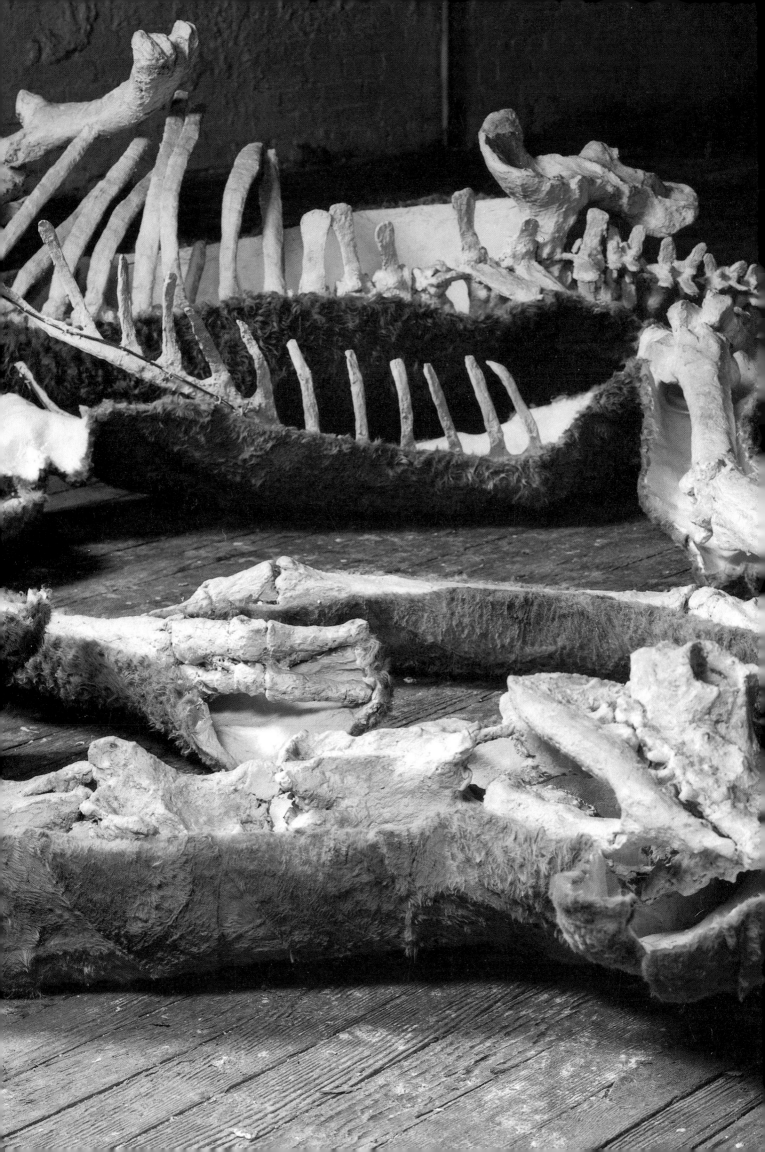

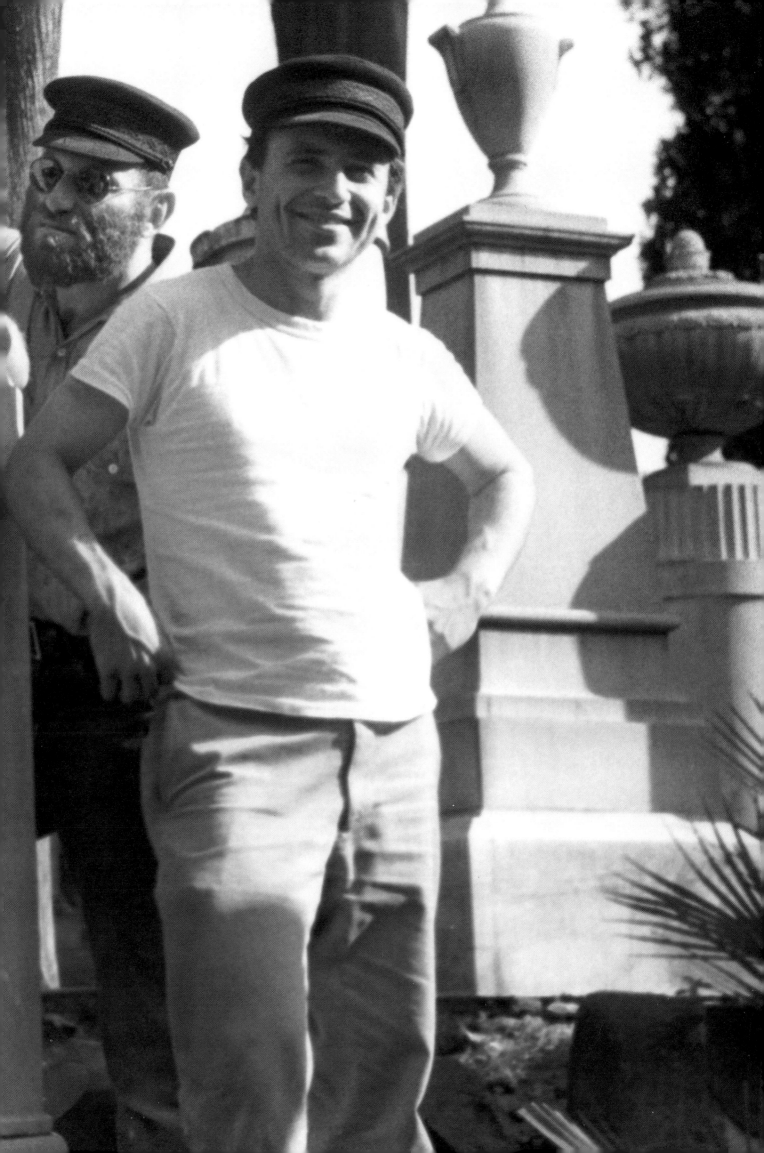

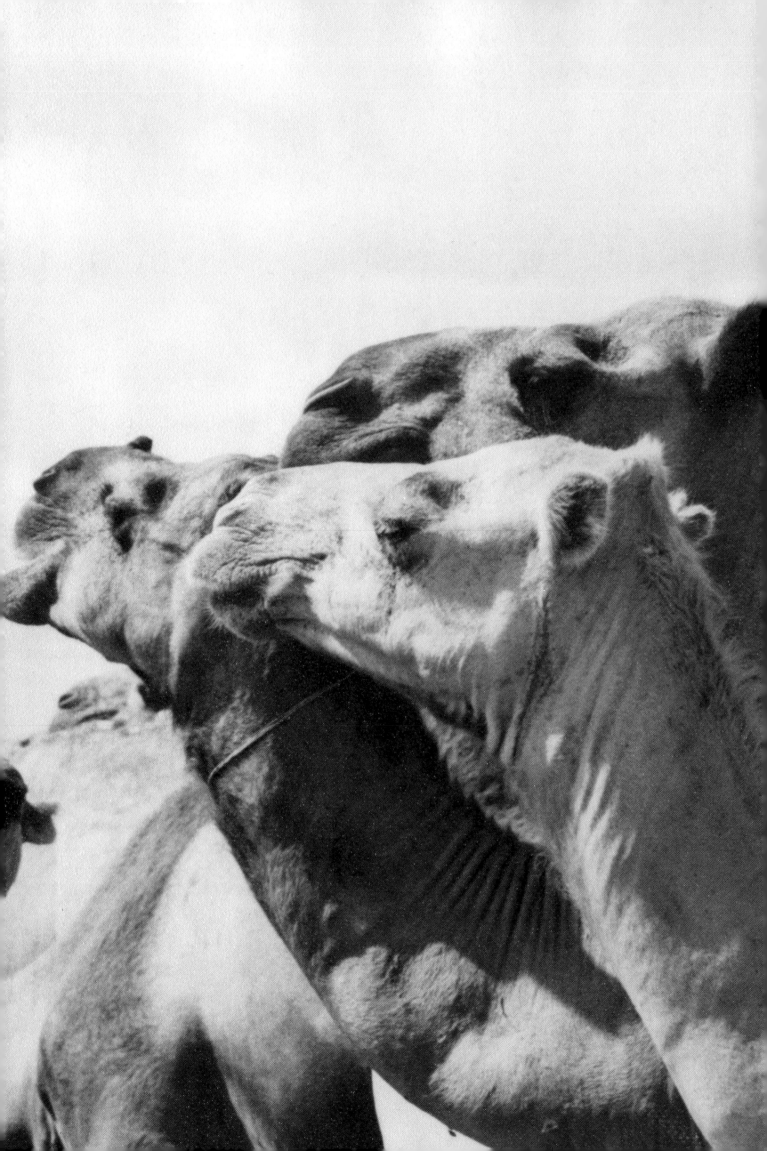

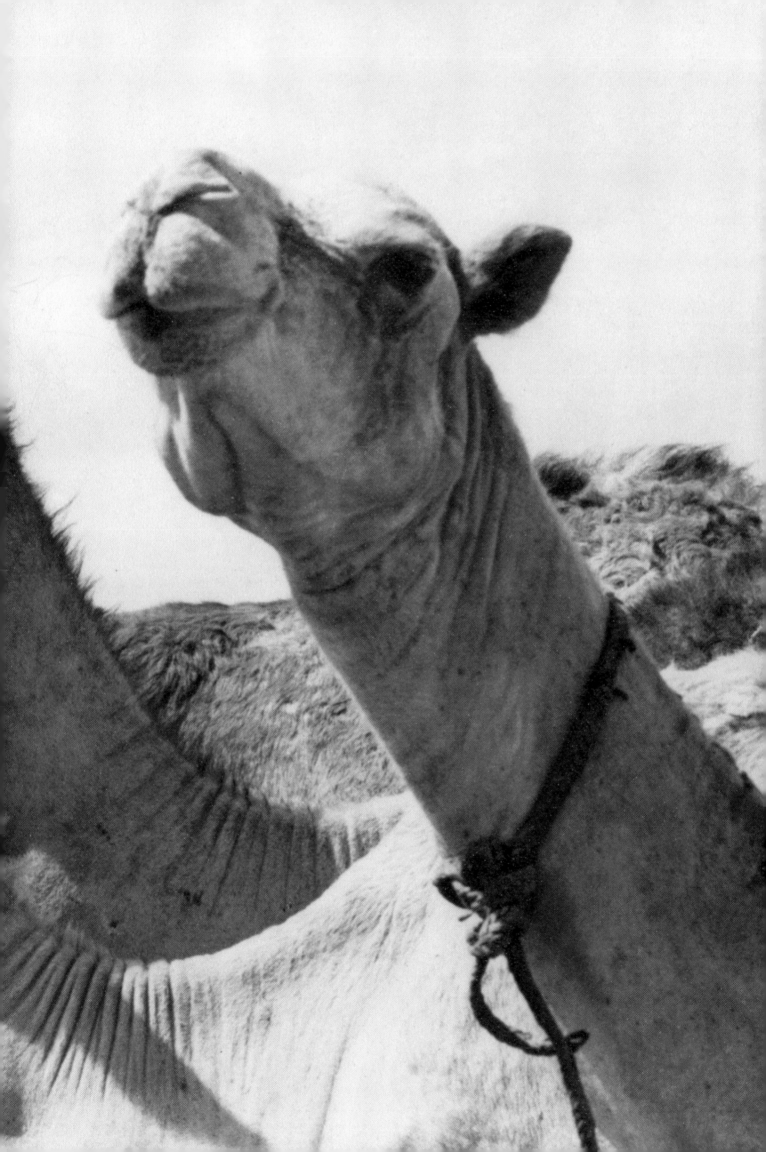

Nancy Graves

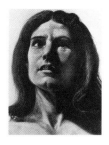

For a book of tape-recorded conversations made in my studio over the last few years, it is odd to begin with an interview not made with me but one that Nancy Graves made twenty-seven years earlier with the late drawings curator Paul Cummings, also a friend of mine.

Nancy, a friend since 1962, was one of the voices I most wanted in this book. Ever since Bill Bartman and I conceived this project, I intended to begin with Nancy, as she was the subject of the first portrait I made other than my own. Her early and tragic death from brain cancer seemed to make that an impossibility. Over the course of the last two years of her life, we tried several times to schedule a lunch at which we could record a conversation. Each time, because of failing health, she was forced to cancel. It became clear that it was not going to be possible for her to participate, and I felt that, with the struggle in which she was engaged and all with which she had to cope, this book should not be another burden. However, she insisted that she wanted to be included. Finally, we decided that I would write down questions that Janie Samuels, her long-time assistant, would read to her and then transcribe her responses, accomplishing this in short sessions as Nancy's strength would permit. She died before this could be achieved. In my conversations with Janie Samuels following Nancy's death, I was told of the existence of this unpublished interview that is now in the possession of the Archives of American Art. The time period and material included in this interview almost perfectly duplicates what I wanted to cover. It includes the time in which we were in graduate school together at Yale and covers the period when we were both in Europe on Fulbright grants. We moved to New York at approximately the same time, and remained close friends. I helped her make some of the early camel and bone pieces and was often called upon to help carry these massive sculptures up and down the six or seven flights of stairs of her Mulberry Street studio.

I am pleased to have the opportunity through this "alternative interview" to include some evidence of Nancy's strong intellect, rich conversational style, and passionate commitment to her work. I miss her.

Chuck Close, November 1997, New York City

• • • •

New York City, August 18, 1972, tape recorded interview with Nancy Graves at her studio, 164 Mulberry Street, conducted by Paul Cummings for the Archives of American Art

© *Archives of American Art, Smithsonian Institution*

Paul Cummings: **You were born in Pittsfield, Massachusetts. Did you grow up there, and did you come from a big family?**

Nancy Graves: I came from a small family. I have one sister who is six years younger than I am. I went to public school in Pittsfield until I was twelve, and then I went away to school.

Paul: What was growing up there like?

Nancy: It was a childhood in the country. My grandparents were a well-established New England family and had an estate of twenty-five hundred acres near the center of the town. My

grandfather landscaped the estate. There was a pond, and he made a trout stream. He had a cabin built in which various trophies of his hunting and fishing expeditions were displayed, as well as photographs of the expeditions and remnants of my grandparents' travels, which were worldwide. They were my paternal grandparents. What I remember most about my early years are these experiences: picnics, fishing, canoeing, playing pool in the cabin, and sleeping there in what seemed to be the wilderness. I went to two public schools. One was called Redfield, and the other was the Dawer School.

Paul: Why did you spend so much time with your grandparents? Did you live close by?

Nancy: Their house was in the middle of the city, and my parents lived about a mile away. Actually, I didn't spend that much time with them. I may have been to the cabin or the house in this large acreage once every two weeks in the summer. They wintered in Florida, and they often traveled.

Paul: Did you make drawings as a child?

Nancy: I must have, as did most children, but most of them were destroyed. I remember certain drawings that I made at age five or six of the sun and trees and houses: the normal things that one was told to do in a classroom situation. I remember a frigate ship that I drew in the fifth grade that was very fine in terms of the details. Evidently that was important to me. When I was fairly young, eight or nine years old, I went to a school in the Berkshire Museum. That was where my father worked. It was a museum of art and natural history, and it was founded by my father's sister's husband's family. I went to classes to study painting. I remember from some of the work that survived for a few years that each of them was detailed in a van Eyckian manner, which is also true of my work today. I remember a cocker spaniel head that I made with an exactitude that was somewhat unusual for a child.

Paul: Did you do that naturally or because you were taught?

Nancy: I did it with my own ability, through my own choice. All of this must have been of my own choosing.

Paul: Were your parents not interested in what you were doing?

Nancy: All of my family was very much against my interest in art. They felt that one should learn to play the piano and make paintings as a—

Paul: —Sunday activity.

Nancy: Right, as a Sunday afternoon activity but nothing beyond. Although my paternal grandfather was a painter of sorts, he was the most disturbed by my interest in studying art. I think he had a Germanic orientation as to what a woman should be allowed to do, and art did not fall into what he considered an appropriate category. I think that to be an artist was a little bit illicit for this son of a Protestant minister. He felt that I would have problems of a moral nature.

Paul: It was off the straight and narrow. What were the schools like that you attended? Were you involved in school activities?

Nancy: I can't remember very well. I was a good student—I always received A's. I remember one experience in the sixth grade, which was my last year in public school. I brought home

a report card, showed it to my parents, and then to my grandmother. Her remark was, "How monotonous." At that point I was wondering exactly for what I should be working.

Paul: *That's extraordinary.*

Nancy: Well, she was rather outspoken. I'm sure, on the other hand, she was very pleased that I had achieved this.

Paul: *Were you involved with extracurricular activities?*

Nancy: There were no extracurricular activities when I went to public school. I joined Girl Scouts. I remember that in one year I earned twelve merit badges and a curved bar, and you were only supposed to earn three per year. Anyway, I did my Girl Scout bit. All of that bored me, including church and Sunday school. What else? I had to go to dancing class, and I had a small circle of friends. I was interested in music, but, unfortunately, I studied the piano for only a year. I read voraciously.

Paul: *What did you read?*

Nancy: In the fourth grade I read everything on Napolean and George Washington Carver. Of course, you have to understand that the hometown library didn't have that much material. I remember that I had read all the Nancy Drew mysteries. I had my tonsils taken out when I was nine, and that year I read *Little Women*.

Paul: *Were there cultural activities at home? Music? Books?*

Nancy: Sure there were books. My father and my mother sang operettas and classical songs, and my mother played piano.

Paul: *Did you identify with your grandparents in a special way?*

Nancy: I sometimes realize a strong identity with my paternal grandmother. For example, there's a photograph of me that was taken when I was filming in Morocco in 1970. I was standing on a hill, wearing an Edwardian jacket with a long flowing skirt, my hair blowing out behind me, and an Aeroflex [camera] on a tripod in front of me, and there were about a hundred camels in the photograph. When I saw it, I thought, "My gosh, I'm doing the same things that my grandmother did," which meant going to the ends of the earth. But for what reason really? I mean, in terms of endurance, I chose one of the most difficult situations as a film location that I possibly could, but recalling some of my grandparents' experiences, I wondered exactly what I was doing.

Paul: *Why did they travel so much?*

Nancy: Well, I have a very curious New England establishment family. One of my immediate ancestors was Cotton Mather. There's a very strong ministerial line in the Graves family of which I am very much a part in personality. My grandfather was trained as a lawyer but gave up the practice of law. My grandmother had an inheritance, so consequently they had the time and the means to do whatever they wanted. He entered state politics, as did she, and they participated in many civic activities. They traveled perhaps two or three months out of every year, which was customary for people who didn't have to work, and consequently they went practically everywhere. I've found relics of their travels. For example, when I went to Morocco, I was given a gun that my grandfather had gotten while he was there, and I have clothing from China

that they purchased when they were there in the thirties. My father went to Russia with them when he was fourteen, and they went to many places in Africa. They traveled extensively.

Paul: What is your relationship to the Berkshire Museum?

Nancy: My father went to business school, which is where he met my mother. He was an accountant at the museum and a very good one. From the time I was about eight or nine until I was about twenty or twenty-one, he worked at the Berkshire Museum. I would go there several times a week when I was younger and wander from taxidermied mammals to minerals to shells to birds. When I got older, I still had occasion to go there. I imagine this influenced some of the images in my work.

Paul: What did you do in the summers?

Nancy: I went to camp. One camp was in New Hampshire. It was a YWCA camp: swimming and boating and tennis and getting up with the bell. As usual in those organized situations, I freaked out.

Paul: Because of what?

Nancy: The regimentation. It just didn't offer enough stimulation for me.

Paul: What school did you go to at age twelve?

Nancy: I went to Miss Hall's School, which is located in Pittsfield. It had a fairly unusual group of young women and was very strong academically. It was establishment East coast and Mid-west largely. After two years I decided that I was going away to school. Northfield was a school with a religious background, and the education was much inferior to that at Miss Hall's, but I graduated from Northfield.

Paul: How was Miss Hall's selected?

Nancy: I think my grandmother probably made the selection because she offered to pay for my education. It was a very good school. I even played sports there. I say "even" because, again, although I was capable, I didn't like team sports. At Miss Hall's, I had a chance for the first time to do quite a bit of drawing and painting. This was something that I loved because the teacher was very good, I had all the time that I wanted, and, for the first time in my life, it was allowed; it meant something; it wasn't just something to be dabbled in. It was taken as seriously as, say, math. At Northfield, however, there was no art.

Paul: Who was the art teacher at Miss Hall's?

Nancy: Her name was Elizabeth Gatchell. She still teaches there. All of the teachers were very good.

Paul: It sounds as if that was kind of an opening wedge into something.

Nancy: Well, I don't know whether it was an opening wedge, but I remember that when I went to college, I felt that the education at Miss Hall's was certainly as good as what I received at Vassar. In a certain sense, perhaps if I had gone to Miss Hall's for two more years, I wouldn't have needed the first two years of Vassar because the courses would have been repetitive. Also, I was misinformed. I was under the impression that Vassar had a very good art program, which is true of their art history program, but I had been led to believe that it was in what Vassar art historians called "applied arts." Once I arrived at Vassar, I was quite dismayed. I was

told by my family that I had to stay. I had also applied to the Rhode Island School of Design and had been accepted, but I wasn't allowed to go there, because my grandmother was paying for my education and my grandfather objected.

Paul: *By the time you chose to attend Vassar you had already had two years of what? Drawing classes? Painting classes?*

Nancy: At Miss Hall's we had drawing classes. We learned to make woodcuts. We learned the differences between oil and gouache, etching, and lithography and were encouraged to explore different media. I think we played in clay for a bit, but I can't remember anything I made. I had the attitude, which I think I still have to a degree, that if I didn't have the time or a strong interest in doing something, then it was best to leave it alone, and I really wasn't interested in playing with clay. I do remember making something. It may have been pottery.

Paul: *Did you have models at Miss Hall's?*

Nancy: Can't remember. It's possible that we did, although you understand that this was only three hours a week. We also had music and theater for three hours a week. My first year at Vassar I took studio. We had models, we worked in still life, I made oil paintings, and I spent all the time I wanted at it. I met some girls who were interested in the creative arts in one form or another: either dance, drama, painting, or sculpture. That was about all that was possible in those days, so I painted as often as I could, and I drew as often and as much as I could.

Paul: *Who were your teachers at Vassar?*

Nancy: I had Rosemarie Beck and Alton Pickens. Concetta Scaravaglione was teaching sculpture, and Lewis Rubenstein was also there. Pickens was a great teacher. They took me seriously, and they made distinctions between people who were serious and people who weren't. I appreciated that. I admired but didn't study with Concetta. I didn't share Rubenstein's point of view, but he was a devoted teacher. After my second year, I received a scholarship to go to Yale Norfolk to study painting for the summer. That was the best thing that happened to me during those four years. It was fantastic. At age eighteen, I was competing with kids who had three and four years of art school and who were much older than I. Everything about it was fantastic. The film and photography programs were eye openers. There were classes in photography every day. There was drawing every day. There were drawing field trips to nearby rocks and driftwood. There were models in the studio all the time, and people painted everyday. They took themselves seriously, and this was one of the most important things for me. That summer program enabled me to go to Yale when I finished at Vassar. Bernard Chaet, who was a faculty member, was really responsible for my getting into Yale, and for that I am indebted to him. Other Yale faculty and visiting artists were there. Chaet taught painting and drawing and took an interest in my work. He felt that though I didn't have the technical background, I was doing something, or—

Paul: *You were an English major at Vassar, right?*

Nancy: Yes I was, because I couldn't get along with art history at all.

Paul: *Why was that?*

Nancy: I found that my intuitive response to art was not at all understood there.

Paul: By the art historians?

Nancy: By the art historians. They wanted me to develop a classical manner of explicating, which I refused to do because there was a conflict between what I saw and the manner in which they wanted me to write. That continued to be a bugbear of mine for many years after I left Vassar.

Paul: Who was teaching art history then?

Nancy: Let me see: Lela Barbour, Pamela Askew. The woman who headed the department, Agnes Rindge Claflin, has since retired. There were a couple of great German scholars there, and Wittkower was there for a while teaching architecture. I took his course for a semester, but regardless of what I took, I wasn't going to come out of it with flying colors, because I was determined not to adopt that manner of thinking.

Paul: What was it that you disliked about that manner of thinking?

Nancy: The language was linear, but the art was about life. It seemed that nothing else was acceptable because, obviously, they wanted their students to be good art historians and scholars in a manner in which they anticipated, and they wanted people to get into graduate school. I wasn't strong enough in my own terms. Had I been, they would have accepted my point of view, I'm sure. This is jumping ahead, but in 1971 I received a grant from Vassar, which was really quite a wonderful grant. It was set up by my English teacher, with whom I wrote my thesis my last year there. He left his estate to the college for these grants in the arts regardless of the field. I won the second one. At the same time I was invited to have an exhibition at the Vassar Art Gallery. It was great. When I was studying at Vassar, I wasn't prepared to compete. I was a country girl. Vassar was a little bit of a shock to me, and I had to try to adjust to all of that sophistication. After I turned twenty-one, I was free to do whatever I wanted. I was accepted at the Yale School of Art, and I was, I felt, very fortunate to be accepted. For the first time I would be putting myself through school, which was a tremendous relief to me. For the first time I was on my own. After I had been there for a few months, the faculty threatened to ask me to leave. I couldn't understand this. Of course, the reason was that I had refused to compete because I had never competed before. I had somehow gotten through Vassar without showing what I could do.

Paul: What do you mean by competing? In what way?

Nancy: I mean by really trying to get a grade to stay in. I was filling a space in which they could put someone else. Once I was told that, I started working. I demonstrated that I was involved. Before that, I would go to classes, and I'd do it, but I'd pretend that I wasn't very interested. Well, for the first time in my life, I showed that I really was interested; that this was something to which I was committed. I wanted to be there the next semester. In six weeks I showed them, and, of course, I got a scholarship, and then I was motivated.

Paul: Yale must have been quite a different world from Vassar.

Nancy: Quite a different world from Vassar! I think there were ten men to every female, and I thought that was just wonderful. It was conservative, but wonderful for me. The main stimulus was that Yale had the funding to invite people from New York: artists who were

younger, artists who were making their mark at that time. It was good exposure to the technical aspects of art and at the same time to the actuality of what was being done. I probably couldn't have gotten that so rapidly had I just come to New York and tried to learn how to make art on my own. I was very grateful for that, plus Yale had that essence of the womb, which is true of all institutions. It nurtured.

Paul: *Who were your first instructors at Yale?*

Nancy: During my first year I had William Bailey for drawing, Alex Katz for painting, Neil Welliver, and Sewell Sillman. I took a number of Yale-oriented courses the first semester, and after that I realized that if I made some fuss about it, I wouldn't have to take them.

Paul: *What do you mean by Yale-oriented courses?*

Nancy: The Albers courses. I had to take lettering and basic drawing, which was how to draw a straight line and how to make it grayer and whiter. It taught manual facility, dexterity. Basic design was taught by Neil Welliver. What I did essentially was take painting and drawing courses the whole first semester. The second year I had Louis Finkelstein for drawing. Tworkov was the new chairman. He was terrific, but he wasn't my crit. The third year I had Tworkov as a teacher, and Al Held, and I had a separate studio away from the newly opened Rudolf Art and Architecture building. I was the only girl selected with nine guys. We had separate studios in a building on Crown Street in New Haven, which was two blocks from the school. In those days women were last in being considered, but luckily I ended up having a whole floor to myself. I had the top floor of what we called "the brothel," because everything was painted pink and blue. It had a wonderful colored linoleum on the floor. I had something like four rooms to myself, and all the men were fighting with each other about which space they would have; they each had about an eighth of what I had. I felt very good about that. During that time we had [Frank] Stella as a visiting critic. [Robert] Rauschenberg came one day. Someone gave him a chicken, and he bowed his head toward it and indicated that it was fine. Immediately, the chicken took a shit. The second year [Philip] Guston came up, and Edwin Dickinson was also a visiting critic. Those two were very interested in my work. I took color from Sewell Sillman, and it was a wonderful course.

Paul: *How did you like having the visiting artists there?*

Nancy: That was the best part of the whole experience at Yale.

Paul: *What was the special quality at Yale for you?*

Nancy: The vitality. It is something that every school should attempt to introduce. The type of criticism you get is very direct and it's going to be apolitical. Someone who is hired over a long-term period is obviously going to get involved with faculty politics. Consequently, his remarks are not going to be as honest as those of a visiting critic. It didn't seem that either the faculty or the students were encumbered in any way by that directness. As long as the visiting artist could get his paycheck and go, he could say anything he wanted. I remember Frank Stella coming and saying things like, "There is no painting here. This is Matisse," and putting everyone in the school down. That was exactly what we needed. Teachers are emulated by the students in one way or another, and obviously this is a deadening kind of thing. Fortunately,

Tworkov was open, so he allocated the budget and made it possible for as many young artists as we wanted to come as visiting critics.

Paul: *He got a variety of critics, young and old.*

Nancy: Young and old, right. Philip Guston and Esteban Vicente came up, and Giorgio Cavallon: contemporaries of Tworkov. That was in my third year. Isabel Bishop was there during my second year.

Paul: *How did you like having the old establishment appear, or weren't they considered establishment by you?*

Nancy: Yes, they were. I was very interested in them as personalities. Even if I couldn't agree with what they said, I was interested as an artist in intuitively attempting to relate to these personalities, which meant that I tried to understand what it was that had allowed them to be what they were. Sometimes they could be explicit about it; at other times they couldn't get into it at all.

Paul: *That was really your first introduction to artists as people: what they said, how they lived.*

Nancy: Right.

Paul: *Did you get socially involved with the faculty at Yale?*

Nancy: Yes, to a limited degree.

Paul: *Are there many co-students with whom you became friendly who you still see today?*

Nancy: I still see a number of people from the class of 1964: Brice Marden, Chuck Close, Richard Serra, Steve Posen, Kent Floeter, Rackstraw Downes. There really was a lot of energy at that time. That was what was most valuable of all. That class was very strong as a group. I don't think there have been nine or ten other students who coalesced as well and who were as independent in their own right as that group.

Paul: *Did you have much association with the class ahead of or behind you?*

Nancy: Well, by the time that year occurred everyone was pretty much out for himself, out for his or her Fulbright travel grant, and involved with individuating himself to a very heavy degree. The attitude was: well kid, you're going to New York next year; you're going to be showing in a gallery; you'd better do something. There was tremendous competition in my class for grants, and with each other, and just about learning. We had very strong personalities, stronger, I think, than the classes around us.

Paul: *Did the idea of coming to New York occur at that point, or before?*

Nancy: Certainly that was the object of going to Yale for anyone who didn't want to be a teacher for the rest of his life. You would go to Yale, get a number of skills, run to New York, whip out those skills, and in six months you'd be in a gallery, and everything would be set from then on. That is somehow the attitude that continues.

Paul: *Did it happen?*

Nancy: I guess a number of people went to New York, but in my class most people had the Fulbright, which was very fortunate. I was away for two years. What that experience meant was that one could divest oneself of all of that academic—

Paul: *Do you think it's important to have that complicated academic background?*

Nancy: Not for everyone, but for me having a college education was important. If I could have gone to Bennington where I would have been around intellectual people and, at the same time, been free to educate myself and have all the facilities necessary, I would have been very happy and at the same time would have attempted to make art.

Paul: *But I mean the academic training an artist gets: figure, drawing, composition.*

Nancy: Well, I think about that a lot. When I came back from Europe I had to go to work, so I ended up teaching for a couple of years at Fairleigh Dickinson University. An artist has to find a unique way in which to make her hand do something. Some people chose not to go through this lugubrious procedure whereby you learn to paint like Tiepolo, Ingres, or whatever. I mean, there were courses to teach you how to make a gesso painting like Giotto. I understood why this was offered: one, for education should you go into museum curatorship or whatever, and the other, to give a sense of how materials are used in order to bring a kind of refinement to your own way of looking at about five hundred to possibly one thousand works of art a day. They have a fantastic slide collection and a wonderful photographic library. You could find an artist and look through all of his work. It was fantastic to me that there was this type of facility—I don't think many institutions had it—and I became voracious about knowing everything about art in order to make art. I had that point of view. I felt that the only way I could do anything was by being knowledgeable about all that had been done before because the media afforded it. If it was there, then I as an artist had to avail myself of it if I was really going to take myself seriously.

Paul: *What about the Fulbright? Where did you go?*

Nancy: I had a Fulbright in painting to study Matisse in Paris. When I got to Paris I learned, of course, that the majority of Matisse's work is on display in New York and Baltimore. I proceeded to paint for a year. Much of the imagery was residual from Yale, but gradually I sifted out what was mine from what I had been taught.

Paul: *Was this your first trip to Europe?*

Nancy: No, this was my third time. I went when I was sixteen. I went to England for a summer with a group of students. I lived with two families in the suburbs of London and traveled through England and Wales.

Paul: *How was the Paris experience?*

Nancy: I loved Paris. I had studied French for eight years. I had a very good studio on rue d'Arsonual, off Boulevard Raspail, with a thirty-five-foot window, north light, a thirty-by-thirty-foot space for painting, and a bedroom, kitchen, bath, and library. It had belonged to a contemporary of Matisse and Vlaminck.

Paul: *Who was the painter?*

Nancy: I can't remember right now. His widow was the landlord. My grandmother wrote to an official at the embassy or something, and consequently there was this neat studio waiting for me when I arrived. Oh! His name was Milich. His wife was Swiss-German. I was living on $140 a month, and I had to pay $90 rent, which meant I had $50 left over. Richard Serra came over on a Yale-sponsored traveling fellowship, and we were married in Paris. Phil Glass,

the composer, was also on a Fulbright to Paris. We met on the Queen Mary. The actress and director, JoAnne Akalaitis, his future wife, came to Paris later. The four of us saw each other often in Paris and later in New York. A painter named Michael Chelminski was also there. He had gone to Yale too. Evidently [Richard] Tuttle was with him, but I didn't meet him. Victoria Barr, Alfred Barr's daughter, also had a Fulbright in painting, and I saw her occasionally. Bob Fiore, the cameraman, was also there. He came over on the Queen Mary. I was fairly friendly with him, and later he filmed *Goulimine 1970* in Morocco.

Paul: *Did you just paint and go to museums and galleries?*

Nancy: I spent a great deal of time in the Musee d'Art Modern de la Ville de Paris where I drew from the Brancusi room. I made drawings there day after day, as well as paintings that were based on them. The charcoal drawings I made in the Brancusi room were quite involved. I spent a great deal of time going to museums of all sorts and making sketches. We also traveled. We went to London a couple of times, we drove to Spain in a Volkswagen Bug that Richard had bought, and we went to Italy the following year and lived there for a year. We also went to Belgium.

Paul: *Did you meet any French artists or other artists who were around?*

Nancy: In the building where I lived also lived an American painter, and through her I met Joan Mitchell and [Jean-Paul] Riopelle. That was important for me. Joan was great. The critic John Ashberry was back and forth, but I never really struck up an acquaintance with him. I didn't meet many French artists, unfortunately. I had a heavy work schedule and a heavy museum schedule. I knew fewer French than Americans. I also met Sonia Delaunay, visited her studio, and had tea. She was magnificent. I consulted fairly regularly with my advisor, Marcel Brion. He was then in his seventies.

Paul: *What was the consulting for?*

Nancy: As a student in painting, I had to visit Brion and discuss the progress of my project. I wanted a renewal of the grant, so I made my pilgrimmage every month.

Paul: *What were Brion's critiques like?*

Nancy: I'd speak in French and say something like, "This is what I am doing," and then I'd show him some slides, and he would say, "Yes. That's wonderful," and then we'd talk about his latest book. He was very cordial.

Paul: *Do you think he was interested in what was happening?*

Nancy: I think that he was, but he was trying to get a book finished on the imagery of animals in art, and he was not in good health. For me, it was a very interesting experience.

Paul: *How did you happen to go to Florence?*

Nancy: The second year in Europe, Serra had a Fulbright to Florence, so we went there to live. We left Paris in May, drove through the Midi in France, stopped at Nice, and spent days on the Riviera looking at art. We visited the Foundation Maeght, the Matisse chapel in Vence, the Leger Museum, the Roman Colosseum in Nice, and, as we came over a hill, saw the landscape that [Andre] Derain had painted. That was one of the most remarkable experiences. We saw

Cezanne's *Mont Saint Victoire* and stayed overnight in Aix-en-Provence. Then we traveled to Genoa, down the Italian Riviera, over to Florence, found a place to live, and then went to Greece and Turkey for about a month. The trip from Paris to Florence and then to Greece and Turkey was absolutely fabulous. While I was in Paris, I made lithographs in the atelier Maurice Beaudet. He was a wonderful man. He printed the book *One Cent Life* by Walassey Ting, some Alechinskys, and had printed for Picasso and most of the French artists. He was pulling Arps while I worked with him, and some of my images were pulled over the Arps. He had one of the few automatic presses, so the whole experience was really fine.

Paul: *Had you made prints before?*

Nancy: I had learned how to make lithographs at Yale. Beaudet was a splendid craftsman, very humble, and was willing to do anything he could for artists. He was just about to retire. He had given all of his stones to Alechinsky, who he claimed, "had a porcupine in his pocket." The studio was in the 20th Arrondissement, which is way up in the northeast part of Paris. He said, "Well, why don't you do something?" So I did. I worked on one stone—thirty-by-fifty-inches. He rolled it off for me at no cost. It was a very interesting experience. We came back to Florence in August. We set up a dual studio system and proceeded to paint, which became more and more difficult for both of us. In Florence, I painted Matisse-Johns-like oil canvases. They were triptychs and six-by-eight-feet or larger. At the same time, I started to collect animal skins. I visited the zoo in Rome and went to the Museum of Natural History to ask questions about taxidermy. The museum is down the road from the Boboli Gardens. I photographed the work of Sussini there. He was an anatomist from the eighteenth century and had made a number of replications of the eye, the brain, etcetera, in wax, to human scale. These examples of human and comparative anatomy were used as the basis for most anatomy classes in the United States until 1945. They are absolutely extraordinary illustrations of craft married to science: bodies of women in beatific poses, splayed at the breast, with natural hair, pubic hair, and blue bows on their locks. It was as if Botticelli had been crossed with anatomy. It was incredible. I photographed this with the intent of documenting it in some way, but I didn't have a good enough camera or the right light. In any case, it was a vital experience for me.

Paul: *You just came across these?*

Nancy: In my explorations of Florence, which isn't really such a large city, I found this museum, and it was particularly appealing to me. It crossed with my interest in natural history, which somehow influenced my choice of skins. I related these cases containing the wax anatomical forms to Oldenburg's store. The next step was the camels, but along the way I made some assemblages of live and stuffed animals juxtaposed with found objects. These I never exhibited.

Paul: *I'm curious to know how the shift from painting grew to—*

Nancy: From being utterly desperate. The experience of being utterly desperate about your work is something that I guess every artist has every day, but when you don't have anything to grasp on to, it becomes even more excruciating. I mean, it was as if my studio had been completely wiped out.

Paul: *There was no work there?*

Nancy: Well, that example cannot really compare with what I'm talking about, because I now have a history behind me. Even if I walk into the studio and it's empty, I have this body of work that was completed in the past; it is a known fact even if it is all destroyed. I was determined to make something, and I had destroyed everything or almost everything. So there I was, with all this education, in an isolated place where no one had any awareness of what I was doing: an American in Italy, with all this heavy culture around, trying to come up with something. I made a number of pieces that in one sense or another could relate to assemblage, but I ultimately rejected them. What didn't work was dumped into the Arno on a weekly basis. It was at this point that I made the first camel with life-sized proportions. I had no experience in making sculpture.

Paul: *How did the image appear?*

Nancy: Well, I had seen a camel in a zoo, but it came about through my encounter with taxidermy and natural history in this museum, and because as a child I had frequently visited the Berkshire Museum's collection of art and natural history. At the time, however, I wasn't clear myself why I was drawn toward this material. I made two life-sized camels, which were destroyed before I left Florence for New York.

Paul: *How did you pick that animal as opposed to another?*

Nancy: I chose it for its size, the complexity of its ungainly ostrich-like form, which was wonderful to draw, and because it was largely outside of western culture. I could relate to it in a human scale, which is an attitude I developed toward painting. I guess it's an outgrowth of abstract expressionism, and when I started painting, everyone was working large, so to deal with an image of this size seemed possible to me or normal.

Paul: *Transference of flat drawing to three-dimensional.*

Nancy: Right.

Paul: *How would you define drawing?*

Nancy: When I refer to drawing, I mean the anatomical structure and the way one can articulate it. There are certain forms in nature that are very interesting from that point of view. The human figure normally is considered to be the most interesting and is not loaded with associations. It is somewhat enigmatic in terms of its culture.

PG: *Do you mean drawing in a three-dimensional object way or a flat surface?*

Nancy: Drawing to me means the way one moves one's hand, whether it be three or two-dimensional, or in film, or in dance. It is the way one defines a space and form.

Paul: *Does that include the gesture?*

Nancy: It includes the gesture of the artist. By that I mean drawing: the specific gesture of the artist as it attempts to define form and its surrounding space.

Paul: *So it's the idea of the act and the produced image?*

Nancy: Right. The resultant image.

Paul: *What was your work like prior to when you made* Camel?

Nancy: Well, I was trained as a painter, and I had no experience in volume. In other words,

I couldn't hammer a nail, I didn't know how to saw, I really had never thought about how things went together. The type of painting I did had a direct relationship to Matisse, and I was very much influenced by Johns as a phenomenon and also as a marker of canvas.

Paul: *In the sense of application or of imagery?*

Nancy: Both. I was interested in the process of application of paint and in the resulting imagery, the way the imagery comes out of the application of the paint, the simplicity and geometry of the imagery. Where I got off specifically was the manner of articulating paint form with Matisse in what I would call color field series, the washes. I wasn't involved with that. I was more interested in determining form through process and in evidencing the process as one related to the final image.

Paul: *Did this develop at Yale and continue while you were in Paris?*

Nancy: Yes. I learned that at Yale. In Paris I continued this process to a degree, although it became more simplified because I was concerned with the linearity of Brancusi, and I had a conflict with the process that I had understood and the new forms, which actually, of course, were not new forms but were interpreted in a new way by me. I began to realize—it basically occurred in Florence—that my interpretation of old forms wasn't enough.

Paul: *What was your attraction to Brancusi?*

Nancy: There's an affinity between the shapes one finds in Matisse and the shapes of Brancusi. Many of them are circular. They have soft contours. The verticals are simplified in a way that was inspired by Matisse's later works. Also, the relationship of one form to the other on the page interested me. The space was more complicated. I had difficulty translating these drawings into paintings. The imagery was insufficient, and I had to find my own vocabulary. Borrowing from Johns's iconography and Matisse's forms was unsatisfactory. So, I stopped painting for a while. Had I not been so overly trained at Yale, I might have had a fresh approach to painting.

Paul: *This all happened in Florence in 1966?*

Nancy: Yes, and by then I had started working in three dimensions with disparate forms, almost anything that came around.

Paul: *What kinds of materials did you use, and what imagery developed?*

Nancy: I spent some time building sculpture by gluing together various plumbing shapes made of plastic. They were new in 1965 and not yet permitted by the U. S. building code. They looked like bad Sugerman or Caro. The lack of complexity of the forms themselves was a problem for me.

Paul: *Was Paolozzi making those things by that time?*

Nancy: Well, he certainly was, absolutely, so there's another one. I was familiar with his work. Anyway, it was a disaster. Then I made a number of assemblage pieces, which were discarded.

Paul: *Was there an intellectual selection of material, or did the material suggest things?*

Nancy: Both. I began to collect skins at that time, and the *Camel* grew out of that. I wanted to make a form with which I could state the metaphor of the form resulting from explicit information or detail. I wasn't trying to make a realistic camel, but a metaphor. I wanted to give

the equation of the actual presence of a camel, but, as a post-cubist, to translate it. In order to do this, it was necessary to develop certain techniques when I came to New York.

Paul: *What was the first camel made of?*

Nancy: The first one I made in Florence. I found a table for which I had not much love. I cut it in half, took off its legs, and angled them. I built up that form in a certain way to indicate the body, and I made a neck for it. Then I took from the vegetable market baskets that were made of something like palm leaves, and by wiring them to this wood form I achieved the volume. Over that mass I placed burlap, which I believe I must have sewn on. Finally, over that surface I attached the fur.

Paul: *How large was it?*

Nancy: It was life-sized, about seven or eight feet tall. It was standing. It had a terrific presence. Its presence was what convinced me to try to pursue it, of course, in total ignorance of the amount of information I would need to know. When I returned to New York, I began to find people who could give me technical information. On the armature I spent three months working every day with a carpenter. I told him my needs, and he devised a process with me that solved the specifics of taking the thing apart rapidly, getting it in and out of any door space, and up and down any stairs.

Paul: *It could come apart and be reassembled?*

Nancy: Right. There ultimately were six or seven pieces, very light weight, made of steel and wood, and really beautifully put together from a carpentry point of view.

Paul: *Getting back to Florence, what were some of your other activities there?*

Nancy: I knew a few Americans, but basically I chose to be isolated. I preferred to work. I went to various surrounding areas: the Fiesole, Venice, Siena, and Arezzo. I spent considerable time in the Uffizi. One does all of those things, and at a certain point, they're finished. On Sunday afternoons I often had a fantastic lunch with an American couple in a villa on the top of a hill overlooking Florence. They were about ten years older and had two children.

Paul: *Who were they?*

Nancy: George and Betty Woodman. She is a potter and he's a painter. They live in Boulder, Colorado, where he teaches. I saw them frequently.

Paul: *Why did you decide to come back rather than stay in Europe?*

Nancy: That's a good question. I had a growing sense of disquietude about my lack of contact with my own culture. After two years, I began to lose my identity in a sociological sense. I had only a surface relationship to Italy, and yet I couldn't identify with America. I read the Herald Tribune three or four times a week, and that was my total contact other than letters. I was missing a lot. A lot goes on every day in America. I came back because I felt it was important for my work.

Paul: *Why did you identify more with Italy than France?*

Nancy: Initially Italy is more outgoing toward people, regardless of who they are. This made it easier to get along in terms of eating or sleeping or driving around: the basics. In France, however, I had a historical knowledge and a fairly good sense of the language. I had none of that in Italy.

Paul: So you came back to America because you needed identity?

Nancy: Yes, and also, the grants ran out. I was determined to come to New York. In fact, I was hellbent to come to New York. Fortunately, I had a place to move into when we arrived, and that made it somewhat easier.

Paul: Was it a friend's studio?

Nancy: Yes. It belonged to a fellow student at Yale, the sculptor, William Hocchausen. He was moving, so I was able to get off the boat—the Constitution—with two huge trunks containing who knows what, canvas, paints, books, and the residue of two years in Europe, and move right in.

Paul: When was that?

Nancy: It was one of the last days of August 1966. We came to New York just before the flood in Florence.

Paul: How was it to be back and living in New York?

Nancy: I remember the first sleepless nights in the studio which was at 136 West Broadway. It's on the second floor, directly above the subway line. I had lived in Florence for a year, mostly in the country, which was very quiet, and I recall being disturbed by the noise for about two weeks. I was afraid to go out at night or to move around if I wasn't sure where I was going, but being in New York was tremendously exciting for me. I was overwhelmed by the fact that I was back here again.

Paul: How long did it take you to set up and start working?

Nancy: Probably a day, knowing my personality. Actually, Serra and I had to do a number of family things together because we had been married in Paris. We had to make peace with both my family and his. Then we came back to New York. He had to worry about getting a job. I've forgotten whether he used that studio first, and I had none, or what the situation was, but eventually he got a studio next door, so we had separate studios. Then Richard got a night job teaching. I think we had a little bit of money from my parents to keep us going. It was very basic at that point. In any case, we both started to make art immediately. It was difficult for us because, for the first time, we were really feeling the challenge of New York. We had been in Europe for the experience and did not necessarily have to come up with a product, so although we were both working very hard during that time, we weren't necessarily producing objects.

Paul: For competition. Were you competing with each other or with yourselves?

Nancy: With myself. By that time, I had determined certain things that I believed were important as a direction for working. The influence of whatever the air afforded, the diurnal experience of other artists in New York, made working harder, but without the European break, I think I would have lost a great deal.

Paul: In the sense of identity development?

Nancy: Yes, absolutely, and for a sense of humility in relation to art history. The American stance is that what we're doing is bigger, better, and greater, but to deal with a thousand years of painting is quite a revelation, one that leads to the acknowledgment that it may not be possible in one's given time to do something that is going to be as meaningful as what has gone before.

Paul: *Don't you think that someone who goes out to do his own work must say, "I'm going to be as good as history," that he has got to believe this?*

Nancy: Absolutely. One has to believe that. But the enormity of the history itself was what I hadn't understood, so whatever I did in terms of my relationship to it wouldn't be the same had I not gone to Europe.

Paul: *Did you find that art in reality was different from art in slides and that growing up on slides conditioned the way you saw things?*

Nancy: I hadn't grown up on slides but maybe on photographs, yes. I think that today everyone grows up on slides. I had seen quite a bit of real art before I went to Yale, and I never felt that what I saw in a book had any relationship to the real thing, although it was an approximation of it.

Paul: *It was a surrogate. It never became the actuality.*

Nancy: Right. Basically my attitude was to make the work. I figured that if I made some work, then someone might want to look at it, but I wasn't willing to go out and meet people before I had something that I could support. Joan Washburn of the Graham Gallery climbed the five flights to my studio and must have liked the three camels encompassing the whole loft, eighteen by sixty-five feet, along with piles of fur coats, burlap, wooden armatures, polyurethane, oil paint, etcetera. Then Bob Graham, Joan Washburn, and I had lunch at a wonderful German restaurant near the loft, and it was agreed to schedule a show. I had the show, but ultimately I destroyed all of the work in that show, because I didn't want it sold individually. I felt the work related to itself and should always be kept in that capacity, and I knew there were very few people who were going to be willing to do that, so I destroyed it even though Alan Stone had offered to buy the whole show.

Paul: *Did you consider it an environmental idea?*

Nancy: No, I don't like to use the term "environment." I felt that the forms themselves related to each other and were not actually strong enough to stand independently. These were camels transporting large burlap volumes. In isolation they were not the way I would have liked them to be, but as a group, yes.

Paul: *Why didn't they work in isolation?*

Nancy: The "drawing" wasn't strong enough—again going back to that manner of articulating form—because the process was based on my research of looking at photographs and studying animals in zoos.

Paul: *Were you pleased with the results of the exhibition? What did you think about seeing the work out of your studio?*

Nancy: It was very good for me to get the work out of the studio, to be able to be objective about it, and to be recognized. Dick Bellamy was very supportive of the work. During the show he brought by a number of people and later sold one of my camels. The next year I had a show at the Whitney, the first one-woman show ever. I'm proud of that! It had tremendous coverage, naturally.

Paul: *How did that show happen?*

Nancy: There were two new curators appointed that year, Marcia Tucker and Jim Monte. They were looking around New York for interesting work and work that they wanted to show. It was as simple as that. It was their first show.

Paul: *What happened because of that show?*

Nancy: You mean what happened to me as a result? I believe the show was in March 1969. After I set up the show, I set about making a couple more camels. The ones at the Whitney were involved with the illusion of motion, which I felt was unsatisfactory, so I made two that were prototypes of both types of camels: the ones with two humps and the ones with one hump. That finished it, although I did have a third one in the studio that was sold to a client but which ultimately I destroyed because I couldn't finish it in the way I wanted. The problems were unsolvable. The client was nonplused.

Paul: *Why?*

Nancy: I destroyed his camel after he had paid for it. I didn't know that Bellamy had sold it, which I guess was a normal thing since he had thought that I would be happy if he did. I had sold two before that to Ludwig of Germany. In fact, I had sold two camels and the miocene skeleton, and they would go in a special room in the museum. I would be flown over to install them, and everything would be as I liked.

Paul: *So how many exist now?*

Nancy: There are five. I then made the skeleton, and I dealt with the problems of armature.

Paul: *Do you still read a great deal?*

Nancy: Yes.

Paul: *Programmed reading or general reading?*

Nancy: Right now I'm reading a book by the Japanese novelist who has just published the first of a tetrology. I'm reading several books for the visual aspect of microbiology. I'm reading a book on stereoptics called *The Cyclopean Theory of Perception* by Bella Julas, which is a fantastic book. I'm basically reading books that will enable me to continue my work. Many of the choices are for the visual material, and some of them are for the written material. Very seldom do I read a work of fiction. I'm interested in the Japanese novel for the sociology as much as anything.

Paul: *What do you mean "for the visual material"?*

Nancy: The books on archaeology very often have drawings or photographs of, let's say, mummies, potsherds, or the plans of different excavations, many of which have been sources in part for certain pieces of my sculpture and drawing. I'm always on the lookout for material that I can use in a drawing or in a piece of sculpture. The interest in microbiology right now is that I'm in the process of thinking out a new piece of sculpture, and those forms that are basically dot-like structures to my eyes will become the most immediate level of imagery for this piece. Recently I was in the American Museum of Natural History Library of Paleontology reading Croupier, but reading only for the written information, not reading the French particularly; looking at Darwin's *Voyages* in the original for whatever insight they could afford me of an approach to the material that is now, so to speak, in my domain. Anything that deals with bones is basically mine at this point. Books on specific areas of natural history are of interest

to me, because again I've found a way of incorporating the material in a drawing. At the moment, I'm making a film on the flight motion of three kinds of birds, so I've studied extensively the visual material on birds. I haven't read much on birds, and I don't pretend to be an authority on their different habits, but how they move is something that interests me. From that point of view, I study them.

Paul: *You mean flight patterns, wings, flying?*

Nancy: That's right. I study them as they relate to the film frame and motion pictures.

Paul: *Kinetics.*

Nancy: Kinetics, yes. My researchers are very sensitive to my needs and non-academic in that sense. I don't thoroughly know anything about many things, and yet I often hone in on a very specific aspect that is visual, normally, and that alludes to my specific concerns. They're usually in the area of natural history.

· · · ·

Nancy: The Whitney exhibition, which ran in March 1969, occupied the lower room at the Whitney, so it was called a one-man show. There were three camels, but, as opposed to the ones at Graham Gallery, I considered them to be individual entities. They were in the act of motion, which is to say that their gestures reported movement. However, they presented a conflict retrospectively for me in that the forms themselves were static, yet they dealt with motion, which caused me to think a great deal about the fact of locuity, and which influenced future sculptures.

Paul: *Were they much the same as the Graham camels?*

Nancy: Yes. It was just that there was a spirit of perfection in the process.

Paul: *What kind of reaction did you get from the artists you knew who saw the show?*

Nancy: I think a few people were very interested in that show because it was unusual and it was strong. It was difficult for people who had gone through pop art to interpret. It was not pop, and I was very careful to stay away from that point of view in terms of the public response, the more general response. I think my own peers were interested, but I'm sure you know that one's own peers do not embrace your work of the moment. They'll tell you about five years later that they thought it was of interest. I think it did have an effect.

Paul: *What was the conflict with pop art ideas at that point?*

Nancy: The conflict was that I was attempting to make something that had no relationship to pop. Oldenburg had made soft sculpture, and inasmuch as I was working in soft materials, one can make that comparison. I think the general response was in terms of the image: the image was, in some way, appealing. I was charged with doing something chic or chi-chi when actually that had nothing whatsoever to do with my concern. It was their own failure to deal with the form itself and to attempt to understand the processes that had gone into making it that led people to that other conclusion.

Paul: *Do you think that images of that nature lend themselves to simpler conclusions?*

Nancy: Well, that certainly was what I call the "New York point of view."

Paul: Was there something about the work that served as a key for those who viewed it with a pop figurative orientation?

Nancy: I think so. If one had looked at the—I will go back to that old term "drawing,"—and considered the use of materials and the way in which the form must have been constructed, they would have realized that much of the craft in the process was unfamiliar and unique. I think that on that basis alone one could not have thought I was doing this to be flip or to put my mark on the New York art scene before I faded out to do something else. I think there was a question of my motivation. That's basically what I'm trying to say.

Paul: What happened after that? You didn't continue making camels.

Nancy: Well, those three camels dealt with the process of movement, the gestures of movement. I wished to work further with the image, and I made what turned out finally to be two additional camels. One was what I would call a prototype of a Bactrian, or two-humped camel, and the other was a dromedary, the African type. It's hard to say except in a negative sense, but both of them satisfied my demands upon myself to produce an image that I felt was a metaphor of a realistic situation. They no longer dealt with a gestural aspect, and I felt that they were much more satisfactory than their predecessors. Then I moved to what I would call the "inside" or the armature by dealing with skeletons. I made two skeletons, one a prototype of a Miocene camel, which was indigenous to North America, and the other a Pleistocene, also of this continent. In working on that flip interpretation, my view was, "Oh, this must be the inside of the camel; this must be how camels are made." I did not understand that I was again dealing with the notion of process and in doing so continuing my own imagery in order to deal with support or armature or that inside-outside contingency that is a familiar prefix to the work of artists like Bruce Nauman, Richard Serra, Alan Saret, and Keith Sonnier. The difference, however, is that each of those artists, with the exception of Nauman, chose to work exclusively with what I'll call "abstract form" and not get into imagery.

Paul: Well, does that mean that your work falls into what they call "concept" art or something of that nature?

Nancy: My relationship to the artists I just mentioned was that I also was involved in treating process as an explanatory end in itself, which is to say that when you looked at a work of mine, if you were interested in how it was made and understood certain facts about materials, which most artists do, it could become clear to you how I had gone about making it. I left evidence. I left a residue of the process visible.

Paul: It's interesting that you say that an artist could recognize it, which would indicate that someone who was not an artist might not recognize it and therefore would have a different interpretation.

Nancy: Yes, that's possible, but the assumption is that artists engage in the process of form-making, and consequently they are aware of materials. Unless you have had that experience, you would not be familiar with materials, although obviously, those who are interested can learn. I don't mean to exclude anyone, but artists usually do have that capacity.

Paul: What about the relationship of the process to imagery in the sense of the artists you just named using abstract forms as opposed to yours?

Nancy: Well, I don't know the reasons for those artists' determination not to use organic forms in their work. Nauman, of course, went from using organic forms, his body exclusively, to dealing with them from a different point of view. The notion, however, is of process in those pieces as well. I think the choice was a New York one. Because of Greenberg, it was more acceptable at that time to make art that was not figurative.

Paul: *I'm interested in again going back to your attitude toward process. It still continues in your work, doesn't it?*

Nancy: Yes. That's one of the aspects that most likely will always be present in my work.

Paul: *What happened after the Whitney show? You did some additional camels, and then you went into the bones. How did the bones develop? What were you looking for? Of what did they become the manifestation?*

Nancy: The bones developed as an outgrowth of the research I did on camels when I was making them. One of the directions in which I went was archaeology and paleontology. As soon as I had the notion of what I would call "going inside" or dealing with the armature, which is that notion of process, I began to do research at the American Museum of Natural History [NY] for visual information as well as to deal with the libraries and to try and rap with different paleontologists in New York and in places where I was lecturing. It was a logical development for me.

Paul: *How did the paleontologists react when you discussed this with them? You were looking at what they were doing from another vantage point.*

Nancy: Right. Obviously, the people who were interested in talking with me were interested in what I was doing, so they were willing to treat me, or deal with me, in layman's terms in order to try to help me.

Paul: *Who was particularly helpful to you?*

Nancy: There are two men at the Museum of Natural History who have been quite kind to me. When I was making the camels, there was a man named David Schwendeman. He is in the exhibitions department, and he can do anything from taxidermy, to making a reproduction of a fish in Fiberglas, to restoring a case, to building new work. Information about these various processes and the materials used was very helpful to me.

Paul: *Was it craft process in which you were interested?*

Nancy: I was not interested in duplicating another craft process but rather in referring to it vis-a-vis my own process. I would visit David on the enormous exhibition floor of the museum; it is half a city block. They had various works in the process of being made, and seeing these gave me ideas in terms of imagery and process. Martin Cassidy is a paleontologist. His job at the moment is reproducing bones in Fiberglas. He is, in his own right, a scientist and gave me a great deal of guidance about things to read, took me to see exhibitions in storage that were unavailable to the general public, and introduced me to people. For example, last summer I wanted to go on a dig, and he tried to arrange it. It turned out that my demands in terms of art making were so complicated that it wasn't possible.

Paul: *It's interesting to think of the research you do in terms of historical activity. You go to places where artists don't normally go to look for things.*

Nancy: Yes.

Paul: *What do you think started that? Does it mean that you reject other sources, or do you just select different things?*

Nancy: As a child at the Berkshire Museum, I always saw the behind-the-scenes world, such as the restoration of an animal for a case or whatever. It was quite natural that I became interested in this field; it was an intuitive decision. As an artist, I'm obviously aware of the art that has been made. Consequently, I wouldn't want to deal with forms that were topical or of which, because of their recentness, there could be no objective understanding of my specific intent. I did actually get into that problem in a certain way with the camels. I found a form that answered certain demands that I put on it, and I interpreted it to my own ends.

Paul: *How much interrelationship do you think there is between your concepts, the forms you find, and the materials you use?*

Nancy: They're very much interwoven. In my painting there is a range of about fifty colors with which I deal, and those colors have become my vocabulary. In the sculpture there were certain materials that I chose and found compatible to certain images. One process could make one thing; steel, wax, plaster, modeling paste, and acrylic would make a bone for me, whereas wood, steel, polyurethane, burlap, and fur would essentially make a camel. I stopped making the camel and dealt with certain aspects of the same process in making bones. In a sense, "going inside" was also taking part of the camel and extending both form and process. The process very often would lend itself to a new idea that might demand a new process.

Paul: *Do you think there was a sense of abstraction developing there?*

Nancy: You mean of process? Of different processes?

Paul: *Well, were those processes leading toward a kind of abstraction? In* Shaman, *I think it is not as apparent as—*

Nancy: Yes. I think that is very definitely true. Perhaps it's logical at the same time. You start somewhere, and then you analyze what you've done, and in so doing, as an artist you wish to make pieces that are equally as abstract as they are exacting in terms of the details specifically related to its source. That has always been my intent. The question, then, is how to depart from that original source, how to take that information, and find a new way to present it. As one grows in terms of formal vocabulary as well as classical vocabulary, I guess abstraction can be the result.

Paul: *You did a number of bone pieces. From where did all the other materials start coming after those works?*

Nancy: What do you mean by materials? All of the bone pieces contain related materials. In the final piece of sculpture I made during June, July, and August 1971—which is to say that I haven't made sculpture for a year but plan to start again in September [1972]—in that single piece was contained all the processes, with the exception of fur, polyurethane, and the wood armature, plus new ones that were contained in the bone pieces and all the developing works therefrom.

Paul: *This is a funny question: how interested are you in the final objects in the sense of the experience of making them, the processes, the research, and whatever physical activity and intellectualiza-*

tion goes on? When you have finished an object, is your interest then completed, or do you still main-tain an interest in it?

Nancy: When I am working, I'm concerned with the development of the piece, the knowledge that I have as to how it started, and a vague notion of where I want it to go. As the work progresses, it becomes more and more specific as further decisions are made. Once I stand back from the piece and look at it objectively, I can make the decision. If it is finished, I kiss it goodbye so to speak. Then I become detached from it in an intellectual sense, and I can look at what I've done. Sometimes I'm amazed that I could actually have gone through the rigorous process required to make it. For example, I made *Shaman* in ninety degree heat during the months of July, August, and September. I was covered in latex every day and got a sore throat from breathing gallons and gallons of ammonia in the liquid bath. The kind of discipline necessary in order to make something is one aspect of the thing, while at the same time, the form that is created is somehow totally independent of that process. I think of the finished object, in a certain sense, as residue. I'm not content, in certain ways, with the fact that objects remain in time with a price on them as a result of my endeavors. Somehow that seems outside the process, and perhaps there's too much emphasis on that aspect of the object at this time. When I think of the relationship of making visual art to, let's say, the performing arts, specifically dance or music, it seems that there's an undue emphasis on the physical fact of things. I suppose this is reflective of the cultural situation we're now in.

Paul: *What do you mean by "the physical fact of things"?*

Nancy: I mean that I am an object-maker of pieces with a market value that is much higher than the market value of something that can have a limited endurance in time, and it seems somehow unjust.

Paul: *Don't you think that a performance of a ballet or of a concert is part of the process of making it?*

Nancy: I think that it is, but what I'm trying to say is that those people whose livelihoods are involved in those traditions are treated with less social acceptance, which leads to economic acceptance, than are those in plastic—

Paul: *How about people who are motion picture stars?*

Nancy: Well, I'm not willing to get into that whole gamut. I'm only thinking about someone attempting to dance at this time, which is on a level comparable with what we're talking about as being art making, or someone trying to write music and the tremendous dilemma there is in contradistinction to that of art making.

Paul: *Oh, right. You need lots of people, and it's a different—*

Nancy: Oh, I need lots of people. That's not the problem. The basic difference is that I can sell what I make, but the satisfaction of having made it is the most important fact to me and will continue to be. It's not possible to gain a livelihood from composing or choreographing, which I see as the equivalent, because there is no remuneration for that.

Paul: *Let's talk more about* Shaman. *It has become something that everybody talks about in relation to your work. How did it develop?*

Nancy: Two of the camels and a skeleton were sold to a museum in Aachen, Germany, in the Ludwig collection, and I was invited to install them. At the same time, the director of the museum offered me an opportunity to work, making work in the museum and having an exhibition, at which I jumped. I thought it was a very good idea. I went to Germany in July 1970 after having filmed in Morocco in June 1970. I started with fifteen assistants on the top floor, which was the attic, of the Neue Galerie in Aachen. I laid the groundwork for seven pieces of sculpture for the exhibition. I wanted to make a hanging piece that dealt with problems of transparency and opacity, with various weight levels, and with small integers in relation to large integers. In Aachen I made the facsimiles of skin, bones, and membrane that were the vehicle. *Shaman* was made after I started this work. In New York I made a piece called *Mummy*, which was constructed of latex over gauze that was supported by wire. It hangs from the ceiling and goes down to the floor. It's about nine feet tall and made of wire covered with hanging gauze onto which latex has been painted. It is cocoon-like in essence, and the wire can be seen through the gauze. Latex forms the structure, revealing the process of its making.

Paul: *Was that the first hanging piece?*

Nancy: No. The first was a bone piece; it was the Miocene skeleton that hangs without the rib cage. That's when I made bones go off the floor by hanging them. Then I started to work in diverse materials. I used latex over gauze, which is something that Eva Hesse had done, but mine was unique in the form of draping and shaping it around the wire that supports it. The essential form for *Shaman* was made in this piece called *Mummy*. In *Shaman* there are eight essential forms that have been treated in a more complicated way, and in which the imagery is based on the Pacific Northwest artifacts contained in the American Museum of Natural History, as well as other observations made in museums and in reading.

Paul: *How did the project in Germany go?*

Nancy: Okay. I spent the month of July there. I started these pieces with fifteen students. It was quite fantastic for me. I had worked with assistants before in New York; I had as many as eight people working in my studio trying to go through the processes with me of finishing the wax and marble dust bones.

Paul: *And that worked well in Germany?*

Nancy: Very, very well. It was fantastic for me. It's very demanding to have people working on your work over a period of time. In New York I worked with assistants for six months, and we finished those pieces. Without them I couldn't have completed the ideas, because it takes enormous energy and I wasn't going to give up the complicated process and the emphasis on tactility. Certain processes could be done by students who had an art background, and the final surfaces I would achieve myself, but all along I would be supervising, advising, and overseeing the whole thing. In Aachen I essentially did the same thing. I did not speak German, but fortunately most of the students spoke English. In January 1971 I returned to New York for forty-five days. At that time *Shaman* was at the Whitney, and it was necessary for me to return to take it down. I was also simultaneously having a show of bone pieces at Reese Palley Gallery, and I needed to take those down as well. I then returned to Germany for another forty days.

In May 1971 I finished all of the work for the opening at the Neue Galerie in Aachen, which was scheduled for September.

Paul: *What was your experience with Reese Palley?*

Nancy: I agreed to show there with the understanding that Carol Lindsay, who was then the director of the San Francisco Reese Palley Gallery, was coming to run the New York branch of the gallery. It never happened, but it was important for me to get my work out, and that was the best space in New York for it. Carol Lindsay, an artist herself, was very committed to my work. Betty Cunningham, who was also on the staff, was very good to work with. Other artists who showed there were William Conlon, John Walker, and Alan Cute.

Paul: *What about the show at the National Gallery in Ottawa, Canada.*

Nancy: The National Gallery showed three camels following the Whitney exhibition. It bought one of them, and a donor gave the museum the other two. In 1969 I first went to Ottawa, and in 1971 they wanted to show *Shaman.* I was very happy to do that.

Paul: *What kind of reaction did you get there?*

Nancy: Ottawa is not Washington, but in many ways it has the same problems. Everyone is imported, and as a result, many of them are quite outstanding. At the National Gallery my experience has been that all the curators with whom I have talked are quite unusual people in their own rights. They do not have the same myopia regarding art as do New York people. On the other hand, because the Canadian art world is small, they are forced to look to New York, but they don't feel the same tensions. My treatment at that museum was probably the most outstanding that I'll ever receive. When one agrees to show something there, one has to sign a paper that releases Her Majesty the Queen of any responsibility in case of death incurred through installation. The per diem for an installation there is $150 plus travel, hotel, and food. There is a real concern for the work in terms of attention to the details regarding how it should be packed and unpacked and whether restoration will be needed.

Paul: *How do you differentiate French and English points of view?*

Nancy: I'm not terribly clear on it, but it was something about which I was curious. I think basically the attitude in the United States has been inherited from the English. The French have a more logical format for establishing the terms of taking a piece of work in, what will be done with it, and how it will be recorded. By "taking," I mean the way it should be purchased and all the formalities concerned with acquiring the work. There's a respect there that I don't feel in museums that we'll call English-oriented.

Paul: *I'm curious about that because French museums are notorious for being offhand about things.*

Nancy: Absolutely, partly because of the bureaucracy, I guess.

Paul: *Who were the curators with whom you worked at the National Gallery?*

Nancy: The person with whom I worked directly was Bryden Smith. I think his interest in my work comes from his own experience, to some degree: before he became a curator he was trained as a biologist. I think he sees certain contextual aspects that are strongly interesting to him. The director of the gallery is Jean Boggs. Bryden's realm is American art, and there's a curator of Canadian art and a curator of French-Canadian art.

Paul: How did your interest in the Northwest Indians develop?

Nancy: It was developed during visits to the Indian Room and Library of the Museum of Natural History. As a child, one of the most striking books given to me by my grandfather was a pictorial history of the American Indians. It must have been published in 1945 or 1950. I became familiar with the photos and etchings in publications and researched and made drawings from these things, which determined some of the forms that I make.

Paul: What about drawings? Do you make the drawings, even on a piece that involves assistants? How do you utilize them?

Nancy: My drawings are sketches in notebooks made by observing something in life, either at a museum or from a book, or they are drawings to be considered for exhibition purposes. These drawings only deal with ideas for sculpture. I treat my sculpture in a direct manner. For example, on *Shaman* the early stages were quite unlike the finished version, although the basic forms were there all along. The process determines the form to a large extent. I wanted to make a piece that was roughly ten feet tall, using specific materials. I had dealt with these materials before, and I was clear about the way in which I wanted to work them. The relationships of the parts to each other and the way I structured those parts were purely visual decisions.

Paul: Speaking of developing visual decision making, how specific is an image in your mind before you start working?

Nancy: To return to the example of *Shaman*, I saw a photograph of a burial site of the Quaqiuitl tribe of Pacific Northwest Indians. It was a series of totem poles, which were probably twenty-five feet high. I wanted to make a piece that approximated that psychological and visual presence, but with my own imagery. I wanted to keep the vertical rhythms contained in the photograph and translate them into my own process of working. Of course, since interior spaces are usually ten or twelve feet high, the actual scale was not viable.

Paul: You seem to have a continuing interest in things like skins, bones, and feathers, and yet you really don't use any of those materials, do you?

Nancy: No. The forms are all made from other materials that are basically sculptural materials: wax, latex, gauze, steel, cotton, acrylic, and oil paint.

Paul: You know, using an old term, you've developed a very complicated iconography. Do you feel that this obscures what you're after, or that it makes it more visible?

Nancy: I think that art can, to a degree, be approached intuitively, and that art that is worth dealing with always demands a certain effort on the part of the viewer. Those interested in natural history, paleontology, archaeology, and recently in bathymetry and geology, can relate to the work in terms of its content, but the usual aspect of the work is strong enough to carry it.

Paul: How do you feel about the way your works relate to metropolitan life? You don't really relate to the city; your work is involved in nature.

Nancy: In the last few months I have been painting *Moon Maps*, which are six by eight feet in height. I have made a series of lithographs from drawings of the same material. New York has the most up-to-date information. So much scientific research starts here. The moon is a throwout from the earth, a negative shape of the earth. My choice of content has related to

levels of abstraction.

Paul: *What about time? You've referred to it in a variety of different ways.*

Nancy: Time is the perceiver, time is process. When I made the leg piece *Variability and Repetition of Similar Forms*, one had to walk by it, and in doing so, walk by the repeated forms that, although varied, gave the illusion of movement. They contain the gestural movement just as if you are walking by a fence made of boards: the negative space is varied by your speed. Either the fence moves or what is in back of it moves, depending on where you focus. The camels contain the illusion of motion. The floor piece *Fossils* is so complex that it becomes almost impossible to view without dealing with either its particular construction or with its "gestalt" for simplification. One is either drawn to the whole or to its parts. The parts themselves are so large in number and so varied in surface incident and shape that it takes an accumulation of perceptions over time to record the sculpture. I carried this concern to *Shaman*. *Shaman* as a whole can be recorded as a photographic image, or if one moves back from it far enough from it, it can be seen as an entity. It is fourteen feet tall, about twenty feet wide, and fourteen feet deep. It is meant to be walked around, and can be perceived not in any one view, but as an accumulation of impressions. It becomes an intellectual record of innumerable complex parts to whole relationships.

Paul: *When did you start making films?*

Nancy: I made my first film, *200 Stills in 64 Frames*, in 1970. It consisted of a series of stills that I had photographed for two and a half seconds each, which equaled sixty-four frames. The problem became how to read a complicated frame in the same amount of time as a fairly simple one. I made drawings; they were a compilation of stills put together in a way that denoted structure time via the media. For example, there's one drawing called *Frog Jumping in 1/24th of a Second* and it comes from a book of still photographs of the movement of various animals, *How Animals Move*. Another is called *Diagonal Linear Movements of the Newt* in which a newt's left foreleg moves from a front to a back position and is recorded in about twenty-five different positions. There are two drawings I made after [Edward] Muybridge: *Camel Walking at 1/16th of a Second* and *Camel Pacing at 1/24th of a Second*. I took the linear, narrative format he used of left to right motion in top to bottom. Then, in my own terms, I departed from that type of information to a degree when I made a drawing of a hypothetical dialogue between Major Beale of the United States Army and Ireteba, using hand signals exchanged while Major Beale was ferrying sixteen camels across the Colorado River near Needles, California. This was an event that might have occurred prior to the Civil War in 1859. Anyway, the hand signals are those of the standard Boy Scout handbook. The dialogue was invented by me. The way they are to be read, which is the point, is structured so that you read the left-hand corner on the left side of the page and then you have to move half way across the page to the left-hand side of that in order to go from Major Beale to Ireteba: the eye has to look from left to right, back and forth, just as Iretaba and Major Beale were looking at each other across the river. This structure is contrary to the normal cartoon space, and it emphasizes eye motion and also provides a time structure for the interpretation of that special narrative. The second film,

Goulimine 1970, was made in Morocco. I filmed groups of camels moving and focused on the relatedness of parts of the animals as they were seen in motion and in depth.

Paul: I'd like to bring up the word "information." It is a word that comes up frequently these days. What does it mean to you? What does it stand for? How do you use it?

Nancy: When I speak about information in my own work, I am referring to the visualization, the reading of the details that I choose to incorporate, or the content vis-a-vis the process. These details invented by me and their juxtaposition would account for "information." What I try to do is transform my research via processing. What I ask of the observer is that he read those visual relationships on the basis of certain related notions to original sources.

Paul: What about your titles? Are they a key or just a reference term?

Nancy: They are reference terms, indicators, titles for means of cataloging. They add another source of meaning.

Paul: You've done a fair amount of traveling. Do you find it useful, or is it because you can work in places to which you travel?

Nancy: I visit museums, make drawings, and bounce off the bizarre in my thinking. This year [1972] I'm sure I'll be on a plane every two weeks. I don't like flying that much. I find that it infringes on my studio time, but at the same time I try to be open to the range of experiences to which one is obviously exposed by visiting so many different cities. I might go to a library or visit a museum that wouldn't be possible otherwise, but there's really no direct contribution to my work.

Paul: Have you associated yourself with any of the women's art associations?

Nancy: No I have not. I am not political in terms of the women's movement because I honestly don't have time, and I feel that the strongest statement I can make is in terms of my work. I'm not willing to do more than that.

◆

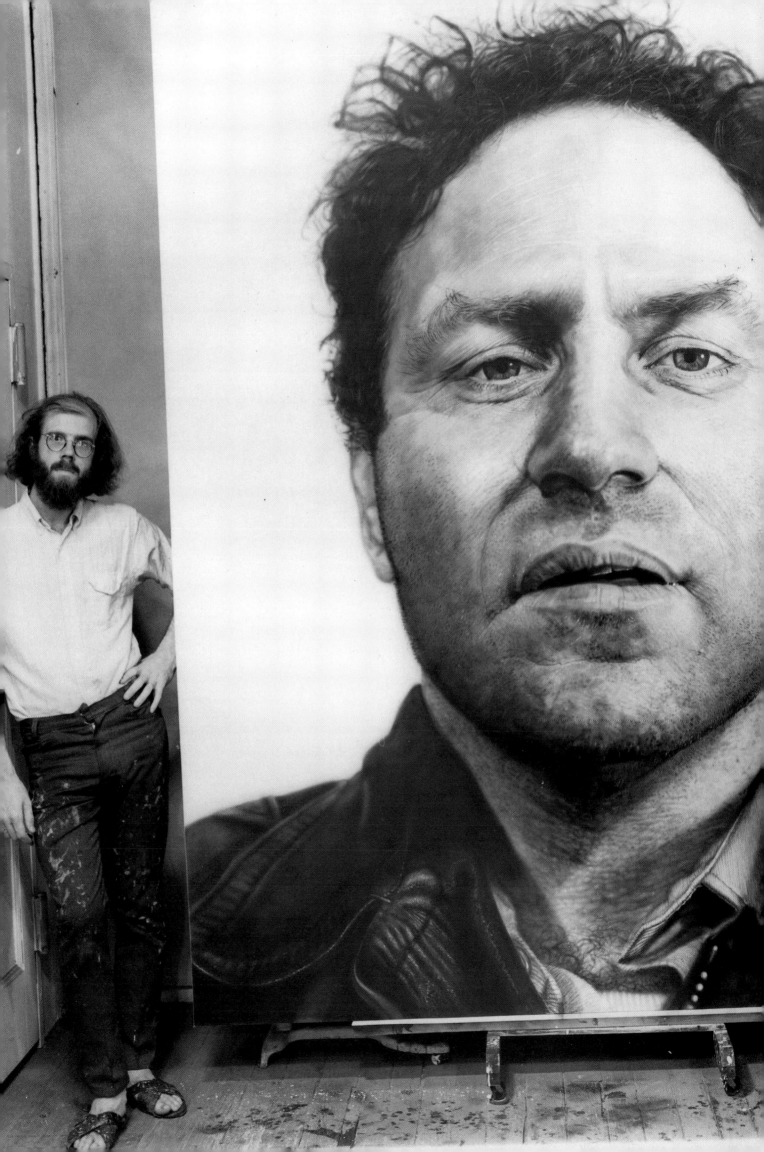

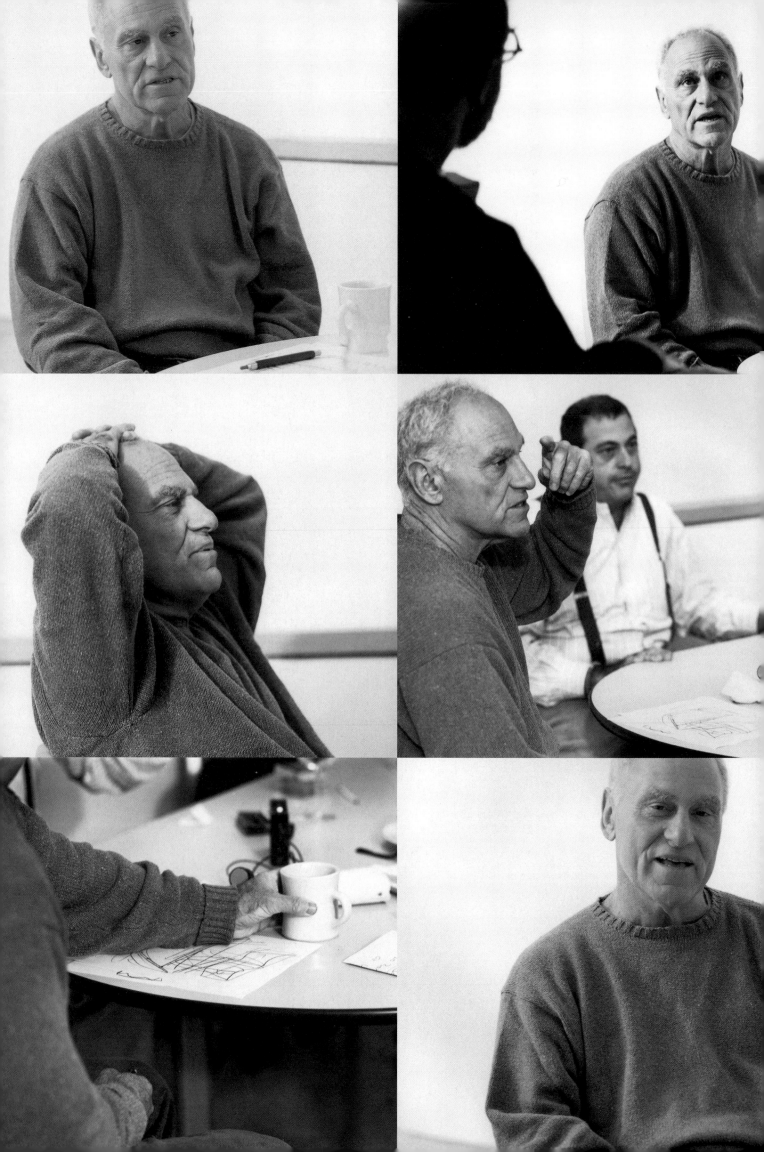

Richard Serra

New York City, October 25, 1995

Richard Serra: *[Looking at early Serra exhibition catalog from his 1966 solo show at the Galleria La Salita in Rome.]*

Chuck Close: **How about that? It's been a while since—**

Richard: I don't even have this.

Chuck: **You don't have it? Well, you can have that one.**

Richard: Great. Boy, it brings back old memories.

Chuck: **Yeah.**

Richard: Jesus.

Chuck: **Those are my hat and glasses, you know.**

Richard: Well, maybe.

Chuck: **Remember that? Huh, maybe!** *[laughter]* **Jesus, the revisionism is starting already.**

Richard: Claiming property. I don't know about revisionism.

Chuck: **Well, I won't give you the goddamn catalog.** *[laughter]*

receding pages:

ne Ton Prop (House of Cards),
969, lead antimony, 4 plates,
8 × 48 × 1 inch each. Photo
ourtesy Museum of Modern
rt, New York.

Vith Nancy Graves, being
hotographed by Chuck
lose for portraits.

ight Angle Corner with Pole,
969, lead antimony, 51 × 98
4 inches. Photo courtesy
ace Gallery, New York.

erlin Junction, 1987, Corten
teel, 2 plates, each measuring
2 feet 11½ inches × 44 feet
⅜ inches × 2⅜ inches. Photo
ourtesy Pace Gallery, New
ork.

arnegie, 1984–85, Corten
teel, 4 trapezoidal plates,
ach 38 feet 10 inches × 12
eet 9½ inches × 2½ inches.
hoto courtesy Museum of
rt, Carnegie Institute,
ittsburgh.

lson, 1985–86, weathering
teel, 10 feet × 33 feet ⅜ inch-
s × 12 feet 9¹⁄₁₆ inches.
hoto courtesy Pace Gallery,
New York.

rop, 1968, lead antimony
late: 60 × 60 inches; pole, 8
eet. Photo courtesy
aceWildenstein, New York.

huck Close with Richard
erra portrait, 1968.

ichard Serra in Close
tudio, October 25, 1995.
hotos: Bill Zules.

• • • •

Chuck: *I was trying to interview Nancy [Graves].*

Richard: She died the day before yesterday.

Chuck: *I know. She was very weak, so she agreed to answer written questions, unfortunately. The idea for this book grew from having lunches and just talking, so don't consider this an interview nor me an interviewer. We've known each other since about 1962.*

Richard: Is that right?

Chuck: *Yeah.*

Richard: Scary.

Chuck: *Isn't it? It really is. You arrived at Yale before I did. You came from California, and I think that you got there about a year before I did.*

Richard: No. Same year.

Chuck: *Same year?*

Richard: Same year. Graduated the same year. Got there the same year. I think I got there maybe a week before you got there.

Chuck: *But you were an English lit major. When did you take art?*

Richard: I took all the art classes that I could at [University of California at] Berkeley and at [University of California at] Santa Barbara. I took a lot of drawing courses with Rico LeBrun and Howard Warscheur, and I sent Yale—

Chuck: *I didn't know you studied with Rico LeBrun.*

Richard: Yeah.

Chuck: *No kidding.*

Richard: I sent Yale twelve drawings, and they said, "We'll give you a grant because we think we can teach you something." *[laughter]* It was a very arrogant letter.

Chuck: *Well, they were looking for people who were teachable. I remember that their big gripe about Don Nice was that he had already figured out what he wanted to do; they couldn't teach him anything.*

Richard: I think I got in on my grade point average as an English major and the fact that I'd made some drawings, not because I was an artist, but because they saw a great deal of talent. I think they thought that they could do something with this guy.

Chuck: *You were a painter then, and you devoured—I never saw anyone run through art as quickly as you did. We could always tell whose work you were into because all the pages of those specific [art] books would be glued together with paint.*

Richard: I think libraries are supposed to be used by students. The books can always be replaced. When I graduated, I had a whole cache of borrowed books that I hadn't returned. I went back, finally. The books were overdue by many years. I returned them to the librarian. She was very happy to get them, and she didn't charge me. She had something very nice to say. Like you, she too remembered all those dirty books coming in, but it just meant that she could get new ones. *[laughter]* Once, when I spent the summer in New Haven, I decided to go through the art history library from a to z, every book.

Chuck: *Uh huh.*

Richard: I did that just to see if I could get the history of art into my head. I mean, I didn't read every page of every book, or look at every page of every book, but I went through every page of every book, which was some chore.

Chuck: *You've always liked ritualized stuff like that. When we were teaching at the School of Visual Arts, you used to take your students to different rooms at the Met[ropolitan Museum of Art]. It didn't matter which rooms. It was a kind of encyclopedic approach to things: go there and find something.*

Richard: Usually when you go to the Met, you have some predetermined idea about what you want to look at. However, students don't know the difference between Bellini and Caravaggio, so you show them one, and then the other, and then Islamic and Chinese, or whatever, without any prediction or plan, and they come away making selections and distinctions they wouldn't have made otherwise. That was an interesting time. In fact, to me teaching has always been a way of seeing the possibility of change or of asking questions, because everybody kind of gets stuck in their own ritual. It's very difficult to get out of it. Daily life probably

confines you, in terms of your freedom and in terms of your limitations, more than you know, so you end up doing things by rote, and over time you just have to make up little games that seem contrary to the logic of the day in order to shift things around. At least, some of us continue to do that, when we feel the urge.

Chuck: *Or, at least, some of us feel that we're doing that, whether we are or not.*

Richard: Teaching is one of the ways in which you can do that. Most people who teach have some sort of institutional way of presenting the curriculum, and if you remember that the students are young people who are open to questioning, then you can explore those possibilities. I always thought teaching—

Chuck: *I didn't know you were still teaching. Do you teach?*

Richard: I teach now and then. I'm teaching at Yale a couple of times this year. I do it when I can, but I travel so much that I don't teach in any one place consistently. I've been teaching on and off at Yale since I graduated.

Chuck: *Yeah, me too.*

Richard: I either teach in their architectural department or their sculpture department, and sometimes the painting department, but rarely. I've taught a lot in the architectural department over the years.

Chuck: *Getting back to Richard Serra, the early years, a lot has been made of the trip that you took with your father to see a ship being launched.*

Richard: I wrote a little essay for a catalog, and as I hadn't submitted much autobiographical material, I thought that, in a few paragraphs in a catalog, I would give an indication about what was important to me. Historians, for lack of originality, jump on those things and make them into something other than what they are, or they misrepresent them to place them within their own agendas, to talk about something that's either true or not. I thought the essay would just get lost in the catalog, but it's been used in ways that I thought were both interesting and off the mark.

Chuck: *Right. Well, you did work in the steel mills.*

Richard: Yeah, I worked in steel mills in Southern California when I was seventeen or eighteen. I worked for the Art and Technology Program in Fontana for a year. I've been in and out of steel mills all my life, and steel mills have, for me, become kind of extended studios. I just got back from one in Korea, actually. It's probably one of the biggest steel mills I've ever seen. I went to Southern Korea and took a helicopter to an island. Fifteen years ago a shipyard opened on this island, and now they are producing forty percent of the world's ships. It was an absolutely fascinating trip. I went to Korea to see if, between the steel industry and the shipyard, they could help me build what I wanted to build, but they can't. I wanted to build a form that required a warped piece of steel. In the past when I was trying to build something similar, I would cut a piece of steel in various places, put it through rollers, and bend it. I have a bender—a roller—but lo and behold, we went over it and over it again, and we couldn't come up with how to do this. I knew about this engineer in the aerospace industry who works for Frank Gehry. He came up with a computer program called the Katia, which means that you

can walk inside a thing after you make it. For instance, you can see all the struts on an airplane. You just give them two coordinates, and they make any three dimensional model. I gave him the two coordinates of my piece, and he would have been able to give it a skin. But the computer was broken, and he said, "Look, you can't get it for two weeks. Call me back again in two weeks." So I thought, "Oh, I'm not going to be able to play with this guy, although I'd like to, but maybe I can figure this thing out by myself, without having to go through him." So I took a piece of wood and eventually, I came up with the form that the guy with the computer would have come up with. I sent him the template, and I said, "Is this the kind of thing that you're going to send me?" and immediately he replied, "Where did you get my machine? Where did you find access to my machine?" I told him that I had done it myself, that I made a model of it, and he asked, "How did you make the model?" I explained it to him over the phone, and he said, "Send me the model, send me the drawing, I'll get right on it." Now we're trying to find places in the United States that can build it. The problem is that when you send them the computer program, they look at it and say, "We can read this, but we're going to have to bend these plates, and in order for us to bend these plates, what we want is a mark on the plate, every millimeter by millimeter." So even though we can work it out, and I can circumvent a lot of model building, I built a model for each of these pieces anyway. We're going to have to go back to mechanical drawings and see if someone in the states can build it.

Chuck: *Before we had computers, my father was a sheet metal man, and he had hundreds of patents and stuff. He would always build everything with models.*

Richard: Yeah, yeah.

Chuck: No mathematics were involved at all.

Richard: Yeah. One of the reasons I liked working in Frank Gehry's office is that, unlike other architects, he doesn't work with drawings; he works with models. He works with cardboard models, and he'll go through fifteen or twenty or thirty models on every project. It's a very hands-on, inventive way of dealing with programs. He's concerned with how to put something together and with the spaces in between. I've always had a lot of fun visiting him, and he's been one of my close friends for a long time.

Chuck: *Before you used models you always either built the piece, or shoved the material around.*

Richard: I think first in terms of models. I don't think first in terms of drawings.

Chuck: *And you use a sandbox. You're still playing in the sandbox.*

Richard: I'm building a piece right now for Luxembourg that I built in the sandbox.

Chuck: *That's for the pieces that are buried in the ground.*

Richard: *[walking around in studio, looking at Chuck's recent work]* No, it's for a piece that, if you have a vertical plane, and you want to shift it on its axis, it's easy to do—

Chuck: *Right.*

Richard: —but if you want to do both this and this *[gestures]* simultaneously, it's hard to do without some sort of fluid fulcrum.

Chuck: *Um hum.*

Richard: You know, most architects just cut a slot and then they're stuck, right? This way you can go through multitudinous results in a very quick time, and throw a lot of them out, or say, "Oh, I'd like to stay with this aspect of what's going on." It gives you a lot of solutions to look at immediately.

Chuck: *It shows you the shape in which you're going to have to cut those pieces that sit straight on the floor to get them to sit flat, right? I mean, do the ones that are buried in the ground continue to their logical shapes?*

Richard: Yes. Always. I always start with a rectangle, and I hardly ever—in fact I don't know if I ever have—cut shapes to hit the floor. Maybe I hit them, or maybe I knock the tip off the corner.

Chuck: *Don't you have to cut a curve at the top and the bottom to get those to roll like that?*

Richard: You have to do that, but I've never thought of it in that way. I cut those out too, the curves, but to make a curve you have to make a cut anyway.

Chuck: *After your having been a painter and dealing with the wall, it seemed to me that your first pieces of sculpture always addressed the wall. Now you address the floor with the same kind of intensity that you used to address the wall.*

Richard: Yeah, I got off the wall, I think, in '69, '70.

Chuck: *Yeah. Well.*

Richard: I've been off the wall for twenty-five years now.

Bill Bartman: *Off the wall.*

Richard: Just because painters are still there, I mean. *[laughter]*

Chuck: *Some of us make art the way God meant us to make art. We go indoors and on the wall, not out there where people bump into it.*

Richard: My mother allowed me to go to any church I wanted, and after about three years, I decided I was an agnostic, then an atheist, and now I'm happy being off the wall. *[laughter]*

Chuck: *I remember the day that we first erected the* House of Cards *in your studio. Do you know what you said as we were lifting up the four plates to put it together?*

Richard: In lead?

Chuck: *Yeah, it was in lead. If you remember, I had a rope tied around my waist that went through a block and tackle, and I was on the inside of the four plates as they came up around me.*

Richard: Well, we thought that if it fell over, it could go right through the floor.

Chuck: *Yeah. And I was—*

Richard: Actually, we thought it might go through the whole building. We put some wood inside, and if Chuck was inside, we probably tied him off. That way, if the floor went, he could hold onto the rope. *[laughter]*

Chuck: *I remember—in fact, I think it's on Bob Fiore's film—hearing you say, "Let's get Carl Andre up off the floor."*

Richard: Uh huh. That's good.

Chuck: *I think the idea was to reinvent walk-around sculpture around which you circled, because until that point you hadn't made such a piece.*

Richard: I had done pieces on the floor, but nothing freestanding, a la monolith, like that, and I think that once you do that you have an obligation to deal with your responsibility in terms of the history of sculpture, unless you're not interested in it at all, but once you're making things that people are going to identify as sculpture, you can't say, "Oh gee, I'm an artist, and I'm sorry I made one of these." You can't cop to that. You basically have to say, "I bumped into a tradition that needs reassessment here." Actually, that was one of the things that split Nancy Graves and me. She said, "If you're going to present this as art, I don't know if we can stay married," and I thought, "She's probably right." *[laughter]*

Chuck: *Which piece was that?*

Richard: *The House of Cards.* She really thought that it was outside the bounds of making art, that it was somehow like—well, Nancy had very definite opinions about what sculpture ought to be.

Chuck: *Was she still making camels and stuff then, or was that later?*

Richard: Yeah, she was still making camels, and she had just started making bones. Susan Rothenberg was making bones with her at the time.

Chuck: *Right. I used to schlep all those goddamn camels up and down seven flights of stairs for her.*

Richard: Chuck, if we start with me in 1969, we're going to be here all day long.

Chuck: *That's all right. Actually, I want to go back earlier than that. [laughter]*

• • • •

Chuck: *To get the early stuff out of the way quickly before we move on to the other things, so much has been made about that particular time that we were at Yale: what went right and what went wrong; why our class and the class ahead of us and the class behind us produced so many people who are still making art of one kind or another. I was trying to explain it recently when I was up at Yale. I thought it was a very conservative place when we were there. Would you agree with that?*

Richard: Do mean the faculty or the institution itself?

Chuck: *Us. I think we were very conservative.*

Richard: The students.

Chuck: *Yeah. We weren't trying to make stuff that looked like art, that we could ship to New York and start showing. There was a real sense of being a student.*

Richard: I think the nature of being a student is to be conservative. I don't think students usually come in with full-blown identities. I think part of the nature of being a student is to accept the fact that that's when you're learning, and you should go through or dismiss as many models as are presented to you, or you should dig them out yourself. I think one of the advantages of being a student is knowing that you're a student, and if knowing that you're a student and not a professional when you're a student is conservative, so be it. I mean, I don't know what you mean by conservative.

Chuck: *I guess because—*

Richard: Chuck, I remember seeing you the first couple of days you were there and you didn't look conservative. Chuck used to wear these, uh, vests—I don't know how you would describe them, you can probably describe them better than I can, Chuck—with kind of silk

shirts that had ruffles, and he looked like he was from a rock n' roll band, a very expensive rock n' roll band.

Chuck: *But rock n' roll bands didn't look like that then.*

Richard: What?

Chuck: *They didn't look like that in 1963.*

Richard: Conservative students didn't look like that either.

Chuck: *But also, rock n' roll bands didn't look like that.*

Richard: Chuck introduced himself to everyone by falling through the window of the drawing class. *[laughter]* Chuck was crawling around the skylight during a session and fell through the window. It must have been about twenty feet to the floor. People were more worried about the glass splintering around impaling the naked model than about Chuck, who was bouncing off the floor. "Who's that guy?" they said. "Who's that guy?"

Bill: *How come we've never heard that story?*

Chuck: *I don't know, I don't know.*

Richard: Chuck's entrance.

Chuck: *I guess what I'm saying by conservative is that, when the students were allowed to pick who would come up as visiting artists or to recommend people, we had people like Edwin Dickinson and Isabel Bishop. She used to live on 14th Street and Union Square.*

Richard: The students picked those or did—

Chuck: *Yeah, the students picked them.*

Richard: Yeah, well, I wouldn't have known who either of them was. I mean, I came from California and had never seen a Cezanne. Maybe the students were—what I found interesting about students was that—

Chuck: *—you don't think that we had a lot of suspicion about New York, and about all kinds of stuff?*

Richard: I think this is what happens. I think you get art students who pretty much look the same all over the country, and you throw them into a very highly competitive school like Yale, and they have to size each other up. They don't know anything about each other. Some are more advanced in terms of talent than others when they arrive. They've learned how to mimic whatever style or convention is out on the scene, and that's probably why they were invited to be there, so if Chuck says it was conservative, there was a lot of colliding between students and egos of students in terms of—

Chuck: *Up all night, throwing brushes at each other.*

Richard: I mean, there was a very—

Chuck: *Smashing chairs. You used to have to hide the chairs that you had broken in the trash.*

Richard: I think it may have been conservative in that the students weren't defined, but it wasn't conservative in the students' competitive vigor. That was fierce. I mean, in New Haven you don't get out of a four-block radius. I mean, you're all stuck there.

Chuck: *It's a medieval walled town, in a way.*

Richard: It's worse now. Then you had some access to the town. You could go to Dixwell Avenue, or you could walk outside of the confines of the campus. Now it's really like a fort.

• • • •

Chuck: Let's see, '64. You went off on a Yale travel grant to Paris. I was in Vienna, and then you guys went on to Florence.

Guest: How did you guys decide where you were going to go?

Richard: Well, you have to get a grant.

Guest: I know that, but in terms of where you decided to go, to Vienna, or to Paris?

Chuck: I applied for Vienna because I knew I had to be back at the end of every month to pick up my stipend check, and I looked at the map of Europe, and it is like a wheel with Vienna the hub. Get to Italy, get back. Get to Greece, get back. It was sort of a pragmatic decision, and I said I wanted to study Klimt and Schiele. What are you going to say if you're going to go to Vienna?

Richard: It's not a bad thing to study.

Chuck: No, it turned out not to be a bad thing to study, although I had no interest at all. You went on to—

Richard: We're not really going to do "This Is Your Life Richard Serra," are we?

Chuck: No. I want to get up to—

Bill: It's so funny that almost all of these conversations end up being about the first third of people's careers.

Chuck: Yeah. I guess I like dealing with the decisions that got you where you are today, more than the adjustments that you make while you are where you are today.

Richard: That's hard to know. The decisions that went—I don't know.

Chuck: You know, I thoroughly remember Nancy in Florence, seeing those wax medical models, those incredible sculptures of people. Also, isn't that where she got all those pelts from which she ended up making her camels?

Richard: No, at the time she was helping me. I made pieces with live and stuffed animals for a show in Rome.

Chuck: Right.

Richard: She was helping me tan skins. We used to go to the zoo all the time, and we used to go see this guy Sesina, in whom she was very interested. He would actually cut up a cadaver and show us the whole dissection.

Chuck: Incredible. Did you ever see his things? One looks like a Botticelli woman, with her eyes open, smiling, but her guts are opened to the world. And he had eyelashes embedded in glass eyes. Bizarre.

Bill: It's funny that both you and Kiki Smith were somehow terribly influenced by that.

Richard: Well, it's kind of a gorgeous necrophelia or something.

Chuck: I guess I'm just looking for a few things on which to hang our hats, such as drawing in the Brancusi Room in the Museum of the Twentieth Century in Paris, which you did for most of a year, right?

Richard: Well, at least for six or seven months. There wasn't anything else there in which I was interested. I had never really looked at Brancusi, and for me, seeing Brancusi for the first time was like a painter seeing Cezanne for the first time: you have to acknowledge the simplicity and the resulting structure of what the guy did. There's no way of getting around it. Also,

Brancusi had an added hit in that he got a lot of emotional content into the simplest of forms. I was interested in the fact that the volume seemed to be drawn on the edge, that where he either cut with an axe or where he stopped modeling seemed to be the places where the drawing decisions were made. To me, it was as interesting to draw from him as from anyone else. I think I really wasn't interested in making sculpture, and I probably didn't understand that Brancusi was going to be a backbone for me, or a core source, until I started just screwing around with different materials. When I really had to start making something by looking at what was relevant and what was not, what was extraneous, silly, trivial, poetic, and what I wanted to do rather than what everybody else wanted to do, to me Brancusi seemed to be better at making sculpture than anyone else in the century. I think that you pick your heroes and ghosts according to what you want to use or what's useful to you in terms of how you want to grow, and different people haunt your studio at different times. Very early in my career Brancusi was very, very instrumental.

Chuck: *Yeah.*

Richard: Right now, there are aspects of his work that I really find too decorative and too much toward the twenties, too art deco, but that's just a small part of his work.

Chuck: *Well, there was also his early fetish finish.*

Richard: I don't know if I want to fault him for that. There are just some things that I don't like, but I think that's particularly personal. I'm certainly not going to slight Brancusi. I mean, he's probably the best sculptor of the century. There are things I like in other sculptors as well. I think that Picasso has a much greater breadth and sculpts with a great deal of ease. He basically sees it before he does it. He was gifted that way. Giacometti kind of hit an emotional corridor nerve that seems to ring through every century as being true to something very, very primal, and that's hard to get around. Giacometti, for me, is good in every century. Brancusi, more and more, is starting to look like a period style sculptor, albeit a great one, while Giacometti is probably good in any century in which you want to drop him, and Picasso, in terms of invention, still leaves the field pretty open.

Chuck: *You know, what's interesting is that Picasso is considered mostly a painter, but I think he really was an incredible sculptor, and for my taste, I'm not very interested in Giacometti sculpture. I'm much more interested in his paintings and drawings.*

Richard: To me, his paintings seem too embedded in the Cezanne tradition. If he didn't make sculpture, he'd be considered a mediocre painter, and maybe even a good painter, but not a great painter, because he didn't really break the rules of painting that much. I think he's a great sculptor. I think there are some things at which you can look, like the dog or whatever, that you may find trivial and trite, but I think the small figures, the standing figures, or the walking men, are fairly terrific. It's hard to dismiss them. I've come to them thinking, "Okay, I'm going to be very critical and as hard as I can be with this guy," and I go out thinking, "It's a big statement."

Chuck: *When the Guggenheim did that Picasso in the* Age of Iron *show, I was surprised at how strong Calder was. I mean, I thought Calder, early Calder, was really interesting stuff. I know you're not a big Calder fan.*

Richard: Yeah, I thought he looked good there too. This is probably an off-color joke, but someone phoned me up right after OJ's [Simpson] arrest and said that he was in the Gagosian Gallery, and he wanted to buy two sculptures: *Woman with her Throat Cut* and *Walking Man*. *[laughter]*

Chuck: Oh god.

Richard: Well, Larry [Gagosian] has a sense of humor. Even if you think of *Woman with her Throat Cut* as just a floor invention, as kind of an erotic piece on the floor—it was in that show, on the ground floor of the Guggenheim—I think it's an extraordinary piece to have been done that early. Not many people followed up on it, and certainly Giacometti wasn't given any credit for being on the floor much earlier than Caro or Andre, but definitely he was there, and it was sculpture, and it still looks, in terms of this century, like one of the better kind of inventive pieces and one of the more erotic, nasty pieces. Just simply putting it on the floor, like a crab, with open legs, a mantis or something, was beautiful, terrific.

Chuck: Speaking of death and nastiness and Calder, not long after the accident with the piece that you were building in Minneapolis, where unfortunately a rigger was killed, there was a similar—

Richard: Princeton.

Chuck: —thing in Princeton where a Calder stabile fell on somebody and—

Richard: —killed a worker.

Chuck: —killed a worker. There was no press, no coverage, because a "happy" piece of sculpture fell on the person.

Richard: Well, I don't know why, but there wasn't any press or any coverage. The same thing happened recently.

Chuck: Don't you think that people attacked you when that happened to you? If they couldn't attack your work, they found another way to do it. I think what was done was outrageous and was an effort to kick you essentially while you were down. I think it was because the work seems aggressive, confrontational, scary, all of those things, and if that kind of work kills somebody, people have an immediate kind of—

Richard: You mean they think the artist intended to do it all along.

Chuck: Well, if you're killed by a "happy" Calder stabile, which implies that it's stable and not going to fall over are you any less dead?

Richard: Yeah, I think people prefigured or prejudged what had happened, and they didn't know that it was a rigger's error. They thought that one of my pieces, given what I was doing, probably caused the accident, that I was up to no good, and they condemned me for it. But I think, particularly if you live in New York long enough, that a lot of whiffs and smells go by all the time, and if you really get out there and play, it's a real traffic accident. On the other hand, you can hide out and it's like a fortress. You have to find the ability to sustain what is your core and your source, without getting knocked off your pins, because people, as soon as you get out there, will try to do that. Once you kind of state your own identity, even people who are friends become very, very resentful. A lot of people come out from behind the woodwork with torches, or whatever, all the time. What that did to me was put me on the road. I mean, I couldn't work

here, so I had to go on the road. It put me on the road, and I'm still on the road. It really meant that I had to find a way of working on the road, so I had to go to shipyards and steel mills, and I had to find a way of extending my studio from one place in New York, to dealing with traveling, and building, and building pieces in Europe. What happened is that I built up a big body of work in Europe. I would say even now that three quarters of what I have built is in Europe. So if you ask, "What decisions do you make," sometimes you don't make a decision. You have to go in a direction in which you wouldn't have chosen. For me, that meant going on the road.

Chuck: *Tell me about it.*

Richard: Yeah, tell you about it. *[laughter]*

Chuck: *Well, the change that took place when you left the traditional studio is interesting. The last time that I was intimately involved in helping you make your sculpture, you were still a studio artist. Essentially, you made the pieces in the studio, and then they would go out and be placed somewhere.*

Richard: Yeah, yeah.

Chuck: *It was a wonderful time in my life and a wonderful time in the art world, but it was also a crazy time, the late sixties, with the whole world falling apart, with the assassinations and everything. Yet so many artists really kind of burst onto the scene at that moment. It was an incredible crucible, I think.*

Richard: I think, but I don't know exactly. I think every generation finds its own context, but what seemed to be true then was that there was a real cross-breeding between the dancers, the filmmakers, the singers.

Chuck: *Musicians, filmmakers.*

Richard: Musicians. And they all got together in one place called Max's, and there was a kind of cross-fertilization. People were interested in making art, not selling art. If someone came in and said they had sold out a show, everybody thought, "Well, it can't be too interesting." I mean that seriously, absolutely seriously. I think it was a very, very healthy time. When I first started meeting with people at Max's, I met Michael Snow, and we went across the street to see a performance on the 22nd floor. Simone Whitman was doing a performance. I think it was Simone, yeah it was Simone. First Rauschenberg did a music piece. Then, we were sitting there and looking out the window, watching the sun go down on the tops of all the buildings, and all of a sudden the lights in the room went out, and the light outside the window was shining in, and a person fell from above, by the window, and disappeared, and then another person fell by the window, and then another person fell by the window, and this kept going on for about ten or twelve minutes until we saw the first person fall by the window again, in a little different pose: *[laughter]* Muybridge in action. I was sitting next to a filmmaker who was completely stunned by this.

Chuck: *That's like the old silent movie thing where the guy is carrying the front part of the ladder, and by the time the back part of the ladder goes by, it's the same guy.*

Richard: Yeah, yeah. All of these different people were going by, and then I think one person didn't show up again because he broke his leg. They had piled up mattresses on the 21st floor, and they were going up to the 23rd floor and jumping by the window in the 22nd floor where we were sitting, and that was the performance. A lot of things like that went on. For a filmmaker, for Michael Snow, it was completely fascinating. It had a lot to do with serialization,

it had a lot to do with image, it had a lot to do with frame, it had a lot to do with slowing it down, speeding it up, whatever, and with memory and anticipation. Yvonne Rainer was an enormous source for many people. There were things like that going on simultaneously that were interesting if you were making art, more interesting than talking to the painter next to you or the sculptor next to you, because you already knew what they knew since you had been in school with them, or you understood the game that they were playing. There were a lot of things that would crossfeed, and there was a lot of hysteria and a lot of people colliding against one another, and issues were taken quite seriously. I remember people screaming over whether Carl Andre's one brick after the other was about a line or about the relevancy of materiality being a brick. You wouldn't think people would stay up all night screaming at each other about that, but they would, they would. Meanwhile, you'd look over and see Janis Joplin, dead drunk, trying to keep up with herself on the jukebox, trying to sing to herself.

Chuck: *Singing to—*

Richard: Crying because she couldn't keep up.

Chuck: *Singing to Edith Piaf or Billie Holiday.*

Richard: No one would interrupt her because she was trying to sing her own song against herself, as a duet, and she was not doing very well, and we were not going to help her out. I mean, it was just sad, and we just let her do it. There was always something. Warhol would go to the back, and he'd lecture his staff on why they weren't working hard enough. I mean, Warhol was the coolest guy in the whole world, and you would never think that he was just some sort of beat 'em up cowboy saying that they had to work harder. I mean, giving a bunch of drug addicts a lecture on working harder was absolutely great. It was absolutely fabulous. *[laughter]*

Chuck: *At the same time he would sign an entire book of checks, and hand them out, hoping that they would go out and buy the right materials.*

Richard: I was actually there when Warhol had just come back from Sweden, and he thought that they hadn't behaved, or they hadn't produced as much as they should have, and he was actually giving them a lecture like Henry Ford, right? "We've got to get in there tomorrow morning and work harder."

Chuck: *Well, you assembled quite a group of people in your studio, none of whom were sculptors, which probably helped.*

Richard: It was better. Except Nancy.

Chuck: *Phil Glass was your only real paid assistant, I think, and you got him out of plumbing, and there was Rudy Wurlitzer, who is a novelist, and Michael Snow, and—*

Richard: Steve Reich.

Chuck: *And Steve Reich. Spalding Gray.*

Richard: Oh yeah, yeah, and this was when none of them had any identities other than being people who wanted to make art.

Chuck: *I was painting anonymous people.*

Richard: No one had "arrived" outside of the small little downtown group who knew each other. It is interesting that most of those people, who went on and distinguished themselves

in some way and made a contribution in some way, were basically just a bunch of people downtown wanting to get through their lives, helping each other out.

Chuck: And you needed muscle. We were not picked for our intellectual—[laughter] There was a helluva lot of lead to move around.

Richard: Yeah, yeah. We once put up a show at Castelli's uptown—I think we put up six or seven pieces, and on a Saturday one fell over, and then they all fell over, which meant that we had to put them all back up again. [*Nine at Castelli*, December 4–28, 1968]

Chuck: Or the Guggenheim, the night when they turned off the air-conditioning, and the pieces all got soft.

Richard: Yeah, people got a little hysterical. They had worked all day and then you phone them up a half hour later and say, "Listen, they fell over and we have to go back up there." People got a little anxious. At one point Phil started taking out insurance on his fingers. He actually did that. He took out an insurance policy on his fingers.

Guest: Well, that would make sense. Those were the prop pieces that were falling down?

Richard: Yeah.

Chuck: Remember The Theodoran Awards Show at the Guggenheim, when you had a bunch of those pieces right underneath the skylight? That was before you were putting antimony in the lead, and they were quite soft.

Richard: Yeah.

Chuck: Then the air-conditioning went off on the day that the museum was closed, and the sun was coming through the skylight, and they went like, like—

Richard: Entropy set in.

Chuck: Yeah, and it was like dominoes, like what was supposed to happen in Vietnam. Everything fell over. We're going to get up to '73.

Richard: You're really going to do this.

Chuck: I'm going to run through the whole fucking thing.

Richard: Do I get to stand up with Art Linkletter and take a bow? [laughter]

Chuck: I think that the Warehouse show at Castelli's was a turning point for you. It was my impression that Bob Morris was trying to make a "followers of Bob Morris show" somehow.

Richard: Yeah, but he got outflanked, that's what happened.

Chuck: Yeah, that's what happened. You blew him out of the water. You had a scatter piece, you had a lead splash against the corner piece—

Richard: And a prop piece.

Chuck: —and a prop piece. That was pretty incredible.

Richard: There were a lot of good people in that show. Nauman was in that show, there were a few interesting Italians in that show—

Chuck: Eva Hesse was in that show.

Richard: Eva Hesse was in the show. There was a really talented guy—I don't know what happened to him—Bill Bollinger.

Chuck: Bollinger was very interesting. There were some beautiful Sonniers in that show, the best he ever did, I think.

Richard: **Yeah.**

Chuck: *I'll tell you, it didn't hurt that you used that heroic picture of you throwing lead. Maybe because of it, I have a theory that the reason that Pollock has such urgency for the art world is that Hans Namuth showed us what an artist looks like when he's making his stuff. He demystified the act of making art. Your art has always explained itself, has described itself, has always been there for people. It's art that made itself, and you can find out what happened, because it's always embedded in the work. But what it took was a photograph of you slinging a caldron of lead—*

Richard: I think the opposite about the Namuth. I think that rather than demystifying Pollock, it showed someone with an enormous amount of muscular acuity and coordination who was able to concentrate on a canvas on the floor without touching the canvas, coming in from all sides, flinging, throwing liquid paint. I don't think it was like showing a painter painting a painting. It was something that no one had seen before. I don't think it demystified. It was a little bit like making the act of creating something profound in its potential, even if the creator didn't know exactly what he was doing. That seemed to be, in terms of process, a real opening to a lot of people: if you just involve yourself in an activity, that doesn't mean it's going to result in a residue that's interesting, but it might.

Chuck: *But if it doesn't, you just move on to another material. It doesn't have the sort of history of usage of traditional materials. Don't you think that was important?*

Richard: **What?**

Chuck: *That in the sixties everybody was looking around for material that didn't have historical baggage attached to it.*

Richard: That, and the change of tools. I mean, Pollock had completely changed the tools: no brushes.

Chuck: *Turkey basters were not part of the art supply store inventory.*

Richard: No, Pollock wasn't coming out of Pearl Paint. No, no.

Guest: *Pearl Paint claims to have been part of your lead inspiration.*

Richard: I used to go there and watch Phil cutting up lead for a repair or whatever and go to the lead supply houses with him. Yeah, that probably had a lot to do with it. My first real introduction to the material was watching Phil cut it and tear it and melt it into other forms. It goes from a liquid to a solid. You can also hand manipulate it.

Chuck: *Prior to that you had been working in rubber.*

Richard: Yeah, but rubber doesn't hold any tension at all. I wanted a material that I could also hand manipulate, that I could also stand up. Eventually, I found that lead wouldn't support itself, but initially it gave a certain kind of possibility of moving into the material via an extension of your hand or your body or whatever, and making it firm, which I couldn't do with rubber. And I liked it, as a material. It's really a flexible material to use. It's a very easy, sensuous material to use. Actually, I'm still making models with it.

Chuck: *Um hum.*

Richard: You asked about the decisions one makes. I didn't set out to become a sculptor. I was just interested in the nature of some problems that probably came to me because of

Pollock and a few other people, but I didn't think, "Oh, now I want to become a sculptor." That never occurred to me. I thought that I wanted to explore problems that I found interesting, but lo and behold, when you make things that look like sculpture, you have to take responsibility for them, which you'd rather not do, but you do anyway. Once you start making sculpture, you want to ask, "Who else made it?" Right? You become interested in the history of art: who else made it, why they made it, in what context did they make it, what relevance or irrelevance it had, and who were the people you think are interesting or not. In some ways, it's easier to come to a body of work if you're not trained in it, because if you're trained in it, you make certain assumptions about its hierarchy, about the do's and don'ts. If you come to it from the outside, you don't care about that. You make some quantum leap into asking the question that seems relevant to you at the time, rather than a question about its tradition. I think that's probably why Picasso is a great sculptor. He was intuitively a great sculptor; he didn't have to worry about the tradition in sculpting as much as he worried about the tradition in painting. I think that's often true. The people who come from the outside into any media can immediately ask the question that's the next question to ask, because they're not encumbered by the tradition of the media. Of course, they have to have the question to ask. If they don't, you know they're nowhere.

Chuck: *But that's why so many painters—*

Richard: I'm not saying that every artist who makes a film is going to be an interesting filmmaker, although that seems to be the case right now. *[laughter]* If you follow, you will find just the opposite is true.

Chuck: *Sooner or later one of them has to make a good one.*

Richard: It's the law of averages.

Chuck: *But it does explain why everybody who is a sculptor and went to Yale was a painting major, and everybody who is a painter was a sculpture major.*

Richard: Yeah, I never thought at Yale that I would be interested in sculpture. I mean, all those guys were buried down in that tomb [of a building] making those little things that looked like the elbow of Henry Moore.

Chuck: *Well, you did teach color.*

Richard: Yeah.

Chuck: *That's pretty interesting because you haven't added color into your work since.*

Richard: I had a student there named Jennifer Bartlett who is doing quite well. *[laughter]*

• • • •

Chuck: *Now, let's move along. The first site-specific piece was* The Varied. *Was that the piece?*

Richard: Well, it was actually a lead splash against the outside wall at the Stedelijk Museum.

Chuck: *Oh.*

Richard: Which was—

Chuck: *Well actually, those were all site-specific because they had to be against the—*

Richard:—in the place where you were hanging them. Those were probably the first that really dealt with the architecture as a device.

Chuck: Well, what was the big piece that was in Ohio or someplace like that and was out in the landscape? Where was that?

Richard: Pulitzers. St. Louis.

Chuck: St. Louis, right. That was the first large-scale—

Richard: Yeah. I had been to Japan, and I had already done the *Running Piece.*

Chuck: Oh yeah, right.

Richard: Joe and Emmy Pulitzer—I knew Emmy before she married Joe—had a summer house. In it they had a big Monet waterlily, they had a beautiful Newman, they had a Matisse sculpture, just one after the other, and they had a Cezanne painting. They had this dog-legs field. They asked me if I wanted to deal with that landscape and I was completely overcome. I had never built really a major work of that scale. I was frightened and vulnerable, and to tell you the truth, I didn't know if I was up to the level of their collection. It made me very anxious, and it took about two years to figure out how to pull it together. I must say that Joe Pulitzer gave me a lot of support and patience, because I was very impatient, and we got into tremendous arguments. He came around and changed his editorial policy. His was one of the first papers in the United States to come out against Vietnam. The country was really full of tension, much worse than it is now, in terms of the tension between those who were against the war and those who were for it. Because of the discussions I was having with Pulitzer at the time, he actually changed the editorial policy. Emmy was also very involved with those discussions. It was interesting to find a man like Pulitzer, who had been steeped in the creme de la creme, basically taking a stand for young people, having that kind of influence, and really going against his whole community. At the same time, he was playing with me in his front yard, allowing me to do something I'd never done before, and still saying, "Go right ahead."

Chuck: That gave you an unrealistic notion of what it's like to try and build stuff because—

Richard: It gave me an unrealistic notion about clients, I think.

Chuck: That's right, because ever since you've been bumping up against difficulties.

Richard: Well, a lot of people who build art build it for other reasons, and a lot of people have different agendas. The Pulitzers were people who wanted to build art because they wanted to live with it, and they had a collection because they cherished the works. To start with people like them made everything after much more difficult. There have been some others along the way, but the Pulitzers really were instrumental in getting me off the ground. They did that just on faith. They had no idea of my potential, they really didn't. When Joe died, I was a pallbearer. He had become a really close friend of mine. He was a guy who went out of his way to help me, just on some eyeball contact, not knowing what the outcome would be, which was incredibly generous of him. There was no reason for him to have done that, but he did. I mean, he was building other people's work, very well-known people, but for him to say, "Go take this seven acres of land and do something with it," or four acres, or whatever it was, was fairly incredible. I guess that wasn't a decision I made either. I mean things happen, and you can call them fortuitous, you can call them luck, you can call them whatever. I think my engagement with Pulitzer was basically a dialogue about his newspaper and politics, and I think he decided,

"I'll keep this guy around, I'll tell him to play in my yard or something." [laughter] I really don't know. We got to be close friends, and I liked him enormously. I think when you're young, you're suspicious about people who are older, but you meet some older people who you like, for reasons that you could never have imagined liking anyone. I liked Pulitzer the way one liked Cary Grant: I liked Pulitzer for his vanity. He was a good looking, intelligent man who knew he was good looking and intelligent, and he had a vanity about himself. Now usually you think, "Who cares about that?" but it sustained his ego and allowed him to do things and gave him an energy that a lot of other people give up on having. He was a very proud person, and it's not that you learn from that, but there was something about his ego that I liked. I liked his relationship to himself. It was admirable. There aren't many men I know like that, and there aren't many men I've ever said that about: that I liked them because of their vanity. His vanity, not that it was infectious or anything, was something that I kind of admired. He was born into it, and he dealt with it well. It's hard to think of anyone else like that other than celebrities who are comics or something, the Johnny Carsons or whatever. He had that kind of notion about himself, and everybody kind of gave him respect for it. When you ask about the decisions one makes, I don't even know if they are decisions. I think things are pretty much in flux, and you bump into some people.

Chuck: Do you think that you can put yourself in a position where something is more likely to happen than not? Maybe it's just recognizing that something happened and taking advantage of it.

Richard: I think that, you know—

Chuck: Let's face it, some people are incredibly self-destructive, and they just shoot themselves in the foot, time after time.

Richard: I think all of us are to a degree. I think it's learning your pace, learning to deal with it, learning to balance it. I mean, everybody's got their smack, whatever it is. It's just hard to know. I think one of the things that was interesting for me is that I always thought I had an inability to deal with people in the world, but once I got out of my studio and got on the road, it became easier. You have to learn the ropes of being on the road.

Chuck: I can't imagine.

Richard: I thought it was easier to work on the road than to work being confined. I had to make adjustments all the time, and it became a source for concentration. You couldn't just sluff it off and say, "Oh, I'll get up later, I'll do it tomorrow." You had to meet a deadline, you had to get on the plane, you had to meet somebody, and even though a lot of those things didn't work out, it gave me an ability to be in the world with my work rather than be in the studio with my work, have my work go out, never to be seen again. I was responsible for the inception and the completion of making it wherever I went, and that kind of made me more like an initiator of a product in which I was involved from beginning to end rather than like someone who makes something and has someone else deal with it. That's why my relationship with dealers became screwed. I really didn't need one.

Chuck: You've had more of them than anybody else. [laughter]

Richard: I did. I didn't need them.

Chuck: You're like a bigamist who says he can't get along with his wife. Give me a break. [Serra is represented by Castelli, Gagosian, PaceWildenstein, and Matthew Marks galleries in New York.]

Richard: As it turned out, I didn't need them to do what I wanted to do myself, and of course, they wanted a lot of the money because they wanted to sell them. I would think, "I can probably make a piece and get it out there without you," and then I would think, "Well, I'd better have more of them," because what you find is that for sculpture in particular, each dealer has a very few clients. There are only so many people out there who are going to buy sculpture anyway, so why go to a dealer who has only three clients, when you can play with them all. I actually think that's going to happen in the future. I think more artists, as they arrive at a certain independence, will deal with the galleries in a way that makes it more interesting for them than it does for the dealer. I think that probably will happen in the future, and it will be good for the art world. I think dealers have a tendency to corral artists into stables and race them like horses against each other and against the world, and I don't think it's very helpful. Dealers put limits on artists, and put brackets on them. Also, if you analyze it, most galleries have a ten or twelve-year cycle, and then they're finished. They don't look at the next generation of young artists because it challenges the artists that they have in their stable. Usually, after a ten-year cycle they can't replenish or renourish. Well, they don't have to do that. There are a lot of artists around. That doesn't have to be the form that galleries take, but they seem to.

Chuck: When you talk about going out into the world and bumping into all this stuff, I can't imagine that. For someone like Christo, going out and fighting stupid bureaucrats became at least a large part of what he did, and he enjoyed doing that stuff.

Richard: I'm not sure he enjoyed it. I think he says he—

Chuck: He makes it part of the work.

Richard: It is part of his work. Yeah.

• • • •

Chuck: I can't imagine that it has been a lot of fun for you, fighting with the General Services Administration and everybody else, and—

Richard: It's not fun, it's just part of—

Chuck: Is it something that gives any—

Richard: Yeah, yeah, I can tell you. I can tell you because I just spent five or six years of my life doing that. It's like a footnote in art history, because existence counts for a lot. The piece isn't there and who cares. On the other hand, it brought me into a law firm, and I have an attorney now who I would not have had otherwise. The guy I originally had for an attorney got a brain tumor in the middle of my case and died, so a really great firm in the city picked it up, and now I'm with that firm. Because of them, I've met people who I really like: Arthur Lyman and people like that. You never know what the consequence of these things are going to be. Certainly it's not something I want to go through again, but it dispelled any illusions I might have had about the government. I mean, after the government finally put together this blue ribbon committee to try to figure out what to do with this crisis—they got [Robert]

Ryman, they got a labor leader, they got people from the architectural world, and they got urban planners—they brought them all together, a blue ribbon committee, and they asked the blue ribbon committee for their suggestions and advice. The blue ribbon committee said, "Leave this piece where it is," and the government, with some repugnant notion of their own democratic institution, said, "Screw you, we're taking it down anyway." You can really see the degree of the charade that they're willing to carry out for their press. In terms of putting a spin on the thing, I was completely naive. I had no idea how that worked. I remember at one point, NBC News or CBS, I can't remember which, said, "We're going to cover this thing, and we'd like you to come and substantiate what site-specific sculpture is." I said, "Okay, fine." They said, "Well, could you let us know where a few pieces are, and we'll have a crew in these various countries phone you, and you can set up times and dates, and you can just do a little interview with them." So there was a crew in Japan, a crew in Holland, a crew in France, and a crew in Germany, and I was on the phone at night doing all this.

Chuck: Is that when you had the piece in Tuilleries?

Richard: No, before. They finally aired the piece on TV, and it showed burned out cars, a big stack of garbage and rubble, and then cut immediately to *Tilted Arc*, and it said, "New Yorkers Have Had Enough of This." I thought, "Boy, oh boy," and I phoned the production manager and said, "What the hell happened?" He said, "It came from higher up. Somebody didn't want to take the slant that you were giving us, so they decided to do it the way they wanted to do it," and I thought, "Boy, that's how the news goes every night, right?" That's how it goes every night. You know, that gives you another kind of relation to politics. It gave me a perspective on politics I hadn't had before. It brings other people into your life, some interesting, some not. It's not a situation I would ever tell anyone to go through, and I don't know if I would go through it again if I had to, or didn't have to, but I think you have to use those things as learning situations. If you don't, then you're going to chew on the bone. It was a difficult situation, and the bottom line was that I met, through that whole fiasco, a lot of people. I can tell you one. Michael Brenson, who really came out against me, is now a close friend of mine. You don't know how those things are going to turn out.

Chuck: It must have been reassuring to have so many people show up and testify.

Richard: That was reassuring, but I think it showed solidarity in the art world. For some people it had to do with me and my sculpture, but for most people I think it had to do with the fact that if that piece could be destroyed, we're all kind of out there. That kind of censorship is really coming down, and this is a situation in which people either have to sit on the fence or get off the fence or draw a line. I thought the fact that the art world showed some kind of solidarity and good will about its cohesiveness—it was the first time I've seen that in New York—meant that there was a community, and it would have to be reckoned with. I mean, if you look at any other subculture, for instance PEN, the writers organization, or Hollywood, they really have the possibility of legislating some change in terms of establishing criteria to protect themselves, but the visual art world has none. None, zero, zip. Maybe you're right in terms of not only students being conservative in the art world, but if you took a cross-section

of artists in New York, and you asked them about various issues or whatever, although people think that they're left of center, that may not end up being the case at all. It may be a very conservative group of people.

Chuck: *A conservative group of people who are, by nature, not joiners, so they're not going to ban together to do anything.*

Richard: Yeah, yeah. That's probably true. Oh, you know when you were asking about consequences that came out of the *Tilted Arc* thing? One was that I got into contracts, and now whatever I let out goes with a contract. Actually, I have an attorney who has drawn up a contract. When we were building a piece for the Holocaust Museum, none of the other artists had contracts. The Holocaust Museum didn't want to give me a contract, so we presented our contract to them instead, and it became the model for all the other artists who participated in the museum.

Bill: *Did Joel [Shapiro] use it too?*

Richard: Yeah, everybody used it.

Chuck: *And what was it?*

Richard: Basically, the contract states that the piece can't be moved, yet it gives them rights that they didn't have. The museum had no idea that they were going to have to do that, and when we first started negotiating with them, I told them I wasn't going to build anything unless I did have that right. Once they said okay I told [Ellsworth] Kelly and Joel [Shapiro], and then it became the contract that they gave to everybody, which protects all of them. I said to them, "Look, I'm not going to have the same thing happen again: that you put this in one day and they take it out the next." It's ridiculous that you've got to go through this.

Chuck: *How did you find working with—*

Richard: Fried. Great. Yeah, James Ingo Fried had Hodgkins disease, and when I first met him he said, "Look, you have to understand that talking for me is a very difficult thing to do if I'm not moving. If I run, I can speak, but if I sit, it's very difficult for me to talk." So I said okay, and he started running around the table, running around the room. This is really true. We went to the Holocaust Museum, and I came back sweating from running up and down the stairs, running all around. We ran the whole day.

Chuck: *He has a hard time talking.*

Richard: I ended up having total admiration for the guy. Here is a guy with diminishing returns working at a level that is probably harder than he ever worked before he found himself in that situation.

Chuck: *And doing his best work.*

Richard: And doing his best work. He's a very open, sincere, generous guy, and I had a very good time working with him. We went to the mussum together to mockup the piece. We were trying to figure out how big it should be, and we played the game "it's too small, it's too big." We had it up to fifteen feet, and we both agreed that was too big, so we got it down to thirteen feet or something, or twelve feet or eleven feet, and we thought it was too small. I mean, we could both see it in relation to the space, right? So we both decided how big it should be.

And how thick it should be. There aren't many architects who want to climb around with sticks and strings in the middle of the foundation doing that, right? He was completely into it, totally into it, and it probably wouldn't have gotten built the way it did, or be as tuned to the space, without his input. He was completely willing to play.

Chuck: *A little different from learning to put flags in the—*

Richard: He's not Venturi.

Chuck: *You had a big, big brouhaha over that. You wanted two stele.*

Richard: Venturi wanted to build some gates framing the Treasury Building. I told him that it looked very fascistic, he came in after lunch with flags on top, and I said, "I don't care if you put up a swastika." So they summarily fired me.

Bill: *Well, better to be fired for the right reasons.*

Richard: I actually think Venturi did some interesting things in his book *Learning from Las Vegas*, but then his own work was never as interesting as what he wrote about.

• • • •

Bill: *After the whole big thing with New York, were you gun shy at all about working in public spaces?*

Chuck: *Why doesn't this happen in Europe?*

Richard: The Europeans have a tradition of building things in public places that goes back to the Renaissance. They've always done that. They have streets named after artists, and art doesn't startle them in terms of what's presented in public. They've grown up with works of art, they know what works of art are. It has nourished them, it's something that is part of their culture, it's something that's part of their tradition, it's something for which they have respect, and they absolutely understand that it is to their economic benefit. I mean, if you look at France and Germany, at how much money they throw into art, you understand that it's absolutely true. I think here, after the Kennedy administration really got into it, public art got off the ground and really got into the provinces. A lot of it wasn't very good, and a lot of people objected. Some of it was good, some of it wasn't. It's hard to take a personal obsession into a public space and make it relevant, particularly in an area where most of the people don't have the same kind of educational background in relation to what its values are. It's difficult. I think there was probably too much done too soon. There was an enormous backlash, particularly from the right, and the art was used as a scapegoat. I think it has very little to do with the art. I think it's basically a scapegoat, you know, an easy target.

Chuck: *There's almost as much censorship and stuff coming from the left, in terms of what you can and can't do, or what men can't do, or—*

Richard: I wasn't aware of that. Is that right?

Chuck: *Oh yeah, I think so.*

Richard: In relation to—

Bill: *Politically correct, you know.*

Chuck: *I hope not so simplistically as just politically correct, but I think there's a lot of self-censorship.*

Richard: That's the criticism of the NEA, I think.

Chuck: *I think it's in the art world in general. I think a lot of things are only accepted—even a lot of people are saying that men cannot make a picture—*

Richard: What about a person in a sado-masochistic relationship with a woman. Doesn't he have a right to make that work of art?

Chuck: *I think so.*

Richard: I think one of the things, if you bring up the OJ case, is that in most of those relationships, both people are involved. I don't think those things sustain themselves unless both are involved. There are abusive men and some women can't get away from them, but there is a kind of S&M thing that goes on about which no one talks, where both people partake of it because it's the juice that drives their relationship.

Chuck: *A lot of major drug use probably exacerbates it too.*

Richard: Yeah. Yeah. I think that a lot of that just gets swept under the rug because the larger society doesn't want to look at what's going on there. It's hard to believe that people can't just walk away. They can't because they're in denial. Well, partly, but I've always thought that in a lot of those situations both people are involved with it. "Don't stop hitting me."

Bill: *Let's get back to what we were talking about before. A transcript was printed of the board meeting, or whatever, of the National Council on the Arts that considered the grant applications of those three artists who they turned down last year. You would not believe the inanity of the discussion. A lot of it was about politics. The NEA sort of committed suicide in its own way, and it didn't make any difference how many people talked about it, because Clinton viewed the NEA as a potential problem for him.*

• • • •

Richard: I always admired Johns more [than Rauschenberg]. I always learned more from Johns, and Johns ended up being a friend of mine. I always kind of approached Rauschenberg as a historical celebrity, so I was never really close to Rauschenberg. Johns, very early on, asked me to build a piece for him, and I got to know him quite well, and I've continued to talk with him. He is very, very private and has a whole different relationship to society than Rauschenberg. You can say whatever you want about Johns's work, but for the past twenty, twenty-five years he has sustained a fairly clear concentration. I find Johns's work very, very admirable. I don't know what to think about his later work, and we'll have to see when he has his retrospective, but up to and including the seventies, I thought his work was very strong. I haven't seen that much of his work since, but he was very important for me when I first came here, important in that he kind of took Glass and me under his wing and introduced us to Cage and Cunningham and really acted like a big brother. That was more support than I thought I could possibly be offered from a guy who was reserved about himself. He was very, very generous to me. If you have a few people like that around, it gives you a great deal of confidence, or at least support. There were a few people like that when I first came to New York, and Jasper was definitely one of them. Jasper would come to all my shows and talk to me about the work, which was invaluable. The other person who did that when I first started working

in New York was [Barnett] Newman. I didn't know why he was coming, or what he was seeing in the work. I put a plate in the corner called *Stripe*, and Newman came to see it the first day it went up. Then he came back, and for the next two weeks he came back about three or four times, and I started talking to him a lot. I had never taken his work seriously because I couldn't, to tell you the truth, read his work. I mean, if you come out of a certain painting tradition, you understand easel painting to a point. You can read Guston very easily because it looks like still life painting, and you can read de Kooning out of Pollock, and you can read Rothko somehow out of the history of landscape or Turner or something, but when it got to Newman I had no idea what he was up to. I really couldn't read it, and it wasn't until after I got to know him, and I started looking back at his work, and then the Modern did a show, and then I really saw it. At that point I really had very little interest in who he was or what his work was about. A lot of that came from having been at Yale listening to some of the abstract expressionists talk about him. They were either frightened of him, defensive about him, or disparaging, and they used to say, "The guy doesn't know how to hold a brush. Aren't his paintings terrible?" Basically Tworkov and Reinhardt—and I liked Reinhardt a lot—were very against Newman, and when I first met Newman, because I'd been loaded with all that, I was very apprehensive about him, but Newman was a very gentle, kind, intelligent man, a really interesting person.

Chuck: *I also think a lot of them didn't think that he had paid his dues.*

Richard: Yeah, but you know, his dues weren't their dues.

Chuck: *That's right.*

Richard: I thought he was a great painter, too. He really changed the space in painting. I think, however, that if you asked Americans right now, they are more apt to consider de Kooning a great painter. We all went through it, we all looked at books, we all painted out of de Kooning, we all knew it, we all grew up with it, it influenced all of us, but de Kooning's retrospective didn't seem as challenging to me or as far reaching as other artists of that period. Pollock and Newman for me are still much bigger figures. I don't think anybody thinks of Newman as being that kind of figure, and subsequent generations haven't picked up on him. I think there are different ways of being an artist. You can be a synthesizer, you can be a rebel redefining the edges, or you can be a precursor. Newman is kind of a precursor. If you're a precursor, you don't have too many followers, and I don't think Newman did.

Chuck: *But the way we tend to define someone's importance is by how many followers they have. That didn't happen with Pollock because no one could really directly make another Pollock.*

Richard: Yeah, Pollock made El Greco look good again. It's funny how that happens, how that spins. I think Pollock has been a pervading influence, although it's hard to really know how it's been a pervading influence. Or maybe it hasn't. For me it has.

Chuck: *I think he's been much more of an innovator than he's been appreciated for. I think de Kooning is appreciated as a painter, Pollock is—*

Richard: Yeah, I think that's right, and I think probably after Pollock, Warhol's been the next real influential figure, probably more than Johns. Johns is probably one of those people who redefined the edges again. Probably Stella wouldn't have been possible without Johns. I mean, the *White Flag* ends up being the black paintings.

Chuck: Yeah, he kicked the door open for a lot of different kinds of art.

Richard: Johns, yeah, pivotal.

Chuck: He kicked the door open wide, and a lot of people went through it.

Richard: Oh yeah. I think even Warhol. That first flag has a series of heads in it, silk screened little heads. It would be curious to see Johns's retrospective, because it seems a little untimely for Johns to be doing a retrospective at the Modern. It doesn't seem as if there is a convergence of interest, societal or cultural interest, in seeing a big Johns show right now.

Chuck: Do you think these shows happen when society—

Richard: No, *[laughter]* although you may benefit from it, you may benefit from it. I think people are probably eager to see a large group of your work right now. I think your wave is on the crest, whereas people are so saturated with having seen the work of some other artists that— I can give you an example. I didn't even go to see it, but I think Baselitz's show is an example.

Chuck: Baselitz, yeah.

Richard: Ten years too late in New York.

Chuck: And ten times too big.

Richard: And the really good [Sigmar] Polke show never happened in the city. It was out at Brooklyn, right?

Chuck: Yeah. Did you see it in Washington?

Bill: Washington. It looked fabulous there.

Chuck: It really looked great.

• • • •

Chuck: So what else do we need to talk about?

Bill: Well, we need to talk about the painting.

Chuck: Oh yeah. I guess we—

Bill: We have this obligatory thing

Richard: I think this is the kernel we've been getting to.

Chuck: No, no, no. This is a little footnote, a little teeny footnote. You're the only person I ever let influence the photograph that I worked from. You had a very strong feeling that you wanted one image rather than the other, and I remember that you said you wanted it because you looked dumb, tough, and ugly.

Richard: Well, I might have said, "Why don't you make it dumb?" I don't know if I said tough and ugly, maybe I did, *[laughter]* but my recollection of it is that dumb was kind of a generic word in art for making something that was obdurate, something that was less than airbrush-advertising-slick. At the time, Chuck had been doing these large nudes, and that kind of work had a counterpart, not in what Chuck ended up doing, but in what [James] Rosenquist had been doing with big billboards. There was some tendency to make early images of people look nice. Phil looks beautiful up there.

Chuck: He was later than you though.

Richard: But there was a tendency to kind of make people—

Chuck: Some people look better than other people.

Richard: If you ever looked at book jackets, you know that authors don't look the way they look on those book jackets. They get themselves up for the portrait. When you have a photograph taken of yourself, it puts you in a funny relationship to yourself and a funny relationship to the person who is taking the picture, unless you have this real candid thing going with them. On the other hand, it puts the person who is taking the picture in a different relation to you than they've been, so there is a certain vulnerability back and forth. It is a certain kind of artifice that you can decide to direct anyway you want. I thought that for my particular physiognomy, it would be better if I came off looking dumb, in terms of what images look like, rather than consumable. I had no idea it was going to be quite as dumb and ugly as it turned out to be. *[laughter]*

Bill: Sometimes you wish for something, and you get what you wish for.

Richard: Actually, it's kind of frightening. I saw it in Paris, and it was very frightening. It looked like Cagney or something. It's like a person I wouldn't want to meet in an alley.

Chuck: Also, someone said of you in one of these interviews that in photographs you never smile, and in real life you smile a great deal.

Richard: Well, to tell you the truth, I had a tooth missing for years—it got knocked out playing football—so I used to be embarrassed about smiling. Several years ago, I had a tooth put in, and I realized that I was opening my mouth more. I had been quick to laugh, but probably not quick to smile for photographs.

Chuck: Gee, your speaking of football reminds me that you also were a surfer.

Richard: Surfer, football player, baseball player. I have nephews, one going to Hunter and one going to RISD, and their notion of me was, "Oh, our uncle the surfer." When I would come home, they would ask me about that. It was something I did for a good part of my life, but I never considered myself to be "that." It was just something I did because I lived four blocks from the ocean, and I learned how to do it when I was quite young and did it, like people who learn how to ski or roller-skate when they are young. I was pretty good at it, but I didn't take it seriously. It became something very big in other people's eyes, but for me it was something that I grew up doing, that I knew how to do, that I liked to do; to young kids it's something heroic or glamorous. I grew up doing it because it was something that my father did. He had one of those huge boards, and I learned how to do it when I was quite young. I didn't do it because it was a trend at the time. There were very few people in northern California doing it. I used to surf at Kelley's, and I used to go to Santa Cruz and do it with the van Dykes. When I got to Santa Barbara, I had a woody and I lived in a house on the beach. The first year I was there, we hardly went to school. I mean, that's all we did.

◆

Philip Glass, restaurant on Aegean coast

June 23, 1990. Allen Ginsberg

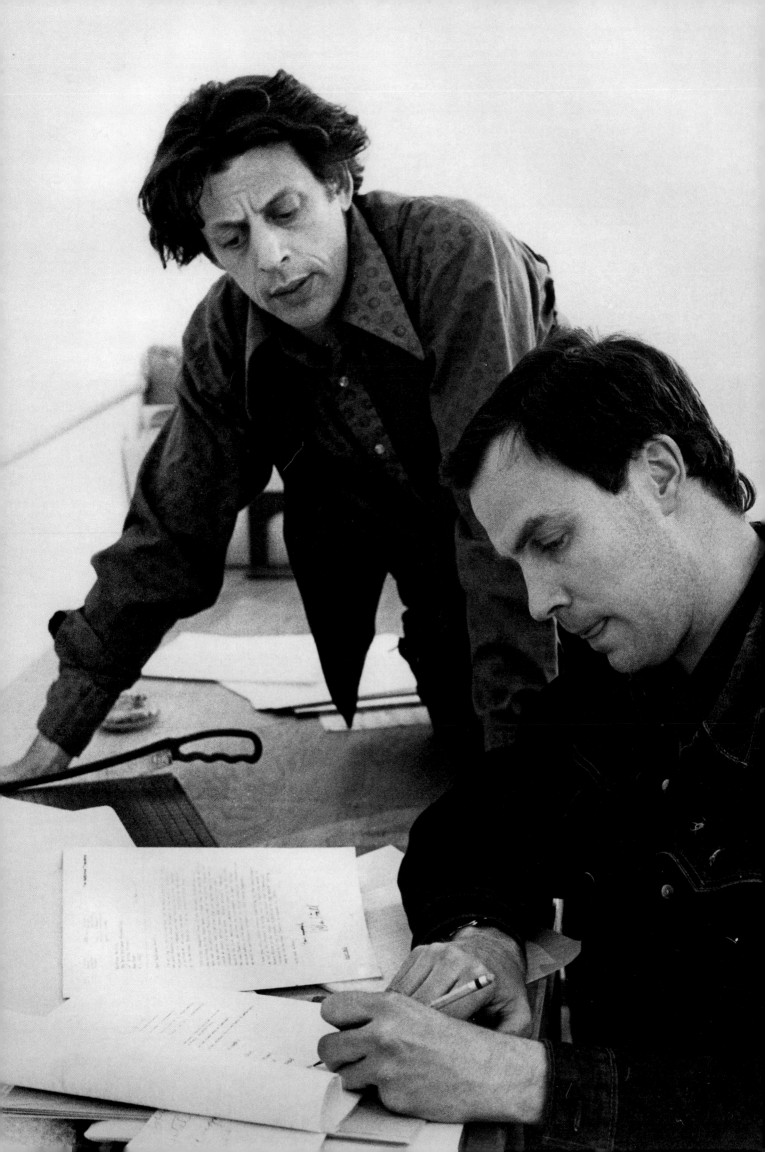

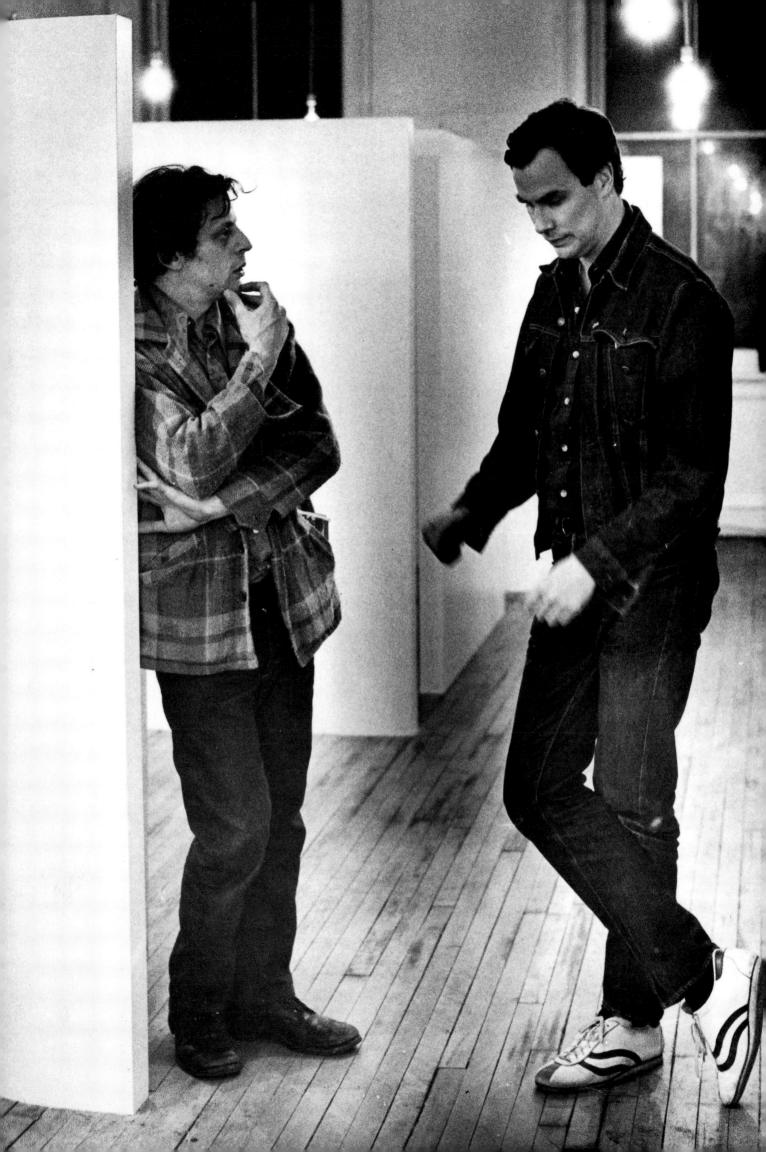

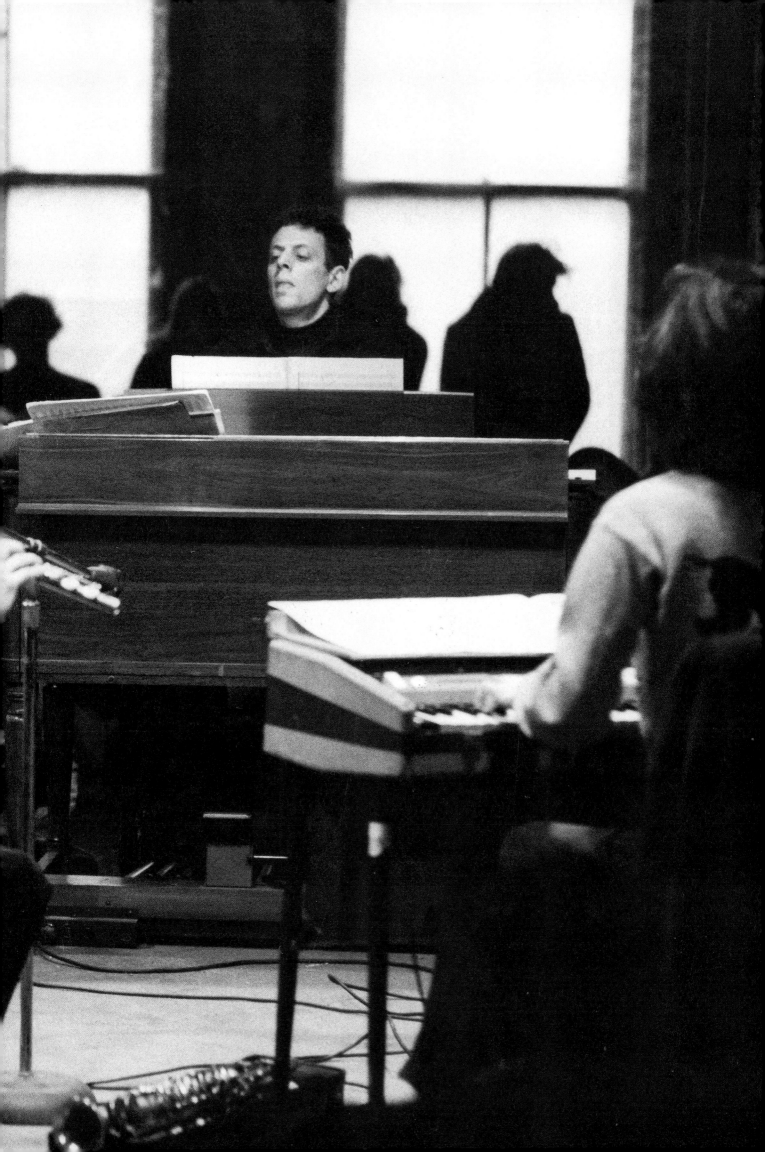

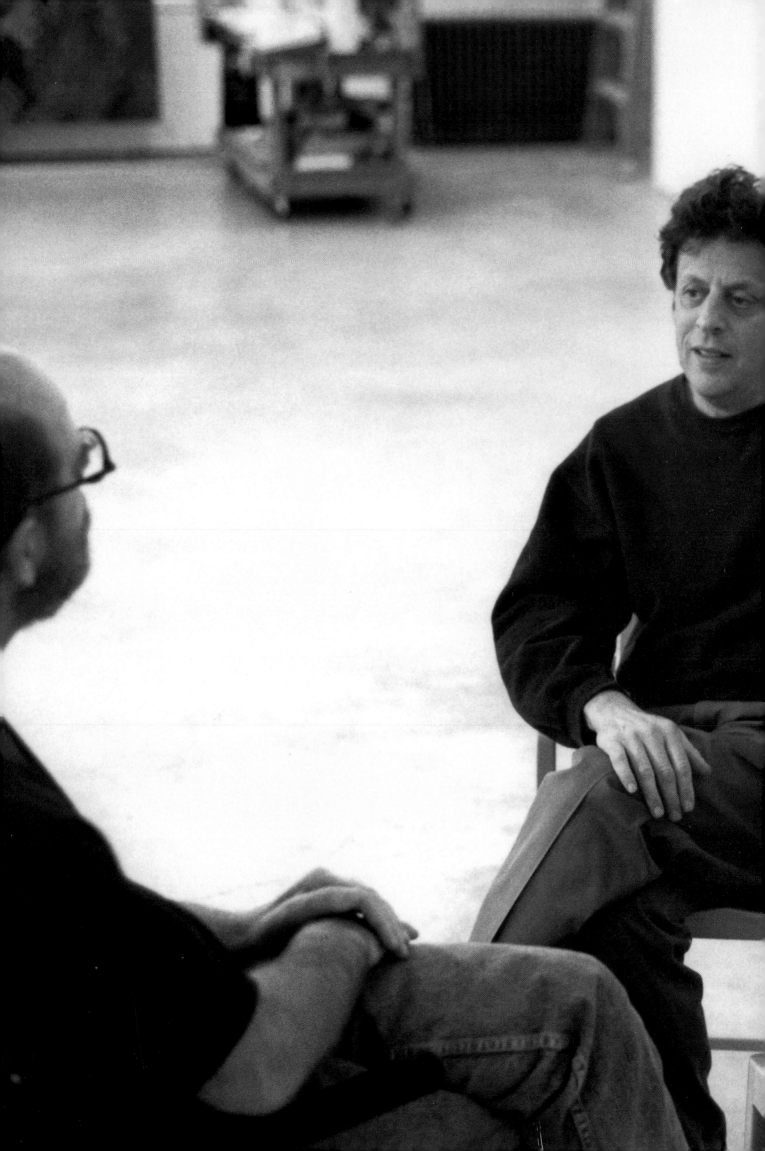

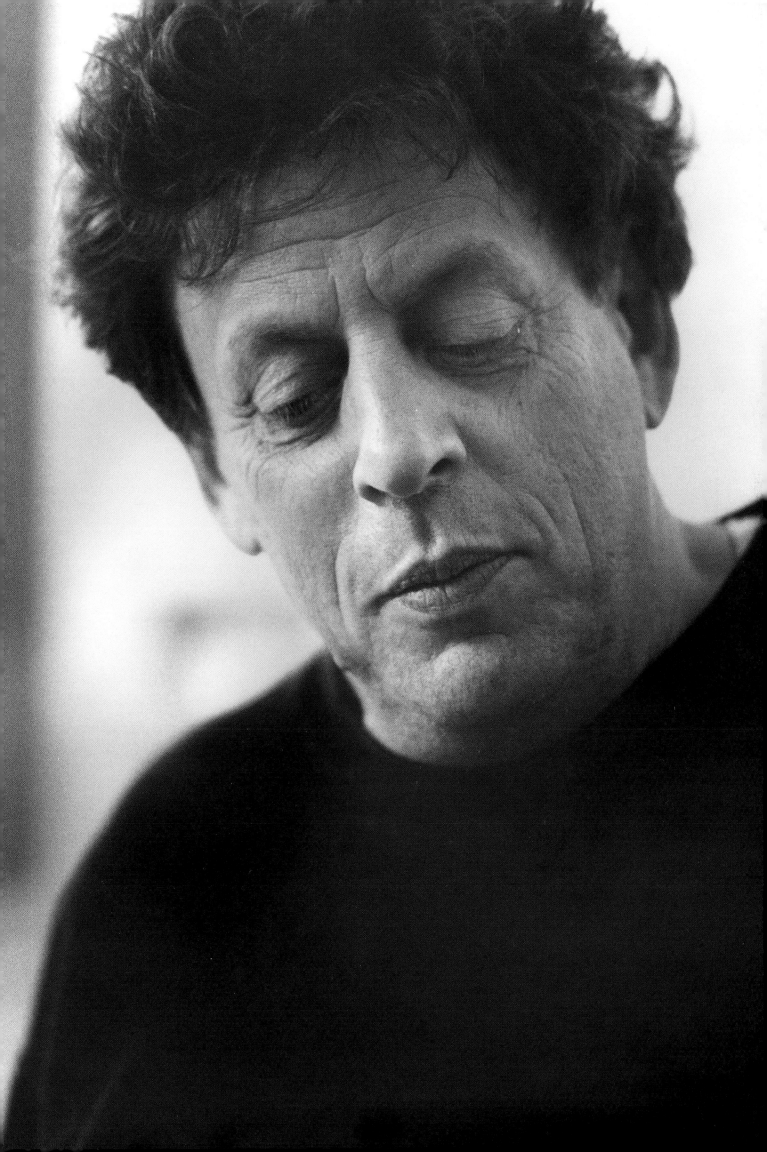

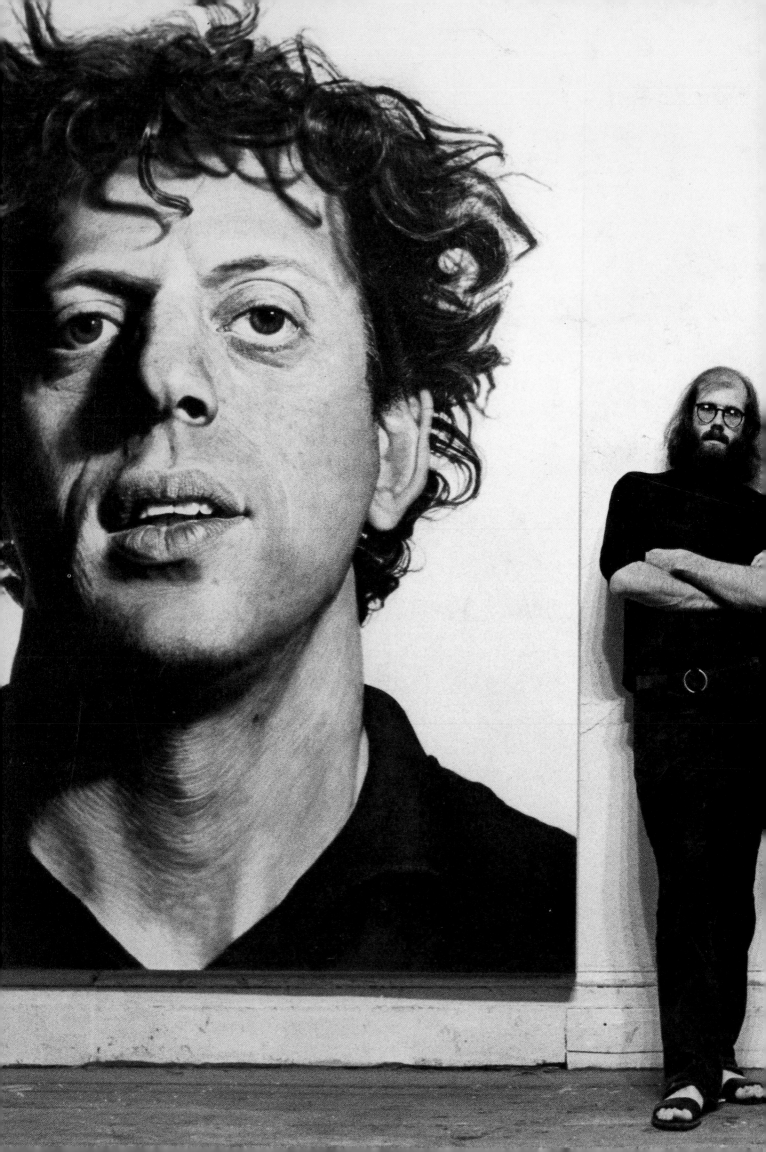

Philip Glass

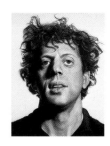

New York City, April 18, 1994

Philip Glass: **Why did you become a painter?**

Chuck Close: I became a painter because art saved my life. It was the only way that I could prove to my teachers that I cared about the material, because I couldn't spit back names and dates and things. I would make art for extra credit. The important thing for me about all of my subjects (and this is a book about the subjects who I painted rather than about me) was that on one level or another, we were either family or friends—sometimes old friends and sometimes not. With those who were artists, the thing that was important was that I not only had an ongoing relationship with them as people but their work was also important to me.

Phil: **Of course, you have to remember that we were very young when we met.**

Chuck: We were.

Phil: **It had to have been in 1969 or 1970.**

Chuck: The first time I met you, I believe, was in Paris when Richard [Serra] and Nancy [Graves] were there.

Phil: **That's right.**

Chuck: That was '64 or '65.

Phil: **That's right, I remember.**

Chuck: How did you get to know them?

Phil: **I knew Nancy because she had a Fulbright. Believe it or not, in those days people took boats to get to Europe. That's how long ago that was.**

Chuck: I had a Fulbright the same year to Vienna.

Phil: **We took the Queen Mary or the Queen Elizabeth, and Nancy was on the boat. I have always been very close to painters. Since I was a very young guy, my friends have always been painters. I don't know why that is, but I've always gotten a lot of my education from painters. So I met this very attractive young woman who was a painter, and we became friends immediately, and we're still friends. It was through her that I met Richard Serra.**

Chuck: Richard was on the Yale traveling fellowship. The next year he had the Fulbright to Florence, and then they moved to Florence for a year where I also visited them.

preceding pages:

Philip Glass: original manuscript, *Music in Similar Motion* (detail), 1969.

Photograph by Allen Ginsberg, on the Aegean Coast, 1990.

With Robert Wilson, 1975 Photos: Betty Freeman.

In the early seventies at 10 Bleecker Street. Photo: Babette Mangolte.

With Chuck Close in his studio, 1994. Photo: Martin Schoellar.

Painting of "Phil" with Chuck Close at his Greene Street studio, 1969.

Phil: Did I ever tell you the story about JoAnne Akalaitis? I think this is a funny story. I hope it doesn't end up in the book. JoAnne was a theater director, and she was in Paris working in the theater. I was working on music, and Richard was doing sculpture. We lived in this little place that was like a garage, actually. We didn't have an icebox; we had a little box like a cage in which we kept food, I guess to keep the rats away or something. Richard was making pieces. Do you remember the pieces that he was making? He was taking containers and stuffing them.

Chuck: *Yeah, live animals in cages as well as some stuffed animals.*

Phil: He coveted that wire box. He wanted that box, and JoAnne wouldn't give it to him because that's what we used for our kitchen. One day he came over when she wasn't there, and he walked off with it. To this day, she has never forgiven Richard for that. Later, he showed us that it had ended up in his art exhibits.

Chuck: *I have the catalog here.*

Phil: It's probably in there. I remember him saying to JoAnne, "See, I really did something with it."

Chuck: *At Yale, Richard would use other people's paint, and we'd say, "Richard, you shouldn't do that," and he'd say, "Well, I'm a better artist than they are." Therefore, he believed he deserved the paint.*

Phil: That's an interesting point of view. That would have quickly led to anarchy in most places. There was another sculptor there on a Fulbright whose name I've forgotten, but he does those little tiny wire pieces or used to.

Chuck: *Richard Tuttle?*

Phil: Yeah, Tuttle. Tuttle was there. Basically, it was that community that we came back to. It was a very strong community in the late sixties and early seventies.

Chuck: *I went to graduate school with both Richard and Nancy, and we all got Fulbrights or traveling grants. I went to Vienna, some friends went to Rome, and one friend went to Spain. I think there were five or six of us in the art school who got Fulbrights.*

Phil: Juilliard was like that too. There were very few composers at Juilliard, but if you wanted a Fulbright, you could get one. It was all about who sat on the committees; there was an eastern establishment kind of thing. I suppose we were as good as any other students, but I don't know that we were that much better, though it's amazing how many people came out of those few years. Klaus Kertess started a whole gallery based on that group.

Chuck: *Klaus was there too. Klaus became friendly with Brice when he was at Yale. Jeff Byers, who was the backer of Bykert Gallery, was also at Yale. Actually, a lot of your early support was really from within the art world.*

Phil: It was almost completely from the art world.

Chuck: *A lot of your first performances were in museums, and certainly the loft scene was—*

Phil: All the first concerts were done in SoHo, and my audience was painters.

Chuck: *One of the very first paintings I sold was sold to the Walker, and they said, "Who else should we look at?" and I said, "You've got to bring Phil Glass out."*

Bill Bartman: *When did you make your first recordings?*

Phil: Well actually, Klaus Kertess and I started a record company. Klaus had a gallery called the Bykert Gallery, and we formed a record company.

Chuck: *Chatham Square.*

Phil: Chatham Square Records in 1970.

Bill: *I was in college in '68, I graduated in '68. You were performing in '68?*

Phil: *Oh yeah.*

Bill: *When I was in college, I always thought you were a performance artist.*

Phil: Actually, I was just getting started then. In fact, Marcia Tucker had a show at the Whitney. What was the name of that show?

Chuck: *It was* Procedures, Processes, Materials, Techniques.

Phil: It was all a bunch of bull, remember?

Chuck: *You mean Richard, Lynda Benglis, Sonnier, and all those people?*

Phil: Marcia also had a performance; in fact, Marcia invited some of the artists to perform. Bruce Nauman performed and so did Meredith Monk; she was already a performer. You have to remember that when I met Laurie Anderson, she was a sculptor. She was doing papier-mache sculpture. She lived two floors above Sol LeWitt. Performance art really came out of the galleries, and people like Marcia and Paula Cooper were very quick. I played in the same places; in fact, since the galleries were presenting artist performers, that was one of the reasons I was able to play there.

Chuck: *Alan Saret's loft was used. All the Greene Street—*

Phil: We did a lot of concerts at the one called 112 Greene Street.

Chuck: *There was a lot of stuff there.*

Phil: It later moved to Spring Street and became a place called White Columns. Is it still around?

Chuck: *It's still around. They moved again.*

Phil: Do you know what was funny? There was a board of directors there, and for some reason, I had always wanted to be on the board. At one point, we all got together and decided it was time for a new generation of people, and we all resigned. We said, "Let's get some younger guys," and we got a young guy to run it. Then he got other people.

Chuck: *Actually, Holly Solomon's son ran it for a while.*

Phil: Yeah, that's right. Jeff Lew started that place. He was one of those great enterprising people. He went down to SoHo and got that building. He took six floors, sold off five of them, and kept one of them for the gallery.

Chuck: *You plumbed that building. I helped you plumb that building. You also plumbed my first loft.*

Phil: Is that right? I did so many lofts, I forget. Forgive me for forgetting.

Chuck: *In fact, one of the favorite things that I remember from that time—you had been driving a cab, and you were doing all kinds of stuff—was when you were going to plumb my loft and I was coming to pick you up in my truck. You were living on Twenty-third Street. You threw down the key, and I opened the door. All the lights in the hallway were off, and I was climbing the stairs, staggering up the stairs in the dark, unable to see anything. Someone, some clanking hulk of a person, was coming*

down the stairs walking very, very fast. I couldn't figure out how the person could walk down the stairs so fast in the black. As he got close to me, I saw horns and all this stuff, and I thought it was a demon of some sort. It was Moondog.

Phil: It was Moondog, who, of course, was unaware that the lights were off.

Chuck: *He was unaware that the lights were off because he was blind.* [To others in the room:] Do you know who Moondog was? He was a street performer.

Phil: I just got a new CD from him, and it sounds nice too.

Chuck: *What was the corner on which he always performed?*

Phil: It was on Fifty-fourth and Sixth Avenue right in front of that hotel.

Chuck: *He wore animal skins, and he had horns. He dressed like a—*

Phil: A Viking.

Chuck: *A Viking.*

Phil: He was a funny guy. I'm still in touch with him.

Chuck: *He was sleeping on your floor or something.*

Phil: No, actually, I gave him a room. We had a large room on the top floor, which no one was using. It was a building that had no certification of occupancy, and, more or less, a bunch of us had taken it over. He didn't like the room because it was too big. I remember going up to him—

Chuck: *He had a long way to go before he bumped into something.*

Phil: That's exactly right. He said, "You know, I would really like a smaller room because I lose things," so I put him in the next room, which was smaller. He explained to me that the ideal room was one in which you could stand up and touch the wall. He built a house up in Ithaca, and I asked him what it was like. He said, "Well, I built it. I got some kids to help me." I asked him to describe it to me because I wanted to know what a house built by a blind man would be like. The way he described it was that there was no room so large that he could not touch both the walls. Now just try to put this together in your mind. Each room was connected by a hallway, and at the end of the hallway would be a room, and then there would be another hallway going off in another direction, and then there would be another room. There was no overall look to it. I began to form this picture in my mind of a house that maybe looked like an octopus. It was basically a bunch of corridors and little sitting places to which you could go.

Chuck: *Actually, that is what a space station ends up being like, because they build them in sections.*

Phil: That's right. That's interesting. Moondog was an interesting guy. He had been working on the street for a long time. There was a notice in the *Village Voice* that Moondog was living on the street and didn't have a place to stay. Jillian, an artist to whom I was married at the time, said, "Philip, go and see him, and invite him to our home." We didn't have much of a home, but he couldn't tell. Let's get back to Chuck. I remember one afternoon when you took photographs of about six or eight people. I don't know if you remember it this way, but this is how I remember it. All of these people were your friends. I was working for Richard Serra at the time. Was that down on Washington Street?

Chuck: *Greenwich Street.*

Phil: Greenwich Street. Did you have the loft next door?

Chuck: *I had a loft on Greene Street.*

Phil: So it was close by. We did the pictures at—

Chuck: *No, we did the pictures in a studio. I borrowed a photographer's studio.*

Phil: You took about six or eight pictures, I guess, and they became the basis of your paintings for years.

Chuck: *For decades.*

Phil: Here's the funny thing about it. I don't know if you remember, but I talked to you about it at the time. I asked, "What's the idea of these portraits?" Tell me if I'm wrong, but I think you said, "I'm interested in portraits of people who are in the arts but not famous." It's interesting that everyone whose portrait you painted became famous.

Chuck: *That's true, that's really true. The same day that I photographed you, I also photographed Bob Israel. You guys sat together. I'm sure you talked to each other, and you and Bob ended up working together. How many years later was that?*

Phil: It would have been 1979.

Chuck: *Ten years later.*

Phil: We still work together. We worked at the Met just two years ago. In fact, we worked together last year. Let's see, who else was there? Was Joe Zucker there?

Chuck: *Joe was there.*

Phil: Nancy was there, certainly, and Richard was there. Did you do yourself that day?

Chuck: *I did Nancy and myself earlier, but I did Richard, you, and—*

Phil: Did you do Klaus then?

Chuck: *I may have shot Klaus, but I painted him years later. Anyhow, that's my anonymous list. I had to grapple with that because you guys kept getting more and more famous on me.*

Phil: We were subverting your idea. That happened to me. I was making a record called "Songs of Liquid Days," and I asked my friends to write lyrics because I didn't know how to write lyrics. I called up people whom I knew. I called up Laurie Anderson and Linda Ronstadt and David Byrne and Paul Simon. Then I thought, "This looks funny. Everyone is so well known." I had better find someone who is not known." I heard there was a very good young singer at Folk City, so I went to hear her, and I asked her if she would write lyrics for my song. I heard her sing, and I liked her voice. She said she would. She was Suzanne Vega. She hadn't made any records yet, but before my record came out, her record came out, and she became very famous. I called her up and said, "Suzanne, you really tricked me. You really messed me up. I wanted one unknown person."

• • • •

Chuck: *You were Richard's only paid assistant. The rest of us were his unpaid assistants.*

Phil: That's right. I was the paid one. Everyone came in, and he made them help put those pieces together. There's a piece named after Chuck, *Close Pin,* now called *Clothespin.*

Chuck: We used to go to a cafeteria that was where the Odeon is now, and we'd all sit and dream up Serra pieces on the back of napkins. He'd take them back to the studio and try them out. None of us were sculptors, so we didn't have any trouble making his work.

Phil: That's right.

Chuck: He was so smart. He had filmmakers, he had Spalding Gray, he had me, and occasionally Steve Reich would help.

Phil: I gave up plumbing because it was really tough, and then I started working for Richard and that was just as tough. No, I think I started working for Richard first.

Chuck: No, you were plumbing first. I remember stealing lead from the telephone company or Con Ed when they left it in the street. That's where we got our first tubes.

Phil: That's right. Then I drove a cab, which seemed safer but in many ways was just as dangerous. It wasn't until 1978 that I quit working entirely. I was forty-one. I was the last. All of those painters and sculptors were more successful more quickly because of the art market. It was a volatile market. Suddenly, these people with whom I had been moving furniture had stipends from galleries and had lofts. Everybody was able to manage. The musicians were the last ones. I think the artists felt badly, so they helped me with my concerts. In fact, people like Bob Rauschenberg had a little foundation; Jasper had a foundation; but the most generous of all people without any doubt, and he probably wouldn't want to hear me say this, was Sol LeWitt.

Chuck: Sol still is one of the most generous people in the art world.

Phil: He supported so many people, but it wasn't generally known because he never made a thing about it. What he used to do with me was buy my scores, because he wanted to see that I had some money. I used the money to live on or to buy equipment. At a certain point, I realized that Sol had all the early pieces. In fact, someone wanted to do an exhibit of my scores, and it turned out that Sol had them. They were up at the Atheneum in Hartford—

Chuck: —to which he gave his whole collection.

Phil: Some very good photographs of me were taken during the same period that Chuck made the image of me from which he did the painting. They were done by a man named Peter Moore who died very recently.

Chuck: When did Peter die?

Phil: About two months ago.

Chuck: No kidding.

Phil: He was kind of an overweight guy who didn't take care of his diet or anything. He had a heart attack or something. Barbara Moore was his wife, and they had a house on West Thirty-first Street. She has a big archive of photographs from that period. We did a concert at the Cinematech years and years ago. It was the first concert that I did in New York. I think it was '68. I had made the scores into structures around which you could walk, and I played them that way, and you moved around. It was an idea that I had. Those could be good.

Chuck: God, I remember all of them.

Bill: When was that concert?

Phil: It was in '69, no maybe '68.

• • • •

Chuck: It is interesting that your first records were published by an art dealer and your first concerts were in artists' lofts, or galleries like Paula's, or museums like the Whitney.

Phil: I wonder if that is still happening.

Chuck: I don't know, but every night of the week I went to see something in somebody's loft.

Phil: There was always something going on.

Bill: I don't think it is still happening. I think it was a unique period of time in which people felt so comfortable with each other. The late sixties to mid-seventies was a very special period of time. I don't think it can ever happen in exactly that way again.

Phil: It was a very supportive community. I remember going to see people like Yvonne Rainer dance, and all the artists and sculptors and musicians would be there, and the Cinematech was the same way. Partly it was the community. We didn't have much money. Nobody had really made a lot of money then. In those days, people were living in lofts down there because they were fairly cheap.

Chuck: I was ridiculed for being so stupid as to spend $150 a month for a twenty-five hundred square foot loft. People said that you didn't have to pay that kind of money.

Phil: When I first came to New York, I moved down to the Fulton Fish Market, and I did have a place for thirty dollars a month. That was when I was in music school in '63.

Chuck: In '67 when we got our first loft on Greene Street, we paid a hundred. There were only about ten people living between Canal Street and Houston anyhow. At night, I would walk down the street and occasionally see another light in someone else's window.

• • • •

Bill: When you first saw the painting that Chuck made of you, what did you think? It's such an emblematic painting.

Phil: I know. My position about it is that I had to immediately look at it in a different way. I was just an occasion for him to be a painter. I think that's how it was. All of those people who were the images were just the images. I had very little vanity about it, but it was scary. It's scary to see yourself. The funny thing is that, if you look at that picture and look at a photograph of me taken at that time, I had a kind of tortured look. In fact, it took me about ten or fifteen years to grow up and look like that picture. I finally ended up looking like the painting.

Chuck: No matter how much you don't like it, eventually you'll—

Phil: —look like the painting.

Chuck: Or you'll look worse than the painting, and then the painting won't look so bad.

Phil: I have one. Chuck very kindly gave me one of the handmade paper ones. It's not at my house; it's at my sister's house. It kind of circulates in the family. Everybody wants it, but it has to move around. It's not in my house.

Chuck: Is your sister married to an ambassador?

Phil: Yeah.

Chuck: I just had a retrospective open in Germany, and the American ambassador came. He said

that he was friends with your brother-in-law and that he wanted one of the tapestries, which I just sent him, for the embassy.

Phil: When you came back from China—

Chuck: I didn't go to China.

Phil: The piece went to China.

Chuck: You know, that Phil tapestry has a funny story. Friends of mine who had come back from China brought these tiny tapestries of Mao. They were little dishrag schmata-sized things. I found out about the factory, and I got in touch with them. I wanted them to make a tapestry for me. They said that during the Cultural Revolution, Mao had a billion of these things made and then had the machines broken so no one else could make them. They said, "We would make some again, but we would have to rebuild the machine. It would be very expensive." I asked, "How expensive would it be?" They said, "Three thousand dollars." I had them set the machine up again, so after the Mao, the first image to be made was Philip Glass, which I did for the benefit of BAM [Brooklyn Academy of Music].

Phil: There are a lot of funny stories about that image. When the painting was on view in Columbus Circle, you could see it from outside the building.

Chuck: Down Columbus or Broadway you could see it for blocks.

Phil: Also, when my daughter was a little girl, her class was taken to the museum, and she said to the teacher, "That's my dad." The teacher said, "No it isn't." A lot of people saw that particular piece because it was at the Whitney. I mean, some pieces went to private homes, and some pieces went to museums in out-of-the-way places, and also for some reason or other, that was the one that went through various incarnations in various media. That one did, and which others?

Chuck: I did a lot of Keith Hollingworth. I did a lot of his image.

Phil: You didn't do yourself?

Chuck: I did a lot of self-portraits. There are some that I have recycled more than others.

Phil: I guess it's because the image has a certain—

Chuck: It is a very compelling image. Part of it is strictly formal. All those locks of hair make for a very interesting edge and a Medusa-like look.

Phil: I quickly depersonalized it in a certain way. I mean, I knew Chuck, and we had a personal relationship. I think that's the only way you can think about that, especially when the image is seen that much, because the Phil series is around a lot. I can't tell you how many times people have come to a concert and said very provocative things like, "There is a picture of you hanging over my bed," or in the dining room or something like that. Many, many, many times.

Chuck: Well, the same people who support your work support our work. There's a lot of crossover.

Phil: I think a lot of people came to concerts because they had the picture, and they just wanted to see me.

Chuck: When you became so famous, I decided to retire your image, not because you were so famous, but because I didn't want you to think that I was trading on your fame.

Phil: You were well ahead of the crowd. You were well ahead. I was at the Metropolitan [Opera] with *Einstein on the Beach* in '76, but it was ten years before I was making a living. Another friend of ours at that time was Susan Rothenberg.

Chuck: Actually, I never photographed Susan. I don't know why.

Phil: She was a little bit younger than we were, but we would all meet for breakfast.

Chuck: There were a number of people who I didn't shoot, and some people didn't want to be shot. Brice Marden didn't want to be shot. I respected that.

Phil: You know, Sol LeWitt has never had his picture taken.

Chuck: I'm really close to Sol, and Carol [his wife] was my assistant for many years. I'd love to do Sol.

Phil: He made a point. He decided very early on not to be photographed. I did a very different thing. I was being photographed all the time for papers, and I needed the publicity to get going. I asked him once what it was all about. He said, "I really like my privacy, and nobody knows what I look like." I thought that was very striking. Sol LeWitt can go into a show of Sol LeWitt and no one will know that it is Sol LeWitt. He is like an invisible person in a way. People just don't know what he looks like, so now he can send other people to execute pieces in Italy. Sometimes he doesn't need to be there at all. He's a very interesting man. First of all, he has this tremendous generosity. I mean, *Printed Matter* was his invention. He supported that place. You can't imagine how many people he supported, bought their work, but he has this other side, this extremely private side. There were years—maybe it was just months—during which he would just stay in his loft and not go out. If you wanted to visit Sol, the best time to go was on Saturday afternoons when everyone else was watching a football game.

Chuck: Sol goes swimming every day. When he lived in New York, he used to go swimming every day and go to a movie almost every day.

Phil: Is that right? I didn't know that about him.

Chuck: He built it into his life.

Phil: There must have been some other people who you never photographed. You really stuck to your generation. You could have done Rauschenberg and Johns and—

Chuck: Now I'm doing Paul Cadmus who is ninety-two, and I'm doing Roy [Lichtenstein,] and I want to do Allen Ginsberg.

Phil: Did you talk to him?

Chuck: Actually, he asked. I decided to do some writers. I've known a lot of writers over the years.

Phil: Have you had requests before?

Chuck: A few. I would never do a commissioned portrait. I would never paint anyone who could afford to buy one. Your former wife, Uba, who was a physician, told me a wonderful story about her mother who was from the Ukraine. On her mother's first trip to New York, Uba took her to the Whitney, and when she saw the painting of Phil, she said to Uba, "Phil must be very important." Uba said, "Oh yes, Phil is very important. He's a very well-known composer."

Phil: This convinced her, more than anything else.

Chuck: She said, "Oh no, no, he must be really important." In Russia, now the Ukraine, the only big images that you ever saw were of politically important people.

Phil: She was impressed with the size of the picture. By that time, I had had several operas produced and had been playing around a lot. She wasn't impressed by that, but that picture really impressed her. It also ended up being on a postcard, didn't it?

Chuck: Yes. It's been around.

．．．．

Phil: In retrospect, one thing that seemed to be easier when we were kids, so to speak, was the ability to develop an individual voice. Very quickly Chuck developed his voice; Richard had his; Keith—

Chuck: *We were driven to make stuff that didn't look like other people's work, which is the antithesis of appropriation.*

Phil: Also, there was a very strong generation just before us. Frank Stella is not that much older than us, but there were Frank, and Andy, and all those guys.

Chuck: *After the superstar sixties, the late sixties and seventies were a very fractured, pluralistic era with lots of things going on but no superstars again until the eighties.*

Phil: The choices you made were so interesting, because no one else was doing that.

Chuck: *Well, it was perversity.*

Phil: That's right. It was quite shocking.

Chuck: *We were looking for materials that nobody had used before, that didn't have art historical baggage associated with them. People were haunting Canal Street rubber shops.*

Phil: I was with him. I was being paid. I was a paid assistant. Somehow, you thought of something else; you started in a completely different direction.

Chuck: *Nancy was making camels out of fur. There were all kinds of strange stuff.*

Phil: Still, yours was very unusual.

Chuck: *It was an interesting time. I think we were driven towards purging our work of every possible reference.*

Phil: You could listen to my music and not hear a trace of my teachers. I got rid of all of them.

Chuck: *There was a lot of cross-fertilization of ideas and cross-disciplinary things. We pared things down and imposed severe self-limitations. I've always felt a real kinship with what some people have written about your work and mine: getting it down to a few elements.*

Phil: I think Michael Snow was a part of that.

Chuck: *Yeah, Michael was part of that.*

Phil: Yeah, Michael's films, and Yvonne Rainer's dances.

Chuck: *Dancers were very much a part of that.*

Phil: I think we're starting to find that again. I know a number of dancers who are working with sculptors. I think it is, and was, the hard economic times. The barriers that were built around commercially successful work just kind of dissolved.

Chuck: *I have a theory based on economics about why the art world changed. When we came to town, we felt that we had the rest of our lives to figure out who we were, to find a personal voice and authentic vision that was idiosyncratic and personal, and it was so cheap to live. I taught one day a week at the School of Visual Arts, made about three thousand something a year doing that, and paid about two thousand of it in rent, and managed to live. I don't know how the hell we did it. We didn't have any heat.*

Phil: We used to pick up crates from off the street and burn them in the stoves.

Chuck: Kids coming to New York today have to make such an incredible sacrifice. The same loft is two thousand a month, which means they must have a full-time job. They have to work a forty-hour week, no matter what, and maybe they use the loft during the day and someone else uses the loft at night. They're making much greater sacrifices, and I have begun to notice that they think differently about investing in that time, making that investment. "I can keep this up for five years, but something has to happen." The only way they can make something happen that quickly is to appropriate some-body else's mature style, because they don't have time to develop their own. I don't mean that I'm against appropriation, but I think its appeal is that you can have instant mature looking art, and I have a feeling that is driven economically.

• • • •

Phil: I just had a talk this morning with a guy who's been working as a producer and kind of an agent for a long time. We have this conversation every once in a while. He said, "Phil, I've been thinking about opera houses in America, and this is what I think we should do." We have this ongoing battle trying to get operas into the big opera houses. People think I can go any-where I want to, but it's not true at all. In fact, now that I've been at the Met, been in Chicago, in Houston, they say, "Well, you've been here," as if that was my turn or something. What, in fact, happened was that the early works like *Einstein* created an audience, and afterwards other people came in, but we still don't have an opera house.

Chuck: How much time are you in Europe now?

Phil: I'm doing a new piece based on Cocteau's silent film *Beauty and the Beast.* I took the film and removed the original soundtrack. I had to make all the legal arrangements to do that. I wrote an opera that uses the original dialogue as the libretto, so that you can see the movie and hear an opera at the same time.

Chuck: Wow.

Phil: It's really interesting. We're opening that in Spain. We'll be in Spain and Italy in the sum-mer, and we'll be in Germany, Belgium, Holland, and the UK in the fall.

Bill: They're going to project the picture?

Phil: We bring everything with us. We project the movie, and we have four singers who don't actually block the screen but are below the screen. It's not staged the way the movie is, but there is my ensemble, and there are the four singers, and there's the picture, and there are subtitles.

Chuck: You know, what I loved, which was in a way similar, was when Sol projected a film of Lucinda's dancers behind Lucinda dancing.

Phil: That was 1979. That was a beautiful piece. Every once in a while it is done again. That was a very beautiful piece.

Chuck: Recorded music had to be used to keep it in sync.

Phil: But now we know how to do it. Now the technology is advanced, and we have devel-oped techniques so that Michael Weiss, who works with me as a conductor, can look at the film and perform the music, and we can synchronize the music to the film, live.

Chuck: Will you do that piece again?

Phil: We're going to do it. It will be here in December at Brooklyn. It's interesting that I do a good piece at Brooklyn almost every year. It has become kind of a home in a way.

Bill: *Your American venue.*

Phil: I've done eight or ten big pieces there.

Chuck: *They often bring pieces that they can't afford to stage. Europe has to stage them.*

Phil: That's just the way we are in this country. I understand a lot more about this country than I did. What we really like is sports and television, and we're not interested in art. We're not. You know, the typical American response to me when I say that I had to spend twenty years driving a cab, doing plumbing, and moving furniture in order to do my art, is "Who asked you?" The fact is that no one asks us. It's very different in Europe. There is a profession that an artist can enter, and there's a kind of collegiality with artists that we don't have here. We've developed it amongst ourselves. Anyone who's lived in Europe, and we've all lived in Europe, knows that. I'll give you an example. There was a guy who used to work for me who was a trumpet player. He went to rent an apartment in New York. He got the lease, and they asked on the form your profession, and he wrote "musician." They crossed it out and wrote "unemployed." Ray said, "I am employed. I work with Phil Glass actually." If you're an artist, you're unemployed.

Bill: *I couldn't get car insurance in California if I wrote down writer, director, or actor. I had to write down teacher.*

Phil: When I travel, I travel as a music publisher. I never say I'm a composer.

Chuck: *After I was making enough money to afford to buy an apartment on Central Park West, and we were selling our loft and moving up there, I went to Chase Manhattan Bank. Arne, my dealer, got me entrance that was supposed to open the door to get this mortgage very quickly. I sat in the room with some guy who still had pimples on his face who told me that I didn't fit the profile of those to whom they gave mortgages. I said, "Well, I have had a consistent income all these years," and he said, "You could end up not making anything next year." "Given the way it's gone," I said, "it's unlikely, but someone who has a regular job could get fired." Anyhow, Chase Manhattan had just bought a nine-foot-high picture of mine. They were willing to invest their good money in a painting that they thought was a good risk but not to give a mortgage to the artist who made that painting.*

Phil: That's very typical because we believe in objects not ideas. Basically, you are an idea, and your pictures are objects that are clearly a good investment. It's interesting that today's young painters and musicians are not spending the time in Europe that we did. I wonder how that's going to affect them. We've all had the experience of seeing a society in which the arts are actually respected. In the building where I lived, the people were actually proud of the fact that they had an artist in the building. I was shocked when I discovered that. My landlady said, "It was a great honor having an artist in the building."

Chuck: *We were treated like princes, really.*

Phil: Here it's completely different. Maybe this is an unpopular thing to say, but I think we should close the National Endowment for the Arts. I think it's better not to have it. I think we should admit that we don't support the arts.

Chuck: *It's better than to pretend that we do. The city of Paris gives more money to art than our entire federal government.*

Phil: What did Jane Alexander say? "The United States government gives more to marching bands."

Chuck: *What it amounts to is three feet of an aircraft carrier.*

Phil: Let's look at it from the other side. What comes out of it is that the art community tends to be much more self-reliant. The community that we came out of was a community that supported each other, because we never got support from anyone else. It's not just the financial support, because we didn't get that, but helping each other.

Chuck: *You were talking about people not understanding or respecting art outside of New York. There was a collector out west, I think in Montana or someplace, who commissioned Alan Saret to do some pieces. Alan flew out, and the staff met him at the airport. They took him to the hardware store where he bought a lot of wire and stuff. He lived in this house for like a week. He was supposed to make one piece, but they treated him so well and fed him so well that he thought, "This is great. You get out of New York and they really know how to treat an artist." So they wined him and dined him and everything. He thought, "Well, I'm going to give these people some extra pieces because they've been so nice," so he did a piece here, and he did a piece there, one outdoors, and one in the bedroom. He did all these pieces, the staff was very nice to him, and they took him to the airport. They thanked him and said goodbye. They went back, cleaned the house, and threw it all away. They just thought the collector had invited some eccentric person, and they were supposed to do whatever this eccentric person wanted, but it couldn't possibly have been art, so they took it all to the dump.*

Phil: He did the cover for one of my early records. Allen Ginsberg still can't have his poetry read on the radio, even though he won his First Amendment case with the Supreme Court. There is a backdoor law about not being able to play it when there are small children awake. He is limited to the hours of two to six in the morning. In a way, I think you're right. The nineties are an interesting reflection of the seventies, and I'm very pleased with what I see the young artists doing. In a way, I didn't see that talent around in the eighties so much.

Chuck: *It was a more monolithic time: there was one thing at a time, neo-expressionism and neo-whatever. They replaced each other one at a time.*

Phil: I think the prospect that no one is ever going to make any money at his art is a salutary notion for artists to have. It keeps their minds on what they should be thinking.

Chuck: *If you do make money, you are pleasantly surprised, instead of being pissed off from raised expectations. When it is expected, it makes for a lot of very bitter and angry people when it doesn't happen.*

Phil: That's right. For me, in 1994, almost twenty years later, I'm actually living in a house. Twenty-five years ago I never would have thought that was possible. Also, if you're around long enough, those things are going to happen.

Bill: *I feel so much more comfortable being part of the art world in the nineties than I did in the eighties. I got to the point where I was sort of embarrassed about it in the eighties. I felt uncomfortable.*

◆

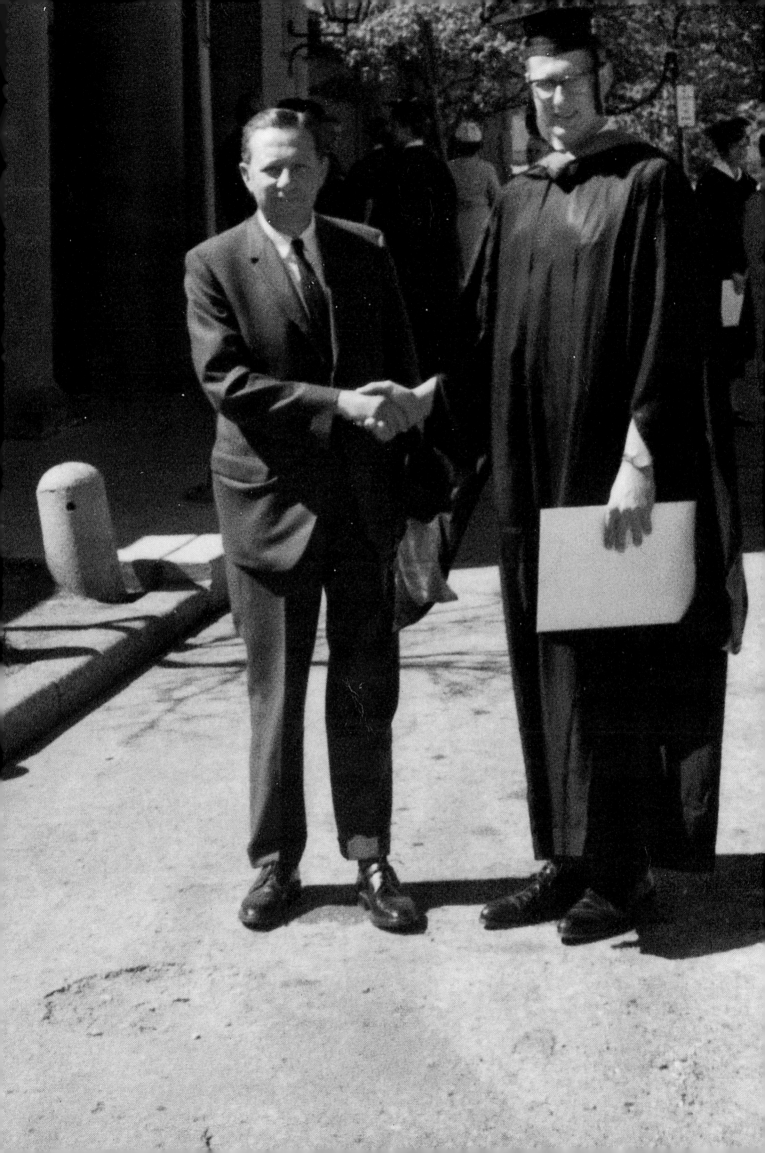

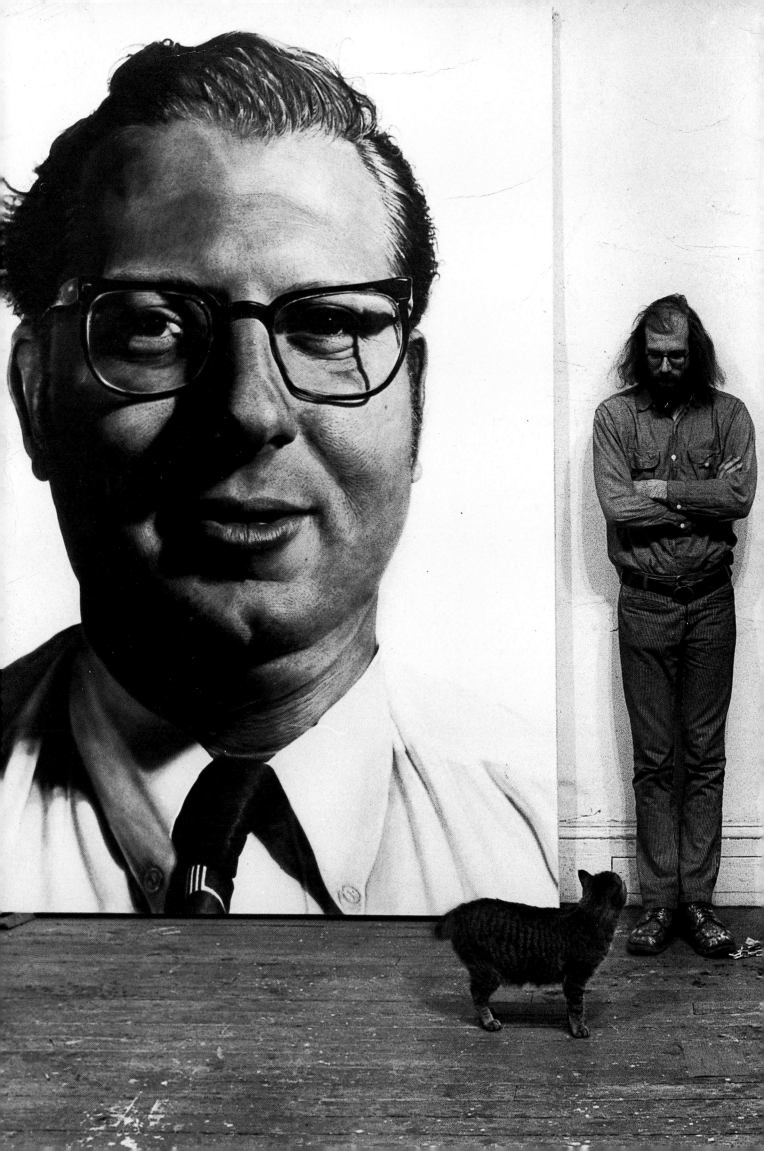

Joe Zucker

New York City, February 21, 1994,

Bill Bartman: **Here we are in Chuck Close's studio with Chuck and his dear friend Joe Zucker. Earlier in Joe's life, when he was young and handsome, Chuck did a painting of him, and they've maintained a friendship over the years.**

Chuck Close: **Someone was just asking whether you liked the way you looked then. I think it is interesting that you looked old then, and you look young now. Do you have any idea why?**

Joe Zucker: **Actually, I had a funny feeling about the painting. Why I assumed that uncharacteristic mode of dress [white shirt and tie] and put gel on my hair, I don't know. Most of the time when people don't care how they look—they look in the mirror and say, "Geez, I look terrible"— most will try to make themselves look better. I think I made myself look worse!** [In *Close Portraits*, the 1980 exhibition catalog from the Walker Art Center's traveling retrospective, Lisa Lyons, curator, posed a series of questions to several of Close's subjects—Mark Greenwold, Robert Israel, Joe Zucker, and Leslie Close—regarding their experience of being photographed and painted by him. See Joe Zucker on "Joe" and Chuck Close on "Joe Zucker."]

Chuck: **You made yourself look worse in order to distance yourself from your real image. My recollection is that you wanted to change the way you looked for the painting so that it almost wouldn't be you. I remember you said something about wanting to look like a Mid-west used car salesman or something like that.**

Joe: **That's true. Of course, in the end, after you've taken the photograph and made the painting, that aspect of it becomes only history. That's why we're discussing this now. It's enjoyable to talk about because the average person doesn't know that I altered my appearance for better or for worse. I've been thinking about why I changed my image. I think it had some relationship to those particular paintings of Chuck's, which were very process-oriented; the process of changing one's appearance had to do with what his work was about to some extent. Who I was in the sense of humanization of a person really had nothing to do with it. That kind of disguise sort of fit into what I thought Chuck was thinking about on some level, and on a personal level it was almost like an anonymity. In a way, it also had something to do with my own painting, which was involved with processes and images that had to do with a particular process or material, rather than with the development of a style. It's not a quintessential picture of me; it's an illusion or a version of myself. I don't know how Chuck feels about it, but I think part of my attitude had to**

do with those years. That's another issue, but I think the late sixties and early seventies had some influence on my belligerent activity and this image in which I chose to address myself.

Chuck: I think there was some posing going on that probably did have to do with the times. A couple years before that, when I did my first self-portrait, I had a cigarette sticking out of the corner of my mouth, and there was definitely some sense that I was looking for more of a James Dean image of myself than was probably accurate. You know that you're only doing it for a hundredth of a second. I had never seen you in a white shirt and a tie.

Joe: I've never had one on since.

Chuck: I'd never seen your hair combed. I was shocked to see what you looked like when you walked through the door.

Joe: I don't think that people realized that my hair at the time of the picture was like this. *[gesturing]*

Chuck: A huge afro.

Joe: I looked as if I had on one of those lamps.

Chuck: You looked like Harpo Marx.

Joe: Absolutely. The effect of the gel on my hair was quite extraordinary. It held it down. Do you think that some of what you're saying had to do with a romantic notion that we had about the cigarette and—

Chuck: Yeah, and also maybe a mug shot, what the police would want if they were looking for you: the most information that one could have about the way someone looked but presented in a kind of dumb, straightforward, flat-footed way. You didn't see pictures of people in the post office smiling. They looked tough, they looked angry, so maybe some of that crept in too.

Joe: It's ironic that later on people did attempt to interview us. I have the feeling too that, at that time, we were involved in the notion of what we were doing rather than who we were. Looking back, I often have had conversations with students, young artists, or people who moved to New York wanting to start out in various careers about how you can watch ten or fifteen years of your life go by and not have any sense of one year from the next. One day you wake up, and you're forty-five or forty-eight years old. The intensity of being in a studio and being in a small community is almost like living in a house without any mirrors. The sense of yourself has so much to do with where your work is going. Your work and the changes in your work are really an hourglass or a metronome of your life. That's what I think is so extraordinary about just looking at, for instance, the works from that period, the paintings that we're talking about now: that record of change in people.

Chuck: It was an interesting time in the art world too. Our whole generation tended to emerge in that incredible period of the late sixties, around '68, when everything was coming unglued in the world. I mean, there were all the assassinations and protests of the war. Everything seemed to be up for grabs, and yet, in the middle of all that chaos and a world falling apart, our whole generation of artists sort of exploded onto the scene at once. It was a very exciting time in the art world, and if you look at that generation now, it's interesting that we're all still working, and I think a lot of us are doing some of our best work. It was a generation that had legs in a way.

Joe: I can tell you a story about someone's reaction to your painting of me that I think ties into what you're saying about that time. That time was very difficult, and a lot of it was very ugly. I think one of the things that changed in the seventies was the changing of the meaning of the word "beautiful." Things that were provocative and ugly were often referred to as beautiful. The whole use of the word was a part of those years, and the change in its meaning reflected how one looked at things. I remember sitting in Charles Saatchi's house the night after Margaret Thatcher was elected in 1979. There was a party of about six artists and Mr. Saatchi and his wife, maybe eight or ten people, having drinks. The painting *Joe* was right across from where I was sitting with the woman with whom I lived, and after about ten minutes she got up, and she said, "I can't stand looking at that anymore." She said, "It is just horrible. It is not you," and she moved. I think that was very interesting because this work was not personalized. It was work of that moment. I think it really had to do with what the aesthetics would bear. [*Joe*, 1969, acrylic on canvas, was then in the Doris and Charles Saatchi collection, London.]

Chuck: By and large my work doesn't go into homes. The fact that Saatchi had one in his house is very unusual. Almost all of them are in public collections. I think they are very difficult things with which to live, although if Britta could live with you, I don't know why she had trouble looking at the painting.

Joe: Now she would rather have the painting! *[laughter]* I saw something that was very strange at about the same time. I was in Cologne during the art fairs: the Kunst Mart and another one called the Unfair Fair, which was a representation of younger dealers from all over the world of younger artists. At the booth of one of the newer galleries—I forget whether it was an American gallery or a European gallery: actually it was Daniel's—there was a photograph of Woodstock on the outside of the booth that was probably the length of this loft. It was so strange because it was one of those quintessential American images, and it caught so much the tone of the shift of sensibility. It was all in that picture. There was almost something scary about that gigantic photograph. It was obviously a snapshot of people frolicking and rolling in the water and the mud with their grannie dresses on, or less, and hats and beards, but it had the same quality of that one moment in time that the black and white paintings about which we were talking had. It was so strange to see it in that context. It almost dominated the entire art fair, and it was almost saying something about the change in sensibility. It was a very interesting moment. Also I don't think artists from other countries felt the same as American artists about making art during the time of the Vietnam War. They had the perseverance to object to that time, but of course they weren't Americans faced with the production of objects during those particularly difficult years of 1968 to 1975. I know that one of the things you're talking about in the book is the role of American artists and how they're seen as elitist by the general public. I think that a lot of the art that was produced in those years addressed itself to where one stood politically. The art was not necessarily political in a literal sense, but how it was constructed and a great deal of its meaning was cognizant of how one was involved politically. I guess that, to some extent, certain aspects of American art really aren't particularly understood in Europe because there is a degree of self-loathing, almost self-punishment, involved in it, and I trace a part of it back to those years. People did not know what to do. Getting back to one of the things that I think is so interesting about

what Chuck was painting at that time, our paintings took so long to finish that many of us found relief from how we were embroiled in those controversies ethically in the fact that so much of our time was spent with the production of the piece. It wasn't necessarily about the beginning and the end, it was the middle ground that spared us from coming to definitive conclusions for which we were forced to make a value judgment.

Chuck: Don't you think we fled into the studio too? So much craziness was going on out in the street. Having something to do that I did every day and that required me to go into the studio was really an important aspect for me. It was a place alone away from all that. If you got yourself involved in a long-term project, at least you knew, in a world in which you couldn't count on anything, what you were going to be doing for the next few months. It was buying into something that was good for your sanity. Also, we had to avoid going to the School of Visual Arts, which was where Joe and I were teaching at the time and which was just a zoo parade. That was a crazy, crazy time.

Joe: That was where all of those issues that you could put aside temporarily in your studio were waiting to confront you. For the last five years, you haven't been able to have a conversation about aesthetics, object building, or painting without talking about the political situation. In 1970, I taught a course called Environmental Studies. Anywhere else in the real world, like in Minnesota where I had spent two years hibernating before I came to New York, you would have called this course Freshman Design and let it go at that, but we had a term called environmental studies that gave one a great range in which to adjust one's curriculum to suit the madness of the week.

Chuck: We brought in plumbers to teach people how to plumb their lofts and electricians to show them how to do electricity, because they were going to have to survive once they left school.

Joe: They didn't graduate, they molted.

Chuck: Also, the war was on, and school was a place where someone could go and get a 2-S student deferment without really having to be even conscious. The burned-out bodies of speed freaks littered the hallways. As long as someone paid their tuition they were safe. It was a safe haven. It was a warm dry place in which to score drugs, and we were trying to teach art there.

Joe: That's true. A lot of our projects were done subversively. The students were so angry. I remember wanting them to do something that had to do with making assemblages. Instead of dealing with subjects like Cornell or Rauschenberg, I asked them to make care packages for their parents. In came these amazing things containing hypodermic syringes, weaponry, boxes of pasta; I can't remember all the things that were in those collages. We didn't deal with aesthetics; we dealt with a kind of metaphorical reality. It was part of that climate. We would come home shell-shocked from six hours of teaching, go and play pool, very often drink a pint of bourbon together, and smoke a pack of cigarettes, because it was hard work, very hard work. We had ourselves and what we were trying to do, trying to think about, but we were probably so close in age to a lot of the students that it was very difficult to have any distance from each day's events. At one point, Chuck and I were accused of being involved in a plot to burn down the Metropolitan Museum of Art. [From 1969 to 1971, the Art Workers Coalition (AWC) organized several demonstrations in New York. The Art Strike was held on September 21, 1971 at the Metropolitan Museum of Art. More than two thousand artists gathered to protest Cambodia and Kent State, as well as racism and oppression.]

Chuck: Actually, do you remember when we were on the front steps of the Met protesting the war? We wanted to stage something like "A Day Without Art," only we wanted it to be a year without art. After we were up there protesting for a while this big bronze door opened, and Douglas Dillon, president of the Met, came out with cookies for us. ["A Day Without Art" has been held annually on December 1, beginning in 1989. It is the unified acknowledgement by the arts community of the devastation of AIDS.]

Joe: They were on a sterling silver tray with a tea service.

Chuck: It was the most bizarre thing.

Joe: At that point Carl Andre—I can still see him—symbolically swept the steps of the museum. The next day you and I ended up being interviewed and were asked what that was all about.

[Carl Andre is a minimalist sculptor whose work in the mid-sixties, self-referential industrial objects such as planks of steel in their natural states, attempted to make an objective distinction between art and non-art forms. He believed that life was the link between art and politics. Andre was an active member of the Art Workers Coalition and participated in the demonstrations and the coalition's focus.]

Chuck: The Museum of Modern Art was very depressed that we had picked the Met instead of them. They had waited all day for us to come over there. They had information tables set up to pass out stuff, but we did an end run and went to the Met instead. I was thinking about the times we taught together at the School of Visual Arts. We had some really interesting projects. Recently I was thinking about the project that you gave for which your students had to make a painting, but first they had to make the tool with which to make the painting. I was thinking about that in terms of my own work and how that may very well have influenced my thinking about some things. Making fingerprint drawings and paintings for which I got rid of the tool altogether may very well have come from thinking about some of those things that you were doing with your students. I remember you had them make a sponge brush or something like that so that the mark was a product of the tool that they used to make it.

Joe: Well, I never knew how long they'd be awake, so we didn't have a lot of time! So many people are nervous about making shapes, and I felt that if they assembled a series of tools in shapes that they could put on the canvas, that would liberate them some from developing skills. This actually gets into the issues of elitism. Those tools had to do with Canal Street and working class ideas. It wasn't like taking a brush and learning a technical academic style of painting; it was something more immediate. I remember teaching a class during which I told them to get a cheap reproduction on which to paint. I didn't care about the scale, but I wanted them to get a painting from history. Then I wanted them to bring it in, and I wanted them to make a significant alteration on the painting and make an aesthetic judgment as to how the painting could be better. One of the kids brought a van Gogh self-portrait, and he had painted the ear back. There was a certain kind of thinking that had to do with a kind of irony.

Chuck: Warhol talked about his place being a factory, but it was a factory in the sense that he had other people make the work. You manufactured cotton balls on huge cookie sheets, as if you were a precursor to David's Cookies. You would roll the cotton balls in all the various colors and then build a painting out of them. That whole idea of building a painting rather than painting it, which was certainly something about which I've thought a lot in my own work, came out of that time too. It sort of related to the way people were trying to purge their work of any reference to any other person's work. People would go down to Canal Street and buy a material that had no historical usage as art, in order that when they

would play around with that material, stack it up, or lean it, or fold it, or whatever, their chances of using it in a way that was personal were greater because there wasn't anyone else around to serve as a role model or anyone else looking over their shoulders telling them how to use that material. I think there was something about that time as well that had us rethinking what went on in the studio and how one approached the building of a piece.

Joe: Do you think in a way that some of those activities were similar to a notion that someone like Richter had about his capitalist style?

Chuck: We were the last of the small manufacturers in a small manufacturer's place. Our spaces all had been sweatshops in which they used to make hats or bras or something or other, and when business pulled out of what's now SoHo and these spaces were empty, artists filled them. Brice Marden always calls himself a "cottage industry." These are former spaces of light manufacturers. We just moved the sewing machines out and moved the paint and stuff in.

Joe: So instead of the traditional method of developing a personal style such as, for instance, studying Matisse and building a whole body of work based on an element of Matisse, you're talking about the notion of manufacturing a product and not calling it painting. The thought really was the goal, not so much what you called it.

Chuck: When you think about it, I was on the seventh floor and you were on the second floor of the same building, and you'd gotten rid of brushes. You were rolling cotton balls in paint and sticking them on the canvas. I'd gotten rid of brushes. I was making paintings without any traditional art materials other than paint. I think there was something about purging our work of anything that had gone before. Sculptors weren't making things out of bronze. They were rolling up felt or letting materials do whatever they did, rather than trying to make something out of plaster or wax or having it cast in bronze. There wasn't anything dumber than making images at that time. It was the stupidest thing you could possibly do as a career move, don't you think? Plus, painting was dead too, which made it a nice time to make paintings as far as I was concerned. Remember that at the time sculpture was hot and everybody was into macho tonnage, moving huge amounts of stuff around. I don't know, but I think there was a lot of perversity at work. One did what was the least likely thing to do, what no one else was interested in, things that seemed bankrupt, things that seemed hopelessly lost. They had some kind of strange appeal. We were talking earlier about aging. No matter how unattractive I made all of you guys look, eventually you won't look so bad anymore. When you get old, the pictures will be the opposite of The Picture of Dorian Gray.

Joe: I think one of the things that is interesting about these paintings and what we're doing is that in a sense you are writing history with paintings, and by getting together we are maybe defining a continuation of history. Every person to whom you talk says they can't read criticism. They're not just saying they can't read it: they're too bored, they're skeptical, but by looking at your paintings of people, for instance, Joel, you think of not only Joel, but you think of what Joel has done. Your paintings not only define people, they become seminars to a generation of people who don't have that much history. We are in a moment of change. Who is going to write the history for the people who have been ignored? You were saying that painting was ignored to a certain extent during those years. By doing this book, you're doing what artists will always do. You can't rewrite history. History finds itself. Somebody makes it, and then those moments go down for posterity. It's a form of dealing with those times and these times other than from a didactic, kind of critical

standpoint. We're in a moment of change now, and that's why I think this is a significant thing in which to participate. I'm doing a book of drawings for an exhibition. The first thing the people asked was, "Do you want to do the book?" and before I could say, "Yes," they said, "We don't want anyone else writing for it. We want you to do everything: the writing, the drawing, etcetera," to make use of a moment in which there's change. I think that it's very much like it was thirty years ago when we were young but we didn't have the distance on change. When you get older, I think that you have a different view of it. Now we're starting to talk about how that came about.

Chuck: I think to a certain extent we've programmed change into the work or increased the likelihood that change would occur because we gave ourselves over to a process. We sort of went along with it. The route there was almost as important as where we eventually got and was a great deal of the experience of making the piece. Therefore, the residue of that making of it becomes part of what the viewer can sense and experience vicariously by looking at the piece.

• • • •

Guest: A lot of the work that was being done at that time was outside of the studio. The boundaries of the studio were blown wide open. When was art produced? Was it strictly in the studio? Was it on the streets?

Chuck: Yes, remember all of that guerilla shit that was going on in the street: people pretending to be raping people on the streets, pigs, rats, blood running through the streets, lofts full of dead animals. Of course, people were out digging in the deserts too. I mean, everything was up for grabs, the whole idea of the gallery was up for grabs. It seemed as if a gallery was a pretty antiquated idea. Of course, everybody who dug a hole in the desert found a way to take a picture and bring it back into the gallery because they wanted their friends to know what they were doing. It wasn't just enough that they got to the desert. At a certain point they said, "Hey, wait a minute, none of my friends know what I'm doing, plus it wouldn't be so bad to have something to sell." There's always this desire to get the work back out again, so you go into the studio, or you go some place to make something, and at the same time that you're having this isolated experience removed from society, you have this incredible desire to go back out and shove it into society's face again and say, "I am here, I am somebody, I did something." It's that kind of dichotomy between the insular personal and this incredibly egoistic notion of the significance of what it is that you're doing.

Bill: The years 1968 to 1972, as you said, were years that never can be lived again in the United States. In a six month period, Martin Luther King and Bobby Kennedy were assassinated. Before Kennedy was assassinated, everybody sort of assumed that he would be the next president.

Chuck: Then Kent State happened, and no place was safe, not even places like school. Instead of being in an ivory tower away from the world, the world came to you. I remember the day that Martin Luther King was assassinated. It was right about this time. I was working on your painting. I went up the street, and it was dark. That was before SoHo and the boutiques. There was an artist living every two or three blocks, and there were no street lights. I was walking up the street, and someone approached me in the shadows. As we got to a street light I realized that he was a black man. He looked at me, and I looked at him, and the world changed that day because for the first time in my life I experienced a black man hating me just because I was white. It didn't matter who I was or what I had done or that I wasn't the enemy. In a way,

I became the enemy that day. I think one can separate time as pre-King's assassination and post-King's assassination. It was a landmark event. [In 1970, the National Guard fired on a demonstration of unarmed Kent State University (Ohio) students who were protesting the involvement of the United States in the Vietnam War. Several students were killed and several others wounded. The troops' actions were absolved by the Nixon administration causing moderates to turn against the war and the administration.]

Joe: One of the reasons that nothing has been changed is that the biggest tragedy of the assassinations of Martin Luther King and the Kennedys is that they gave us *Hard Copy*. Those events led to the birth of the anchor person. As artists we're really feeling the results of Murphy Brown, who is a parody of a newsperson, stepping out of the illusionary role and attacking contemporary art. The moral issues almost died with King and the Kennedys and other people, and what was born was impersonality and the acceptance of televising horror. I think that's the legacy of those years. It's one of the reasons that artists have so much trouble. I still don't know in my work who I am siding with out there. That's the problem with our audience. When the public sees an artist, they don't see him as a total human being. They see him as a caricature. They don't see him working in his loft and then going out to play with his cat or going to a basketball game. They have a Moulin Rouge vision of artists, just like *Hard Copy*: a one-dimensional flat view, a stereotype. I think that's been proven by the Morley Safer issue. I think that kind of journalism is what happened after the war. Gore Vidal said that after the death of the Soviet Union, television replaced the Soviet Union as the number one villain in the world. I'm bringing this up because I feel that there is still this unresolved situation that we opened up when we were talking about the sixties, which is: why at the age of fifty-three am I still shouting at the television set? [Morley Safer's segment, "Yes... But Is It Art?" was broadcast on the CBS newsmagazine *60 Minutes* on September 19, 1993. In this segment, he exposed what he believes to be the fraudulent nature of contemporary art, propagated by the hype of art dealers, critics and the artists themselves.]

Chuck: We've always been shouting at something. Now we're shouting at the television.

Bill: When you look at the faces that Chuck has chosen to paint, there is nothing about the faces that identifies them as artists. They could be the faces of factory workers or horse trainers. There is nothing that says that it's Joel Shapiro and that he's a famous artist. What's interesting to me is that these are artists and human beings. These are workers.

Chuck: We certainly thought about the artist as a worker. Carl Andre wore overalls, and there was always a big thing on May Day identifying with workers; when we did the art strike, it was about the artist as a worker going to the place where his work is shown and saying, "Hey, wait a minute, what uses are being made of this stuff?" It was certainly something that was in the air. Now people look at those paintings that I made in the sixties and see Nancy Graves and Joe Zucker and Phil Glass. People got famous on me, but I really wanted anonymous people. I didn't want to paint movie stars or politicians or people who would be recognized. Some people in the art world would recognize them, but they were not supposed to be famous people.

Bill: No matter how famous they've gotten, one step outside of this little tiny community they're still anonymous.

Joe: A painter once asked Bob Israel, "Am I famous now?" and Bob said, "We're all as famous as we're ever going to get." I think that's a statement for that time. We were talking about being famous. It's questionable whether subsequent generations of artists will become famous.

Chuck: We certainly weren't, as a generation, under the white hot glare of the spotlight in the same way as artists of the sixties and artists of the eighties were. Ours was not a generation of superstars. I think that fact was one of the things that allowed our generation to mature more slowly, and the fact that we haven't had that white hot glare of the spotlight has meant that we followed our own odd personal idiosyncratic paths a little bit more wherever they led rather than peaking early and going into a slow and steady decline. A lot of the artists, whether it was Richard Serra or Brice Marden or Joel Shapiro or Elizabeth Murray, were all in lofts within a few blocks of each other and are all doing some of their best work right now thirty years later.

Joe: It's strange that people who perhaps have a greater degree of visibility always wind up being the spokesmen for the issue of visibility, because I think that a lot of artists who teach across the United States or are involved in other ways in supporting their art are interwoven into the society that surrounds them. They have a different read on this. Many of those people chose a life in which they have a Saturday afternoon as a father tossing a football around. I think they chose that kind of integrated cultural identity. I don't believe that everybody out there is a victim of an elitist art world. Some choose that.

Chuck: As Adam Gopnik, the former art critic of the New Yorker, said, "How elitist can the art world be if I'm in it?" No one remembers who the mayor of Florence was when those guys were working. The people who sum up a generation or sum up a time are probably pretty anonymous people. They could move through the streets of Florence without being recognized, yet if we think about that time historically, we don't remember the political people, we don't even remember who was Pope. We don't remember the people who would have been on Hard Copy, if there had been one. I remember going to a restaurant in Little Italy. Rauchenberg and Johns were eating at one table, and Roy Lichtenstein and Rosenquist were eating at another table, all in total anonymity. No one in the restaurant knew who they were. Some third-string washed-up pitcher from the Yankees came in. He had had about ten minutes of visibility: he had come up from the minors and gone back down in about thirty seconds. The whole place came unglued. Everyone in the joint came running up to get the autograph of this guy, and here were these incredible figures in the history of art eating dinner in total anonymity right next to that.

Guest: Something that is really interesting that you were both talking about is that again you are at a moment of change in a cycle. We talked about the assassinations and all the activities in the streets during the late sixties and early seventies. Coming from Los Angeles, and in a way seeing and experiencing something similar to what you had in the late sixties of the great schisms in the city, and seeing great catastrophies taking place along some of the same lines as those of the late sixties, I recognize that, in a sense, a change is happening. Addressing those more recent changes, how does the work, Chuck, hold up?

Chuck: I think an artist is both an instrument of change and an anchor at the same time. The degree to which we're still involved in the conventions and traditions that go back to the caves—and really things haven't changed a whole lot: people smearing colored dirt on the wall of the cave, putting it on a portable piece of canvas, and shoving it out, or taking it another step further to producing an environment of some sort or a video—is really part of being tagged onto a long series of traditions and conventions that in many ways make us an island of calm in a sea of change. At the same time, there's an aspect of pushing the boundaries, trying to find where the edge is, trying to make something that doesn't look like art,

trying to make people rethink everything they thought art could be, so that you have people putting stuff out that doesn't look like anything that anybody ever thought art was. We push a ways and then we sort of hold ground, then push again, and then regroup. It's a funny role that artists have in society.

Joe: Sometimes change is going in opposite directions. I think it's a shocking idea that occurred at one point in the seventies when people would say that the definition of art was what the buyer or the lover of art could carry home in a brown paper bag. There was an attempt to put things on a tactile level: hold it, take it home, it's small so start out with this, take it home, and try it. That is a very unelitist attitude: something you can have in your hands that you don't have to understand. Basically, the thing that led to the East Village was an unelitist art market. There were things that anyone could afford—$3.95, $4.95, take it home—but people rejected this notion and still wanted to go to the Modern and see the Clyfford Still and the Barnett Newman with the Giacometti stuck in between. If you are trying to reach out and define art in a way in which the public can understand the identity of the people who make the things, you still have other forces pulling in other ways. I think the reason why a number of dealers in New York are now selling drawings and objects is because they recognize that a part of New York for years was that every two and a half years you make your quintessential statement, a public demonstration of what you've done for two and a half years by yourself in a quiet room. Most of the public can't understand that passage of time, the anxiety, that a life exists in a thirty-month sphere, so you can help people understand more if you find something that they can hold in their hands that is written in a decipherable language that is real.

Chuck: There is also an attempt in making big nine-foot-high pictures to make something that is, on one level at least, sort of anti-elitist. No one is going to want to put one of those suckers over their couch. I didn't make them to go into people's homes. I didn't make them for collectors. If someone had asked, "What do you want to make to sell?" I certainly wouldn't have made a picture of someone else. Who's going to buy a picture of someone else and put it over their couch? When I first came to New York in the sixties—I came from a family of no financial means—I was amazed to find that the whole art world was open to me, that even though galleries functioned to sell work to people, anybody could walk in and see the stuff. It was available free of charge to anybody no matter how broke they were. I wanted to get these pieces out into public collections, and to a certain extent we used wealthy people to get them into places where everybody could see them. There wasn't this notion of trying to figure out what the market was for them. If you thought you had something to say, you'd figure out a way to get it out in an almost subversive way.

Joe: Well, the scale of your work is suited to a museum environment in which people can see an object from two hundred feet back and in which you use that sort of tactile relationship, that curiosity. It's interesting that it fits into a notion of what was a tough attitude about making things because one felt there was support, that people could buy and give, that there was this patronage that enabled one to have the ambition to have one's work on that level. That's how one thought. Now we're living in a time when just as recently as last week there was an article about whether museums will even stay open. We've tried to find a way to put things into the museum context so that the masses can see the work, and now there's a question of whether it's even possible, or whether all the works will have to go out to Long Island City to the world's biggest basement.

Chuck: Or be filmed and put on CD ROMS. We were both at Bykert Gallery in the sixties where it was about anything but selling work, and there was show after show of nothing but the dust on the floor. Bykert wore as its badge the fact that it wasn't about the making of saleable products. I think there was even some embarrassment when a sale was actually made, like "Oh my god, maybe I'm a merchant after all." There definitely was a sense that what we were doing was about something else. Not that we were unhappy when a piece was sold, but I think we were all surprised, and I think our dealer was just as surprised as we were.

Joe: But that was part of the system, and I think partly, also, you had faith. You're talking about a notion of some people who thought a great deal about what they were doing. I think, to some degree, talent entered into the equation, and there was a conviction that what you made was of value because you had certain aspirations.

Chuck: We were totally prepared to have an occupation to support our profession for the rest of our lives.

Joe: We did. We taught at Visual Arts! Part of that process was that the art was introduced into the art world much the way monster movies are produced. In the beginning you never see the monster, in the middle you see the monster once in a while, and then in the end the monster is there all the time. There was this faith that people would come around to seeing and to developing that kind of culturation of acceptance, and I think we accepted that. That faith allowed us to take the tough stance that we took. Maybe we had seen so many of those monster movies that we became invaded with that process. I still had students five years ago in the graduate department at Visual Arts who believed in that system of introducing tough art into the world. I would tell them that I didn't know if that notion of "you affront, then people get accustomed to it" still existed. That's what I think helped that process of introducing our work into the museums. We believed that people would come around.

Chuck: Build it and they will come.

Joe: Also, when Chuck is talking about Bykert Gallery, in defense of it—well, I'm not really defending it because sometimes we poke fun at the gallery in a good-natured way—the nice thing about that place was that it also had a very different format. It was almost like a *kunsthalle* type of situation. The man who was involved in it felt an obligation to show what he saw whether it was at two o'clock in the morning or two o'clock in the afternoon. He had a view of art that was different from a nine-to-five attitude, and it was sort of conflicting in a way, but he had a willingness to say, "Well, these people are doing this, and I'm going to sit here at my desk, and I don't care what people say about it." Klaus sat there, and people came in, all six of them in three weeks, and if they didn't care for the work, too bad.

Chuck: You know, there was a widely-held belief at the time that everybody important was going to see the show, even though there were only six people.

Joe: Exactly. You're confirming what I said.

Chuck: You know, one of the best things about Bykert was that it was right across the street from the Campbell Funeral Home, and every time an abstract expressionist died, you'd get spillover. I remember when Rothko died. I was hanging a show on the same day, and I had thirty aging abstract expressionists standing in my show. It was great.

Joe: You could always recognize those guys too. They had no complexions. The other institution that was so incredible during that time was the Madison Pub where you could go and find out anything you wanted to know.

Chuck: *What about the importance of the watering holes at that time like Max's Kansas City, and Remingtons, and Longview, and all those places where we sat all night long convincing ourselves that those issues would be really important if we just kept talking about them? It was like a shark that has to keep swimming or it dies. Nobody cared if we made the stuff, nobody cared what we said about it, but we kept talking as though if we ever stopped talking the air would deflate out of the balloon and it would just all fall flat, limp on the floor. It was like psyching ourselves out in some way. Don't you think?*

Joe: Absolutely, but I also think that at the time most people downtown knew each other regardless of what they were doing in the studio. I think people hated each other's work, but I don't think there was any question that people were able to give each other more leeway. It created controversy. The feedback was part of it. If you had a show, or a piece in a group show very often what you heard gave more room to more talking. All we did was work and talk.

Chuck: *The importance of a neutral space where one could go to bump into people without having a formal invitation or without making an appointment was, I think, incredibly important. Certainly there were other times in history when that was important too, like Paris and cafes, or whatever. It's why I think New York was a greater art center than perhaps LA or San Francisco or some place where people don't tend to go to hang out in public spaces in quite the same way, where you would just bump into someone and start talking.*

• • • •

Chuck: *I don't think the proportion of quality work to crap has changed, but you used to be able to see it all, and then if you saw it all, you could figure out what you thought was good. Now there are so many galleries, you can't cover the waterfront in the same way. You tend to see a handful of galleries over and over, and you tend to go to see the work of people you already know. "This is the last day of so and so's show. I'd better get uptown to see it." When you were an emerging artist as we were, if you were on the circuit and you were in one of those galleries, everyone was going to see your work, but that's not true today. You can be an emerging artist today in an emerging artist gallery, and people are not going to see it.*

Joe: Well, people very much wanted to show in a certain handful of galleries. Prestige in 1968 or 1969 was to get a painting into a gallery of that stature, not to build a house in Water Mill. In those days, you could wait a few years before you got a house in Water Mill. Those having a painting in a group show in 1970 in a gallery—

Chuck: *The whole notion of success was very different then. If you got your work in front of your peers, maybe got a review somewhere, and sold a piece, that would have been a really successful show. Today there are such raised expectations about what success is that anything short of having a show simultaneously at three galleries, an article in Vanity Fair, and a waiting list for your work is not seen as success but is seen as failure. I think it has put a lot of pressure on.*

Joe: I was of the opinion for years that the event that changed the meaning of the environment in which we had lived for a long time was the party for the 420 Building. When the 420 building opened in 1972, there was a line of people four blocks long trying to get a free glass of red wine. That event was the beginning of a significant change in SoHo. Openings used to be for artists. You had an opening to celebrate with your friends, you celebrated the show, but that was the first-ever opening for a building. It changed that whole street, that whole situation. I don't think it was a malevolent decision to do that. I think that artists are maybe in the same boat as rich athletes: there's a lot of resentment that Michael Jordan makes fifty-three million dollars a year. I think that what people are looking for is a way of bringing artists down, finding a flaw or something with which the people who look at art can deal and relate. I think that it's a very similar phenomenon.

Chuck: *Boy, are we sounding like a bunch of grouchy old men.*

Joe: I don't know. I think that's the way things are.

Guest: *I think that's part of a particular moment. Right now I think there's a lot of discussion about populism in art. Can you define what the public is and how to reach that public beyond what you are already doing?*

Chuck: *One of the things that I have against public art is that there is no active participation by the viewer. You accidentally bump into the stuff whether you want to see it or not. I think there is something very important about a person choosing to go out and find art. It puts some of the responsibility onto the viewer. It's not just about being entertained and satiated and having the stuff dropped out there for your benefit, it's about an active choice to choose what you look at, figure out what it means, and decide for yourself what the important issues are. I think that the only really important responsibility for the artist is to make something that you think is of value on some level, do your best to get it out, and let the chips fall where they may. Art is not very good at instruction. It's not very good at propaganda. That's why so much of political art is using the same media that those institutions that do educate and propagandize use, because they're better suited for it than painting is. Painting is a sort of old-fashioned buggy-whip business that sort of stuck around. It's kind of amazing that anybody still wants to look at it. I happen to believe that finally it will sum up the times much better than the hundred thousand hours of Hard Copy and that kind of evidence of what society was supposedly into, but it will have to do it in its own quiet way without a lot of attention.*

Joe: There's one great thing about painting: it enables you to make one significant choice. It has a philosophical level to it. You can ask, "If there was one painting that I could have, what would it be?" That indicates a different level of commitment. That is a responsibility, not a choice. It's a more complete sense of responsibility; it goes beyond the parameters of what pleases you; it's how you define yourself in the sense of knowing about something and making a choice. I think artists make that incredibly difficult for people who love art. Artists present such difficult works to people that it is hard for them to answer such a question as, "What is the quintessential Chuck Close painting? Which one of these?" It's a terrific thing to be able to say to yourself, "I saw a Rivera painting that I would give anything to own because that's what sums it all up for me."

Chuck: *That's why we're not in the masterpiece business anymore. I try to make every painting as good as I possibly can, because you never know which one will be the only one that somebody sees, that's going to be in their mind, that's going to set their standard for everything that you do.*

Joe: I think that one thing has changed. Now the artist sits in his studio and says, "I will take the eight paintings that I like best and put them in this exhibition. I'm not going to give people the installation. I'm going to give the things that I'm making the judgment about and that's it."

Chuck: *That's the other important thing about painting. The best thing about painting is that it's cheap, and you can afford the best materials and make the best product you can without having to make any compromises and without having to cooperate with anyone else. It's not a product of collaboration. You totally control everything, and you don't have to say, "Well, if only I had an extra few hundred thousand dollars I could really make a better movie," or, "If I could afford somebody to design the sets and somebody else to make the costumes, and if I could afford an orchestra, boy, could I make an opera." The great thing about painting is that for a few bucks you can control the world in every issue with which you want to deal without having to ask anybody else whether they think it's a good idea.*

Joe: What's very interesting and beautiful about your work is that there is a level of metaphor in the painting that covers all of that. A painting is a metaphor for a kind of completeness, and in a great sense a great painting has its own skin; it has its own identity; it's so complete. I remember one day we were talking about a friend who was having some trouble, and you said, "You know, it's very hard to spend two-thirds of your life in a room by yourself and not go mad." A great painting has a sense of completeness: the processes, the notion of the imagery, every single part. It's molecular. I think that a lot of paintings that speak to us have that intrinsic value: for instance, Rousseau's wonderful way where every leaf, every facet becomes every piece of woven canvas. You can have that much control over it without having directors, without having it fabricated. At one point I was going to do a CD, and the funniest thing about the project was that the smallest thing in the whole production was the painting image that came out. It was a little bitty image. After all the work around it, the scanning, the slides, and choosing the music, the image was the smallest part of it, and it had no relationship to the materiality of those things.

Chuck: *The thing about working incrementally, which you have always done whether you were rolling cotton balls and putting them on the canvas or making the things that you've been doing more recently where you let the little ribbons of paint stack up on the ropes until eventually you close the whole thing in, is that there is an aspect of this that reminds me of a whole series of ways of making things that we used to call women's work, like crocheting, knitting, quilting, and that sort of thing. Whenever you would find a little bit of time in the day, you would sit down and do a little bit more of it, and it's all positive. You're adding, adding, adding until ultimately it builds up and you have made something. I wonder how you feel about that and what your thoughts are about that as a way of filling time.*

Joe: Often people have been surprised when they've seen me because they probably thought I was going to look like Grandma Moses. I think that had to do with the universal notion about making things that you didn't have to make: things that looked like they had been made by a man. Don't forget that we came after a generation of the most macho performance artists in history. One day I was talking with Chris Knight, the art critic of the LA Times, and he said that one of the problems with the art of the eighties was what to do with all the art that was performed. He completely refused to deal with it in a traditional painting sense. We were talking about making things that could have been made in various ways not indicative of learning how to paint and

draw in art school, for instance, crocheting. What this diversity has done paves the way for some changes in the way in which modern art is viewed, the way museums hang work, and the provincial attitudes that are embraced in a certain fashion. There was a democratic idea about art; some people acknowledged the wide diversity of forms—it could have a a political content without being propaganda. You may have made things out of eccentric materials, but you still dealt with visual imagery, not necessarily literal propaganda. I think the change is that some of these things are done today. I think somewhere along the way things have changed and certain ideas like that have been developed and used in a more literal fashion. I think that a reaction to some of it had to do with the kind of periods of painting that had come before the seventies or the sixties.

Chuck: If in fact, as I believe, you are the only person who anticipated the problems of living with one of my paintings and what those problems might be, and if you are the only person who figured that out and changed the way you looked before I painted you, what can we learn about that experience twenty-five years later? When we look back at the image now, is it you or is it him?

Joe: I think one of the reasons why that image is like that is because we were close friends and were talking about a lot things, whereas some of the other people that you painted didn't have the same common interests in the studio. I think that's one of the reasons that image exists. Also, I was changing my work too at that time, having left Minneapolis. I think that the change that occurred there was part of an evolving situation. Ironically, one of the interesting things about that painting is that my identity is still undefined because of the way I am personally and also because of the way I dealt with my work. I don't mind saying this: I feel that perhaps I am as faceted in how I see my life as some of the newer paintings. I try to separate myself intentionally; I have not curated an identity for myself. Someone was criticizing me and said, "This is your true intent, it's about this." I said, "There are about five or six things that I am capable of being very intense about: coaching basketball, fishing, painting." Maybe that notion of change has a certain truth to it; maybe I don't necessarily have a quintessential style of making work. My work changes, and somewhere there was a very personal kind of thing that you could see; maybe you could see it as a front, on one hand, for what you wanted to do or having a level of futility because the image is frozen and ultimately you have control of it. I do think that we saw a lot of each other and there was a lot of interchange, and maybe that communication had something to do with it.

Chuck: Certainly it was important for me. People always ask you who your influences were and who was important in New York, and I'd like to say on the record that probably more than anybody to whom I talked, especially early in those first ten or twelve years or so, you changed my mind about the way paintings could be made. You had an influence on the notion of building the painting rather than painting; about working incrementally; about making things out of building blocks and slowly arriving at something, finding it rather than preconceptualizing; giving yourself over to the process and letting it go wherever it was going to go. It was very important to me.

Joe: Those certainly were very important times, but I look at the painting and find it very emotional because there have been times when I've come back to New York and walked through the streets, and sometimes one has a hard time with the reality of those years. It hits you at certain moments. People have come up to me and said, "Well, we have the painting. Do you want to see

it?" I find that I've never been curious about standing by myself with that image and having those years and all of that wash back. I take it as a very real thing, more like a segment of one's life. "There it is, go see it again." I don't feel that way about it. It's something that's a deeper feeling. Sometimes you just can't look at what you do. It's too hard to deal with at an emotional level. It was a moment that was very unusual. Don't you think that a lot of the other people were very defined in a sense, defined how they wanted—

Chuck: You mean they defined how I saw them. They controlled—

Bill: Do think that you would feel the same way if Chuck decided to do another painting of you now? Would it take on a different kind of feeling for you to see a painting done now than it did then; would it play a different role in your life?

Joe: It would be interesting to me, because I feel that the new paintings are visually so different. They have a different life; I don't know how I see myself. I would have to see that painting in order to answer those questions. They are very interesting questions that I can't answer.

Bill: Would there be an anxiety about how you would look? The paintings, in and of themselves, no matter of whom they are paintings, have a tremendous power, and I think that most people who see them don't know whom they are anyway. So again it becomes a personal sort of thing for the person who is the subject.

Joe: I don't think many people can look at this painting and understand and learn about mortality. When you bring people to look at a painting like that, which has such a physical life of its own, I think you have to really understand that it's not just about the image and how I would prepare myself to be painted in another fashion. I think there is a curiousness about Chuck's paintings, a flip-flop. The newer paintings are curiously molecular, but this has almost a compression of corporal reality. I think the reason that they are so incredible to look at is their relationship between illusion and material identity. I'll tell you honestly that I don't like the way I look now as much as then. By age I feel more vague. I can't identify with that image as strongly.

Chuck: Now that painting is in a Japanese museum so you're not only representing yourself, but you're representing American maleness.

Joe: *Oh, my god.*

Chuck: That's pretty scary isn't it.

Joe: Maybe it's the perfect ugly American painting.

Bill: Maybe you have a huge fan club in Japan.

Chuck: It's back to the American used car salesman selling Toyotas.

Joe: Absolutely.

◆

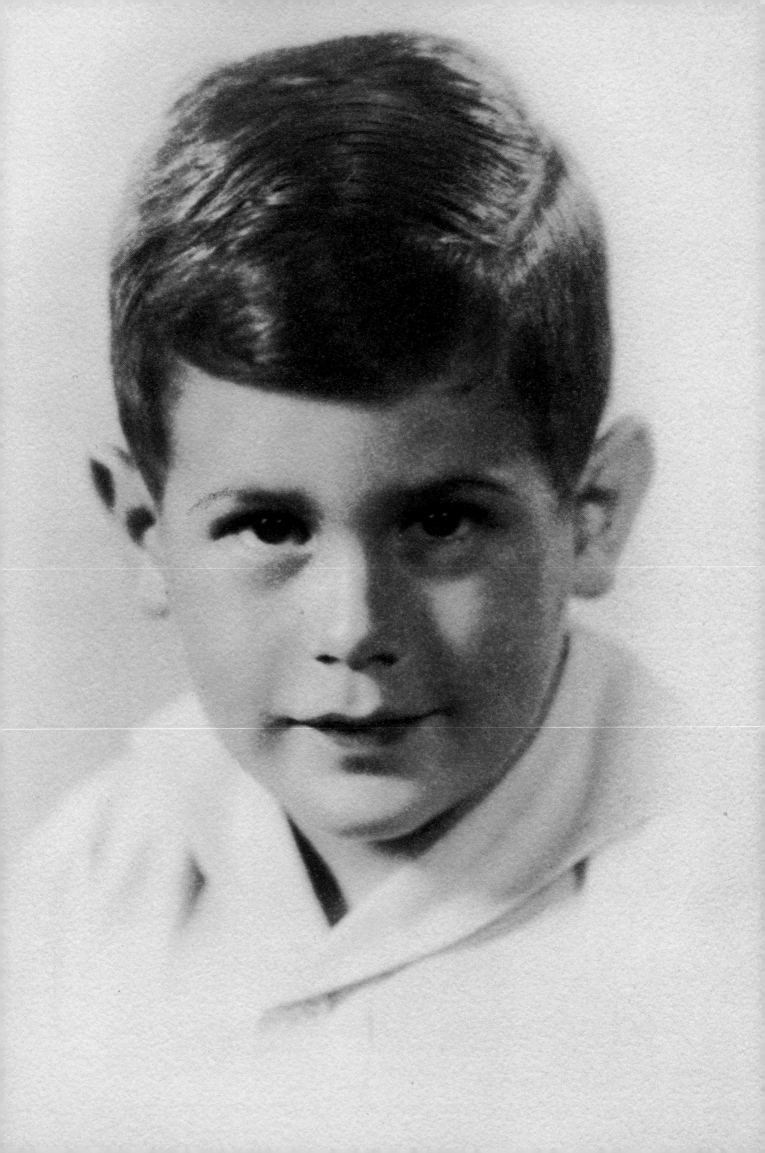

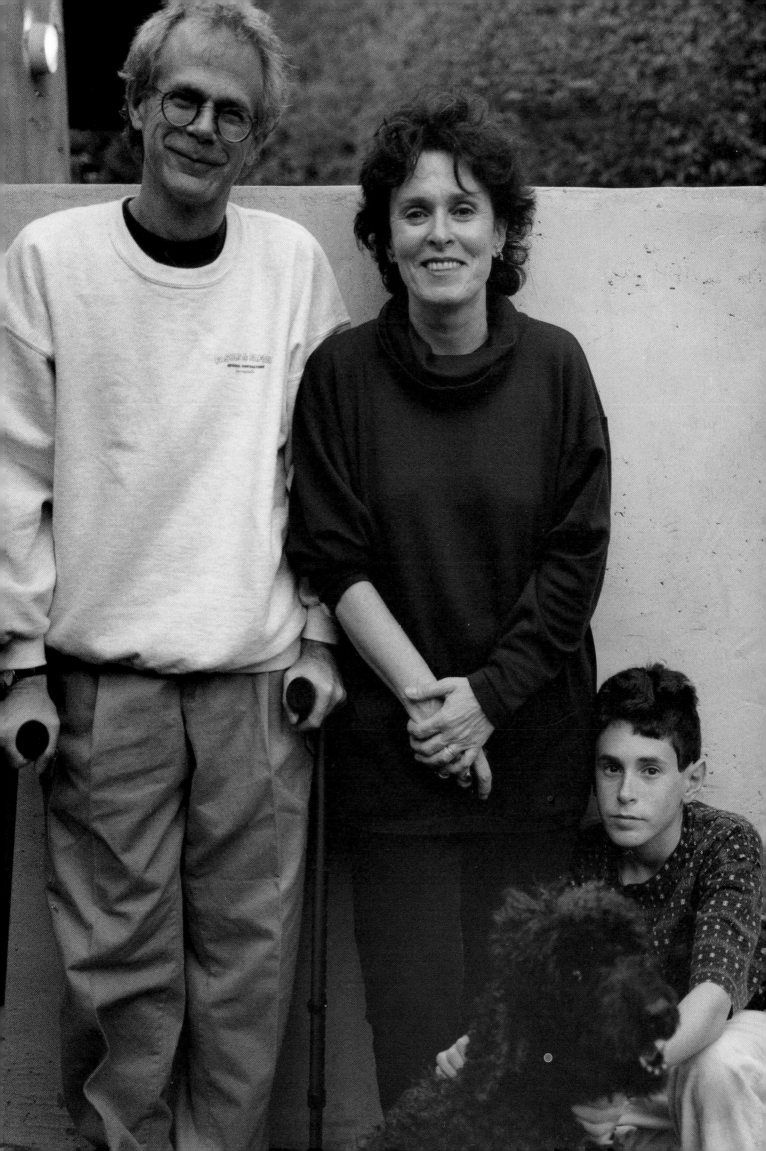

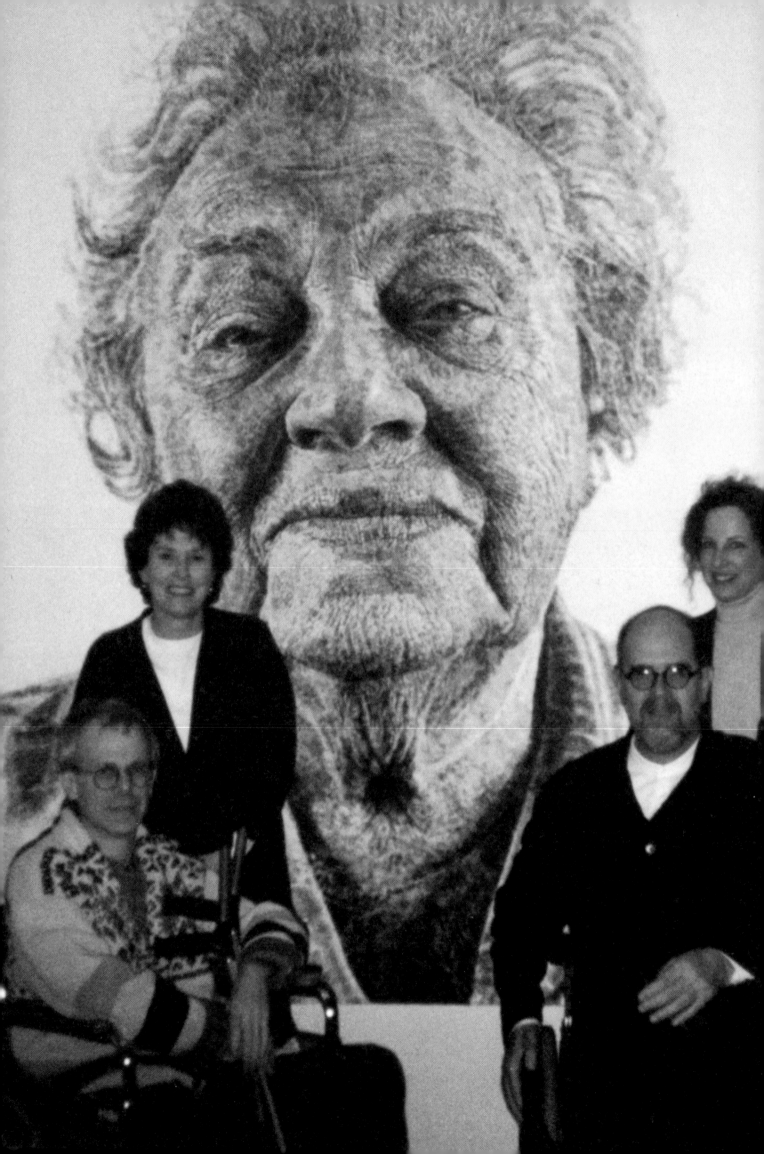

Robert Israel

Pace Gallery, Los Angeles, September 28, 1995

Chuck Close: I was thinking that we might start by talking about when we first met. You were working in Minneapolis at the Guthrie Theater.

Bob Israel: I was actually at the Walker [Art Center].

Chuck: Oh yeah, the Walker.

Bob: Martin Friedman rescued me, and I was working for him at the Walker. The Walker put on operas at the Guthrie. The theater company and the opera company were separate entities, and the Walker ran the Center Opera company. That's when we first met. You and Leslie came to Minneapolis.

Chuck: Right, but actually, you were at my studio before I was out there.

Bob: That's right. I came to New York on a trip.

Chuck: The Walker was the first museum that bought a painting of mine. Our mutual friend Chris[topher] Finch was a curator at the Walker at that time, and, as I remember, Don Nice told you about me. Did he tell you or Chris?

Bob: He told me. I told Chris he should see your work.

Chuck: Had you seen it yet?

Bob: Yeah.

Chuck: You saw it first?

Bob: That's right. I was in New York and saw the *Big Nude* [1967–68] and your *Self-Portrait* [1968].

Chuck: Right.

Bob: It was on a cold winter's evening with the space heater and my allergy to cats.

Chuck: Right. [laughter]

Bob: Then I went back and told—yeah, you're right. Don [Nice] was instrumental in my meeting you.

Chuck: Yeah.

Bob: Then I came back and told Chris and Martin about you.

Chuck: And Chris came out.

Bob: Yes.

Chuck: He looked at my work, went back, and lobbied Martin.

Bob: So did I. It didn't do any good.

Chuck: Martin came out. The painting in question—the Self-Portrait—was thirteen hundred bucks, and coming up with the money was a major problem. It took them two years to pay for it.

Bob: Yeah, I know. I know.

Chuck: What was really funny was that every time Martin came to New York, it was as if "welfare for artists" had arrived. We'd have Martin take us to Ping Ching, a Chinese restaurant in Chinatown, and people would just fall in step with us on the way to the restaurant. We'd start out with three or four people going to dinner, and others would just come out of their lofts and get in line. By the time we got to the restaurant, there would be forty people for Chinese food, because we were all starving to death. After Martin bought the Self-Portrait, he wanted to see a lot of artists' studios, so I set up a lot of studio visits for him. He immediately bought a Richard Serra. I think it was the first prop piece that Richard sold.

Bob: Oh really?

Chuck: It was one of the early lead prop pieces; we're talking about '68 or '69. Yeah, it was great, and, you know, no museum in America was open to that stuff. Nobody was interested. Martin was ultimately responsible, all of you together were responsible, for my first three sales.

Bob: Really? What were they?

Chuck: They were all in Minneapolis. One went to the Walker, one went to the Minneapolis Art Institute, and the third went to wonderful Gordon Locksley, hairdresser-turned-art-whatever-he-was. He had an incredible mansion in Minneapolis. Gordon was a hairdresser, I think, and his lover, a peroxide blonde, was also a haircutter. Wasn't he?

Bob: No, he was an Oriental scholar and had been a professor at the University of Michigan, but he turned hairdresser.

Chuck: Right. They had all of the early hand-painted Warhols. They owned virtually everything.

Bob: They owned the Warhol *Elvises* with the guns. [*Elvis I and Elvis II*, 1964; *Two Elvises*, 1963; *Single Elvis*, 1963.]

Chuck: Uh huh. They had the Dance Floor piece on the floor, the way it was supposed to be.

Bob: The nose, the nose job. [*Before and After*, 1962, is currently in the collection of the Whitney Museum of American Art.]

Chuck: The nose job, yeah. It was great. Minneapolis was an interesting crossroads for people who were moving from the West Coast to the East and vice versa. All kinds of people stayed there for a short while. It had a major impact on their careers, and then they went on to other things.

Bob: Martin was really one of the two people who was responsible for my career. It's that simple.

Chuck: You were making sculpture at the time.

Bob: Bad sculpture.

Chuck: Well, we don't know that. You had a show at the Whitney of inflatable sculpture. You made inflated phallic plastic sculpture. What year was that? [*Robert Israel*, a one-man exhibition, was presented at the Whitney Museum of American Art, New York, in 1969.]

Bob: The best thing about it was that the plastic aged and wouldn't hold its air, so the sculpture was actually disposable. The drawings I was making were probably more interesting than

the sculpture. That's how I got into theater design. Martin showed a bunch of drawings at the Walker, and he asked me if I wanted to design something.

Chuck: A young artist, essentially unknown, making these drawings—what other institution would have shown them? Who else would have taken you under his wing?

Bob: I was really lucky. He was open to that, and, also, we became friends and have had a really wonderful relationship.

Chuck: The Walker was a great training ground for curators too. Virtually every curator in the country went through there.

Bob: And artists too. Joe Zucker was there. Barry Le Va was there. I was there. Don Nice was there. Who else was there? All of these people who made a great impact kept coming through, because, as you said, it was kind of a crossroads.

Chuck: People who were afraid to move all the way to the other coast could stop off and live for a year or two in Minneapolis. I was thinking of our mutual friend, the artist who used to do the lighting.

Bob: Boyd Medford.

Chuck: Was Boyd there?

Bob: Boyd, no. Boyd was in Vermilion, South Dakota or North Dakota. I can't remember. He was there, and I remember saying, "God, is Boyd there?" I can't remember why, but I was invited to go to Vermilion where Artschwager was teaching. That was the first time I met Artschwager. All of these people were in weird places. Artschwager gave a lecture in the middle of nowhere, and it was a wonderful, wonderful lecture. I couldn't figure out what was going on, why this was happening in Vermilion.

Bill Bartman: The weird thing was that Artschwager claimed that one should never teach.

Chuck: Well, he knew firsthand.

Bill: Right.

Bob: Yes.

Bill: But the year before, he had taught too.

Bob: What's the Woody Allen line? "Those who can, do; those who can't, teach; those who can't teach, teach gym."

Chuck: Oh, we've got to make sure we talk about Siah [Armajani].

Bob: Siah was there, of course. Siah was there when I first moved there. Oh, Siah is such an extraordinary character. [Siah Armajani was born in Teheran, Iran, in 1939. An artist who creates work for public spaces, he is most concerned with the issues of location, function, and context of art. He believes that "public art's basic aim is to de-mystify the concept of creativity. Our intention is to become citizens again… and we must begin a search for a cultural history." He has exhibited widely, including exhibitions at the Kunsthalle [Basel, Switzerland], Stedelijk Museum [Amsterdam], Tate Gallery [London], Hirshhorn Museum and Sculpture Garden [Washington, DC], and the List Visual Arts Center at MIT [Cambridge, MA].

Chuck: Siah came from Persia because his brother or some relative taught at MacAlester. Is that right?

Bob: I think his uncle taught there. Yeah, Siah came from Iran, which he always called Persia. His uncle, who had to leave for political reasons, moved to St. Paul, Minnesota.

Chuck: Right. I remember a wonderful story he told. In Persian society, you don't accept anything the first time it's offered to you. Siah had to take five flights, or something like that, to get here. He

flew from Iran to Rome, from Rome to Paris, from Paris to Shannon, from Shannon to New York, and from New York to Minneapolis. He didn't speak very much English. They would come around and offer lunch, and he'd say, "No, thank you," and they'd take it away. Then they'd come around and offer him dinner, and he'd say, "No thank you." As I remember the story, you have to be asked three times before you can accept something, so on the last leg of the trip, when he was starving to death, he said, "No, thank you, but ask me two more times." I remember that you complimented him on a watch and he—

Bob: —gave it to me.

Chuck: You complimented him on a carpet—

Bob: —and he was going to give it to me.

Chuck: Didn't he bring it to your house or something?

Bob: I can't remember, but after that I learned that I shouldn't mess around. If you even vaguely said that you liked something, he would give it to you. I'll tell you a great story. You know, he is an incredibly finicky eater, and he went to a dinner with Barbara, his wife, and they put a dish of shrimp in front of Siah. He didn't want to eat it, but he didn't want to leave it on his plate, and he didn't know what to do, so he—

Chuck: He's such a gentle person. He would never hurt anyone's feelings.

Bob: He managed to put all of the shrimp into a napkin and put it in his pocket, and then he went into the bathroom, pulled the napkin out of his pocket, emptied the shrimp into the toilet, flushed the toilet, and, of course, the shrimp went around and around and around. So he was in the bathroom, and he didn't know what to do because—

Chuck: They wouldn't go down the drain, right?

Bob: They wouldn't flush, so finally he peeped out—I don't know the end of the story. The way he told it, he peeped out of the bathroom and called "Barbee," and she came in and helped him somehow dispose of the shrimp.

Chuck: What a wild man. Remember when he proposed that sculpture for the top of a building?

Bob: Yeah, the building standing on top of itself, upside down.

Chuck: Yes. He was going to do a hologram of a building on top of a building, and they asked, "How much would you like as a commission for doing this?" He said "One million dollars," and they said, "Gee, isn't that a little steep?" "No," he said, "it's one million dollars," and then they said, "Why? Isn't there any flexibility on this?" Siah said, "No. Why does it have to be a million? I have always wanted to know what it feels like to be a millionaire."

Bob: He went to buy a new car—he was a terrible driver, an unbelievable driver—and this guy started giving his pitch. Siah said, as the guy was about to lift the hood, "No, no, no, don't. Don't do that, don't do that," and the salesman asked, "Why not?" Siah said, "All I want to do is kick the tires." Christopher and I were in the Walker offices, and Siah brought in a film he was making. It took him forever to make a film. This was a film of driving down a street in Minneapolis at different speeds, until finally you're going down the street at the speed of light. Of course, what you see is this flood of light. Siah is not a great mechanic, but he managed to thread the film and turn it on. We were looking at this film, and either Christopher or I said, "It's mangling the film." The projector was eating up the film, and I think it was Christopher

who said, "Look, it's eating the film. Turn it off," and Siah goes, "Ha ha, ha, ha, ha." The film is being eaten, and we're all roaring with laughter as the film is being eaten up.

Chuck: I remember my favorite of his proposals. He did these proposals for pieces set in the landscape. This one was for a lake that was a half-mile wide. He proposed a boat that was ten feet short of a half-mile long. You would get on the boat and walk the entire length of the boat, and then you would be staring, from the bow, at the remaining ten feet to other side—too far to jump. Then the boat would move the ten feet.

Bob: Do you know about the tower at the border of Minnesota and North Dakota that would have cast a shadow the full width of the state? He said it would be the only worthwhile thing in the state.

Chuck: Minneapolis was a wild place; it was a crazy town. I remember when Leslie and I drove across the country. Remember in the old days when we used to drive other people's cars? We didn't have a car, we lived in New York, and we were going to Seattle to visit my mother. We got a Volkswagen from a Village Voice ad. We had to drive from New York to Seattle, and they give you a certain number of days in which to do it. Just as we arrived to pick up the car, Leslie noticed that her driver's license had expired, so I had to drive all the way across the country in four days.

Bob: Oh man.

Chuck: We started driving, and I drove straight to Minneapolis from New York without stopping, all night long, one of those hallucinating "taillights were headlights" nights. It was awful, but we finally arrived at your house in Minneapolis—

Bob:—and I put you to sleep.

Chuck: You put me to sleep, and I slept for twenty-two straight hours, or something like that.

Bob: It seems so long ago.

Chuck: I remember you had a Marilyn print over the bed.

Bob: That's right, Warhol.

Chuck: You were the only person I knew—

Bob: Thirty-five dollars or something like that.

Chuck: It was fifty dollars, but you got a—

Bob: I got a discount.

Chuck: So, you stayed in Minneapolis for how many years?

Bob: Four years, and then I moved back to New York. I had lived in New York before that. I moved back to New York. Barry, Joe, and I all moved to New York.

Chuck: And you continued your work. You designed the costumes that Leslie helped make.

Bob: Yeah, that was for *Punch and Judy*, an opera at the Guthrie. [The Minneapolis Opera Company presented the world premiere of Harrison Britwhistle's *Punch and Judy* at the Guthrie Theater in 1972.]

Chuck: Leslie and Debbie Hollingworth worked together.

Bob: Oh boy, it was a ton of work, just an incredible, enormous amount of work.

Chuck: You showed the drawings for those costumes at the Jay Farnsworth Gallery.

Bob: Yeah, that's right. It's amazing that you remember that.

Chuck: It was probably the first time I'd ever seen costume design in a regular art gallery. You're a brilliant draftsman. You've always drawn so beautifully.

Bob: Those drawings and a couple of the large puppets were there, weren't they?

Chuck: Yes, yes.

Bob: I hadn't thought about that in so long.

Chuck: They were wonderful costumes, stuffed with foam rubber, for all the characters in Punch and Judy. *They were done in white muslin, and you just sort of—*

Bob: There was an armature made out of conduit on castors. The singers were in identical costumes, and they would run in and out of these puppets that they could wheel around the stage as alter egos of the—

Chuck: —big, big tents and all kinds of—

Bob: Oh yeah, they were huge. Judy must have been eight and a half feet high. They were really, really big.

Chuck: They had such an apparitional quality too, because they were so faint, like a drawing. They had a drawing quality.

Bob: Yeah. They were more stained than painted—no pun intended—punchy colors. I could see that I was not going to stay in Minneapolis, that my future wasn't there. I guess everyone else out there felt the same way, except for Siah, who remained there.

• • • •

Bob: I guess to a certain degree I was reticent about becoming a theater designer. I really wanted to paint; that's what I really wanted to do.

Chuck: Boy, did you make the right move.

Bob: Yeah, I made the right move, but it took me three or four years. I was really reticent.

Chuck: Yeah, I remember how torn you were.

Bob: It was agony. I'm sure that it came from having had bad experiences with my parents during my childhood and knowing that with a painting you didn't have to compromise, you didn't even have to collaborate. You were just there, and it was it, and you could contend with it in the most primary way. Even if you failed, you were contending with it. To me, the theater was full of, if not compromises, full of contending in a good way, and collaboration in a good way, but it wasn't that one-to-one primary tussle. In the work that I do now, I don't compromise. I work with directors with whom I want to work, and our vision, if it's good, and it's good a lot of the time—

Chuck: Are you given a budget ahead of time, and as long as you stay in it you're okay?

Bob: It depends on where I work.

Chuck: You said the Met was unbelievable.

Bob: I'm never sure what the budget is at the Met, which means it's always a big budget. If I'm at A.R.T. [American Repertory Theatre] at Harvard, I know I don't have much money, but I also know that I'll be working with a director with whom I really want to work. If I go to Vienna or—

Chuck: You do more work in Europe than in America, don't you?

Bob: Right now I am. I'll give you an example, a terrific example, of the difference between the arts in this country and the arts in certain places in Europe. About four years ago, the

population of Austria was between eight and nine million, and they gave approximately twenty-three million dollars to the opera to redo the stage—just the stage.

Chuck: They would have had more if they'd kept the Jews.

Bob: Well, probably.

Chuck: Who was it who said, "Germans are my second favorite people. My favorite are all the other people"? [laughter]

Bob: Here's another one: the Austrians were the greatest PR people in the world because they made us believe that Beethoven was Austrian and Hitler was German.

Chuck: Uh right. [laughter] Where is theater lively in this country? Is Seattle interesting?

Bob: There is good theater in this country, but Americans tend to be—I'm pretty down on American theater. You know, when people talk about great American musicals, they don't realize that there's no contest. The best musical of the twentieth century is a German musical. Everyone thinks we invented musical theater, but it's the *Three Penny Opera*. I mean, look at something like *Oklahoma*. It's an embarrassment in terms of the book, of the libretto. It's an embarrassment. I mean, there are some nice songs in American musicals if you like to sing embarrassing lyrics like "walk on, walk on, with hope in your heart."

Chuck: I'd have to change them to "roll on, roll on."

Bob: Roll on, roll on, okay. There are lots of problems with theater. In England, the craftsmanship and the commitment are so good, the quality of the acting is so wonderful, that it's a different experience. Here in Los Angeles the production isn't important. What's important is showcasing yourself so that you can be in a movie.

Chuck: But in Europe the state pays for the arts. We don't have that kind of support here.

Bob: It's less and less the case, even in Europe. Less and less. I think the whole premise of American theater was focused, at least in the early part of this century, on real estate considerations. The theaters at which people were looking were the theaters on Broadway, which, of course, were jammed into existing buildings. Lots of them were very dear in terms of the amount of money that had to be paid for rent. The classical proscenium theaters in Europe are built on a whole different premise. They have wings and big back stages. In fact, their proportion is three to two, with the backstage area being the three and the front of the house being two. That has great ramifications in terms of creativity. I think the biggest innovation in theater in the twentieth century is the ascension of the director and all his collaborators to power. In a theater where there are wings, the director can articulate ideas, because things can be moved in and out, but look at musicals in the Broadway theater like *My Fair Lady*. The Broadway theaters are structurally built so that one scene plays downstage and can be changed with stuff that can be collapsed in the wings and brought on while something else is happening by the footlights. Then, in the next scene, the stage can be opened up. There are no alternatives. Look at a new production like *Carousel*. It came here from London, and Americans just kind of went gaga over it. The reason that they went gaga over it was that the director had had the ability to articulate ideas on a stage in England that allowed for all kinds of juxtapositions that can't be accomplished in the Broadway theater or can't be accomplished, generally speaking, in the

American theater. The only place they could put it was Lincoln Center. Also, the training is different. The directors and designers here are trained in theater schools. In Europe, directors aren't school-trained; they come to their discipline either through apprenticeship or from other areas. The designers go to art school, they don't go to theater school.

· · · ·

Chuck: You grew up in Detroit.

Bob: Well yeah, if you can call it growing up.

Chuck: One of these days you might make it. You might be a grown-up yet.

Bob: I might. *[laughter]*

Chuck: I was in a race with my children to see who was going to be a grown-up first.

Bob: Well, I'm losing.

Chuck: Where did you go to school?

Bob: In Detroit? Mumford High, the same one to which Eddie Murphy went, the one on the tee shirt in *Beverly Hills Cop.*

Chuck: Where did you go to college?

Bob: Pratt in New York and then the University of Michigan. I was almost a classmate of yours at Yale.

Chuck: No kidding?

Bob: Yeah, I was accepted both at Yale and the U of M for graduate school, but I couldn't get any money from Yale.

Chuck: Yeah, but you only had to pay for the first semester, and then you didn't have to pay anymore.

Bob: I didn't know, I didn't know, and so—

Chuck: If you're any good at all, you go on full scholarship the minute you get there.

Bob: Really?

Chuck: They gave me a refund for my first semester.

Bob: Really? Wow. I didn't know what I was getting into. I decided that since I was accepted both at Michigan and Yale, and I really didn't know the lay of the land whatsoever, I didn't know that art department—

Chuck: It's funny that we still would have known each other, but in a totally different way.

Bob: Yeah. So I went to Michigan because they gave me a work fellowship in the museum.

Chuck: My friend Mark Greenwold, with whom we also did an interview, was accepted into a Yale summer school session that I attended, but he wouldn't go because he didn't want to share a bathroom.

Bob: Oh, he couldn't pee with anyone listening. He's a crypto-crapper.

Chuck: Otherwise, he would have gone, and I would have known him from Yale.

Bob: We were going to talk about the painting.

Chuck: Oh, yeah.

Bob: And we didn't.

Chuck: Well, what's funny is that, just to relate it to opera, I photographed you and Phil Glass on the same day.

Bob: And Joe [Zucker].

Chuck: And Joe, in this photo studio, and you and Phil Glass sat next to each other for an hour waiting to be photographed.

Bob: We had never met before.

Chuck: You had never met each other, but I'm sure you had some kind of—

Bob: I knew who he was.

Chuck: Yep, and you had a conversation while you were waiting to be photographed. How many years later did you guys end up collaborating?

Bob: Let's see, it must have been about five years later. I had moved to Holland, and Hans De Roo, who was then the intendant of the Netherlands Opera Company, was going to commission Phil to write an opera. Since I was working there, I said, "Oh, I know him, and I'd like to work with him," or something like that. That may be a little bit fictional because I can't remember exactly what the dynamics were, but I can remember going to New York at one point and meeting with Phil.

Chuck: How many pieces have you done with him?

Bob: One, two, three. Wait a second. Four.

Chuck: Name them for us so that we have them listed.

Bob: *Satyagraha.* [World premiere, 1980, Rotterdam.]

Chuck: That's the one that everybody immediately thinks of as your collaboration with Phil.

Bob: *Akhnaten.* [American premiere, 1984, the New York City Opera and the Houston Grand Opera.]

Chuck: Yeah.

Bob: *Orphee, and The Voyage.* [World premiere, 1992, joint production at the American Repertory Theatre, Harvard University, Cambridge, MA and the Brooklyn Academy of Music, and world premiere, 1992, Metropolitan Opera, NY, respectively.]

Chuck: Great.

Bob: Boy, Phil's music has changed, and my designs have changed.

Chuck: Yeah.

Bob: I can also remember not wanting to pester you while you were making the painting, but wanting to peek in as often as I possibly could to see how it was coming, and every time I did see it, I was struck both by recognizing myself and by not being able to see the whole face—

Chuck: Uh huh.

Bob:—and only being able to see the parts.

Chuck: Well, I did that film of you, also, in which that was exactly what happened.

Bob: Yeah.

Chuck: I did a thing where I panned the rectangle that Bob's head was in. There was a flash as the lens opened and it was white, and then you saw the little fuzzy things go by and it was white again, and it flashed and it was white, and then you saw some fuzzy hair and then some sharp hair, and fuzzy hair, until you had slowly gone all the way over his face. You knew everything in the world about his face, but you didn't know who you'd seen, because you couldn't put all the pieces together.

Bob: In retrospect, I think it was just profound narcissism because what you end up looking at—all of us to a certain degree are narcissistic, I guess it's part of the way human beings are—you start looking for the flaws. You can't see the whole because you're looking for some terrible problem.

Chuck: *There is a kind of odd intimacy too, because you're seeing more than you normally would, and you know all this stuff about the subject now, but you still don't know what he looks like.*

Bob: Yeah. You always said that you knew more about my face than I did, and I absolutely believe that's true.

Chuck: *You know, your face has changed the least of that of anybody I painted.*

Bob: Really?

Chuck: *You look—you look exactly the same.*

Bob: I'll tell you something that not many people know. I've had plastic surgery. Now is a good time to reveal this. I had a pre-cancerous mole.

Chuck: *Oh yeah?*

Bob: It had to be removed, and I had a slit from the bottom of my nose through my lip and through here. There's no scar; we live in the land of plastic surgery. Even with it, I've changed. Can you see any difference in the indentation under my nose?

Chuck: *Yeah, it used to be—did it—it almost was a bigger—*

Bob: That's right, you've got it, you've got it.

Chuck: *There was a bigger indentation, yeah, but other than the fact that you're grayer, you look essentially the same.*

Bob: It was always amazing to see that painting. For some reason I couldn't focus on it, although I could look at Phil's painting or look at any of the other ones.

Chuck: *I remember that when I had a painting of you in a show at the Whitney, an optometrist told me that he could build the glasses you were wearing by looking at the painting. He saw how your lenses reduced the size of your eyes and caused an indentation in your head. By looking at that curvature and how it distorted your face, he could make, maybe not your exact prescription, but one good enough for you to read with. I see you have trifocals now.* [Lisa Lyons, in her essay "Expanding the Limits of Portraiture" in the Close monograph she co-authored with Robert Storr, said, "Occasionally, even Close is seduced by his own illusionism. He recalls a particularly disturbing situation while working on the portrait of Bob [Israel]: 'I had taken a break and was walking back into the studio. Looking at the painting, I noticed that a highlight in one of the eyes was too bright. And I said "Damn it, now I'm going to have to take his glasses off to fix it." But when I realized what I had said, I pivoted on my heel and walked out leaving the lights on, the compressor on, and the airbrushes full of paint. When you start believing in your own illusion, you're in serious trouble.'"]

Bob: Weren't you telling me that in Vermeer paintings you can detect the aberrations in his lenses? Was it you who told me that?

Chuck: *No, uh uh.*

Bob: Someone told me that by the flares in some of his paintings you can tell that there were problems with the grinding of the lenses in his camera obscura. [The camera obscura is an optical device used by painters in the seventeenth century. It works on the principle that focused rays of light, whether direct or reflected, will project an image of the source from which they derive. With the addition of a convex lens and a focusing tube, camera obscuras became portable, enabling artists to use them for landscape painting.]

Chuck: *Wow. Well, in the* Artist in his Atelier *in Vienna, there's a brocade curtain on the left with a window behind it, and the light comes through those things, and it has the shape—the little white things come through with the lens shape, instead of—*

Bob: What do you mean?

Chuck: *Well, you can tell that it was not a direct observation. You can tell that there was glass between the artist and the scene.*

Bob: Is there a curvature?

Chuck: *There's a flare of light when it expands, yeah. It's so clearly photographic. It's really amazing.*

Bob: It's interesting to see those paintings and then to look at something like the *View of Delft* where he obviously didn't use a camera obscura.

Chuck: *I'm not sure he didn't use a camera obscura.* [Arthur Wheelock analyzed the use of the camera obscura in his essay in *Vermeer and the Art of Painting*, 1995. He wrote: "Because a camera obscura leaves no physical traces on the painting, one must rely on an interpretation of the image to determine whether it exhibits characteristics that could only have derived from the use of the camera obscura." He continues with a formal analysis of Vermeer's *View of Delft.* "The diffused highlights Vermeer painted on the boat in the distant right are so similar to the halation of highlights seen in a camera obscura that it seems probable that he conceived this scene with its aid. Vermeer, however, used these phenomena creatively and not totally in accordance with their actual appearance in a camera obscura. In the *View of Delft*, Vermeer painted diffused highlights on the side of the boat on the right where they would not have occurred because the boat is in the shadows. In this instance he probably depicted them to suggest the flickering reflections of the water in the side of the boat."]

Bob: Oh, you think he did? How could he have done that? He set it up outside?

Chuck: *Well, Canaletto used them in Venice. Canaletto painted in a black box.*

Bob: Oh, I didn't know that.

Chuck: *He painted inside a black box, or drew, at least.*

Bob: So, he had this portable room where he'd do these—

Chuck: *There's no reason why he couldn't. There are some rooms in which he apparently used a mirror to turn the image around.*

Bob: Upside down, you mean upside down.

Chuck: *Yeah. They were looking for a room in which he may have painted, and they think they found one, but the window is on the other side because the image had been reversed.*

Bob: Did a lot of artists use camera obscuras?

Chuck: *No, not that early, not that early.*

• • • •

Bill: *What about Woodstock? [laughter]*

Chuck: *Never go to Woodstock with—the only person who is as big a panty-waist as my wife is sitting right there. Neither one of them could pee or shit in public.*

Bob: Oh, it was so dirty.

Chuck: *Oh god. I mean, talk about not catching the spirit of the times. Everyone was rolling around in the mud.*

Bob: They were selling water there. They were selling *water* there.

Chuck: *People were fucking in front of us, people were bathing and rolling in the mud, and these two guys would not—I mean, they were going to have uremic poisoning because they couldn't—I couldn't believe it. I've always held that against the two of you. We had to leave the goddamn Woodstock.*

Bob: It took us six hours to leave.

Chuck: Yeah.

Bob: Do you know the W.C. Fields joke about the whiskey and the water chaser at the bar? He pushes the water away and asks for another whiskey. The bartender brings him the whiskey and, again, he pushes the water away, and the bartender says, "What's wrong? Don't you like water?" and W.C. Fields says, "Never touch the stuff. You know, fish fuck in it."

Chuck: Right. [laughter]

Bob: That's how I felt. I don't think I'm that way now as much as I was. I think being married has, to a very large extent, cured me of certain needs for privacy. You could take it. Leslie and I really couldn't deal with it.

Chuck: Boy, was I mad. [laughter]

Bob: I think both of us were so relieved to get out of there. I mean it was really—

Chuck: I didn't want to speak to you for months, either one of you.

Bob: You know, you came over this rise, and there were 750 million beatific people not making any noise at all. I kept thinking to myself, "What's wrong with all these people? They're not making any noise. Look over there. There's a stage and there's some singing. Who is it? It's so far away, I can't even tell who it is." He's still mad. *[laughter]*

Chuck: If I had known that you couldn't go to Woodstock with a couple of Jews—[laughter]

Bob: That's what it was. Oh God. That really cured me.

Chuck: They were trying to sleep in the back of Leslie's father's station wagon, a Chevy station wagon.

Bob: We had the most comfortable accommodations of anyone at Woodstock, but neither of us could take it.

Chuck: And whine, the whining, gosh, it was unbelievable. We were, of course, the only people stupid enough to have actually bought tickets ahead of time. We had paid—

Bob: I'll bet we paid twenty-five or thirty dollars.

Chuck: But when we got there, they just tore the fences down.

Bob: Everyone just went in.

Chuck: So we did everything wrong with Woodstock, but we were there.

Bob: We were there.

Chuck: Haven't you always worn that as a badge of honor?

Bob: I was there. Yes I was.

Chuck: What an incredible time the sixties were. What a mix of ideas. Everything was up for grabs. Nobody believed in anything anymore. I mean, every institution was challenged.

Bob: There was also a sense of power, because it seemed as if the whole country was up for reinvention.

Chuck: Yeah, that's right. For an emerging artist today, the power structure—and everything—is so different. The world was ours, it really was.

Bob: When I talk to young people, I find it very discouraging because of their discouragement, and because they want to fit in so much.

Chuck: I think things are worse now than they have ever been.

Bob: I think they are too.

Chuck: They are worse than the Eisenhower era of the fifties.

Guest: Even things that squeaked by prior to 1960 aren't going to squeak by now.

Chuck: Are you optimistic about theater today? How political it is? Is there any aspect of it that you think—

Bob: I don't see young people getting much of a chance today because institutions are scared and are trying to cater to so many different factions. The artist doesn't have a chance to be an artist, he has to be a politician first. I'm not saying that art isn't political, I'm just saying that there has to be some kind of driving, burning, artistic flame at the center of it all rather than a politically propagated—

Chuck: Well, you mean rather than careerism, you think it's the—

Bob: I think it's incredibly political. There's a production that probably is going to be done in LA that sounded so exciting to me, a theater production of Oscar Wilde's *The Importance of Being Earnest*, by an all-black cast. It sounded like such a terrific idea. It could be such fun.

Chuck: Yeah.

Bob: I think it's probably going to be a mess.

Chuck: Really?

Bob: Yes, because of a kind of political agenda that will override the fact that this could just be totally outrageous. You know, English society can be, and black American society can be—I mean, if there is any precursor to the Marx Brothers, it's *The Importance of Being Earnest,* but the chance of having a riotously irreverent good time is almost impossible.

Chuck: It's very diminished right now. There is such self-censorship, as well as institutional censorship.

Guest: I think that's the worst. I think that most institutions don't even have to enforce censorship. I think the censorship and the scare—

Bill: It's pre-censorship.

Guest: —has been internalized. If you see a sort of disspiritedness in younger artists, I think it's because a lot of younger artists feel that they themselves are disemployed and that they themselves don't have any latitude. It's not even the institutions that are feeling those limitations. I don't agree with that, I'm just saying that there are certain people who feel that way.

Bob: I'll give you an example. I told some students last year that there are incredible possibilities that are taboo, and no one's using them. The idea of a black man sitting on the stage eating a watermelon is such a phenomenally powerful image at this political time, but no one is using it because they're afraid they'll be accused of having used it contextually for the wrong reasons.

Chuck: Well, the only people—

Bob: That's the time to use those images, not because we want to make fun of someone who is black, but because powerful images and words are what art is made of.

Chuck: If you're going to make paintings that have sexual imagery, deal with violence, or have sexual organs in them, you have to be a woman artist. No man today can make those kinds of paintings. It's really amazing.

Bob: To carry that further, in terms of theater, the most violent last scene in any play I know is in *Hamlet,* and you can't do that today without being criticized. Violence in and of itself in art

isn't either good or bad. [*Hamlet*, c. 1601, one of William Shakespeare's greatest tragedies, centers around three sons, Hamlet, Laertes and Fortinbras, each trying to avenge their murdered father. In the play's violent final scene, they are gathered together. Laertes and Claudius have plotted to murder Hamlet by either striking him with the tip of a poisoned sword or, if that fails, with a poisoned drink. Hamlet's mother mistakenly drinks from the poisoned cup, and then both Laertes and Hamlet are fatally scratched by the deadly sword. As Laertes lies dying, he confesses the King's guilt and begs for Hamlet's forgiveness. Hamlet then stabs the King and forces him to drink the last of the poisoned wine.]

Chuck: And The Terminator. [1984 film starring Arnold Schwarzenegger.]

Bob: **There are more. There are couple of good ones.**

Guest: And Medea, or whatever. There are a lot.

Chuck: I'm really very concerned about the way the art world is holding up a mirror to society rather than taking a critical position of society. They really are reflecting what people want to see.

Bob: **Also, if we talk about art being the mirror, it's not a Walt Disney true-life adventure mirror, it's a metaphorical mirror. It is a terrible shame for us not to express our most terrible fears and most wonderful aspirations, but somehow, a sense of proper containment about which you're talking defines art today. Take a Frank Stella painting: it is like Mickey Mantle hitting a home run—at the instant of that crack** [*snaps finger*] **there is no containment. It's an incredible, unbelievably powerful image. The containment is so terrible today.**

Bill: If you lived through the late sixties and made it through as an artist, you felt as if you could do anything. There were no limitations, you could do literally anything, and it's so untrue today. I think people feel so contained. When I got out of college in 1968, I felt I could start my own theater, that I could do any plays I wanted to do. It didn't make any difference how hard they were, how many characters there were, what the politics were; those concerns weren't even a consideration.

Chuck: Everything seemed possible.

Bob: **There was an empowerment and a sense of power; and you came across the country to New York.**

Chuck: Well, kids are still doing that. They're still moving to centers.

Bob: **Yeah, they're still moving to the centers, but not for the same reasons.**

Guest: Well, I think the dream is there.

Bob: **You think the dream is there?**

Guest: Oh, absolutely. I think the dream is there. Of course, I can only speak for myself. I moved to New York in 1980, and I left New York because of the incredible eighties glut. I stepped out of the art world because I felt that making objects was just so market driven and so completely steeped in commercialism that it made no sense to do work at that moment, but I think that the dream of being able to live in New York, produce good work, and be part of the community—I think that still is an incredible draw.

Bob: **Is it?**

Guest: Yeah, but I don't think it's just New York that has that draw.

Chuck: We're sitting here right now in this major art power center, Pace Gallery, Los Angeles.

Guest: Right, that's true.

Chuck: There is nothing in visual art today between the bluest blue chip galleries and the most marginal emerging-artists galleries. Those are the only two functioning parts of the art world in this economy. Every artist I know who has had a substantial career, fifteen, twenty, twenty-five years of working, maybe making a handsome living, is scrambling.

Guest: I have some questions for each of you. Bob, they are kind of based on what you said when you were watching your portrait being constructed. Did that change your point of view of Chuck's work in a way? Did that give you new entry or anything? And Chuck, I want to ask you if there was any particular major point at which you were introduced to Bob's work, or was it kind of incrementally?

Chuck: Well, we were a bunch of young people, and it was like, "Hey kids, let's get together and make a play."

Bill: That's exactly how it was.

Chuck: It was like one of those old Mickey Rooney movies or something. Everyone was helping each other.

Bob: Everyone was supporting each other, rooting for each other.

Chuck: Working. We were all helping Richard Serra make his sculptures, because he needed a lot of bodies to push the lead around. It was such an exciting time, and the cross-fertilization between media was so great that you could see the relationship between the kind of minimal reductive nature of Phil Glass's music with its severe self-imposed limitations, and Richard Serra's sculpture, and my paintings. It was in the air, it was.

Bob: It was really in the air.

Chuck: Yeah.

Bob: It was almost tangible. You'd go to other people's studios and you were just energized because of—

Chuck: Artists helped you make costumes for your operas. You didn't go to costume makers, you used sculptors. Everyone was trying to help everyone else develop their personal visions. We didn't want to look alike. It was how you could drive yourself in another way. I think your sets and costumes have a very particular look to them; and what an interesting personal vision you have been able to maintain within a genre that has so many conventions and traditions, and within a standard frame that everyone accepts.

Bob: I think that's a really interesting point. I have to say that I was very fortunate to have friends like you who enabled me to have a dialogue that had to do with the frame, because the space in the theater behind the proscenium, behind the frame, was described to me, in all kinds of conversations that we had. We would talk about our work, and we would look at each other's work. Looking at the work of other artists was really important and allowed me to do things in the theater that you don't learn in theater school.

Chuck: Something helped you break with conventions and traditions. I remember how hated Phil Glass was by the musical establishment. He couldn't get a gig in any place that was a real music venue. All of his performances were in art museums.

Bob: That's right.

Chuck: Martin made possible one of his earliest performances at the Walker. We seemed to take license at that time to break with tradition and convention instead of accepting it as something within which we had to operate, or instead of just operating in there and chafing under the oppressiveness of tradition.

Bob: I thought a lot about stuff that no one talked about in theater, and it had to do with

structure and illusion and what was real and what was not real. When we got together and talked shop, those were the things about which we talked.

Chuck: *Yeah.*

Bob: People in theater weren't doing that.

Bill: *At least, not in the United States.*

Bob: That's right, not in the United States.

Bill: *But it was done at the Living Theater.*

Chuck: *What about the Living Theater and all that stuff? God, it was such*—[Founded in 1948 by husband and wife Julian Beck and Judith Malina, the Living Theater was a pioneer in the establishment of experimental Off-Off Broadway productions in New York. The Living Theater sought the marriage of a political and aesthetic radicalism. "We insisted," Beck said, "on experimentation that was an image for a changing society. If one can experiment in theater, one can experiment in life." The Living Theater produced plays by Gertrude Stein, Garcia Lorca, Pirandello, Cocteau, and Brecht. Their works and ideas are described in Beck's *The Life of the Theater* (1972) and Malina's *Diaries 1947–1957* (1984)].

Bob: —it was great stuff.

Bill: *It was fabulous. Also, La MaMa.* [La MaMa, founded in 1962 by Ellen Stewart who used her earnings as a fashion designer to start Cafe La MaMa in a Manhattan basement, became one of the important New York theater spaces for new playwrights. La MaMa introduced early works by Sam Shepard, Harvey Fierstein, and Rochelle Owens.]

Chuck: *And all the dancers; Yvonne Rainer. It was all operating on stage. It was all body movement. Traditional dance stuff was out the window. They were all formally trained. We were all formally trained.* [Yvonne Rainer, born in 1934, was a pioneer in modern dance. Her work as a dancer and choreographer started in the sixties; she used the human body as the subject of the dance.]

Bob: That's right, that's right.

• • • •

Chuck: *Speaking of teaching, you teach. What do you teach in this course of study that you seem to have trouble with how it's taught?* [Israel has been a professor at University of California, Los Angeles, since 1987. Prior to UCLA, Israel taught at the University of California, San Diego, Cooper Union (NY), The School of Visual Arts (NY), and the Minnesota School of Art.]

Bob: I teach graduate level scene design in the theater department at UCLA. I also teach a course in the collaboration between the director and the designer. I think the most important thing to teach is what you learn when you fail; what failure is about; and that you have an obscure glimpse of success when you can recognize where you've failed and take advantage of that failure. In fact, I think that a lot of what I do on stage has to do with strategies of failure and how one circumvents those failures, or how one takes advantage of the absurdly wonderful notion of the proscenium that the viewer has a singular point of view, as in a painting. Because of the fact that there are three-dimensional objects up there, one has to constantly explore other facets of the discipline to make the discipline more than it is at any time. It's hard to teach that, of course, because young people don't want to fail, they want to be proficient, and they want to be facile, and they want to have—

Chuck: *—a competence.*

Bob: —the jargon of authenticity that says, "I am what I am."

Chuck: *Competence is such a trap. "To be competent…"*

Bob: Absolutely. You know, it has to do with how you think, how you strip away your discipline and get to its essences from other directions. I'll give you an example. I was just thinking yesterday that basically there are only two kinds of spaces on the stage. Those two kinds of spaces are predicated by the fact that theater is always about confrontation. There isn't a play that isn't about confrontation, so those two kinds of spaces are either claustrophobic or agoraphobic, and they deal with the plays. That's all there is. There are no other possibilities. If you don't deal with those two things, you're going to come out with mush. You may deal with them in very convoluted and indirect ways, but it's another way of seeing that space. It's not the only way to see the space, but it's one way that we define it. I just read the best criticism I've read in years. I picked up one of my wife, Randi's, psychoanalytic books, and it had an eighteen page—I'll call it a critical essay for lack of a better name—written by a psychoanalyst on problems of love as seen through Wagner in *Tristan and Isolde*. It is so amazing to imagine a situation where two people are not in love with each other but are in love with love. It was such a wild idea, and seeing the opera libretto through that kind of perspective allows you to see it in a different way. It's a very involved essay, but it's like reading Freud's essay on Michelangelo's *Moses*: it allows you to see the sculpture in a different way. Then you can go back to your old way, but you have had that shock of recognition for a moment that allows you to—I mean, you can see it in your work. The paintings are about primary relationships and distances—if you want to cull it down to its essence—of illusion, and reality, and the structure, and how you make marks on a canvas.

Chuck: *Well, for me it's the tension between artificiality and reality. They are just as artificial as they are real.*

Bob: That's exactly what I'm talking about in the theater. It's exactly the same thing. That's why all those discussions that we had were so helpful to me when I made theater, because, as far as I knew, no one in the theater talked about that.

Chuck: *Can you talk a little bit about what it's like to make all the drawings or models, but have them fabricated or built by someone else? What is that process like? I mean, you used to make everything yourself.*

Bob: I don't make anything anymore. What is it like in what respect?

Chuck: *You were showing me these incredible charts about what you see from various parts of the theater, and there were drawings that had to do with sight lines and all the things that you have to keep in mind to design this stuff.*

Bob: For someone who isn't familiar with it, it may seem like a lot of incredible stuff, but a theater is really a simple place. For instance, there's an audience that, in a proscenium theater, can be perceived of in a few fixed positions with certain restricted areas on the side; and there's the stage, and the stage is really based on basic Newtonian physics: things go up and down, in and out. That's all it does. So the technical knowledge can be full of all kinds of mumbo-jumbo, but it's really not, at its philosophical essence, a very complicated place.

Chuck: *So, because of your past experience, when you're working with a model, you know what it's going to feel like when it actually gets built. Is there an acceptable amount of interpretation by others?*

Bob: Yes, but you want them to be able to do what you indicate, so you have to be as specific as possible and get the best craftsmen possible. If you're working in a theater where the painters are not very good, you've got to remember that, or you ask if the bid for drops can go to some other place. I had a discussion with some people about that yesterday. There's an incredible painter in England who I think is reasonable in terms of his work, in terms of bidding for the job. I'm so confident in his work, I don't even need to go to see it. I can just give him the painting and say, "Here Alex, just do it." Sure, you're always trying to deal with that kind of stuff. I don't know if it's true with printmaking.

Chuck: *Yeah.*

Bob: It is?

Chuck: *They wrestle control away from you, and you've got to try to take it back from them. Sometimes you get a dialogue going, and it can often be very interesting.*

Bob: Yeah. It's the same thing.

Chuck: *They push you somewhere you might not otherwise have gone.*

Bob: *Chuck, has our conversation gone like the other ones?*

Chuck: *They are all different.*

Bill: *They are all completely different. The only person who talked about Chuck's painting without ever talking about himself was [Richard] Artschwager. He never talked about what he looked like in the painting.*

Bob: What did he talk about?

Bill: *He talked about the quality of the painting, how he was able to look at the painting, but that it could have been a painting of anybody.*

Bob: Oh, he was able to divorce himself from it?

Bill: *He was the only person who completely divorced himself as a personality from the painting.*

Bob: How can you do that?

Chuck: *Well, he said he did that. I'm not so sure I believed him.*

Bob: How can you do that? I'm skeptical. The painting is so incredibly provocative; it's you. It's someone else making you. How can you divorce yourself from that? There's too much of yourself at stake.

Chuck: *That's why people's generosity about lending me their images is really moving. I'm messing with something very primal, very central to who we are.*

Bob: When you said that you know my face better than I do, you were wresting something away from me. When you first said it, for a second it didn't make sense, and then I thought, "My god, he's right."

Bill: *Well, the old Indians, the native Americans, were afraid of cameras because they thought that their spirit was going to be taken away from them.*

Chuck: *Yeah, and they were right.*

Bill: *They were right.*

◆

Leslie Close

New York City, December 13, 1996

Leslie Close: When Chuck made the first painting of me, I was an artist.

Bill Bartman: I know. It would be interesting to know what kind of art you did.

Chuck Close: Actually, I just saw a piece by Merrill Ryman, Robert Ryman's wife, that looks exactly the same as a piece that you made in the sixties, the one where the lines go across and you line them all up on the floor. You really should take a look at this show.

Leslie: Did we ever take photographs of that stuff?

Chuck: There are photographs somewhere.

Bill: You did three-dimensional work?

Leslie: They were really like drawings on the floor made of paper, string, and wax paper, and I made some clay sheets of paper and then broke them. I was very interested in drawing.

Chuck: You made a piece that was slabs of wax on the floor with electric wire in them that made a liquid line down through them.

Leslie: I made a lot of pieces using legal paper, pencil, and string. I was a student at Hunter at the time. That was about '72.

Bill: Where did you meet each other?

Leslie: At the University of Massachusetts. I was an innocent little nineteen-year-old. He was a lecherous twenty-seven-year-old.

Chuck: No, because I was twenty-seven and you were twenty when we got married.

Leslie: Right.

Chuck: So I wasn't twenty-seven when you were seventeen.

Leslie: No. When did we meet? We met in—

Chuck: We met in 1965. You were in my very first college drawing class—

Leslie: And watercolor class.

Chuck: —and you hated my guts.

Leslie: Yeah, I wrote to my parents that school was great except that I had a jerk for art, and it was quite disappointing because—

Bill: Do you have any of those letters?

Leslie: I'm sure my mother does. Chuck would show up to class hungover.

Chuck: *So, Leslie was in my freshman classes, hated my guts, wrote home—*

Leslie: I didn't hate your guts. I just thought that you were irresponsible, not the fine understanding professor that I thought I was going to have. He came late to class—

Chuck: *—and left early.*

Leslie: He left early, and he was working his way through the freshman class. *[laughter]*

Bill: *No wonder Chuck didn't want to do this interview.*

Leslie: Uh uh.

Chuck: *I'm not sure I really want to do this interview. [laughter] You were actually dating a graduate student.*

Leslie: We don't need to talk about that.

Chuck: *Wait.*

Bill: *If you can talk about him, he can talk about you.*

Leslie: It was an interesting time. We were there for two years.

Bill: *It was a very interesting time. It was during the middle of the Vietnam War, it was during the Civil Rights movement. I think 1967 and 1968 were the most interesting years of my life.*

Chuck: *It was an incredible time. We moved to New York in 1967, right in the middle of all that. We'd been involved with standing in the peace vigils at Amherst, having the FBI watch us wherever we went.*

Leslie: Well, we'd like to think they were. We had an inflated sense of our own danger and importance. We were calling Marlin Perkins, the zoo expert, asking him questions such as what was the biggest baboon baby ever born or things like that. We had arguments with Ray Johnson in the middle of the night.

Chuck: *Actually, that was Joe Zucker.*

Leslie: That was Joe Zucker. Oh yeah, it was with Joe Zucker that we called Marlin Perkins.

Chuck: *One time we called Pauline Kael to find out who the female lead was in* A Big Hand for the Little Lady.

Leslie: That was with Ray Johnson.

Chuck: *We called her in the middle of the night.*

Bill: *Did she give you the information?*

Chuck: *She was so pissed off that she had to let us know that she knew the answer. Do you remember who it was?*

Leslie: No.

Chuck: *Joanne Woodward.*

Leslie: Oh yeah.

Chuck: *When we came to New York, you went to Hunter, and you studied with Robert Morris.*

Leslie: Is this "This is Your Life?" Yes, I was an art major.

Chuck: *You also studied with Ralph Humphrey and a bunch of other people.*

Leslie: Yeah, I was at Hunter College when Alan Saret was there, and I studied with Ralph Humphrey, Robert Morris, Bob Hewitt, and Mac Wells. It was an interesting time to be in school as well.

Chuck: Our first loft was on Greene Street and had no heat. When we rented this twenty-five hundred square foot loft in August, we naively thought—

Leslie: —that it was warm enough.

Chuck: Yeah. There was a little heater on the wall at one end of this twenty-five hundred square foot loft with leaky windows. It never occurred to us that the little electric heater wasn't even enough for a bathroom, let alone a whole loft.

Leslie: We put in a gas heater.

Chuck: We went through the first winter with no heater.

Leslie: Yeah. We used to go to the movies a lot, and we used to sleep in Don Nice's studio a lot.

Chuck: We would take hot showers and baths in his studio. We had a little two and one-half gallon hot water tank, and you'd go through two and one-half gallons in a second. So, in the middle of this freezing loft, you'd get wet and then have to turn the water off while you soaped yourself up and put shampoo—

Leslie: We were young. It was fine.

Chuck: —then you'd turn the water back on to rinse off and hope that you got rinsed off before the hot water ran out.

Leslie: I think about those times, and I think about how crazy our logic was; it was so specific to our age and the time. I look at Georgia now, who is about that age, and it's deja vu. I remember seeing the world that way. She will call during a snowstorm late on a Friday night when she's got the flu and say that she is going to drive with some friends to Boston or something, and I will start screaming, "What? You're doing what? That's the stupidest thing I ever heard." Well, we'd get up in the middle of the night when we were that age—

Chuck: First of all, we were already up in the middle of the night.

Leslie: —and decide to drive to Philadelphia to see a friend. It seemed a perfectly logical thing to do.

Chuck: Maybe you can say something about what SoHo was like in the—

Leslie: —olden days?

Chuck: In the late sixties, because when we were first there—

Bill: Fanelli's was the only restaurant open after six o'clock at night, right?

Chuck: Yeah. It was the only place.

Leslie: Yes, we spent a lot of time in Fanelli's with Joe and Susan Zucker.

Chuck: It was the only restaurant, really. The only bar. There was only one place to buy—

Leslie: The *bodega*, where they used to deal in fighting chickens and dogs, the *bodega*, on the corner of Prince Street and West Broadway, was the only business in SoHo.

Bill: There was another little diner that was right near Lafayette and Prince, just a little tiny coffee shop, like a hole in the wall.

Chuck: That's where—what's the restaurant now on the corner of Prince and Crosby?

Leslie: Oh, the Savoy. Yeah, there was nothing there. There were bins of chopped-up rags and cardboard. We were in there. I made art out of that stuff for a long time, out of bristles.

We lived next door to a brush factory—it's probably now a very cushy co-op—on Greene Street, and there used to be flatbeds out front filled with hair, the bristles from these brushes. I made some art out of that.

Chuck: *Out of placemats, and shower curtains, and—*

Leslie: There was no one on the street, and when you did see someone on the street, you greeted them. It was very "small town." I remember that Julie Patz, Etan Patz's mother, was pregnant with Etan when I was pregnant with Georgia, and we used to talk to each other on the street and greet each other all the time.

Chuck: *There were very few parents.*

Leslie: Georgio De Luca opened a cheese store on the corner of Prince and Greene when we moved to—Georgia was a baby, so it was 1973, I think—Prince Street. I couldn't believe there was going to be a real shop. It was called the Cheese Store, and his mother used to sit in there with him. It was a tiny little place. I'd go over there, and we'd chat about the neighborhood.

Bill: *I remember that the only gallery that was really open was Ivan Karp.*

Leslie: Paula Cooper.

Chuck: *No, Paula was on Prince Street.*

Bill: *She was open only by appointment, wasn't she?*

Leslie: No. She was right across from where we lived at 101 Prince.

Chuck: *In fact, Paula's was not the first gallery in SoHo. The first gallery in SoHo was Feigen Gallery. Feigen had a gallery on Greene Street, just south of Houston.*

Leslie: It was where the Aesthetic Realism thing still is.

Bill: *I hung around Ivan's because Patterson [Sims] worked for Ivan.*

Chuck: *Bill was Patterson's roommate at Trinity College.*

Leslie: Oh my god, is that right?

Bill: *He got that job in 1969, and even then he lived on Mercer, and there was nothing open at night when he came home after seven o'clock.*

Chuck: *Just rags and rats.*

Bill: *Rags and rats. It was all factories.*

Chuck: *And garbage trucks.*

Leslie: Every once in a while I would take a taxi home at night. The cab driver wouldn't want to let me out. I looked like a child, and it looked so dangerous and gruesome. The cab driver would always say, "This can't be where you're going. Why do you want to get out here?"

Bill: *That sounds like what Georgia said about that little girl who used to come over.*

Chuck: *No, that was our loft on Prince Street. That was much later. Georgia was talking about kids [from Dalton] not wanting to come downtown to visit her.*

Leslie: Yeah, it was a "bad" neighborhood.

Guest: *There were, however, a lot of people who chose to live there at that time.*

Leslie: Yeah, but there were so many factories and businesses that it was hard to get a sense of neighborhood. It was a sort of hidden community. We knew that there were people around, and we visited each other. I mean, we had friends in the neighborhood.

Bill: Were you the only ones in your building?

Leslie: Well, on Greene Street there were three of us, on three floors.

Bill: In Patterson's building on Mercer, he was the only person in the building. It was really spooky at night.

Leslie: When we lived on Greene Street, a loft came up for sale on Prince Street. It was a building filled with artists, and that was wonderful. We had to borrow five thousand dollars from my parents to buy that loft, and they couldn't believe that we were going to put that kind of money into that place.

Chuck: We didn't borrow five thousand dollars from your parents.

Leslie: Yes we did. That's what we needed for the down payment on that loft. We only made five thousand dollars a year.

Chuck: By then, I had taken that summer teaching job in Seattle. We may have had to borrow it for a few months.

Leslie: Yeah. It was the only time we ever borrowed money, ever.

Bill: Patterson stayed in the same loft, and all of a sudden in 1970 or '71, they realized that people wanted to live in these things. He was renting, and they decided they were going to sell all of them because they weren't making enough money from the factories. They told Patterson he had to either buy it or move, so he borrowed money from Kippy.

Chuck: Our entire seven-story building on Prince Street cost a hundred thousand dollars. Now Jerry's is the tenant on the first floor, and he pays more in rent per year than the entire building cost.

Bill: When you started living down here, it was not a popular thing to do.

Chuck: Do you remember your folks coming to visit our first loft?

Leslie: I remember that we had to lift my mother up onto the loading platform. I was so terrified of their first visit. We tried to camouflage the fact that there was no heat. Even after we got heat and for the next fifteen years, my mother never came to visit without keeping her coat on. *[laughter]* She just recently started taking her coat off when she comes to visit us.

Guest: Did you feel that where you were living at the time was really a community? Did you all talk with each other?

Leslie: I think our immediate circle was Chuck's friends from graduate school at Yale. I was this little kid, I was in over my head—

Chuck: Uh god.

Leslie: Definitely. It's true. I was a graduate student, and the people around me were Richard Serra and Brice Marden and Nancy Graves, and we spent all of this time together at Max's and all these bars, and they were overwhelming.

Chuck: They still are.

Leslie: They were the most combative, competitive group of young artists and art talkers, and I was completely intimidated by all of them. I was eight years younger than most of them. Kent Floeter was part of that group. Who else was around the table all the time? I remember Brice and Richard, and I remember Phil Glass, who was always very modest. He was not one of the combative art stars.

Chuck: We spent a lot of time with Keith Hollingworth.

Leslie: I felt very much that that was the community and I was sort of a witness. We were involved with a lot of dancers. I used to dance for Joan Jonas sometimes and Judy Paddow. Does anybody know Judy Paddow? She was great. There was so much going on.

Chuck: All those people were sort of around Yvonne Rainer.

Leslie: I was just talking to someone recently who said that it's such a different time in terms of the audience for dance and music. It really was a much more visual art world, and there was so much interchange, and exchange, and friendship, and community among the music, dance, and art worlds. I don't think that's the case anymore.

Chuck: Do you remember that there was a set of foam pads that were stored at Paula Cooper's gallery that was used in every loft whenever anybody was going to do a dance concert, or Phil Glass was going to give a concert, or Steve Reich or—

Leslie: And poetry readings. We met Ann Launterbach years and years and years ago. I don't think we had a sense of history or self-importance at all. It was sort of a little counter-culture, and what was going on in the larger culture was so powerful and important that I don't think we were very self-conscious about our own importance at all. Everybody was very poor, and there were a lot of survival issues.

Bill: I remember making monthly payments on a $150 Claes Oldenburg for a year.

Leslie: Well, we bought that Warhol *Marilyn* with our entire paycheck, and it was "over my dead body," I have to admit, but there it is. Somehow, we made the rent. We used to borrow money from the waiters and waitresses at Dave's Corner Luncheonette for cigarettes. They would advance us money or car fare to get uptown.

Chuck: We would have our paltry salary changed into pennies at the bank, and we would go through the pennies looking for pennies that were worth more than a penny. [laughter]

Leslie: I was going to Hunter College when we first came back to New York from UMass. I went to Hunter College, and that's where I met Bob Morris and Ralph Humphrey, who were teachers.

Chuck: Was Tony Smith still there?

Leslie: I don't remember. I never had him for painting. I was working. I had a couple of jobs. I did illustrations for an orthopedic surgeon. I illustrated a book called *Your Aching Back,* which actually I could use right now. *[laughter]* What else did I do? There were some other sorts of wacky things. I was going to school, and I had jobs like that. I was doing a lot of things. I was making sculpture.

Chuck: Then you started doing work that was very autobiographical. You made paper quilts out of letters and other memorabilia.

Leslie: I used to collect photographs and letters. I've saved every letter anyone has ever written to me from the time I was a child. I've always loved letters, and I've always loved reading books of letters and journals, so I bought a sewing machine and started collecting this stuff from friends, and I would make paper quilts. Actually, I liked those things.

Bill: I know Kim [Abeles] used a lot of her own personal memorabilia in her early pieces, like her father's journal and things, and she sold them.

Chuck: Well, you tried to throw this stuff away and I rescued them and put them in my studio on Third Street and kept them, because you were finished.

Leslie: Are they still around?

Chuck: Yeah, we still have them.

Leslie: I still have some of the files that people gave me. I returned some of them recently, like my friend Bob's draft card and the letter he got from the army sending him to Vietnam. I have letters from people from Vietnam.

Chuck: After you made that work, we were living on Prince Street in a building in which artists had been living for many, many years. It was one of the few buildings in SoHo that went way back. Ray Parker was one of the artists who had a studio there for many years, as well as Jack and Sandy Beal. Joe Zucker and Susan moved in at the same time as we did.

Leslie: It was a pretty paranoid time too. Our source of information was WBAI and the Village Voice. We thought these were the ultimate sources of information, so there was a fair amount of paranoia. Phil Glass was the plumber for our loft on Prince Street, and Tony Shafrazi actually put the ceiling up.

Chuck: He defaced our ceiling before he defaced Guernica. He did such a crummy job with plaster.

Leslie: I thought he did a great job. My father was the electrician.

Chuck: We were on the top floor. We had a skylight. We pulled down the tin ceiling, and all the rat stuff fell out. We took the roof off in the middle of some hurricane, and thousands of gallons of water came in. The reason that I mention it was that Sandy Beal [Freckelton] was living downstairs. They had a farm in upstate New York, and they were real gardeners.

Leslie: Chuck was working in that loft, and I was trying to make art. Partially in response to the scrutiny to which I was subjected from these Yalies—Chuck and Richard Serra and all these people who were tromping through my space—I started barricading myself in and tried to find a way to hide from all of them. Richard would just come in, and he was so challenging and so confrontational. "What do you think about this piece?" or "What do you intend to do with this?" or "Well, it's kind of strange that you did it that way." I was nineteen years old, and I couldn't take it. So I retreated, and I found it very hard. I just didn't have the ego of an artist.

Bill: It's so funny. This is similar to Paul Cadmus talking about E. Hopper, who so dominated his wife's artwork. Hopper would never let her see his artwork.

Leslie: Oh, how interesting.

Bill: He had nothing against going over and looking at hers, however. She signed things J. Hopper since he was so pissed off at her anyway, and he would try to totally manipulate her. She used to do still lifes, which were 180 degrees from what he did, and he'd say "Those pears, they look like balloons ready to float up in the air," and she'd say, "Ha, that's exactly what I wanted them to look like."

Leslie: Well, I have to say that no one was especially critical. If anything, they were all probably very supportive. I was just not ready for that kind of scrutiny at all.

Bill: At that age.

Leslie: I really needed that wonderful period of late adolescence and early adulthood to gradually develop skill and all of that. It's important, but I sort of skipped that, and I didn't want Richard Serra reviewing my work on a daily basis. I really didn't. Chuck couldn't understand it,

because the thing about Yale at that time was that it was nose to nose. They had to defend their work, and it was as much intellectual as it was aesthetic, visual. They argued art. They were so facile with their mouths, and it was also very macho in its own way, it was very combative. It had a lot to do with beer and a lot to do with—

Chuck: *It was macho, but women like Nancy Graves and Elizabeth Murray and Jennifer Bartlett—*

Leslie: Traumatized. I'll bet if you asked them, they would say they were traumatized by that whole scene. I have tremendous admiration for Nancy and women who could navigate those waters, because I thought it took enormous ego, but I think to be Nancy Graves—to be a woman—in that atmosphere, with those people, at that time, must have been unbearable. Jennifer Bartlett and Nancy and Elizabeth Murray and—

Chuck: *Elizabeth talked a lot in her interview about trying to raise a kid down here and be an artist at the same time.*

Leslie: Well, nobody objected to raising kids, but making art around all those people was very difficult, and I couldn't handle it. I frankly couldn't. My first response was to try to barricade myself in some space into which no one could come. I had padlocks on the door, literally, and beyond that I just wanted out of the whole thing. It was a tremendous relief when I finally just said, "I'm not doing this," and found other things in which I was interested, that I found very compelling. It didn't feel like a big loss, although later I thought about it. Now I find the idea of making art just wonderful, and I do have some regret that I couldn't hack it.

Chuck: *You loved reading Eva Hesse's diaries because they are about the same time period and about the same issues. It's really very interesting, very poignant, how she felt around Tom: she was married to Tom Doyle.*

Leslie: Yeah, the sexual politics of the time were really pervasive, and it was *before* there was any discussion, before it was on the table.

Chuck: *The women's movement hit the art world in the seventies like a ton of bricks. Almost no relationships survived it. Very few of our friends survived intact, as couples. Let's talk about how you got interested in horticulture.*

Leslie: Well, I'm trying to remember the chronology. Jack and Sandy Beal lived downstairs from us. There's a very brave woman too. *[laughter]* Sandy Beal is making art, she's an incredibly talented person. She does many things very well.

Chuck: *She shows under Sondra Freckelton now.*

Leslie: I'd always been interested in gardens and plants, but just peripherally. I converted my little barricaded, padlocked studio into an office, and I was doing a lot of reading and writing. Sandy had these wonderful plants, and she gave me some cuttings of her begonias. I got very interested in them, joined the American Begonia Society, and sort of got a little bit obsessive, and the next thing I knew, I had something like four or five hundred varieties of begonias, and I was corresponding with people from all over the world on the culture of rhizomous begonias.

Chuck: *We took them with us on our summer vacation in a twenty foot U-Haul van. We would take hundreds of begonias out to the country.*

Leslie: I joined the Indoor Light Gardening Society and a lot of different plant societies, and they had just developed wide-spectrum fluorescent lights, so you could really raise plants indoors.

Bill: *I know people who used them to raise pot indoors.*

Leslie: Well, we did that too, but not very successfully. I got very interested in horticulture, and I started studying. I took a correspondence course from Penn State. I was pregnant with Georgia, so it was 1972, and I got a certificate of proficiency in horticulture from Penn State, sending the exams back and forth. I was really smitten with all of it. I studied at the Botanical Gardens and the Horticultural Society. We house sat in Garrison, New York when Georgia was a year old, so that was '74.

Chuck: *She had her first birthday there.*

Leslie: They had a garden, and I separated all of their irises, cut out all the iris borers, and grew tomatoes there.

Chuck: *Boy, did you grow tomatoes.*

Leslie: I over nurtured those tomatoes, so we had ten-foot-tall tomato plants with tomatoes this big *[gestures]*. I started collecting garden books from junk stores and tag sales, and I was fascinated by a whole genre of garden books written by women. I noticed that all of these wonderful books that had been written in the teens and the twenties—American books, also English—were written by women, and I found that kind of interesting. I loved the books, and I learned horticulture from those books, and I learned about garden design primarily from those books. I became very interested in the genre of garden literature, and we made a trip to England when Georgia was three or four and looked at the Gertrude Jekyll gardens.

Chuck: *That was before anybody in America knew who Gertrude Jekyll was. Now, it's so chic, but then it was really obscure.*

Leslie: Anyway, that's sort of how I got into gardens and landscape, and I'm still very interested in the literature. I ended up getting a masters degree, and my thesis was on Mattie Hewitt, who was a photographer of landscape architecture in the teens and twenties. I started designing gardens for us and for friends. When Georgia was about seven, I went to graduate school at NYU, and I got a masters degree and started working at Wave Hill. The first exhibition and catalog I did was on women landscape architects of the teens and the twenties, and we had some of them there at a conference. They're all dying or almost all gone now, but some of them actually came to this conference. It was a wonderful thing.

Chuck: *They actually started a program in American Garden History.*

Bill: *What's interesting to me is that it seems like a natural progression from the art that you were making to your garden work. It's not as if the progression was broken, in a sense.*

Leslie: No, I saw it as very related. Gardens are very sculptural and painterly and have a long tradition. There are many precedents for artists being gardeners.

Chuck: *One of the things that is really distinctive about your gardens, especially the garden we have now in the country, is just how painterly they are. The way you garden, to me, is like an abstract expressionist scraping some part of the thing out and—*

Leslie: —moving it over two feet.

Chuck: Yeah, and then putting something else in. They really are kind of framed with borders and things and sort of striped inside. They are sort of striped paintings inside baroque frames.

Leslie: For me, gardening is a much more profound and fundamental activity than making art, most likely because I'm really a gardener and not an artist. Gardening is a tremendously satisfying thing to do. It is intellectually exciting, and there is always something to learn about. I mean, you can focus your attention as closely or as broadly as you want. If you become interested in tomatoes, you can think about tomatoes for twenty years: the many varieties, the way they look, the way they taste, the way they ripen, and the way they fit into the garden. I had a flower garden for years, and then I really became interested in food. A garden is just a way to learn about something else. When we moved to Bridgehampton, I decided to do a food garden so I could learn about growing food, and I find it more interesting than growing flowers. I love to cook, and I grow everything that we eat in the summer. It's just wonderful, and the kids have always been involved in it too. It's great.

Bill: I love tomatoes.

Leslie: I love tomatoes, and, in fact, Ray Johnson used to visit us, and I'd make him a BLT every summer. We made it a ceremony. He loved ritual and ceremony, so he never stopped talking about this BLT. That was at our house in East Hampton, so it was many years ago.

Chuck: It actually started in Garrison.

Leslie: Oh, in Garrison, right, so that was very, very early. I made him a BLT, and every summer he would call and I would say, "When are you coming for your BLT?" and I'd call him when the tomatoes were ready and he'd come, and he'd have this BLT, and then he would write to me all year about the BLT and talk about the BLT. *[laughter]* Those were good days.

••••

Chuck: Should we talk a little bit about the dreaded hospital and all of that stuff? I would just like it on the record that—

Leslie: —you got sick and it was terrible.

Chuck: No, just how important you, and all that you did, were for me in the recovery, and what an incredible experience it was for all of us, and how I appreciated how difficult it was for you, I think.

Leslie: There's just about nothing to say. It was just a horrendous thing.

Bill: I think it's sometimes easier for the person who is sick than for the people who have to help. When I was originally sick with my leg, I was in the hospital for almost two years. My father would come every single day, but I had nothing to say to him after awhile because I was there in the hospital and he was in the outside world. Eventually, I started pretending I was asleep when he came. He would finally leave after about forty-five minutes, and I would turn over and go back to what I was doing.

Chuck: I think it's much easier to be the person to whom it's happening. I think it's even easier to remain optimistic when it's you rather than when it's someone else.

Leslie: Well, it's two different experiences. The person in the illness is living one reality, and the people around him or her are living another reality, and it's not one experience. It's many.

Bill: It's two completely different experiences.

Leslie: They are totally different experiences, and sometimes those experiences are in opposition, in conflict, at cross purposes. Chuck was in the hospital trying to cope with what had happened to his body, and I was in our life trying to keep it going, trying to keep our children going.

Chuck: *Just getting uptown and downtown every single day to visit me was a complicating enough factor. Then there were all the calls you got when you got home: everybody needing to know what happened.*

Leslie: Yeah, it was a crisis kind of time. In a lot of ways, that year, as horrible as it was, was less difficult than everything since. I mean, an illness, the crisis part of an illness, is manageable because there are many things to do and many decisions to make, and there's the illusion that you can have some impact on what's happening, that you can make the right decisions, talk to the right people, do the right thing, and have some kind of effect. It's when you come to the end of those options and go home that you realize the full impact of what's happened and the limits of your potency in doing anything about it. It's sort of like looking back at photographs of people to whom terrible things have happened: you study the photograph, and you realize how innocent that person was of the knowledge of what was coming. I think that in the hospital we had no idea what was going on. My initial reaction to Chuck's illness and that whole crisis was that I became hyper and manic. First, I'd get my daughters off to school, and then I'd go to the hospital for ten hours and do things there: try to organize Chuck's room, fight with the nurses, track down the doctors—

Chuck: *Get the therapists working.*

Leslie: Then I would come home, and I would be so wound up that I couldn't sleep, so then I would cook ridiculous things way into the night. I would make demi-glace and all kinds of exotic things late into the night, in massive quantities, and pack them away in the freezer; I would clean out closets; and I just—

Chuck: *She threw away all of my favorite clothes while I was in the hospital, knowing that I wasn't there to fight for them.*

Leslie: I threw away his rotten tee shirts with brown armpits.

Chuck: *You haven't slept through the night since, actually.*

Leslie: Actually, I developed insomnia that is with me to this day.

Chuck: *You fought the occupational therapists to get me back to work, and you were really —*

Leslie: I did a lot. I interviewed doctors, I read books, I went looking for some cure. There was a point at which I thought that some cutting-edge engineering solution was going to help, that we were going to find someone who would wire him up or something, or find the person who did the electronic hands, and I thought, "Well, anything is possible."

Chuck: *Now we know nothing is possible.*

Leslie: That's right. I'm sure at Rusk the occupational therapy is effective, but I found it frightening and degrading that they would wheel these captains of industry into this room— these fallen intellects who had had a stroke or something or some guy who was the CEO of some big stock market firm—and give them pipe cleaners and beads and have them stack the beads.

Chuck: *This is occupational therapy.*

Leslie: When I saw them the first few days getting ready to do this with Chuck, I just could-

n't deal with it, so very early on, when Chuck couldn't even sit up in the wheelchair without getting faint and was hooked up to IVs, when they first took him into this occupational therapy, I cornered the therapist. I followed her down to the cafeteria, and I said, "Look, I'm not interested in you having him string beads. You've got to get him back to work right away. He has got to know that somehow he's going to be able to make art because that's his occupation, that's what he does, and there is no point in wasting time with playing checkers or stringing beads." So very early on they started figuring out ways for him to hold a brush, hold a pencil. She was afraid that he would find it discouraging, but I was afraid that the longer he was away from it, the more he realized how little he could do, the more impossible it would seem that he could ever make art again.

Chuck: I remember the first day that we put a brush into the brushholder. We had cheap poster paint and a piece of shirt cardboard. I drew a pencil grid, I guess about a half inch or an inch grid, on the cardboard and tried to get some paint on the brush and stab it into the interval of the grid. Oh god, was that hard.

Leslie: You had these spastic arm movements, and your arms would just suddenly fly backwards.

Chuck: I was devastated.

Bill: The first time that I looked in a mirror and saw that my leg was actually amputated was so frightening that for two or three weeks, even though they were getting me to stand up, I kept falling down, even with the artificial leg on. I had given up. I thought I would never walk again.

Chuck: The first time I tried to stand up with the braces on, oh god, did I cry, but I remember breaking down on the first day of actually trying to paint.

Leslie: There's actually something in the John Guare book that really is upsetting to me. He got the story a little bit wrong. He said that when Chuck first started trying to make marks, make art, I started crying, and that is so untrue. Chuck started crying, and I wouldn't deal with it at all. I told him there was absolutely nothing at that point that he could do except continue, and I just knew that once he'd made something about which he could feel good, it was going to be so much better.

Chuck: I have no recollection of this, but Michael tells me that when he started coming, they found me a place to paint in the basement, a really depressing room. Was that the most depressing room?

Leslie: No, I was so happy that they did that.

Chuck: Me too, but—

Leslie: I asked the occupational therapist to find someplace, and I asked them to build an easel that he could attach to his chair, a desktop that he could use. There are all these people in the hospital who can do these things, but they often don't attempt anything that ambitious because—I don't know why really, but they don't. Anyway, we looked for a space. I remember going down there with Phyllis, the occupational therapist, and with our friend Barbara, who came down every weekend to hold my hand.

Guest: That's the thing that would depress me: reflecting on the reality that I would like to have.

Leslie: Well you know, there are no recovered people in hospitals. There are very sick people in hospitals.

Chuck: People are thrown out before they are recovered.

Bill: I don't ever want to be in the hospital again for more than twenty-four hours.

Leslie: The smell of Rusk Institute makes me absolutely sick to my stomach. Even driving by on First Avenue or on the FDR Drive and seeing the place makes me sick.

Chuck: My stomach turns over.

Leslie: The thing about that sort of disaster is that the future is so unclear. You don't absorb the reality of it because you can't even comprehend it. You can't comprehend something as catastrophic as what happened, so when you're in the moment and it's happening, it's like an accident. There is no fear, in a way. I mean, I was distraught. I cried all the time but much more at watching Chuck in that state than from projecting into the future. I really didn't understand what the future would be like, but just seeing him that sick was devastating and horrible.

Chuck: You were trying to plan for the future. You were having our house ramped and all of that stuff.

Leslie: Well, later. Chuck was in the hospital for seven months, and when we anticipated his coming home, there were things to do. I had a pool put in at the house in Bridgehampton because he was able to stand in the water. There was lots to do: ramps into the garden, ramps in the house, plumbing changes, and all that.

Guest: What has this long time of both the recovery and getting back to a sort of normalcy been like?

Leslie: The last seven years have been the hardest experience of my life. Accepting what's happened has been very, very hard for me. It was almost as if we had one life until that day, and now it's something else; it's having to start all over again with a whole different set of "givens." Everything is different. Very little is the same. Our friends are the same, and that's wonderful. The sense of discontinuity is very upsetting. Actually, as time goes on, I see more continuity. There seems to be less of an abrupt polarity between that life and this life, but the lives of the children, what we can do as a family, is the difficulty. Everything is very difficult. Chuck's life as an artist is, in some ways, the strongest continuous thread.

Chuck: It's the least affected on some level.

Leslie: His role as the breadwinner of the family and the artist is a wonderful continuous thread, but that's much more Chuck's experience than it is mine.

Chuck: Of course, that's changed too. I still can paint and still do it, but it's a very different studio than it used to be. I've had to do everything in a different way. Having to have so many people around limits spontaneity; you can't just decide to go. You have to plan. So many things like that are really very different, but I am struck, on some levels, by how much the same certain things are.

Leslie: That's not my experience. We were very productive, active people, and we worked very hard to maintain an ambitious life in terms of the house, the garden, the kids, the traveling, and whatever we did. Life was packed, and it took a tremendous investment of energy and focus for both of us. Now we have the same life. We have not gotten rid of the house or the garden. The garden is bigger than ever, and there are the kids' lives, and our friends, and thirty-two people for Thanksgiving, and traveling, and whatever.

Chuck: Everything falls much more heavily on you.

Leslie: It's more difficult, and when I say that I've had a hard time accepting what has happened, I think that part of it is that neither one of us has wanted to give much up. We are sort of trying to frantically hold onto what we can and cut the losses, and I think it's been unrealistic to a certain extent. I've seen other people who have gone through similar catastrophes, and I think trying to minimize the losses is a common response, but I think real acceptance at some point will lead to making life a little easier. I mean, I don't think we probably should have that house and garden and do as many things as we try to do. It's just too hard.

Chuck: *But it's also too depressing to give up things that matter to you, that you really enjoy doing.*

Leslie: Yeah, but at some point the cost is too great, and it would be good to cut back on some things. It has given me a much more acute sense of my age and how hard things are compared to what they were. The only concession I think I've made to all of this is that when our last dog died and our older daughter went away to school, I didn't get another dog. I miss the dog, but I was the only dog walker left in the family, and I just didn't want to be out at twelve o'clock at night walking the dog. We got a cat, which is really no substitute for a dog. I think we are very much in the process of working out a second life. We have been married for twenty-eight years, and we did everything together. I had never traveled by myself. I went from being a kid to being married to Chuck, and then we had kids. Chuck's illness has forced me to grow up and determine that I'm going to have to do some things on my own. That's been a tremendous change, and not a bad thing at all. I've traveled quite a bit by myself and with the kids or with friends, and I've had to learn to do more things as a separate person. Women who get married at nineteen and are swallowed up into that whole life of raising a family and being part of a marriage often later try to figure out who they are by themselves, as well as men who have been married or with someone for a really long time. I've spent more time with my children without Chuck than I ever would have had he not gotten sick. I'm the only one who can go for a bike ride now or a walk on the beach. That's not always great. I always wish that Chuck could be doing that as well. I have a different relationship with my children than I did before this happened. They needed to have a chance to do the things that we could do that Chuck couldn't do, so there was a period, I would say the first four or five years, of accommodation and trying to adapt as a family. A more recent on-going process is figuring out how to have a life together and a life separately, which is an important thing for everybody to do, but it was kind of forced on us by the illness. I don't know that we would otherwise have done it. Chuck has often said that he is so grateful to have survived, and from where he is, we're still here, our friends are still here, and we have this wonderful life, and we do. We're very, very lucky.

Chuck: *I sit in a wheelchair, and I look out at the world that hasn't changed. When I roll by a mirror and see myself in a wheelchair, I'm shocked. "Who is that in that chair?" I think it's a much different view for you to look at me than for me to look at you. You stopped talking about your own work before you described what you are doing now.*

Leslie: One thing that I did as a direct result of Chuck's illness was start getting a space outside of our home, someplace to go to escape the nurse, the assistants, the physical therapists, and the illness itself. I started renting studio apartments in the neighborhood. Actually, the first

few months that I rented the first office, I would just go there and cry, because I had been in this adaptive mode for a year, just coping with the emergency, and I had really never had a chance to be alone. I just went. I rented this apartment. I went there. I had no furniture. I had nothing in there. I would just go there everyday and kind of get into my own head, my own thoughts, and try to recover a little bit. Then I started working again. I have been teaching the history of landscape, and writing, and I'm working on a book right now. We do have a routine. We've adapted. We do have a pretty finely-honed routine at this point. It has been a real struggle for me to keep the illness in its place, to keep it out of our faces. I think I've been a real bitch about the nurses and how much contact the kids have with all of the products of the illness, all of the markers and the accoutrements of illness, and I struggled very hard to keep it out of our lives as much as possible. I'm sure the nurses don't like me very much, but that's okay with me.

Chuck: *Well, we won't give them a copy of the book so they won't know that.*

Leslie: I have nothing against them except that I don't want to live with them.

Chuck: *I think with the time we have left, we should talk about some of your thoughts about the paintings. Did I paint you or your father first?*

Leslie: Me.

Chuck: *You first. Then I did your father. I did two versions of your father, and I did you just around the time that Georgia was born, and I painted you again just around the time that Maggie was born.*

Leslie: No, you painted me before Georgia, and you painted me after Maggie.

Chuck: *Then, of course, I painted your grandmother, Fannie. I thought maybe you could talk a little bit about your reactions to the paintings of you and the other paintings.*

Leslie: Well, when I see the first painting of me, it is a frozen moment in time. The reason I looked the way I do in that painting is that my eyes were running, my nose was running, and I could barely keep my eyes open. I'm very light sensitive. I could not stand the lights, and I was struggling to keep my eyes open. In fact, I had my eyes closed, and the moment the photo was shot, I was told to open my eyes, and my eyes were just tearing. I can't take the light. So I find that when I look at the painting, all I can see is someone whose nose is running, and whose eyes are running, and who is struggling to keep from squinting.

Chuck: *I think it's a loving, beautiful image.*

Leslie: I've also had the experience, over many years, of having many people say to me, "Oh, you don't look like your painting at all," or "That wasn't a very flattering painting Chuck did of you," so I have my vain complaints about the painting.

Bill: *You're not the only one.*

Leslie: I know. I know.

Bill: *It's a running commentary.*

Leslie: I look at it almost as if it's a snapshot in an old photo album. I remember being that young, being in that studio, and the sweater I was wearing, which my mother had made when she was younger than I was in that painting. I remember the earrings that I was wearing, where I bought them, how I loved them, and that I used to wear them all the time. They were probably three dollars, and I wore them for years and years and years and years.

Chuck: They're the ones that look like a pop-top beer can thing.

Leslie: It's a beautiful painting. That first painting is just beautiful, but I find it hard to confront the image. I think it was unflattering, and, of course, I thought that I should have some kind of special privilege as the artist's wife.

Chuck: Well, the special privilege of the artist's wife is to have more than one unflattering painting done.

Leslie: That's right. I got another chance, and the next time he was interested in painting me was when I weighed about 170 pounds, and I had just delivered my second child.

Bill: Have you heard what Georgia said about the painting of you in her bedroom in the country house?

Leslie: What did she say?

Bill: She said it was like being in a room with you watching her all the time, so at night she would turn the painting around to the wall. She said that one time you came in when the painting was turned to wall.

Chuck: I think she had the same problem with you watching while she was in bed with someone that we had with the painting of your father in our loft with no walls. He was omnipresent. I was working on the painting of Nat, and we slept on a mattress on the floor in the middle of the loft, and his eyes followed us wherever we went. In Georgia's case, she expressed it as "Big Sister is watching you."

Leslie: I'm sort of disappointed in myself that I can't deal more objectively, or simply make an aesthetic decision about the pieces. It's so personal. I've watched other people have difficulty over the years with their own images, but it's impossible not to do it. I don't like seeing myself in photographs, and I don't like being photographed.

Chuck: Even my own dealers, Klaus Kertess and Arne Glimcher, who both had little patience with people's vanity and difficulties with having their images painted, have had tremendous problems with their own images.

Leslie: Friends of mine have said that they remember me at the times of both paintings, but I'm thinking of the more recent one in the yellow checked shirt with Maggie in a front pack. When Maggie was a few months old, which was when Chuck took the picture, I used to wear that shirt a lot. A couple of friends who have seen that image have said, "Oh, I remember seeing you in that, so happy and having such a wonderful time with the baby."

Chuck: What about the images of your father and Georgia. Do you want to talk about them?

Leslie: Well, the image of Georgia is so wonderful. She's my beautiful child. I love it. We sent that paper piece out on loan to a show, and I really missed it; I really wanted it back. I always found the painting of my grandmother uncharacteristic of her. The photograph was shot from below, it wasn't at eye level, it was slightly below, and she has this kind of imposing look as a result. She was the least imposing person, and I always saw my grandmother from above because she was less than five feet tall. She was a little round Jewish grandmother, so this shot up—

Chuck: Too monumental.

Bill: It's funny. I always thought of her as a very short person from that painting.

Leslie: Really? She was sort of looking down her nose into the camera in a very solemn and, I don't know, monumental way, and I've always felt that it was so "not her." It's a beautiful painting, but it's not how I think of her. I think of her as much smaller. I remember her response

to the painting. She was horrified, and she said—she spoke in the third person—"Ugh, she's so ugly," almost as if it wasn't her. We have a very upbeat, very sweet image of her, a dot drawing of a smiling image of her.

Chuck: She was much younger.

Leslie: I love that. That's much more how I think of her. My father was so excited to have his image done. He was constantly asking about it and telling people about it.

Chuck: The height of that was when he was walking up Madison Avenue one day near where Sotheby's is now, and a limo screeched to the curb, and a woman jumped out of the back seat of the limo and said, "I own you." [laughter]

Bill: Everybody has similar but different reactions to the paintings of them. Dorothea [Rockburne] said that it didn't look like her at all.

Chuck: You know, she's changed that. Originally she said it didn't look like her or whatever. Now she thinks it's the ultimate portrait of all time.

Leslie: She told me all along that she loved it.

Chuck: She always liked it, but she didn't think it looked like her.

Leslie: I don't think mine look like me either. That first one looks like me with a runny nose, trying to keep my eyes open, and the second one looks like me with thirty-five pounds added and a goofy haircut.

Bill: Lucas's certainly looks like him.

Chuck: I've certainly done nothing to make images of myself more flattering when I've made images of myself.

Leslie: I don't agree.

Chuck: Oh ho. [laughter]

Leslie: Actually, except for the first *Self-Portrait,* which was an unfortunate moment in your personal style vocabulary, you've painted yourself so much that you've had many chances to get it right.

Guest: I thought those new black and white paintings at the Pace opening were pretty tough.

Chuck: Pretty grim.

Guest: I think they are the most amazing paintings that you've ever done. You did for yourself what you did for Alex in a sense: you showed something, some frozen moment, that was not just blank. They weren't blank at all.

Chuck: Joanne told me that she thought they looked like death masks.

Bill: That's not what I saw at all. I saw the person I know more than in any of the other paintings of yourself.

Guest: They weren't, however, necessarily flattering.

Bill: It's sort of shocking to see the profiles. The expectation is that the paintings will be very confrontational. I agree with what John Yau said in his catalog essay about the profile of Roy: it's a whole new direction in your work. It's like finding a new challenge. It gives you other options. I know that, for most people, it would be a small change, but for you, it's a monumental change.

Chuck: **They are not the first profiles I've done. I did Cindy [Sherman]. It was the last painting I did before I went into the hospital. I did a profile. A circular one like the Lucas. I do think, as we were saying yesterday, that a lot of people look so much better now than they did when I painted them. They've aged well.**

Bill: **I think Philip Glass looks exactly the way he did but just a little bit older, and I think Alex looks exactly the way he did.**

Chuck: **That wasn't very long ago, but if you look at the early ones, for instance, Mark, he looks better now than he did in that painting.**

Bill: **The painting really changed his life. He made *himself* look better. I think people sometimes react to their painting by getting better.**

Leslie: It's kind of interesting that the early paintings were of young people and now there's a lot more grey hair showing up in the paintings.

Bill: **But there are a lot of paintings of young people again, like Lorna and Cindy and Kiki. It's a sort of odd mix. When we go from people in their twenties to people in their nineties, a lot of distance and time is covered.**

Leslie: There are other issues, as a number of people have died. They have a sentimental and historical content.

Chuck: **Nancy died. Grandma Fannie died. There are drawings of other people who have died. Any other paintings?**

Leslie: Well, you never painted Gwynne or Ray Johnson.

Chuck: **No, I photographed him. I wish I had painted him.**

Leslie: He had no hair. You weren't interested in bald people.

Chuck: **Nothing to paint.**

Bill: **But you're still doing self-portraits, Chuck!**

◆

ested himself by suggesting Peter write a guidebook for straights about gay

at exotic things exactly went on in those waterfront bars. Peter himself was

hout apprehension, for no other reason than that Leandro had by now acqui

fection that there was no possibility he might have carried such a vile infect

Another war was beginning. Still he found himself unable to release th

across the lines of his paper pads. Notes, a dictionary, reading glasses, hi

per were arranged every morning around the svelte swell and taper of his Ch

this ritual still life remained still and functioned only as the pedestal for the

dreams around the birdbath. Even an expensive new pen lacked the power

Slowly, as his garden began to crumble into fall's rusty palette, his foc

re and more to the ocean. Here he could not control or cultivate; here he ha

a vaster music. Here he risked total beauty. Here his loudest screams were

isper. The ocean absorbed all and released only what it desired to release.

stantly shifting rumble of its percussive patterns aroused but eluded compr

ter's body, as always, found release in this rhyming vastness; direct access t

s one of the very few possibilities he envied the rich for. He couldn't begin

hours he had spent drifting into the rippling reflections slowly gathering an

well that delivered the sun in a roll of foam at his feet, or else reaching out to

stening of the surface at sunset; or losing himself in the pearly thickness that

ough an enveloping mist. Rollicking playfulness, magisterial calm, and roa

rage all engaged him equally. How often had the repetitive rhythms -- alwa

t always different -- lured him into slumber on the beach? How often had th

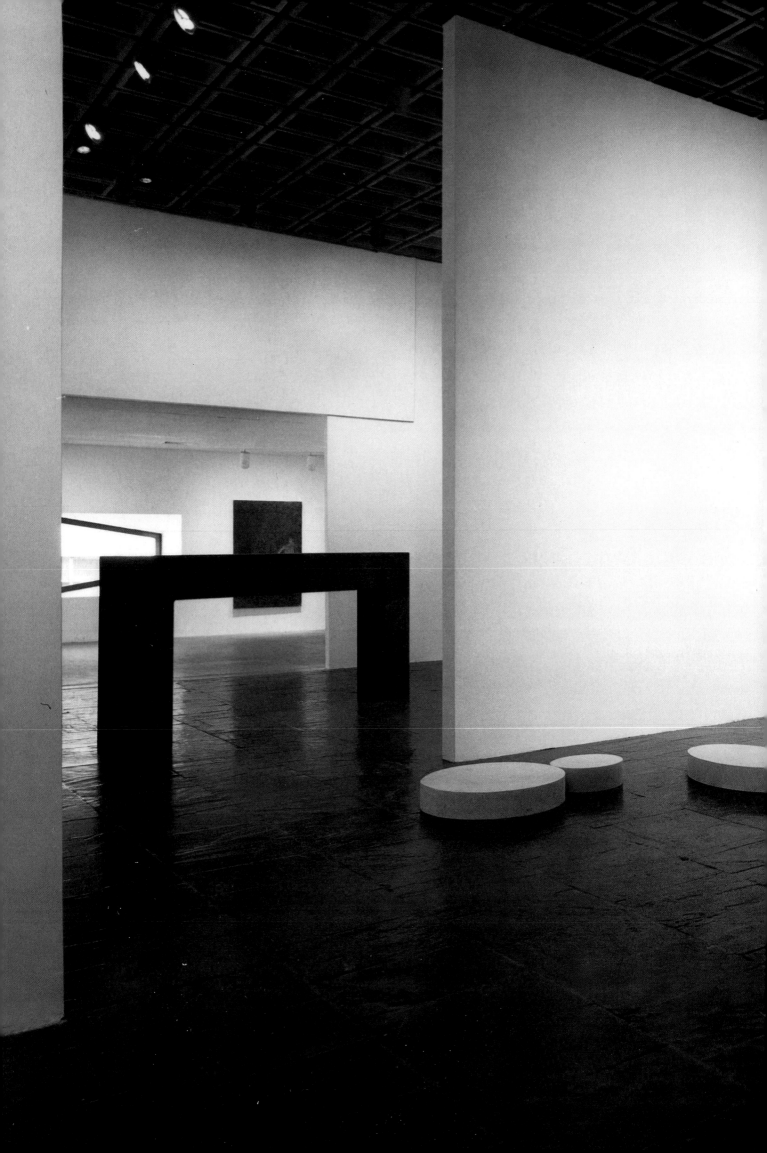

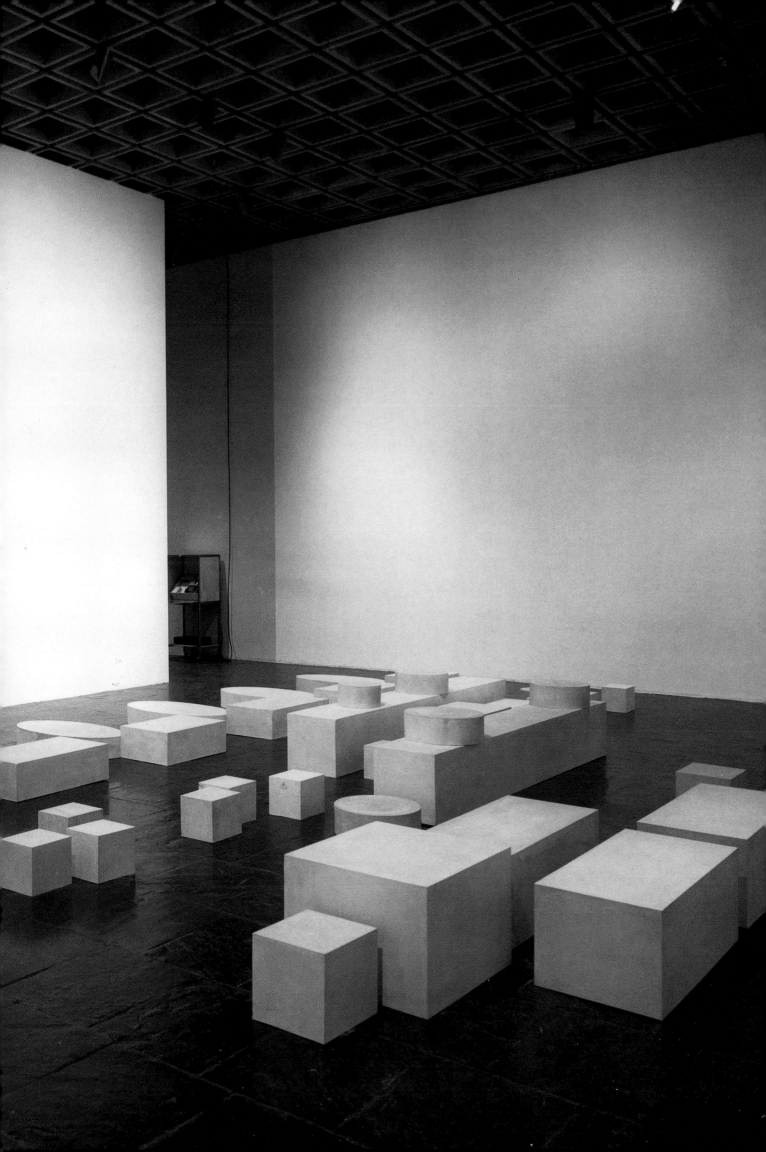

15 W 57 NYC

BYKERT GALLERY

OPENING 5-7 P.M.
TUESDAY MAY 16

CARL ANDRE
ROBERT MANGOLD
BRICE MARDEN
AGNES MARTIN
PAUL MOGENSEN
DAVID NOVROS
MAY 16–JUNE 12

MR AL
EAST
NEW Y

Sculpture by
Robert Lobe
Drawings and Prints by
Jan Dibbets
Eva Hesse
Ralph Humphrey
Brice Marden
Agnes Martin
David Novros
Dorothea Rockburne
Alan Saret
Opening Saturday,
November 6th
Through December 2, 1971
Bykert Gallery
24 East 81 / New York

Lynda Benglis / Porfirio Di Donna
Sol LeWitt / Brice Marden / Dorothea Rockburne
Robert Ryman / Richard Tuttle
Opening 5-7 p.m. Tuesday, May 18 – June 22, 1971
Bykert Gallery / 24 East 81 / New York City

Brice Marden
Gordon Matta
Dorothea Rockburne
Gary Stephan
Richard Van Buren
Bykert Gallery
24 East 81/NY
Opening May 19, 5-7pm
May 19–June 20

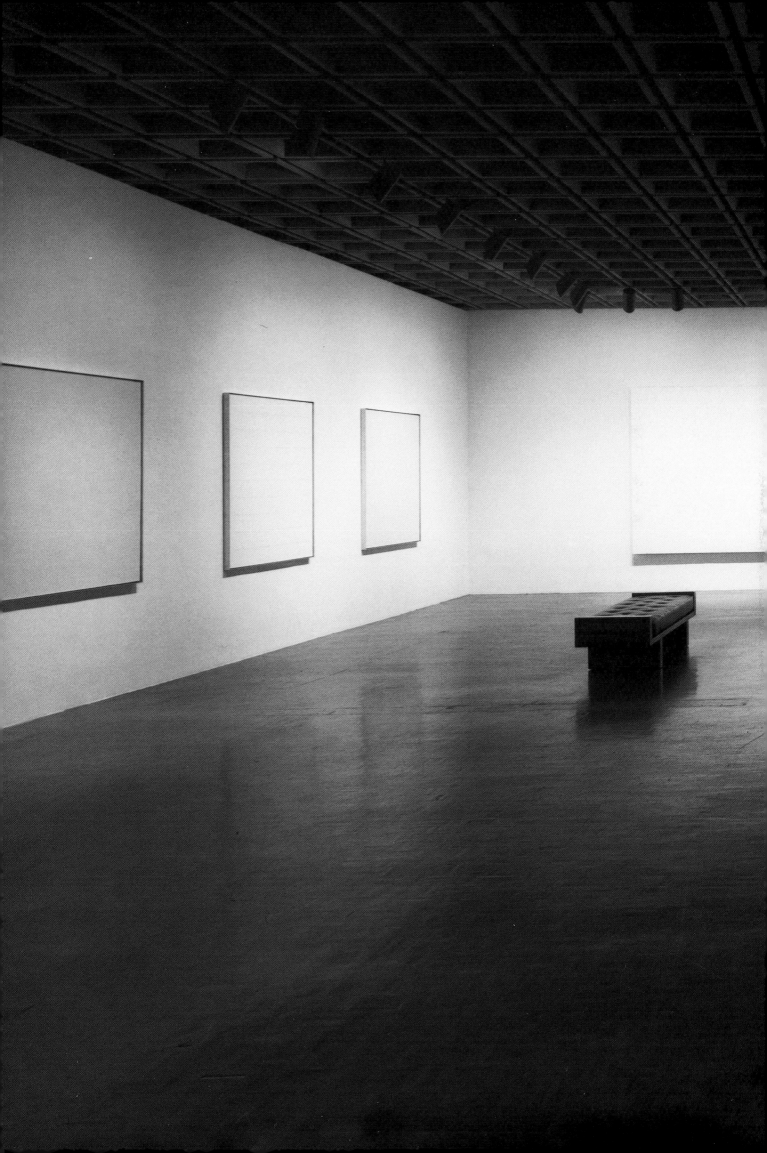

Klaus Kertess

New York City, June 29, 1994

Bill Bartman: One of the reasons that we decided to do this interview, besides the fact that Chuck painted you, is that your name kept coming up again and again, and Bykert Gallery seemed to be seminal to the group of artists that Chuck painted. It became obvious that we had to do an interview with you, or this book wouldn't be complete.

Klaus Kertess: **So here I am.**

Bill: So here you are for the Chuck and Klaus show.

Klaus: **So what do we do?**

Chuck Close: I don't know. I don't want these conversations to be only about me. When I'm talking with another artist, I try to talk as much about his or her work as mine, and, as Bill said, your name keeps coming up.

Bill: Phil Glass even talked about you guys producing a record together.

Klaus: **We started a record company with almost all of the people in the gallery. Half of the people I knew got loans from the Hebrew Free Loan Association because they didn't do credit checks and they gave you five hundred dollars immediately. They called me at the gallery and asked, "How many employees do you have? I think I've written thirty recommendations for the Hebrew Free Loan Association and all of them said they were employed in the gallery." Phil borrowed five hundred dollars from the Hebrew Free Loan Association, I put in five hundred dollars, and we stole time. Kurt Munkacsi, who is still Phil's engineer, was working for Yoko Ono and John Lennon. They had this great sound truck, so for the price of tapes we got ten thousand dollars worth of studio time for nothing, and the first record was paid for.**

Chuck: Chatham Square Records. They are still wonderful records. Did they ever reissue them?

Klaus: **They keep threatening to reissue them. I never see Phil anymore. You knew Phil at Yale?**

Chuck: No, Phil was not at Yale. Everyone else was from Yale. Phil wasn't from Yale. I don't know how Richard [Serra] met Phil. They met in Paris I guess, and I met Phil in Paris when I went over to visit Richard. We all had Fulbrights the same year, and Richard and Nancy [Graves] were living in Paris.

Klaus: **The art scene is still a tribe, but it was a smaller tribe then. Everybody knew everybody else in a way they don't anymore.**

Chuck: *Richard needed so many bodies to shove lead around that everyone ended up working there, including filmmakers.*

Klaus: I met Richard when he was an art mover. He moved Brice's first show into the gallery. I was totally aghast. Richard had figured out a whole progression of steps that he was going to take on the way to the Castelli Gallery, and a group show with me was one of them, but that never happened. He did end up at Castelli.

Chuck: *Well, a list of the people who you "almost showed" would be an impressive one: all the people who came through the gallery early on, even though they didn't ultimately show with the gallery. There were a number of people who were in group shows as well. Didn't Mapplethorpe show his first photographs there?*

Klaus: His first photographs shown in New York were in a group show. It was sort of awkward because I thought that if he put in a sex photograph it would take the group show away from everybody else. On the other hand, I felt obligated to show one or felt that I would be a coward if I didn't. The compromise was that it hung over Mary Boone's [then Klaus's secretary] desk in her office.

Chuck: *Was it one of his bondage and discipline photographs?*

Klaus: No, it was actually fairly tame. It was a really sexy half-naked blond leprechaun-type who leered out at you when you walked in. There was also a photograph of patent leather shoes in the main room.

Chuck: *There were so many incredible shows there, and you showed people who weren't best known as artists, people like Michael Snow. The first group show I was in was with Lynda Benglis in May, 1969.*

Klaus: Yeah, Lynda did *Bounce*, that "pour on the floor," and it never went away. I guess it's still there. Who was in the other room? I don't remember.

Chuck: *It was Richard Van Buren and David Paul.*

Klaus: Oh my god, shower curtains with fiberglass. You and Lynda together were really outrageous.

Chuck: *Yeah, I loved that.*

Klaus: It was really beautiful.

Chuck: *That was a terrific show, and that was my first gallery exposure. I think I was in the Whitney Biennial that same year, but I think that may have been the first piece that I'd shown. I think I showed the one piece with you and then almost immediately after was selected for the Whitney Biennial.*

Bill: *When did Bykert open?*

Klaus: September 20, 1966.

Chuck: *In the former Green Gallery space on Fifty-seventh Street.*

Klaus: On Fifty-seventh Street at 9 West on the same night that, I think, there was an opening of President Eisenhower's paintings at the Huntington Hartford's Cultural Center. After two years, I moved to Eighty-first Street, Richard Feigen's old space between Fifth and Madison. That's where Chuck had his show.

Bill: Is that the one that was across from the Campbell Funeral Home?

Klaus: Right. When Judy Garland's funeral was going on, hundreds of people came to the gallery because someone who had come in to see what show was up had discovered that there was air conditioning. It was hotter than hell, and all of a sudden the gallery was filled with people lying on the floor: a million people.

Chuck: We got a lot of people from Campbell's. Every time an abstract expressionist died, people came across the street.

Klaus: That's true.

Chuck: I had an opening on the same day as Rothko's funeral.

Klaus: A lot of people came to the show, but not happily.

Chuck: Talk a little bit about how you knew Brice at Yale.

Klaus: I didn't know Brice at Yale. When I was at Yale, I hardly knew any artists. One of the horrors of the art history department was that all the artists had to take art history courses, but there was no dialogue between the art department and the art history department. I knew Richard Serra by sight because he wore that same oversized scruffy sweater every day in the art library and he was such a burly presence, and I knew Paul Tschinkel, who shared a studio with Brice. I didn't meet any of the artists until afterwards. I wasn't even aware of Brice. The only artist that I remember meeting was Newton Harrison.

Chuck: That's funny because he was never at Yale. He had some kind of off-campus arrangement.

Klaus: He was in some show.

Chuck: Everyone was surprised when he graduated because we didn't know he had been a student there.

Klaus: He probably didn't either. I met Brice through Carlos Villa. When I started the gallery, I really didn't know what I was doing, but there was immediate and endless goodwill extended towards me because there just weren't many galleries around. Pretty quickly I just became part of the network. Did you every meet Carlos Villa?

Chuck: Sure.

Klaus: I guess Carlos is still in San Francisco. Carlos had the fattest address book of anyone in New York. I think it was at the opening of the *Primary Structures* show at the Jewish Museum when Carlos came up to me and asked what sort of artists I was interested in. The artist who most perplexed and troubled me was Ralph Humphrey, who had a show of framed paintings. It was one of the last shows at the Green Gallery in '65, and I couldn't believe that anyone could make work that empty. It seemed like a hostile gesture. I kept going back to the show, and it totally changed my life. That really was the beginning of the gallery. When I was going to start the gallery, Ralph was really the first artist I wanted in the gallery, but I didn't know where he was. When Carlos asked what sort of art I liked, Ralph was the name that came up. He said, "If you like Ralph Humphrey, you'll like Brice Marden." Brice was working at the Jewish Museum as a guard at that point.

Chuck: Guarding the bris knives.

Klaus: Yeah, and he was leaning, drunk and stoned, against some case with silver in it. Carlos dragged me up and said, "This is Brice." I went to his studio a week later, but that was the first time that I met him. Who else? David Novros. David and Brice were really close. David was showing at Park Place at that point, and I kind of knew his work. There was no Yale connection per se, although it seemed as if there were.

Chuck: *Park Place was a gallery on LaGuardia Place owned by, I think, Virginia Dwan and run by Paula Cooper. David Novros had a two-man show there with Mark di Suvero. I knew Brice and David Novros from Yale summer school in '61, and then Brice and I went to Yale together, although David didn't go to graduate school.*

Klaus: I remember sitting behind Janet Fish in art history classes, but we never knew each other, and I never knew Mangold. I never knew any of the people who were there at the time.

Chuck: *What were the first shows at Bykert on Fifty-seventh?*

Klaus: It opened with a group show that I think had David and Paul Tschinkel and probably Brice, but I don't remember.

Chuck: *Was Bollinger there then, or was that later?*

Klaus: Bollinger. We had a really complicated moment. Bill was going to join the gallery, but he ended up going to Biancini because Dorothy Lichtenstein was working there. Then he left Biancini and came to Bykert. The first one-person show was Terry Sieverson, a painter from Canada. He was a Barney Newman protege. It seems weird now, but there were a lot of artists who would just arrive in New York, call Barney, and say, "Hi, can I come by?" Barney called me and asked me to see Terry's work. Barney and I never got along, but he was amazingly supportive of younger artists. Terry was also a friend of Bob Murray's. There was this whole sort of Vancouver contingent. Anyway, he had one show and then never had another. He kind of disappeared into the wilds of Canada. He was a really good painter who sort of messed up. I've seen him recently, and his new work is actually quite beautiful. Bykert just sort of bounced along from there. I think Brice had the second one-person show in November, and then there was Ralph. It begins to telescope after awhile.

Bill: *Just for the uneducated amongst us, what did the name Bykert mean? How was it chosen?*

Klaus: "By" from Jeff Byers and "Kert" from Kertess. The backer of the gallery was a man named Jeff Byers, whom I had known in college, and who was a friend of mine. I had left graduate school at Yale to screams of horror. I had gotten a masters degree, was a sort of teaching assistant, and left in one year. When I walked in and told the head of the department that I was leaving, he asked me why. When I told him that I wanted to open an art gallery, tears came to his eyes. He told me that I was going to be a horrible whore, and he started yelling at me. That was the end of my life in graduate school. Then I came to New York. I knew that I wanted to start a gallery, but I didn't have the money to do it. Jeff and his wife, Hilary, were living in the city, and I saw them frequently. I had a job that I hated and at which I didn't do anything, and I went through two or three potential backers. Jeff was very reserved and very sort of nineteenth-century gentlemanly, and I kept thinking that he had to say he wanted to do it; I couldn't ask him. One night I had dinner with him and his wife. I had received an offer to

become the head of the Kalamazoo Art Center and was actually thinking of leaving New York. His wife turned to him and asked, "Why don't you start a gallery with Klaus?" He said, "Okay," so I made a proposal, and he accepted it. One of the few fights we ever had was over the name of the gallery. He wanted to call it the Brooke Gallery, which was his daughter's name, and I said that sounded too waspy and not very contemporary. His other child was named Frick, and clearly we couldn't call it the Frick Gallery, so then Kynaston McShine said that he thought Kerby would be good because that was a combination of our names—K-E-R-B-Y—but it sounded too much like a bar. So we ended up with Bykert. He didn't want it to have just my name on it. He felt that his name should be involved in some way, so it became the Bykert Gallery. It was the most awkward name for the first two years because people kept coming in and asking for Mr. Bykert. I'd usually say that he was dead. Gradually, it just became the name of the gallery, and it was fine, but it was very weird in the beginning. Jeff was amazingly supportive.

Bill: Is he still involved in art?

Klaus: He did away with himself. I left the gallery in '75, and the gallery sort of hobbled on. I should have closed the doors and said, "It was great, let's quit." I wasn't worried about artists like Chuck and Brice and Barry Le Va, but I was worried about the next tier down who didn't have a place to show, so I thought the gallery should stay open. A man named Frank Kolbert took the gallery over—disastrously.

Chuck: He was later involved with Donald Droll, and the gallery was then called Droll/Kolbert. He had several shots at it, none of which succeeded. You can't hand a gallery to someone else because it is built on very personal relationships. In the end, all Kolbert got was a pretty empty file cabinet. There really weren't very many records or files kept or even photos.

Klaus: Jeff was reasonably wealthy and in real estate, and he was probably not particularly geared toward the business world. He never really told anyone that he was unhappy. I had lunch with him the week before he killed himself.

Chuck: I photographed him the week before he killed himself. I'm going to give those photographs to the Modern.

Klaus: That would be really nice.

Chuck: He was on the board of trustees of the Modern.

Klaus: He was being groomed to be the next president of the board. That means he was one of those people whom everybody loved.

Chuck: He originally started the expansion program. His real estate firm was involved in figuring out a way to expand the Modern. He was an interesting guy.

Klaus: He was really terrific.

Chuck: Let's talk about some of the other people you showed at Bykert. Dorothea Rockburne came in.

Klaus: I met Dorothea when she was working for Rauschenberg. Brice was working for Rauschenberg. Dorothea was very secretive about her work. I was one of the few people who asked if I could go to her studio. We always had kind of the same process: an artist would first be in a group show. Some people were in endless group shows and never got solo shows.

Chuck: It was like opening in New Haven and wondering whether or not you were ever going to go to Broadway.

Klaus: You were only in one group show, because you made so little work you couldn't have been in another. There were, however, people like Joe Zucker who was, I think, in four group shows before I finally broke down and offered him a solo show.

Chuck: Is it fair to say that you were reasonably slow to commit?

Klaus: Yes. At that point it wasn't quite as rushed as it is now. People emerged more slowly, so one could have that luxury. There were two artists I knew I wanted to show instantly upon walking into their studios. One was Brice, and the other was Alan Saret. Everybody else was a more painful process. In the case of Chuck, I couldn't believe that I liked the work. I didn't want to like the work, but it kept seeping into my head. Then there was the group show that we mentioned with his painting and Lynda's poured piece. I couldn't believe that I could spend a month looking at this painting and still like it. It seemed so dramatic and one shot to me, but then the painting got more and more complicated as the month went on.

Chuck: Even before you came to my studio, I remember going to a back room at Bykert where everybody sort of hung out.

Klaus: The most accessible bathroom uptown.

Chuck: There was a long low couch on which people would lie. I remember that things were often so touch-and-go at that point, and Klaus was very generous. He was always giving money to any artist who came along and needed money. At night, we'd take the cushions off the couch and look for change that had fallen out of people's pockets to get subway fare back home. I remember coming into that back room, throwing my photographs on the desk, and in a sort of negative way saying, "You wouldn't be interested in these would you?" Klaus would look through the photographs in sort of a bewildered way. I'm not sure whether Brice was instrumental in convincing you to come to my studio or not, but anyway you came down.

Klaus: Brice said, "There's an artist you should see. I'm not sure you'll like him." It was as if no one wanted to say this work was really good and, given that we were all so conditioned by a certain kind of abstraction and Chuck's work related to that, it took so long. It seemed that people were really militant about abstraction at that point; it was really still a big issue, and you could have been involved in related issues.

Chuck: That's precisely why I wanted to show in the gallery. It was the only gallery in New York that had never shown a recognizable image. Even Dwan, which was an outpost of minimalism and reductive non-objective painting, had shown some imagery, albeit borderline. I wanted the work to be seen someplace really unexpected, someplace where people wouldn't come who were predisposed towards figuration. I wanted to separate myself from other photo-derived paintings that were beginning to emerge in New York. The appeal of Bykert to me was the fact that it was such a bastion of abstraction. I remember when you came to my studio for the first time. The door was in the middle of the loft, and you could either go to the left where the paintings were or to the right into the living area. Klaus sort of took one quick look into where the paintings were and went right into the living area where we had a drink, and then another drink, and talked and talked and talked, and I didn't think

he was ever going to get into the studio. After you'd had at least a couple of drinks, you went in, and there was absolute silence. I don't think you said a word in the studio.

Klaus: I never say anything in studios. People think I don't like the work or something, but I never verbalize until afterward. So much is about my intuitive response and my gut response, so I just look. I had dinner with Frank Stella last week, and I'd been in his studio about a week before. I said at dinner how beautiful I thought his work was, and he looked at me almost suspiciously and said, "You're really a hard take." I realized that I hadn't said more than two sentences while I was in his studio.

Chuck: I remember that you told me later that the more we talked, the more you liked what I had to say, or you thought I was smart, and you kept thinking, "Why is this person making that work?"

Klaus: It was really hard to understand at that point. I wasn't alone. You still are so verbal and articulate, and that helped get me into the work.

Chuck: Well, the quieter you were the more I probably talked.

Klaus: But the paintings kept speaking for themselves. I couldn't believe that this blown up image of a face could be that powerful as a painting, and the drawing really amazed me. I remember looking at hairs, getting close and seeing this incredible amount of detail. That the paintings were that giving, I guess, was a surprise to me. That was the reward of that group show. I really liked that process. I liked doing group shows because I spent more time in the gallery than I spent at home, and I really began having feelings and opinions about the work. Of course, one of the things that began to annoy me, as the gallery became more established and more successful, was that the artists in the gallery began to shit on me for having those shows; a lot of the time they were quite bad or half bad, and they seemed very unprofessional for an uptown gallery. They were, however, really important to my learning process.

Chuck: I think it's really sad that the whole convention of putting stuff together, seeing how it works, seeing whether or not you could live with it, and providing a great mix for the public is no longer often done.

Klaus: I think everybody could learn something from it. I don't want to sound like an old fogy, but things move so fast now. You have to make snap decisions, and if you show a young artist in a group show, you are worried that someone is going to take him or her away right away. There's a lot more pressure.

Chuck: I think you could have had Richard if you had committed yourself to him earlier.

Klaus: It's so odd the way those things happen. I think the last two shows that Richard had were two of the greatest pieces of sculpture that have been made in years and years and years. When Richard started doing the splashed-lead pieces, I really wanted one, and he was stunned. I was living in that goofy loft.

Chuck: It was right down the street at the other end of Bond Street.

Klaus: He said that if I could pay for the materials, he'd do the piece in my place, but I couldn't pay for the materials, so it never happened. As good as I knew he was, I didn't have the same kind of personal response to the work that I had to Alan Saret's. There was this goofy mix-up once about Alan Saret's group show. Richard heard the name—there was Saret, Serra, and Sonnier—and Richard thought he was going to be in a group show at the gallery, but it was

Alan. I had a more visceral response to Alan, which was completely unexplainable. I knew how wonderful Richard was, but somehow I didn't see myself dealing with him. I was so vulnerable; I worried about people taking artists from my gallery, and the idea of taking an artist from another gallery wasn't very interesting and just seemed wrong.

Chuck: Boy, times have changed, huh?

Klaus: Robert Ryman was not very happy where he was. Then he was in a group show at Bykert. It was not a trial group show. Every now and then there would be an exquisite combination of people, and Bob was in one of those shows, and he sold the painting. I think he told me that it was the first painting that he'd ever sold, which seemed outrageous to me because he'd been showing for years and years. The woman who bought it was Ginny Wright, who was the aunt of the person who was to become Robert's wife. She bought it somewhat reluctantly, saying it was partially because of the family. Bob sort of indicated that he would like to come to the gallery, but I didn't feel that I could do it. That was just stupid.

Bill: Because you really liked the work.

Klaus: I liked the work a lot. We weren't close friends or anything, but we'd see each other, and I should have just said, "Tell them you're leaving and then come to me," but I felt so awkward that I just let it stumble by, and then it was too late.

Chuck: You had show after show of essentially unsalable stuff. Who did the dust on the floor?

Klaus: Bollinger. That was a nightmare. It wasn't dust, it was graphite. In the back room of the gallery there was pure graphite powder on the floor, and its density and sort of sexiness was overwhelming. In the front room, he painted the floor gray—it was just one of the several repaintings of that floor—and then he spread that green sweeping powder around. It was totally beautiful, but clearly nobody was going to buy that. The gallery was basically run on a shoe string. You could do that then. When the gallery started, we had nothing but black and white photographs. We used the same photograph of Brice's and just changed the dimensions, because they all looked the same in black and white anyway. I painted the gallery and cleaned the toilet.

Chuck: Not too often.

Klaus: Well, as often as I could, and I had a part-time assistant, Lynda Benglis. I was on Fifty-seventh Street and the gallery was credible. It was a little funky. It didn't look as if it was out of the way. It was in a major location, so you could do that. Even on Eighty-first Street, the first mark of coming success was when I didn't have to paint the gallery anymore. I could hire people to do it.

Chuck: I remember you spackling the walls right up until the end.

Klaus: I never trusted anyone else to do that, although I didn't do it very well.

Chuck: There were so many pieces done directly on the wall that if an archaeologist ever removed the layers, there would be a hell of a show.

Klaus: Since the eighties crash, there have been younger galleries in the city that are playing around a lot more. Places like Feature, American Fine Arts, Pat Hearn, and David Zwirner are really doing risky shows, and you sort of wonder how they survive. In the late sixties and seventies you could do that and put up a good front, but it hasn't happened for a long time.

Chuck: You had a downtown space for a while.

Klaus: On Wooster Street. It was a building that Jeff owned, and Brooke Alexander had his gallery there. Brooke had half a floor upstairs in which they lived, and I had the other half of the floor. I wanted to start a theater as an adjunct to the gallery, but could never get the money together, so I used it for storage, and we did a couple of shows there. Ralph [Humphrey] had an incredible show there, and I tried to bring Bob Whitman back into the world again. He did a piece and a performance there and also a couple of group shows. Barry Le Va did just one show there, those walking stick pieces, and it was really wonderful. In the end, it got sort of lonely uptown because Elkin died and Leo moved to Seventy-seventh Street, so I was just sort of hanging on a thread at Eighty-first Street. Alan Stone was on Eighty-sixth, Street if you could make it that far.

Chuck: You could easily see all the contemporary art shows in New York in an afternoon, starting at Eighty-sixth Street and moving on down to Fifty-seventh Street and then finally to Paula's in SoHo. Perhaps because of the shoestring nature of the gallery, Jeff would occasionally buy a piece from a show and sort of keep things going. There wasn't a need perhaps to sell as much work. I always thought that you were just as surprised as any of us when things began to happen and pieces began to sell. To a certain extent, I thought you were sort of uncomfortable with that.

Klaus: I don't think that's true. I was surprised in your case, because none of us were used to prices like that. I didn't expect to sell any of Chuck's work at the beginning nor did you.

Chuck: Who's going to buy a nine-foot-high picture of someone you don't know?

Klaus: By the time of your second show, your prices were ten thousand dollars, and the show sold out. That was completely unheard of at that point. It seemed an almost obscene price, not just to me but, I think, to you to some degree as well. No, I wasn't adverse to selling things.

Chuck: You had a less than aggressive sales manner.

Klaus: I wasn't as cavalier as Betty Parsons, who would occasionally kick collectors out of her gallery. I certainly worked at it. The thing that interested me the most was being around the process of the art, so I thought of selling a painting as making it possible for you to make another one. It didn't seem as if there was real money to be made. I mean, my salary the first year of the gallery was six thousand dollars, and I think I spent half of that on paintings and didn't pay my income taxes. Towards the end of the gallery, two things happened: I began to write, became more involved in that than I thought I was going to be, and was questioning whether I could do both things at once; and as the gallery began to become more established because of you and Brice and Barry and Ralph, it was on the verge of becoming a serious business, and that really didn't interest me so much. It became harder because there were only so many artists you could show, and the thing that I really liked was showing younger artists and sort of watching them grow. That was the excitement. In a way, the gallery was kind of built to be a starter gallery—that sounds sort of silly, but in a way it was like that. Everyone, including me, had to move on at some point.

Chuck: I think there was a tremendous loyalty to the gallery, especially in contrast to the way artists change galleries so frequently today. There was tremendous loyalty. If you had stayed in business, I can't

imagine that any of us would have moved. We didn't think of it as a starter gallery, as if we were plan-
ning to go from it to someplace else.

Klaus: It's sort of unfair to the gallery to put it that way, but I was having trouble dealing
with the next step. I felt, at a certain moment, that the only way I would figure out if I were a
writer or not was to just dangle myself out there as a writer and not as a dealer. The gallery
was open for nine years when I was there, and I would say that six of those were really glori-
ous for me, but the last three became more and more complicated. In the end, it was like
divorcing eighteen people. It was very painful and crazy, and I got sort of mentally fucked-up
and withdrew for about a year to sort things out again, but the experience was really seminal
to my life.

Chuck: And to all of ours. It was a terrific time.

• • • •

Chuck: Maybe we can talk a little about the experience of being painted. I remember the difficul-
ty you had with looking at the painting of you after I painted it. If I remember correctly, when other
people whom I had painted expressed some discomfort with their images, you would say something
like, "Come on, why can't you just look at it as art? It's just a painting. Don't be so vain."

Klaus: I lost that attitude when it was me.

Chuck: You would come into the room where your painting was and maybe glance at it out of the
corner of your eye.

Klaus: I have an aversion to being photographed. I don't know why, but I have some sort of
superstitious feeling that my image is literally being taken, and it frightens me a little. I never
had photographs of myself around. Mapplethorpe asked me if he could photograph me for a
book once, and I said sure. I thought I would get to know him better, but we just ended up
taking a lot of cocaine, and it was very stiff and unpleasant. Then he gave me the photograph,
which was a rare act of generosity on Robert's part, or gave me a print of it. I had it up on the
wall, and my mother walked into my house and said, "You look like an intellectual homosexu-
al," and I said, "I am." I kept looking at it when I came home at night, and then I took it down.
Billy has it now. I was going to give it away, but it's in Billy's loft. When you asked me, you used
the word "drawing," and I thought you were going to do a small drawing. I thought that was
kind of okay, so when I sat down to be photographed, I immediately began to get uncomfort-
able. There's an aspect of your work that is almost like death masks. There is so much about
the mortality of flesh involved, especially in the earlier work. Doing a head that size with all
the pores and facial mistakes magnified sort of frightened me. I felt in some way possessed,
and I resisted that. I still remember running into Sydney Lewis at the Modern; he turned and
said, "I bought you." I got really upset.

Bill: I bought you.

Klaus: I got really upset and said, "You didn't buy me." He said, "I did buy you." He's such a
nice man, and I was standing there being so hostile. I was really pissed off. Finally, I said the obvi-
ous: that he had bought a painting of me. The word "painting" somehow mediated that

moment, but in a sense, he did buy me, and that was my fear.

Chuck: I remember that after I painted my father-in-law, he was walking up Madison Avenue where Sotheby's was and where Gagosian is now. A limo screeched to a curb, and Anita Reiner jumped out, ran over to him, and said, "I own you!"

Klaus: It's sort of like that. I had a moustache when you did me. A woman who I knew but not terribly well, came up to me and said, "You look terrible with that moustache. You were much more attractive before." I went upstairs—I lived right next door—and I shaved my moustache off. Somehow, that changed everything.

Chuck: Still today, when I see that painting, it looks like you in a disguise.

Klaus: It's like Joe [Zucker], who slicked his hair down, and didn't he part it in the middle? Joe went with camouflage.

Chuck: But you didn't grow you moustache for the photograph.

Klaus: No, the moustache was part of the process of whatever was going on in my head. I think I wouldn't have shaved it off so soon.

Chuck: Have you seen the painting lately?

Klaus: No, I haven't seen it for ages.

Chuck: I hadn't seen it until just this year when I was down in Virginia. I think some of your reaction had rubbed off on me, and I had sort of put the painting out of my mind and maybe chosen not to show it but I was really pleased with the painting. I really liked it a lot. I think my own feelings about it were perhaps somehow contaminated by your difficulty with it.

Klaus: Being portraitized, in any fashion, seems to me a really complicated experience. One of the goofier things that happened in the gallery was during your first show. Andy Williams walked in wearing a white suit, kept pacing back and forth very briskly, then walked up to me and said, "Yep, yep, I'd like him to do my portrait." I flipped out because I couldn't believe that there was anyone as vain as this man, who wanted to have his features blown up to that degree. It seemed like such false megalomania to me. You were sort of stunned, and I said, "He doesn't do portraits," and he said, "What are these?" I said, "These are paintings," and he said, "I want my portrait," and I said, "He doesn't do commission work." I think that, out of my perversity, I actually wrote him a letter and asked him to send some photographs, so he sent a press kit showing him in all his white clothes.

Chuck: You just wanted his photograph, that's all. [laughter]

Klaus: But I never put it up on the wall. We wrote back and forth for a little while, and then the thing gradually disappeared.

Chuck: He offered to pay twice what they were selling for. He couldn't believe that there wasn't some amount of money that we would accept.

Bill: If you had done it, now it might revive his career.

Chuck: I'm really glad I never kicked that door open, because it would have been impossible to slam shut.

Bill: You do get requests from people who you painted early on to do newer versions of the painting.

Klaus: Really?

Chuck: Richard has offered to do it again. Nancy Graves has offered to do it.

Bill: They want an updated version.

Chuck: You don't see Klaus begging.

Klaus: I'll wait until I have my first face lift.

Chuck: You've changed almost the least amount of anyone I've painted.

Klaus: I always think that Richard has changed the least, but when one looks at other people, they seem the same, because you have to look at yourself everyday, and you don't have to look at them.

Chuck: Well, you look better actually.

Klaus: I think I do too. Richard looks pretty much the same to me but not as stern.

Chuck: Of the early ones, Bob Israel looks almost the same.

Klaus: That's true. Bob looks almost the same. Phil has changed more. Joe had that slicked-down look.

Chuck: When I changed galleries—I can't even say changed galleries because Bykert closed—I ended up going to Pace, and, although it may have been difficult for Arne, it was interesting to have you involved in the work afterwards. You wrote a couple of catalog essays over the years. I really feel that you've remained an important person in my career. The last things that I showed with you were the dot paintings, and then I did the color paintings. What was the last show that I had with you? I had just done the self-portrait watercolor when you closed. I remember that I was going to try to sell that myself, and you very kindly told me who was interested in the paintings after you no longer represented me. I thought that between galleries I'd sell a couple of paintings and I'd be able to keep the entire amount instead of splitting it with someone. Donald Marron was on the waiting list, and he came to my studio on West Third to see the painting that he wanted to buy. He asked me how much it was. I opened my mouth, and nothing came out, so I thought maybe I'd write it on a piece of paper and hand it to him. He was sort of hemming and hawing around and so was I, and finally I said, "I can't do this," and he left. When I went with Pace, I called Arne and said, "Donald Marron wants a painting and all you have to do is tell him how much it is, and I'll be very happy to give you your commission because you can say it and I can't." I don't know how the hell you guys do it with a straight face. I had renewed respect for that job of interfacing with the public, which is such an important buffer, and I was always free with you and with Arne to make whatever I wanted to make without having people in the studio trying to sell the work. I've been very lucky having two great dealers in my life.

Klaus: With that we should stop. I have to run uptown. That's enough, isn't it?

Chuck: Thanks, Klaus.

◆

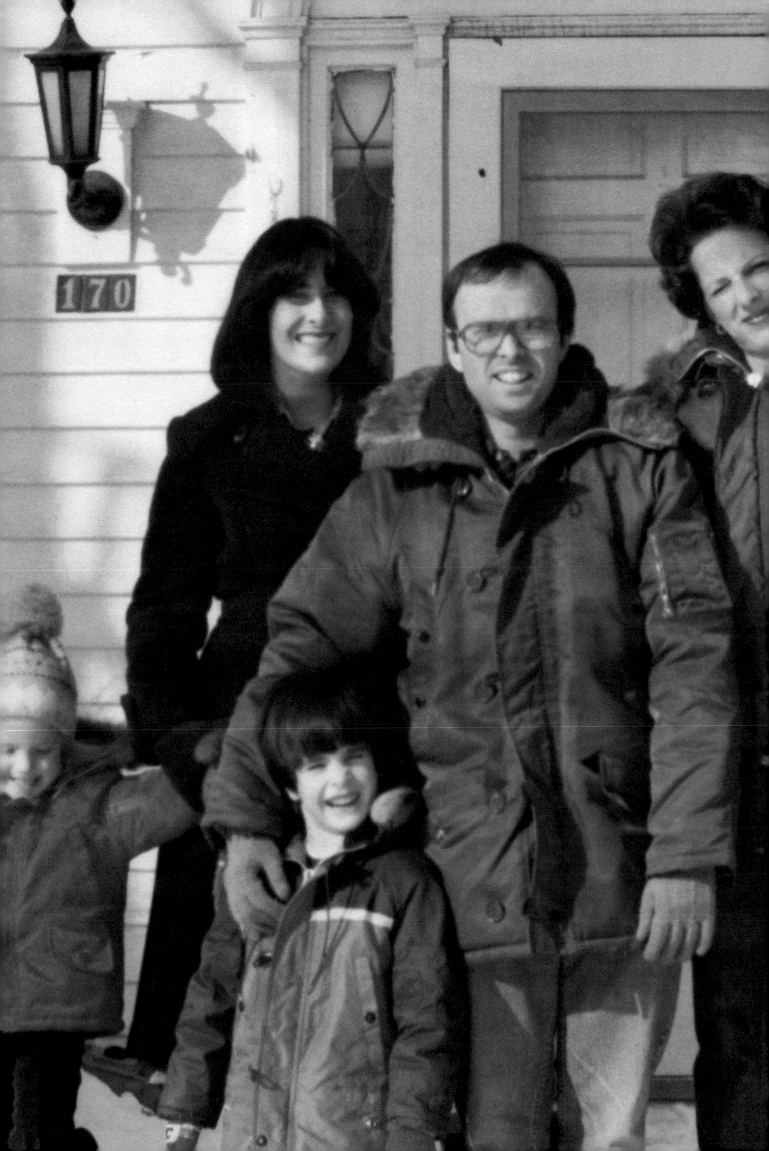

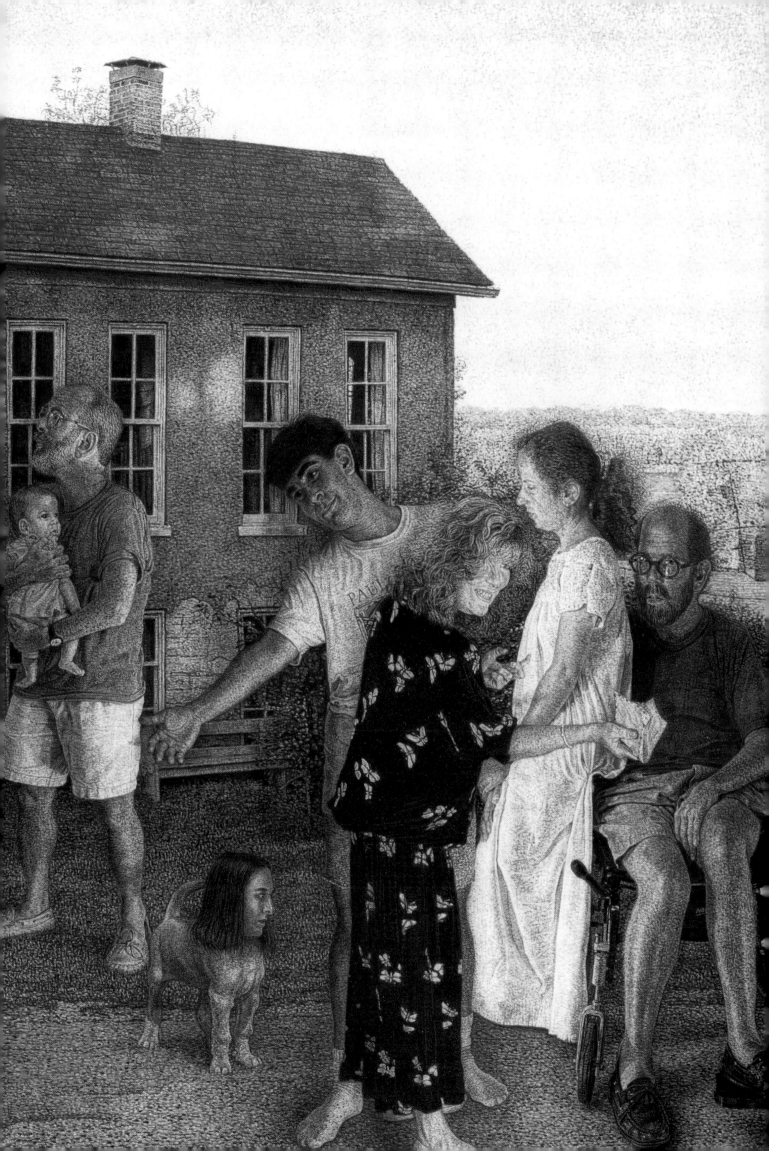

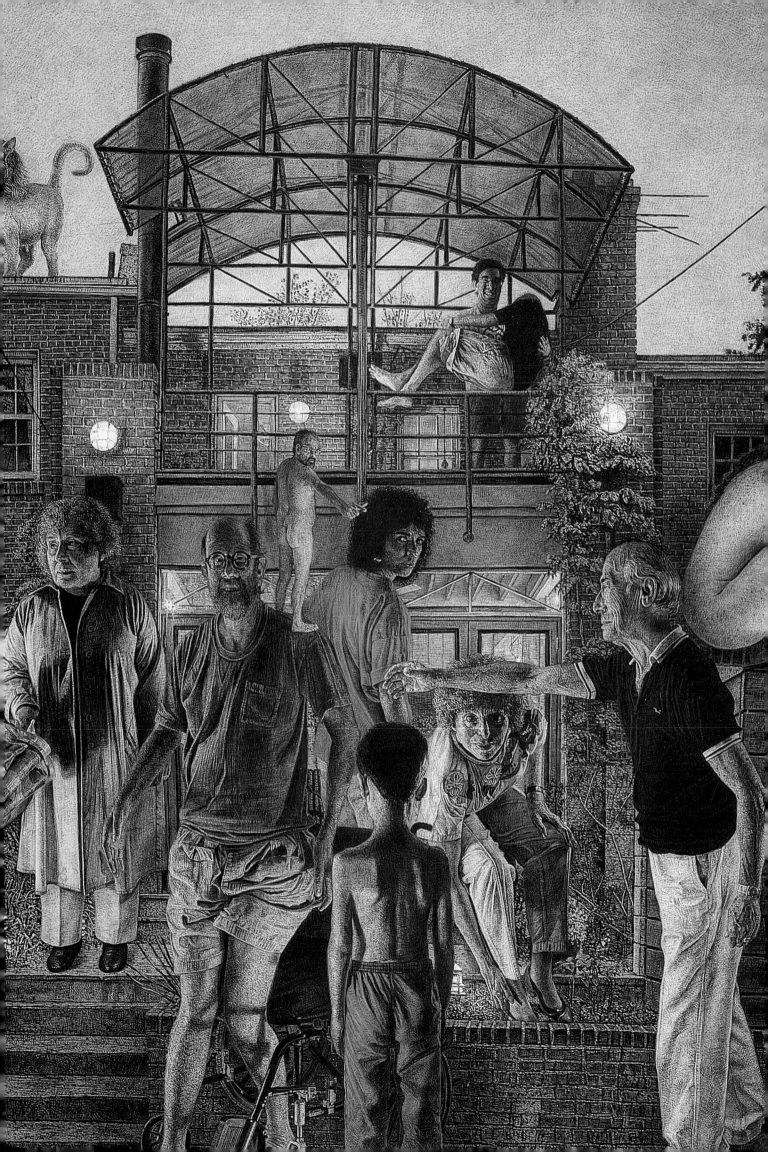

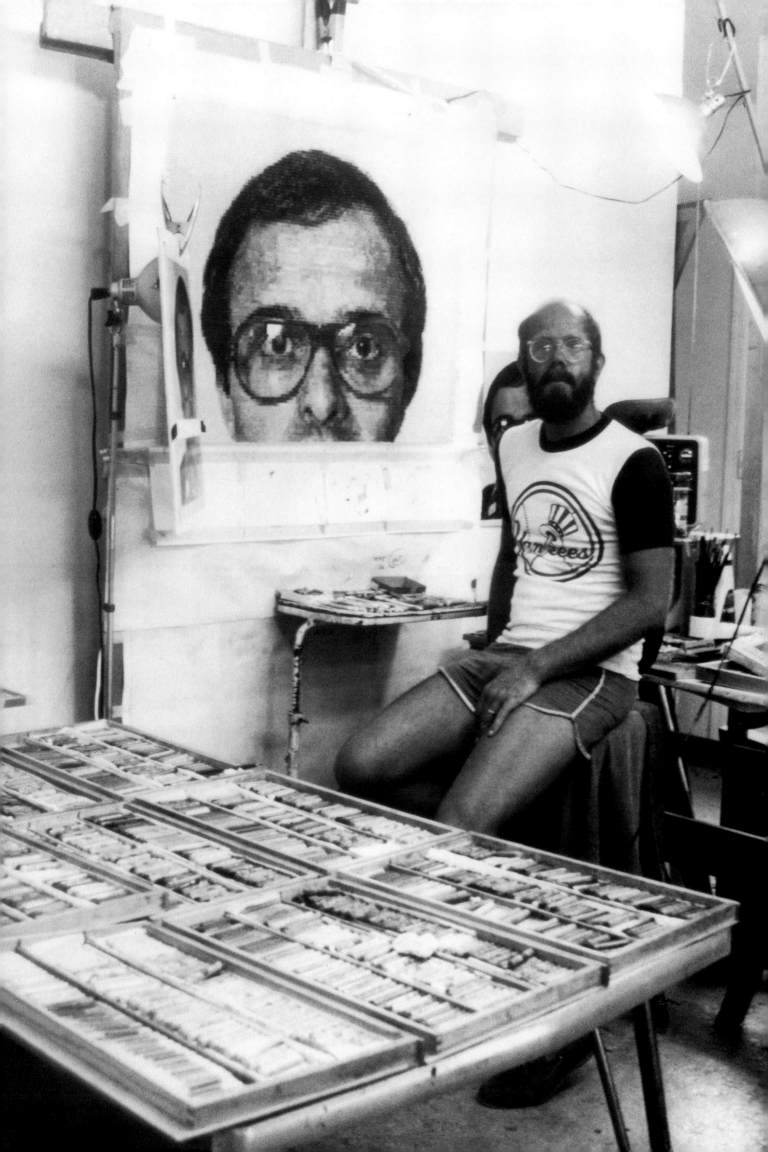

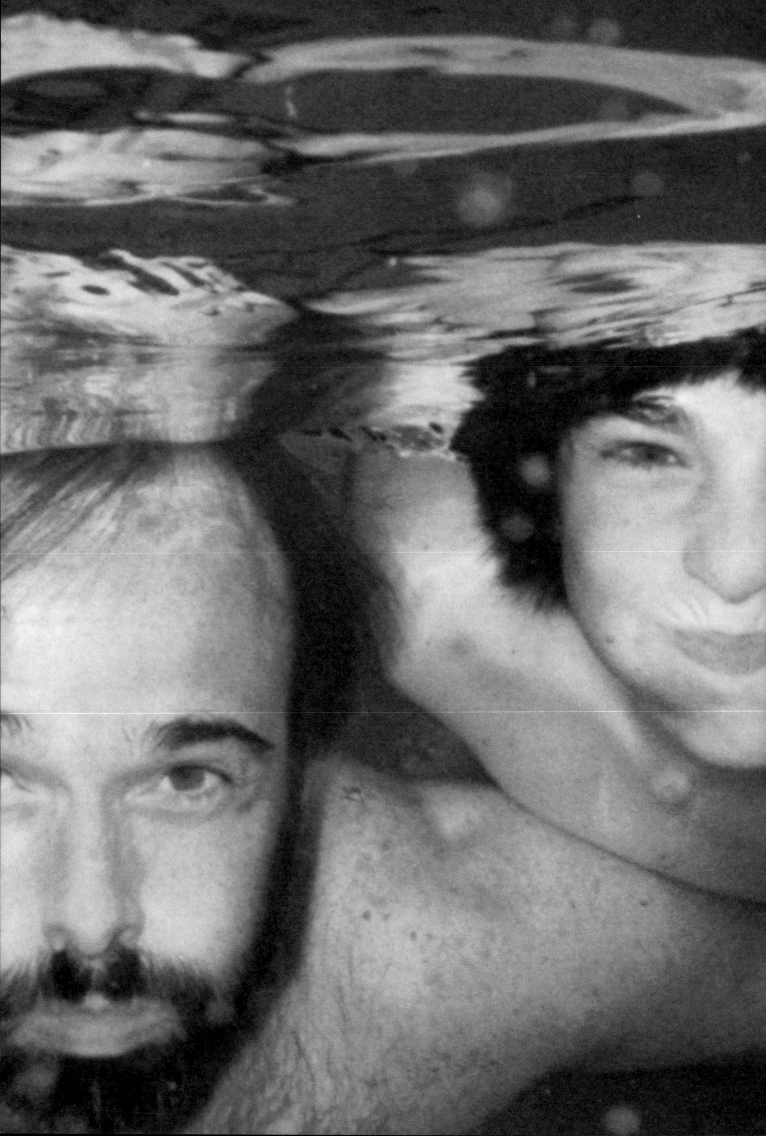

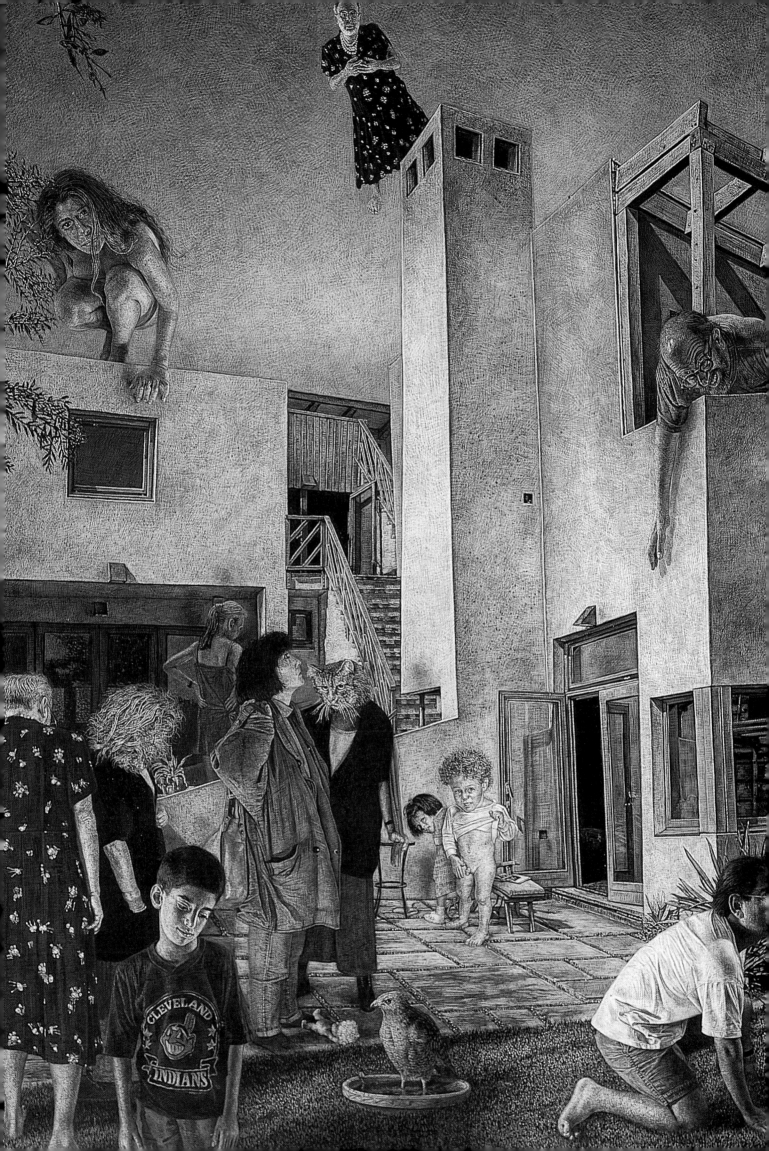

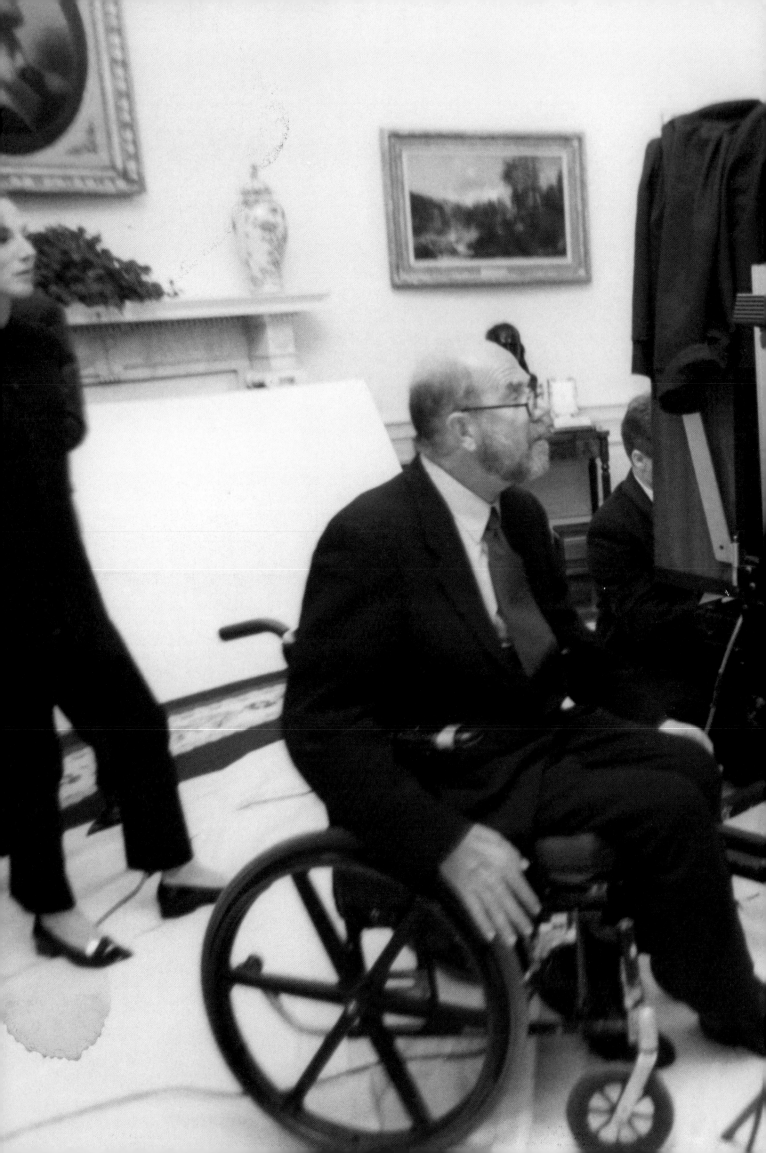

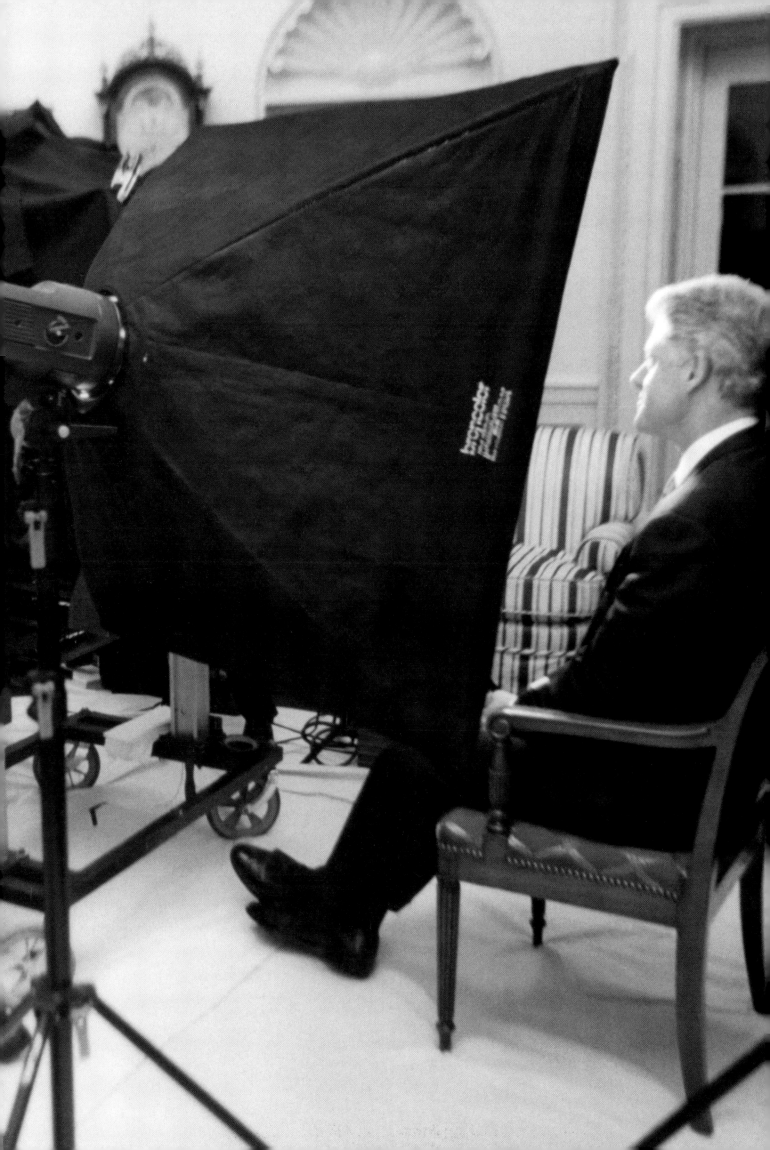

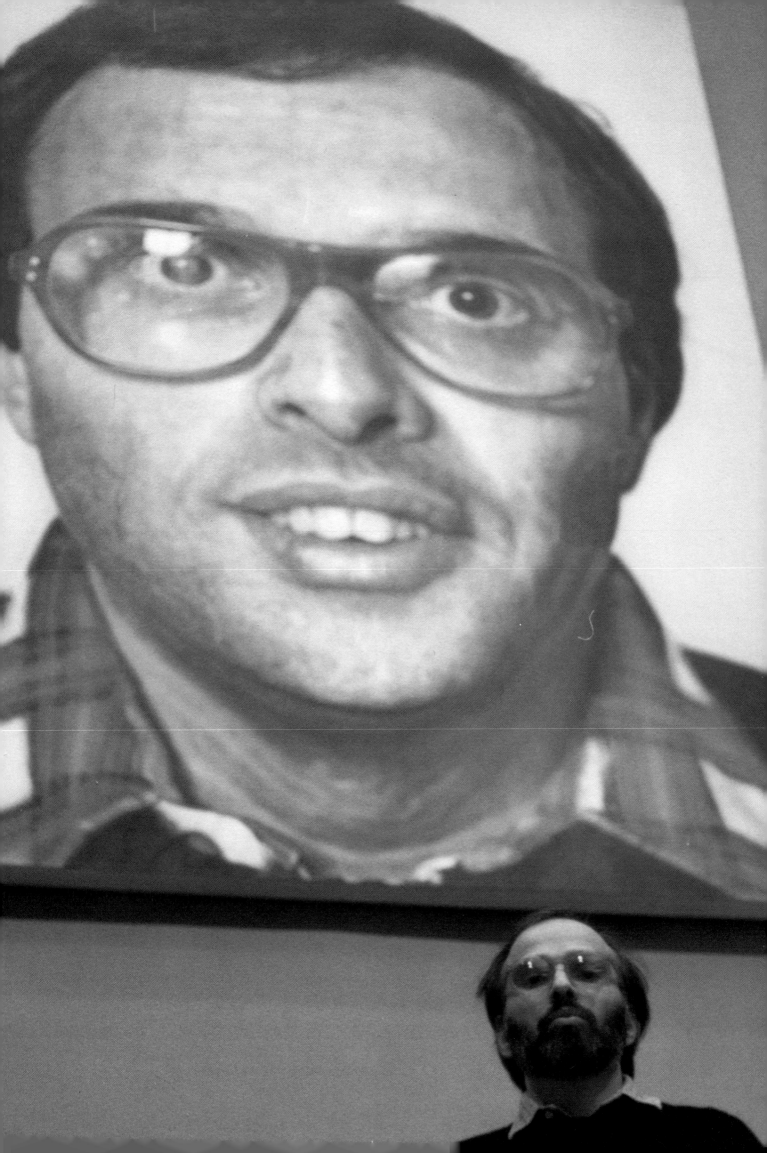

Mark Greenwold

New York City, February 23, 1994

Chuck Close: We've known each other since 1970, which is twenty-three years.

Mark Greenwold: Should we talk about how we met?

Chuck: Sure.

Mark: I was teaching in Seattle at the University of Washington. You had come for a summer stint, you and Leslie. One of my colleagues called you and invited you to have a beer, but I didn't want to go. I didn't want to meet you. I felt a certain ambivalence about your work—

Chuck: —which you still maintain.

Mark: Absolutely! But I'm slowly warming up to it. My then-wife and I and you and Leslie fell in love with each other that summer.

Chuck: [Laughing] That's because you recognized that my wife was Jewish, and you hadn't seen any Jews the entire time you had been in Seattle, so you rushed into Leslie's arms.

Mark: It was a very intense summer. I don't think anything like that has happened to me since, in terms of two couples. Maybe it was just being young, too.

Chuck: We were young. You were one of the only persons I knew who was working from photographs, so I don't know why you had that ambivalence, because we had that shared—

Mark: The work that you were making, the big black and white paintings, was so radical in scale, and I'd never seen it before. I think the interview in *Artforum* had come out, and a lot of people were excited and confounded by the look of the work. I had always used photographs as a source, but my relationship to the source was different from yours, and it continues to be, but perhaps not as different as I had initially thought.

Chuck: I remember when I first saw your paintings. They dealt with such heavily charged psychological content, nudity, and domestic violence, but they had more implied violence than real violence—

Mark: Surely psychic violence and sexual transgression.

Chuck: —and a compulsiveness to which I responded.

Mark: I think it's the obsessive work aspect that you've always had with your art that has sort of bonded us: the pathological nature of what we do.

Chuck: I've always been honored that I was one of the only people you let see your work while it was still in process. Mark covers up all the finished parts of the painting on which he is working, in an

absolute denial of pleasure, so that he can't see what he's done, and also to keep it clean. Uncovering it—pulling off the little pieces of paper, and exposing the image underneath—was very exciting.

Mark: The paradoxical nature of our relationship is that you're obviously not covering up anything, at least not on the painting surface.

Chuck: *Clearly, what interested me was that our work was similar on some levels but antithetical on others in the sense that you were dealing with such hot and loaded subject matter. At the time, both of us were out of it, but for different reasons. Out of favor, out of fashion.*

Mark: Out of sync.

Chuck: *I am sure that there was more resistance to the kind of subject matter that you used.*

Mark: In those days there was no bigger taboo than content. It was also interesting that you were the only person who literally wouldn't take no for an answer in terms of seeing my paintings in progress. You were very persuasive, and if you couldn't persuade me, you'd badger me and, finally, force your way into my studio.

Chuck: *Who, me?*

Mark: Literally, there was no choice. Everyone else I could put off. That first summer of teaching in Seattle you were so open. Your studio door was open, and you were making those drawings, but you were there for students, who could just walk in. It was so unlike my relationship to my work—you know, my secrecy.

Chuck: *There was, far more then than now, a constipated quality to your work. You were not going to give. Sometimes it would take you four years to complete a painting. I always liked having you around because it made me feel as if I was really speedy. A year for a painting seemed very rational compared to four years for a painting, and your painting was this big [indicates a few square inches with hands].*

Mark: It's also ironic that the painting that took you the longest to complete was the painting of me. It took you fourteen months, approximately twice the amount of time that those color paintings generally took, and at the time you were immensely frustrated. You hated working on it.

Chuck: *I didn't want to make another color painting. I thought I wanted to do one more, but once I was into it, it didn't feel right. It was also the goofiest of all the images that I made.*

Mark: I learned that one of the by-products of being your friend was that my face would get a review. The issue of *Arts* magazine that had the review of the show said that the painting was wonderful but the image was immensely goofy. [*Arts* magazine, February, 1980, review by Barbara Cavaliere, p. 33.] "What possible kind of mind could be behind this inane and pathetic face?" I was criticized while you were praised. [*laughter*]

Chuck: *The funny thing about that painting is that while most of the paintings that are full face are usually the most confrontational, the painting of you is anything but confrontational. In fact, I often thought that if we added two big black ears, it could almost be the logo-like image they use for Mickey Mouse in the Walt Disney movies.*

Mark: Thank you.

Chuck: *The image is accessible in the same way the cartoon is. It was very different from the way you've always posed. You sucked in your cheeks and looked very angry and intense. Somehow, I managed to subvert that.*

Mark: And make me look goofy. More goofy than I am? *[laughter]*

Chuck: *And allowed the real you to come through. [laughter]*

Mark: So sweet and goofy. "The trusting me." Personally, I've always hated that image, not as a painting, but as a way of being remembered. [See Mark Greenwold on His Portraits, in *Close Portraits,* the 1980 exhibition catalog from the Walker Art Center traveling retrospective. Lisa Lyons, curator, posed a series of questions to several of Close's subjects—Mark Greenwold, Robert Israel, Joe Zucker, and Leslie Close—regarding their experience of being photographed and painted by him.]

Chuck: *You've been lobbying for a new version.*

Mark: You claim I don't have ears, but—

Chuck: *The beard covers up the fact that you don't have a chin. Underneath there, somewhere, is no chin.*

Mark: One Halloween I wore the *Arts* magazine cover that reproduced that image as a Halloween mask with two eyes cut in it. It is amazing how well-known that image is.

Chuck: *When I had the traveling retrospective that started at the Walker Art Center and ended at the Whitney, when the elevator doors of the fourth floor of the Whitney opened, the Mark Greenwold room was straight ahead with drawings and watercolors and stuff. So obviously, I wasn't embarrassed by the image, although I have had some ambivalence about that image. Also, I've kept it. It's one of the few paintings that I own.*

Mark: How many images did you make from that photograph?

Chuck: *Oh god, let's see. There must have been seven or eight. It was endlessly recycled. Well, now I'll have to do a new one.*

Mark: Well, now you're on the record. Finally.

Chuck: *When you look back at that image, does it even seem like you?*

Mark: No. I always thought I looked more like Montgomery Clift.

Chuck: *Most people change the way they look right after I paint them. Did you grow that beard right after I painted you?*

Mark: I grew it and then shaved it off. I hate to give your work that kind of power, but that's what I'm here for: to mythologize the work. "Yes, it changed my life. I became a heroin addict." I think I grew a beard and shaved it off, then realized that I didn't have much of a chin anyway and grew it back, and I've been anxious to shave it off again and also scared. Maybe if you would paint me without a beard again, it would be an incentive. I've only painted myself with a beard.

Chuck: *That is one of the things that I wanted to talk about, because recently you've returned the favor. I don't know whether it's a favor or whether it's a punishment, but you've decided to include me in your paintings. I've wondered if you waited until I was in a wheelchair so that you could knock me down to size.*

Mark: I did, yes. Curiously, the work that I've been doing for the last fifteen years has been very small, and there was always something about you that was so mobile when you were mobile. I always pictured you walking away when you were walking, and, also, you are a tall guy. My world is little Jewish people, friends and family, and you always seemed to be a very different kind of presence. But the moment that you sat down, the moment that you couldn't move around, you suddenly seemed like such an interesting person to paint. The first painting, with you and Leslie, was called *The Weight of the World* (1990). It was very moving, very sad.

Chuck: I was very moved when you visited at our house in the country and shot those photographs from which you painted. Boy, was I in rough shape. When I look at those paintings now, I seemed so wasted. I had just gotten out of the hospital. I tried to stand up, which I can do much more easily now, and could just barely hold it for the length of time needed for you to take the picture.

Mark: I remember that I brought my paintings to the hospital for you to look at. I became more open when you were in the hospital, since you couldn't come to my studio and force yourself on the paintings. One time I came in and brought a new painting, and your former shrink was there, and he interpreted the painting for me at no charge. *[laughing]*

Chuck: You and a lot of other people in the art world came to visit and bring news of the outside world. Probably the funniest period was when I wasn't able to sit up. When I sat up, I would pass out; I couldn't get close to vertical. They had a tilt table, which was sort of like the table that Frankenstein was on before he became alive. They tilt the table slowly, closer and closer to straight up and down, so you can get used to being upright. I was strapped to this goddamn table. When they do this in the hospital, they don't even notice that they have faced you toward a wall, so you spend an hour strapped to the table, staring at the wall, or if you are facing out, you see a bunch of other people in wheel- chairs and a lot of drooling stroke victims. You came to visit and read art criticism to me while I was strapped to the table. I remember that you read Peter Schjeldahl's review of Jeff Koons in the maga- zine Seven Days.

Mark: Which was hilarious.

Chuck: It was so funny.

Mark: Chuck was dying to laugh. He was vertical, so he must have been ten feet off the floor with very little ability to actually laugh out loud.

Chuck: My lungs were compromised, and I couldn't really laugh.

Mark: But you were dying to laugh.

Chuck: I had tears running down my cheeks and all over my "strait jacket," which was the straps that held me to the table.

Mark: It showed the power of a really wonderful, funny critic. It gave you a certain kind of immense pleasure. I don't remember what was so funny about it, do you?

Chuck: No. It was about the silver bunny show. What year was that? 1988?

· · · ·

Mark: So far, having this conversation taped has not changed the way we talk to one anoth- er. They always said that the documentary about the Louds destroyed their family, but we're just talking like we normally do.

Chuck: You have, in the past, made disparaging remarks about my media absorption, with com- ments about how Loud-like I am—

Mark: —how comfortable you are with public situations.

Chuck: So are you Lance Loud? ["An American Family," an episodic cinema verite documentary about a real life family, the Louds, was shown on PBS in the seventies.]

Mark: No, I'm not Lance. I can't remember anyone else's name. He's the only one I remember. Maybe Albert Brooks—

Chuck: —in Broadcast News in which he sweats profusely. Quick! Bring the powder puff.

Mark: Make-up, please. [laughter] So what did you and Joe [Zucker] talk about?

Chuck: We talked a lot about the sixties. We talked a lot about the political climate and what it was like to hide in the studio when all that was going on in the street. You're someone who's hidden in the studio through good times and bad, and I know that for you, as for me, the best times are when the Republicans do something stupid. The Watergate hearings and the Iran-Contra hearings were golden times for anyone who was in the studio.

Mark: Talking about work again, one of the things that strikes me is that you have always taken pleasure in your career and in being an artist in the community of artists in New York— I've always lived away from New York City—but you have never talked about your pleasure in the work itself. Since your injury, however—do we call it an injury?—

Chuck: Event. We call it an event.

Mark: —you've talked so much about the joy in working. For me, since I also teach, the studio time never feels like pleasure, exactly.

Chuck: God forbid.

Mark: It feels good in a sado-masochistic way. It has its own benefits. But am I right in saying that your perception of your relationship to the work has changed?

Chuck: The element that was always the most pleasurable to me was the physicality of painting, pushing the paint around. When I was in the hospital, you were one of the first people to rush to my side. Did we talk about what I was going to do?

Mark: Yeah.

Chuck: We talked about making little paintings with my teeth and stuff like that?

Mark: Spitting the paint onto the canvas.

Chuck: We talked about that if I couldn't make work, it would have to become conceptual. The one thing that I really worried about was whether or not I was going to be able to have the pleasure of the physicality of painting. I was talking to my assistant Michael yesterday, and he reminded me of that, because he was the first person who tried to help me paint in the basement of the hospital in that hideous little room.

Mark: It was amazing that you could paint there.

Chuck: I was so exhausted. Also, I had totally forgotten that every time I painted I would break down and cry and say, "I can't do it, I can't get back to it," but, ultimately, I finished that first painting of Alex. [Alex II, 1989.]

Mark: It's a wonderful painting.

Chuck: Since then I have had greater pleasure in the act of painting, and painting fills a larger portion of my time, when I'm not being filmed. [laughter] Maybe I simply have more eggs in that basket, but it has brought me real pleasure, and it is one of the only things that I can still do. There are so many things that I used to love to do. Whack down brush, and mow lawns, and build things, and dig,

and haul stuff, and walk on the beach, and rough-house on the grass with my kids, and swim in the ocean. Thank God the one thing I can still do happens to be the thing that, aside from my family and friends, means the most to me.

Mark: Were any photographs taken of you working in the rehab room?

Chuck: I had a photographer come in and shoot the whole thing, but I've lost the slides.

Mark: Isn't that interesting.

Chuck: I think I may have lost them on purpose.

Mark: When you made that first painting in the hospital basement, you were working in the most depressing room. It had stained, green carpets, and there were paintings all over the walls that were done by people who were obviously trying to rehabilitate themselves. They all looked like Metro Pictures appropriation paintings, fake van Goghs, or abject garage-sale type stuff.

Chuck: A wood-burned version of The Last Supper.

Mark: They were hanging on strings.

Chuck: Like a clothesline art sale. That is probably the most vicious thing done to people in rehabilitation medicine. It's hard enough to make a painting if you have everything going for you; otherwise, there would be a lot more good painters. To take someone who has been paralyzed, who has never before made a painting, and expect them as therapy to make a painting is cruel and inhuman punishment, but once you already know how to make a painting it's not so hard to get back to it. You just find another way to spread the paint around.

Mark: I remember teaching summer school one particular year. For some reason, it is believed that it's a good thing for disabled people to learn to draw, and I had three students who I think had muscular dystrophy. It was so frustrating to assume that people who can't write their names can somehow be helped by trying to learn to draw a figure.

Chuck: When I went into occupational therapy, I thought, "Great, they'll help me get back to my occupation," but instead, it's all about stacking spools on top of each other.

Mark: Which is what your occupation is about. *[laughter]*

Chuck: I think they're preparing you for no career at all. That is really what it amounts to. In fact, doctors would say to me, "What was your occupation?" These were rehabilitation doctors who should have been encouraging, but instead, their assumption was that the patient would never again do what he used to do. It took some pressure, especially from my wife who really pushed the therapists, to help get me back to work. She said, "You have to get him back to work, or he's not going to be fit to live with."

Mark: *One assumed that there would be wonderful technologies that would enable you to hold a brush, but their device was like a pipe cleaner or something, and that was literally the best that Phyllis, your rehab person, could offer. She was wonderful. I remember Leslie and I were devastated by how low tech the whole thing was.*

Chuck: I now go to physical therapy in a sports medicine program because sports medicine is sexy and hot, and they've got lots of money. Rich people have skiing injuries and jogging accidents, so there's lots of equipment. There's nothing like that in rehabilitation. It's interesting that you were talking about how depressing it was. I had a good time there, which is sort of bizarre. I think it was even harder for people who loved me than it was for me. I think it's harder to watch something happen to someone you

love than it is to go through it yourself. I couldn't see rehab as ugly. If I had seen it as grotesque, ugly, and awful during the eight months I spent there, I would have gone out of my mind. You and Leslie went over to see it while I was still in intensive care, and Leslie was devastated. She came back and tried to prepare me for how awful the place was: broken bodies and stroke victims sitting around drooling.

Mark: There was one guy always in the hall with his mouth open, and he eventually died.

Chuck: They eventually closed his mouth. After I graduated and left, I went to my house in the country for the summer. When I came back in the fall to start outpatient therapy and rolled into the same place in which I had spent eight months of my life, it looked horrible, and it shocked me. I couldn't believe this was where I had been, and I realized that I had not allowed myself to see it in that way because it was a place where I needed to be, and I needed it to be positive. It couldn't be the snake pit that it really was. You know, it's interesting that people look at me and see someone who has been changed. They see me in a wheelchair. I sit and look at the outside world, which is unchanged, and when I roll by a full-length mirror, I even shock myself. I think, "Who is that guy in a wheelchair?"

Bill Bartman: In your dreams what are you?

Chuck: I almost always walk in my dreams. I've had dreams in which I was in a wheelchair and all of a sudden I could get up and walk, and pretty soon I've walked several blocks. Then I walk through the city, and then I walk on the paths that I used to take to get places.

Mark: It's always struck me as ironic that, at least initially, you always talked about your work in very formal ways and claimed that your work was about facts—the passport photo notion. My work was about feeling and story, although I don't think painting really tells stories because a painting is a single image. I always felt that even though I was looking at the life of Christ or whatever, I didn't know what was going on. Was he bad or was he good? What was he doing up on that cross? Did he want to be up there? Was he part of some sort of S&M cult? What was he saying to us? There's a kind of ambiguity built into single images that I love in painting. I mean, film can be a narrative medium, and literature certainly has a kind of narrative potential that painting doesn't. The assumption of narrative content in painting is something about which we've always talked and argued. You've sort of come to a very different place, and your work has been seen very differently over the years in terms of its psychological reading or in terms of people as humans.

Chuck: I used to not even call them portraits. I used to refer to them as heads. Then I adopted the mug shot for the same reason that the police use it: it provides the most information that can be given. There's something about the police procedure that has run all the way through my work. Later, I did fingerprints. I sort of used all the aspects of booking someone.

Mark: You insisted on the concept that there wouldn't be an emotional resonance, even in a mug shot, but when we look at pictures of criminals or at passport photos with that kind of neutrality, there is a certain level of content and humanity that can't be denied.

Chuck: I always wanted to present the image in the most straightforward and flat-footed way possible, without editorial comment, and without trying to crank it up for any particular psychological reading, but I do believe that the face is a road map of a person's life and that it contains indicators of what kind of life he or she has led. If someone has laughed his whole life, he has laugh lines, and if he has frowned his whole life, he has furrows in his brow. I think the picture that I did—you see I even

call it a picture now when I normally would have called it a painting—of my wife's grandmother Fannie was perhaps the ultimate realization that what I was doing was, in fact, far more about the person than I had ever realized myself. I think it's often the case that early in one's career, you decide how you want to present your work. I was very concerned that people see my work in a particular way. I wanted to make paintings that were about the time in which we lived, and I was denying any connection with the history of traditional portraiture. I wanted to make it twentieth century. I was concerned with things like all-overness, which was a modernist issue from Pollock, and that sort of thing. I tried to extend it to the portrait. I tried to make every piece the same and every piece interesting or uninteresting in the same way. As I mellowed, I was no longer interested in having people see the work in exactly the same way as I thought it should be seen, and became far more interested in the way they responded to the work. I think people, especially other artists, have helped me to see other aspects of the work that were always there. I don't think the work was ever as coldly calculated and mechanical as some people thought. It was always more intuitive.

Mark: Physically, there was a lot of Pollock in those early black and white heads, in terms of a kind of messiness.

Chuck: Now people look at the ones that are looser and more open and identify with a more expressionist handling. To them they seem much freer—

Mark: I hate that people see them as more emotional, more expressionistic. It's bullshit.

Chuck: I think there is a real similarity between all the work. This work isn't as expressionist as it seems, and that early work wasn't as methodical and systematic as it seemed.

Mark: You're one of the few people who doesn't subscribe to an art historical belief that expression equals messiness or that the cold calculated nature of my work means that it is not about feeling and strong emotion. It seems as if even the brightest people have this belief that that kind of looseness equals a heating up of an artist's psychological relationship to his models.

Chuck: One of the interesting things about your choice of subject matter is that people are really upset about the violence that occurs in your paintings.

Mark: The so-called misogyny in my work bothers people.

Chuck: That's right. If you are showing a woman stabbing a man or a man being kicked in the balls by his wife, it is believed that in some way you are advocating that violence.

Mark: It's absurd. Reductive.

Chuck: However, if a filmmaker makes a film dealing with the same content, it's different. Nobody assumes that in Taxi Driver *[Martin] Scorsese is endorsing violence.*

Mark: Certain people get similar heavy weather. For instance, Mike Leigh's film *Naked* (1993) is being called misogynistic, but I think in art—

Chuck: In that case I think they're right.

Mark: Well, you agree. I think a tolerance for art, coming out of Greenbergian modernism, for any kind of subject matter, strong emotion, violence, or sexuality is so rare. I remember all the controversy over the censorship in my first one-painting show at Phyllis Kind's, which was a painting of a man stabbing a woman. One of the most prominent critics in New York at the time, Lucy Lippard, wrote Phyllis Kind a letter chastising her for showing this incredibly chau-

vinistic work of male murder, and she wrote a long piece in the *Village Voice* about it. I wrote a letter stating that that was like saying that Picasso's *Guernica* was endorsing war: just because you picture something doesn't mean you're celebrating it except in the way that picturing something can be about positive and negative feelings. Again, that's always bothered me about art world orthodoxy. Another thing, in terms of your own relationship to history, is that as someone once said—I won't mention who it was—you didn't have a book about any artist that was more than fifty years old. In other words, your shelves weren't filled with books about early Renaissance painting, which is basically true. In my case, most of the artists who I really love, although I'm also very interested in contemporary art, come from the past. That's interesting to me because you're very knowledgeable about work of the past, but we have a very different relationship to history. Yours is probably more a New York art world notion about history, and mine is more like that of an outsider, which is what I am, in that it easily moves back to Giotto in terms of influence and relevancy. [Lippard's article "Retrochic: Looking Back in Anger," *The Village Voice*, December 10, 1979, p. 67–69, prompted Greenwold to respond with a letter to the editor, December 31, 1979, p. 4. Lippard, in turn, responded to Greenwold's letter, December 31, 1979, p.4. John L. Ward discusses the content of these exchanges in *American Realist Painting 1945–1980*, 1989.]

Chuck: It's just been in recent years that I realized that whenever I went to a museum, I tended to look at portraits more than anything else. I realized that I am tagged onto a long series of traditions and inventions of portraiture, some of which I tried to celebrate in the show that I did at the Modern. I tried to acknowledge the fact that there is a long line that leads into my work, although my entrance into the work was training as a "junior abstract expressionist." [Close curated *Artist's Choice: Chuck Close Head-On/The Modern Portrait,* Museum of Modern Art, NY, January 10–March 19, 1991.]

Mark: Mine was too. I'm from the Mid-west. When you were looking at Jasper Johns or [Jackson] Pollock, I was looking at Leon Golub's monster paintings or something. There's such a natural conflict. I don't know, I'm sure we've discussed this in some way, but I have a feeling that you believe that there is progress in art. I think you believe that, like in science, there is a notion of advancement, perfectability, of things getting better and better.

Chuck: I think that there is movement and change but not progress. For instance, the work of the twentieth century is better than the work of the nineteenth century. I do believe that there is movement and change. I think one of the things about the New York art world that is good for art—and bad for artists—is that it gobbles up work and says, "Now, what's next?" It makes for a very dynamic, changing art world.

Mark: It's a journalistic idea.

Chuck: It's very hard on careers.

Mark: I think it's very hard on art because it provides a short-lived notion of what is possible and what is not possible. It provides a very difficult environment in which to make art that might be personal or idiosyncratic.

Chuck: The myth or the cliche in Europe, and I'm not sure that it's true, is that you have your whole lifetime. They don't assess your work until you're an octogenarian. You're left alone until then. I'm not sure if that's true, and it's certainly not as true today, if it ever was true. You have remained outside of the art centers except for a short time in Los Angeles.

Mark: Los Angeles always seemed like a province. It seemed in its own way extremely limited. For example, a figurative painter was not really a presence there. Unless one was working with this notion of light or a kind of finish fetish, one didn't exist. There are a lot of interesting figurative painters and others who aren't really considered Los Angeles artists.

Chuck: *That's why I wanted to leave Seattle. If you didn't buy into the whole northwest grey, mystic, Mark Tobey, Morris Graves thing, and if you didn't look to Asia for your inspiration or maybe to native American sources, you didn't belong. Few artists had gone to Europe, but everybody had been to Japan. I wanted to come to New York, which was a continuation of Western art from Europe. I wanted to make paintings here where there seemed to be a marketplace of ideas about the times in which I lived. New York is a province. It's just a bigger, richer province and a more diverse province. You have never been a provincial person, although living in Albany, you know more about what's going on in New York than anybody I know who lives here.*

Mark: There's an interesting kind of balancing act that people who live in the provinces, people like me, not wanting to be unaware of what's going on, go through. So I'm more obsessed with what's going on. I also think that because I'm a teacher I feel the need to keep up.

Chuck: *You see more shows in New York than ninety-nine percent of the artists who live here.*

Mark: And I probably read more criticism and concern myself more with all that shit.

Chuck: *No question about it.*

Mark: It's an obsession. It's something in which I'm interested.

Chuck: *Let's talk about obsession. My belief, and you may disagree, is that the word "obsession" is tossed around far too casually.*

Mark: It's like the word "creativity." It's like you can "dust creatively." I love this kind of banal humanistic notion of—

Chuck: *I don't know an artist who I would say is truly a compulsive person, who is driven to do something, has no control over it, must do it, but I know many artists, myself included, and certainly you, who behave compulsively, but I think that's a very different notion of compulsion.*

Mark: Do you mean who behave in their art compulsively?

Chuck: *Yeah. Much of what I do is an absolute attempt to overcome laziness and a short attention span—*

Mark: All sorts of dyslexia—

Chuck: *—all kinds of problems. I put myself in a position in which I go to the studio each day and keep working in what appears to be a relatively compulsive way, but for me it's all about not giving in to my slothful and slovenly nature.*

Mark: You've always said that, and I always thought that it was a kind of self mythology or some kind of childhood conception of your behavior. I always felt lazy too. You've been very reinforcing about the fact that if you've got something that's going to take four months to complete, you've got to go to the studio because there's no other way to do it. You don't have a particularly compulsive personality, but you work compulsively. It's like an actor behaving in a certain way, and it becomes, in time, a very positive addiction.

Chuck: I think it's a counter-phobic kind of thing, like people who are the cliche of every actor who is on The Tonight Show *who says, "I'm really shy."*

Mark: And comedians who are dour.

Chuck: And they are on stage performing. I think there's something to that. You end up driven to do the thing that makes you the most nervous, because there is an importance to edge and a kind of resistance. We both have put many rocks in our shoes over the years. It's as if you get credit for the degree of difficulty.

Mark: You don't? Obviously, I feel that I've been a lot more self-destructive in the choices that I've made than you've been: again, making very small paintings that take a year. On two counts I'm punished.

Chuck: People feel that if you make a little painting you're not ambitious.

Mark: That's right. There is that whole notion of scale and what's deemed major and minor.

Chuck: That's why I make big paintings, so people will think I'm ambitious.

Mark: Those stupid assumptions about expressivity and looseness and the notion about scale and ambition are amazing.

Chuck: There is an insular, inward-looking quality to your work that requires the viewer to be contemplative. Your paintings can't be understood in a few seconds; they're very intimate. You've often talked about how you wanted to put them on a book stand so that people would sit and look at them instead of walking by them on the wall. I wanted to make the biggest fucking painting I could so that nobody could ignore the fact that it was on the wall. I used to say that I make them big because the bigger they are the longer they take to walk by. Therefore, they are harder to ignore. I did not want people to go to a Whitney Biennial and not notice that one of my paintings was there. I didn't care whether they loved it or hated it, but I wanted them to address it. I think you want people to find your work themselves.

Mark: Yeah, but I think if my work were in a biennial, it would be easier to find. It's not unlike our different relationships to visiting each other's studios.

Chuck: I was described as remote and distant, which was partially connected to my learning disabilities and other things that have happened in our lives, but I've worked very hard to change as a person, and I think that I relate to people in a more intimate way than I used to.

Mark: Of our circle, you were certainly more resistant than I was to therapy, although I was pretty resistant as well. I remember when you first went to some male piece of shit psychiatrist. At the first meeting he immediately psychoanalyzed your paintings and saw them as aggressive—

Chuck: —and controlling. He saw them as masks. He said that I was hiding behind a mask.

Mark: It was the last thing in the world that you wanted to hear at that time, but those are aspects of the work that you would probably endorse now. Again, it's keeping people there.

Chuck: What about the relationship to the model, to the subject, to the person who you paint. You have a kind of ensemble cast of characters in your life who inhabit your paintings: your wives, former and present.

Mark: Often my wives are made into half-animal/half-human hybrid forms that I like to call sphinxes.

Chuck: *You placed your former wife's head on a dog's body. You called it a sphinx—*

Mark: It's kind of a mythological idea. You know, the endless loop of unanswerable questions. [*The Addiction of Innocence*, 1992.]

Chuck: *—and she called it "my head on a dog." [laughter] There also are your father, your sister, your children. There are pictures in which your son, when he was younger, was shooting you, and you found someone who looks exactly like your first wife to stab.*

Mark: That was pre-therapy, and when I made it, I thought I was happily married. I thought I was making a fantasy, a fiction. Retroactively, I realized that the painting might have been about us. I also dedicated it to her in a very loving tribute—this painting in which I was murdering her. But again that's the dark side. [*Sewing Room (for Barbara)*, 1975–79, oil on canvas.]

Chuck: *The divorce series. The get-out-of-my-house series.*

Mark: There was only one "get-out-of-my-house" painting. It just seemed like more. I took the photographs for that divorce series while I was happily married, and about six years later I painted those images about the family, but obviously this family had broken up.

Chuck: *A sort of dysfunctional family.*

Mark: Show me a family that isn't. I dare you! *The Broken Home* (1983–84) painting of a boy shooting his parents with a gun was an imagined drama that summed up the failure of my first marriage. I worked from photos many years after the fact.

Bill: *Chuck, have you had any similar experiences in which a photograph was taken but not used right away?*

Chuck: *Many, and there are also many images that I recycle. You recycle the same photograph in a collage way. You place the character into a different painting or use different views that were shot on the same day, and you use the interiors and exteriors from house magazines.*

Mark: When I painted you and Leslie, I put you in a different environment from the one in which you posed. You were never in that environment. People thought the paintings were of the Hamptons, but the paintings were of a house in Minnesota that I particularly liked. It's curious that what people see they assume is true—that whole concept of fact and fantasy.

Chuck: *You also have people in your paintings to whom you're not particularly close, as well as paid models. Especially the nudes. You can't get us to take our clothes off.*

Mark: I don't want you to take your clothes off. [*laughter*]

Chuck: *I've been recycling some of the same images for twenty-five years.*

Mark: What generates your interest in them? You mention this Philip [Glass] image. It looks as if he's capable of movement.

Chuck: *Phil's image has a little too much animation. I like them to seem on the verge of moving rather than as if they are moving. Alex [Katz], with his teeth bared in that bulldog look, was very animated when I photographed him. He grimaced a lot. He changed a lot when he was posing, but I still got that frozen moment. I want that moment, but I don't want it to look like—*

Mark: —Munch. We've always argued about Munch's *The Scream*. I love that painting, but you've always said that's exactly what you don't want—that heated, hyperbolic moment, so your passport model still exists to some degree.

Chuck: In the artists' series that I started in the eighties in which I did Francesco Clemente, Alex Katz, Lucas Samaras, and Cindy Sherman, I got Cindy to pose in some very unusual poses. They were not always just frontal. More often than not I would have their heads slightly turned. Initially, I wanted to get away from composition. I found a formula for fitting the figure into the rectangle, which meant that I didn't have think about it anymore. It always fit in so far from the top edge and centered from left to right.

Mark: Do you miss having those choices or compositional possibilities?

Chuck: No, not at all. It's liberating not to have those choices. I enjoyed taking photographs of other things. Parts of bodies, flowers, nudes, and other things, but I haven't wanted to put them into a painting.

Bill: When you recycle an image as you've done with Alex many, many times, is there a different reason each time for doing it?

Chuck: The great thing about working from a photograph is that it's like a well to which you can return again and again and each time get a bucket full of different stuff from it. If I am looking for a certain thing in the photograph, then I make one kind of work, and if I deal with some formal aspect of it or make a different choice of material and technique, I will find entirely different elements embedded in the photograph.

Bill: Over the years that you've been painting that image, during which you've obviously had an ongoing relationship with Alex, have the choices of how to use the image been affected by whatever personal relationship you had with Alex?

Chuck: The case in which that is most true is probably in my relationship with Lucas. I've made several images of Lucas over the years. He has, more than anyone else, generated a particular kind of image with which to deal. He so intensely poses, and he holds it for just the split second the camera lens is open. He pumps himself up, and he makes this face and kind of stares you down. The fact that I know Lucas, that I know that he would control your every thought if he could, that he likes to intimidate you and make you uncomfortable, sometimes creeps into the work. The choice to make the piece with concentric circles radiating from where the third eye would have been is a nod to the kind of mind control Svengali relationship he likes to have with virtually anyone to whom he talks. So, to a greater or lesser degree, I think personalities influence some of the choices that I make.

Mark: This reminds me of one of the best quotes in your Vija Celmins book. I don't remember who said, "People think, artists think, and very sophisticated people think that if you're looking at a photograph you're not looking." Especially in academe, if something is in front of you it has a kind of aliveness, a literal aliveness, but a photograph is dead and therefore incapable of releasing information. You're not seeing anything, or worse, you're cheating.

Chuck: Do you work from photographs or can you really draw?

Mark: Again, that someone would have a complex, ongoing relationship with a photograph and get beyond the levels of its literal reality is very different from just copying the photographic facts. I work from photographs, but unlike Chuck, I have no interest in the work having

any kind of specific relationship to photography except a very pragmatic one: I need it. As Vija does. I don't get the feeling that she wants her work to look like a black and white photo.

Chuck: You get down to an almost cellular level in the making of your things.

Mark: Molecular, which may be more photographic in the long run, although I mostly want to deny that.

Chuck: Your work almost duplicates the grain in a color photograph. In fact, you seem to love what are considered to be the mistakes in color printing: the kind of color edges around objects when they weren't registered perfectly. All of this ends up being a part—

Mark: A lot of this has been done without a great deal of intentionality. I've just stumbled along.

Chuck: You're just looking at it.

Mark: There is that focusing aspect that we both love: in photographs we break down the image into doable fragments that we can endlessly examine.

Chuck: And the rest of the figure hangs out of the rectangle.

Bill: What was your response, Chuck, to seeing your image in Mark's paintings?

Chuck: A lot of people have photographed me over the years, but very few have actually put me into paintings. Your work is work that I love and of which I have been a big fan since I first met you. Being in your work was like being let into a club or a fraternity or something, and I felt a real emotional response to it.

Mark: I've often pictured you in not terribly flattering ways, in vulnerable ways, as in the picture that I've just finished.

Chuck: I didn't flatter you either, did I?

Mark: Well true, but you've never acknowledged until this moment that you were fucking with me. I've shown you in very fragile moments, physically, and in moments in which you're not particularly aware of being in the world. Did you feel that I was violating—

Chuck: I felt that you were ruthlessly exploiting me. [laughter]

Mark: Yeah, I was trying to do that. It didn't work. *[laughter]* I will continue to try.

Chuck: No, I thought that it was very loving. I chose to see it as very loving and tender.

Mark: Exactly. Again, you and I know that painting someone about whom you really care— there's a kind of ritual relationship to that. It also holds for self-portraiture.

Chuck: As a kid, the first paintings that I saw were on the cover of The Saturday Evening Post. *I'd never seen a real painting. I used to scrutinize the covers of all the magazines in the forties. I used to try and decode them. I would look at them with a magnifying glass and try to figure out how the hell they made them. More than anything, I wanted to be an illustrator, and I wanted to do* Time *magazine covers. Recently—well actually for the last twenty years—I've been asked to do* Time *magazine covers. Previously, I would have done anything to be able to do one, but, of course, now I don't want to do them. The main reason that I don't want to do them is that I am not friends with the people who I would be asked to paint. They wanted me to do a portrait of Clinton for* Time's *Man of the*

Year cover. I've never done commissioned portraits, and I've never worked from other people's pho-tographs, and I don't want to make a painting of someone I don't know. It just doesn't interest me.

[Close has made exceptions to this policy. On August 23, 1996, he photographed President Bill Clinton in the Oval Office to raise money for can-didates who support federal funding of the arts in the United States. The *New York Times*, for its May 18, 1997 Sunday magazine section, commis-sioned a group of photographers, working in styles that range from strict documentary to conceptual work, to photograph different aspects of the revitalization and transformation of Times Square. Close was selected to photograph a selection of actors opening on Broadway during this season, including Stockard Channing, Willem Dafoe, Rip Torn, Julie Harris, and Christopher Plummer.]

Bill: **So everyone you have painted is someone to whom you feel close in some way?**

Chuck: **Close in some ways, but not always in the same way. Some people I've painted are people with whom I have a relationship more through their work than with them personally. Their work speaks to me on some level, and I feel we have a relationship; maybe I've gone to all of their shows for ten or fifteen years, and I feel as if I have some connectiveness to them that is important. It is not nec-essary that they be my lifelong best friend.**

Mark: Also, when I think of your work, your relationship to self is so—I'm not going to say narcissistic because I don't think it's simply that. I mean, the kind of intensely personal rela-tionship you have to painting yourself is very powerful. Often your best painting, or one of the best paintings in a show, is of yourself.

Chuck: **I typically have a self-portrait in every show.**

Mark: Especially recently the self-portraits have been so poignant. I've wondered whether you allow certain aspects of feeling to exist in your self-portraits that you wouldn't allow to exist in a Samaras or a Katz.

Chuck: **I think I have a similar arm's-length distance to my own portraits. In fact, I've often referred to myself as "him" while I'm making the painting. It's almost necessary.**

Mark: You don't think this is denial?

Chuck: **Probably, but it may be necessary in order to make the paintings have a little distance. I tried to be as uninterested in making me look attractive as I am uninterested in making other people look attractive. I'm sure I'm as vain as the average person, but I try to be as ruthless with myself as I am with everyone else.**

Mark: I thought you allowed a certain lack of vanity and public persona, as if you knew your-self better, and you'd have been bored painting yourself in a way that would have looked cool. Again, there seems to be something more intimate—I don't know how to characterize it—in your recent paintings.

Chuck: **There was never anything all that cool about doing portraits. When I started making por-traits, it was pretty unlikely stuff to make. No one was very interested in work like that. If I had been trying to make something cool, I would have made something else.**

Bill: **When you were making the painting of Mark, was your studio open to Mark to come and look at it as a work in progress?**

Chuck: **Yeah, people can come and see it as often as they want. Usually they don't. Usually they come in once or twice in the middle of the painting or wait until it's completed.**

Mark: Our relationship is sort of funny in terms of logistics. I mean, it's not funny to us. We

talk at least once a week and generally a couple times a week, and I've tried through the years to see Chuck once a month to go to galleries. When he was mobile, he would also come upstate quite often.

Chuck: *We still do the galleries like madmen. We rent a car and go from gallery to gallery and even trudge through ankle-deep snow.*

Bill: *What was your reaction when you saw the finished painting for the first time?*

Mark: I knew the photograph, the image, for quite a while before he painted it. I don't think there was an epiphany. It is so gradual, and the process is so slow, and the work itself is so formal. I remember him being really pissed off about this painting. I remember there was a lot of frustration in making it, maybe because it took so long. But it had a kind of density, a kind of physical all-overness that interested me. I always thought he took longer on me because I take so long. I've often critiqued Chuck's paintings, and he does the same with me.

Chuck: *Having an old friend, a trusted eye, look at your work is so important—someone who's been there all along.*

Mark: Yeah, friendship. Chuck can sometimes be a really tough critic. He's always said that magic isn't magic to another magician.

◆

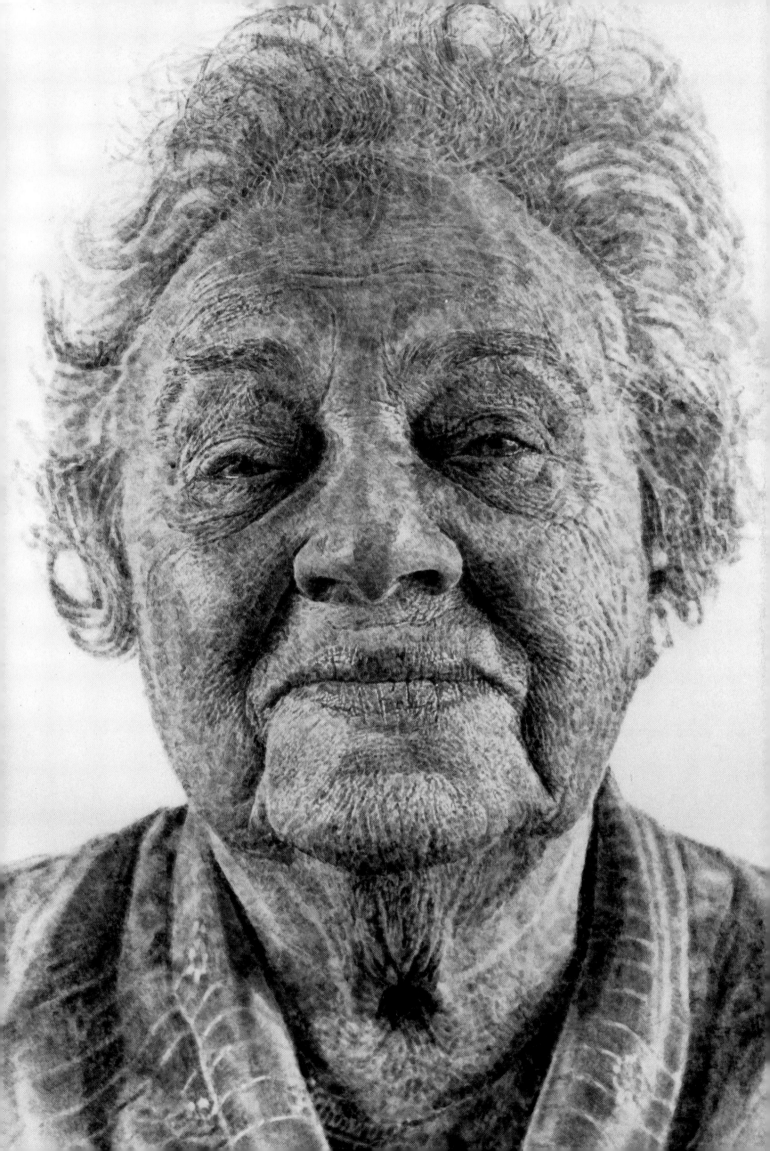

Georgia Close

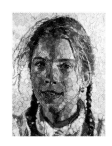

New York City, June 20, 1995

Bill Bartman: **Here we are. Finally.**

Georgia Close: **Being interviewed by my own father. I have to hear his voice everyday, you know.**

Chuck Close: You usually aren't up before I leave, and you come home after I go to bed.

Georgia: **I'm not that bad.**

Chuck: What we've done in these interviews is have the artist talk about what the art world has been like. The conversations have collectively ended up being a portrait of the art world from various points of view ranging from ninety-year-old Paul Cadmus to young artists, but since you grew up in SoHo in the art world—

Bill: —and lived in a building in which your parents were the only married couple—

Chuck: There were a lot of married couples in the beginning, but by the end I was the only male mascot in the building.

Georgia: **I was certainly the only child. I was the only person under thirty-five.**

Chuck: You were one of the only children in all of SoHo. You were born in '73, and we were already living on—

Georgia: **It's good that you remember in what year I was born.**

Chuck: What was it like growing up in SoHo?

Georgia: **I don't know. I think SoHo, at least when I was there, was very different than it is now. It was mostly artists. Broadway today basically looks more like Madison Avenue than anything else. I loved growing up down there. I learned how to talk to adults, or adults in the art world, before I learned to talk to kids my age. I remember sitting at openings, or going to galleries, and having to amuse myself by sliding on the floor in my socks. I was in a stroller looking at art before I could talk. I love the way I grew up. I think most people are very quick to admire other people's childhoods. I definitely went through that phase. All of my friends at Dalton were the sons and daughters of CEOs of huge companies, and I lived in this loft down in SoHo, but in retrospect, I really appreciate the way I grew up. I have a knowledge and an interest in art that I think is incredibly valuable, and I'm aware of it all the time. I'm twenty-two and I was dragged to art shows during my whole childhood, but I still come to New York**

and actively seek out shows. I have to go to the Whitney Biennial. It's wonderful, There were days when I was bored as hell, but you know, I don't regret it at all. I loved it.

Chuck: We took you to the Museum of Modern Art in a snuggly bunting pack when you were three or four days old.

Bill: **Do you remember that?** *[laughter]*

Georgia: **My memory isn't that good.**

Chuck: We were guaranteeing that you would not end up being an artist, although you thought that you might want to go into art before you saw the light.

Georgia: **Actually, I regret it in a lot of ways. I was protecting myself from the "Julian Lennon Syndrome"—prominent father in the art world—but I loved looking at art. I loved growing up the way I did. I grew up with a real appreciation for it, and I loved making art, I loved painting, I loved drawing. I went to Yale thinking, "Okay, I'm going to Yale because it's got a great art department," and my first semester at Yale, I ended up a psych major. I think that I don't paint or draw recreationally because I don't know how to do it that way, but I don't think that I was brought up in such a way as to ensure that I wouldn't be an artist.**

Chuck: In every photograph we have of you in childhood, you're either sitting in a gallery or sitting in a garden.

Georgia: **The gardens. I definitely had more of an affinity for galleries than for gardens, but I'm sure there are photographs of me rolling my eyes with a pained look on my face. It definitely wasn't all fun and games, but I don't regret it at all.**

Chuck: There were very few kids in SoHo.

Georgia: **Yeah. I had a few friends from Grace Church who lived in SoHo, but most of my childhood friends were children of artists: Jesse Alexander, who is Brooke Alexander's daughter, and Andrea Snelson, who is Kenneth Snelsons' daughter, and Alexandra Posen. I've kept in touch with those artists' children. We talk about the fact that we grew up very differently from a lot of other kids. A girl in my third grade class came to our loft and cried and said that she wanted to be taken home because I lived in a bad neighborhood. She lived at Seventy-second Street and Park Avenue.**

Chuck: She said, "Ugh, you live here."

Georgia: **I cried for days. I was mortified. "Why can't we live on Park Avenue like everyone else? I live in a slum."**

Chuck: And then we moved uptown.

Georgia: **And now I want to live down there again.** *[laughter]* **Now I can't stand living uptown. When I went to Grace Church School, most of the kids lived in SoHo, and that's how I had friends who lived in my neighborhood, but once I went to Dalton, there were only the six of us who had to take the bus to school. Being a child in New York City is very different from growing up with a huge backyard and woods. I really talk to friends of mine at school who came from suburban families. One of my good friends is from Durham, North Carolina and has this huge forest behind his house. He said, "I can't believe you grew up in New York and you didn't have woods to play in, or a backyard to romp around in," but I learned how to**

amuse myself in a huge gallery space, which was my own sort of arena. I did more imagining, and running around, and creating games, and sliding, and whatever in a huge open SoHo gallery space than I did in the park. That was my version of what my friends who grew up in the suburbs and in the country did, and I thought that was great.

Chuck: Of course, we always had a summer house, too. I remember you saying when you took art history—what course was it? The History of Painting since 1945?

Georgia: Painting and Sculpture post-1945.

Chuck: You said it was as if you were going on a tour of SoHo. It was about Janet Fish and Richard Serra.

Georgia: It was about all the people that we have over for dinner. It was bizarre. It was bizarre having my art history professor talk about you for an hour. I was sort of hiding in the back of this lecture hall in the British Art Gallery, and it was very strange. They were talking about Lucas and Alex Katz, and it was extremely weird.

Chuck: Tell them what your midterm exam was.

Georgia: Oh yeah. My final exam for that class—and they must have known who I was. I know that my teaching assistant knew who I was. The main essay was a comparison of your painting of Grandpa and Lichtenstein's *Hopeless.* I laughed so loud in the middle of that exam that everyone turned around. I'm sure they thought I was a freak, but—

Chuck: At first you were pissed off.

Georgia: Well, I was pissed off because everything she had ever said about you in that class was a scam. It was a real window into art historians for me because I sat in my art history class at Yale and listened to what they had to say, and I took everything they said as being the word of God, and then she tells me that your fingerprint paintings are a parody of the abstract expressionist gesture. I was gagging in the back row. Another major point of hers—she put up a slide of your painting of Joe Zucker and said—

Chuck: And Joe lived in our building.

Georgia: She said that Chuck Close always paints portraits of people as they really are, he doesn't cover pimples, he doesn't cover blemishes, and Joe Zucker was the one person who came in dressed absolutely, completely differently. The chances of her picking that one painting—I couldn't believe it. It was really a trip for me to sit in that class and listen.

Chuck: You told me that even though you were pissed off that that was the exam, at a certain point it occurred to you that you would at least get that part of the test right because they couldn't say, "You don't know the artist," or "You don't know the subject," because the subject was your grandfather.

Georgia: Interestingly enough, although I really wish I hadn't done this, I decided to give her her view of your painting rather than my own because, obviously, what she said was totally bogus. I sat there for ten minutes and thought, "Okay, I can either give her what she wants to hear and verify everything she's ever thought about your work, or I can give her what I really think, or what you really think." I figured it was a gamble, but it was my final exam, so I wimped out and gave her what she wanted to hear, and to this day I really wish I had said what I thought.

Chuck: I have no trouble with public speaking, and I never blank on things to say, but when Maggie was about six, she brought her class from Ethical School to my studio. She was sort of freaked that

her whole class was in my studio, and she was nervous about it, so she insisted on sitting on my lap.

Georgia: I did that, too. I remember doing that.

Chuck: Just as I was beginning to open my mouth and talk, she looked up at me and said, "Daddy, how come you say "uh" in between every word.

Georgia: You lost it.

Chuck: That was it. I became so self-conscious about saying "uh" that I couldn't talk. It was the only time that I've ever been really inarticulate. What was it like to take art courses?

Georgia: In high school? A nightmare.

Chuck: What about in college? We should just say for the record that you just graduated from Yale in psychology.

Georgia: With a B.A. in psychology.

Chuck: Psychology, which in our family, is like going into the priesthood. The family religion is psychotherapy.

Georgia: People keep saying to me, "Do you want me to pull some strings for you?" and, "Do your parents know anyone?" I tell them the only people that we know are artists and shrinks. Art has always been something that came naturally to me. I took art for years and years and years. At Dalton they have an amazing art department, so I had a ton of things to choose from. I took nude drawing with models when I was fifteen, I took still life painting, there was printmaking and all this stuff, and it was really difficult for me, partially because I had to be "that much better" than the next person. There was a teacher in high school who taught me graphic design, which was actually the last thing I was probably interested in. I took her design course for three years, and she made my life a living hell. For instance, we would have to paint a series of self-portraits, and the joker of the class would draw something like a smiley face, and she'd take it and smile and say, "That's very inventive of you." I'd do a huge oil painting study in three different mediums. I'd do oil painting, watercolor, and pastel, and I'd work my butt off for a week, and she'd throw it back at me and say, "It's a piece of shit," and I would freak out. That's really why I didn't end up as an art major. I was sick of that. I took a photography class in college from a photographer whose work we happen to own. She's actually sort of apologetic to me about the whole experience. I know that I was incredibly difficult, and I intentionally took bad photographs, intentionally sabotaged my relationship with her. She had pulled out your book and said, "Why are you denying your heritage? Why are you denying who you are? Look at the way your father uses light sources, look at the way your father angles the camera," and I sort of said, "Well, fuck you," and really never took a decent photograph after that, never really tried to, spent no time in the darkroom, and was so angry at her. I was so sick of it that I decided, "This is it, forget it, I'm not doing it anymore."

Chuck: The world needs more shrinks more than it needs more artists.

Georgia: Well, not in New York. In New York there's a shrink and a Gap on every corner.

Chuck: We should get the Rizzoli book, which has a lot of images of you, and maybe we can talk about them. When you were about eleven years old, you made that oil painting of Bob Elson. You had real art materials.

Georgia: Oh, I loved that. I loved the pastels, because when you're a little kid, you open up all those drawers and stuff, and you have hundreds of thousands of pinks. I loved it. I remember going over there. The only thing that I didn't know how to do was the paper pulp pieces. I didn't quite know what to do with those, but I always had great art supplies, and I really loved to draw separately from my father, so it was great.

Bill: *Do you have pieces of Georgia's?*

Chuck: *Oh sure.*

Bill: *Mixed in with all the other artists.*

Chuck: *We had an altar, essentially, in the country. Remember that glass chest with all your stuff in it?*

Georgia: The plasticine face of Mark Greenwold was in there too.

Chuck: *Yeah. Georgia had a wooden sculpture. Remember that one with the green shape of the—*

Georgia: Ugh, I hated that.

Chuck: *It was on our coffee table for years, and all kinds of people would look at it and ask, "Who did it?" Actually, the painting you did of Bob Elsen was a better Alice Neel than almost any Alice Neel that you've seen.*

Georgia: I also did a drawing of Alex Katz. I'd often do you, but I never did Mom, which is interesting. I think she takes it personally.

Chuck: *That's okay. She's a hard one to please. We'll look at some of those pictures of your mother that she hates.*

Georgia: When I was in fifth grade, I made a mask of you. They told me I had to do some fantasy figure, but I wanted to do you. I ended up making a big clay mask of you with an eye patch, so you ended up being "Pirate Dad." I cheated. I also used to make images of you, not of Mom. I know how to caricature your face better than Mom's. I don't know why. Maybe it's because I've seen you paint you.

Chuck: *It's also easier.*

Georgia: You look more like a muppet.

Chuck: *Look at this dot drawing of Grandma Fannie with what-do-you-call-it, the cookie lady thing.*

Georgia: The cookie lady. God, I haven't thought about the cookie lady in years.

Bill: *Who's the cookie lady?*

Chuck: *Oh, it's a pin that she always wore. What do you call those kind of brooches? Cameos.*

Georgia: Well, I called it the cookie lady because I had no idea what they were called—

Chuck: *—and it looked as if it was made out of dough. Here's an early watercolor version of your mother, done in the year that you were born.*

Georgia: Mom hates this image. She claims that she was sick, although she's making the most distinguished, pained face in this picture. I love it.

Chuck: *I thought it was such a beautiful, loving image.*

Georgia: I love this painting too. This is one of my favorite paintings, and she hates it.

Chuck: *She does an impersonation of it by sticking her lip out.*

Georgia: Well, I think she looks beautiful. A lot of people, when this was in the Yale Collects Yale show, thought it was me, which is interesting because I don't think we look that much alike, and my hair is certainly curlier than that.

Chuck: *So is hers now.*

Georgia: I love this image. It's one of my favorite paintings.

Chuck: *Here's Grandpa Nat.*

Georgia: Oh, Grandpa. You know, he doesn't look much older now. I always thought that these two paintings were more similar than most, but I don't think Mom will admit that she and Grandpa were more similar than she and anyone else in this book.

Chuck: *When I did the first painting of Grandpa, we had no walls in the loft, we slept on a mattress on the floor, and there was this image of Leslie's father looking at us. It was very difficult. We built a wall right away. We couldn't go to bed with Grandpa looking at us.*

Georgia: There was a fingerprint painting of Mom in my room in the Hamptons when the upstairs used to be all one room. For years it faced my bed. I turned it facing the wall, and Mom was really pissed. She immediately wanted to analyze why I couldn't have her looking at me, and know what I had done recently that made me unable to have her look at me.

Chuck: *Here you're about eleven. Back up. There's some more of you here. Uncle Mark. There are all of my pastels.*

Georgia: This is quite an outfit you have going in this picture, Dad.

Chuck: *Actually, in the slide that I always use in lectures, you were sitting on my knee while I was working on that—*

Georgia: Love the shorts.

Chuck: *Here's a fingerprint drawing of you that was done in '81. You were still at Grace Church because you're wearing the uniform.*

Georgia: I still had my chipped tooth. That's an image of myself that I remember only because I've seen it reproduced so many times. It's probably from a time in my life that I wouldn't remember.

Chuck: *This is the collage that has hung over our fireplace in the city since we've moved uptown. It's one of my first pulp paper collage pieces. Do you remember that one?*

Georgia: Yeah, I loved that.

Chuck: *It looks like the bottom of a dried-up river bed or something.*

Georgia: It really is very weird for me to see my image in paintings. It still is. I have never really gotten over that. When you brought home that phone card from Japan, it was the most bizarre thing.

Chuck: *I did a color finger painting of Georgia, which was sold to a Japanese museum. In Japan, they sell phone cards like the ones they use in Europe. Essentially, it's a credit card that gives you ten calls.*

Georgia: It's the only way to make long distance calls.

Chuck: *They reproduce paintings from Japanese collections on all of these cards, and apparently the most common denomination has the color finger painting of Georgia. So, all over Japan, people are busy stuffing Georgia into the phone booth.*

Georgia: I think I should take credit for the boom in Japan. It's just my face that causes everyone to make phone calls as much as possible!

Chuck: *Well, it's certainly appropriate since you make a phone call or two yourself.*

Georgia: Mom is my rival for the phone title.

Chuck: *That piece was done in collaboration with Joe Wilfer who unfortunately just died of a brain tumor. I'm going to his memorial service tonight. Oh, here's the color finger painting of you that was made when you were a little bit older.*

Georgia: This is the face that I most associate with the way I look now. Was that in '84 when I was nine?

Bill: *One of the repeated things in the interviews is your father's fantasy that if he were Ayatollah, everybody would have to wear name tags.*

Georgia: Yeah, I know. You should see him say, "Oh hi! How are you?," and, as we walk away, "Who was that? I have no idea."

Chuck: *Well, learning disabilities run in the family too.*

Georgia: Okay, but I have no problem with names. I'd be a pretty bad shrink if I had to say, "How's your husband, what's his name?"

Chuck: *Here's the big color fingerprint of Mom.*

Georgia: Woo, that could spark some nightmares, that huge Mom. *[laughter]*

Chuck: *And here's a big black and white finger painting of Grandma Fannie.*

Georgia: This is one of my all-time favorite paintings ever.

Chuck: *I wish Fanny was here so she could talk to us about it, but since she's not, maybe you can. The first time that Grandma Fannie saw this painting, her one-word review was the Yiddish word* feh, *which means "ugh, spit it out, yuch."*

Georgia: She was great. In eighth grade I did a biography of Grandma Fannie. She was an amazing woman. She had been through a whole lot of shit. She used to feed me oranges with a spoon, and brush my hair for hours and hours and hours.

Chuck: *And play cards. An infinite number of card games.*

Georgia: We would play Go Fish and Crazy Eights with Grandma Fannie until we were blue in the face. She was incredible. She doted on me. She used to bring me candies and stuff that I wasn't allowed to have. She was great. I loved Grandma Fannie. This particular image is the way I think of Grandma Fannie.

Bill: *Where is that painting?*

Chuck: *At the National Gallery in Washington. It will be back for the retrospective. I just saw it in Germany. Taking Grandma Fannie's image to Germany was not easy. Not easy.*

Georgia: I can imagine.

Chuck: *It also went to Paris, and she always said there were more anti-Semites in Paris than there were in Germany.*

Georgia: What was the response to Grandma in Germany?

Chuck: *Well, she wasn't wearing a Jewish star, so I don't think it came up too much, but I definitely had some discomfort. When it was in Munich, it hung a half hour from Dachau, where her brothers were sent from Nancy. They made it all the way to the end of the war in Nancy, France, right across the border from Baden-Baden, and they were shipped to Dachau during the very last moments of the war. She's the only survivor of ten brothers and sisters. She lost nine brothers and sisters, their mother and father and—*

Georgia: The only reason she escaped was that the man she married, who was my great-grandfather, had arranged to marry her older sister, but when he saw Fannie, who was then eighteen, he said "I want that one." Her sister ended up being killed, and Fannie ended up getting out.

Chuck: *She came at the end of the first world war. Her husband had made some money by shooting craps. He had actually been in the American army, shot craps, won a fortune, like ten thousand dollars, gone back to the town where they lived, which she always referred to as Austria, because when she left it was part of the Austria-Hungarian monarchy, but was in fact Poland, and taken her and saved her aunt.*

Georgia: Really? I didn't know that.

Chuck: *She wouldn't go on this steam ship alone. She insisted on taking a maiden aunt with her, and she was the other survivor of the family. Here's another finger painting of you.*

Georgia: I hate that painting. The black makes me look alien. I don't know why the white on black looks so bizarre to me. Yeah, I love that one of Maggie. She looks so cute. So, what else Dad?

Chuck: *What should we talk about? I was always reluctant to talk about the psychological aspects of portraiture because I'm such a dyed-in-the-wool formalist, but—*

Georgia: Well, that's right up my alley.

Chuck: *It is right up your alley, so I'd be interested in how you see the paintings not only of you but of other people. Do you think anything is revealed?*

Georgia: That's an interesting question, which just threw me off. To me, your photographs are an isolated moment in time that will be transferred back to a painting and become even more subjective. You take photographs of people you love, people you work with, people you admire, or people you used to know well but don't really know well anymore, or people in the field. When I look at paintings of Mom or of you, obviously I think there's a helluva lot revealed, but I live with you everyday. When I look at paintings of someone like Janet Fish, who lived in the building when I was growing up, I think that it's really a portrait of who she is, but I don't think that it's a testament to her psyche in any way. I mean, it's definitely Janet, and those glasses are definitely Janet, and the way she appears on canvas is definitely Janet in total Janetness, but I don't think that your paintings reveal the intricacies of the people's minds, or the way they think, or who they are. It's definitely who they are, but not who they are emotionally. There's a certain distance with the camera and translating a photograph into a painting, and I think that it's an intimate process, but it's not necessarily a portrait of intimacy.

Bill: *Janet talked about the earrings.*

Georgia: You look at that painting and it's really what she's about. She always has crazy glasses and crazy clothing and crazy earrings. You look at Alex Katz, who has that grimace of a smile, and Lucas's hair, which is all over the place, and those are things about these people that are very much who they are, and the portrait is sort of an homage to who they are, in an unairbrushed, non-commercial, very real way. I think that the portraits capture those people as they were at that time rather than what they were thinking.

Chuck: Alex, interestingly enough, said that he thought I captured his rage.

Georgia: **Really?**

Chuck: I think that, more than any other painting, there's definitely something going on with Alex in that picture, but then you look at one like the painting of Judy Pfaff. I think that's Judy Pfaff, but I don't think there's anything that jumps out at me about the way she was feeling, or who she was, or what she was thinking about at that point in time. It's the same with Elizabeth Murray. The painting of Cindy Sherman was really interesting to me because I had followed her photographs for a long time. Her work is focused on the concept of being someone else all the time, and all of a sudden here was Cindy Sherman, who looks very shy and sort of withdrawn.

Bill: That's really who she is.

Georgia: That's how she comes across in that painting, you know, sort of quiet or reserved or whatever, yet she is someone whose photographs are so outrageous. We have a bunch of them in our house.

Bill: When we were doing the book with Laurie Simmons, she was trying to decide between Cindy Sherman and Sarah Charlesworth for an interview. She said, "I'd really rather have Cindy do it, but there won't be any interview. Nothing will be said."

Georgia: I love the story you told me about how she started taking photographs.

Bill: What is that story?

Chuck: It's in her interview. She didn't want to be naked in front of all those people at the picnic, so she went into her studio and took nude photographs of herself to show that she wasn't chicken. What about the works of art that have been in our house over the years. What about Tina Barney's photographs?

Georgia: Oh god. I actually find the scenario in the Tina Barney photograph that was taken at our house to be slightly disturbing; it's a disturbing testimony to the way we interact, in a weird way. My sister, in this photograph, is crying, I'm laughing at her, my father is about fifteen feet behind her with this amused look on his face, and my mother is bent over in the garden, working. The fact that I'm laughing at Maggie crying is a little disturbing to me. To have that captured and shown at the MoMA is not exactly—I don't want everyone to think I'm some sadistic older sister. I had a very interesting conversation with Molly Cottingham, who is Bob Cottingham's daughter, about what it's like growing up around all that art, or being the daughter of a prominent artist. It's very interesting. I talk to Katie Kurtz, my long-time friend from childhood all the time about how I—she laughs at the fact that I had no idea that you were someone who anyone cared about until I was in college. I sort of knew in high school, but I tuned it out. We had art of all of our family and our friends all over the house, and I think in a lot of ways, I really ignored it. I don't mean I didn't know it was there, but I sort of didn't want to dwell on, or think about, or address the importance of why that work was there, what it meant that you had made it, or what it meant that it was about Mom, or of me, or Mom, or Maggie, or whatever, and it was interesting. You know, in a lot of ways, to me it was the dining room, the faucet, and a painting of Mom. Art was a fixture in my house that I knew to be

familiar and that I knew to be something that was part of my home. It was what I believed my life was filled with, but I definitely didn't focus on it. It was just sort of there, and I was sort of out of it, I guess.

Chuck: It is pretty funny though that when you went to college, two of you roommates—one was Lindsay Brant, who is Peter and Sandy Brant's daughter, and they own Art in America—

Georgia: *Interview* and *Antiques*, and Ingrid Sishey, who is a good friend of yours, is the editor of *Interview*.

Chuck: She used to be the editor of Artforum. *I think you and Lindsay were roommates for several months before either one of you asked the other one what your dad or mom did.*

Bill: It was serendipitous that they were assigned together.

Chuck: Another one of your roommates was Grace Goodyear, whose father Frank Goodyear did the big realist show in the Philadelphia Art Museum.

Georgia: It was funny. We laughed actually the first time. I was actually told by Ingrid to seek out Lindsay. You were eating with Ingrid before I left for Yale and she said there was someone I had to meet. I was friends with Lindsay for a good seven months before I realized that she was who Ingrid had sent me to meet. Lindsay is now a sculpture major. She was originally an environmental studies major. My mother, the landscape architect, would shoot me in the head for that. She was an environmental studies major, then an American studies major, and then all of a sudden in her junior year she said she wanted to be a sculpture major. I know Sandy Brant very well, but I don't know Peter Brant at all, and I certainly know Frank Goodyear very well. He's a riot. It's very funny that we all ended up together. We were "art world children."

◆

not me,
Ad

4¢
U.S.POSTAGE

ARNOLD GLIMCHER
PACE GALLERY
9 W. 57 ST.
N.Y.C.

DEAR ARNOLD, OUR LETTERS CROSSED, MAYBE
YOU'LL WRITE A POSTCARD AND CROSS THIS,
I'M SENDING YOU TWO PAINTINGS, THEN YOU'LL
HAVE FOUR, THEN IN NINETEEN HUNDRED AND
SIXTY EIGHT WHAT'S TO PREVENT YOU FROM HAV-
ING A SHOW, MAYBE YOU'LL HAVE A SQUARE
ROOM (SPARE ROOM), A PAINTING FOR EACH
WALL, FOUR WALLS, (YOU KNOW I HAD TO ARGUE
SAM HUNTER INTO PAINTING BLACK DOORS
WHITE?) (YOU KNOW TWO CRITICS "PICKED IT UP"
BEFORE IT WAS DONE?), WHO'S TO PREVENT YOU
FROM HAVING A ONE-MAN-SHOW, PLATFORMS
ALL AROUND, SOFT LIGHTS, SWEET MUSIC, WH-
ITE DOORS, EURASIAN ODALISAVES IN ATTENDANCE?

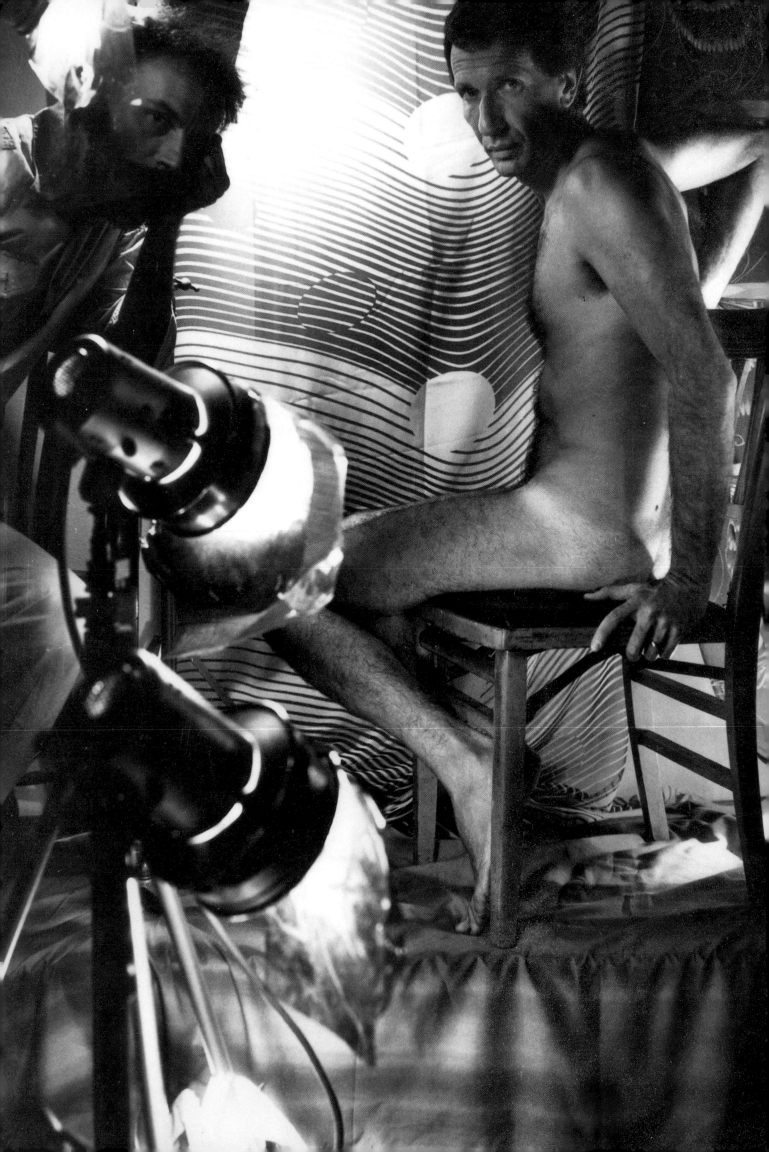

Arne Glimcher

New York City, July 18, 1995

Chuck Close: So, Arne, how is it that a nice Jewish boy grew up on a ranch in Minnesota? I didn't think that was possible.

Arne Glimcher: I was the only nice Jewish boy on a ranch in Minnesota.

Chuck: Were there a lot of shitty Jewish boys on ranches in Minnesota?

Arne: There were no other Jewish boys, shitty or nice. In fact, we were the only Jewish family for hundreds of miles, or at least fifties of miles. We used to go to the annual church picnic. Everybody there was Swedish, and everybody there was Lutheran. We went because it was the biggest activity around and all of the people with whom my father worked and who worked for him were involved in it. I remember that I wore a ribbon that said, "I am a Lutheran."

Chuck: Huh?

Arne: Everybody did. We all got ribbons. Anyway, I don't know; it just happened. I woke up one morning and found myself, a nice Jewish boy, on a ranch in Minnesota. I was shocked, and all I wanted to do was get to the East Coast. So I did.

Chuck: How did your parents end up in Minnesota?

Arne: Well, my parents were originally from Boston. My grandparents moved to Minnesota, and my mother insisted that if she married my father, he would have to move to Minnesota because she wanted to be near her family. That's how they got to Minnesota.

Chuck: You lived there from when to when?

Arne: I was there from birth until eight years of age.

Chuck: We know when birth was because you're older than I am.

Arne: Just slightly. You seem to be getting older by the day, but I'm holding my ground. The Minoxidil is keeping the hair there.

Chuck: It's soaking in and getting to your brain; that's the trouble.

Arne: It's keeping my brain young. We went back to Minnesota from Boston every summer. My father maintained that business, and we went back every summer until I was sixteen. After I turned sixteen, I thought, "You know, this is really for the birds. They can't make me go back anymore."

Chuck: The gallery was named after your father, Pace.

Arne: Everyone called my father Pacey. My dad died a month after I opened the gallery.

Chuck: By the time you got to Boston, you were a student. You were an art major. Were you interested in art when you were a kid?

Arne: Yes. I was a weird kid, and I wasn't interested in sports. I played a little basketball, and I skied a little when I was a kid in Minnesota, but basically, I just drew. I had crayons and paper, and ever since I can remember, drawing was the only thing that interested me, and that interest continued. The first weekend after we got to Boston, my mother took me to the Boston Museum's [of Fine Arts] Saturday morning art classes, which were taught by Miss LeBrecht. Actually, my wife, Millie, who I didn't meet until some ten years later, was also in those classes with Miss LeBrecht.

Chuck: Oh, no kidding.

Arne: Everyone in Boston who was expanding the culture of their family dragged their children to the Boston Museum. That's the only place I liked to be. Every Saturday at noon after class was over, I would find someone with whom to have lunch, and then I would take them to another gallery. I was mesmerized by the Egyptian galleries, the Chinese galleries, the whole Asian collection, which is breathtaking in the Boston Museum, and the impressionist collection, too. By the time I was about twelve or thirteen years old, I had a very solid education in the history of art.

Chuck: I know you liked the Gardner.

Arne: The Gardner Museum was one of my favorite places. I spent tons of time there.

[Founded in 1899, the Isabella Stewart Gardner Museum is unique in that, by Gardner's will, nothing may be added or sold from the permanent collection. Patterned after a fifteenth-century Venetian palace, the museum aims for a total impression created by its garden, architecture, and art collection. The art collection is unmarked and casually arranged, reflecting Mrs. Gardner's belief that art should provoke a unique emotional response from the viewer. The museum is best known for its Italian Renaissance, seventeeth-century Dutch and Flemish paintings, and an eclectic selection of modern works by John Singer Sargent, James Abbott McNeill Whistler, Edouard Manet, and Henri Matisse.]

Chuck: You liked it so much that you broke in and stole a Vermeer. Is that it?

Arne: A Vermeer, a Rembrandt. You noticed that they never came up again. [Vermeer's *The Concert*, c. 1664–66, and Rembrandt's *Storm on the Sea of Galilee* were stolen from the Gardner Museum on Saint Patrick's evening, 1990. They have not yet been recovered.]

Chuck: When you were growing up, did you have art in the house?

Arne: Yes, we had reproductions. On the landing of the stairs outside my bedroom in Minnesota was Millet's *Angelus*. They were of that sort of nineteenth-century sensibility. One day my sister, who everybody thought was so artistic, painted over Millet's *Angelus*. She put a bunch of red tomatoes in the basket that the woman is holding. She used a palette knife, so they were 3-D tomatoes. I thought it was pretty terrific, and I thought it was a much better picture after she added the tomatoes. [Millet's *Angelus*, 1859, Louvre, shown at the Salon of 1859, is a picture that has perhaps been more widely known from reproductions than any other picture in this century.]

Chuck: You were not a little bit competitive with her, were you?

Arne: No, not at all. I was never competitive with her. She was thirteen years older than I was, so she was not someone with whom to compete. Besides, one is not as competitive with a sister as with a brother. Anyway, we had that kind of art around. In Boston, my mother had a Chagall hand-colored etching from the *Bible*. That was a big deal. By the time I was about sixteen and was in high school, the subject of all the papers I had to write for which we could choose our subject was something to do with Picasso.

Chuck: *It must be a hoot to end up representing Picasso.*

Arne: Yes, it really is. When I was sixteen, I sent Picasso a check for one hundred dollars. I told him that if he could just give me a little drawing, anything he might be able to give me for that much money, I would love to have it. He never answered. He didn't even answer me. So all these years later, it is a hoot.

Chuck: *Did he take the hundred dollars?*

Arne: He didn't cash the check, but he didn't send it back. It's interesting, though, that the artists who mean a lot to you become a part of your life on a daily basis. It was that way with Dubuffet. When I was in graduate school at Boston University, I wrote a major paper on Dubuffet's prints, and later I wound up representing Dubuffet.

Chuck: *Well, the story of how you got Dubuffet, as I remember it, is an interesting one. See if I remember this right. You didn't have any money. You opened the gallery for about a dollar and a half.*

Arne: Twenty-four hundred dollars, please.

Chuck: *You decided to advertise, to take the back cover of* Art International, *because it would take longer for the bills to come in from Europe.*

Arne: I did an advertising blitz, and I used a stencil to letter "P-A-C-E" on the layouts. I did the blitz every place—"P-A-C-E"—and didn't indicate where or even what it was. I did that everywhere for about three months, and then I introduced "125 Newbury Street, Boston." And it wasn't Dubuffet, it was Nevelson. [The *Art International*, December 1963, outside back cover advertised the Louise Nevelson exhibition.]

Chuck: *As I remember—or I think this is what you told me—Jean Dubuffet wanted to change his New York dealer. He saw the ad, I think for Nevelson, on the back of* Art International, *and figured that if you were successful enough to afford the back cover of* Art International *and have Louise Nevelson—*[Dubuffet's "art brut" (raw art) was derived from his studies of the art of children and the mentally ill, and is intended to reflect the innocence and vitality of expression found in that work, as well as in the work of folk artists. Alfred Barr wrote of Dubuffet: "He combines a childlike style with bold innovations in surface handling and a grotesque sense of humour."]

Arne: I like that story. It's not true, but I like it. *[laughter]* Maybe we should just let it stand.

Chuck: *Well, if you didn't tell me that, who did?*

Arne: I have no idea.

Chuck: *That is not what happened? He didn't call you and ask you if you would represent him?*

Arne: No, no. I pleaded my case. I was very involved with his work for a long time in Boston. I bought his prints, and we were selling them. A "carrot nose" that now brings sixty or seventy thousand dollars was selling then for a hundred dollars. We had Giacometti prints for fifteen dollars—

Chuck: *Yeah.*

Arne: —a signed and numbered edition. At the same time, we were selling Oldenburgs for a hundred fifty and two hundred fifty dollars and Warhol's Marilyn Monroe paintings, the single images, for two hundred fifty dollars. It was a very different time.

Bill Bartman: *What year was that?*

Arne: It was 1960–61. This is what happened with Dubuffet. I had already moved Pace from Boston to New York. Three years later, a very good friend, Annette Michelson, who was a very good friend of Dubuffet's Paris dealer Jean-François Jaeger, told me that she had heard that Dubuffet wasn't very happy with his American dealer Seidenberg because he didn't like being in the same gallery as Picasso. *[laughter]* Picasso wasn't in my gallery, so I asked Annette if she would make an introduction, and she did. Annette was very important to me. She was generous, she believed in my gallery, and she had the ear of a lot of artists. She was, and has always been, an extraordinary intellectual. We made a date, and I went and talked to his Paris dealer who said he was with Beyeler and he was with Seidenberg, and they didn't think anything would come of it, blah, blah, blah, and then I had another conversation with Beyeler, and finally a meeting was set up with Dubuffet. They said, "You know, he's very megalomaniacal, and he doesn't like any other artists, and he only likes artists outside of society, and the most important thing is to remember not to mention any of the other artists in your gallery, especially Nevelson, because she's the only famous artist you have in the gallery and he won't like that." So I went to this lunch, which was in a little place on the rue de Seine called Le Petite Zinc. We were in a private alcove, and Dubuffet was there. It was awesome. He's a little guy but has a radiating presence. When people are your gods, they have no discernible scale, right? Beyeler was sitting on one side and his Paris dealer [Jean-François Jaeger] was on the other side, and Dubuffet said to me, "Well, tell me all about your gallery." I saw everyone's white knuckles, and I told him when the gallery started and why I moved it from Boston to New York, and then he said, "Well tell me, who are the artists that you show?" At that point, these guys were writing me off. I told him whose work I showed and he said, "Tell me about Louise Nevelson. I think she's incredible. She and Oldenburg are the only artists in America who interest me." I decided, "To hell with it," and there was a "zip-zap" between the two of us, and we locked in together. I told him all about Nevelson and Oldenburg. I had had two Oldenburg shows, including objects from Oldenburg's store, in Boston in 1962 after the store closed in New York.

Chuck: *You also showed a number of pop artists in Boston before they were—*

Arne: Absolutely. I showed Warhol before he showed with Leo [Castelli]. I showed Oldenburg when he had just shown with the Green Gallery. I showed a lot of pop artists back then. I had a very big show called *Stock up for the Holidays* which was about—

Chuck: *—stocking stuffers.*

Arne: *Stock up for the Holidays.* That show got its name from Dick Solomon. Dick Solomon was my first collector. He bought the first thing we sold, a sculpture by Mirko Basaldella, an Italian who, at that time, was head of the Carpenter Center at Harvard. He was a very big deal, and he was showing at the World House Galleries. Phillip Bruno, who was then director of the

World House Galleries, came to Boston to see Mirko. Mirko said to me, "You know, I can't show with you unless it's agreeable to Phillip Bruno." I knew who Phillip Bruno was, and one day he came into the gallery, looked around, and walked out, without saying anything. Finally, I got a couple of sculptures from Mirko, and Dick bought one of them. We became very good friends, and then we found out that our wives had grown up together and gone to camp together. They had been friends since they were little kids. Dick helped me put on shows. On Sundays we would nail together pedestals. I'd go to Grossman's Lumber and get them to cut the sides the right size, but I wouldn't allow for enough space for the overlap, so the tops wouldn't fit. There was always some catastrophe. I would stuff the pedestals with paper, tape them, and paint them, trying to make them look right. Anyway, Dick used to help me with those shows. His family owned a chain of supermarkets, and still does, called Stop and Shop. We were shopping at Stop and Shop, as everyone did around Christmas. It was about a month before our pop survey. There was a poster in the window, about fifteen by thirty, of an airbrushed Santa Claus knocking back a bottle of Coca-Cola. In Old English lettering underneath him were the words "Stock up for the Holidays." I thought, "Wow, here is the title for my show," *[laughter]* and I said to Dick, "Can you get me about a thousand of those?" He said, "Sure." We printed the names Segal, Oldenburg, Indiana, Warhol, etcetera all around the edges of the poster in red letters, and it was my poster for the show. It was my first full-color poster.

Chuck: *When you did that show in Boston, did people stock up?*

Arne: They did. It was really great. Dick bought [Oldenburg's] *Lunchroom Pastries,* which was displayed in a Plexiglas case.

Chuck: *Did he buy the Warhol* Marilyn *that he has?*

Arne: He bought the *Marilyn* just before that show, but out of that show he bought Warhol's *Close Cover Before Striking,* as well as the Coca-Cola bottle painting. We had Warhol's huge *Troy Donahue*—about eighty portraits in full color of Troy Donahue—which I bought for a thousand dollars. That was our most expensive thing. I got all of my friends to buy things. I said to them, "If you don't like this in a year, I'll buy it back," or, "If you don't like this in two years, I'll buy it back at double the price." God knows how I could have done that, but I knew the work was great. I was obsessed with those artists at that point. Very few people in New York, let alone in Boston, were buying, but we sold great things. We sold all the work: the trays of food, the ice cream sundaes, boxes of jockey shorts, and boxes of Hathaway shirts. In the middle of that show I installed the *Lingerie Counter,* the piece that Ludwig bought many years later for many hundreds of thousands of dollars. It's now in the Cologne Museum. That was the centerpiece of the show. We had the *Stove* in the show. Our window was flush with the street, and in it I placed George Segal's *Helen on a Bicycle.* We had Marisol's *Self-Portrait* in the show. We had everyone in that show, and they all came for the opening. All my friends put them up. The Wesselmans stayed with the Solomons, and there was a big trauma. Anne [Solomon] called and said, "What do I do? They're not married. Do I offer them two rooms?" I said, "You know, Anne, you're from Boston, so if it makes you happier, you can ask them if they'd like two rooms, but only make up one room." *[laughter]* Oldenburg brought the film of his birthday

party, and we showed it. We had a brunch for everyone on the following morning at our house. The show opened on a Saturday night, and on Sunday morning everybody came over; all the artists were there. Ginny Wright, who remains a good friend, was there. She was with Sam Hunter, and they were talking about a project at Brandeis. He was the head of the Brandeis Art Museum then. It was terrific. And I met Fred Mueller, who was to become my partner in the New York gallery.

• • • •

Arne: I was a painter, and I think I was a very good one but not good enough for me. I was a good draftsman, but my life was like a Saul Steinberg cartoon. I would make a painting, and I would finally like the painting. The next morning I would open the studio door, and I would say to the painting, "Are you as good as Picasso?" and this giant "NO" would hang in the air above the canvas. The "NO" was driving me nuts, and I figured—

Chuck: I wonder if Picasso ever asked that question? What was the transition from deciding that you weren't Picasso. Most of us go ahead and continue making art, even though we realize we're not making Picasso.

Arne: If you're totally enmeshed in it, nothing else matters. I guess I was on the outside rather than on the inside. There's a big difference between making things that look like art and making things that are art. I think I was an expert at making things that looked like art.

Chuck: Me too. I was a very good student. I had a great hand. I could make stuff that instantly looked like anyone else's stuff. You get lots of rewards, and scholarships, and pats on the head for demonstrating that you know what art looks like, but I think one of the greatest and most difficult transitions is going from being a student to being an artist, making even an awful thing that is your own.

Arne: It is, but you know, I don't think a real artist has the option that I had. I had the option to stop. I don't think that option exists for someone who is really, profoundly, going to make art.

• • • •

Arne: Getting back to what my "P-A-C-E" ads did for me, the following summer I took my first trip to Europe. I went to the Hanover Gallery in London and met a fantastic woman, Erica Browsen, who ran the gallery. She died just last year. Erica Browsen sort of took me under her wing. When I first went into the gallery she said, "Oh, you have that gallery in Boston that I keep reading about." Nonsense. She didn't read about it at all. She just kept seeing the name PACE everywhere! She had an extraordinary exhibition called *Masters of Modern Sculpture* [1959]. It had Giacometti's *Walking Man*, Jean Richier's *Don Quixote*, Giacometti's *Four Figurines on a Base*, and Matisse's big bronze *Figure Decoratif*, the nude with her hands behind her head. It had some of the greatest sculptures of the century, and I said to her, "I would love to have a show like this in Boston," and she said, "Well, I'll send it to you." I said, "For a show in September?" and she said, "Sure." She sent me that whole show. [John Russell commented in *ARTnews*, September, 1959, that there is "a superlative exhibition of twentieth-century sculpture at the Hanover Gallery...[including] the entire pleiad of those who have made modern sculpture a matter of world-wide concern: Maillol, Matisse, Arp, Picasso, Giacometti, Marini, Richier, Cesar... Nor were these just venerable anthology pieces, but novelties in many cases, or works familiar only from reproduction."]

Chuck: *Huh.*

Arne: The show opened, and we sold nothing. The only client to whom I had sold things like that—I had sold a couple of Giacomettis—was Dick Solomon's uncle, who was the head of Stop and Shop. His name is Irving Rabe. He was away on vacation that month. It was really bad luck. He came back the last Saturday of the show, and I called him and said, "Irving, you've got to come to see this." He came in, and he saw it, and he said, "Oh, it's wonderful. I've never seen a show like this in Boston," and he said, "Well, I'll think about these." I said, "You can't think about them for very long because I've got to send them back," and he said to me, "What would it take to buy all of these?" I said, "I can buy this whole show," which was about fifteen masterpieces, "for two hundred and fifty thousand dollars," and he said, "I'll give you the money, and we'll split the profits," and we bought the whole show. I sold Giacometti's *Walking Man* to the Chicago Art Institute for fifty-three thousand dollars, so that was really something, but it took a year to sell it. By then we had opened in New York.

Chuck: *How long was the gallery in Boston?*

Arne: For three years, and then we stayed another year with both Boston and New York. Erica Browsen became a great supporter of mine. We showed Nevelson together and many other things. I remember going to Paris soon after I sold the Giacometti. She told me to meet her at the Deux Magots; that we were going to have lunch with Giacometti. I got to the Deux Magots with my knees knocking, and I was completely tongue-tied. It was '64. Giacometti looked just like one of his sculptures, which is a corny thing to say, but he did. He was covered with plaster dust, and I was tongue-tied. At one point Erica said to Giacometti, "You know, Arnold just sold *Walking Man* to the Chicago Art Institute for fifty-three thousand dollars," and Giacometti turned to me and said, "You will be arrested." *[laughter]* Isn't that great?

Chuck: *Yeah, wonderful. So when you opened in New York—*

Arne: I opened in New York because I was doing all these great shows in Boston. I knew who Oldenburg was. I knew who Warhol was. I knew who the next wave of great artists were.

Chuck: *But you could only show them—*

Arne: I could only show them in Boston.

Chuck: *You couldn't have them in New York.*

Arne: You know, the history of art is so myopic and short-sighted. Ivan Karp was the most important person in the art world. At the crest of the Jackson Gallery, he was the director. When Castelli's gallery came to real prominence, he was the director.

Chuck: *And before that he was at—*

Arne: —he was at Rubin.

Chuck: *Rubin, yeah, Rubin, downtown. He helped put together that first big Tenth Street show.*

Arne: Right. Ivan was brilliant; Ivan was one of my mentors; Ivan would take me around New York to artists' studios. Every Monday he'd pick me up at the airport and take me around in his car. He helped me look for locations. He was wonderful. Anyway, Fred [Mueller] and I decided to open a gallery together. I asked him to come down for a big pop art opening and he did. The day I met Fred, I went home and said to Millie, "You know, I met this guy, and I

should open a gallery with him rather than with Erica Browsen," and she said, "You don't even know him. You just met this guy." This guy had infallible taste, extraordinary taste, and I liked him. We became terrific friends. He was like my third brother.

Chuck: *How did you guys decide who to represent? Did you have some artists, and he have some artists?*

Arne: No, I had all the artists. If I didn't want to show a piece, we didn't show it, because his taste was much broader than mine. He had a great collection of Chinese art, Chinese furniture. He liked more decorative things than I did. I had very strict taste. I was still coming out of modernism. He was in post-modernism about twenty years before post-modernism, but there weren't any post-modernist artists. Everything he liked had value, but there were things he wanted to see that I didn't; he deferred. I had been in the business for three years. Hell, I was an expert! *[laughter]* What did he know? I was a dealer.

Chuck: *Where was Jim Dine? Dine was with—*

Arne: Dine was with Janis.

Chuck: *Janis, right. With Segal.*

Arne: But they weren't all together.

Chuck: *No.*

Arne: Leo's gallery became "the pop art gallery" after pop art began. Nobody remembers that. He consolidated it into his gallery. He had Jasper Johns and Roy Lichtenstein and Robert Rauschenberg. Lichtenstein was brought into the gallery by Ivan. He was Ivan's artist. I remember going through Provincetown with the Karps in the summer of '62, going to the Lichtenstein's, and spending time together. The Lichtensteins were in Truro, and Ivan was in Provincetown, but Ivan ran the salon. Ivan has a dazzling mind.

Chuck: *Janis had the first really big great pop art show on Fifty-seventh Street.*

Arne: He had the first anthology.

Chuck: *Upstairs. He rented the ground floor space, and there must have been forty different artists.*

Arne: It was called *The New Realism*. He did that huge show, and the abstract expressionists walked out of his gallery *en masse* as a response to the fact that he was supporting this next group of artists, which they obviously considered a threat. [The Janis Gallery, with its reputation for picking winners, showed in November 1962 twenty-nine young artists from England, France, Italy, Sweden, and the United States in *The New Realism*. Mr. Janis spoke of them as "a kind of urban folk artists." They were known as new realists, factual artists, or pop artists. Their cult symbols were the objects of mass culture: Campbell's soup cans, automobile tires, assorted cosmetics, comic strips, etcetera. They presented these delights of our time in strange combinations or out of context, which was supposed to evoke a new aesthetic experience.]

Chuck: *Hilton Kramer, then the editor of* Arts *magazine, wrote an editorial that said, "Well, Mr. Janis, you've been lucky up until now, but brother have you just made a big mistake."*

Arne: Janis was an amazing dealer. He was not the sweetheart that Leo was, but he was a man of extraordinary style, elegance, and taste. We saw all of Leger's late work there for the first time; and Schwitters, whoever knew who Schwitters was, except for the great shows Janis had; and the Picasso shows—

Chuck: And he invented the great group show phenomenon of doing a historically important group show that could really be put up against a museum show, by borrowing stuff back.

Arne: Yes. When Janis gave all of his paintings to the Modern—and that's some hell of a collection that he gave to the Modern—I wrote him a letter congratulating him and saying how, more than any of the dealers, as a dealer, he was my mentor. He was never very generous with anyone. He wasn't very generous with me either, but I got an incredibly complimentary letter back from him. It's the most important letter I've ever received.

Chuck: When I joined Pace Gallery—and Sidney had been one of the dealers who wanted to represent me—I went around to tell all the other dealers that I had decided to go with you. Everybody was somewhere on a scale from neutral to nasty about my choice, but Janis was very generous and very nice, and he said, "You would be successful wherever you go, and I wish you would come here, but Arnold will do a wonderful job for you." He was the most generous toward you of any of the dealers. Other dealers said, "I think you made a terrible mistake." So you opened in New York, but you couldn't transplant to New York the stable that you had in Boston, so with whom did you open?

Arne: I opened with Nevelson. I had shown Nevelson in Boston.

Chuck: Nevelson had been with Martha.

Arne: She was with Martha Jackson in New York. I was only aware of the big wall in the **Museum of Modern Art.** [Nevelson's wall sculpture, *Sky Cathedral*, 1958, painted black wood, 8-1/2 × 11-1/8 feet, was acquired by the Museum of Modern Art in 1958.]

Chuck: I think it's fair to say that her career was in eclipse.

Arne: But she wasn't in eclipse. It was a very strong moment of awareness of her work, but no one was buying it.

Chuck: Right. But at that particular moment, the cycles of the art world being what they were—

Arne: Before she left Martha Jackson for Janis, I did a show of her work in Boston. She was in the '63 Venice Biennial and I took the back covers of all of the art magazines. In *Art International,* which was the big magazine, I did an installation view of my Nevelson show in Boston, and I wrote, "Nevelson at the Pace Gallery," the dates of the show, and then underneath "Bienniale Venezia." It looked as if I represented her. No one else did any ads as she decided in Paris to leave Jackson and Cordier, who both represented her, and to go to Janis, which turned out to be a mistake. Janis didn't want any artist he represented to show with other dealers. He also didn't believe in showing his artists in Europe. That was his failing, and that was Castelli's strength. What Castelli brought to the art world was making these artists international reputations. He did it for the first time. Leo disseminated the work in a really brilliant way. So Nevelson left Martha Jackson and Cordier for Janis. I was very depressed in Venice, because I was already thinking about opening a gallery in Europe. Nevelson and I were having lunch on the roof of the Danielle, which I can still see, and she said to me, "Look, you'll open in New York. Eventually, I'll be with you. Eventually, everyone will be with you, so I'll have to be with you." And that was that. Then a year later, Janis chose to open her show on New Year's Eve. Who opens a show on New Year's Eve? It was a failure and she was in debt for about

seventy thousand dollars to Janis. She also had bought the Connecticut house of Sidney Janis's lawyer and owed the mortgage on that house, and she was really tied hand and foot. She was very upset about the whole thing, and she was drinking very heavily because of it. I would call her practically every week, and we would talk, and I would go to see her. She was having a very hard time. Everytime I would go over she was drunk. She couldn't even talk. She wanted to leave Janis, but she couldn't because Janis had taken all of her work and locked it up in storage, and he said, "Repay me and you can leave." But she didn't have the money, and we didn't have very much money. We were just opening in New York, and we needed everything for reconstruction; but we took seventy thousand dollars out, and we paid Janis off, and we sent all the work back to Nevelson. We had nothing at the gallery for the first couple of months. I wanted her to feel secure that she had her work, that it was hers again. She came with us, and we opened the gallery with her, but we didn't show her for almost a year.

Chuck: *Really?*

Arne: But then we sold out the show.

Chuck: *Why didn't you show her for almost a year? Because she had just had the New Year's Eve show?*

Arne: She had just had that show, and we wanted enough time to go by for her to feel as if the work was hers. We had extended the money, but she didn't owe us anything. So, what was left for me to do? What was left for me to do was to start showing eccentric people like Lucas Samaras, who appealed to me. Besides, remember the little kid in the Boston Museum for all of those years going from the Chinese galleries to the Egyptian sculptures to the impressionists? Why should I be satisfied with one thing? You know, I don't mean to be corny, but there's a wonderful quote in *Auntie Mame* in which she says, "Life is a banquet and most poor sons of bitches are starving to death." So why did I want one course? That attitude was my detractors' artillery at that time, because galleries were only one course, and if you didn't define yourself by showing only Noland and Louis, or only showing Johns and Rauschenburg, or pop images, you were no one. I had this weird gallery, and I cared about the installation of things. At that time it was considered too slick, and the California people were too slick. Everything was "packaged," they were saying. But my sensibility was not that of the Green Gallery. It was great, but wherever on the wall the nail was from the last show was where the next painting was hung.

Chuck: **Yes.** *[laughing]*

Arne: I have always believed that there is a way of making art look its best, and I think that's very valid. I think the responsibility to the artist and the work is to present the work at its best—how will it look best?—and that's sort of what I did. If I've had any real profound effect on the art world, it is in the way art is shown. I think that I am responsible in some way for the way art is now shown. Mine were the first shows where platforms were put in front of the paintings, not so you couldn't get at the paintings, but so that the light would kick back up on the bottom of the paintings. The [Bob] Irwin "dot" paintings were bowed, and the light would come back up on the bottom of a huge painting where you couldn't possibly otherwise

light it. My mentor for all of that was Irwin. You know, for the first Irwin show I did, I had a ceiling divided into quadrants, like four ceilings that hung together, and the lights were all behind the sections.

Chuck: *That was the gallery on the other side of Fifty-seventh Street.*

Arne: At 9 West Fifty-seventh. We put up the Irwin show, we painted the walls, we put platforms around the pictures, and we put the lights on as best we could, but the corners of the ceilings had twelve-inch little diamond-shaped shadows coming down in four places on the wall, and we were going crazy trying to light them out. Irwin said, "No, no, we're not going to light them. Take down all the pictures and leave the lights on." Irwin mixed pale grey paint—white paint, with a tiny bit of grey—and got the exact same color as the shadow, and we painted the whole wall except for the shadows, and the shadows were gone. I thought, "That was dazzling, that was brilliant." People said, "No, this is chi-chi," "This is not muscular," "This is the sissy way of doing things," but boy, did those paintings look fantastic. And what Irwin was saying to me is that when you are viewing a work of art, everything in the line of your perception is part of it.

Chuck: *You would think that this was a battle that would have been won by now, but I know that in Agnes's [Martin] recent show at the Whitney, her retrospective, they wanted to use the walls in the same position in which they'd been for the last nine shows or whatever, and you, at your own personal expense, went in and renovated that space to make those paintings look the way they looked.*

Arne: You know, they are some of the great paintings of the century.

Bill: *Right. It was definitely one of the great shows.*

Chuck: *I think you really put your money where your mouth is on issues like presentation.*

Arne: Well, catalogs and presentation of shows are all that I care about. [This was noted as early as 1968, when critic Grace Glueck wrote in a *New York Times* article "A New Breed is Dealing Art," that "Pace Gallery in particular is famous for its meticulous installations and first-class artist treatment.]

Chuck: *There isn't a nickel to be made from it, and I know what it costs for many of these installations.*

Arne: But you know, you have to. I never thought I'd make a dime when I opened my gallery. Who in the sixties thought you'd make money running a gallery?

Chuck: *Your brother, Herb.*

Arne: What? Yeah, my brother Herb did. He lent me the twenty-four hundred dollars to open Boston. Eleanor Ward ran the Stable Gallery. She was Nelson Rockefeller's mistress. That's how she ran the Stable Gallery. Everybody running a gallery had an angel.

Chuck: *My first gallery, Bykert Gallery, was a tax write-off for Jeff Byers.*

Arne: Bob Scull was supporting the Castelli Gallery. He was buying all the artists. That's why he got everything. He kept lending Leo the money to stay open. No one ever thought they'd make money. What I did then, and what I do now—and what I think young people should think about—is to decide, "What do I want out of this?" This is not a profession. This is not a profession in the same way that being a stockbroker is a profession. The way I answered that question to myself was that I wanted a life in art. I wasn't a painter. This was as close as I could get.

I have this theory that it is a congenital thing, that when you have a very distorted, disproportional aesthetic, you become an artist. We're not all the same. Someone's liver is bigger, someone's aesthetic is bigger. There are people whose aesthetic is just under that of an artist, and they should be the dealers, the writers, and the critics; and then there are the people just underneath them, and they should be the buyers.

Chuck: In Japan they have that kind of stratified society that works along very similar lines to what you just suggested.

Arne: Well, I believe this is true. I'm not just saying this. I believe this is true.

Chuck: Yeah.

Arne: I think we could weigh your aesthetic and weigh my aesthetic, and we'd get different weights.

Bill: What you're saying makes so much sense. That's why I liked you from the very beginning. That's why we started doing these books. This is as close as I could get to making art and to doing things for artists.

Arne: It works only if you're satisfied with it. If you're doing this just because you can't be an artist and you're bitter, then it doesn't work. If you're doing this because you can't be an artist, it presents an astonishing opportunity. I think being a dealer is a very noble thing. I think it's one of the noble occupations in the world.

Bill: I've had the same experience doing this book that you had meeting Giacometti and all those people. I've been in a room with people who are like gods. For instance, Philip Glass. I used to just sit and listen to his early things when I was in my senior year of college. We'd get stoned and listen all night to Philip Glass. And to think that I was in a room with him. I was barely able to talk.

Arne: Yeah. It's very important how one spends one's life, and in the company of which people.

Chuck: With the gallery, you have a life in art. A gallery is a very organic thing. It's not static. It keeps changing.

Arne: True.

Chuck: You've had an opportunity to have many different galleries in the length of time that you've been in business. I know that Lucas Samaras took you to see my first show at Bykert Gallery. I took you to see Julian Schnabel's first show.

Arne: Also Kiki's [Smith]. You live with artists, and your perception is extended, and you find out where your interests lie. How much can I hone my perception, and what can I get out of it for myself? It's a miracle that I made money. It was not part of the plan. I'm awfully glad it happened, but it was not my priority.

Chuck: What a mindblower, though, it must be to have Picasso, to bring together the work of people who you saw in museums when you were a kid, not just to have an occasional piece, but to put together a historic exhibition like the drawing show.

Arne: Process is an aspect of his work that I like. You can't understand these works by seeing only one or two works. You'd say, "Oh, they're unfinished works," but when you view the exhibition, you suddenly realize there's a vein of drawing that runs through all of the work, which this exhibition is designed to reveal. Not only does it run through the work, it directs the work. That's the thrilling thing. [*Picasso and Drawing*, Pace Wildenstein Gallery, April 28–June 17, 1995.]

Chuck: When you did the notebook show, you had the opportunity to actually leaf through them. [*Je Suis le Cahier (The Sketchbooks of Picasso)* installation at Pace Gallery, May 2–August 1, 1986.]

Arne: I think there are only a few of us who have ever seen every page of those seventy-two notebooks—everything—and I had an amazing realization. I realized during that show that the notebooks that existed for some of the great paintings were done a month or two after the picture was finished. So, in a funny way, Picasso turned the entire process around: the painting is the sketchbook, and the notebook is the finished work.

Chuck: I think that's true. All of my drawings come after the paintings because I'm recycling the image by altering the other variables. There's more to be learned by doing it that way, but we have this notion that a drawing exists as preparation for something—

Arne: Exactly.

Chuck: —instead of being a thing in and of itself.

Arne: That's why I really did *Picasso and Drawing.* I thought, "The point of the notebook show was not assimilated, but in this show I can make it happen. If they see big works on canvas that are drawings, they will understand that drawing is an end in itself." That was pretty thrilling.

• • • •

Chuck: You were about to show Ad Reinhardt when—

Arne: —when he died.

Chuck: —when Reinhardt died, and his estate went to Marlborough. The first thing you did when you got the estate back was the show that you were planning when Ad died. It was a wonderful show. It was so touching.

Arne: I did. It was funny too, because the gallery was smaller when we were on 9 West [Fifty-seventh Street], so I made the new gallery, the gallery we're in now, the same size as the old one at 9 West, and I put in only the three paintings.

Chuck: And you had to scour the world to find those pictures.

Arne: But we got them. When I had originally wanted to make the show, Ad put it off for a year. I told him that I wanted to do an installation like the one I did for the Irwin show, to have platforms around the room kicking the light back, and to have diffused light. He liked it. He always made jokes about things, and he sent me a postcard, which is one of my treasures, that said, "Dear Arnold, I think we should not do the show right now, but don't worry, you'll eventually have the show you want, with soft light, sweet music and maybe odalisques around the room." When I got the estate—this was ten or twelve years later—the announcement for my show was the postcard that Ad had written ten years earlier. We did the show. It was a beautiful show. [Ad Reinhardt, October 2–30, 1976, Pace Gallery, New York. In a 1967 postcard to Glimcher, Reinhardt wrote "...who's to prevent you from having a one-man show, platforms all around, soft lights, sweet music, white doors, evrasian odalisques in attendance?"]

Chuck: There's a kind of wonderful closure there too. Before you could really represent Ad, you had to get back the show that you had lost.

Arne: Oh, I was devastated when that happened, just devastated.

Chuck: And what about Rothko?

Arne: Rothko. This is actually a very interesting story. I loved his work. I lived across the street from him, and I used to go there about once every two weeks. Nevelson introduced me to him. They were very good friends. She was the sculptor who was adored by all of the abstract expressionist painters. Nevelson was their artist, because of the scale of her work and its pictorial format.

Chuck: *Flat. Painters like sculpture that's flat.*

Arne: It was flat, it was anti-classical, it was assemblage, and they were all nuts about her. That's why going to Janis was a terrible mistake for her. She went to Janis because Janis never had a woman in the gallery. All the men that she respected were in the gallery, and she wanted to break that trend. I liked that she wanted to break it, but he didn't care enough about her work or have the necessary sensibility. That feminist move really backfired in a bad way, because he just wasn't right for her. Anyway, Nevelson introduced me to Rothko, and we had lunch together in a Japanese restaurant. I lived across the street, and we became friends. He let me come in every two or three weeks, and I saw the Chapel paintings being painted. I also saw the work before that. He was very unhappy for some reason with Marlborough, and he called me and said, "It might be time for us to do something," but he didn't want to show in America. He was against the way the American collecting public had taken to pop art. He called, and I went to see him, and he said, "I want five hundred thousand dollars for a group of works, and they can't be shown in America. They can be shown in Europe." I didn't have anything approaching that amount of money. That was '67. I called Beyeler, with whom I had dealings because he was Dubuffet's dealer in Europe, and I said, "Would you like to come here, and we could maybe do something together? This is a huge opportunity. You could show them in Switzerland, and it would be the beginning of a relationship with Rothko, one of the greatest American artists who ever lived, blah, blah, blah…" He said, "Is that the Russian who makes those blocks, blotches, of color?" Finally he came, and we went to see Rothko. Rothko liked Beyeler's gallery a lot because he showed more classical things. It's interesting to see that the pop generation, even your generation, at some point is interested not in being seen with their peers, but in being seen in the context of earlier periods of art. If you're in this game, you're going to be in the game for the long run, and you're going to be up against all of art history, not just the guys in the soda shop.

Chuck: *And you learn more by hanging with people from other generations.*

Arne: Rothko said that he would sell this group of works if we agreed to buy a group of paintings at thirty-six thousand dollars a picture. It was very exciting. We came back the next day to choose the pictures, and he said, "I can't sell you these pictures," and he had tears in his eyes. He didn't even let us into the studio. He just said, "I'm just not free to sell you these. I just can't do it. I can't do it," and BANG, I never saw Rothko again. That was it. After Rothko died, his children brought a court case against Marlborough. Gus Harrow, the assistant attorney general, made his rounds through the galleries to try to get information and knocked on my door and asked, "Did you ever know an artist named Mark Rothko?" "Sure," I said. "Tell me

about him," he said. So I did, and when I got to this story, he said, "Would you be willing to testify?" I said, "Of course." It was a time when being an art dealer was a terrible black mark. I remember going to parties and being asked, "What do you do?" and saying, "Art dealer." They would say "Ugh, aren't they all thieves?" or something like that, because the Marlborough case was in the paper every day. So I said I would testify, and he said, "I'll tell you why I want you to testify." Marlborough had paid twelve thousand dollars a picture. They bought the paintings with twelve years to pay, interest free, at twelve thousand bucks, which gave them a negative cost, but they were saying that there was no one else to make the acquisition. If there had been anyone else to buy in bulk, then their testimony could be disputed. He said, "If you can prove that you were there to buy in bulk, we can shoot their case down," so I said, "Absolutely. I'll get Beyeler to come." The Art Dealers Association, through Ralph Colin, called me and said, "Don't testify against Marlborough." I asked "Why?" and he said, "You know, it's just something a dealer shouldn't do: testify against another dealer."

Chuck: *Sounds like doctors.*

Arne: I said, "I think that if the Art Dealers Association doesn't speak up, then we're all accomplices by association." Everybody was very angry with me, but I never had many friends who were art dealers anyway, so what did I have to lose? I wasn't invited to their parties. I went to testify, and there was a battery of about ten lawyers on their side. They kept saying that I'd never been in the studio, that I was lying. "Describe the studio, blah, blah." It was horrible. I was really quite shaken. I remember one lawyer, Arthur Richenthal. He was very slick. I'd never been to court, and I've never been to court since. It's a horrible thing to go to court, to be in the witness box. He said to me, "What were Rothko's paintings worth in 1950?" I told him. He said, "What were they worth in 1960?" I told him. "What were they worth in 1970?" This was happening in the seventies. I told him. He said, "So, you knew what they were worth in 1950, you knew what they were worth in 1960." I said, "Yeah." He said, "Are we to believe that you knew the value of Rothko's paintings when you were sixteen years old?" He quickly did the math. I was thrown for a moment, but I composed myself quickly and said, "Don't you know legal precedents that were set before you were born?" The whole courtroom applauded, and the judge told everybody they had to leave the courtroom. I was on the stand for three days, I think. I was supposed to be there for only an hour, and I was on the stand for three days, soaking wet the entire time. The next day Harrow said, "Look, our big problem is that, although I think the judge is sympathetic to you, you can't corroborate your testimony. There is no way to corroborate it unless Beyeler comes." So I called Beyeler, and I said, "Would you come?" and he said, "No, I don't want to get involved in this." I said, "Listen, they're saying that I'm a liar, that you and I didn't try to buy these things, and it's your name as well as mine. It's on the front page of the [New York] Times every day." All of my testimony was on the front page of the Times. So Beyeler said, "Okay, I'll come," and he came and testified. If you were a witness, you could not be in court while another witness testified. The next morning I opened the New York Times. Well, I didn't have to open it because the story was on the cover. It said that Beyeler testified that he was there, and then Richenthal asked Beyeler if he had ever been

involved in dealings with Rothko other than with me. Beyeler said, "No," and they brought out a letter that Beyeler had sent to Frank Lloyd right after we had lost the deal with the paintings, trying to make a simultaneous deal with Lloyd for the pictures, in case I didn't get them. So Beyeler had been on both sides of the fence with this, and it was tremendously embarrassing for him, and our relationship was never again the same. Art dealing in New York, right?

[The Rothko v. Marlborough case, begun in November 1971 and lasting eight years, was one of the most important contemporary art cases in this century. Rothko's daughter, Kate, sued to remove the trustees of her father's estate—Bernard Reis, Theodoros Stamos, and Morton Levine. The suit by Kate Rothko was joined by New York State Attorney-General Louis J. Lefkowitz on behalf of the Mark Rothko Foundation. The will left by Rothko before his suicide in 1970 specified that the trustees were to sell the paintings at fair market value, and the profits were to be distributed to both the Rothko Foundation, created to financially aid older artists, and his heirs (effectively his children because his wife was dead). One hundred of Rothko's best paintings were assessed at $1.8 million and sold at that collective price within three months of Rothko's death. However, the price did not account for either the jump in value of a deceased artist's work or the delayed financing of the paintings, which were scheduled to be paid in full over twelve years without interest. Manhattan Surrogate Court Judge Millard L. Midonick removed the three executors of the estate and assessed damages and fines totalling $9,252,000 against the executors, Frank Lloyd, and Mr. Lloyd's Marlborough Galleries. The judge found the executors had acted in a conflict of interest, or negligently, in selling and consigning 798 of the artist's paintings to Mr. Lloyd for much less than their true value and under terms that were highly disadvantageous to the estate. The Marlborough Gallery subsequently resigned from and was expelled from the Art Dealers Association of America, an organization formed to promote and uphold ethical practices among dealers. In 1978, Pace Gallery was selected by his daughter and administrator of the estate, Kate Rothko Prizel, to act as the worldwide agent for the sale of Rothko's work.]

Bill: **It's still going on today. I mean, there are awful things happening.**

Arne: **But there's good stuff happening too.**

Bill: **I know, but I'm just saying that there are dealers who are, right now, doing things to artists that are so awful, I can't even imagine.**

Chuck: **On the other hand, it's amazing that one of the only really active areas of the art world in these troubled financial times, besides the high end, is the emerging artists. There are lots of people opening galleries and trying to—**

Bill: **It's more like what Arne is talking about. There's stuff going on with some fairly important galleries. They're taking their best artists and basically stealing from them without their knowledge.**

Arne: **Well you know, at the bottom of everything, that's just bad business, because you can't be in the business of being an art dealer and have artists saying bad things about you.**

Bill: **The particular person I'm thinking of is someone I know very well, and he was so totally depressed when he found out what was going on that he was almost suicidal. Nothing hurts me more than to have people deceive you.**

• • • •

Chuck: **I think the reason we get along so well is that we both grew up with all those Scandinavian Lutherans.**

Arne: **I think so too. And we weren't Scandinavian or Lutheran. [laugher]**

Chuck: **And we're far away from that kind of unemotional, arm's-length environment in which we were raised. I mean, being in your gallery is not just a business relationship. Think about your relationships over the years with Agnes [Martin] and with Bob Irwin.**

Arne: They have been very long relationships, probably longer than with almost any other dealer. Nevelson: thirty years. Dubuffet: the last seventeen and a half years of his life. He was never with anyone for five years, let alone seventeen years.

Chuck: *And Agnes has been with you since she left Ekstrom. When I first joined the gallery, you were absolutely the biggest control freak I'd ever known in my life.*

Arne: I was a dictator.

Chuck: *You could not delegate sharpening a pencil, because it wouldn't be done in the way that you wanted. You would sharpen your own pencil. It's really interesting to see what's happened to the gallery.*

Arne: I've trained all of these people to do it my way, or I respect their way.

Chuck: *The idea that you could give up enough control to let someone else design a catalog, even if it's done in a way that you like, really represents a change. You've moved from one kind of organizational style to another kind of organizational style. It is very difficult for most people to make that kind of shift.*

Arne: You know, Mike Ovitz was sort of my mentor on organization. Michael knows how to give power to people within the organization. He does it brilliantly, and I kept watching him. Different people affect your life and your style, and I realized that if I was going to have the level of people I wanted working for me, then I had to give them responsibility; they weren't going to be there to not sharpen pencils.

● ● ● ●

Chuck: *We have to talk about what it's like for you to be painted or drawn or whatever—to be the subject of these works. I must say that of all the things I've ever made, you've been able to sell everything I've done except the images of you, and it's not because you wanted to hold onto them for yourself.*

Arne: Actually, I liked that you made those images of me. I like the idea of them a lot. I was just looking at the big eighty-two inch or eighty-four inch Polaroid. I had it framed. I thought I might give it to an institution at this point. You know, what's hair-raising is how long ago that was and how young I was. My God, I look at that and it's like looking at *The Portrait of Dorian Gray,* except I'm the portrait. [Robert Rosenblum also used this analogy in writing of Close's work, saying: "The evolution of his [Close's] portraits, which started with photorealism, reminds me of Oscar Wilde's *The Picture of Dorian Gray.* The people inside the paintings seem to be decomposing, but their hearts are coming out. It's very disquieting work."]

Chuck: *Pre-Minoxidil.*

Arne: Pre-Minoxidil, with all that hair. You can't be objective. I mean, one has an idealized view of oneself. Not that I think that I look better than this picture. I don't think I do, but I would like to. [*laughter*] The pictures are brutally realistic, especially those pictures that make every single fault the size of the Grand Canyon. It's very hard to look at them. Lucas did portraits of me, as you know, and—

Chuck: *—and even nude ones.*

Arne: Nude ones. Those are very idealized. Lucas was doing a romantic fantasy. You are using these pictures as a grid for another process. You're investigating something that does not

necessarily, at least not in the past, have to do with the persona of the character. I think your work has changed radically, vis-a-vis that, in the last four or five years. I think the persona of the character is coming into the application of the paint, whether or not you know it or like it. It's becoming a kind of portraiture. I don't consider that your work pre-five years ago was portraiture at all. I don't think it belonged in portrait shows. I think it belonged much more in minimalist shows, much more in perceptual shows, shows in which Irwin would be, or that kind of thing. Lucas's portraits address themselves to my idealized view, and even though they are embarrassing because I'm nude, the lights are right, *[laughter]* and they catch my body at its prime, about fifteen years ago. They are idealized in that way, in an interesting way. The difficulty that I've had with showing them to clients is not that I don't like the images, but that I'm embarrassed. That doesn't mean that someone else can't sell them, and has. The Chicago Art Institute bought the portrait you did of me, but someone else sold it, which I think is legitimate. It's also a very scary thing to be frozen in time, either by Lucas or by you or by whomever has taken my picture, by Penn or Arnold Newman or those people, because you like to think that you change less than you really do. Inside I have changed hardly at all, so it's a real shock that this exterior is aging. It's like people who have face lifts. I often think to myself when I see someone who's all brand new again, "Don't they know they're rotting inside?" *[laughter]* I prefer to think that I'm not rotting inside, but that I'm rotting outside in those pictures.

Chuck: Or rotting at the same rate. I have a theory as to why you have difficulty selling your images, and I think it's interesting. When people on your staff describe your selling style—and everyone thinks it's truly amazing to watch you at work—they say that you don't really sell anything, but you share your infectious enthusiasm for whatever it is that you are representing. I don't think you can have that infectious enthusiasm for your own image.

Arne: I think that's true. That's what I meant when I said I find it embarrassing. The psychological vanity is embarrassing. I love the fact that you've done my portrait. I think it's very exciting that it's in the Chicago Art Institute. The big Polaroid that Lucas did of me is in the Australian National Gallery. It's very nice, it's a kind of immortality, but at the same time it's sort of embarrassing. You're doing portraits of all these people, and I'm not sure I'm in the same league with a lot of the people of whom you're doing portraits. So it's that kind of thing. It's not being too humble, but as you know, I'm a shy person. You also know that I don't court publicity, it just comes. We do what we have to, but I find it an invasion. [*Arne Fingerprint* [second version], 1981, litho-ink on paper, Art Institute of Chicago.]

• • • •

Chuck: Why does everyone in the art world want to make a movie?

Arne: I can only speak for myself. I was a painter, and I was an actor, and for me, directing is the perfect hybrid of painting and acting. I think films are popular culture, not high art even at their best, so it's not as though I feel that I'm making my art. I'm very satisfied with the ability to express myself in so individual and personal a way as I have been able to do with film; it satisfies me and fulfills a certain kind of need. I don't know why Julian [Schnabel] is doing it

except that Julian knows so much about movies, and he's so damned smart and talented. You know, I was on Julian's set, and I was watching him. You don't know if Bertolucci's next movie is going to be a catastrophe or a masterpiece, so you don't know what Julian's movie is going to be, but it was really interesting to see this neophyte, who knew nothing about the equipment, in possession of himself and the set. I was really impressed. I think the work of someone like Robert Longo was already very cinematic, in the vein of the film that he made, but I didn't see the film. I think his work was influenced by movie superheroes. I don't really know David Salle very well. Making movies is not so far from making paintings. They are called moving pictures, motion pictures. I think that, if they have some level of composition and they are lucky enough to have a story to tell, most artists could make better movies than most directors. You see, I'm not an artist. [Glimcher produced *Legal Eagles* (1986, Universal Pictures), *Gorillas in the Mist* (1988, Warner Brothers/Universal Pictures), *The Good Mother* (1988, Touchstone Pictures), and directed and produced *The Mambo Kings* (1992, Warner Brothers) and *Just Cause* (1995, Warner Brothers). Julian Schnabel directed *Basquiat* (1996). Robert Longo directed *Johnny Mneumonic* (1994, TriStar), and David Salle directed *Search and Destroy* (1995, October Films).]

Chuck: *One of the great things about being a painter is that, first of all, no one needs to agree that a work needs to exist before you make it.*

Arne: And I don't have to come down everyday, see what the dailies look like, and tell you to paint a little more green on the left-hand corner.

Chuck: *That's right. And I can afford the best materials. I never have to make a compromise and say, "I can't afford to use green, they didn't give me a big enough budget." What I asked was really more from the point of view of the artist. You've always collaborated. That's how you get things done, but for an artist to give up that kind of complete control—It's interesting that one of the most widely held misbeliefs about the art world is that dealers routinely attempt to influence—*

Arne: Cull production.

Chuck: *—and cull production, to ask the artist to make things that sell and not to make any others.*

Arne: Never, ever. I think only an idiot does that.

Chuck: *In all the years that I've been with you, you've never—*

Arne: —told you to do landscapes.

Chuck: *You've also never told me that you didn't like something of mine. You were always very supportive of anything I wanted to do. Later, five years later, you might say, "Well you know, that piece, or that series, wasn't my favorite."*

Arne: If you like someone's work enough to be responsible for it, then you always find something that is interesting in it.

Chuck: *I think that what you do is represent an artist, not his or her works. If you only supported particular works, then you'd have to run a resale gallery.*

Arne: I wound up as Dubuffet's only dealer for that reason. Dubuffet left Beyeler in '76. Dubuffet did a series of works called *The Theaters of Memory*, which I think contain some of the greatest works of his career. They were the biggest works of his career. Beyeler had this little gallery in Switzerland, and we would choose works together. We would choose what we were going to buy from Dubuffet. We'd buy a few works, and then come back and buy some

more. Dubuffet would flip a coin, and I'd say "heads" or Beyeler would say "tails," and then I would get the first choice, he would get the second choice, I would get the third choice, and he would get the fourth choice. There were thirty-five of these incredible works, and Beyeler came up to me and said, "You know, these are not so good, and they're not going to sell. It's very hard in Europe. I'm just taking two. Why don't you also just take two, and then later you can come back and take some more. I said, "No, I'm taking more." He said, "Okay." So he chose one, I chose one, he chose one, I chose one, and then I took thirty. Dubuffet was furious with Beyeler. He had spent the last two years on these works and Beyeler was not supportive. I didn't know how I was going to pay for them, even in '76. That night Dubuffet took me out to dinner, and he said to me, "You know, the role of a dealer is to support the artist. You supported me, Beyeler hasn't, and he's no longer my dealer." So I said to him, "You know, I'm going to have a lot of trouble paying for this," and he said, "Well, could you pay for it over a year, in twelve installments?" I said, "Yes," and that was that.

Chuck: *I think it's really true. You buy into an artist's vision, but you're not going to like everything.*

Arne: Every series of Picasso is not that good, but every series is interesting.

Bill: *And important, because it leads to the next.*

Arne: If an artist is good, there is something interesting in all of his work.

◆

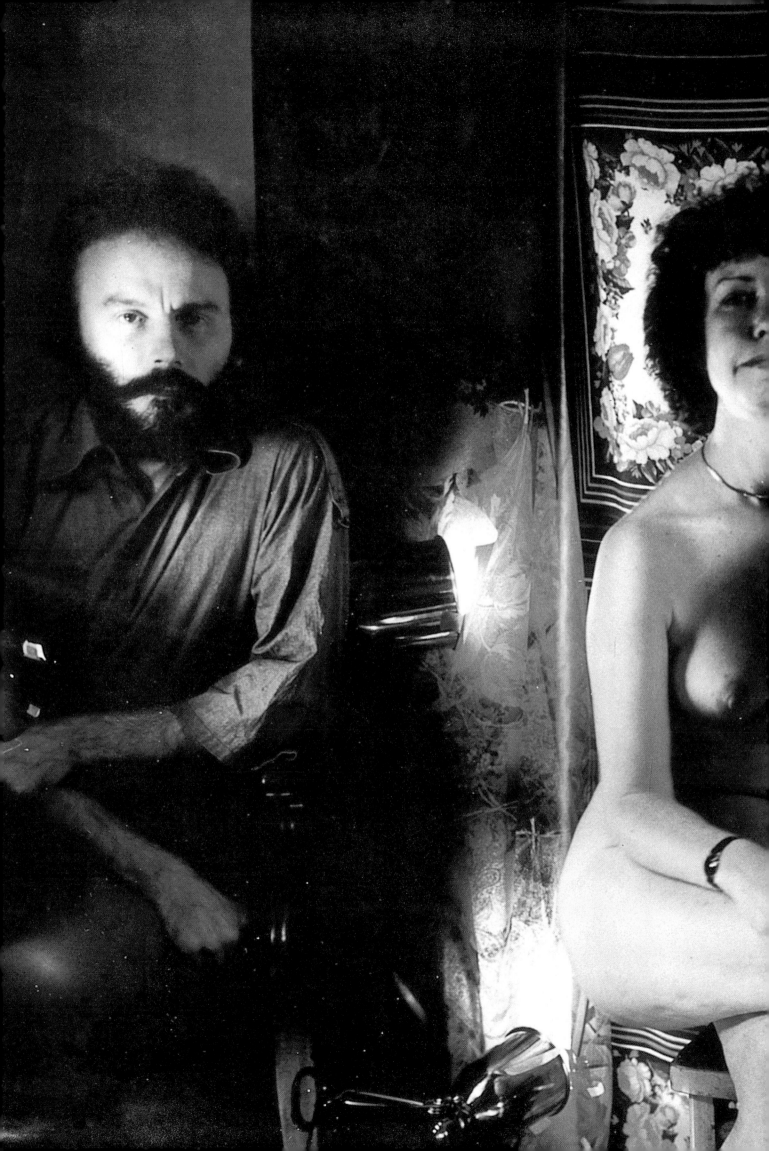

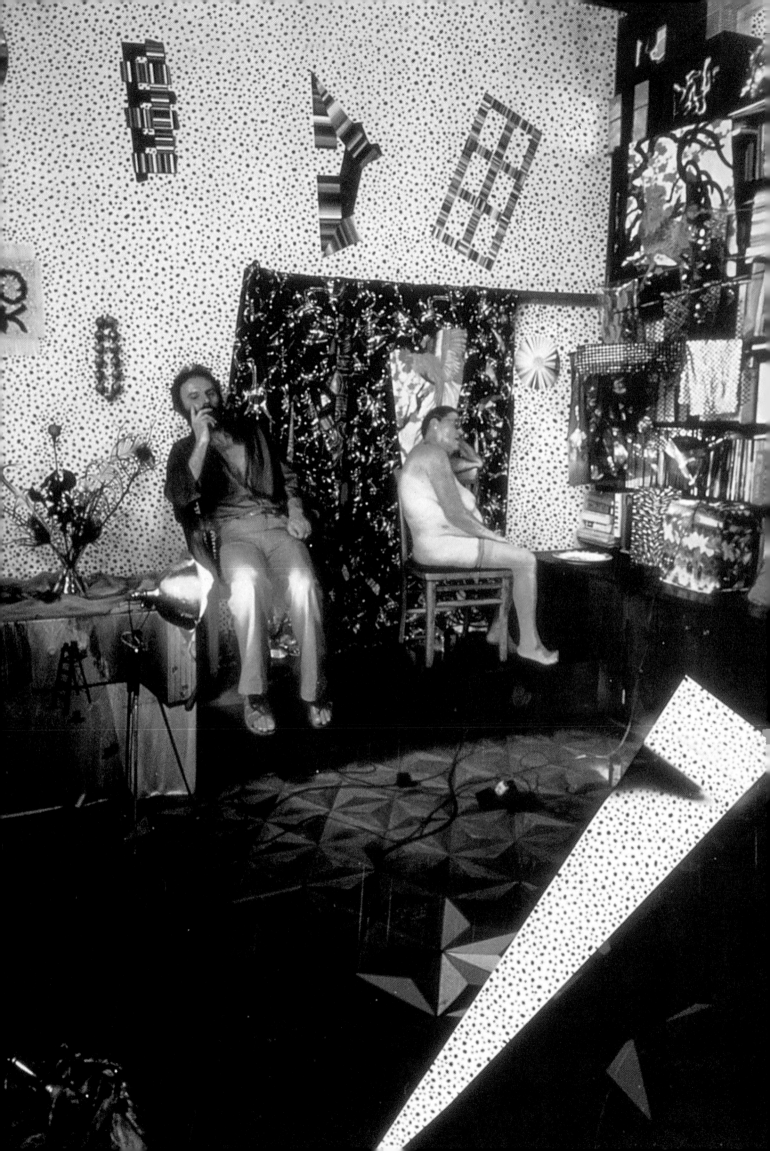

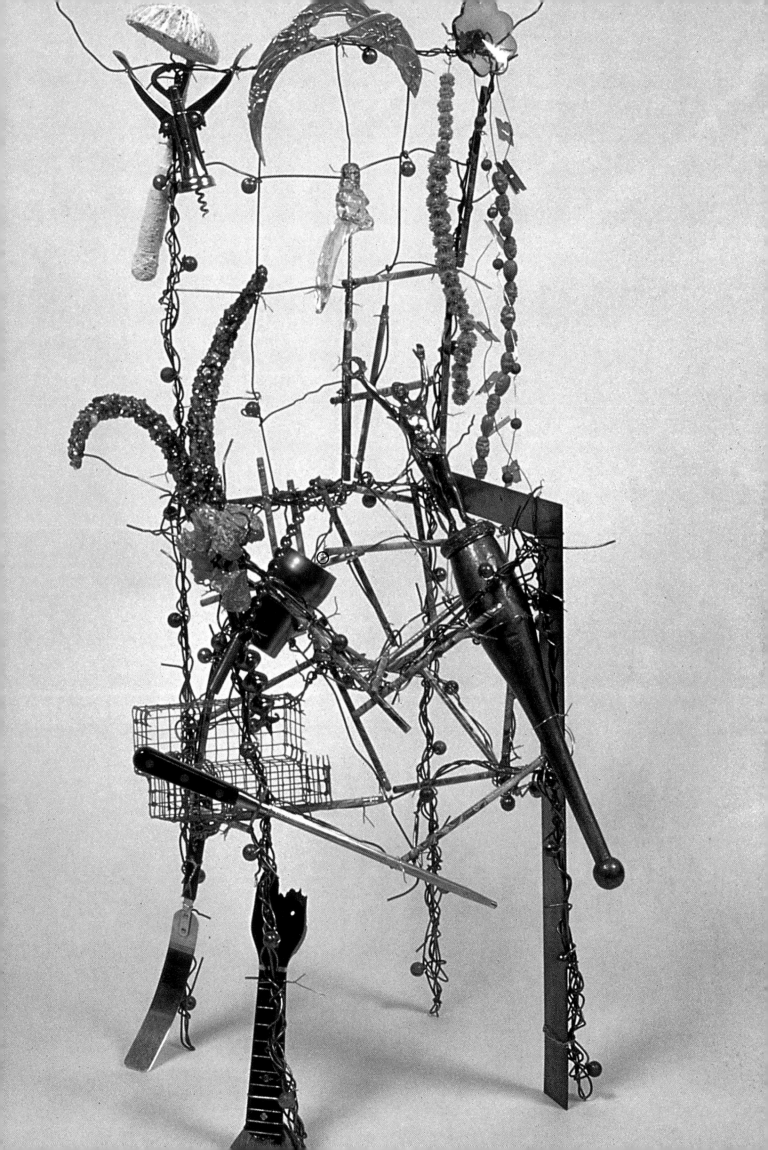

Lucas Samaras

New York City, November 18, 1994

Chuck: I do this interview with fear and trepidation, but if it doesn't work out, you can just interview yourself, which you do very well.

Lucas: Sure.

Chuck: I was looking through your voluminous resume trying to figure out the first shows of yours that I saw. Wasn't your Reuben Gallery show in 1960?

Lucas: It was in 1959.

Chuck: Right, '59. Your first Green Gallery show was '61. What did you have in that show?

Lucas: I had some plaster things, some pastels.

Chuck: Liquid aluminum pieces, pastels, and plaster. I remember that show. The next show was the one in which you lived in the gallery.

Lucas: I didn't live in the gallery; we had reproduced my bedroom.

Chuck: Right. You didn't hang out in there?

Lucas: No. Actually, what happened is that I had to leave the place at which I had been living with my parents, because they moved to Greece. I had taken a place on Seventy-seventh Street, and those were the remnants of the old place, so I didn't have to live there.

Chuck: I had remembered that you actually lived there.

Lucas: Well, it looked as if I did.

Chuck: You know, they just had that show at Exit Art with all the artists living in the gallery.

Lucas: Oh, right.

Chuck: Let's cut to your most recent show, which is currently at Pace, and which I think is really a wonderful show. I've seen it maybe five times now, and one of the things that I thought was really interesting about it was how perversely you have purged your work, yet again, of everything that people have come to expect or like about your work. In other words, there was nothing decorative and there weren't a lot of bright colors, all that stuff that people associate with you. For me, you're the artist who has reinvented himself more than anyone of whom I can think, and I love the way you ruthlessly purged this work of everything. People come in and expect to see what they saw last time, and you always bring them up short. I thought the cubes, not cubes—what do you call them? Do you have a name for them?

Lucas: We call them cubes. My first name was bases.

Chuck: *Do people use those bases for other things?*

Lucas: I thought so.

Chuck: *Without Brancusi on top of them?*

Lucas: We thought of sculpture. Who needs sculpture?

Chuck: *Well, unless it's yours.*

Lucas: Just the base.

Chuck: *I thought they looked like the Sol LeWitt open cube series would have looked if Sol had been on acid.*

Lucas: Well, we've come to a delicate point here of who does what, and whatever. Everybody has their own developmental history, you know. It begins at age five, or fifteen, or twenty, or whenever, and then you go on, and as you're making objects, works of art, you find that some look better than others, so you put away the ones that don't look right. You may decide to go back to them later on, you know, which is what I did.

Chuck: *They do harken back to a lot of other earlier works: the chairs and stuff.*

Lucas: In the early sixties, I made a series of boxes or small cubes. In the catalog I reproduced four drawings, but I have twenty more. I made these cubes out of plastic, mylar, or whatever was transparent, and I showed them in the show where I showed my bedroom in '64. Barbara Rose reviewed the show, and she said they weren't very well made, and I agreed with her, but I didn't know what to do about it. A year later when I joined the Pace Gallery, we tried to make one that was more solid looking, but it didn't look right either, so I abandoned it.

Chuck: *What did you make it out of?*

Lucas: The same as mylar, only thicker. Somebody else made it. We commissioned someone else to make it, but it still didn't look right because of the edges. It was impossible to have perfect edges, you always saw the glue or some imperfection. Thirty years later when I moved my apartment and all that, I used a substance that is like Formica, only it's called Nevamar, in constructing my furniture. I thought, "Well, let me try it again with this substance," and then I drew the color just a grey, actually it's taupe, t-a-u-p-e. As for the permutations, that's a natural part of my artmaking. I always do that whether I'm making boxes, or paintings, or whatever. I make one, and then I try to find another way of making it again, and so on. So it's okay to mention Sol LeWitt or somebody else, but you also have to know that I have my own history.

Chuck: *Oh, of course. I guess I was suggesting that some of the same kinds of investigation, of re-inventing, or permutations that we associate with minimal aesthetics—*

Lucas: Also, there's this thing called art, and it has so many different tentacles, so many different areas. You could decide to, like you, go into one cave and just stay there, but if you decide to go to another cave, maybe someone else is there, but you say, "So what. I want to see what I can do in that cave." It may be a cave you visited thirty years ago, or some other place. Whenever I have a show and have some criticism, my work is always compared to that of other persons who are having a show at that time, no matter who it is.

Chuck: *That's right.*

Lucas: It could be Grandma Moses, it could be Matisse, it could be *The Book of Kells*. It used to irritate the hell out of me. "God, I hope no one I hate has a show at the same time, because they'll connect me with that person." Now I just prepare myself for that.

Chuck: Well, your work is always primarily inward looking, and you've talked and written about your-self as the center of your own universe. It's like when Woody Allen said that he liked to masturbate because at least he was having sex with someone he really respected, which reminds me of your famous quotes about your autoeroticism. However, I think it is a mistake to look at your work from the point of view of what other people are doing because you fall into such an idiosyncratic, personal, self-reflective kind of path. Do you think that has made it more difficult for people to deal with your work critically, that if they can't relate it to something on the outside, they don't even know how to describe it?

Lucas: What bothers me is not that they mention them with me. It's that they never mention me when they write about them. They always mention them when they're writing about me, you know? "The skeleton of a cube." Why in the fuck don't they mention my skeleton, which predates Sol LeWitt's. They never will, you know, never, but anyway, I don't consider you an enemy, so—

Chuck: I'm not an enemy anymore. When I first joined the [Pace] gallery, and I was the new kid on the block, I got the focus of your, uh—

Lucas: Interest?

Chuck: Yes. Perhaps beaten up unmercifully for the first couple of years is more accurate! Thank God, someone younger came along. I was so happy to see Julian [Schnabel] come into the gallery, go to a couple of Arne's parties, and see the gun barrel pointing—

Lucas: But you see, I never think I'm attacking anybody. I always think that it's like playing with a cat or a dog: you sort of goose them up to get them excited, you know. It's not meant to kill, it's meant to excite.

Chuck: As opposed to maim.

Lucas: Not to maim either. The maiming is accidental.

• • • •

Chuck: Who's written about your work that you think has gotten it?

Lucas: Well, as you know from your own experience, everybody who writes about you has a couple of interesting insights, no matter who they are. It's just that they never get the whole thing.

Chuck: Did the fact that Kim Levin lived in the same building with you and had a chance to know you more personally offer her entrance into your work? How much does a critic have to separate the person who makes it from what's made? Are you perfectly happy to have people just look at the work? I mean, there's a lot of myth and other things that people want to write about, like where you live. I hate it when people come to my studio, look at the bookshelves to see what I read, or look around to try to figure out who the hell I am, who made this stuff, but you've made your environment, especial-ly your old apartment in which you had made all those pieces, such a mythic kind of place.

Lucas: I do so many different categories of work or whatever you want to call it. Different critics respond to different aspects and hate the others, so if I feel nasty, I hate them for hating

all the other stuff. I like them for liking a certain thing, but why don't they like the other things?

Chuck: So it's the old joke: your mother gives you two ties, you wear one, and then she says, "Why, don't you like the other one?"

Lucas: Right. Exactly like that. I know exactly what they like about my work and what they don't like, but I hate them for not being able to move on, to come with me, instead of waiting until I go back to the thing that they like. This is why I can't answer the question, "Who writes perfectly about your work?" You want them to join you, to come with you as you're moving on.

Chuck: I've always thought your work was very generous. I think it's all out there for people to see, and it's very celebratory in a way.

Lucas: That's when I show it, when it comes to a point where I feel exalted, or enjoy it, or am stupefied by it. That's the time to show it, when I feel I can afford to allow it to live by itself because it has energy. If it doesn't, then I don't show it.

Chuck: What percentage of the work that you make do you actually show? Do you have any idea? Are there huge undiscovered troves of stuff?

Lucas: Sometimes it has to do with me, other times it has to do with the gallery or whatever, because if they don't like something, they don't necessarily respond to it.

Chuck: Have you ever had that? Have there been instances when Arne hasn't responded to something?

Lucas: Well, any dealer has preferences.

Chuck: Arne has always told me afterwards that he didn't like a certain body of work.

Lucas: I see immediately whether he likes it or doesn't like it.

Chuck: Oh, I think I choose not to see it. I think I don't want to see a negative reaction while I'm doing it.

Lucas: I don't know why, but, generally, I expect people to *not* like whatever it is I'm doing.

Chuck: Does that drive you? Do you try to make stuff that they're not going to like? And then do you get pissed off?

Lucas: No, no. I don't do it because I think they're not going to like it, I do it for my own internal reasons. I could put it another way: I think it's part of my psychology, mumbo-jumbo, voodoo or whatever that I think it is going to work out that way. I'm confident it's going to work out that way. It usually doesn't. Yesterday there was an opening for the art nouveau furniture and jewelry collection of Sydney and Frances Lewis from the Virginia Museum. It was from six to eight o'clock. I haven't gone out at night for a long time, and I was going to walk from Fifty-sixth Street to Eighty-sixth Street through Central Park. Automatically, I started thinking, "How do I dress so that I don't attract attention and get mugged, or shot, or something?" Automatically, that's my attitude, the attitude that somebody's going to get me, I had better watch it, and do I have my last will, and all that, right? Then I go out, and I see people walking in the streets. It's amazing. I was shocked, because for four years now I've been living a kind of semi-sheltered life, and that's the attitude I have, even with shows.

Chuck: Shows are the same as going out, huh? You seem to give yourself over to a process. You've done photographs for a while. You bring the photo studio into your space and you do everything there,

or you rig up a sewing machine and sew for a while. Whatever it is, it seems to be a kind of belief in the process in which you engage yourself entirely.

Lucas: It's like an obsession. In the beginning you think, "Gee, can I do something, can I do something?" for days, for weeks, or whatever, but once you've made one thing with that process that looks legitimate, you're in heaven because you've found mother, father, and you know. Then there's joy, and you can't stop working until you're exhausted.

Chuck: You invited people into your studio to be photographed, and I was one of the people.

Lucas: Well, that was interesting. A friend of mine first posed. He was perfectly relaxed with his clothes off, but then I asked Arne, and he wasn't used to that. The beginning is usually the most exciting part, when I do one or two or three works. So Arne came to my house and I said, "Come on, pose for me," so he was going to pose with his shorts on. I said, "Come on, take them off," but he was terrified, and then I said, "Okay, enough of this crap," and I went over to pull them off, and he said, "Okay, okay, I'll do it." So he did it, and he liked it. Then I thought I'd ask some other types. I asked a friend of mine who was eighty years old, and she did it. She's an artist. She was an artist, she's dead now. Eventually, I wanted a young person, an old person, a fat person, you know, whatever.

Chuck: You had sisters and—

Lucas: No, no. No relatives.

Chuck: No, you had Julie Harney and her sister.

Lucas: Ah, sisters, yes, but not my sister.

Chuck: No, no, not yours. Then you had that incredible portrait of Joyce Schwartz and her son. God, is that a perverse photograph. A woman with—how old was her son?—sitting on her lap.

Lucas: I thought it was a wonderful gift they were giving me, you know?

Chuck: Oh, absolutely.

Lucas: I was even thrilled with critics who didn't write positively about my work, like Sidney Janis. He never had a big thrill for my work, but when he accepted it, I thought it was such a wonderful gift. He was the dean of dealers, and he was eighty-four years old or something. It was even worth his not having shown me, you know, and I think some of them came out all right.

Chuck: Oh, I think it's a wonderful series.

Lucas: There are some parts that are nice but in other parts there are problems.

Chuck: For someone who had already done so many auto-photo works, been viewed in your own photographs for so long, there you were fully clothed, sitting in the edge of the frame with the—

Lucas: Well, I didn't want to compete.

Chuck: You mean whose was bigger?

Lucas: Well, yeah, or whose was prettier or whatever. There's no need to do that. There was no need. Plus, they were materializing my fantasy, not their fantasy, but they serve the same function as material. You posed pretty straight.

Chuck: Except for my cowboy boots.

Lucas: Others gave me more angles, and this and that.

Chuck: I'm a pretty formal guy.

Lucas: **Yeah.**

Chuck: *It's interesting who you got, because some of the people who in life seem to be the straightest, most conservative people, maybe because they thought they really needed to give you something that fit their perception of who you were and what you were going to do, did the most outrageous things.*

Lucas: **I never asked them why they posed for me.**

Chuck: *You didn't? How many people refused?*

Lucas: **Two people.**

Chuck: *Really? Only two?*

Lucas: **And I didn't miss them.**

• • • •

Chuck: *What about the initial response to your work? You've been with Arne forever, and you were with Green Gallery—*

Lucas: **I had three dealers: Anita Bessman of Baker, Reuben Gallery; Dick Bellamy of Green Gallery; and then Fred Muller; and now Arnold.**

Chuck: *What was the initial response to your work? Did you go around and show your work to a lot of people?*

Lucas: **I did, but Arne called me when the Green Gallery closed, so I didn't have to do that. From time to time at the Green Gallery, when I decided Dick wasn't showing me often enough or whatever, I would get my pastels out and do a little round, but it didn't work out. With Arne, I didn't have to do that. He called me.**

Chuck: *So a long relationship began and, on some level, one different from any relationship the rest of us have had with him. It was more family or something than perhaps—*

Lucas: **But that comes over the years. I think I began to like him when his children got to be a certain age. When I met him, they were three years old or something, but when they got to be eight or nine or ten, they really showed a lot of affection for me. I decided that if they were showing affection, it meant the parents also were affectionate toward me, and then it was over, and there was no struggle anymore. As always, I'm hesitant about being close to anybody, but the children helped in that. I'm not used to dealing with other people, you know. I'm always aware of the major differences rather than the similarities, even like the misunderstanding we had for years, the one in which you felt that I was out to get you every time you came to the gallery.**

Chuck: *I took it as a first impression.*

Lucas: **I never gave it like that, but you took it like that. It's another indication of two different people.**

Chuck: *On the other hand, I must say that I took some pleasure from it because I thought that at least you took me seriously. If you hadn't given a shit, you would have just totally ignored me. There was something about getting your attention that was pleasurable.*

Lucas: **I told Arne to bring you into the gallery in the first place. Why would I—**

Chuck: *I know. It was one of the things I wanted to mention. When I was showing with Bykert, apparently you brought Arne to see my first show.*

Lucas: I didn't bring him, I told him, because Arne was not figurative, so he had to learn. He's still learning.

Bill Bartman: *I remember reading in your bio that you went to the Neighborhood Playhouse?*

Lucas: No, I studied with Stella Adler.

Bill: *Why did it say that?*

Lucas: Why? Because I thought I would become an actor. I made the rounds in New York, and I didn't like it.

Chuck: *The nice thing about making a work of art is that you have the performance in private. Nobody's around while you are making the thing, and then you have the reaction, the reaction takes place—*

Lucas: —when you're away.

Chuck: *When you're away. You shove the work out into the world, and you don't have to experience the rejection on a personal level.*

Lucas: However, I loved lecturing and going around the country in the eighties. I loved that warmth of a bubbling audience, especially outside of New York.

Chuck: *Why did you like it? I mean, it seems so unlike you to enjoy something like that.*

Lucas: You don't have any responsibility afterwards. It's as if you prove yourself to them there, and they give you immediate satisfaction: the applause, the laughter, the giggle, or whatever, and then it's over.

Chuck: *What you just said made me remember that Warhol was the most private person in public. He was in public all the time, and he was the most private person that he could possibly be. You never got through to him, you just had to be there. You're the most public person in private. You show us everything about every orifice of your body, every piece of you, and you do it all at home in a totally private way, and then you put it out for all the world to see. You don't have any problem with exposing yourself if you're not there. You'll show anybody anything.*

Lucas: I don't just expose myself. I photograph certain private parts of myself, but in a way that they look better than I thought they would. I wasn't interested in showing the reality, I was showing my aggravated reality. It's as if you're talking to yourself, you have an idea, and you say, "Gee, that's a nice idea, I should tell it to somebody else," but if you told it the way you said it to yourself, it would probably sound stupid, so you work on it. After you work on it, you tell it, and it's okay. If they don't like it, they don't like it, but at least you've worked on it, you've protected it, you've chiseled it, you've manipulated it. At that point, it's not just exposure anymore. There are such elaborate layers of beauty that you've put on it, according to what your sense of beauty is, that it's beyond exposure. Someone might see it and say, "Well, it's exposure." You schmuck, you idiot, you moron, look how beautifully it's done. The colors, the shape, the positions, and all that, you know? So again, what I get from those auto-Polaroids are different than just pure exposure, because I couldn't use the first shot I took. I'd look at it and say, "God, it's ugly, I can't show that, I don't even want to see it."

Chuck: *You got in trouble with Polaroid, right? Were you using the word "Polaroid"? Didn't they want to stop you?*

Lucas: Yeah, they were upset. They were going to sue us or whatever.

Chuck: *But then they bought a Polaroid that didn't have any nudity in it, and they gave it to the Museum of Modern Art.*

Lucas: That was different. They had a project, a commercial advertising project. They asked various photographers to take a picture, and they were going to use them in the ads.

Chuck: Time *magazine had a big full page ad with "The Museum of Modern Art owns this photograph…"*

Lucas: Or some other museum owns somebody else's work. I showed my Polaroids to the guy who was in charge of the ad campaign, and they picked one. They didn't show genitals. I could understand that. It was not a big deal.

Chuck: *Except that they must have figured at some point that it didn't hurt that you were classing up their amateur medium. They've got to know that the main use of Polaroid is for people to take—*

Lucas: Dirty pictures.

Chuck: *—dirty pictures of themselves in the act.*

Lucas: I took dirty pictures, but I made them pretty. Also, I turned them into museum things, because before that nobody showed photographs in a painting gallery.

Chuck: *That's right.*

Lucas: It's as if I legitimatized it, but the whole thing was so weird then. The audience was ready for that, they were ready for photography.

Chuck: *I think the whole history of art photography—*

Lucas: I guess photorealism opened some kind of door, just as regular photography—Robert Frank, Avedon, and all—opened a door. Photorealists opened the door, and then came real photography, and it was accepted. Photographers should accept the small format and not make big blow-ups. Big blow-ups are like someone shouting aloud something that shouldn't be shouted. It was a very bad mistake. I made that mistake in my first lecture. I had a joke in the lecture. I had a microphone, and I was talking to the audience, and when it came to the joke, I was so excited that I told the joke louder than I should have, and nobody laughed. It was a terrible thing. I was mortified, but I learned the lesson that you have to underplay. Every other time I told it, it was wonderful, they applauded, they screamed, whatever. So they're doing that, shouting, very bad. Whereas with you, Chuck, the whole concept was big, it wasn't the idea of a blow-up. The original came out automatically that size, you know. But then you tried doing a figure big. It didn't look as great as a face big.

Chuck: *Still wasn't big enough.*

• • • •

Chuck: *I remember seeing you at Johnson Church in the sixties at one of those—*

Lucas: Happenings?

Chuck: *Happenings. When you were doing those happenings, were you still interested in the idea of being an actor?*

Lucas: That's why I was participating in my friends' happenings. I was studying with Stella Adler, and you study Stanislavski, you know, for traditional acting, and then you go to a happening and

do sort of expressionistic stuff, like talk to aliens. At a certain point, I had to make a choice to either do a number of scenes for the Stella Adler group or do an Oldenburg happening, which was the same week. I picked doing the Oldenburg number, not Adler, and that became my future.

Chuck: *Besides Oldenburg, whose others were you in?*

Lucas: I was in Allan Kaprow's, which was the first happening, and then I was in a lot of Bob Whitman's stuff.

Chuck: *Oh, Whitman is such a good artist. I just heard from Arne that somehow the Dia Art Foundation threw all of Whitman's work away.*

Lucas: Well, he's had some tragedies throughout his life: his first set of works was destroyed and now the problems with the Dia Foundation.

Chuck: *Bob was really interesting.*

Lucas: That's different from having them burn up, like Al Leslie, who lost his studio. That's more like fate. With Whitman, sometimes it's almost as if he—

Chuck: *—is self-destructive?*

Lucas: Yeah.

Chuck: *So, ok, let's talk about self-destructive.*

Lucas: Certain people now perceive me as being self-destructive, but I'm not really self-destructive.

Chuck: *Yeah, I wouldn't think so, but when you write or when you talk in interviews, so much of what you say about your work is negative.*

Lucas: About what? What am I negative about?

Chuck: *About everything. Well, maybe not negative, but difficult. You did a book with Arne, right? Didn't you do a very scatological book with him?*

Lucas: Scatological?

Chuck: *Yeah. Am I going crazy?*

Lucas: You're going crazy.

Chuck: *No, it was a book. Millie Glimcher was involved, I think.*

Lucas: Oh, my stories. Sure, Millie published my stories, *Crude Delights*.

Chuck: *The way the work keeps in the accretionary kind of way; it keeps adding. And I was really interested in what you were saying about beauty because you've built this really rich mosaic of work over the years. I see your work as far more positive than the way you actually talk in interviews, or some interviews.*

Lucas: Yeah. Are you referring now to my manner, my daily manner, my demeanor, whatever?

Chuck: *Yeah.*

Lucas: In front of people generally?

Chuck: *Well it's the only time I ever see you.*

Lucas: Generally, it's as I explained before about going out on the street and thinking I am going to get mugged.

Chuck: *Did you think you were going to get mugged then?*

Lucas: Not mugged.

Chuck: *You know, people can experience loss in a show. As we were saying earlier, you're not giving them that piece of you that they want, and because you're dealing with your whole history, they're not really responding to you as much as they're saying it's not blah blah blah.*

Lucas: Well, it's not right for them to say that. I just think that, generally, there's not much contemplation on their part. You know, they have to get out to work every week.

Chuck: *There's another thing that critics aren't: they're not fans. When a fan loves the person, the fan sees anything that they do. If I see a Woody Allen film, even if I don't like it, it has added something more to what I already know, and it makes it more interesting to experience. If I had to be a film critic and say whether or not this is one of his greatest films, I'd have to say that this film falls short, has problems, or whatever, but as a fan, I'm just glad to have more work.*

Lucas: Well, about criticism. I make a body of work, and then I get ready to show it, and if it approaches sort of dangerous areas concerning the outside's perception of what art is, I think, "Ok, they will attack me for this, they will attack me for that," so by the time I have the show open, I know how I'm going to be attacked. When you have a show, are you ever surprised about an attack on you?

Chuck: *I'm more surprised if they don't attack. When I give a lecture, I always hope for some hostile people in the audience, because it gets the rest of the audience on my side.*

Lucas: My question is: "Do you know the attacks you're going to get?"

Chuck: *No.*

Lucas: See, I do.

Chuck: *Well, I know the few standard attacks.*

Lucas: Yeah, standard, but every time there's a new one that may come out, which you have to know before they know it, right?

Chuck: *Sometimes I'm dumbfounded by new attacks that I hadn't anticipated.*

Lucas: Oh, you are. Well, generally, I think I know exactly how they're going to attack me, although I hope they don't.

Chuck: *Is that because you're self-critical, and you've thought of everything that somebody could say about it long before they can say it?*

Lucas: Yeah, but it hurts just the same.

Chuck: *I think I bury my head in the sand, and it's not easy in a wheelchair to bend over and get your head in the sand, let me tell ya. It's interesting that Roberta Smith at one point wrote only advocacy journalism. She only wrote about work she loved, and she wrote kind of puff pieces, stroking the people of whom she was a fan. Then when she went to the* Times, *she got the "Hilton Kramer Chair of Poison-Pen Journalism."*

Lucas: Yeah, but nobody's as good as Hilton.

Chuck: *That's true. She's become so fucking nasty, it's amazing, but Lucas has gotten back because he did those wonderful heads of the critics. I don't think you can go wrong with the heads.*

Lucas: Well, you can't go wrong with Byzantine.

Chuck: *With extra mouths to spew. You gave artists extra eyes, though, didn't you?*

Lucas: I don't remember.

Chuck: What about this whole thing? These conversations are mostly about the other artists who I've painted, their work, and how they entered the art world, but one thing that we've tangentially been talking about, since the common denominator is that I've painted all of you, is some short reaction to having been painted. Also, I feel that it has been an act of tremendous generosity on all my sitters' parts to lend me their images to do whatever I've done with them.

Lucas: Ditto, you know. It's also generosity on your part to select them. Anyway, I was thinking about it today, and I thought, "Gee, isn't that interesting. Most of the heads that I've seen of Chuck's tend to be people in different states of pain." They're either a little to the side, or in profile, or whatever, and sometimes they don't want to share the pain with you. Other times it's a very delicate pain, but when you painted me, it was as if I was giving the pain, not receiving the pain, and I wasn't expressing pain either.

Chuck: Well, you were the poser of all posers. When I did that series I was doing people—

Lucas: Do you accept that?

Chuck: Yeah, I was just going to comment on that. That series was of artists whose faces we know because they make self-portraits. It was you, Alex, Cindy Sherman, and Francesco Clemente. When I photographed that group of artists, unlike all the other people I've photographed, they had a strong sense of how they wanted to be portrayed. All of you got more into the photograph than other people who I consider amateurs at posing. You pumped yourself up in the most amazing way for each hundredth of a second that the lens was open. This kind of intense anguish could only be held for a split second, and it would dissipate the minute the lens snapped shut. Also you wanted the back light so that it would look as if you had more hair. Cindy was the most self-effacing; she was like nothing until I gave her a role to play. But you played your own role. That's why I did the concentric circle piece from the third eye, which is not something that I would normally choose to do; I thought you were exercising some kind of mind control from the other side of the camera.

Lucas: But I recall that when you were taking the pictures, you would say, "Give me more."

Chuck: Oh, I don't remember that.

Lucas: So I gave you more.

Chuck: You gave me more. When you photographed me, I wished that I could have given you more. How come you didn't use anybody's genitals?

Lucas: I thought it was a problem at the time. With a woman, it was no problem: breasts, big deal; even if you spread the legs, it's nothing. With a male, which is better? An erection or something hanging? You know what I mean? You don't know what to choose. If I were a classical sculptor, I would say, "Well, the male has to have some proportion, and the size of the genitals has to be only this much and nothing more," because if they were too big, it would be like a Satyr in a Satyr play: a comedy, not reality anymore. The classical Greek, the Romans, I don't know, would probably want something bigger, but in our time, I just thought that the genitals of males in a photograph—and the males that I picked ran the gamut from old to young, nice looking to not nice looking—it would be too vulnerable, you know. The viewer would notice and would see the embarassment of the individual.

Chuck: I thought that if you were going to do us with our genitals showing, it should have been something like, "Gee, it was very cold in the room."

Lucas: Well, you vote for comedy; I vote for seriousness, you know.

Chuck: *But we all would have wanted to say, "Well you know, it was very cold and it shriveled. It's usually much bigger than that."*

Lucas: I just thought it would be a big problem, and I think it was. When I photographed myself, I used a lot of cold lights, waited for the right moment, took the right picture. I wouldn't have had the same amount of time with the guests, to make everything look all right, and there's an element of catharsis in making them.

Chuck: *Well, you built a different environment for each person.*

Lucas: Yes, and also I learned a strange thing about the camera: the most beautiful people don't come out beautiful. It's as if the lens has its own criteria.

Chuck: *It loves some people, it really does.*

Lucas: Yeah. For instance, I had two gorgeous women. If you saw them on the street, you would say, "Gorgeous," but they didn't come out gorgeous. I was just shocked.

Chuck: *The camera does love certain people. I was talking to a photographer who had photographed Marilyn Monroe, and he said that as she was walking towards the camera her legs looked too short, and she looked kind of dumpy like a housewife-looking person. Then he would look through the ground glass plate and when she moved into the rectangle, she immediately became a movie star. How do you feel about what's going on in the country today: the problems with the Endowment, and the reception of difficult work, or work that has sexual content?*

Lucas: Well, I came from a background in which sex was a taboo, so you have to pay the consequences. For example, when I was graduating from college, I did a project that had the word "fuck" in it, and I was not going to be allowed to graduate. Finally, my teacher, Allan Kaprow, convinced them that it was okay and that I should graduate, but he was fired. This kind of strife for ten years about that can be boring. That's one. I think I'm sick and tired of the interest in ghoulishness: cadavers, and malformed babies. I'm tired of it, just as I'm tired of environments. Some things should be done very delicately once or twice, and then you go on, you know. You do it because you have to, it's part of your education, but if you stick to it—I'd rather not. It's almost like Roman times, when they tortured people, chopped them up, and all that. It's too much, it's not necessary. There are ways of finding drama, beauty, and other reality without all that.

Chuck: *So many of your objects are small boxes. I was just looking at the wonderful little bell jar pieces over at Pace. So many of them have the kind of intimacy or private nature that we might associate with opening a book: you can go into your room, open a book, and read something intimate, and it's about a distance rather than a big thing on a wall. The pieces are like some wonderful little boxes in which you brush the gems away and uncover your image or something. They seem so much about presenting something in a very intimate and personal way.*

Bill: *How did you feel about the painting of you that Chuck made?*

Chuck: *I loved your comment when they called you and asked how you liked being made into a rug. You said that at least it was better than having your image on toilet paper.*

Lucas: Were there two images all together?

Chuck: *I did a black and white one and two color ones: the concentric circle one and the big painting that the Met has. They often have you hanging and looking at Warhol's self-portrait—the two of you staring at each other.*

Lucas: I know. It's down. I was so depressed.

Chuck: *It's over in Germany.*

Lucas: Oh, I mean at the Metropolitan. You mean it was sent to Germany? Oh, that's why. Is it going to come back again? I went to see de Kooning and—

Chuck: *You wanted to visit yourself?*

Lucas: I wanted to visit myself, right, but I didn't see it. The colors are a little different here *[looking at book]*. I think everybody likes this one more than the other one.

Chuck: *The "target" one in Seattle?*

Lucas: Seattle, right, but the black and white one in LA is my favorite.

Chuck: *I should give you one of those prints.*

Lucas: No, no. My narcissism is different from other people's. Narcissism is an interesting subject.

Chuck: *Certainly for you.*

Lucas: Yeah, but I think people who have children are narcissistic.

Chuck: *To want to reproduce themselves?*

Lucas: More narcissistic than those who don't. Also, do you think there's anybody who looks in the mirror and says, "Ooh, how gorgeous"?

Chuck: *I never look in the mirror.*

Lucas: So there you are. Never even as a child?

Chuck: *No, I've never liked the way I looked.*

Lucas: I think there's no one who likes themselves in the mirror.

Chuck: *Have you seen that new mirror that reverses your image so that you see yourself the way other people see you? I mean, that's why people don't think that they're photogenic.*

Lucas: Well, in my bathroom, I have two mirrors like that. It's a little shocking, but it's not that different.

Chuck: *The thing that I like about that concentric one is that it has some of the kind of look of "spin art," you know that stuff where you put the paint on and it spins.*

Lucas: Yeah, I know, but it isn't. Now you're trying to be funny. See, in a way ego prevents you from describing it in a strange way. If you say something nice, you're not only saying something nice about the painter, you're also saying something nice about yourself. Well, you say, "He's here to present me." That's the first question, right? So, my answer to that question is that you're right. There's nothing I want not shown that's shown, right? It's not derogatory, it's not demeaning. One of them makes me more of a proletariat sort of member than the other one, because the other is almost like the ruling class.

Chuck: *Which do you prefer?*

Lucas: This one is the working class. I prefer the ruling class.

Chuck: Yeah, that's surprising. Well, I've always said that of all the people I know, you could apply for the job of the Ayatollah. That would be a position you would be well suited for.

Lucas: Yeah. Do you think I could live with the guilt of so many rolled heads?

Chuck: Well, you could be a benevolent dictator.

Lucas: The spiral one is almost like an ideal, it's a fantasy. It's not really me, it's a couple of steps, a couple of degrees beyond me. If I were emperor or something, I'd say, "Okay, you got that piece."

Chuck: It's a more manipulative image.

Lucas: Yeah, it's a manipulative image, but it has power. It's beautiful, it's powerful, it's pretty. It has all the qualities that imperial art should have. Whereas the black and white one is almost a picture of me in middle to late age. I almost don't want to see myself in this condition, which may be paternal identification.

Chuck: Like fear of the father?

Lucas: With this other one, I don't have to deal with my own mortality and the changes that take place. Internally, I'm a child, as is everybody: twenty, fifteen, you know, around there, and then you look in the mirror and you see a certain age and you think, "God, this is my projection outside," and you forget about it as quickly as possible because this is not how you feel inside. This may be a parent or somebody, but it's not you, although it is how you look. So, this usually has problems, it gives you problems with your state in life. If this is how you really look, then you're much closer to death than you thought. With this one, it's almost like a game. Sometimes I stand by it to see if anybody recognizes me. They never do.

Chuck: That's funny. When I have a show, a lot of the people who I paint show up. They are like a rogues' gallery standing around in space with their images. It's very odd. It's odd for me. I'm such a dyed-in-the-wool formalist. That's all my training, interest, and work. I've always denied the psychological aspects of the work and all that, but clearly they are portraits of people—still something to be dealt with. I think you are one of the most formally inventive artists I know. For instance, when you take a chair and run it through all the permutations, the formal investigation, and all the changes, the permutations you run through and the range of stuff you get are so astounding. The interesting thing is that, after they have gone through all those formal changes, each one of those chairs has such a different personality. What drives you when you are working on a series like that? Is it the more formal aspect of it, or are you actually working towards those pieces each having a distinct personality?

Lucas: Distinct personality, and hope the formal stuff is there and it meets it.

Chuck: It just comes along as you're working?

Lucas: Yeah, and if it's there, terrific, but to start out formally would be a disaster. I have to do it almost unconsciously, or in a sleep state, or in a dream state. I'm like a mathematician or a chemist.

Chuck: One of the analogies that I use is that of the magician. You may want to make an illusion. The only way you can make an illusion is to go through a lot of steps. You can't just want the thing so badly that it will appear. You can't really pull a rabbit out of a hat. You've got to go through a number of steps to make that appear to happen.

Lucas: Yeah, but I see a magician in the old sense, the oriental sense, the middle eastern sense, magic, rather than the new sense of trickery. I can't stand regular magicians. As a child I used to be thrilled by them, and now I can't stand them. If there's one on television, I'll turn my back. I don't know why. They killed the fantasy. I had thought that it was real magic, that it was something really unbelievable, rather than pure trickery.

Chuck: *It's real alchemy, in a sense, when you take a bunch of humble materials and make something quite wonderful out of them. That really is a kind of alchemy. It is greater than the sum of its parts.*

Lucas: I think I probably associate formally a little bit with modern day magicianship, in that if you practice the trick, you can do it, and some do it better than others. But you read the book and you do it, whereas with the other magic, you can't read a book.

Chuck: *Formal limitations free me to be very intuitive. I can't be intuitive on a blank slate. I can't just take a page and make up interesting shapes. However, if I construct some system within which I can operate, then the rigor of that system somehow liberates me to function on a very intuitive level. I need that overlay of a formal system or else I am crippled. No pun intended.*

Lucas: Well, I'd rather listen to magic, like an opera singer. All the stuff that stupid voice can do, rather than a hand, is magic, you know?

Chuck: *Well, the magic that occurs in your work is that rather than a display of virtuosity or technique, you seem to pick up the skills you need to do whatever it is you're doing, but it seems front-driven from the point of view of the thing you're trying to build. People think of artists as having a bag of tricks, and that seems to be something that artists exploit. "I can do this, therefore I will make something." If you, on the other hand, want to make something badly enough, you'll find some way to do it. I assume you didn't always sew. You must have had to figure out how to run a sewing machine. You were not exploiting a skill that you already had.*

Lucas: Yeah, but I found a way not to have to learn the skills that you would need in order to make a dress, which are tremendous.

Chuck: *You took a sewing class to learn all this stuff you don't need. How important are your culture and background to you?*

Lucas: They are important to anybody.

Chuck: *But I mean to you, in particular.*

Lucas: How can they not be important? Is it possible?

Chuck: *It seems especially important to me. Do you feel like a permanent outsider?*

Lucas: Well, outsider in the sense that I can't go back. I would love to go back, but I would have to go back to 1948, when I left. The question to ask you is are you in a transvestite period now or what? You know, I see all these males you're doing, but it's almost as if you're giving them sequins and you're taking their mouths and turning them into button mouths. Are you unmasculinizing, are you doing something nasty?

Chuck: *Well, when I did the portrait of Paul Cadmus, I ended up with all these sperm shapes, and then I ended up with something that looks like a reservoir-tip condom on the side of his nose, which was probably unconscious. You've said that the portrait of Roy looks like earrings, or something like that.*

Lucas: Well, this one has earrings. Roy does have a strange shape. I mean, it's not a normal head.

Chuck: *He looks to me like—have you ever seen Ren and Stimpy?*

Lucas: Yes.

Chuck: *He looks like Ren, the chihuahua.*

Lucas: Could be, could be.

Chuck: *I don't really know what's happened in these paintings. So much of it is unconscious and intuitive. Sometimes they end up being donuts, hot dog shapes, and whisky bottle shapes. I was in Vienna for a year on a Fulbright, and I was supposed to be studying Klimt and Schiele. I think that somehow these shapes have something to do with Klimt and the kinds of patterns and things that occur in Klimt.*

Lucas: The squares and so on. The side view of that one of Roy is very interesting. What you've done with the outline of the nose and the chin is very interesting. It's not quite a peeling of the surface, but it's a painting that has suggestions of the inside without being academic about it. It's almost as if, it's not—

Chuck: *You mean flayed or something?*

Lucas: It's almost flayed, only it isn't.

Chuck: *I don't know. They're too deconstructive to then reconstruct them. I'm often so lost, really so lost, when I'm making the paintings. I don't even know what it is that I'm working on part of the time. I think I've evolved a method of working since I was so overwhelmed with how to make something; I broke it down to little bite-sized pieces.*

Lucas: Do you think about the work that these people do, or don't you?

Chuck: *No, I don't try to, but I think the painting of John ended up being like all those car things. It's much more sculptural in some ways than others. It was not a conscious decision. I've always thought the paintings looked more like the people than the photographs, so I must be getting something in there of what I know of the person I paint.*

Lucas: But if someone were to study this, they could never come up with the work that he does.

Chuck: *Oh, really?*

Lucas: No, no.

Chuck: *When you think about who's important in our society today, or who society thinks is important, they're politicians and ball players and people like that, but if you go back to other periods, nobody remembers who the mayor of Florence was or anybody else who was important. They only remember the artists. Well, should we wrap it up—whatever we did here today?*

Lucas: Yeah, it's over.

◆

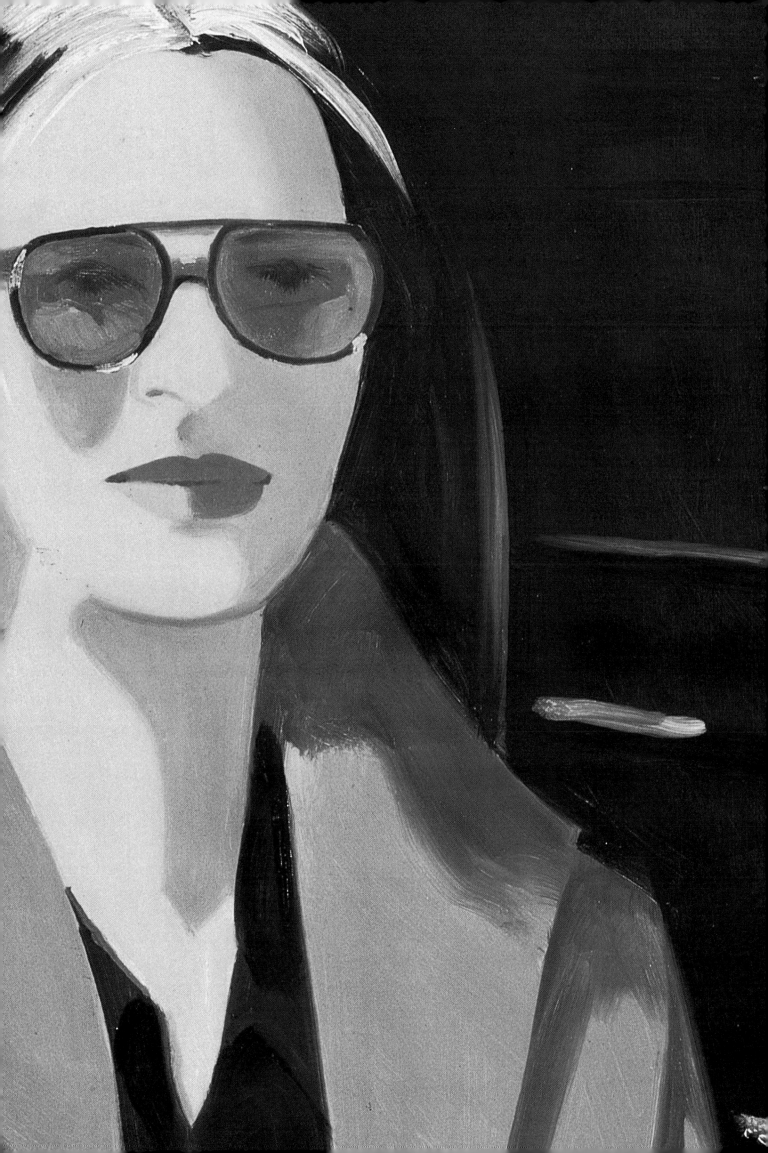

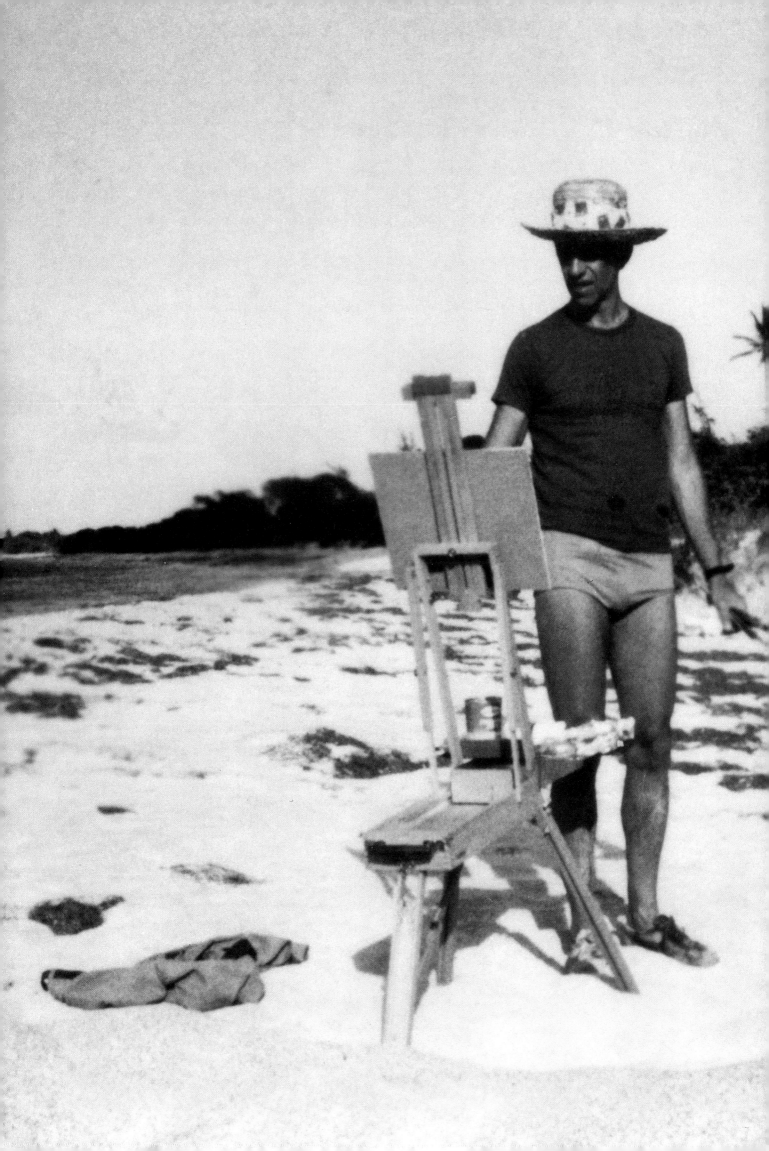

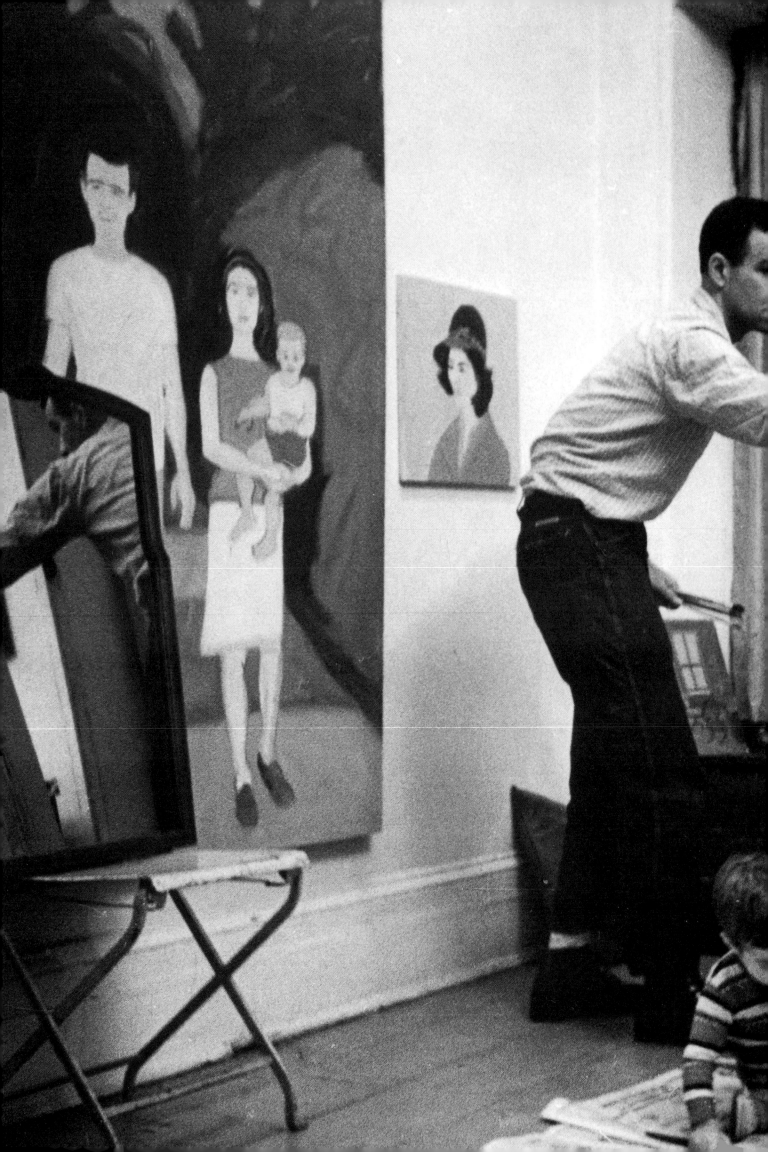

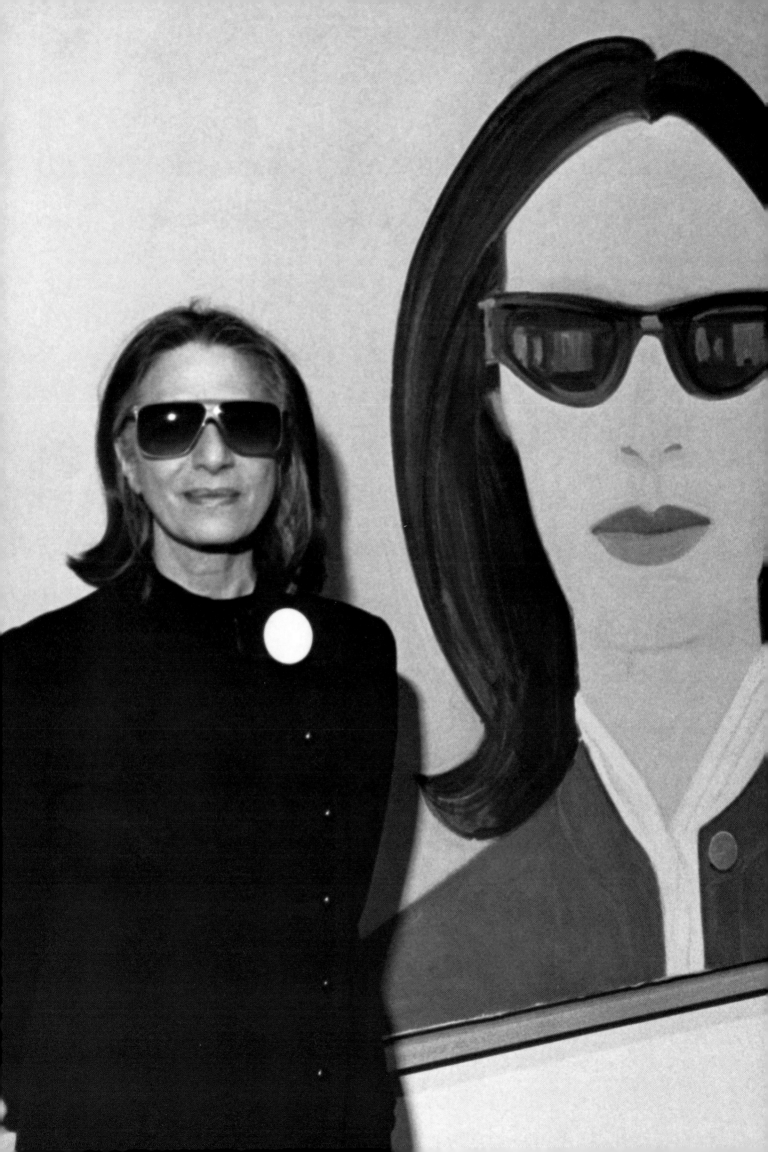

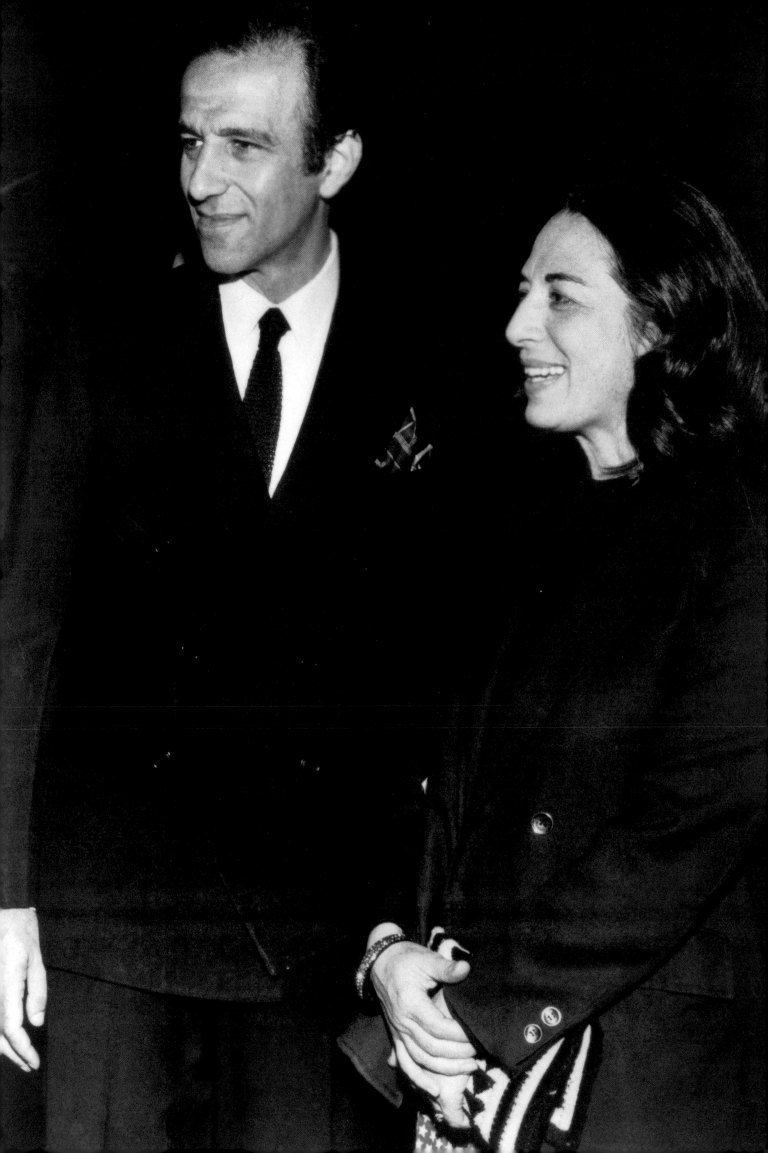

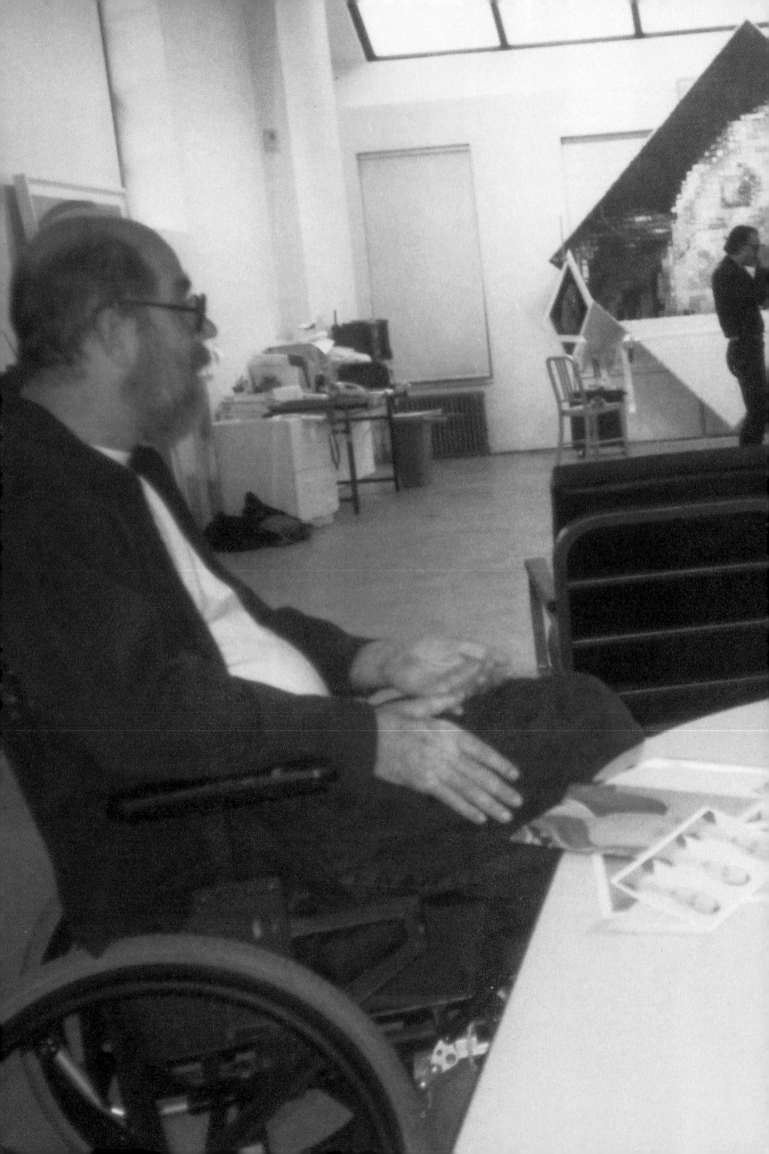

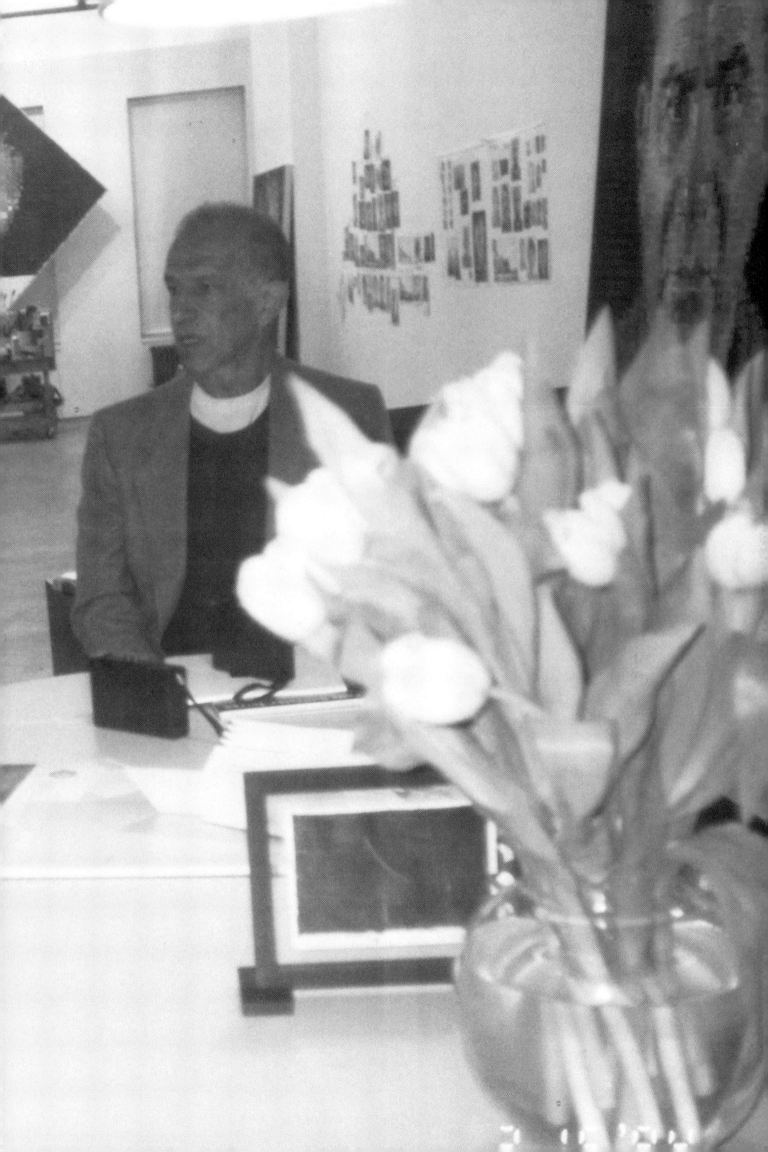

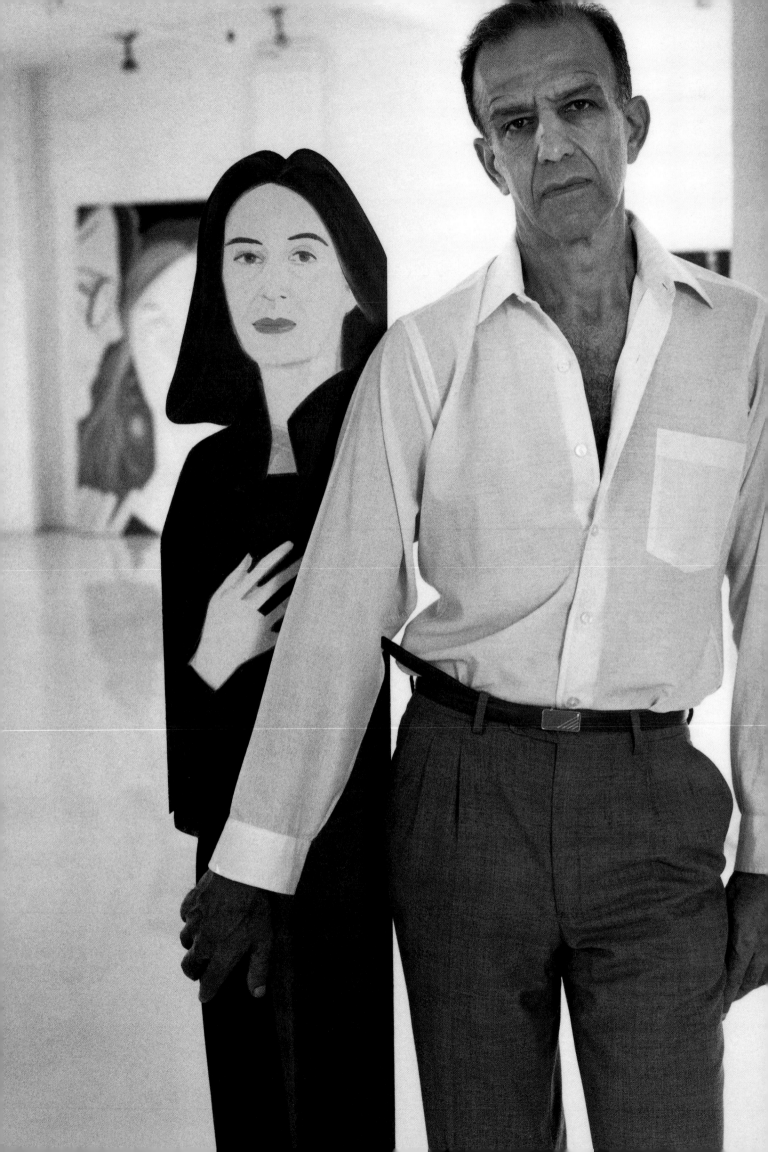

Alex Katz

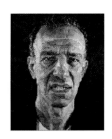

preceding pages:

Ada in the Sun (detail), 1994, oil on canvas, 48⅛ × 36 inches. Photo courtesy Marlborough Gallery, New York.

Sand Beach (detail), 1993, oil on canvas, 66 × 90 inches. Photo courtesy Marlborough Gallery, New York.

On Nevis Island, British West Indies, 1977.

At work, c. 1961. Photo: Rudolph Burckhardt.

Vincent, Ada and Alex in Maine, 1962.

Spruce (detail), 1995, oil on canvas, 120 × 96 inches. Photo courtesy Marlborough Gallery, New York.

Ada and Vincent (detail), 1967, oil on canvas, 95 × 72 inches. Photo courtesy Marlborough Gallery, New York.

Ada at Baltimore Museum, February 1987, exhibition of the collection of Frederick Weisman.

With Ada at Skowhegan Awards Dinner, 1975.

December (detail), 1979, oil on canvas, 132 × 108 inches. Photo courtesy Marlborough Gallery, New York.

With Ada in Rio de Janeiro, 1991.

With Chuck Close at his studio, March 1994, photographed by Laurie Simmons

In his studio, New York, 1987. Photo: Dmitri Kasterine.

New York City, March 15, 1994

Alex Katz: I ran into Arthur Danto. He had given me a kind of shitty review on my Whitney show after which I had written him a kind of shitty letter. I ran into him yesterday, and we seemed to have come to some kind of peace. I thought it was a very nice essay that he wrote in your catalog. Then he started complimenting me on being your model. I accepted that for a while. I had a show on, so I finally said to him, "Gee, I guess I'm getting more famous as a model than as a painter." I think that has sort of happened. Your portrait of me has made me famous.

Chuck Close: *You certainly have done enough portraits of yourself so that I could only add to it, but maybe now you know how your wife, Ada, feels.*

Alex: Oh, no, well maybe a little bit, but Ada is like a real professional model. She's quite indifferent to it. It's really amazing. I think a professional dancer or actor know what they're giving you.

Chuck: *I found that when I photographed you, Lucas, Cindy Sherman, and Francesco [Clemente], it was very different from photographing other artists or my friends because you guys were all pros at posing. You pose for yourself.*

Alex: No. I was posing for you.

Chuck: *No matter what I asked Lucas to do, he ended up doing what he does, which is look like Svengali.*

Alex: I knew what you wanted, and I worked within those perimeters. It was really conscious on my part—self-conscious, I should say.

Bill Bartman: *Did you choose very carefully what you were going to wear?*

Alex: Yeah, I knew exactly what I was going to look like. I didn't know what the painting would look like. That's a different story.

Chuck: *All painters are posers, but we do it through our work. We send our work to stand for us wherever we go.*

Alex: I think some people have more consciousness of how they appear than other people.

Chuck: *It was really funny when I photographed Cindy Sherman. It was as if she were invisible, and it wasn't until I gave her a role to play and told her what her motivation was that she immediately swung into action and took those poses.*

Alex: She seems like one of those really good actresses who have a completely phlegmatic look, but when they're on, they just go up like a rocket. I think it's incredible what she can do with herself. It seems as if she can change her appearance at will.

Chuck: She also changed the way she looked from inside the view finder. If I looked at her with my bare eyes, she didn't look like anything, but the minute that I looked at her through the view finder, she was something.

Alex: She really knew how she wanted to look.

Chuck: She was doing it only for the lens. She told me that one of the photographers who photographed Marilyn Monroe said that this dumpy woman with short legs who really looked like a housewife could walk in front of the camera, and the minute he looked at her through the lens, she became a movie star. Outside of the camera, she was very ordinary.

Alex: Today's movie acting has changed a great deal from the old movie acting, which was more like stage acting. Modern movie acting is done a lot with the eyes and nothing else.

Bill: A real lesson for me when I first started working in pictures was how much of a movie is really done in close-up. When you start looking at movies, probably thirty to forty per cent of a movie is done from the chin up.

Chuck: I just did this silly little part in Six Degrees of Separation. *All of us amateurs thought we were acting. We were saying our lines.*

Alex: I heard you were really good. I didn't see it, but I heard you were good. I can't believe you weren't good.

Chuck: Thanks. You know, I've known you since the sixties when you were teaching at Yale, although I never studied with you. I made one of those stupid mistakes that students make. I thought I wanted to be an abstract painter, so why the hell would I want to study with someone who was involved with figuration, and I avoided your class. I remember that was in the early sixties. The first show of yours that I saw was at the Stable.

Alex: That's where I had the big head.

Chuck: That show really knocked me out, and I think it really kind of ground around and ate at me for a long time. Actually, Larry Rivers had a cut-out show around the same time, Washington Crossing the Delaware. *It seemed so odd to me at the time that anyone wanted to be making figurative paintings. It seemed odd to almost everybody.*

Alex: It seemed odd to me. I thought that step into making a figurative painting was modern. I didn't realize how stupid it was.

Chuck: You were a real hero for me because you kicked open the door for a kind of figuration that was not retrograde, that was not backward looking. It was really modern. It was about the time in which we lived and no other.

Alex: Thank you. That was the idea. The first ten years, it was one of those things where you cut all of your bridges with painting in America. I had no support. There was none from the abstract group. I was completely isolated. There were other people doing figuration, but most of it was much more traditional; it was retro, it wasn't modern. I must say that when I

saw your show, I was shocked out of my mind. I think there were only two shows to which I ever went back, and your's was one of them.

Chuck: *That's nice. Who's the other one?*

Alex: It was [Jim] Rosenquist's first show. They both seemed very original. It was something that I had to think about.

Chuck: *Where one got support is such an interesting thing. You were obviously involved with all those writers and poets and whatever. Your support often seemed to come from people who were around the art world as well as from other artists.*

Alex: I got a lot of support from artists. They bought my work. They bought about half of my work until way into the sixties. There were also a lot of poets and writers who liked my work. Generally, I don't think institutions liked it, and a lot of big time collectors didn't take it seriously either. When I had the first show of flat figures, Edwin Denby came over and said that if I ever needed money, he would loan me money. That was a really big deal because I realized that I wouldn't be broke until I had spent all of their money. Before that, I was really running on empty.

Chuck: *I remember something that Al Held said to me when I had my first show in New York. Actually, it was my first solo show, and I think Rothko had just died. Everyone came from the Campbell Funeral Home across the street to Bykert, and I was hanging the show. I used to get all the leftovers from abstract expressionist funerals. Al came in, and I was hanging this show. I really liked Al at Yale. We had a lot of fights. I kept throwing him out of the studio. I said to him, and I meant it, "I really appreciate your coming to the show. You really helped me a lot, and I can't imagine that I would be making this stuff without you," even though it looked nothing like work he would have made. He said, "You can't hang this shit on me." A couple of years later, Al gave me some advice. I was showing in a gallery that only showed abstract work. He said, "Be careful that you don't become the abstract painters' favorite figurative artist, because I'm one of the figurative painters' favorite abstract artists. They never love you, they only tolerate you."*

Alex: That's true. You have no other place to go though.

Chuck: *That's true, but a lot of your support and a lot of the interest in your work was not necessarily normal, traditional, figurative support but was really from people who were interested in painting.*

Alex: It seemed that way. It seemed so strange to get an idea in your head that you thought was OK and rational and try it out. I think that we're just breaking out of merchandized art or negotiated art through "isms," starting with impressionism and then abstract expressionism. I think it was a kind of efficient way of negotiating avant-garde art.

Chuck: *I think the seventies were an aberration in that respect, because it was a pluralistic decade.*

Alex: More things were going on. The seventies were a really goofy time.

Chuck: *I liked the seventies.*

Alex: The seventies were much better than the eighties. They were more open. The eighties closed down again.

Chuck: *What do you think is happening now? I know you see a lot of shows. I see you at a lot of shows. You're out looking at work.*

Alex: It's sort of stumbling along. The last couple of years were kind of depressing. It seems a little better now. There are enough good shows if you're up to it. About three years ago, for a while, it seemed as if there weren't any interesting shows. I looked around, and there just wasn't much to look at. I think things have picked up a little bit in the art world. I think the standard of living and the economy are real killers of the art world.

Chuck: *The sacrifices young artists have to make right now are so great.*

Alex: As well as people in their fifties. You could be painting great paintings and living on the crumbs.

Chuck: *At the time that you were teaching at Yale, a lot of well-known artists were studying there, many of whom were your students. What did you think of that group of people? Were you able to handicap the artists in order to try to figure out who was going to make it?*

Alex: I had a terrific time there. I taught for a very short time in my life. I taught first in Brooklyn, and then this thing at Yale popped up. I was amazed at how literate the students were. They all read. I could talk about the show of a new artist, and some of them would have seen it and knew what I was talking about. It was really pretty good, and they were all pretty talented. I didn't think Janet Fish was going to blossom. She was a real surprise. When I saw her doing the cellophane-wrapped fruit and vegetables, I realized she was a very ambitious artist. There were two people to whom I gave A's and then never heard of again.

Bill: *When was that?*

Alex: It was in '62, '63. I was there for two or three years.

Bill: *Was Albers there then?*

Alex: No. He wouldn't have had me around the place. They were actually afraid to have me there until I had the first show at the Stable before it opened. I think I had a reputation of being some kind of crazy Bohemian or something.

Chuck: *I don't know where that came from.*

Alex: I don't know where that came from either, but anyhow, they felt a little better when they saw the show. I knew Mangold would go. He was doing black paintings sort of like Louise Nevelson's that I thought were quite adventurous. He had a very adventurous intellect. Serra had great animal energy. He was painting novels. He had a lot of energy.

Chuck: *Did Brice [Marden] study with you?*

Alex: Yeah, Brice was terrific. All of his other teachers were beating up on him because he was painting like Franz Kline. Get a master painter; paint like the master; figure out how to do it yourself. It seemed like a great thing.

Chuck: *We were all painting right out of someone.*

Alex: But most of the stuff wasn't that focused. His was really focused, and I thought it was a terrific idea of how to paint. You knew that he wouldn't be doing that for the rest of his life, whereas people who paint in a more general style will do that for the rest of their lives. Nancy Graves was painting with browns. I thought it was great. I thought it was a mistake for her to ever go to color. Her work was so great in browns.

Chuck: *I remember. It was Matisse-ian kinds of shapes.*

Alex: There were all sorts of browns. She had a terrific sense of low-chroma colors.

Chuck: *Rackstraw Downes was painting exactly like Al Held at the time.*

Alex: Half realistic and half abstract. I said, "I think you ought to make a decision and stick with it for a while." I showed him Al Held's stuff and he liked it, so he started doing that. Yale wanted me to go up there two days a week and become staff, and I said, "No, I can't stand the railway, but I've got the guy for you," and I sent Al. When I think back on it, it was an absolutely phenomenal time in art school. There was an incredible amount of stuff going on.

Chuck: *The thing that I think was interesting was that no one was doing anything that remotely resembled what they're doing today, with the possible exception of [Robert] Mangold and maybe Marden.*

Alex: Mangold is the closest, actually.

Chuck: *I have some early etchings made in '61, won from Brice while shooting pool, that have a calligraphic look very similar to what he's doing now.*

Alex: I think everyone changed a great deal, which is good because usually people don't change from art school. They do their best paintings in art school, continue the rest of their lives, and their paintings get a little worse every ten years.

Chuck: *People are very defensive about the work they made in graduate school, and they want to show it.*

Alex: They think they were making art.

Chuck: *We knew that we couldn't show that shit in New York. There was no way. Nobody was making finished showable art. We would have been laughed out of town. Don Nice was the only one who did, and he was showing at Feigen. He was a dean at the School of Visual Arts at the same time that he was a graduate student.*

Alex: He was very advanced. It was really kind of phenomenal that he was doing that.

Chuck: *The faculty hated him for being that advanced. They said, "What can we teach him?"*

Alex: He was better than his teacher.

Chuck: *Don't you think that's the mark of a good school?*

Alex: Definitely.

• • • •

Alex: How did you come up with that system of funny marks that you use now?

Chuck: *Oh, these things?*

Alex: I'm very curious. I might as well learn something.

Chuck: *Well, you know that all of the pieces, even the earliest ones, were made in blocks, but you couldn't see the blocks because the edges were fudged and therefore disappeared. At a certain point, I started making work wherein the incremental marks stayed put.*

Alex: More physical.

Chuck: *There were dots, later finger prints, and then I made oil paintings within which there was basically one colored dot and some pastels. Then the dots got more and more complicated. For instance, the dot would be on a colored field, and would have a different colored dot in the middle of it.*

Alex: That's what I mean.

Chuck: Then the dots got bigger and more complicated. Each painting ended up having a differ-ent pictorial syntax and vocabulary.

Alex: Do the marks come out intuitively?

Chuck: Yes, very intuitively. The work has always been far more intuitive than anybody thinks.

Alex: When I look at your work, the early ones seem to be done by the more logical process, and the later seem to me—I couldn't figure them out.

Chuck: You know, I used to do the full color paintings by making three one-color paintings on top of each other, which was really crazy.

Alex: That seemed totally bananas.

Chuck: It was bonkers, but I learned a lot about mixing colors because I had to make all the col-ors out of the same stupid red, yellow, and blue. I learned so much about how to build a color in con-text, rather than by making a decision on the palette, that I really wanted to continue to find the col-ors in the middle of the painting. So instead of laying three colors on top of each other transparently, I started putting them next to each other or on top of each other with other colors.

Alex: That's a very nice way of doing a painting. It is basically a construction technique.

Chuck: Yeah, right.

Alex: It's very constructivist. Basically, it's the way Bill de Kooning paints.

Chuck: Well, that's where I learned.

Alex: I'm much more conceptual than you are.

Chuck: Yeah, I think you are.

Alex: In color anyway.

Chuck: You do the little studies and then figure it out.

Alex: Whereas you get to it intuitively. That's really fascinating. It's much richer with those marks.

Chuck: It's been fun to see how each one has it's own vocabulary. I haven't seen all these things together for a long time, but I will soon. I was just looking at one from the eighties, and I realized that I had thought the different periods were much more seamless; I had thought the changes were much less drastic.

Alex: A big change happened about four or five years ago when the marks became really idiosyncratic.

Chuck: Now they're even bigger. The painting I'm doing now of Paul Cadmus has many more col-ors in a square because the squares are bigger, and I have to comment on more things.

Alex: It's amazing the way the color pattern goes.

Chuck: Underneath there's a kind of painting using the tee-off color. I just sort of tee-off in the wrong direction so the next color has to correct like crazy.

Alex: That's wild.

Bill: When did you do the original painting of Alex?

Chuck: Well, I did a color version of Alex for my last show before I went into the hospital, seven or eight years ago. Then the first painting I made in the hospital was that small painting of Alex that I made on the first sort of laptop, handicapped-accessible easel devised for me.

Alex: That was a big deal.

Chuck: That was an amazing experience. My assistant Michael reminded me of something that I had totally forgotten: when I was working on that painting, I painted it with tears dripping down my face.

Alex: Was it painful?

Chuck: I was so depressed.

Alex: I remember how depressed you were in the hospital. It was really kind of shocking, and it seemed as if there was nothing that anyone could do. One could say something, but there was nothing that one could do. We were completely impotent to help.

Chuck: Except that the art world really showed up for me, and it was incredibly moving, and it made getting back to work all the more important and in some ways doable. I realize now how important it was for me to be involved in that dialogue with other artists.

Alex: I don't think you make art work by yourself. I think you somehow make it with a community. You have close friends or other friends. It's made with other people whether or not you see them. Don't you think?

Chuck: You don't have to see the people as long as you see the work. You still engage with it.

Alex: You're talking to the work, and your friends help you. There is always someone who comes in and says something about the picture, tells you that you're not nuts.

Chuck: Or tells you that you are nuts.

Alex: When someone would say to me, "I think that corner on the back of the picture is great," I would just want to throw the picture away.

Chuck: I think sometimes praise is harder to take than if they don't like it. I remember when Philip Guston was a critic at Yale. I brought my painting in first, leaned it against the wall, and went across the street to get a cup of coffee. When I came back, everyone had put their paintings out, and mine was covered. He tore everyone to shreds. He hated everything. Everyone was dragging their paintings out with their tails between their legs, and they uncovered my painting. He called everybody back in. He took a later train so that he could come over to my studio to see more paintings. This so totally fucked me up that I spent the next two or three years trying to repaint that painting and trying to recapture whatever it was that he saw.

Alex: Guston was the kind of guy who did that to painters. I was in a gallery when he told a guy that he liked the upper left corner. The guy was thrilled. I realized two things: if I were that guy I would be livid, not thrilled, and I realized that I was very different from that guy. Guston had a way of totally identifying with something that was great.

Chuck: Tom Hess, who was a critic I really loved and really respected, unfortunately said in a review that he saw the word "cash" written in the beard of my self-portrait like some kind of subliminal advertising. I thought, "Well, we could do without people pointing out things like that," especially since I couldn't find it in the painting.

Alex: I think that when critics get into the areas of intentions, they are in an area in which they don't belong. "He painted this picture because he wanted to be successful," or "He painted this picture because he wanted to make money," or "He painted this picture cynically," all

of those things. I usually say that the artist is doing the best he can and leave it at that. I don't think you can judge intentions.

Bill: The whole role of critic has changed so much since the word was invented. Criticism used to mean a dialogue between the artist and the critic.

Alex: I think it has changed a lot in the last six years. There's been a big change. The critic used to be leading the artist around in the sixties, but today I think the artist is free of the critic. It doesn't matter. Critics do not have the power they had twenty years ago.

Chuck: One thing that I miss is critics who wrote about what it feels like to stand in front of a painting. Now it's only about iconography. That's the only part that is reproducible, but the touch, the physicality, the scale, all those things that you could write about aren't discussed.

Alex: You don't have color, you don't have scale, and you don't have touch in a photograph. They can describe everything else, but generally for a painter that's where all the marbles are.

Bill: Historically, the role of the critic was to have a real interaction, a growth interaction with the artist, to give the artist a point of view about something.

Alex: The critic is part of your public. I have had criticism that helped explain the work to me. When you're painting, I don't think you really know what you're doing. You have an idea about what you're doing, but by the time it goes through your system, it might be more than the idea you thought you had.

Chuck: One holds one's breath hoping not to get praised by some critics.

Alex: I think I've gotten more bad reviews than anyone.

Chuck: Don't you wear them like a badge of honor? My favorite reviews are all bad reviews. Hilton Kramer called me a lunatic. He called my work "trash washed ashore after the tide of pop art went out," and things like that. I loved those things. John Canaday hated my work. I saw him just before he died. I had never before met the man, and this small, old, old man walked up to me at an opening and said, "Mr. Close, I just wanted to tell you that I made a terrible mistake with your work. I didn't get it, and I really missed the boat. I made a terrible mistake, and I'm sorry for what I said." It was absolutely amazing.

Alex: Everyone has a right to change their minds. The artist does, and so does the critic. It makes everything more interesting. Essentially, you don't paint truth. You change your point of view. I remember a panel once with [Harold] Rosenberg and [Fairfield] Porter and Tom Hess and a bunch of guys in the club. About two hours into this thing, Rosenberg said to Hess, "You said this, this, and this twenty minutes ago, and now you say that, that, and that." Porter said, "Did I say that? It was rubbish."

Chuck: I remember a panel with Philip Guston. Someone said that squiggly lines were out. Everybody looked at Guston, but he didn't say anything, and then in a little while he said, "Well, who uses squiggly lines?"

Alex: That's perfect. There used to be the Artists' Club that kept moving around. They would have symposiums that were really kind of interesting in terms of dialectics; they were very developed. They were also interesting in terms of ideas.

Chuck: Those things got picked up and published in magazines, and so it got around, it got out. I think one of the reasons that I first made black and white paintings was that I was trying to figure

out what the hell a painting looked like. I had been studying black and white reproductions in ARTnews, using a magnifying glass. Of course, I didn't know what color a de Kooning would be.

Alex: That's amazing.

Chuck: I mean, I hadn't seen any of them yet. It is one of the first publications that came out with big color reproductions of contemporary work. It also had the artists' own words, which was very important, instead of filtered—

Alex: The poetry.

• • • •

Bill: It would be interesting to hear your reaction to the images that Chuck has made of you.

Alex: I think that there is tremendous distortion in these photos because of the proximity of the lens to the face. The nose gets much larger.

Chuck: Everyone knows that you have a very small nose, Alex.

Alex: I have a small beautiful nose, and it looks enormous in that photo. Look at what this guy did to me! He put me in this thing, and my face is all distorted, and because it's painted so strongly everyone thinks—like this dealer in Florida who said to me, "You look just like that painting of you by Chuck Close." I said, "Thank you," and she said, "I'm gonna have to buy it." I said, "That would be wonderful." This was my dealer. So I've been haunted by it or followed around by it. For me, it doesn't have to do with appearance; it is more like a psychological portrait, more like an inner statement than an outer statement. I don't think it has much to do with the way I appear, but it has a great deal to do with the way I am. Don't you think?

Chuck: The paintings are always about the way the camera sees, and the camera does distort.

Alex: It distorts, but somehow it became an inside portrait rather than an outside portrait.

Chuck: The interesting thing about that first portrait of you that I did after I was in the hospital was that the photograph was not a sad looking image and yet when I made the painting, it ended up looking very sad, even though I used a much brighter palette. It really deals with the dichotomy of how depressed I was and, at the same time, how pleased to be back at work. I was celebrating being back to work. I think all of that stuff is part of what the painting is about.

Alex: I thought that in the big one you were in a rage, and it shows on the surface.

Chuck: The big black and white one?

Alex: The great big one that I saw. It seems as if the big images show the rage inside that doesn't get to the surface much.

Chuck: My rage or yours?

Alex: Mine. I think the portrait has it. My portrait is distant. I'm cast in a role very far away from who I am. This seems more like a mistake.

Chuck: Huh. It's interesting that you see it that way.

Alex: When I say it, do you see it?

Chuck: Yeah.

Alex: I think it's an excellent psychological portrait.

Chuck: Also, your face is a very active face. To freeze-frame it is like freezing something that was in movement.

Alex: Yeah, it's frozen in movement, but you don't get any real movement out of it. It's static.

Chuck: One thing about doing it in all those little pieces is that they're always sort of in a state of flux. They're always bouncing around.

Alex: The way you do it with the painting changes it completely. It's no longer like a frozen icon.

Bill: More than any of your other paintings, somehow the paintings of Alex, for me, are more about a working man, about someone who has spent his life working. Like the photographs from the depression, they are not so much about being an artist but about someone who is a worker, who has really spent his life working.

Chuck: You identify with the worker as an idea.

Alex: I think a painter is very hard to pin down; a painter is a lot of different things. I'm a seven-day-a-week guy, but I'm not a nine-to-five guy.

Chuck: Well, self-employed workers are smart enough to figure out that they don't have to work from nine to five.

Alex: I don't give away very many obvious social things. Basically, you're judged by your haircut and your clothes. My clothes and haircut are fairly neutral.

Chuck: And always have been. You never went through a long hair period.

Alex: Basically, I'm fairly neutral, "socially neutral," so you can say worker and it would be okay.

Bill: You could be almost anything but somebody who obviously spent their life doing something. That's all in the painting.

Alex: My mother said to me once when I was around forty-five, "You finally got to look interesting."

Chuck: Well, you were talking about that arm's length thing that you do when you're painting a self-portrait—keeping it at a distance.

Alex: I try to.

Chuck: I find myself doing that with myself too.

Alex: I clearly dislike the amount of literary information that you get on a Rembrandt. I think it's just kind of revolting.

Chuck: I don't like his paintings at all.

Alex: I like some of the paintings, but I don't like that amount of information about anyone up front, so I think it's nice to put yourself in a role so it short circuits the whole thing, and you get a little distance on it. I think it's more interesting.

Chuck: It has only been recently that I rather reluctantly have come to think of my work as portraits at all. I used to refer to them as "heads."

Alex: Your sensibilities were all towards abstract painting, and it was very hard to reconcile yourself to the fact that you make figurative paintings.

Chuck: The things that influenced me were the things that influenced minimal and process artists.

Alex: You felt more connected to Mangold than you did to Larry Rivers.

Chuck: de Kooning was always my favorite painter, but Ad Reinhardt changed the way I thought

about painting more than anyone. Reading Ad Reinhardt and understanding that his choice not to do something was a positive decision was very important to me.

Alex: That's exactly what I mean. Your mindset is an abstract sensibility, so then you have a tough time reconciling the fact that you're really painting figurative paintings.

Chuck: The other thing was that I had been putting too much stuff that I liked into one painting, and I was crippled, I couldn't make any decisions. I discovered that the more self-imposed limitations I gave to myself, the easier it was to work. It happened to be at the time when a lot of people were applying severe limitations to different kinds of work.

Alex: Mostly abstract.

Chuck: For instance, I think that your work was not constructed in the same way or was not minimal in that sense. Your work is reductive. It's pared down. The economy of your work is amazing.

Alex: It's not a minimal process.

Chuck: No, the process is something else, but the notation system that you use of a few marks that activate a whole field and work it into something is really a remarkable restraint.

Alex: As you can see, I was going for the same process right from the beginning. I think I built the technique of painting landscapes every day: every day a painting. What happened at the end of ten years was that I had a technique. I didn't have many paintings, but I had a technique.

Chuck: You have a show coming up at the Robert Miller Gallery of your landscape paintings.

Alex: The early ones, most of which I've never shown. They were absolutely non-negotiable at one point, but now that I'm doing landscapes again—

Chuck: What do you think about the career aspects of what I describe as "legs?" So many artists peak early and have a slow and steady decline. I think you're making the strongest work that you've ever made right now. You have "legs!"

Alex: I think I have the strongest technique right now. My technique is stronger. I think my energy always spread out a little bit, and now it's more focused. My technique is stronger, and I have range. I feel that I'm really connected now. It's as if the missing part sort of fell in. I don't know if the paintings are any better than the ones I did eight years ago, but I know that my technique is stronger, and I'm more focused.

Chuck: You're painting with a kind of self-assuredness that is like a great Japanese master or a haiku poem writer.

Alex: Yeah, that's the technique. I always wanted to make a painting like a Greek sword that had such a high degree of craftsmanship in it that it was unassailable, you couldn't question it. I think the landscapes are like that. It's all in the painting.

Chuck: I wanted to get craft in there so people wouldn't throw the paintings away. If they look like they're hard to do, people value them. That means that, at the very least, they'll keep them in the basement of the museum, and maybe they'll reassess them sometime later, but if you do something with no particular craft and it's out of fashion, it's just considered a piece of garbage.

Alex: Craft in itself is one of the things that is an interesting occupation, but I think craft totally by itself is mindless. When craft gets into highly developed areas, it is very interesting. It's how someone does something.

Chuck: People look at the stuff I do and think that it's so process oriented or so much about system, but no painting ever got made without a process or without a system. It's just not always so obvious.

Alex: When Jackson Pollock dripped, it wasn't an accident.

Chuck: That's for sure. Someone pointed out a difference between Pollack and me that I thought was really brilliant. They said that Pollack didn't know what his next painting was going to look like, but he knew exactly what he was going to do in the studio the next day, whereas I know exactly what my painting is going to look like, but I don't know what I'm going to do in the studio the next day, which is a very interesting difference in focus.

Alex: Yeah, he had a lot of problems.

Chuck: His process finally became quite formulaic in a sense.

Alex: He got in and out of it though. He spent so many years with this and so many years with that. The different cycles were very short. He led a very unhappy life. I don't think we, or the society in which we lived, could gracefully accept a painter like him. It just didn't work at that time. It's easier now.

Chuck: You think the role of the artist in society is easier now?

Alex: Yes. Society can accept an artist being successful. At that time, they couldn't really accept an artist being successful; everyone was jealous.

Chuck: I think artists have a harder time accepting a successful artist than the general population.

Alex: I think artists feel guilty about feeling successful. The older guys did.

Chuck: I certainly always have. I expected to have an occupation to support my profession.

Alex: You were really lucky—the right thing at the right time. It's like being born in the right place.

Chuck: Believe me, I think luck is important.

Alex: Luck is a big thing.

Chuck: I've always been in the right place at the right time: the golden time to be in graduate school, the best time to come to New York.

Alex: It's terrific. I have felt like that in my own life. Going to Cooper Union was a big break. Tenth Street [where most contemporary art was shown] was about one block away. I went from a provincial school to the big time in one block, and it was all there, and all the people that I knew were all in it. I'm giving ten paintings to Cooper Union. The painting department at the art school seems a little stagnant, and I wanted to give a chair that was non-tenured, which means that someone can teach there for a year or two and go on. Also, they can come from anywhere in the world. I think you should have the world as a place to solicit for that kind of thing. You can get more professional painters. That's logical.

Chuck: Who was teaching at Cooper when you were there?

Alex: I had Morris Kantor and Robert Gwathmey, both very famous American painters. It was easy to get successful painters then because there wasn't much to their success. Peter Busa, a design teacher, was terrific. There was a woman named Carol Harris who taught design and who was really very good. It was a really good art school when I was there, but it was provincial. You went straight from Cooper Union to the Whitney and the Modern: a direct line.

Chuck: I remember that the kids from Cooper Union came to Yale because Cooper didn't give a degree, and Yale was one of the few schools that would take their credits even though they hadn't been working in a degree program.

Alex: You got a three-year thing, and you got a certificate, and then you could get a degree at NYU in a year. A lot of us went to Yale because they would give a degree to anyone whose work they liked. At that time, I figured one really didn't need a degree to paint. I worked a lot at the frame shops. You could support yourself by working two days a week.

Chuck: I did when I first came to New York. The Cooper kids who came to Yale were so intimidating to the rest of us, who were really provincial.

Alex: You were from the boondocks.

Chuck: Those people had been at the White Horse Tavern with Dylan Thomas or had hung out at the Five Spot and listened to Thelonious Monk or whoever. The Five Spot was right across the street.

Alex: It wasn't there when I was there. It was later. The Five Spot was in the late fifties.

Chuck: I think the lack of watering holes is a very bad thing.

Alex: I think everything fell apart. I don't know where anything is.

Chuck: You know the role that a neutral space played in the art world.

Alex: Openings were a big deal. They're not anymore.

Chuck: You could see every show in one day.

Alex: It was much smaller and much closer, but it made people more conventional too because of all the pressure.

Chuck: What about the difference between galleries like Tanager and today's alternative spaces?

Alex: Tanager became the Green Gallery. If you had a show at the Tanager, everyone saw it. It was like showing at Mary Boone or maybe a little better. All the museum people came down to see it. It was the same with the Hansa Gallery. They were really high focus places. I don't think that the alternative spaces have any focus at all. They're unfocused spaces. If I were a young painter, I wouldn't touch them.

Chuck: When I first started showing at Bykert, they had a kind of talent-scouting reputation.

Alex: It was a focused place. I don't think it was as highly focused as the Tanager. It was on the street floor.

Chuck: Nobody saw the shows at Bykert.

Alex: You had a focus there, but it was a small one.

Chuck: Klaus [Kertess] was great, and the gallery was great, but he fostered a perception that it didn't matter whether only twenty people saw your show, everybody who was important saw it. Obviously, however, that was not the case, because I never run into anyone who ever saw those shows.

Alex: They're all dead now. That was the old thing: you made the art for one person. I think he had a highly developed public. I think your shows were mostly seen by everybody. They were really sensational shows.

Chuck: Anything else that you want to say? Get a little rage off your chest? Thanks very much, Alex.

◆

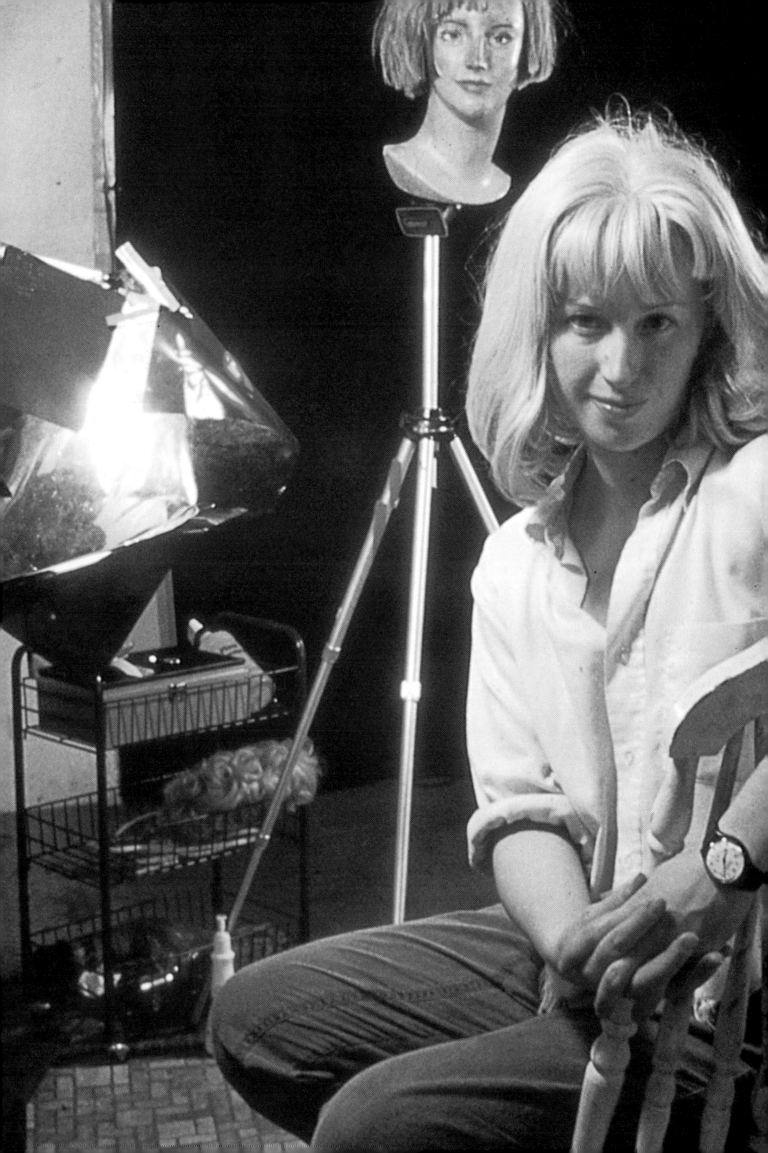

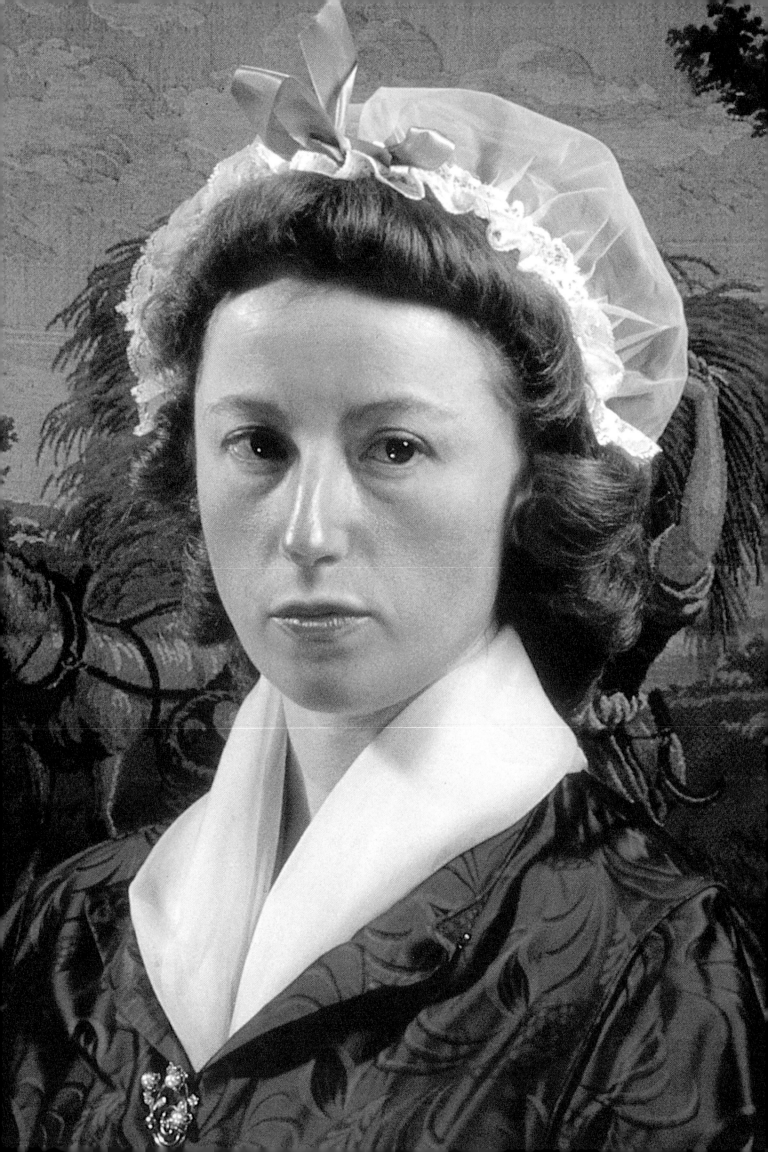

15

Thats me,

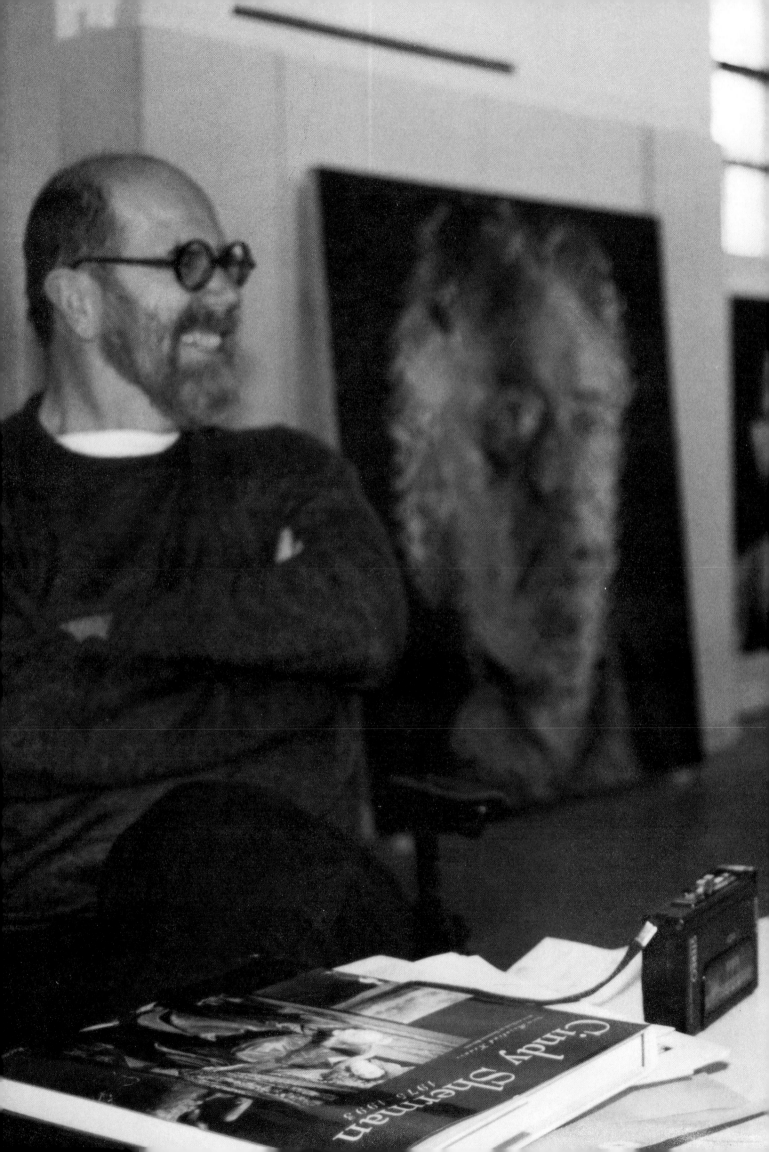

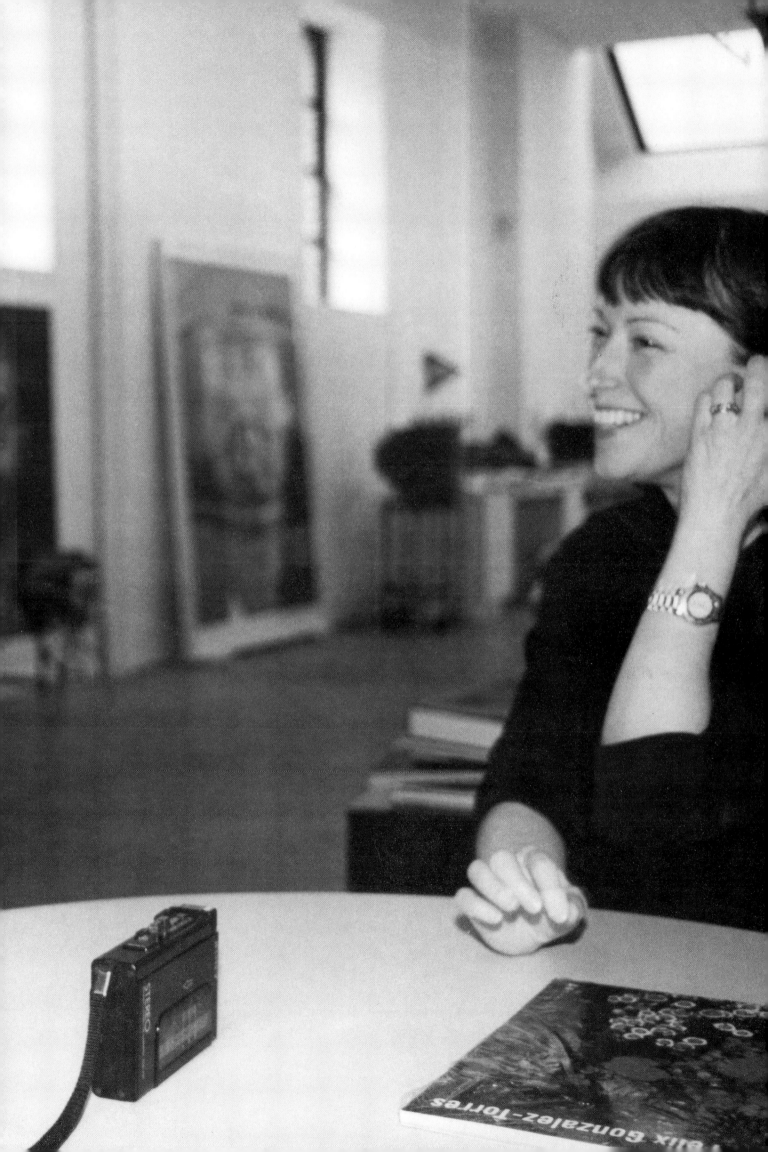

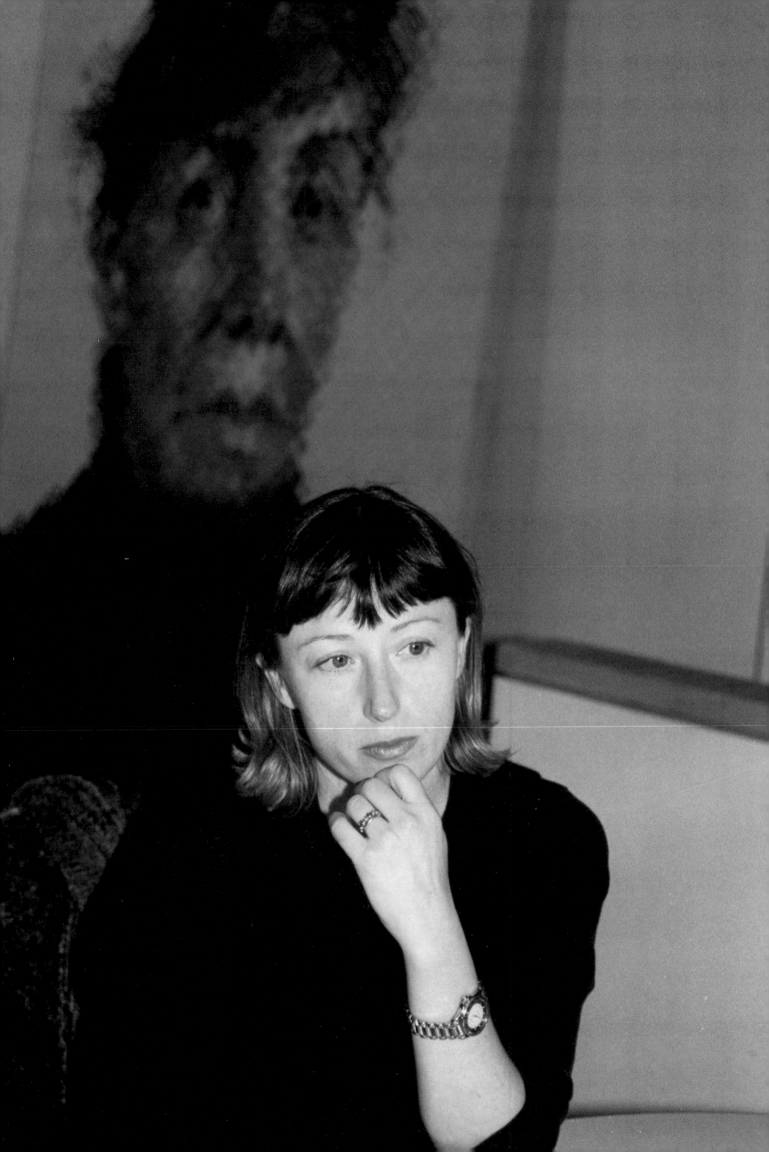

Cindy Sherman

New York City, April 6, 1995

Chuck Close: Where did you grow up on Long Island?

Cindy Sherman: I grew up in Huntington. Why? Are you from Huntington?

Chuck: No, no. We don't actually know each other very well.

Cindy: No.

Chuck: I always feel as if I've had a relationship with you through your work. I've known your work since about '76. Was that your first exhibition at Artists' Space?

Cindy: Wow. Artists' Space. Yeah. Yeah.

Chuck: Then there was another Artists' Space group show.

Cindy: Right, that was probably about '77, I guess, or '78 maybe.

Chuck: Yeah, I think it was '78. I also remember that you were at Buffalo. Did you study with a friend of mine, Lynda Benglis?

Cindy: Up there? Who did I study with? Um, there wasn't really anybody.

Chuck: Someone who was commuting from New York to Buffalo saw your work up there. I remember talking about it.

Cindy: Well, it could have been someone like Lynda Benglis, because we invited a lot of people up there to either give a performance, have a show, or give a lecture. It could have been someone passing through.

Chuck: Anyhow, how did you end up in—

Cindy: —in Buffalo?

Chuck: Buffalo. Shuffling off to Buffalo.

Cindy: Basically, my parents just wanted me to go to a state college but didn't want me to go to a New York City college. Buffalo was the one they picked. There were other choices at that time. I think I considered Plattsburgh, but we went there and it was really in the middle of nowhere. I guess we also considered New Paltz. Purchase wasn't around yet, so Buffalo was it.

Chuck: What about your early involvement with Hallwalls? You guys really—

Cindy: It was mostly Robert Longo and Charlie Clough. They had studios off of a large hall-way space, maybe not quite as wide as yours, but with the same feeling of concrete floor and

big empty white walls. They decided, "Let's put some art on it," but they weren't really interested in putting up their own art. They wanted to get real working artists up from New York City to talk and visit. Mostly, they were starving for information and would devour every art magazine that came and pick the brains of every artist they got to come up. I was more likely to retreat into the back of my own room and ignore the goings-on of the art world, or just peripherally listen to what was going on, because I wasn't into the theoretical discussions and all that stuff. However, a lot of my real education came through the Hallwalls experience: having all of those conceptual and performance artists coming through.

Chuck: How important were the performance artists to your decision to start shooting yourself and dressing up, and—

Cindy: I suppose I didn't really think of it as performance. Initially, I thought of it as serial photography, and just using myself.

Chuck: Well, there is a way to think of it almost as a performance: a performance with no audience, a performance with the camera.

Cindy: Later, I think I realized that was what I was doing. Even though I was totally obsessed with people like Chris Burden, or Eleanor Antin, or Susie Lake, all of whom used their bodies as the medium, I still wanted to use a camera and wanted the privacy of just working by myself in my own space. I did try two performances in front of an audience, and I didn't really like it. It didn't really click for me.

Chuck: Is that a pun? Click for the shutter?

Cindy: That's good.

Chuck: For the movie stills and stuff, did you always shoot yourself with a timer, or did you have someone else?

Cindy: I've always worked completely alone in the studio—no assistants—so a shutter-release cord attached to the camera was the only way to take the pictures in those days. One of my first photography class lessons was to confront the camera. I photographed myself naked in front of the camera, totally straight on, like a documentary. Mostly that was because the teacher had a tradition that every spring, at the end of the season, the class would go into the woods around Buffalo, take off their clothes, and take pictures, "art photographs," of each other naked. I thought, "I can't do this, I can't do it," so I prepared for that by taking those photographs. Thank god we never did do the romp through the woods naked, but I started doing more and more things with myself, using the shutter cord as a prop, almost so that I was using the cord to define the clothes on my body, wrapping it around, because it was twenty feet long.

Chuck: Did you start out as a painter?

Cindy: Yeah.

Chuck: Robert Longo told me that you painted self-portraits before you—

Cindy: Yeah, yeah. All through my childhood I studied how to draw by using my own face, and later, instead of using my face, I would copy from photographs in magazines. I was really good at meticulously copying things. That's basically all I did.

Chuck: Some of us have made a career out of that. [laughter]

Cindy: Well, of course, your work was highly influential in that purpose. Maybe that's why I felt as if I couldn't deal with it. I couldn't do the same thing, so I had to think of something different.

Chuck: Did you airbrush on photographs?

Cindy: No, I never did that.

Chuck: In reading about you, I realized that there's almost never anything personal written about you. I just read a review somewhere in the last week or so—you could probably tell me where it is—and it said, "Will the real Cindy Sherman please come forward." Do you remember where that was? I just read it recently.

Cindy: Well, that title sounds really familiar, but I can't remember. I guess I don't know.

Chuck: I thought, "God, they're so busy trying to figure out who she is." It reminded me that when I was first looking for a shrink about twenty years ago, I got a referral, I went to his office, and right away I knew he was trouble because he wouldn't let me smoke, although he smoked, and so—

Cindy: Wow. Mean.

Chuck: Control issues.

Cindy: He probably smoked more when you were around, too.

Chuck: When I sat down for the very first meeting with this guy, before I had a chance to say a word, he started telling me who I was based on my work. He said that I painted masks, and that I hid behind the masks. He psychoanalyzed me through my paintings. I thought, "God, I can't wait to get out of here," and I ran out of there and never went back. I found a different shrink, and now I'm on another shrink. I was really outraged and shocked at this notion of what it is an artist does. First, you expose yourself, and leave these clues lying around for people to read because you can't help it, and then, on top of it, you're accused of hiding behind them.

Cindy: Wow.

Chuck: So, I wondered how someone who, as an individual, seems as private as you seem to be feels about the way your work is examined. You have been more or less psychoanalyzed through your work.

Cindy: Well, because I'm often in the work, people seem to think that I must be revealing something of a personal or autobiographical nature, and they are constantly looking for it in the work. What's always bothered me about going to openings, especially my own openings, or just meeting people who are meeting me as the artist, is that I feel as if they're staring into my face, trying to analyze me. I don't think it's the same way in which they would meet another artist or go to another artist's opening. Since I haven't been in the work recently, I actually enjoy my openings much more. I don't feel as if people are looking at the work and looking through the crowd—

Chuck: —as if they're still looking underneath all the junk to try and find you.

Cindy: Yeah, which I like. That's good.

Chuck: "I think that's a piece of her, right there."

Cindy: Yeah, yeah, but somebody asked me recently, "Why haven't you ever used real nudity, since you've alluded to it by using those prosthetic props?" I would never have considered

it, and part of the reason was that I didn't want to add to the already loaded issue of nudity in art or in photography. Also, I thought it was going to add another level to people feeling as if they knew me, as if they even knew what I looked like under my clothes. I thought, "Forget that. I'm not trying to reveal myself in any way through my work," and I realized that was why I had never wanted to do that.

Chuck: *You didn't want to run around in the woods in Buffalo, and you don't want to do it now.*

Cindy: And I don't want to do it now.

Chuck: *Well, the difference between the way in which an artist and a novelist is viewed in relation to their subject matter is interesting. A writer can talk about things that he or she has experienced in life and use that as a basis for a novel, but if he ends up killing someone in the novel, no one would say that, in real life, he really killed—*

Cindy: —wants to kill somebody.

Chuck: *—wanted to or did kill someone. Whereas, if you're involved with visual arts, it is viewed as if you are advocating something, advocating violence. Years ago, my friend Mark Greenwold had a show at Phyllis Kind of a painting that took four years to paint. In it, he is stabbing his wife with a pair of sewing scissors in the kitchen—*

Cindy: Oh, yeah. I never saw it.

Chuck: *—and Lucy Lippard wrote a piece in the [Village] Voice urging people not to see the show.*

Cindy: Oh, no.

Chuck: *If he showed an image of someone stabbing a woman, a man stabbing a woman with scissors, she believed he was advocating violence to a woman, and that it was an anti-feminist piece.*

Cindy: Oh, god.

Chuck: *If a woman had made the painting, it would have been viewed in the opposite way.*

Cindy: Yeah, right. It would have been okay.

Chuck: *But I think as visual artists, we have a special cross to bear. We are examined for intent.*

Cindy: Well, I think at the time it seemed as if the work had a lot more similarity because the term "appropriation" had been tagged onto a lot of us. We were using photography in a different way than in the past, and we were trying to copy different forms of photography or extrapolate from it and put it together with something else like Sarah Charlesworth would do. I think that, because of the fact that we were women, and men had dominated the painting world, it seemed like open territory for us.

Bill Bartman: *Laurie [Simmons] says that she wasn't even allowed into the conversations with male painters.*

Chuck: *Boy, I don't think that was the case at Yale. I remember that we had a lot of noisy women around, but we screamed at them.*

Bill: *There's almost two generations between the two of you.*

Chuck: *One would assume, however, that because you guys came up post-women's movement— the art world really changed around '73, I think—there would have been less segregation.*

Cindy: Reading Laurie's interview, I got the impression—she is a few years older than me and maybe it was her art school situation—that those few years made a difference. For me,

it's hard to say, because I was never interested in those kinds of discussions with painters, so I would just phase out and let them have their conversations. One story that I kind of kick myself for mentioning, because people read too much into it, is that early on in New York, Robert—I was living with Robert Longo at the time—was visiting David Salle's studio. While they were getting off on some discussion about which I could have cared less, I was just wandering around the place. I started to look through a bunch of innocuous, schlocky photographs that he was laying out for some photo novel kind of magazine, I guess. Maybe he was also using them for some of his paintings at the time. Anyway, for me, seeing those images suddenly made me realize what I wanted to do with photography. Previously, I had been doing these meticulous cut-outs, using myself, but making these little scenarios with cut-out "paperdoll" photos so that there were whole scenes of interacting characters. The process was so tedious and seeing those things on his desk made me realize that I could take a photograph that implied that there were other people outside of the picture, and it would still have a lot of drama. I don't think that the things he had were stills from movies. I don't know what they were, you'd have to ask him. Anyway, it was one of those instances where the guys were off picking each other's brains and I was just snooping around.

Chuck: *If you had been talking to him, you wouldn't have noticed the pictures in the room.*

Cindy: Yeah, right. I'd just have been kissing his ass. Yeah.

Chuck: *That'll teach ya, you should never talk to David Salle. That's the moral of the story. [laughter] You were talking about those of you who were associated with appropriation. There certainly was a time when invention and personal vision was not something for which everybody was aiming. The thing that interests me about your particular form of appropriation is that I barely think of it that way because you put your own indelible stamp on everything. It is so idiosyncratic and personal and really inventive that I don't look at it and see someone else's recycled work.*

Cindy: That's good.

Chuck: *When you think of the post-modern notion of appropriation, you think of it as it was used in architectural work: all those god awful buildings on which they put the porch from one building on the facade of another: stupid columns in front of something else. Your stuff always seems to me to be made all over again from whole cloth, which really interests me.*

Cindy: We definitely all had the same interests; I'm sure whatever we talked about had a big influence on each other's work. It was not so much talking about the work, but probably complaining about other work that we saw and didn't like. Also, we were going to a lot of performances and meeting people at those performances. There was much more social activity going on. I knew so many artists who, besides their visual art, were involved in making films, or being in bands, or being stand-up comics. All of us were meeting up at these other functions at places like the Mudd Club, Tier Three and The Kitchen. One of the reasons I started making the black and white film stills was that it didn't seem like high art, it seemed like cheap throw-away stuff that you'd find in a bin in a thriftstore. That was also a result of my anti-establishment art attitude: that it was art for the common people; that anybody could get the point without having gone to art school.

Chuck: Well, certainly it was an entrance into the work. Were the rear projections a way to continue that without having to go out of the studio? Your work seems to get more and more insular in a sense.

Cindy: Yeah, yeah. At a certain point, I realized I was starting to repeat some of the motifs in the black and white work, so when I went into colors, I wanted to try this rear screen projection idea. Technically, however, I just didn't have the proper equipment or it just didn't work very well. That's why I only did a few pieces. My take on those images is that they look as if I was going into television as a motif, but the set after that was more experimental, which is where I really was. There was a self-education process taking place through the work. I was teaching myself lighting techniques, or camera angles, or different things like that.

Chuck: Did you take much in the way of formal photography courses and stuff?

Cindy: No, just in college.

Chuck: I took one photography course. I always thought photography was all on-the-job training; that you learned the things you needed to know, in the very narrow way. You learned the things you needed to do, but you didn't know anything about other stuff. Then when you needed to do it, you would go out and equip yourself with whatever it is there is left to do.

Cindy: The first time I took photography, it was required. At that point I was going for a Bachelor of Fine Arts in painting, but it was required to take one course in all the other fields. I failed my first photography course because I just couldn't grasp the technical aspects of it: the exposure, and the aperture, and all that.

Chuck: I never really understood it. It still remains magic to me. You stick a blank piece paper into a clear liquid, and an image comes up.

Cindy: It's magic.

Chuck: It's magic, it really is. It wasn't until I worked in Boston with the 40-80 Polaroid, which is a room, and actually stood inside the thing while the image is thrown across the space upside down and backwards on the back wall that I ever realized how it happens. I mean, it's like in the—what's that funny movie in which they shrunk Raquel Welch down, and they injected her—

Cindy: Oh, *Fantastic Voyage.*

Chuck: Fantastic Voyage. It's like they shrink you and they put you inside the camera, and you say, "Oh, now I get it, this is how it works." You know, I really began to understand it. Were you ever interested in Lucas Samaras's Polaroids?

Cindy: Sure. Yeah, oh yeah, absolutely.

Chuck: Who else made a difference?

Cindy: Actually, some of my favorite things were the ads that several artists did in those days, like Lynda Benglis and Robert Morris, and Judy Chicago did a great ad, I think boxing. Eleanor Antin, too.

Chuck: People are troubled by your photographs, and I never really quite understood that because, for me, they have such a layer of artifice.

Cindy: And humor. I think it's a double-edged thing: the grotesqueness or horror, and the humor, and the artifice. Some people only see one of those sides.

Chuck: I've found your recent use of the medical models interesting, especially now that I've spent so many months and years in and around hospitals and around people who make prosthetics and orthodic devices. I find it particularly interesting because I've watched all these prosthetic limbs being made. It's no wonder doctors treat the patients the way they do, after they've been trained with—

Cindy: —with these fake people.

Chuck: —with these fake people. I mean, they spend eight years in medical school sticking things into orifices, and those kinds of orifices, and those images, are so grotesque. Nothing that you could do with the stuff is as grotesque as it is in its original intent, in the way in which it was supposed to be used. Anyway, I was also wondering about the way in which people talk about your work. Maybe because you started with movie stills, they often talk about the work in cinematic terms. They talk about David Lynch and people like that, and I wondered if you are resisting the temptation to rush out to make movies, which many artists seem to be doing?

Cindy: Actually, someone has approached me about making a horror film, and yeah, I'm considering it, partly because she's a friend of a friend who is a woman, and she prefaced the offer by saying that all these guy artists are making films and we need a woman artist to do it also, and it would be a horror film. So I thought, "Well, as long as it's horror." I think that is probably the only way I would do something like that, since horror films are supposed to be bad anyway, and cheap, and trashy.

Chuck: Did you ever feel as if still work was any kind of compromise and that you would have preferred to have done films?

Cindy: No, no.

Chuck: No, I didn't think so.

Cindy: No, never. I mean, people have asked me, "Why don't you make a film?" For years it's come up, but I never wanted to give up the control that I have by doing it myself.

Chuck: And the isolation and privacy. I mean, you've got to go out and work with other people.

Cindy: Right, right, unless you have a big studio that's funding you. Robert Longo's got a film that is about to come out, and he had to give up so much control to the people who were paying for it, but with smaller budgets—

Chuck: That's right. I wonder why so many artists are rushing to give up that control. My dealer also makes movies, and he's constantly chafing under those limitations.

Cindy: I also realized that I'm terrible at giving directions. I don't have any studio assistants. I used to have people who would come by to do errands for me, but I tended to make them coffee or tea, sit and talk, ask them about their lives, and become their friend. I realized that I wasn't getting any work done, and I realized that I couldn't boss them around. I'm just terrible at that. So, as for being a director, I felt that I wouldn't be able to say, "Hey you, go do this or do that." But this friend, the producer, said I could just take her aside and say, "Look, I hate the way this looks," or, "That guy's acting is terrible," and then she would take care of it. That seems feasible to me, but I hate the fact that it's kind of jumping on the bandwagon of artists making films.

Bill: The one thing that all the interviews have in common is the question "How do you feel about the portrait Chuck did of you?"

Chuck: Two. I did two.

Bill: **Has he uncovered the real Cindy Sherman?**

Cindy: Well, I don't know how many years ago that was, but every time I would see it my hair had changed. I mean, my hair changes all the time, but I think it's now almost exactly how it was then except I don't have it pulled back. I think I had bangs, and I know I had a pony tail.

Chuck: *You wore your glasses because your contacts were bothering you or something, or you wanted to wear your glasses.*

Cindy: Or something. I forget.

Chuck: *When I was doing that series of people, I had just spent years, after initially painting mostly other artists, painting my family and my children, my father-in-law, my grandmother-in-law. I had been painting family for so long that I wanted to do something else, and I thought, "Well, the other family is the art community and people with whom I have a relationship through their work." Then I thought, "Well, there are all of these people who are familiar to us because they use their own bodies or their own faces in their work," so I decided that I wanted to make portraits of pros, the people who pose themselves. I did you and Lucas, Alex Katz and Francesco [Clemente], and whoever else is in that series. Boy, did Lucas and Alex know how they wanted to be seen, from years of posing for themselves, and I couldn't change it.*

Cindy: They would sort of assume their "pose"?

Chuck: *They would do what they do. Lucas would pump himself up for a hundredth of a second, and he'd look like that, and then the shutter would snap shut, but you were the most self-effacing person. You seemed to have no particular need to be anything, which considering—*

Cindy: I had no knowledge of what to be, maybe.

Chuck: *But for someone who's silly-putty in your own hands—you make yourself into whatever you want—it seemed that you were not very interested in producing any particular kind of image for me, which I thought was sort of interesting. When I finally asked you to do things, you had no trouble performing.*

Cindy: I think I always need directions when someone else is taking my picture. I always feel so awkward posing for anything, and if they say, "Well look, it's in your hands, do whatever you want to do," then I can probably come to the photo shoot with some ideas. About fifteen years ago, Timothy Greenfield Sanders did a picture of me, and I decided to bring a wig with me. It was a very straight-forward picture, his kind of picture, but I was wearing a wig, which didn't look unnatural, it just wasn't at all what I looked like. I was a bleached blonde at the time with really short hair, and this was a longer, dark wig. It was a way for me to assume some sort of character for the picture. Otherwise, I feel totally self-conscious and say to people, "What do you want me to do?" which is usually really bad in those kinds of situations because then they say, "Okay, lie down on the table, I'm gonna put all this stuff around your head, and you're just gonna be lying there like one of your props," and then I'll look at the picture and say, "Oh, god, why am I so vulnerable?"

Bill: **It must be disconcerting to see yourself portrayed on such a large scale.**

Cindy: Yes, especially without any of my usual wigs or the things behind which I hide. It's really hard to look objectively without feeling self-conscious that you are looking at yourself.

I mean, when I walk down the street I try not to look in the windows. Part of it is not wanting other people to know how self-conscious you really are, not admitting to yourself—

Chuck: —how narcissistic are you really?

Cindy: I'm aware that people, perhaps because of the nature of my work, presume that I'm narcissistic.

Chuck: I don't think people see you that way, honestly.

Cindy: Well, not in relation to the work I'm doing now, but in general, people assume that when you take pictures of yourself, you must be preoccupied with yourself.

Chuck: I don't see you as someone who's looking in the mirror all the time.

Cindy: No.

Chuck: Me either. You know, I've done self-portraits all my life, but if I get into an elevator or someplace where there's a mirror, it depresses me so much to see myself. You'd think that since I've done so many self-portraits, I must really be interested in the way I look, but in fact, I'm not.

Guest: Chuck earlier brought up a kind of interior quality that seems to have increased in some of your work. Do you see anything else in terms of how your work has evolved? I also see an exploding of the body, in a way, that is taking place. Is that pretty conscious or pretty organic, in a way?

Cindy: It's totally organic. I just look for a new way to play with the same things, whether it's myself or the same body parts. When things seem to stagnate, I might say, "Well, let's just cut this up and see what happens." It isn't as if I consciously decided to "deconstruct" the figure, or the self, or anything like that.

Chuck: Actually, there's been remarkably little talk on that subject today, considering what I have read about you and considering that's the way your work is talked about. However, it's not the way you yourself talk about it. I do have one question that came from that stuff.

Cindy: What?

Chuck: No, it's a comment about the male gaze, and I wondered what your reaction was? They talked about the to-be-looked-at-ness of femininity and about the male gaze, and I wondered if you, as a woman presenting yourself, had any sense of what it is to provide images for men or women, or whether there was any difference—or whether you thought about—well, I'm just interested in your reaction.

Cindy: Well, thinking about my whole life, especially the formative years, what was expected of me as a young girl growing up to be a woman was really the basis for the way my work came out, because I personally am really uncomfortable with the whole idea of glamour or trying to look lady-like or sexy. I have always been more neutral in that area, but I sort of liked it on this other level. As a child, I played dress-up, and it was fun because it was artificial. It still is artificial to do any of that, so in the mid-seventies when I was starting to do black and white work, it seemed interesting to be collecting these costumes that were relics of an earlier age. It just didn't make sense any more to wear girdles, or pointed bras, or go to sleep with big curlers in your hair, and things like that just in the name of beauty. It had a love-hate relationship because I liked some of the artifice of it, but I personally couldn't relate to it anymore. So,

it seemed to make perfect sense to incorporate it into my work so that I could still play with it on one level but then be able to say, "That's it. I've had enough."

Chuck: I certainly understand what you meant in what you just said, but I think the thing that keeps the work from being about the male gaze is that you make it for yourself. You are the primary audience.

Cindy: Oh, yeah. As far as the male gaze goes, that's been attached to my work as a label by theoreticians, but it never even occurred to me in the work. It was really just for myself. I wasn't even trying to make a statement about men looking at women, even in the black and white work. It was just about me dealing with these role models from film.

Chuck: Speaking of influences, do you see the work of younger photographers? There is a lot of photography in the new Whitney Biennial. You end up looking classical in comparison.

Cindy: A lot of the photography is more on the documentary side, I suppose, or has a documentary feeling, which is not exactly my real interest because I tend to prefer staged imagery that contrasts reality from fiction.

Chuck: Many photographers are photographing real world examples of what you have fantasized, graphic things like body piercing and all of that stuff, which is simply implied in yours.

Cindy: It's scarier, I guess, when you see it in reality. What I really liked in that show was a surprise because I had never seen his work before. I think his name is John O'Riley. I loved his sense of collage and scale. It was really nice. I also loved Nicole Eisenman's work; not so much the mural downstair, but the other stuff that is all over the place.

Bill: When Chuck painted you, the picture was really just a painting of you, in the same way as a snapshot of you just sitting around talking, you know. It's so different from the way you work with yourself. When you deal with that painting face-to-face, do you feel uncomfortable looking at yourself that way, without—

Cindy: No, I think I'm more into the way he painted it, how it's so broken apart from the photograph.

Bill: In fact, it looks so much like you, you're revealed in a sense.

Cindy: Right, but I guess because it's painted the way Chuck paints, I feel that, as opposed to your earlier style, it's more abstract.

Chuck: Yeah, you can get away without thinking it's really you. In the old days—

Cindy: Right. You don't see the pores, blackheads—

Bill: You can get away with it, but in many ways, the paintings are much more like the people.

Chuck: Yeah, but your zits aren't spread out for the entire world. When I shot Cindy, she was saying, "Oh god, wouldn't you know that I would have a pimple on the day that I'm being shot." I said, "Well, in the old days, that would be something to paint, but now it'll just be another circle." I always say that, no matter how unattractive I make you look, eventually you'll look worse than the painting does, and then the painting won't look so bad.

◆

Betty Murray

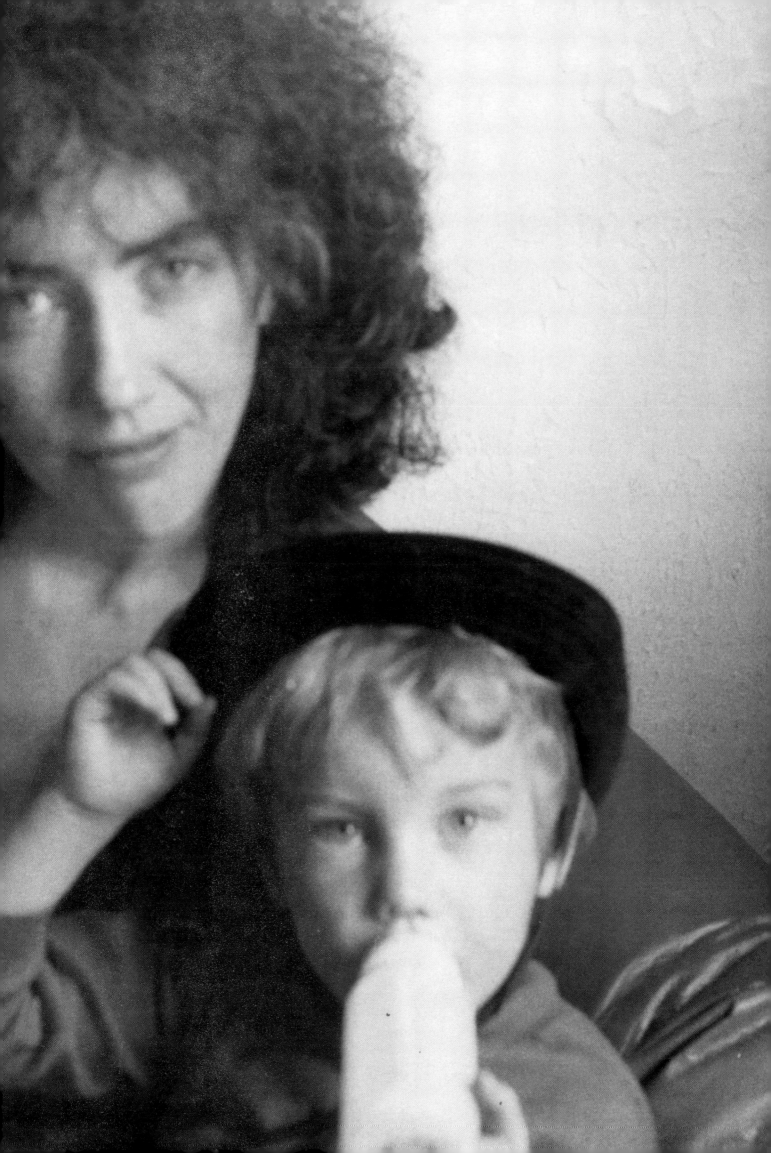

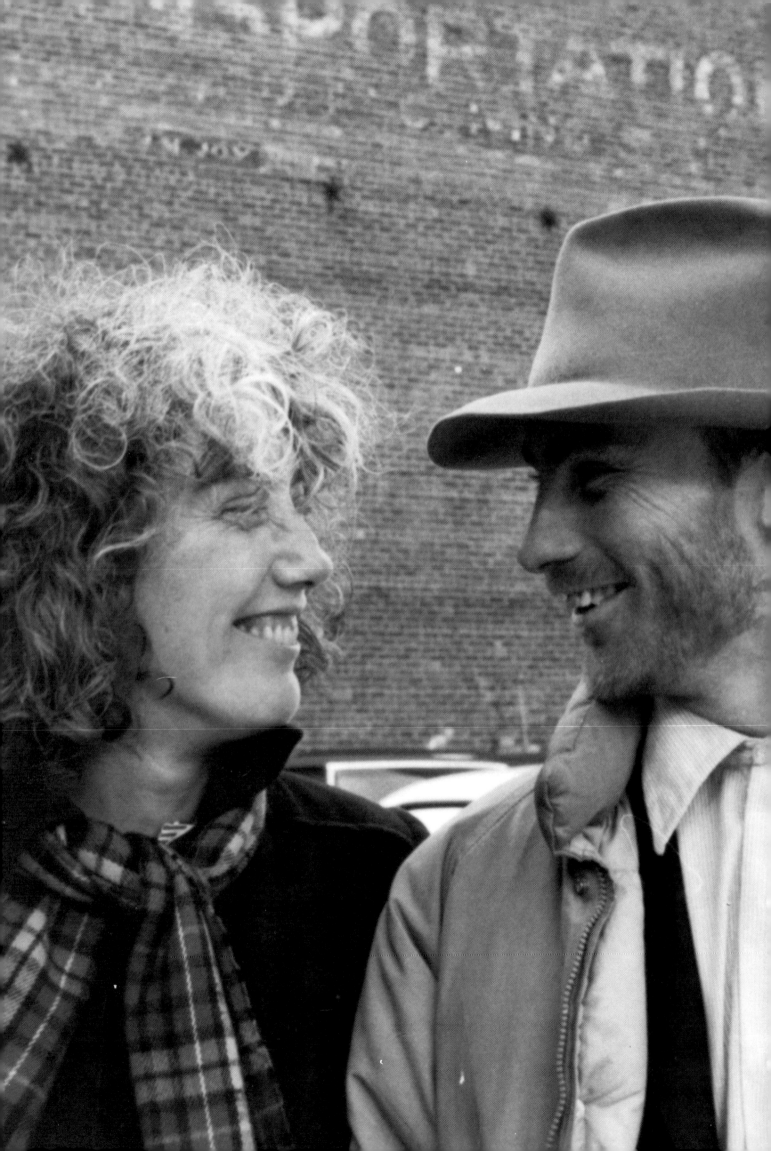

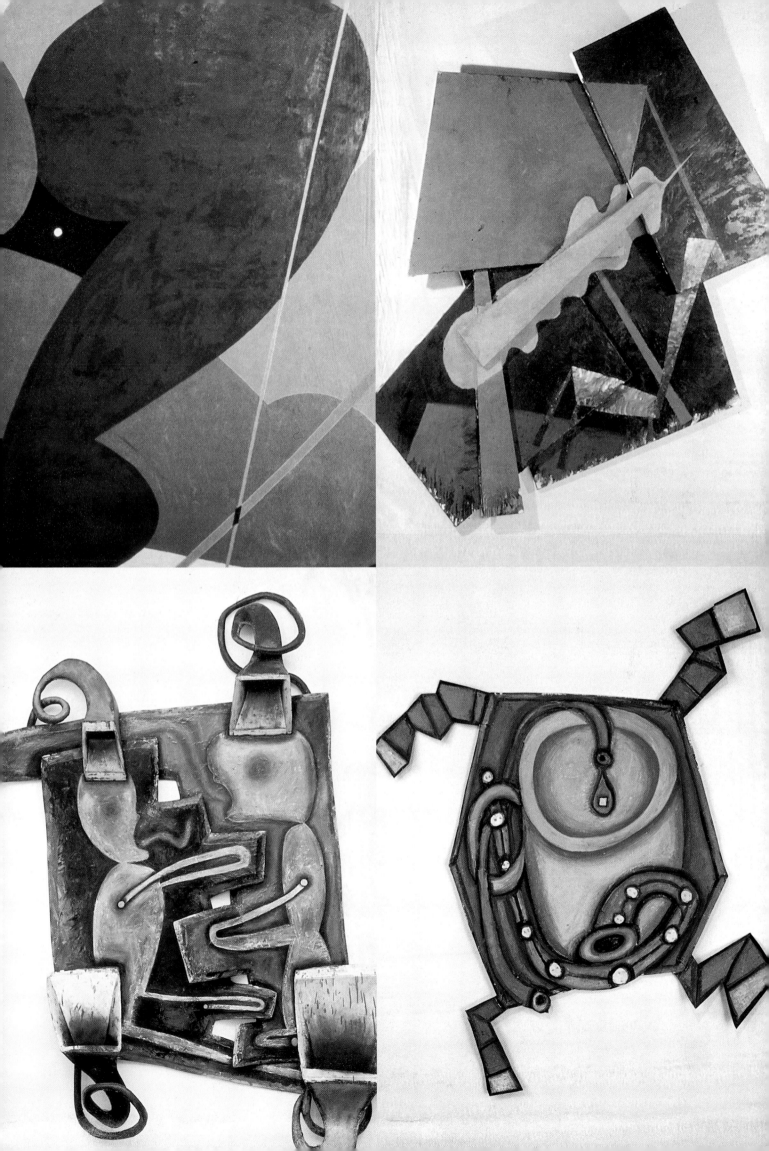

Elizabeth Murray

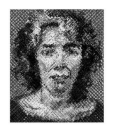

New York City, May 23, 1994

Chuck Close: I've been down to Winston-Salem [NC] and some other places like that. They have very active arts programs.

Elizabeth Murray: **An arts group in Georgia put on a show that had some homoerotic content. The public rose up against the artistic community and passed some local law against homosexuals. It was a big deal. Do you remember that? It all blew away, but the thing that was fascinating was its virulence and its particular hatred. It was in a community in Georgia that had a very strong arts group that fought back, and the upshot was that it all turned around on the homophobic group, it all turned back on them. I was in Washington, D.C. about three years ago doing the First Amendment thing, and I went around with a bunch of people from these small community arts groups. I went to Nancy Kassebaum, the senator from Kansas, and she was actually great to talk to because she was so honest. She listened to us very carefully, and she said, "Well you know, my constituency back home is really upset about this Mapplethorpe thing, and I'm afraid this is an area in which I really have to follow my..."** [Citizens of conservative Cobb County, Georgia, attracted national attention in August 1993 with an anti-gay resolution designed to reject federal arts funding in order to censor potentially offensive art in their community.]

Chuck: That's so disappointing. Congresswoman Pat Schroeder said that there was no way she could explain to her constituency why she was voting for [what they perceive as] pornography, so she had to vote against it.

Elizabeth: **And when you ask them, "What is your definition of pornography? Where does it appear? What exactly are you talking about?" they cannot get their minds to go into those refinements.**

Chuck: I was trying to convince Jane Alexander, the head of the National Endowment for the Arts, that there was no sense in playing that game, that she needed to take the moral high ground, to say, "Sure, some of this stuff is offensive, but we're a big enough country to tolerate it."

Elizabeth: **To tolerate diversity. Of course, art is provocative. That's what art is. It's the nature of the territory, it goes with the territory. What's interesting is what a small percentage of it anyone would find really offensive. Look at television.**

Chuck: Right. But there's no sense in denying that there is going to be something that everybody is going to find offensive on some level. I find a lot of color field painting offensive. So?

Elizabeth: I find it offensive, but on the other hand, there's a big difference between it being in an art museum to which you choose to go, where there are now signs on the walls that warn that this may be offensive to your child or whatever the hell that stuff says, and turning on the TV set on which you see all kinds of bloodcurdling mayhem.

Bill Bartman: There are something like 249 acts of violence in each half-hour episode of Power Rangers, *which all the kids are watching.*

Elizabeth: And during which they're promoting cigarette smoking.

Chuck: You know what I think? I think the fight against cigarette smoking is exactly the same as the problems with the visual arts, because we're such a fucking judgmental society and we're so puritanical.

Elizabeth: On one level we are but on another level gun control, homophobia, and violence against anything of which we disapprove is condoned: for instance, the guy who shot the Japanese kid. I mean, my god—[On October 17, 1992, Rodney Peairs of Baton Rouge, Louisiana, shot to death Japanese exchange student Yoshihiro Hattori when the young man approached his front door at night. Although Mr. Peairs was acquitted of manslaughter charges, Mr. Hattori's family was later granted a financial settlement.]

Chuck: And the guy who shot the abortion doctor. A number of ministers were saying that it was justifiable homicide. [Dr. David Gunn's murder by Michael Griffin in Pensacola, Florida, was justified by anti-abortion activists as saving the lives of unborn babies.]

Bill: That he's a saint.

Elizabeth: Yeah. It's terrifying to imagine that people could say that.

Chuck: I'm afraid if they—although I'm not for capital punishment, except for art critics—

Elizabeth: No, we want to *torture* them, we don't want to kill them! Slow torture.

Chuck: I'm afraid that if they do send this guy who killed the abortion doctor to the chair, it's just going to make an incredible martyr of him and cause even more violence.

Elizabeth: You know, it's so complex and so simplistic at the same time. I know how I feel about it, but I'm against capital punishment. I'm really, really against it, but they're going to kill him now, and I agree that it could end up making him into a martyr. He already is, no matter what is done with him. The feelings about that are so—to me, I'm not religious, I don't have a religion, I'm an atheist.

Chuck: Me too.

Elizabeth: And yet—this is Christian, you know—I can understand somebody feeling that abortion is wrong. I completely feel for them, and part of me even feels that way too.

Chuck: Did you see that bumper sticker? "Against abortion? Don't have one."

Elizabeth: Hey, that's great.

Chuck: Against abortion, don't have one.

Elizabeth: You know what it is, there's no humor or depth to this diet at all; it's gotten so leveled out, it's so leveled out, it's so disgusting. When you go to Washington, you feel as if these people are almost—I mean, all they care about is winning the election. They'll do anything, they'll do anything.

Bill: What you realize from going to Washington—what I realized—is that the real power is not in these people, because they don't read anything. It's the young staff people who have tremendous power. They write all the legislation, and if you want to get something done, you don't talk to a senator because the senator never reads the legislation that he sponsors. Do you think any of them read the twenty-eight thousand pages of the GATT treaty? Not one of them. They have these committees.

Chuck: Well I don't know if I'd want to have a senator who wanted to spend the time it takes to read twenty-eight thousand pages of legislation.

Bill: No, I understand that, but most of them don't even know what it is they're voting on half the time.

Chuck: Somebody should be reading it and letting them know what it says.

Elizabeth: I think it's a bit that way in the art world too. I think it's less so in museums, but I see Washington—I see everything right now as being about these little increments of power where the issue isn't about humanity and how we can make it better to live with each other in what is clearly a very diverse changing world. To me, it's all about tolerance. I feel the same thing is happening on a much smaller level with people in the art world; it's about little bits of power, it's not about how moving or real your art work is. People don't see art anymore; they don't really see it, but they judge it. "Oh, this is cool; I'm going to go for this right now," or, "Oh, this isn't so cool, so I really can't see it, I can't let it in." I feel very much that that's what it is.

Chuck: I think that happened a lot when power shifted to the collectors, when they were going around with a hit list, and every collector was buying the same ten artists.

Elizabeth: For a while, for about two years.

Chuck: Yeah, and then the winds would shift and some people would be taken off the list and someone new would be put on the list, but everyone wanted the same work. It was an amazing phenomenon. Connoisseurship just no longer existed. Defining one's taste by the work they collected—that was gone.

Elizabeth: I know. Bob Holman, my husband, was reading me something the other night that's like the story of fame. The way it starts out is that somebody says, "Who is Truman Capote?" Oh, it's four sentences in the story of fame. One: "Who is Truman Capote?" That's the first sentence. The second sentence is: "I've got to have some Truman Capote." The third sentence is: "Can you give me something that's like Truman Capote?" and the fourth sentence is: "Who is Truman Capote?" *[laughter]* I just love that story. The media controls so much, including the connoisseurship thing you were just talking about.

Chuck: So how do you feel about having either just theoretically been helped by or used by the New York Times for the trip to the Met? What kind of taste did that leave in your mouth? [Elizabeth Murray's tour of the Metropolitan Museum of Art, *"Looking for the Magic in Painting,"* in the New York Times, October 21, 1994, was part of a series written by Michael Kimmelman profiling New York artists touring the Metropolitan. Other artists in the series included Roy Lichtenstein, Brice Marden, and Cindy Sherman. Murray selected, among others, Cezanne's *Madame Cezanne in Rocking Chair,* Courbet's *Young Women From the Village Giving Alms,* Vermeer's *Young Woman with a Water Jug,* and Picasso's *Portrait of Gertrude Stein.* Kimmelman noted: "Ms. Murray's characteristics of modesty, her ideological independence, her non-elitist insistence on supporting and assisting fellow artists, and her belief that art should provoke, not placate" were evident on her tour. Murray's comments on Philip Guston included: "The importance for me of Guston is that I saw

he had made this switch from abstraction, and though I didn't fully understand it then, I thought it was brave. Now I think of it as something natural and something that happens as you grow and find yourself. You begin to turn toward what comes most naturally to you. Guston couldn't help himself. And that gives me hope."]

Elizabeth: Good, basically, although I think I was both used and using. I feel at this point that if somebody asks me to do something—

Chuck: *That's actually about art.*

Elizabeth:—that actually is about art, I really can't say no, I shouldn't say no, and I don't want to, although I could have another point of view. It was basically a really good experience, but I feel as if I'm old enough, and I've been down that road enough, to know that it can go either way—that it's be used or use—but maybe underneath it, there is something real.

Chuck: *I think it's an interesting—*

Elizabeth: Well, first of all, I made a great connection with Michael Kimmelman, and I like him. On the whole, I like what he writes. I like a lot of the stuff he has to say.

Chuck: *He's not a poison-pen journalist.*

Elizabeth: No, he's not a poison-pen journalist; he doesn't want to be that.

Chuck: *I thought it was a really nice piece. I think it's interesting to give the viewer permission to look. It seems to me to be a lot healthier way to approach something than giving the viewer an Accoustaguide and telling him, "Now move to the next piece on the left, and this is what the thing is about." I think it encourages people to go to the museums and look at great art. I saw the most bizarre thing. Have I mentioned this in one of the other interviews? They got Steve Martin to do a tour of the "dogs of the Met."*

Elizabeth: The dogs of the Met?

Chuck: *We're not talking about bad paintings, of which there are some, but actual images of dogs in the Met.* [Comedian and art collector Steve Martin recorded a cassette tour of works at the Metropolitan Museum of Art. The *New York Times* reported on January 15, 1988, that "His (Martin's) subject, animal imagery, runs the gamut of real and imaginary forms from various periods and countries. Each work is seen in its gallery setting, taking one on a snaking (so to speak) path through the museum. The tour was designed to acquaint the public with the museum's permanent holdings."]

Elizabeth: Oh, I thought it was bad paintings. *That* would be interesting.

Chuck: *That would be good. That would be interesting. No, people strap on their headphones, and they run through the museum to a dog painting. They look at the dog in that painting, and then they run to another section of the museum where there is another dog, and then, of course, they are running right past everything else. They wouldn't look to the left or the right because the cassette is telling them where to find these dogs. It is the most bizarre thing.*

Elizabeth: That's hilarious. He can be so funny. Actually they should make the people put on a pair of Steve's cruel shoes to do the tour in. I guess they feel as if they have to do almost anything to get people to pay and give them some dough.

Chuck: *Yeah.*

Elizabeth: That's what it sort of comes down to, what it's all about. I don't know, I get confused and depressed when I start to think about it, because it makes me feel as I did when we came here, and then I start feeling as if I'm getting nostalgic, which is a dangerous emotion. When we came here, when you came to New York, did you have any idea that you would make a cent?

Chuck: Never. Actually, that is what these conversations are turning out to be. This is just an excuse to do what I've done for years, which is to have lunch with people and talk to them. The curious thing is that these conversations are only very tangentially about me having painted the person. They end up being, in a strange way, a kind of portrait of an era. When we came to New York, there were such lowered expectations; if anything was going to happen, it was going to happen a long time from then. I think that is very different from what happens to a young person who is coming to the city today.

Elizabeth: Well, I think it's better now.

Chuck: Better now? I think it's much harder now.

Elizabeth: I think it might be better now.

Chuck: What did you pay in rent when you came here? When did you come to New York?

Elizabeth: I came here in 1967, and I paid—

Chuck: So did we.

Elizabeth: —we paid $150 a month for two floors on Twenty-eighth Street. They were pretty crappy floors, but we made them really nice. I put up little curtains—I remember spending hours making those curtains—and little wooden rungs, and it was great. Then I had Dakota, and we had to move out because they started to build the Fashion Institute of Technology right across the street from our building. It was a nightmare. There was no law then that you had to stop running bulldozers at eleven o'clock, so the bulldozers would go on all night long, and I had this new baby. I was going nuts.

Chuck: Dakota was born in what year?

Elizabeth: In '69. So we moved to Westbeth.

Chuck: So Dakota's a little older than Georgia.

Elizabeth: He must be two years older.

Chuck: Georgia's twenty-one.

• • • •

Elizabeth: I would come down here to see Jennifer [Bartlett]. She was the first person I knew who lived down here. To see her, I would have to figure out how to get back uptown by looking north to the Empire State Building. They had just finished building the projects, the New York University projects [Washington Square Village], on Bleecker Street. It was different. It was all so different.

Chuck: Cab drivers wouldn't let Leslie out of the cab at night. They'd say, "You can't get out here, no one lives here, you can't get out here, this is…" And it was actually a very safe neighborhood.

Elizabeth: Yeah, it was cool. It was really, really great, and on the other hand, when things started to happen, and we started to show, and we started to make some money, that was incredible too. It was so exciting. I loved it.

Chuck: For Klaus [Kertess] making money was embarrassing. He didn't like that. He didn't want to be a merchant. He sold things despite himself.

Elizabeth: Yeah. I wonder how he feels about that now. Are you interviewing Klaus?

Chuck: Yeah, we already talked with him. He did a very interesting interview. It was totally about

the 1960s time period. We never got up to today. I have this theory. We had a loft. I think it was one hundred dollars a month for a twenty-five hundred square foot loft on Greene Street.

Elizabeth: The one on Greene Street. Oh. Then you moved over to Prince Street.

Chuck: Then we moved. We bought that loft at 101 Prince Street for five thousand dollars. It's over Jerry's [restaurant] now. The whole building cost what Jerry now pays in rent for one year.

Elizabeth: That's pretty wild.

Chuck: At any rate, it was possible to live in New York then. I taught two days a week at the School of Visual Arts and could paint the rest of the time. I earned less than four thousand dollars a year. And we even ate meat. We had money for groceries. You could go to the co-op on Grand Street and for twelve bucks you could get several bags of groceries. We felt as if we had the rest of our lives to become successful, if we were ever going to be successful. Young artists now have this sense that they are making such an investment, thousands of dollars a month for rent, that they've got to make it happen in a hurry. It makes for a kind of rampant careerism, I think.

Elizabeth: It confuses me, actually. I think that aspect is there, but I don't think it's just there because of money. I think it's encouraged in the society. I think it's pushed by the media, that there's a whole outer shell to it.

Chuck: Desensitization is really amazing.

Elizabeth: I get confused. I think of these young artists, and I look at what's going on now. I know that part of what you say is really true, that it does have to do with the fact that it costs so much to get a decent place to live in Manhattan.

Chuck: They're making sacrifices that we didn't have to make. A space costs three thousand dollars a month and you've got to live with ten other people. It's super competitive. How do you find yourself? I feel as if we got to find ourselves, really, and we had each other too.

Elizabeth: When I came to New York, I knew Jennifer Bartlett, I knew Jenny Snider, and through Jennifer and Jenny, I met Joel Shapiro and Amy Snider, and through them I met Jonathan Borofsky, through Jennifer I met you, John Torreano—

Chuck: Joe Zucker.

Elizabeth: Joe Zucker. You would give me your teaching jobs at NYU when you didn't go in—which was great. And also, Chuck, you were really different because sometimes we'd sub for people and they'd never pay us, but I remember you calling me up after I'd done your thing and sending me your day's salary, which was like a hundred and fifty bucks, and telling me that I was great. I'll never forget that. You would call me up and say, "You were better than me, they liked you a lot better than me. Would you like this job?" [laughter]

Chuck: I used to sub for Serra. We all subbed for each other.

Elizabeth: Yeah, it was fantastic to have a network.

Chuck: They were paying six dollars an hour when I first started at Visual Arts.

Elizabeth: Yeah. I didn't feel as if we were constantly in competition with each other or that if you did better, somebody was going to try to sit on you, which I think is somewhat the feeling now.

Chuck: I don't think we saw each other as competitors.

Elizabeth: No, we were peers, and it was about support. It was about our art. We wanted people to come into our studios and really dig what we were doing. If someone came in and really got it, and really supported it, it was just heaven. For instance, Jennifer Bartlett brought Alan Saret over, Joel Shapiro brought Roberta Smith—

Chuck: It's interesting too because, as opposed to the current age of appropriation in which everyone is freely quoting, we really wanted to purge our work of any reference to anyone else.

Elizabeth: That's absolutely true.

Chuck: We didn't want viewers to be thinking about anybody else when they were standing in front of our individual work.

Elizabeth: I know. Isn't that interesting? It's true, of course. But now I feel as if anything I can use, I do. Also, when I look back at my work, I can see how influenced it was. My struggle to be different seems so transparent now.

Chuck: I think it's an interesting thing though, our coming of age. I think 1968 was a watershed year for many of us and for the world. I mean, the world changed in 1968—all of the assassinations, Robert Kennedy and Martin Luther King. I remember feeling differently about everything after that. But so many of us emerged in the late sixties and early seventies. I think there was something very unique about the seventies as a decade. There weren't real superstars in the seventies in the sense that there were in the sixties and eighties. I think it was good for us. We had a nice, slow chance to develop without the white hot glare of the spotlight that the artists had in the sixties and eighties. One thing I think is interesting about our generation is that unlike some groups, which peaked early and started a long and slow descent and became just imitators of themselves or whatever, and also cut themselves off from the community, moved to Florida or someplace else to live and lost that community, I think a surprising number of people of our generation—I believe this very strongly about you, about Richard, about Brice, about Joel—after all these years, are actually doing some of their best work, and that's something. I think there are a lot of legs in our generation.

Elizabeth: I've never looked at it in that way, but I think that may be true.

Chuck: No, I think it was just an accident.

Elizabeth: I think so too. I think it was an accident.

Chuck: It was an unfocused decade. It was a very pluralistic time with so many different things going on.

Elizabeth: Remember how people complained?

Chuck: They hated it.

Elizabeth: "Nobody's involved."

Chuck: "No focus," they said. "Where's the focus?" they said.

Elizabeth: It's interesting that that's when we really were growing. I mean, I think of that as the moment when I figured out that I was really going to do this, and that I had something to say. That's when it felt as if I really got my feet on the ground in terms of my work, not my life, personal life at all, but certainly my work.

Chuck: There's another thing about the seventies that I was just thinking. There was an almost naive belief in process, that if you got yourself involved with something and just went with it, you would be safe, you could live.

Elizabeth: That was like a holy grail.

Chuck: Yeah. Give yourself over to some system or some way of working and just follow it wherever it goes.

Elizabeth: I think so. I never thought of that either.

Chuck: Or even materials. Give yourself to materials; see what they can do.

Elizabeth: I think that is true. I mean, when I realized that painting was what I had to do, no matter how simplistic it might seem, to use oil paint, to put it on some kind of a support, was what could focus me. I never imagined what it would turn into.

Chuck: I think the other thing that happened in the seventies that had a profound influence on all of us was the women's movement. It hit like a ton of bricks around '72.

Elizabeth: Actually, that was exactly what was going on in my mind. That was really how I met you, because Leslie was briefly in a women's consciousness raising group, and we met a couple of times on Prince Street.

Chuck: I think it had a profound influence on both sexes; it changed the art world.

Elizabeth: I don't feel any dubiousness about how it survived, because I think it's been a very positive but very painful process for men and women.

Chuck: Don't you think because you were born in one generation, straddled that, and expected to live in another generation where everything that you—

Elizabeth: Yeah, I think that's it. I think that's it exactly, Chuck. It's like we were children in the sixties and we thought that what we were doing was going to change the world. It would be changed and that would be that. The Civil Rights Movement, ending the war in Vietnam— we did that, or so we fantasized.

Chuck: It gave us a tremendous sense of power. That's right.

Elizabeth: It was mind-boggling. It gave us a tremendous sense of power, but I never bought into the idea "don't trust anybody over thirty" because I was a little too old for that.

Chuck: We were getting very close to thirty, so— [laughter]

Elizabeth: And knew it. But I think that was good. I just didn't quite buy it because I knew people were distrustful of us, too, as artists. Somehow, we were part of the establishment, we were making these little objects for the elite bourgeoisie. It was good, actually, because it made me have a wider view. There was that, and from the beginning of the seventies there was the excitement of women coming together. I'd never had a group of women friends to whom I felt I could talk. I mean, women were culled off and separated from each other at a very young age, especially in the fifties and sixties. It was as if you were expected, if you were born in the forties, to continue, no matter what you did, no matter what your leanings or yearnings were as a young person, to still deal with being a woman. You had to always deal with that cultural thing. I thought I was totally isolated and totally by myself because I wanted to be an artist.

Chuck: Yeah.

Elizabeth: And that was really a powerful thing for me.

Chuck: You know it really did change everything. It's funny, I think I have far more women artist friends than men.

Elizabeth: Well, you're different.

Chuck: I have regular lunches with a half dozen women artists, and I think women are half of the talent pool. If you don't have women artists, you're losing half of the pool of talent.

Elizabeth: I think you're right, but I don't think all men artists see it that way. I think that the war of the sexes is just incredible and fascinating; it's a great battle, but like all battles some awful damage is done, some terrible damage, and people lie bleeding on the floor. Sometimes I think that whether guys are straight or gay, they basically all just want to fuck each other. *[laughter]* You know, I think that men are powerfully attracted to men, and there are so many things in society that try to pull men apart. You're supposed to be this way, you're supposed to be that way.

Chuck: Oh, I think the greatest winners of the women's movement are men, by far. I really do. I think it gave us permission to be different.

• • • •

Chuck: You know what's interesting? I hate the way, in terms of money and power and the government and stuff, I hate the way art is sold. I think it's really bad. They have to say that the reason art is important is that it attracts and brings more money into a community than sporting events; more people attend museums than go to sporting events, and it's good for the economy. Therefore, it's important to support art, and art should be in the community. The trouble is that what's being missed in all this is not that art is just good for the economy and good for business, but that it's a humanizing—

Elizabeth: I know. It's about food for the soul. That's basically the bottom line. That's what art is. There are so many different things going on now, on the one hand, and I really—it will be great to talk to you about this honestly—feel guilty because I've made money from my work.

Chuck: I was a kid with no money, and I came to New York. I couldn't believe that I could just walk in and see all this stuff, a kid, a poor white-trash kid. It's only there because the collectors give it to them. There is the whole elitist vs. populist thing, and one of the funny things is that the Republicans are saying that art should only be judged on quality; we shouldn't have quotas; we shouldn't make sure that minorities and women are represented; we should just do it on quality. Well, the wonderful thing about that—I've been on a zillion juries over the years, I'm on five, six juries a year giving grants away—is that you don't need a quota if you really just judge work on quality. Half of the grants go to women, without any effort being made to do it. But first, you had to kick the door open for women. I would like to make the elitist world available for all people rather than do away with it because I think that there are quality issues involved.

Elizabeth: Yeah, me too. I believe in quality.

Chuck: I don't think you have to lower standards to let other people in. I think you need to open the doors and let people rise to the level of all the work that's being made.

Elizabeth: Yeah, you just let people in and give them the opportunity to educate themselves.

Chuck: You know, Leslie did a lot of research on American women who are landscape designers, which is a field dominated by women, and you know what caused it to happen?

Elizabeth: No.

Chuck: The First World War. The Harvard School of Landscape Design was the elite school and had always been an all-men's school, but in the First World War they emptied out the school to send the guys off to fight, and they allowed one class of women in for the duration of the war. They became all the great landscape designers in America, and they formed their own firms, and they hired other women, and since the First World War the field has been totally dominated by women. It shows that, if you just give an opportunity, you don't have to do anything special except give everyone the same chance.

Elizabeth: Yeah, many, many people are so eager to—

Chuck: And, of course, the minute the war was over they kicked the women out and brought all the men back.

Elizabeth: Yeah, but it was too late. *[laughter]* That's interesting, that's really interesting.

Chuck: In my opinion, you're one of the great American painters, period. I don't think it has any-thing to do with the notion that the work is special because you are a woman. I think it's very differ-ent because you're a woman, but I'd put your work up against any painter there is. I don't want to just talk about your work as "women's art," you know what I mean?

Elizabeth: Yeah.

Chuck: Just like I don't want to be a "handicapped artist." I happen to be an artist with a handi-cap, and it informs the work, but I don't want to be the poster boy for quadriplegia. Can you talk a lit-tle bit around the issues of how important it has been to be a woman, what makes things different, what were the obstacles, what were the opportunities? You've been with a woman dealer all these years. What's that been like?

Elizabeth: Well, I know I've talked about it before, but it's really interesting to talk about it with two men, because I've never done that. I never thought about it when I was younger, but no young woman would have, because we had never heard of sexism. I never heard the word feminism until I was thirteen. I was a weird kid. You were probably a little weird too. I was a weird kid, and I never fit in, quite, but I wanted to fit in when I was younger.

Chuck: That's before the art world became so fashionable. I mean, we were always misfits. Now you see models and all kinds of other people hanging around in the art world.

Elizabeth: It's so funny, and I still feel, underneath it all, like a misfit. But I've read some of the Lacanian stuff and feminist literature and I understand some of it, all the Freudian things, castration, Oedipal, and, in the end, even though you understand it, it's hard to explain your-self, ever, as a person. I know that because once I understood, in my late twenties, what it meant to be a woman in the world as opposed to a man, I was glad I was a woman. I felt as if men, on the whole, got more bullshit because they had to be more tied into a thing, and as a woman there was a moment when I realized that I was free, that because nobody really cared, I could do anything I wanted to do.

Chuck: There are tremendous expectations and pressures on men. I don't think there is any ques-tion about it.

Elizabeth: But in the sixties, there was sort of a window of opportunity when you could step in, and no one would know that you were doing this stuff. And also, in the sixties, there were a lot of really great men around, like yourself, like Joel [Shapiro], like Patterson [Sims], who had those things, but who were totally supportive of women, who weren't threatened by women.

Chuck: *You know, for generations half of the art students in art schools were women.*

Elizabeth: I know, and they were all taught by men who were disappointed and bitter.

Chuck: *But the generations prior to that didn't end up coming to New York and setting up shop. There were people like Grace Hartigan, who went by the name George; Nancy Graves went by N. Stevenson Graves when she was first showing—*

Elizabeth: I didn't know that.

Chuck: *—so that she wouldn't be recognized as a woman.*

Elizabeth: She did?

Chuck: *Oh yes. Absolutely. She entered competitions and did everything under N. Stevenson Graves.*

Elizabeth: I was not aware of that. I was really out of it.

Chuck: *I was so out of it in that way. I just felt as if I came from such a situation that for me to try to be an artist was salvation. Being an artist saved me. Psychologically, I was really a mess when I got into art school, and I didn't even realize what I was doing. Art was like a religion for me. I used it to get past that stage and into a slightly more psychologically together state of mind. Then I started to pay attention to the political part of it and think about it, but in the beginning, I didn't think about it at all. I had father figures in art school who kind of helped nudge me along and who, whatever else they did, encouraged me in my work.*

Bill: *Elizabeth, where did you go to art school?*

Elizabeth: Art Institute of Chicago, which is a big male patriarchal place, and yet, you could see all this great art. I was very ambitious. I wanted to be a great artist.

Chuck: *Yeah.*

Elizabeth: That was it.

Chuck: *That's the same aspiration any man painter would have.*

Elizabeth: I thought I could be one. It didn't occur to me at that point that anybody would be offended by the fact that I was a woman, or that I shouldn't try because of that. It just felt as if it was as open to me as to anybody else.

Chuck: *You are, without a doubt, a great model of someone who, at least from the outside, appears to have had it all or done it all, balanced having children and a career. I know it hasn't been smooth sailing, it hasn't always been easy, and that people looking from the outside never know what the real story is, what the pressures—*

Elizabeth: There have been times—honestly, Chuck—when I've said, "Wait a second. What sort of a fool was I to think I could have two kids in my forties and continue working?"

Chuck: *Geriatric parenthood is tough, isn't it?*

Elizabeth: It is, but I'm learning a lot from my kids.

Chuck: *It is different for men. Men can have children without it interfering in their careers in the same way.*

Elizabeth: Biologically, it's very different, and there's a part of me that says, "Yeah, we're animals, that's what it comes down to." We're always dealing with trying to not see that we're animals. I've gone through menopause now, and I'm taking estrogen. I love it because I think it's extremely helpful medicine, and I think there are sexist things there too, but, actually, that's been a very interesting process too, going through a physical thing where you have a sort of death, a real death.

Chuck: *Wow! Interesting.*

Elizabeth: Creatively, physically, a part of you is over. My procreative part is done. There's a whole other thing. Men don't whistle at me in the streets anymore, I'm not in that little arena—

Chuck: *You still look pretty darned good to me.*

Elizabeth: Thanks, Chuck, but will you whistle from a truck? *[laughter]*

Chuck: *I never whistled from trucks. Not my style. Whistling was never my strong suit, I guess.*

Elizabeth: Then, on the other hand, I've never felt more internally creative. I mean, it's as if you arrive at a whole other place in your work, and I seem to be there. It's lucky, you know, for a woman in her fifties to have something to do that she loves. Not all women have it.

Chuck: *Do you know how few people have anything that they do that they love, period?*

Elizabeth: I know, it's not just women.

Chuck: *I'll bet you that more women than men have things they love to do.*

Elizabeth: Actually, that seems to be a possibility. I was reading something incredible about that.

Chuck: *Women seem to be more contented.*

Elizabeth: Yeah, I am. It makes me realize how we see the world very differently.

Chuck: *How do you think that's influenced the imagery? I mean, when and how did the domestic kind of imagery creep into your work?*

Elizabeth: Well, I'm starting to paint figures. There are real people in my work and—

Chuck: *You are returning more to a rectangle and a flat surface, like in* Look Back *[1994] and* Early Light *[1995].*

Elizabeth: Yeah, although that's kind of going back again. I think I've gone back to the flat surface to get back on the playing field again and sort of rethink things, because now I'm starting to pull it out again, and I really needed to think it over again. But I think it also was part of working. I want to paint more. I want more surface so that I can paint, can actually brush it and work it up in a painterly way. That's part of it, but I still want the other thing, so I think I'm just trying to figure things out again in another way. And even though it's scary to feel as if I'm losing some things, and I don't know where I am again in some ways, it also feels great to be— see, I think it's all about doubting.

Chuck: *About what?*

Elizabeth: Doubting. I find doubting more preferable than knowing.

Chuck: *Oh yeah, you mean getting yourself into trouble so that you don't have the answers—*

Elizabeth: Yeah.

Chuck: *—so the search is still on.*

Elizabeth: Don't you? How do you feel about that?

Chuck: *I think it's kind of a "rocks in your shoes" thing too. There's a certain resistance and a certain*

degree of difficulty that is really necessary, and so, I think, to get yourself into trouble is very important. When things go too well, you're just sort of demonstrating the fact that you know how to make something.

Elizabeth: There have been times when I have felt, maybe more than for any other artist, envy at your procedure, at your practice.

Chuck: *Oh yeah?*

Elizabeth: Basically, throughout your work, you've done shoulders, you've made heads and shoulders.

Chuck: *Yeah, a pretty narrow guy.*

Elizabeth: Yet within the practice there has been so much growth and change, and that's unusual Chuck. There haven't been too many people, except maybe Richard Serra, who have done it. Serra would be another artist who, on a certain scale, has grown. Artists sit around and bitch and complain about this and that other artist. "Oh God, when is he going to do something different?"

Chuck: *Well, there are people like [Robert] Ryman who do it in a non-objective way. When you see a Ryman show, you actually see all the ways to skin the white cat.*

Elizabeth: I know.

Chuck: *It's such a celebration. Talk about not being a Johnny-one-note.*

Elizabeth: But to me that's still a little different. I don't connect as much to his work as I do to your work or to Richard's work. It's not that it isn't great work, but I don't have the same emotional connection to it. I know what I was trying to get at thinking about your work. I thought the opening up of the structure and the huge changes that seemed to occur when you came back from being sick, from losing your motor dexterity—I've wondered if that would have happened anyway?

Chuck: *I think my work is more emotional. There's more emotional content, and I care more. I've got more eggs in that basket. There are so many other things that I used to love to do that I can't do anymore.*

Elizabeth: Yeah.

Chuck: *I used to be very active. I used to chop down trees and mow brush and do stuff like that. And I used to walk. I loved to walk and walk on the beach and stuff, and I just can't do any of that, so basically I'm either at home with the kids or I'm working, so it's made it more important; I think it's really focused me. I think I also care more about the people in the paintings in a funny way. I mean, I always cared about the people, but it's more emotional now.*

Elizabeth: I think that's definitely been a major thing in the work.

Chuck: *Formally, I don't think it's that different. Luckily, I was able to continue to work. I can't draw because drawing you do with your wrist and your fingers, but painting you do with your whole arm. Since my wrists don't work and my fingers don't work, I just strap the brush on and paint, and I think I'm doing essentially what I would have done. The last painting I did before I went into the hospital was the profile of Cindy Sherman, and that was very much like the paintings that followed.*

Elizabeth: Yeah.

Chuck: *I actually started a painting of you just before I went into the hospital, and I abandoned that work. I didn't like the way it was going. It was one of the only paintings I've ever stopped working on.*

Elizabeth: **Really?**

Chuck: *It was a big painting of you. And then when I came out of the hospital, yours was the first larger painting that I did.* [*Elizabeth* was first publicly displayed at the Museum of Modern Art in January 1991. In Nancy Princethal's review of the painting in *Art in America* (March, 1992), she comments: "Close addresses [*Elizabeth*] as a fully rounded [character]; we get some of the electricity of one artist eyeballing another in reciprocal imaginative comprehension. The vitality of these paintings' surfaces is nowhere more remarkable than in the [subjects'] eyes, which never really settle into place, though they are the focus of each painting."]

Elizabeth: **I know.**

Chuck: *I just couldn't face a really big painting, so I did the biggest one I thought I could make. I did two little paintings in the hospital, and then yours was my first larger one. I can't tell you how important that painting was for me to do, and I have a real soft spot in my heart for you for being the image that represented getting back, getting back to work. Also Kirk [Varnedoe, Chief Curator at MoMA, NY] was very supportive when I was in the hospital and came to visit me a lot. On my first foray out of the hospital, we rented a handicapped van and he invited me to the Modern for a private tour of the Warhol show on a day that it was closed. He had a lunch for me in his office, and it was a very nice thing. I could barely move. When he wanted to get* Elizabeth *for the Modern, that was a kind of "Good Housekeeping Seal of Approval" that I was back. I assumed that they weren't going to purchase work as charity, and there was the fact that Aggie [Gund] wanted to do it and was very supportive. That really signaled to me that I was going to make it, that I was going to get back.*

Elizabeth: **That was really kind of amazing, Chuck. Did you know they bought a painting of mine at the same time?**

Chuck: *Yeah.*

• • • •

Chuck: *You know, one of the things that we didn't talk to Lucas [Samaras] about was his great quote. We should have asked him when he was here. Lucas called me when I had finished the portrait of him, and he said, "That painting is too good for you to have done. I should have done it."*

Elizabeth: *[laughter]* **He must be something else.**

Chuck: *[laughter] So everybody has some of that, some of those problems or whatever, from being the subject.*

Elizabeth: **I didn't have any problem with it at all. I love the painting. The only thing that I felt later—it was right before you got sick when I saw you on the subway, and you said that you were starting work on my painting—**

Chuck: *Yeah.*

Elizabeth: **—and then you got sick and I was really upset—I'm just superstitious enough—and I thought, "Oh shit, he's working on my painting."**

Chuck: *Oh. [laughter]*

Elizabeth: **It just really bothered me a lot, so when you started the new painting, and I had come over to see it, it was as if this little burden was removed. Then I did a painting of you that I've never shown you.**

Chuck: *I'd love to see it.*

Elizabeth: One of the reasons that I've never shown it to you is that when Douglas Baxter saw it at Pace, I was going to call it "Chuck," and Douglas said, "This painting is kind of scary."

Chuck: *It's not too late to change the name.*

Elizabeth: Well, I know. I called it *Specs*, for your glasses. No one even saw it as a face for a while. It is a very disturbing painting.

Chuck: *Well, let's use that image. In the book, we're reproducing my painting of the person and a painting that person made.*

Elizabeth: It's one of the paintings that nobody has been able to buy. Somebody recently wanted to buy it, but they didn't want to pay enough money for it, and I just thought to myself, "Fuck, I'm going to keep this painting. I'm just gonna keep it," so I've got the painting.

Chuck: *Didn't you show this painting?*

Elizabeth: I did show the painting.

Chuck: *Oh, then I saw the painting.*

Elizabeth: Oh, so you did see the painting. What did you think? Because it's really about struggle.

Chuck: *But I didn't realize that it was about me.*

Elizabeth: Yeah, yeah.

Chuck: *I liked the painting.*

Elizabeth: It's folding over like a kind of tongue that's folding and then the glasses are up at the top and the hands are coming through with a paintbrush, but there's a web. There's sort of a web.

Chuck: *A grid?*

Elizabeth: A grid, which is really about your grid, and it's where I got the idea anyway, it was the inspiration. Your hands are coming through holding your brush. When I focused on what I thought the painting was about, it was really about your struggle to begin to paint again and having to hold the brush, because I was really amazed by that. It made me realize that when you have to work, you work, somehow or other. I was fantasizing about when I came to your studio and you showed me how you were working, how you were strapping on the brushes, that if I had to use my feet, I'd use my feet probably, that you figure it out. I think that changed something for me, it focused me on my work again—like this is my job, this is his job, so here he is. The painting is really about that, but I got a little nervous when I showed it to Douglas. He wasn't scared, but you know Douglas. It hit him, and he was honest about how he was hit by it, so I thought, "Well, maybe this would upset Chuck too."

Chuck: *Actually, I love that painting. It's a terrific painting. It's interesting how our generation has influenced each other. You know, my pieces have always been made incrementally. Joe Zucker was building pieces out of cotton balls, and Jennifer [Bartlett] got started doing dot things around the same time I was doing fingerprints.*

Elizabeth: Yeah.

Chuck: *I see a real connection with my work and what has been traditionally called women's work, knitting or crocheting. If you give yourself over to a process and just keep doing the same thing long*

enough, eventually you get done. If you knit and purl long enough, you get a sweater, and if I do what I do long enough, eventually I have a painting. A lot of these things I think, but certainly Joe is someone who had a tremendous influence on me with the whole idea of building a painting on one surface.

Elizabeth: **Yeah.**

Chuck: Our whole generation, I think, really took from each other in not very obvious ways, but in attitudinal ways and—

Elizabeth: **I know, without realizing we were taking all the time.**

Chuck: Yeah.

• • • •

Elizabeth: **I was going to say that there is an analytic thing in your work that resembles weaving. Your work is like a slow weaving.**

Chuck: Uh huh.

Elizabeth: **The layering of these things builds up and builds up, so that when you combine that analysis with the physicality of it, the thing starts to happen. It's like when you're watching a Polaroid, and you keep looking at it and looking at it, and then it starts to get real and you start to recognize it, but even if you stand there and look at it the whole time, you still miss the second or the split second when, all of a sudden, you recognize who it is.**

Chuck: Um hum.

Elizabeth: **And that's exactly what happens. I mean, there's still an element of magic when one looks at your work.**

Chuck: Absolutely. I love that about art. Everything is getting more and more coarse in my work. You can't define things quite as easily. Some people can't even tell the sex of some of the people I'm painting. A big aspect of your work is the physicality as well. I think our whole generation is somehow really in love with physicality, with pushing paint around.

Elizabeth: **With process, with how it got made, in one way or another. How we made it will always be a part of it. In some ways, I think there's a big difference between your earlier and later work. Still, you see there's a face, and then you sort of go into it, or I go into it and lose the face and get completely involved. Whether it's an earlier one or a more recent one, I always do the same thing. Even if I'm looking at some of the earlier tonal ones in black and white and greys. I'm looking at Phil Glass's—is that the one that the Whitney has?**

Chuck: Yeah, it's Phil.

Elizabeth: **It's Phil. The face is there, then it disappears, and then you slowly watch it become the thing, and then you say, "Oh, I know him," and there's the young Phil. God, he was good looking. You go into so many different aspects of the face. It is like looking at a photograph, and then it isn't like looking at a photograph because it's a big painting, and if I get up close to it, it disappears into these dots and it has a depth.**

Chuck: Well, there's that.

Elizabeth: **It's got a dimension that is thought, as well as physicality; it's thought, as well as analysis; there's a kind of slow caring and building of something that makes it a complete thing.**

You know, it makes it into life. It has a heart, it has its gut, it has its genitals, it has the whole thing, and you do see it in a particular way. I think there is a different way that you look at my work, somehow. I could be wrong about that, but your work, I think, has a softness in the beginning, and my work, I think, is aggressive in the beginning, especially the shaped ones, because there you are, you have to deal with the shape.

Chuck: *In your face.*

Elizabeth: Yeah, right, it's much more in your face right away, which can be off-putting, like "take it or leave it."

Chuck: *To return to the imagery, the domestic imagery or whatever it was, was there anything political in that decision or was it just—*

Elizabeth: No. It really shocked me a lot when people started to talk about it as being domestic because it just felt like subject matter or something. I mean, I know I've said this before, but artists have always liked painted chairs and tables and plates and cups. It's nothing new.

Chuck: *Yeah. I wonder if you were a man whether they would even have used the word?*

Elizabeth: I don't think so. I don't think that's bad necessarily, but I think whatever anybody does, whether they are male or female, the first people who try to talk about it, beyond artists, are critics or art historians, and their minds just have to find a label for it.

Bill: *Context.*

Elizabeth: A commentary.

Bill: *They have to compare it to something; they can't deal with original work.*

Elizabeth: It's too scary.

Chuck: *Well, the first thing that's always said about any tendency, if they can find two or three people to whom they can relate it, is about the common denominators, which are probably the least interesting aspects of a work.*

Elizabeth: Right.

Chuck: *It takes years before they get to what's individual about someone's work.*

◆

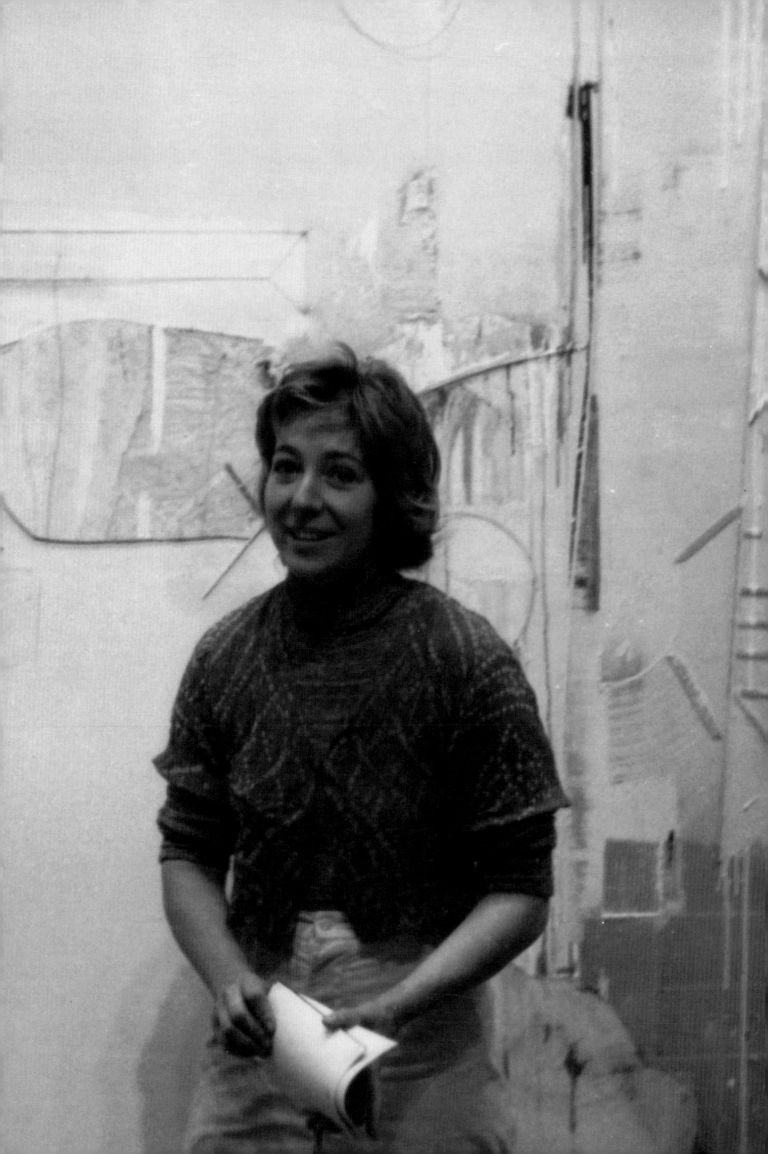

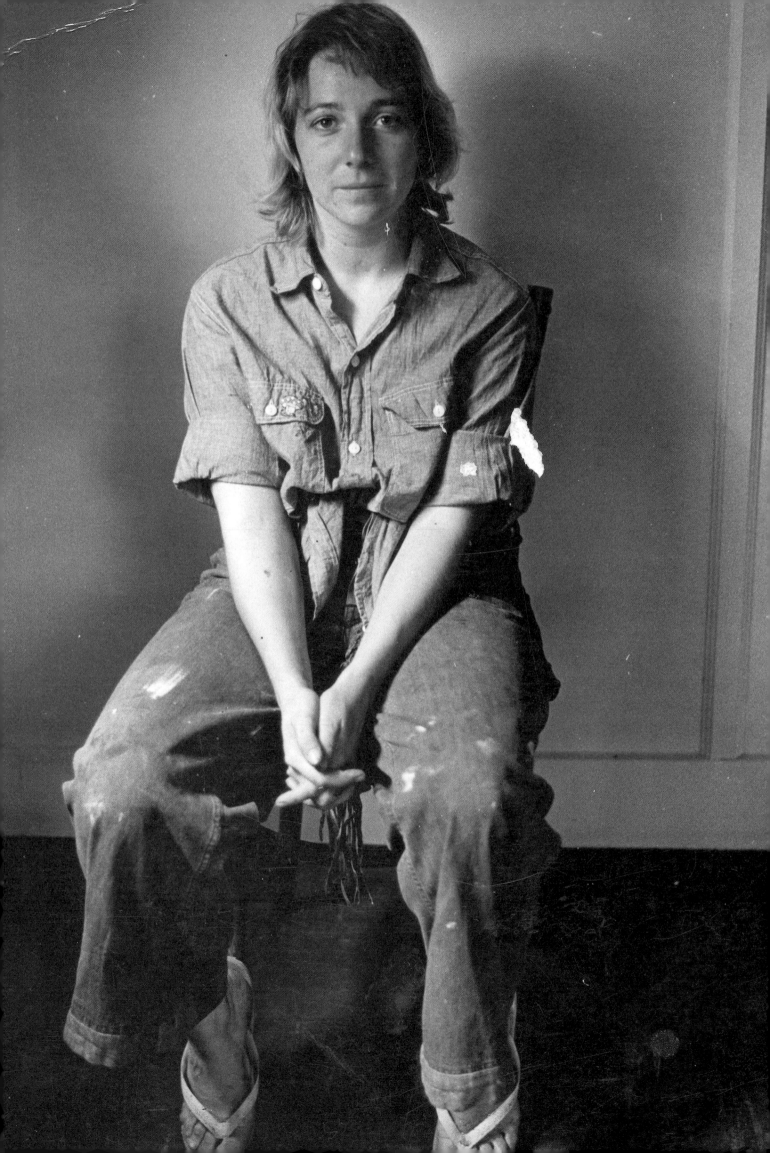

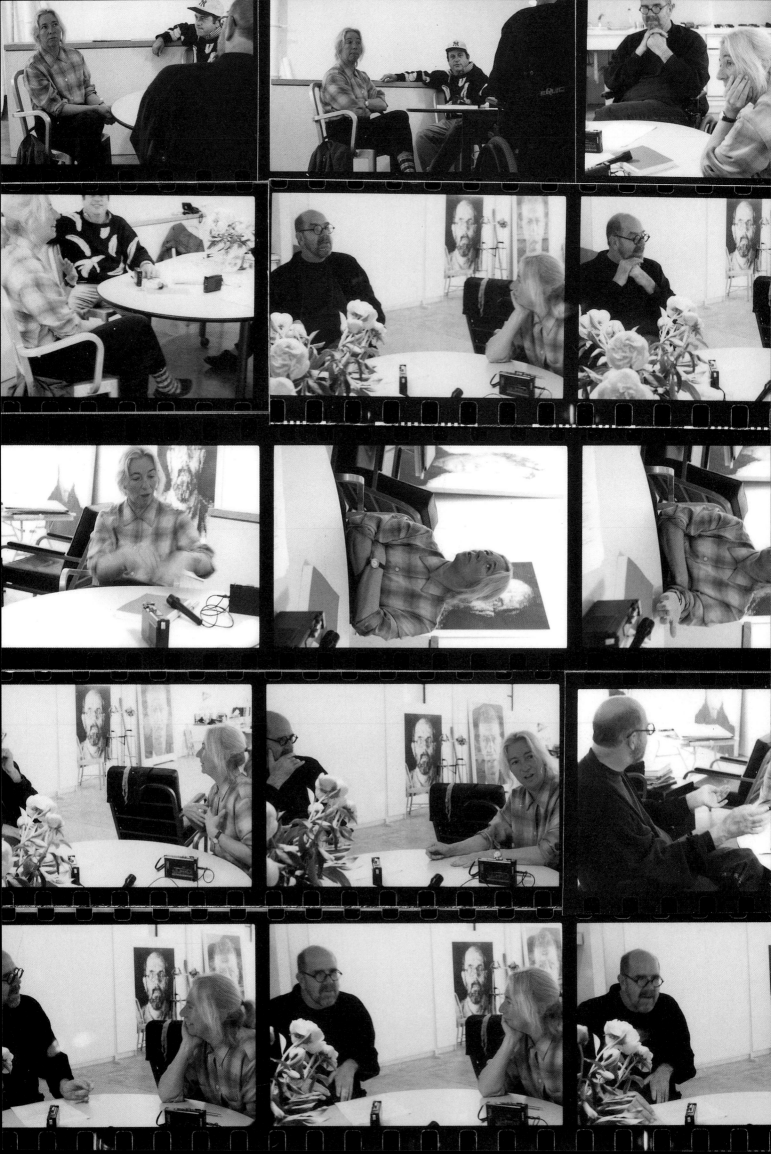

Judy Pfaff

preceding pages:

N.Y.C.B.C.E, mixed media installation, Whitney Biennial, 1984. Photo courtesy Holly Solomon Gallery, New York

At Yale, 1973.

Wall piece, (detail), 1975.

La Ciudad De Los Angeles, (detail) 1976, aluminum foil, aluminum, steel wool, Styrofoam, paint etc. Photo courtesy Anderson Gallery VCU, Richmond, Virginia

cirque, CIRQUE, 1995, steel, aluminum, stainless steel cable, urethane, glass and lacquer paints. 250 × 210 × 40 feet (variable). Commission by the Pennsylvania Convention Center Authority.

Seated left to right: Judy Pfaff, Karen McCready, Hisako Toda, Hidekatsu Takada and Al Held, Kyoto, Japan. Print project for Crown Point Press, 1983.

MOXIBUSTION, (detail) 1994, glass, fiberglass, tar, steel, plant material. In *The Garden of Sculptural Delights,* EXIT ART, March 12–April 22, 1994.

At Yale Summer School, 1971. Photo: Millie Wilson.

Ziggurat, 1981, Installation, West Kunst, Cologne, West Germany.

In Chuck's studio, May 1995. Photos: Leslie Ernst.

New York City, May 8, 1995

Chuck Close: Anyhow, Miss Pfaff.

Judy Pfaff: Holly [Solomon] used to call me Judith Pfaff when I had to meet someone important. "This is Judith Pfaff," she would say.

Bill Bartman: Are you from England?

Judy: It was so long ago that I think I should stop saying that.

Bill: No, no, no. It's just that when you leave a message on the phone answering machine, the English accent comes out, and I'd never heard it in your voice before.

Judy: It's nervousness. I think it just comes out. I revert back to my childhood. *[laughter]* "I didn't do it, I didn't do it."

Bill: I never thought, whenever I met you, that you were from England.

Judy: When I feel comfortable, I sound like I'm from Brooklyn.

Chuck: When did you come here?

Judy: When I was twelve.

Chuck: Were you born in London?

Judy: London, yeah. I was cockney.

Bill: Really?

Judy: It gives me some reverse class.

Bill: We'll do part of the interview in cockney. Of course, these are not really interviews. They're discussions, as you can tell.

Chuck: I'm trying to figure out how long we've known each other. Was it 1970 or '71 when we met?

Judy: I think it was '71. I tried to find that catalog. We were in a little catalog for a faculty show at Yale/Norfolk.

Chuck: You did something that most of those in our generation couldn't do. It would be interesting to know how you did it. When my class graduated from Yale, none of us could have gone to New York and shown our work, but you showed almost instantly after getting out, or maybe even while you were still in graduate school.

Judy: It wasn't while I was still in graduate school. My first New York show was at the Razor Gallery. Do you remember Jack Lembeck?

Chuck: Yeah. I see Jack all the time.

Judy: He was a member of the Razor Gallery.

Chuck: *It was a cooperative gallery.*

Judy: Right. It was a very interesting space. Anyway, Jack had this show. He'd just come to New York, and he didn't need the back-room space at the Razor Gallery. He didn't want to deal with it, so he asked me to do an installation there. Through that show I met so many artists: I met Elizabeth Murray, Joel [Shapiro], Ron Gorchov, Jane Rosen, and Gordon Matta-Clark. The art world was really small then. It felt as if it was made up of about ten people. It was really small, and we all sort of knew each other. There was a restaurant named Food on Wooster Street.

Chuck: *There isn't a place like Food anymore. It was the working man's—working person's—lunch place, if the industry in which you worked happened to be art. There was a different sense of social-ization when you came to New York then, compared to what people are finding when they come now.*

Judy: When I think about it now, I realize that it was so incredibly tiny. I also worked for Jed Bark. I drove into the city and found a job on the first day. I had my truck, and I was dri-ving the streets trying to find a job.

Chuck: *Was that the truck with the house painted on the back of—*

Judy: I had cut off the back of a station wagon and replaced it with a house-like tent. It was a great look.

Chuck: *Your dog lived in the house.*

Judy: He lived in the house. When I was at work, he could go in and out. Dennis Kardon was working for Jed. He had a place on West Broadway, and he was moving beneath the Paula Cooper Gallery. I had the truck and these objects were coming down, so we just put them in my truck and drove them around, and I got a job. It happened really fast.

Chuck: *The reason that I mentioned that you came to New York and showed your work very quick-ly is because you were, in a sense, fully formed as an artist when you were a graduate student, which is unusual. You had your own odd and eccentric vision that distinguished you from a lot of other peo-ple who I knew at Yale at the time. Maybe you were confused, but you didn't seem as confused as some of the people.*

Judy: Well, Yale was really divided then, and probably still is, into the sculptors who were extremely conceptual—meaning people were jumping off of balconies and noting what spot they'd made—and the painters, who were all about process.

Chuck: *But pretty conservative.*

Judy: But very conservative. And I stopped painting after the first few months or so that I got there.

Chuck: *That's always been true at Yale. The faculty says, "Well, we need figurative artists."*

Judy: Choices were made—to be fair—and then you were on your own.

Chuck: *So they bring in all these figurative artists, and the minute they get in the door they stop painting. They never paint a figure again for the rest of their lives. It drives the faculty crazy.*

Judy: A lot of people who got beaten by the school, as far as I could see, were very talent-ed. They were from Iowa or Oregon; they were chosen for their differences. The only conver-sation was about the New York art world. I was interested in that world. Coming East—I was

from the Mid-west—suited me.

Chuck: Was Martin Puryear there after you? [Martin Puryear (b. 1941) was a student at Yale in the late 1960s. His sculpture explores issues of duality. While a student at Yale, his proximity to New York and exposure to the minimalist sculptors, such as Donald Judd, Carl Andre, Dan Flavin, and Robert Morris, influenced his earlier works, such as *Hemlock* and *Oak Coast* and *Oak Wood Pile*.]

Judy: He was before.

Chuck: Before you? He was there when the place was bombed, right?

Judy: He was there during the whole Black Panther thing in the late sixties—'68, '69.

Chuck: Well, the funny thing about that Bobby Seale period is that, according to Dennis Kardon, one year the entire class was passed without ever having gone to school. No one went to class. At the end of the year, they just pushed everybody out.

Bill: No one went to class for the whole senior year.

Chuck: They bombed and they burned, which is pretty hard to do with concrete buildings. They burned the art school, and they picketed some stuff. It was all about the Black Panthers and the trial of Bobby Seale, and there was Martin Puryear, the only black student in the art school. He said, "Look, I came here to work. I want to get to work," and all the white upper class liberal kids were out in front with the signs. He just wanted to get in and get to work. It was a funny time. [On Mayday weekend 1970, a political demonstration was initiated by the Panther Defense Committee to protest the trial of seven black youths arrested for the torture and murder of Alex Rackley, a member of the New Haven Black Panther Party. Also protested was the arrest of the party's chairman, Bobby Seale, who was accused of ordering the murder. The demonstration's white radical leader, Thomas Dostou, threatened that "before we see the Panthers crucified, we will unleash something this country can't stand, a race war."]

Judy: A funny time. Yeah.

• • • •

Chuck: I remember that I had to write something about you very early on.

Judy: You said I was like Pig Pen.

Chuck: That's right.

Judy: You think I don't remember those things.

Chuck: I wondered if you remembered that. I was just thinking about it the other day.

Judy: You know what? Someone sort of called me that the other day. *[laughter]*

Chuck: Oh yeah?

Judy: Things are in motion around me. I gather stuff.

Chuck: It's the stuff around you. You're just constantly in a kind of—

Judy: A cloud.

Chuck: —a tornado of dust and—

Judy: —debris and stuff.

Chuck: There was glitter, and junk, and stuff.

Judy: I came to Yale with two hundred pounds of precision-cut glitter.

Chuck: Really?

Judy: It was before those guys made glitter famous. You know who we're talking about?

Chuck: Yes, I know. [laughter]

Judy: I had iris flakes, diamond-cut flakes.

Chuck: Every time you went to the etching press after Judy had used it, there was a crust of glitter.

Judy: I remember being so neat.

Chuck: Someone would be trying to run their print through the press, and they would pick up all this extra glitter and stuff that had fallen off your print. I guess we weren't used to people putting stuff together. There was always traditional collage and all that stuff, but you were really odd, in a very interesting way.

Judy: Yeah. Our studios were right next door to each other, and that's how we met.

Chuck: You had wonderful stuff all over the floor. You couldn't get anywhere.

Judy: You couldn't get anywhere. But I was trying to categorize and find something in these piles. I think, Chuck, that like everything else, one's method probably comes from something in one's childhood. After the war London was just filled with debris. I mean, there was debris everywhere. I went back finally; I don't know when. Holly Solomon took me to London for an art fair. It was the first time I'd ever been back, so it was probably in the mid-eighties, maybe even later. She asked, "How does it feel?" and I thought, "It's unrecognizable." It was just rubble when I was there as a child. Because of my childhood experience, my method was sort of like finding this half here and that half there: it wasn't developed. It was, you know, piles of stuff that once had form and meaning.

Chuck: Do you remember the—

Bill: **Bombings?** [Beginning in August 1940, England's refusal to surrender to Hitler prompted the "Battle of Britain." Goering assured Hitler that his Luftwaffe could destroy the British Royal Air Force (RAF) and began massive bombings of cities, industrial centers, and ports.]

Chuck: The bombings and stuff?

Judy: I was born right after them, but I remember London was really destroyed, especially where I was. My grandmother, brother, and I lived in government housing. My grandmother was a sergeant major in the Royal Women's Air Force, and she made blimps. She told me that she single-handedly saved London. *[laughter]* [In 1941, Winston Churchill initiated the Auxiliary Territorial Service (ATS), a women's auxiliary of the army, comprised of well-trained women between the ages of eighteen and thirty. The Women's Auxiliary Air Force (WAAF) and Air Transport Auxiliary (ATA) were subdivisions of ATS, specifically created for pilot duties such as transporting aircraft to and from the continent.] And if you met my grandmother, you'd think she did! She was a seamstress before the war, and she used to sew with crews of women. Large silver-painted gas-filled blimps floated over London. They were silver, so in the sun they would disappear. Invading planes would explode overhead.

Chuck: Is there a long line of women in your family who gave you the sense that powerful, strong women could accomplish things; that they could do things?

Judy: I know so little of my family. My grandmother is the only woman I knew, because my mother was in America when I was raised. My mother is very smart and sort of curious, but having given birth to my brother during the war and me after, I imagine she was frightened about life in England. My grandmother was independent and strong; she was someone I could identify with. My mother says I'm just like her mother.

Bill: You should compare notes with Vija Celmins some day.

Chuck: Vija's war stories are unbelievable.

Bill: Unbelievable. She was there when they bombed the hell out of Latvia. She carried around photographs that she never painted. She couldn't paint them, they were too close, too personal. But do you remember when she showed us all those little pictures—piles of rubble with kids playing in them.

She ended up painting the ones with airplanes that dropped the bombs—that's where all those air-planes came from.

Judy: The impressions are very strong. I think it's just coming out that there are artists whose mothers were young women during the war but who didn't tell the war stories. Now the children are telling the war stories. Vivian Corland: she makes paintings of children in refugee camps and stuff, which is not her experience, but her mother's experience. I remember doing a piece in Italy. We were at the Venice Biennial, on the Guidecca, in a bombed-out building. The materials for my piece hadn't arrived. They were lost on a boat—it was one of those wonderful Italian stories. I remember sitting in this place and having vivid memories of the war, which weren't mine, about bombs, and screeching, and the sounds. Maybe I had subsequently heard a lot of broadcasts over the radio, but I think they were mostly from my grandmother. They were so vivid, and something about this empty, dark space was sort of amazing, so I made a piece about the war. The piece, *Either War,* operated over your head: tubes and futuristic cones were suspended. I thought it had an accuracy of an experience imagined.

Chuck: Well, most of us don't actually remember our childhoods. The only things we remember from our childhoods are stories that people told. So, in a way, if something happened before you were born that is constantly being referenced while you are growing up, it almost becomes your own experience.

Judy: Your own, yeah. Those images are very, very strong.

Chuck: So you came here when you were how old?

Judy: I was twelve. We moved to Detroit.

Chuck: Boy, talk about culture shock!

Judy: Also, I was the only white student in my school in Detroit. You know the way schools were: certain neighborhoods went to certain schools. The school in my neighborhood was entirely black. I had come from an area in London that was all cockney. My idea of America was one of wealth and space. Detroit wasn't in this picture, so I went into a kind of shock in Detroit. Also, because I was sort of self-taught in a funny way, I didn't talk a lot. Now I'm like "Ask me anything, I'll tell you," but I didn't talk then, and at the time, I had real blonde hair that was uncombed and sort of matted.

Chuck: As opposed to blonde hair out of a bottle.

Judy: Out of the bottle that I've had for thirty years. I'm getting worse at dying it too. *[laughter]* I really stuck out like a sore thumb, but I'm a real scrapper.

Chuck: Well you know, you seem black to me. [laughter]

Judy: I think so. You know, I kind of got adopted because they thought I was a stray, and I wasn't like a white girl. You know, I was sort of like this "other thing."

Chuck: There's always been kind of a street kid quality to you.

Judy: Yeah, if anyone messes with me, it comes out really fast. It's like "boom, boom, boom!"

• • • •

Guest: I remember, Judy, that one time—I don't know if you remember this conversation—I asked you, when I was at SVA [School of Visual Arts], how you got to the work you were doing, and you mentioned that you were doing some sort of science experiments at Yale.

Judy: Oh yeah, yeah.

Guest: *I thought it was really interesting that your work looked so spontaneous and yet you were using a scientific method. There was this really structured order underneath this apparent disorder. I was really curious.*

Judy: What happened was that I got these little books from *Scientific American* or maybe not *Scientific American*. Some of them were from *Scientific American*. They were mostly children's books on science, like "Seventy-five Science Experiments from the Cupboard," about experiments with household things. You could get a glass of water, put a little something in it, and it would go up in smoke or the needle would shake or something like that. They were household experiments that you could understand through the world. Since I thought that I understood very little, I got these books. Actually, I thought I had to get them. Meanwhile, the apparatus became interesting. Also, at the time, there were a lot of people in New York doing really wonderful things: Alan Saret, and Lynda Benglis, and Joel, the early Joel Shapiro.

Bill: *The early Joel Shapiro.*

Judy: He had a show of handmade clay balls, evidence of an activity, very simple, very innocent. I was apprehensive of the big idea. I wanted to start at the most essential place—the bottom. So I did these experiments. It seemed like a logical thing to do. Also I thought all those people knew something—I still do—that I don't know, because I'm so pragmatic. I was probably interested in botany when you knew me.

Chuck: *You went through Wayne State and then to Southern Illinois. During that period of your life you were a Mid-westerner from England.*

Judy: I was also married. You know, I got married when I was about sixteen.

Chuck: *Oh, really?*

Judy: And then I was living in Newfoundland, and then Sweetwater, Texas, and then Sweden. I had sort of done everything by the time I was twenty-one.

Chuck: *Detroit, besides having produced Bob Israel and some other friends of mine, is also where Mike Kelley went to school. I was talking to Mike Kelley, and I was shocked to find that his heroes were the heroes of every Mid-west art student: the Burchfields, and people like that, the kind of Mid-west minor-master-types that we on the East and West Coasts never—*

Judy: —heard about or cared about.

Chuck: *I was wondering, because it seems so removed from anything you do now, whether that stuff had any kind of influence on you at all, whether you liked it, or whether you just wanted to get the hell out of Detroit. I just wanted to get the hell out of Seattle.* [Charles Burchfield (1893–1967) was an American realist painter who sought to express in his work the truth of Mid-western life during the twenties, thirties, and forties. He aimed for a truly indigenous American art.]

Judy: I wanted to get out.

Chuck: *There was nothing there that I wanted. I just wanted to get out of there.*

Judy: Mike probably wasn't in Detroit proper. I think he was a little bit outside of Detroit. I was in Detroit. We're talking downtown Detroit, not Cranbrook. I only visited Cranbrook about ten years later.

Chuck: *Another place you couldn't get into.*

Judy: Cranbrook was another world. Detroit in the early sixties was very intense. There were fantastic poets, musicians, artists; they were radical and rough. I watched and hung out.

Chuck: Right. I was going to ask about music.

Judy: You know, I just saw a movie last night called *Once Were Warriors*. Have you seen that? It's about these New Zealand Maoris. All of a sudden I thought, "The only time I've experienced being frightened by a kind of energy—and it was not middle class energy, it was the kind of energy from the street—was in Detroit at that time." We're talking about '64–'68.

Chuck: That was such a great time for music in that town.

Judy: Fantastic. I mean, Motown. Everyone I knew was either in back-up bands or were hanging-out poets. It was wild shit. [Motown Record Company, founded in 1959 by Berry and Bertha Gordy, was based in Detroit and became one of the largest black-owned entertainment businesses. All of the great "girl groups" were first recorded on the Motown label.]

Chuck: Lots of small labels were recording. Otis Redding. Everybody was there.

Judy: It gave an identity to Detroit. Now you just think of the riots. It's this dead place. I think it had a real energy.

Chuck: Hydroplanes. It had hydroplane races.

Judy: Is that true?

Chuck: In the middle of the river, there are these boats going around. It's sort of the sport of the town. A strange town.

Judy: But it was very creative. Anyway, I wasn't influenced by people like Burchfield. No. There was so much going on there with contemporaries—probably they were a little older than I was. They certainly were hip. They were so hip.

Chuck: You were always hip. Well, you hung around with black people.

Judy: Yeah. *[laugher]* You know, you do get feelings for things. I was welcomed into that community for whatever reason, so I always felt very comfortable, except that I was the captain of the girl's basketball team, and I was the shortest and least talented. But I liked it so much, I made the outfits, and I captained.

Chuck: In another school you would have been a cheerleader.

Judy: I would have been a cheerleader.

Chuck: But in this school you were the captain.

Judy: Yeah, in this school I was the captain of the team. Yeah, exactly.

Chuck: Joe Zucker played basketball in Chicago, in the worst area of Chicago. He was the only white kid in the high school, and he was captain of the basketball team. When they played for the school championship, they played an all-white Catholic school for the state championship, and it looked like Joe had on the wrong uniform. He was playing on an all-black team as well. But I do think that it—

Bill: It's like the NBA today.

Chuck: Yeah.

Judy: Yeah. *[laughter]*

Chuck: I think it clearly gave his work a funkier quality, and I think it also has to yours.

••••

Judy: I probably don't have a lot of respect for authority. I don't do well when someone says, "You must," or "You should," or "You gotta—." There's something in me that just says "Fuck you." Al Held, with whom I was very close, was my teacher at Yale. He knew how to ask very tough questions and test the answer. Both of us are combative and love a good fight. [Held, b. 1928, was an professor of Art at Yale University from 1962 to 1980. His more celebrated minimalist paintings, from the fifties to the seventies, essentially dealt with the analysis of space and line. He is often defined as a hard-edged geometric expressionist.]

Chuck: *You went to Japan together.*

Judy: Yeah, we did go to Japan together. We didn't talk to each other for a year after that.

Chuck: *I can just imagine. He's such a bull in a china shop. I can see him in the middle of all these—*

Judy: Well, what happened is that we discovered where our paths split. We both like complexity, we both have strong opinions, we kind of argue things. For example, he would say, "This is a culture of sticks and paper, and Rome is a culture of marble." I would think, "I like sticks and paper." He would say, "It's a language of the ensemble. It's not about this object, it's about this object, with this flower, and these leaves on top." He wanted it to be only about the object. I would say, "Of course it's not about only the object, it's the thing within its world." We just locked horns on a daily, weekly, hourly basis.

Chuck: *I think Katherine Brown told me that you guys went to the Moss Garden. Did you go to the Moss Garden?*

Judy: *[laughter]* Where you have to do that ink thing? *[laughter]* You have to see this. You've got to do this ink drawing.

Chuck: *The place is run by these Zen—no, not Zen, but some kind of monks.*

Bill: *In Kyoto?*

Judy: Yeah, in Kyoto. With the monks.

Chuck: *You have to sit on the floor with your little sumi ink thing and your brush, and you have to write calligraphy. You have to do a whole page of it, and it takes a long, long time.*

Judy: It does take a long time.

Chuck: *When you finally get done with it, and you give it to a monk, he burns it. I heard that Al—*

Judy: Al wouldn't do it.

Chuck: *Yeah, he wouldn't do it. I'll tell you a funny story about someone else, but first tell me what happened. [laughter]*

Judy: I was very excited because I thought—was it Laurence Olivier who said, "If you get the outfit on, you'll do the character a little better"?—I figured, "We'll do this and something will happen. We'll become calmer, nicer people." So Al was sitting next to me with this sheet that has a kind of bottom sheet, with an overlay on top for guiding. You just copy.

Chuck: *You can trace it.*

Judy: Basically, you can trace it. They give you the ink and—

Chuck: *I tried really hard.*

Judy: It was hard.

Chuck: *But I tried to do it. I took it very seriously.*

Judy: Oh, I tried. I wanted them to think I was very good. Al was looking out the window, singing songs, sort of waiting, as if he was thinking, "Hurry up Judy." He wouldn't participate. He didn't think it was interesting. Did you hear that other things happened?

Chuck: *No, no. I only heard that he was not cooperative. But the best story was about when Helen Frankenthaler went there. Did you hear about that?*

Judy: No, but I heard so many stories generated by her.

Chuck: *Frankenthaler went there, and when she handed the monk her completed drawing, she was shocked that he burned it, and she said, "Do you know how much my drawings are worth?"* [laughter]

Judy: Can you imagine? She's a genius. But you tried—

Chuck: *Oh, I tried very hard.*

Judy: But could you do it?

Chuck: *I thought it looked pretty good. I was happy with it.*

Judy: Actually I was quite pleased with mine too. What was funny was that you could tell where you really concentrated or where your mind had drifted.

Bill: *Wandered off.*

Judy: Wandered off and came back.

Bill: *Did you know up front that they were going to burn the drawings?*

Judy: No, no, I didn't know. I was terrified, actually, because I thought, "What kind of test are they going to give us?"

Chuck: *Who were your art world heroes and heroines? Who do you think kicked open doors or made things possible?*

Judy: Marcia Tucker put me in a Whitney Biennial. She had curated a retrospective of Al Held's work, so he told her about me. He also nominated me for Artists Space. In terms of heroes and heroines, I liked Jean Tinguely and Calder and, oh gosh, Claes Oldenburg, especially his store days. Also, when I first came to New York, I really liked all the theater people like Patricia Brown and Yvonne Rainer, Robert Wilson and Richard Foreman.

• • • •

Judy: When I was a student at Norfolk, do you know who came up there? He used to show at Paula Cooper and made stuff with resin, and he was married to Batya Zamir.

Chuck: *Richard Van Buren.*

Judy: Richard Van Buren. Eva Hesse had just died a few months before the summer—maybe the summer of '69–'70. He was very distraught by her death. I didn't know who she was, and he was determined to educate me. I think that he thought I was a good candidate to know about her and all of her activities. He talked about a whole generation of artists and ideas that were new to me. He thought that I would be sympathetic, although, at the time, I was making paintings.

Chuck: *Were they real paintings?*

Judy: They were real paintings.

Chuck: *The first work I saw of yours was after you had already stopped making paintings.*

Judy: Yeah, exactly. Van Buren gave me a list of people to see so that I could learn what was going on. Eva Hesse was very important to him.

Chuck: Talk about the art world being small. There was no way not to deal with Eva, no matter what kind of work you were making, because she was—

Judy: **Gregarious.** [Eva Hesse (1936–1970) considered herself an individual, not belonging to any movement. She received instant recognition when her work was shown in Lucy Lippard's 1966 *Eccentric Abstraction* exhibition. While her work may have appeared minimal because of its repetitive use of structure, her use of variation enabled her to express the importance of the object, the viewer, and the fabricator. Some of these ideas stemmed from her time in Germany and the influence of Joseph Beuys. She claimed these factors were the "additive process" of sculpture that could not be experienced in painting. Her signature materials, fiber glass and latex, were combined to contrast the materials' individual properties of deterioration vs. permanence.]

Chuck: Also, she operated in a very funny position in the art world, which actually was typical of the times. If you look at the Yale catalog from the Eva Hesse show—it has wonderful excerpts of her letters and diaries and stuff—you realize that in the art world, at that time, all sorts of different kinds of artists were friends. You were not confined to one segment of the art world. You had friends who made very different work from yours. That's really the model, I think, for my view of the art world. You pick and choose from everything that's out there, and you're not an apologist for one stylistic point of view or one attitude. Eva had a tremendous influence on the way people, who made work nothing like hers, thought. She was really terrific. What a loss. So, is there anyone else, in terms of installations or in terms of getting away from the object status of works, who influenced you?

Judy: I think the show that was just at the Whitney recapitulates the process stuff. I thought Barry Le Va was really significant.

Chuck: His distribution pieces were wonderful.

Judy: All that stuff that [Robert] Smithson set up: it wasn't about his objects, but about a way of thinking about things.

Chuck: Well, he brought all that stuff out of the field and into the studio—dislocation.

• • • •

Chuck: It seems to me that you bring the art world back into your personal life. I remember tennis shoes that you painted that were really wonderful objects. I remember the way you dressed. It was as if every aspect of your life, including the kind of—

Judy: You know, when I was a kid I got kicked out of a lot of schools. I was kicked out of one school in England because my grandmother and I made my clothes. I had to wear a uniform, but I would go to school dressed as an Indian, or as the wicked witch of the West, or as a clown. Then I had the idea that everything I wore had to be reversible. It looked one way on the outside, but its alter-ego was on the inside. I went through a couple of years during which everything I had was reversible. If it was silk on one side, it would be maybe leather or fur on the other side. I was always making things.

Chuck: I was recently talking to Lisa Yuskavage, and she said that when she was at Yale, clothing was such a problem for her that she went to a thrift shop and bought twenty wrap-around skirts. Then she didn't have to ever worry about clothing again. From then on, she just wrapped a skirt around her. After a while they were coated with paint and encrusted with junk. As children, so many artists got involved in dressing up, wearing costumes, puppetry—

Bill: Magic.

Chuck: —magic acts, or whatever, and then entertaining the troops became a thing that led right into making art. The idea of making art is that you're not only making it for yourself, but you're making it for other people. I think the plaintive cry of the little child, "Hey, look at me! I'm here. I'm somebody too. Pay attention to me!" is still operating for a lot of us, as artists, today—a desire to get attention in a healthy way. Kids also learn to act out and be delinquents to get attention, but I think that we found a positive route to take.

Judy: That actually sounds correct. You know, I have avoided thinking about where, how, or why I do what I do, but it's funny to me that I didn't really remember that I was doing that kind of thing so long ago.

Chuck: I always had every kind of costume; I was never in regular clothes during my entire childhood. I even had a monkey—

Judy: I've also figured out that every child thinks they're adopted.

Chuck: [laughter]

Judy: Even if you look identical to a parent, every artist is convinced they're an alien, they're from Mars, they come from this wild, sordid—you know. There's no artist I know who thinks they're from their mother's body.

• • • •

Chuck: I keep thinking that we ought to get up to date and talk about your current work, but then I wonder what people who look at your work now, minus that history, think of it.

Judy: It's changing. I think that initially it was seen as a kind of precursor to the East Village— young, colorful, and anarchistic—but I never thought of it in that way. I always thought it was more rigorous; the color was coded and structural. I thought it was very pitched and emotional, and I think I would often do kind of formal things to hold it together, because it seemed as if it would otherwise fall apart, or I would fall apart. Those are the things I recognize in the old installations, the things I would do to keep it all working, that kind of painterly training. I always thought my early work was very feverish, and strange, and a little nightmarish. I don't visit my installations. I don't like to sit around and look at them or think about them. I do them, and they're done. They are the end of an obsessive thought. Linda Nochlin wrote an article on my work called "The Persistence of Chaos." She spoke of chaos as having a gendered meaning. For the male artist, chaos had existed as sort of a battlefield; it was heroic. She wrote about the way these same words, when speaking of women's work, were "a hodge-podge of unelevated objects thrown helter-skelter, without defense, into a shapeless, feminine receptacle." The same word was now negative.

• • • •

Judy: I think there are differences in my work. As big as my work gets, it is ambient and operates in your peripheral vision. Frank Stella's big work, with which mine is compared, holds the center. It's very there. I do share his ambitions, his penchant for chance. The difference is that fleeting thought—the impulse—temporality, ambiguity, the forming of those concepts

gives me insight. I think people like Bob Kushner, Kim MacConnel, and Thomas Lanigan-Schmidt are really kind of amazing, formally. Also Joe Zucker. This kind of affiliation with pattern and decoration was seen as a woman's movement, even though the last five people I've mentioned are all men.

Chuck: All men, right. I guess I also have an association with what was called "women's work," to which I think my work has some relationship. Women would knit or crochet or do some activity over and over. Because they were women, they had to put their knitting down and make dinner or perform some other chore. They could always come back to the knitting, or quilting, or, whatever the hell they were doing, and pick it up again, exactly where they left off. That's one of things that has always appealed to me about a process, an activity that you just DO, and its something that women approach very differently from men. And again, it's against the odds.

Judy: Have you talked to other women about that?

Chuck: Yeah, it's come up several times in these conversations.

Bill: I think the way Chuck paints—why he grids his pieces—is so that he can continue working on them despite interruptions.

Chuck: Today I do what I did yesterday. Tomorrow I will do what I did today.

Judy: Yes.

Bill: The process of completing each square is similar to the process of knitting.

Judy: I am beginning to use that string image made on your hands, that child's game—

Chuck: Cat's cradle?

Judy: Cat's cradle. I remember when I went to the Louise Bourgeois show, I thought, "How interesting, Louise is the spider." Then I thought, "I make webs, but she sees herself as the powerful—even if it's a metaphor for her mother—spider." You know, she is incredibly powerful: "Don't mess with me."

• • • •

Guest: You were talking a little while ago about drawing, and I remember when I was at SVA from 1985 to '87, you were teaching there. At the time I was actually doing a series of toilet drawings, different kinds of swirly—all kinds of expressionistic stuff. I was studying with Craig Owens. I was over in one camp and there was another painting group that seemed to be pretty vacant in terms of their critique and their own investment in their work. You were there and really came through in an emotional and perceptive way. You were really involved, as I remember, and very astute about drawing, as if you were right in it, as if the drawing itself was very present for you. Anyway, you were really an important person in that landscape of instructors.

Judy: You know, not only have I been teaching for a very long time, but an extremely large part of my life has been teaching. I didn't ever teach only one day a week, but always at least two or three days a week, and now at Bard, I'm trying, with Bill Tucker, to form a new department. I feel like it has taken over my whole life.

Guest: It must have been exhausting, because you rode this emotional tidal wave with your students.

Judy: Well, it's interesting, and my nature is to get too involved with my students. As with

most things, the lines get blurred, and once I begin to talk about their work, I am simultaneously asking about their lives. SVA was the cleanest, easiest teaching because you really did just bop in and bop out. There were so many good artists and good teachers that I didn't worry about the students as much.

Chuck: Didn't you start at Visual Arts by substituting for my class?

Judy: Yes, yes.

Chuck: When I started to make a little bit of money, I didn't want to show up to teach. There were so many people who ended up teaching at the School of Visual Arts because they were substituting for me or for Richard Serra.

Judy: That was a long time ago. Teaching has become—I don't know if it's a big deal—but significant. Mike Kelley, Jim Shaw, Jill Giegerich, Jim Casebere, and Jim Iserman were at Cal Arts at the same time. They were the class Yale might have had if Yale had been on the West Coast. Mike Kelley was there when something was happening.

Bill: And now Mike teaches every year.

Judy: At Art Center College of Design [Pasadena, California]. Yeah.

Bill: He teaches one class there and has always taught one class there. He says he will always teach. It's something he wants to do. You know it's interesting, because the reason I mentioned the drawings is that I've become very interested in artists' drawings and sculptors' drawings.

Chuck: Sculptors' drawings are always very different from painters' drawings.

Bill: Well, they weren't intended to be seen by anyone.

Judy: I've been known as a painterly sculptor, but my sculpture is really sculpture, and although my drawings use one language to back up the other, they are what they are too.

Bill: Almost every sculptor I know who is not a painter has discovered that their drawings have a quality of their own.

Guest: Do you think that, in certain ways, you are looked upon as a female sculptor? That, in fact, someone might read your work as almost autobiographical instead of being about the work itself? "Is this about the object? Is this about—?"

Judy: I don't know if you've experienced this, Chuck, but if your work is written about early on—and perhaps you even fed the writers some of the language—for the rest of your life you carry that same critique. Maybe they would throw in a new word or two, but because I was so bad at interviews and would say, "Oh I don't know, I just did that," my work was always seen as kind of fun-filled and inventive. I did a piece in Germany, and I realized how the work was being treated and how I was being treated. I was reminded of Grimm's fairy tales and the Black Forest. I was uncomfortable there. The piece was extremely surreal, emotionally dark, and it showed. The response was that it was fun. I thought I was in the middle of a nightmare. Yesterday, I saw a little review of *Elephant*, a piece I recently did at Brandeis, which was probably the moodiest, strangest piece I've ever done, in which you felt as if you were going into the inside of an animal, an elephant. It was very viscous. It alludes to the story of the seven blind men touching the elephant, and depending on what they touched, they each "saw" something different. It was the first time—and it was because the writer hadn't done his homework but just experienced the

piece—a review has had some new language, a response that seemed accurate to the piece.

Chuck: You know, the best example of how we think about someone permeating their work and how it's seen from then on is the difference between Calder, who is seen as making happy, whimsical, light pieces, and Richard Serra: what happened when a Calder fell on somebody and killed them, and when people have been maimed by Richard Serra's work.

Judy: Did a Calder kill somebody?

Chuck: Yeah.

Bill: He *didn't do it.*

Chuck: No, no, the sculpture fell on someone.

Bill: The sculpture killed someone?

Chuck: Because Richard Serra's work is seen as aggressive, dangerous, confrontational, and scary looking, the minute someone is killed or maimed by a Serra, then Richard becomes a killer. But a happy piece of Calder's falls on someone, and not a word is said.

Guest: "An unfortunate accident."

Chuck: But if you're dead, you're dead. Does it matter to you that a happy piece of sculpture killed you? [laughter] But no one, absolutely no one, would say that Calder's is dangerous work, but Richard, of course, has been seen as being virtually equal to the guys in Oklahoma City or something. In fact, in both cases, the riggers simply didn't follow—

Judy: Didn't follow the directions.

Chuck: And attempted to take a piece down in a way that was unsafe. I think that the way the work has been discussed really does influence the way it's seen.

• • • •

Bill: The word "critic" comes from Greek, and it meant that there was an interaction between the artist and the art, but that doesn't exist anymore. The critic was a person who was able to look at an artist's work, look at a play, or look at anything that was new, and see it as if they were seeing it for the first time, and have a dialogue with the artist. None of that happens anymore, so I don't think they should be called critics anymore.

Chuck: Well, the other thing that I think has influenced the way your work is seen is the jerrybuilt quality to it.

Judy: Yes, oh yeah. That's funny, because in the eighties people would say, "And who is your fabricator?" [laughter] And I would think, "I'd better get one of those, because everybody has one."

Chuck: Well, the difference between you and Stella is that Stella's pieces are industrial strength. Right?

Judy: Yes.

Chuck: A thing that perhaps has been off-putting to some people and perhaps is also a difference between the way a woman builds something and the way a man would have it built by someone else is that yours is so much about weaving the stuff out of disparate materials, and dangling things or—

Judy: You know, that's funny Chuck, because when I've seen Stella shows, especially say the last one at the Modern, it has dawned on me that in a funny way, there's an image that the thing has, but when you look at the side or the back, it always falls apart. You can see that this plane

is just being held together at the most convenient point. Everything has dazzling complexity in the front, but the sides are straight-forward, because he wasn't making those decisions. They were being translated.

Chuck: "I want this to float there."

Judy: Exactly. "I need it here, so how do we get it there." I would go behind the piece and think, "I had more ways of engineering" or "I know other ways to get there from here," and it would have made the side have a much more—

Chuck: Yeah, you don't want to see one of those things from the side.

Judy: Never. They really kind of fall apart.

Chuck: All the magic is gone.

Judy: All the magic is gone. I actually decided from seeing the Stellas that you should never have that many brains interpreting your work. Besides, it's not an option.

Chuck: It's art by committee.

Judy: Exactly. It dawned on me that my engineering [how it gets into space] is very important. The sides and backs were taking all of my time. So my backs actually became my fronts, and if you took all the images off, then this transparent structural stuff remained. It was a lesson I got from seeing how different we were. In fact, on one level, our work sort of looked similar, until you really investigated how you got there, who made the decisions, and how the decisions were made. I've been getting more and more responses from structural engineers and students of architecture, who ask "How did you know how to cantilever that?" or "Doesn't that weigh about a hundred pounds? It looks as if it's out there quite easily." It's been interesting. I've actually taught myself a kind of back-door engineering and structuring. The pieces I'm building now are for a commission in Philadelphia that will be two hundred feet long.

Chuck: I wonder if there isn't a connection between you and your grandmother who was a seamstress. There's certainly a difference in the product of clothing designers who actually came to it through making clothes, who draped cloth and sewed it together, and people who design with a pencil and hand the design to someone else to figure out how to make it.

Judy: Make it.

Chuck: You know, there's something about a relationship with the material which also was very big in the late sixties, early seventies—

Judy: Very, very.

Chuck: —that had to do with the fact that you'd take the material into your room and wrestle with it.

Judy: For me, that "wrestling match" is what I thrive on. Studio work is considered, understood, there is time. The "show," the installation, is for me to see what, in real terms, I'm doing. I am as surprised as anyone when I am finished. I can see inside myself. The installations usually finish a desire or a need that I wasn't fully aware I had. I live a relatively normal life in the studio. The focus of the show, the "beat the clock" aspect, makes for the extraordinary.

Chuck: Well, if you were a novelist, would you hire someone to come in and write the next chapter even if you told them "Write it the way I've been writing it," and "This is the content of this chapter"? I can't imagine giving up putting each word—

Judy: Word together.

Chuck: *Word next to another word because that is, for me, where the pleasure lies, not just in the story being told, but in the placing of one word next to another. It's not a moral decision. I don't think those people are corrupt and that their work is bad or doomed. I think a lot of interesting work has been made doing things that way. I just can't imagine giving up the particular relationship, which interests me so much, of fashioning one thing out of another thing.*

Judy: Yeah, yeah. It's so necessary. I was going to tell you about this little experience when I was in Dallas building a big piece for GTE. We had been working in 110 degree heat because we didn't have air-conditioning. We had had it. The crew decided, as a diversion, to go to a rodeo and to the art museum in Fort Worth. There were paintings and things all around, and all of a sudden, I saw your painting, Chuck, and—

Chuck: *Of you.*

Judy: Yeah, it's me, it's me. I didn't know it was there. I'd forgotten. I'd completely forgotten, because it was done a couple of years earlier, and I thought, "I'm not sure, but I think that's me." *[laughter]* I was being sort of loud in this place, and my crew was laughing and getting hysterical, because I was saying, "I was younger then," and I was trying to act like the person in the painting. Then the sweetest thing happened. The guard came over and said that he would like me to stop making fun of this painting because it was a Chuck Close painting of an artist whose name was Judy Pfaff. "That painter's name is Judy," he said, and I said, "That's me, that's me," and he looked and said "Right, but please—."

Chuck: *Did you bring your driver's license?*

Judy: He knew everything about how the painting was made and who I was, and he was caring for this painting. I think it was because in this room of abstraction, it was the thing that not only had a person in it, but the person was also an artist, and there was a relationship, and it had a name and—

Chuck: *That's great.*

Judy: And so he knew, and was caring for your painting.

Bill: *Who was the guy who used to stand next to his painting?*

Chuck: *Oh, Bob Elsen, yeah. He used to go and pick up girls in front of the painting.*

Bill: *At the Met.*

Chuck: *At the Modern, yeah. He'd stand there in the same outfit he had on in the painting.*

Judy: In the same outfit. The funny thing was that when my photograph was being taken, I knew it was a Polaroid, and I knew it was going to be big. That camera is huge but it takes about one second. I was going through a divorce. I mean, you couldn't have gotten me at a more traumatic time. I was demolished. Chuck was so kind, and he kept saying, "Well, let's take another one. We can take another one." And I was thinking, "It's not going to go away, Chuck. It's in there, it's not going to go away." But when I saw the painting, I could not see the angst, and I felt very grateful. I think you were very kind.

Chuck: *Oh well, thank you.*

Judy: You did a nice thing, but there must be some decisions that you make on a formal line too, because I remember looking at those photographs and thinking—

Chuck: Well, no matter how unhappy you were at that moment, my memories of you are all very pleasant, so I probably made the painting reflect that.

Bill: You do that frequently. I mean, that painting of Lucas is really evil looking, but he is evil looking.

Judy: But he also would like that. He would like being a sorcerer.

• • • •

Chuck: We always talk about art. We knew each other a long time ago and then—

Judy: That's right. When I was on my way over here, I thought "I feel so guilty because I think of us as friends, yet I hardly ever see him."

Chuck: Yeah, I do too.

Judy: I'm the world's worst friend. When I'm there, I'm there, but when I'm not there, I'm no where. My life is really fragmented and broken apart. I have very good friends who I don't see except at an event. That is no way to see someone—at those parties.

Chuck: You know, one of the reasons why I painted people was to get to know them, and one of the nice things about doing this book is that it's really nice to see and talk to them again.

• • • •

Judy: There were very few female teachers. There was Miriam Shapiro. I went to California, and suddenly I was a woman artist. It was as if you had to have the right iconography to be a good woman artist.

Bill: Who was the head of CalArts, at that point, in the art department? A woman?

Judy: It was Huebler. Doug Huebler had started. There was a slide library, and I was always going to the slide library and pulling slides and trying to find—oh I don't know, it could have been anyone. I wouldn't be able to find it, and then someone would say, "Oh, that's in the Women Artists' slide library." I would have forgotten the artist was a woman. I get a little blurry about these things because I think I'm looking for the artist.

Chuck: Was Lynda Benglis out there then?

Judy: Yes, she was. She had just done the—

Chuck: The dildo piece.

Judy: She was living a kind of mythological lifestyle. I was living in Sylmar, where the remnants of the quake were.

Bill: The first quake.

Judy: Yeah, so this was not an attractive, high-gloss town. Lynda was on Venice Beach with a Porsche that was to die for. I was looking at her picture just the other day, and I thought, "At my best I never looked that good." She really took on the body culture, and in some way I think she was very understanding of what messages were out there.

Chuck: Today she's heavy but, I think, very comfortable.

Judy: Yeah, comfortable with herself. At the time, I think she was engaging in a kind of theater, and she was doing these pieces in which—I mean, talk about glitter—she made everyone look like what they were fearful of. She was living out this LA experience, and it was a pretty boy's town, it really was.

Chuck: *Pretty boys with actress girlfriends.*

Judy: It looked good. This is funny. Ellen Phelan came to LA. Ellen and I lived together for the last year I was at CalArts. She looked at the way I was living, and she just said, "Hello, we are not going to do this Judy." We found an apartment in the Hollywood Hills or on Sunset Boulevard. We were in LA, and Ellen said, "In this apartment we will live like Japanese." What that basically meant was that we had no furniture, but we had style. Ellen has significant style.

Chuck: *You didn't have to buy a couch.*

Judy: She found a way to make it totally classy. We had a futon and these tufted quilts, two bedrooms that were beautiful, one flower in each room, and Ellen was playing the violin. The music stand was the only furniture in the living room. Ellen used to practice, and she would read Emily Post. She got her hair done at Jon Peters. It was very sparse, but a very different life for me. I love Ellen.

Chuck: *Aesthetic bourgeois.*

Judy: Aesthetic bourgeois. I was trying to scrape by and work, and she was saying, "Live a little." I mean, I actually did this. So anyway, that was that. It's true that the women's movement was very, very stringent and very difficult for me as a woman.

Chuck: *It was a very difficult time when the first women's movement, in the sixties or early seventies, hit the New York art world.*

Judy: It was big, wasn't it?

Chuck: *Everyone thought of themselves as liberals.*

Judy: Open.

Chuck: *To say the least. If not, the men would be painted as—*

Bill: *Male chauvinist pigs.*

Chuck: *Yeah, to be the enemy was very difficult. In my building, every single couple except Leslie and I broke up during that period. I ended up being the male mascot in an all-female building. Of course, the equality ended in the basement, where the rats were.*

Judy: Where the rats were?

Chuck: *I still had to take care of the furnace and do that type of work, but it really was a very interesting time. I think ultimately, strangely enough, the real winners were men, because we got softened up, and we got in touch with—*

Bill: *—our feminine sides.*

Chuck: *Especially those of us who were WASPy, repressed and, you know, never cried. Now I cry at a Coke commercial, I tear up at a moment's notice. For women who were raised in one way, and then expected to live straddling those two worlds, I think it's been—*

Judy: Very hard.

Chuck: *So unbelievably difficult, and it is something that our generation has never really quite gotten over.*

Judy: Yeah, I sort of agree with that. What I inherited, which was kind of interesting, was a kind of softening, especially with people who came to the studio to see what I was doing. They would say things like—and I actually get this sometimes now—"I don't really like this, but my

wife would like this." In a way, no matter what the thought was, it seemed like, "This is not good enough." They would pull back a little bit and say, "It's not my cup of tea," and I might not be understanding of the parameters. There were some ideas that were made available to me that perhaps have helped my conversation soften. Judy [Fiskin] and I used to joke about it. I used to think that it wasn't until I'd been showing for about fifteen years that I was in a women's show. If a show was ever put together about women, I would think I wasn't invited.

Bill: Were you in LA when they had the Woman's Building? There was a studio building in which only women were allowed.

Judy: Yes, yeah.

Chuck: But I was looking through your bio this morning, and you were in a great number of shows with women, and group shows with women, but they weren't—

Judy: —women's shows.

Chuck: —all women, and it wasn't the focus, but there were—

Judy: —a lot of women.

Chuck: During your generation and, actually, the generation just before was the first time that the playing field—

Judy: Almost the first.

Chuck: —was leveled enough, but even Nancy Graves started showing under N. Stevenson Graves.

Judy: Did she?

Chuck: Yes, and Grace Hartigan had shown as George Hartigan.

Judy: I didn't know that about Nancy.

Bill: And I have a friend named Kim Abeles who's an artist, and they always think that she's a man when she gets grants.

Judy: What's funny is that it has worked in reverse for Kim MacConnel because everybody always used to think that he was a woman.

Bill: When Kim Abeles shows up at a museum or whatever with a daughter and being a woman, because they didn't read the bio very well, they're surprised. I must admit that that period of time was such an anathema to me, because I had never felt any of the things of which I was being accused. Whenever I had anything, it was always primarily women with whom I worked and who were in the positions of authority. When I had a theater, a woman was its executive director; I used women directors all the time; I collected women's art.

Judy: When I was a student at Yale, there were two women in my class: Joyce Owens, who was a black woman artist from Washington, and myself. We were really close. She left after three months, so in my class, I was the only woman.

Chuck: Really? Are you kidding? Half of our class was women.

Judy: In my class I was the only one.

Chuck: Really?

Judy: And never had a woman teacher. I mean, it was rare.

Chuck: We had such strong women. The thing that I got used to was the that half of the talent pool was—

Judy: Was women?

Chuck: *Was women, and it just sort of naturally stayed that way when we came to New York, and we were all within a few blocks of each other.*

Judy: Yes, yeah.

Chuck: *Jennifer [Bartlett] was there, and Janet Fish, and—*

Judy: Well, Elizabeth Murray.

Chuck: *Yeah.*

Judy: Your class from Yale. And Nancy [Graves] was in that class.

Chuck: *Yeah.*

Bill: *When I started collecting art and realized you could buy women's things, which I love, they were about one eighth of the price of men's work, and they still don't come close to men's prices.*

Judy: I did a show in Germany, and there was a historical section to the show; it was a survey from 1935 to 1981. I'm not exactly sure, but I don't think there was a single woman in that historical section. There was a corridor of younger artists who were an annex to the show. Jenny Holzer was working collaboratively with a man named Peter Naden, and there was me and one other artist in that section. We couldn't even go into the historical section, we had different catalogs, and our opening days were different. It was like "that was that." They had reconstructed Joseph Beuys' first show, they had Kurt Schwitters, they had—it was wild—the "history" of modern art.

Chuck: *Right.*

Judy: Once when I was teaching at Yale—again, I might have these numbers wrong, but the idea is there—I looked at a list of tenured professors. There were something like 600 tenured professors, 590 of whom were male.

Bill: *It's not just women. It's also minority artists.*

Judy: Oh yeah.

Bill: *Felix [Gonzalez-Torres] has had so many experiences when people thought he was the janitor at the place rather than the artist who was installing the work. They've actually told him to sweep up a room. He doesn't even think about it anymore; he just assumes it's going to happen.*

Chuck: *I just heard a story about an artist, a person of color, who went to his own opening in a museum guard's uniform and, because he was black or Hispanic—I don't remember who it was— everyone was asking, "Where's the artist, where's the artist, where's the artist?," and he stood there at his opening without anyone ever—*

Judy: —ever assuming. Yeah, it's something when your eyes open up, but how it gets that way, what really is making it so, I have not put together. Well, I'd better go now.

Chuck: Thanks.

◆

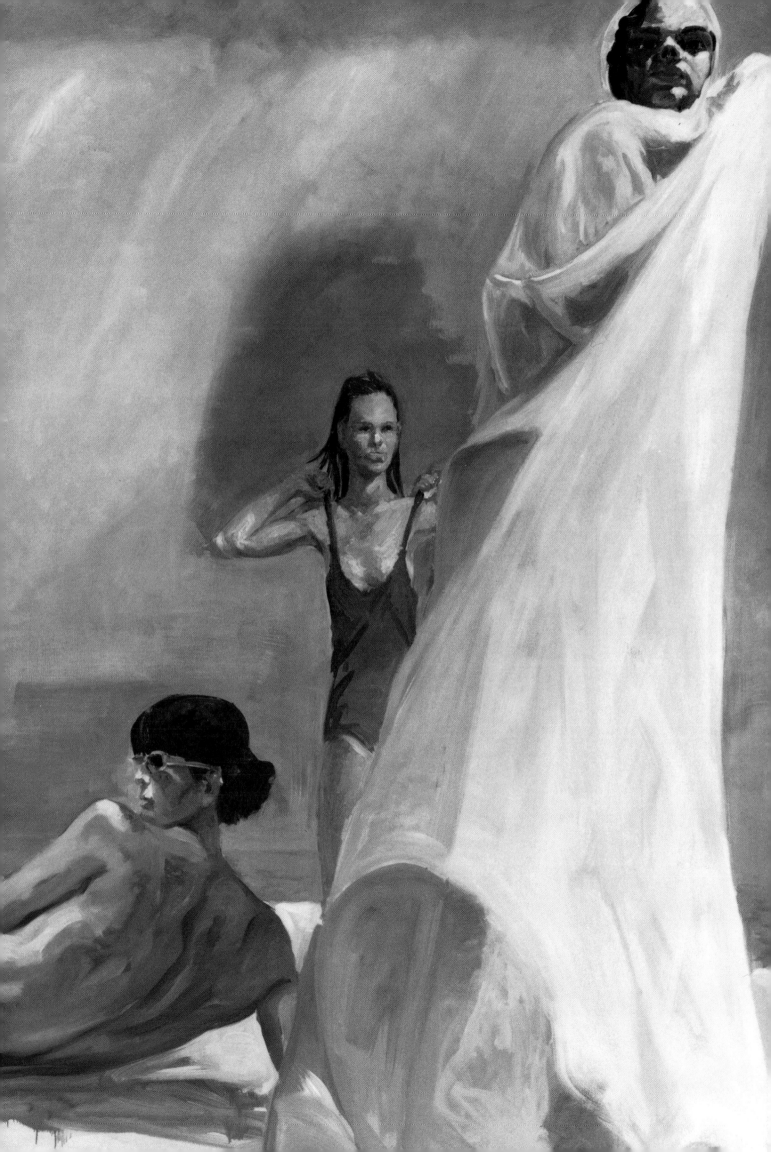

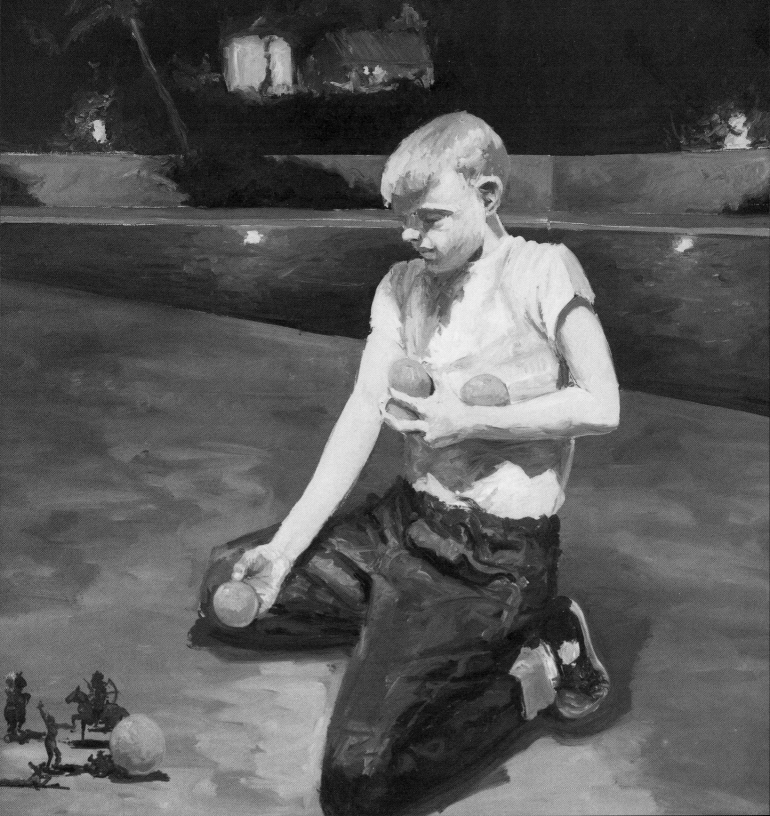

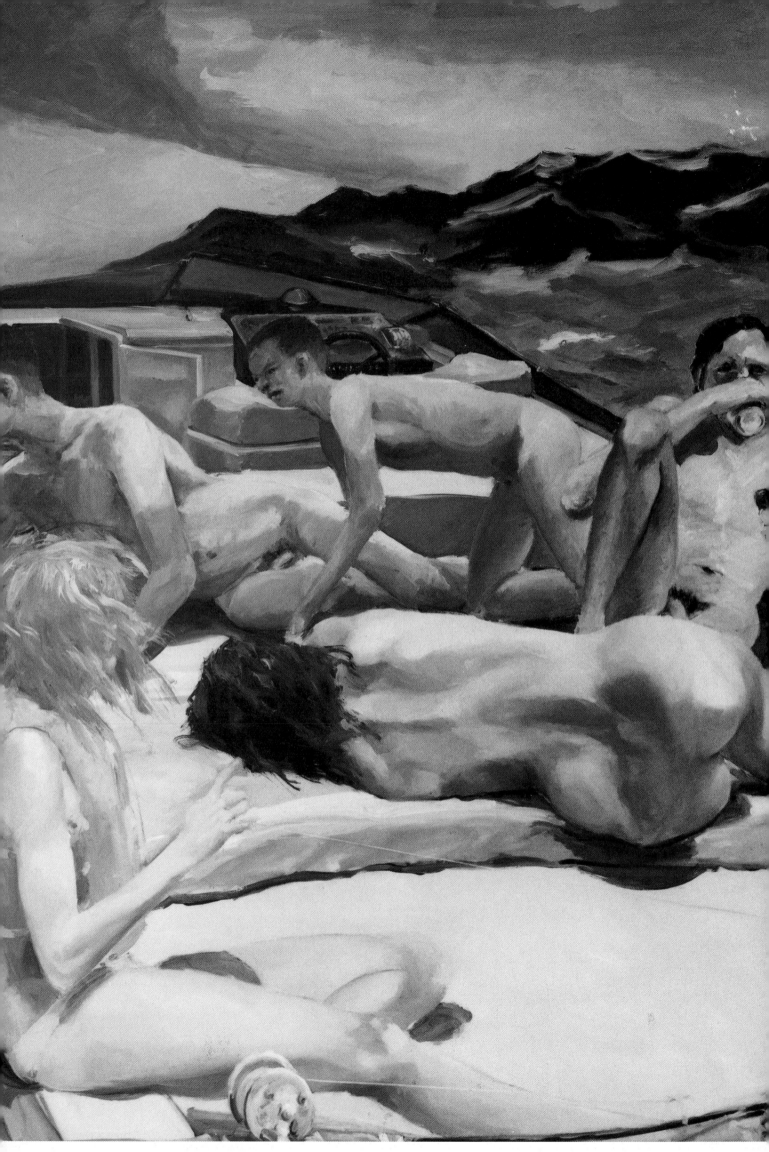

Eric Fischl

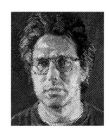

New York City, October 13, 1994

Bill Bartman: What's the name of the academy at which you teach?

Eric Fischl: **The New York Academy of Art.**

Chuck Close: That's where Kiki [Smith] studied anatomy.

Eric: **They had a big upheaval last year. They fired all the "toga" painters.** *[laughter]* [Established in 1982, the New York Academy of Art is a two-year graduate program focusing exclusively on the human figure. Albert Landa, dean of the academy, states, "We teach figurative training without any expectation that these students will become figurative artists." One of the early supporters of the academy was Andy Warhol, and his estate continues to support the school. However, the academy is not immune to politics and greed. In early 1996, it was involved in a scandal of embezzlement, negligence, and power plays to the extent that several instructors left or were asked to leave.] **And they hired Alfred Leslie, for example.** [Alfred Leslie (b. 1927) began his career as part of the second wave of abstract expressionist painters, but in the 1960s he broke with abstraction and began to reinvestigate the human figure. Painting in both grisaille and color, his figures are large in scale and are frequently referred to as confrontational. The figures are often nude, and high contrast lighting is used to create an unsentimental yet hyperrealistic atmosphere.]

Chuck: Uh, oh. **Either Alfred will drive them crazy, or vice versa.**

Eric: **Exactly. At least the change brings a little more contemporary thinking to the students. These are graduate students who have already been to school, realized that they didn't learn the techniques that they wanted to learn, and decided to go back to a foundations course. They have an egoless quality; they don't think they're artists yet, which is wonderful. I can't stand it at CalArts and Yale or places where all you get is attitude. The guy's in third year and it's attitude, man. I mean, do I need this?** *[laughter]*

Chuck: And gossip. We all love gossip, but—

Eric: **Right. I think with other mediums, with photography and video and conceptual things, and even to some degree with certain types of abstraction and painting, you can arrive at a sophisticated image faster than in the more traditional mediums of figure painting or sculpture and stuff like that. Traditional mediums take twice or three times as long, so these poor kids are sitting in school with peer group competition watching someone with a photograph come up with something that looks like it could be in the Museum of Modern Art, and they're sitting there with these muddy, horrible colors, and paint keeps soaking into the surface, *[laughter]* and they're freaking out. The pressure is just horrible.**

Chuck: *Well, when I was at graduate school, there was no way any of us could have left graduate school, come to New York, and shown what we were doing. Actually, Don Nice was a student at Yale, and he was showing at Feigen Gallery while he was still a student there, but he was the only one.*

Eric: Really?

Chuck: *He was also the dean of students at the School of Visual Arts while he was a student at Yale.*

Eric: No.

Chuck: *Yeah, but—*

Eric: Was he also your age?

Chuck: *He's a little older. Everyone was down on him because he had something that he wanted to do, and he was showing it. They thought there was nothing they could teach the guy. Other than Nice, if you had a list of the people with whom I went to school and examples of their work at the time, with the possible exception of Brice Marden, I don't think there is anyone who you would be able to guess—*[Brice Marden (b. 1938) studied at Boston University and Yale University. His abstract minimal style was developed early in his career. More lyric in style and inspired by his interest in eastern religions, his current work uses subdued colors and organic, overlapping loose lines that resemble skeletal structures.]

Eric: —what they're doing now?

Chuck: *—yeah, that this was the work that they made when they were in graduate school. There was a sense that you had a lot of time after graduate school in which to find yourself. You weren't supposed to find yourself in the graduate school.*

Eric: What was the purpose of going to graduate school?

Chuck: *Well, in my case, it was to stay out of the draft. The Bay of Pigs came along while I was— it was '63 or '62. When was the Bay of Pigs?*

Bill: *It was '63.*

Chuck: *The Cuban Missile Crisis. One of them got me. They lowered the standards. I had been 4F and all of a sudden they decided that I wasn't so bad after all. I had to scurry and get into something.*

Eric: You were 4-F because of your eyes?

Chuck: *Eyes and my flat feet. Then all of a sudden I was reassessed, and I was made 1-A. I literally had about a month to get into graduate school. It was in the summer between college and graduate school, long after the application dates for schools had passed. I was able to sneak into Yale because I had been at the Yale summer school, and they liked me and managed to get me in. I had had no plans to go to graduate school at all, but I'm really glad I did. It was a great experience.* [The Selective Service System was created in 1940 to administer the draft. Men were called up on the basis of a classification. The classification 1A was the top listing, meaning the draftee was in good physical and mental condition and ready for duty. The lowest category was 4F and reflected the fact that the draftee was unfit for duty.]

Eric: It gave you that extra time to develop, or did it introduce a new set of problems to you?

Chuck: *More than anything I developed work habits and made really important friendships and relationships with other artists. We all moved to New York together and really kept it as a kind of "Yale South" for quite a while. We all lived within a few blocks of each other and worked with each other. I helped Richard [Serra] build all of his early lead prop pieces. It was an instant community, which was very nice. We were used to reading each other's paintings and work and talking about it.*

Eric: Was there a free exchange that way? Was it a critical exchange?

Chuck: Oh yeah, it was ruthless. Now we all sound exactly alike. No matter what kind of work we make, the rhetoric is the same because we learned to talk about art before we learned to make it. I can spot someone who went to Yale, at least during that time frame, in a second by the way they talk about art.

Eric: Do you remember my book *[Sketchbook with Voices]* that I gave you?

Chuck: I was just thinking about it today.

Eric: I had interviewed everybody, from Jasper Johns and Larry Rivers and that generation to myself and my generation, but even with all of the different styles, there were certain common threads that ran through everything. An essential fact of being a late modernist, living in a late modernist time—what kind of problems you give or the kind of problems you work under—is that you always try to undermine your preconceptions about what it is you're getting, what you want from it, and how to go about getting it. All the problems designed by the artist were geared toward fucking up the student, right from the start.

Chuck: Hmmmm.

Eric: Did you have any sense of that at Yale? What was the underlying attitude there?

Chuck: Well, we were very conservative. When the students were asked to propose the names of visiting artists, we asked for people like Edwin Dickinson. The faculty would suggest Rauschenberg, and everybody would put the suggestion down. [Dickenson (1911–1978) was a realist painter best known for his small, romantic landscapes in the nineteenth-century tradition.]

Eric: Really? That is such a surprise.

Chuck: Rauschenberg was giving a crit one day, and we bought a white chicken from a live poultry store, tied its foot to the top of a sculpture pedestal, and put a box over the chicken. We pulled the box off, and there was the chicken, so Rauschenberg, who took it all very well, began to give a formal crit of the chicken. [laughter] The chicken had been asleep in the box. The chicken woke up in the box, got up and sort of ruffled its feathers—

Eric: With one leg up?

Chuck:—and as soon as Rauschenberg started to speak, it took a big shit. [laughter] We were very suspicious of what was going on. I remember that when Frank Stella came up to give a lecture, Richard Serra got up and asked a very hostile question. He questioned his integrity, called him a fake and a fraud, and walked out of the lecture.

Bill: [laughter] That's pretty hostile.

Chuck: I went down to New York, and I bought a Lichtenstein print. I think it was from his first show.

Bill: At Castelli?

Chuck: Yeah. It was a signed print—ten dollars signed, five dollars unsigned. I brought it back up to Yale, and I got such shit from everybody. "What do you want this stuff for?" Later everything that was produced by graduate students in art schools was the mean average of the last five Artforum covers.

Eric: When we did crits at CalArts, they didn't contain a tremendous degree of substance. Somehow, the language that we learned was an aggressive language that was somewhat formalistic but not disciplined formalism; it was really meant to inflict pain. Part of the reason that

you inflicted pain was to verify that painting was still alive, because if you could make someone cry, it must mean that the painting meant something to him. You know what I mean? We all had this terrible suspicion that what we were doing was completely wrong, you know, idiotic.

Chuck: I think the main benefit of being at Yale in the early sixties was exposure. I had grown up in Seattle where I never saw any real examples of contemporary art other than Mark Tobey and Morris Graves and the local heroes. They were all looking toward the east, looking toward the Orient. I was interested in New York and Europe, and there was very little interest in that out there, so I spent all my time looking, with a magnifying glass, at black and white reproductions of de Kooning in art magazines, trying to figure out what the hell one of these paintings would look like. [laughter] You know the close proximity of Yale to New York. We went to New York twice a month and saw all of the galleries, and visiting artists came up, so instead of famous artists only being people about whom you read in magazines or books, you met them. It demystified them. It took them off the pedestal and made them real people. You saw them hungover, you saw them being assholes, you saw them when— [laughter] I remember sitting in the Heidelberg, which was a bar in New Haven, with Phil Guston and Jack Tworkov. Jack was the chairman of the art department. They really got into their cups. They were really sloshed—this was before Guston started to paint the cartoon paintings—and they started crying. Philip said to Jack, "Why are you doing this? Why are you here?" and Jack said, "I can't sell my work. I got thrown out of Castelli when Rauschenberg and all of those guys came in." It was Tworkov who was responsible for turning Castelli onto Rauschenberg in the first place, and he said, "I haven't sold a painting in two years," and Guston said, "I haven't sold a painting in three years." [laughter] [Leo Castelli is perceived as one of the most prestigious and powerful art dealers in New York. He founded his gallery in 1947 and has been at the forefront of many contemporary art movements, especially pop art.] *In comparison to what was to happen to art students later, with their raised expectations as to what kind of career might be possible and the conviction that the art world owed you a living, and a handsome one at that, it was a very different view.*

Eric: **Yeah.**

Chuck: I think Al Held was extremely important at Yale. [Al Held (b. 1928) was an associate professor at Yale in 1962. He started painting in the fifties and developed a style that was geometric and hard-edged. In his paintings, he plays with space and multiple perspectives, often employing massive geometric shapes and minimal color.]

Eric: **To?**

Chuck: Everyone. He talked up New York. He kept saying, "Don't get a teaching job. Don't go to the boondocks and teach. Go to New York. Go be an artist. This is what it's like." He made it seem not so scary. He told lots of stories about what it's like to survive as an artist and how to do it. You do sheet rocking, you do this, you do that. His advice helped make it a very easy transition.

Eric: **When did you graduate?**

Chuck: I graduated in '64.

Eric: **I was at CalArts in '70. So you see, in six years painting had died. When I went back to CalArts, they killed me, just the way I killed the ones who had been there.** [laughter] **It was karmic payback, you know. Oh man, I just sat there, and I figured, "I have to take this, I know, because I did it myself."**

Chuck: Uh, huh. Is it like fraternity hazing? Once you've had it done to you, you want to do it to someone else?

Eric: Yeah, something like that I guess. I remember when Lynda Benglis came. I was so outspoken. I was vicious as a student. I was absolutely vicious towards this person. There was something in the schooling itself that made me think that everyone's motives were suspicious.

Chuck: Yeah.

Eric: It's that sort of Robert Hughes idea. He believes that all modern artists are trying to put something over on the audience.

Chuck: But that's also a West Coast thing, don't you think?

Eric: Except that the faculty of CalArts was all East Coast.

Chuck: Oh.

Eric: Yes and no. I think it was an incredibly competitive place without necessarily acknowledging that it was. If one had said, "This is an incredibly competitive situation, so basically I'm going to try to win, and I'll use anything to do so, because I want to be right and because it threatens me that somebody else is getting what I'm not getting," it would have devalued the lofty aspirations of art, but it would have put the situation on an understandable level.

Chuck: Who was teaching when you were there?

Eric: Well, Paul Brach was head of the department, and there was Allan Kaprow, John Baldessari who was West Coast, and Allan Hacklin, who was teaching painting. That was sort of the core of people. Stephen Von Heune was teaching sculpture.

Chuck: Uh huh. Was Ross [Bleckner] a student at the same time as you?

Eric: He was a graduate student.

Chuck: He was my student at NYU before he went out there. He was a terrific student.

Eric: As I was saying, painting was dead, so the school didn't teach drawing or art history or anything.

Chuck: Is that still true?

Eric: I don't know. They didn't teach drawing then because they figured that if you wanted to reproduce something, there were mechanical ways to do it, so why spend time drawing. They didn't believe that drawing developed eye-hand coordination; it wasn't a skill that was necessary. They didn't teach art history because they didn't want you to be hampered by knowledge, by familiarity. *[laughter]*

Bill: By information.

Eric: The pressure, and it was tremendous pressure, was for the student to teach the teacher. We had to actually come up with ideas about which they hadn't thought.

Chuck: If they had known how important appropriation was going to be, they would have taught it as source material.

Eric: That's right, that's right. "Please," seriously, "copy this." *[laughter]* Yeah, it's true. They were really behind the times. Anyway, painting was a vacuum. If you *had to paint,* if you absolutely *had to paint,* you had to paint what they considered to be left of modernism, which was large-field abstraction. It could be geometric or open, but it had to be about surface, structure, and process.

Chuck: *That stuff really was dead as a doornail at that point.*

Eric: Uh huh. Lyrical abstraction had pretty much finished off most of that. [Lyrical abstraction was a rather vague term used to categorize certain aspects of the more intuitive forms of abstraction in the early seventies. It generally implied a lush and sumptuous use of color.]

Bill: *What were your paintings like when you were at CalArts?*

Eric: My abstract paintings were sort of like Brice Marden surfaces but with kind of garish color and with more triangulation than rectilinear form in the geometry. They were sort of somewhere between Diebenkorn and Brice. That kind of color and opacity absorbs light. It's luminous, but it absorbs light rather than reflects or emits it. It didn't have anything to do with the light of California. It was a more psychological light. They were awful paintings, really not very good. During my last year, I was flipping out about leaving school. I hadn't gotten it together. I had not applied to graduate school, I didn't know what I was going to do, and I was really floundering. Out of frustration with the narrowness of my work, I started to make these joke paintings. I would cut out figures and cowboys and glue them onto my painting, and make wreaths and decorative elements and start to paint on them, and do this sort of silly collage thing. They were pretty bad too, actually. They were pretty limp, but within the context of CalArts, which was so prejudicial against anything other than this rigorous type of stuff, they caused a sensation.

Chuck: *Isn't it great that we're not responsible for our pre-public work?*

Eric: Yeah. Do you have any regrets about work that you let out?

Chuck: *No. I think that, at least when I came to New York, there was a sense that you had better not go public with anything that you couldn't—*

Eric: —defend?

Chuck: *—defend for the rest of your life. There was a sense that the work done before was nobody's business, but after you go public you are accountable for everything you produce. I think that was good. It kept us from little, tentative forays into something. After CalArts, you went from LA to Nova Scotia?*

Eric: Chicago. I lived in Chicago for a couple of years. I was a guard at the Contemporary.

Chuck: *You didn't study in Chicago?*

Eric: No. I ran off with a girl who was from the Mid-west, and neither of us wanted to go to New York because it was big time and we weren't ready. So she suggested Chicago, because it's a big city, and I thought it would prepare me for New York.

Chuck: *It was sort of halfway there.*

Eric: Yeah, halfway there. You kind of get used to urban life and the dynamics and so on, but of course, Chicago is nothing like New York.

Bill: *What year was that?*

Eric: It was '72 or '73.

Chuck: *You were a guard at the Art Institute?*

Eric: No, I was at the Contemporary. That was great. It was really a lot of fun. There was a staff of ten people or so. It was like a family. Everybody did everything. You'd install the shows, you'd guard the shows, you'd be the receptionist. They knew I was an artist, and even though

they didn't see any of my work, they had this reverence. I could say anything about the work on exhibit, and they would believe it, so I used to tell them things. I'd just make up things, and then I'd hear the docents telling them to their groups. *[laughter]* The best one was about a Francis Bacon painting of the Pope. The Pope was like this *[gesturing with his hands]*, and there was a ray of golden light as thin as a piss line. I told the docent it was a golden shower of piss; that Bacon was into this weird, marginal S & M homosexuality, and—

Chuck: *—and you didn't know you were actually right?*

Eric: I actually thought, "This could be one way of interpreting it, this sort of fallen Catholic humiliating the Pope in this horrific way, with inside homo jokes and…" I told her this, and then I forgot about it. About three weeks later she had this group of high school students, and she started talking about this stuff, right? And she turns around at one point—this is a really sweet, Jewish, suburban lady—and she said, "Now, is anyone here Catholic?" and every one of them was wearing a Catholic girls' school uniform, right? And they were all looking at her. It was really good. *[laughter]*

Chuck: *What did you do while you were in Chicago?*

Eric: What kind of work did I do? Well, I was really floundering when I got out of school. I continued to try to work with images for a while, and then I reversed direction and went back to abstraction. I did a body of these geometric abstract things the last year I was in Chicago. They had a narrative content for me, but it wasn't a public thing, it was just the way I was thinking about them. I would choose certain colors. I was doing these things that looked as if they would be diptychs. They looked like two envelopes stuck together in this kind of x-ing pattern with the one flap overlapping, and when you put them together, a diamond would appear. I was collaging paper onto brown paper, then painting, and I sort of scratched the surface. Then I put some kind of striped thing at one point, and it looked like a tail, so I was thinking about a princess/tiger choice. I had this whole narrative going on in my head, but of course—

Chuck: *No one else—*

Eric: —no one else could possibly penetrate this. Anyway, that's what I left Chicago with, this kind of abstraction, and then I went to Nova Scotia.

• • • •

Chuck: *What about the Chicago imagists and the Hairy Who?* [The Hairy Who, a Chicago-based group of painters, first exhibited together in 1966 at the Hyde Park Art Center in Chicago. The group included Jim Nutt, Ed Paschke, and Gladys Nilsson.]

Eric: They were the ones who were in power there. I have a tremendous respect for them. Theirs was the kind of work I wasn't capable of doing myself, but it gave me a certain permission. I mean, certainly the atmosphere of Chicago was more out of the surrealist tradition than of the cubist tradition, which was New York. Plus, there was also a psychology, a psycho-sexual component to their work with which I could have worked, but then again, I didn't. I had a tremendous admiration for Jim Nutt. [The cartoon-like imagery of Jim Nutt (b. 1938) depicts nudes in menacing fantasies. Although the figures are engaged in erotic encounters, sex is never explicitly depicted.]

Chuck: *Yeah, he's a wonderful painter. I think he's making great paintings now.*

Eric: Oh yeah. I haven't seen any in two or three years, but they're amazing. I remember that after I moved to New York, I was building crates in the 420 Building, at Hague Art Services.

Chuck: *It's where Mary Boone had her—*

Eric: Yeah, right. Hague took over her half of the space. Anyway, I was building crates. The truck drivers were these Hispanic kids who used to go around to the studios and pick up the work. They thought Jim Nutt was the greatest, and they also loved Chamberlain. They thought Chamberlain was a real artist because they would go over to his studio at ten in the morning and he'd be sitting there swigging back a Jack Daniels and throwing his hammer at a sculpture. *[laughter]* They loved him for that, and they loved Jim Nutt's stuff, too. It was like Hispanic mystical painting to them: the colors, those turquoises. Nutt's work really talked to them. It was great, the drivers would go on and on and on about the work. Yeah, the Chicago School was great, plus they made a stand against New York, and they came up with an original language. Outside of New York, in terms of the general population, they were the most effective for a long period of time. Everywhere you went Hairy Who type of work was being done, all through the Mid-west to the Coast, into Seattle.

Chuck: *Absolutely.*

• • • •

Chuck: *Well, I want to hear about what happened in Nova Scotia, but there's a question I have to ask first. [laughter] April [Gornik] said, and I quote, "Eric shows you shit-loads of himself in his work."*

Eric: (laughing) Shit-loads of himself.

Chuck: *I forget exactly what the context was. This was the last time we talked. I don't know what you think about it.*

Eric: What do you mean? One, whether it's true? Two, why would I bother? *[laughter]* And three, why should you care?

Chuck: *It was the glee with which she was talking about psychoanalysis. She was psychoanalyzing people through their paintings, except she found it a lot easier to psychoanalyze you through your paintings than she would have found it to psychoanalyze herself through her paintings, and she said, "Eric shows shit-loads of himself in his work."*

Eric: Well. Yeah, I don't know how to—I mean, I always thought that it was obvious, so I don't know how to expand on it. I always get uptight when someone tries to pin my work down to being autobiographical, to a strict and literal interpretation of what the things are, because I think it's really more fictional. One's work always includes the self, but the techniques of fiction are that you conflate various aspects of experience—or various times or events, but you don't portray them in the exact way in which they happened. You can include more or less depending on how you do it, so that it becomes an expansive kind of experience, because it includes consciousness and reevaluation: reinterpretation.

Chuck: *How much of the "April" attitude do you think is because America is such a repressed country, is so uptight toward sexual issues? I'll tell you what I was thinking about. I was just in Munich. We left the Modern museum—it's right in the middle of town—and we rolled through a park that is called English Park or American Park.*

Eric: I've never been to Munich so I don't know.

Chuck: *The people who work in the office buildings go on lunch hour to this park to eat their lunches, and they take all their fucking clothes off. Half of the women are at least topless, if not bottomless too. All of the men are totally naked; their business suits are all in a pile.*

Eric: Right.

Chuck: *They eat their lunches and sunbathe right in the middle of the city. It's not as if it's near water. My first thought was, "Gee, I wonder if Eric's been here," [laughter] because that aspect of your work seems so peculiarly about the forbidden in this country.*

Eric: Yeah, my understanding from experience of the difference between Europeans and Americans is that Americans believe that if you think something, you have to act on it.

Chuck: *Or to think of it is as bad as doing it, so you might as well do it.*

Eric: Yeah, Jimmy Carter had lust in his heart.

Chuck: *That's right.*

Eric: It almost got him thrown out of office. Europeans don't think the same way. They're much more comfortable. They also don't see the space between people as an aggressive space. They're much more voyeuristic, comfortably voyeuristic. They don't mind leaning into that space, looking through the space between people, listening, eavesdropping, that kind of thing, because they don't think that it's going to come back at them. New Yorkers know that if you make eye contact, it means one of two things: either you're going to fuck, or you're going to get killed. *[laughter]*

Chuck: *Or you're going to get fucked and then get killed. [laughter]*

Bill: *Or get killed and then fucked.*

Eric: Yeah. *[laughter]*

Chuck: *It depends on what part of New York you're in. [laughter]*

Eric: There's the sense that the space between people is a charged and dangerous space.

Chuck: *We were talking to Wegman yesterday about how dogs are used in this city as a way to talk to people. The only people who talk to strangers in New York are people who have dogs.*

Eric: Yeah, you see that on the elevators all the time, but that shouldn't be surprising to a painter because that's what painters do. Painters are very indirect about who they are and how they feel. There was an interesting article about how cats, unlike dogs, don't come directly to you when you call them; they go to a third thing. They rub up against a chair leg or something, whereas dogs, when you call them, just walk over to you. It's a direct exchange. A cat will go to a chair and make you appreciate the chair with them; connect you to this object that is neither you nor them, but is part of their territory; and then come to you. When I was reading that, I thought it was amazing because painters do the same thing. You cannot approach a painter frontally, you always have to go through the thing that they've made to show you, so I understand why it's easier to talk to a dog to connect to the person rather than directly to the person—especially since you might find that you'd rather know the dog than the person. When I went to Europe, especially to Southern France where, for the first time, I saw that kind of nudity within a very structured social framework, I was confronted with my own sense of

outrage and horror and amusement. I didn't have only one reaction to it. I wasn't cool about it; I wasn't on top of it. I was so taken by it that I had to take photographs just to see what the hell I was looking at. I couldn't believe it. I became aware over the course of time, in fact, and I think I've found through the reception of my work, that a lot of people are aware that the looking is not innocent. It's filled with ambivalence, it's about wanting and not wanting, not being sure whether you want or should have. In other words, the exchange is always sexual. The question is always a kind of charged, "What do I want from this person?" Is it a sexual thing that I want, or does it have nothing to do with sex? If it has nothing to do with sex, why not? Why shouldn't it have something to do with sex? I was doing these pictures from St. Tropez and using images of beach umbrellas and beach mats from beaches in St. Tropez, and I was thinking, "I'm going to do to Southern France what David Hockney did to LA." You know? I'm going to name it. Right? I was giving a talk someplace, and I alluded to having seen French life, and a woman stood up and with a heavy French accent said, "But this is nothing like France. This looks like Long Island." *[laughter]* And I thought, "Oh fuck, you can take the boy out of America but—I don't know."

Chuck: *Recently you've been using watercolors and subjects found out on Long Island, and your most recent paintings at Mary's [Boone] are studio pieces with regular models.* ["The Travel of Romance," September 1994, Mary Boone Gallery, New York.]

Eric: Actually, some of the watercolors were from photographs of beach people, similar to what I've done before. I've started a couple of things for which I brought in a model and began working, and I have one that I started in Italy last summer. I taught a Drawing Foundation course for a week at Lake Como. It was held in a church, a sort of emptied-out nineteenth-century church with beautiful light. They had a model, an Italian girl who was an actress, and the problem I assigned for the students was a simple one. I wanted each of them to individually pose the model. To facilitate the fact that there were thirty kids and limited time, I wanted each one to pose the model, take Polaroid pictures of the model, and start to construct a drawing from the photograph, possibly a narrative drawing in which the pose was contextualized. They could put things around the image, use other photographs from magazines to bring in objects or light or whatever, and when they needed more information, they could go back to the model and get more specific information. I would sit there watching this model being posed in ways I would never have thought of myself, some of which were really interesting, and I would take photographs of her. Sometimes she was between poses, just being herself. I found her very compelling. She always seemed to be thinking of something, and I found her especially compelling at those times. She didn't express herself through poses but rather through postures, through body language. They revealed thought, and they revealed feeling and stuff. I got interested in her, and she's the model in those paintings, my most recent paintings.

Bill: *So those paintings were done in Italy?*

Eric: No, the photographs of the model were taken there, and the room was actually from a photograph of a room in which April and I stayed at the [Surhid and Asha] Sarabhai palace in India. I liked the atmosphere of that room, so I used it, and it seemed to work. The way I paint

is that I take pictures, or I have in the past anyway, of people I don't know. I see them on the beach or somewhere in public, and I take their photograph. Some of them catch my imagination in ways I can't even explain. I just find myself using them over and over; they become like part of a theatrical troupe, and I become incredibly intimate with them, even though I've never met them. I live in fear of meeting one of them. You know, someday someone is going to come up and say, "You know, that's me. How dare you? Who do you think you are?" Meanwhile, I can tell them things about their bodies of which they might not even be aware.

Chuck: *That contextual aspect of your work is really interesting. When I started photographing nudes, I tried to do it in a straightforward, flat-footed way, as I do much of a person's head, by moving the camera down to another part of the body. They were never in a particular environment. I thought for it to be sexual, the model had to be in some context. You know, in art school everybody in the class is clothed, and the tension comes from the fact that you have your clothes on and the model doesn't.*

Eric: Right.

Chuck: *But that tension may seep into the painting.*

Eric: That's because artists are saints.

Chuck: *You take that same nude in an art school pose and put that nude in a kitchen, and all of a sudden, she's not just nude, she's naked; all of a sudden you ask, "Why is this naked person in a kitchen?"*

Eric: In a kitchen, which is an inappropriate place for her to be.

Chuck: *That's right. Nothing about the pose would have to change.*

Eric: That's something I discovered very quickly: precisely how psychologically charged the different environments are in which we live, and how specific they are to the activity that is supposed to take place in them. Therefore, a useful dramatic device is changing certain kinds of behavior within the context that's supposed to occur in a particular environment. Did you ever read Gaston Bachelard's book *The Poetics of Space*? Basically, he does a phenomenological breakdown of the house: what the difference is between an attic room and a basement room, and the master bedroom versus the children's bedroom, hallways, closets, stairways, kitchens, bathrooms, all of that stuff, and how we mythologize it. He writes that, in fact, when families move their eldest son up to the attic room, they are essentially putting the son above them; that there is a metaphoric interpretation as well as a practical reason. It sort of reaffirmed what I had discovered in my own pictures, which is how charged these spaces are. [Bachelard's *Poetics of Space*, published in 1954, is a pivotal work of French structuralism and has influenced many visual artists. Bachelard is a philosopher who probes the existence of intimate and immense space, whether rooms, forests, shells, closets, or corners.]

Chuck: *You know, I did some transitional work between my abstract work and what I'm doing now. The first work that I based on photographs was involved in a big lawsuit in the State of Massachusetts about painting pornography. It was a landmark decision. I've run into lawyers through the years who, when they heard my name, although they didn't know what else I did, they knew this decision.*

Eric: Close versus the University of Massachusetts, 1969.

Chuck: *Close versus Lederle was a landmark decision that extended free speech to the visual arts.*

Eric: Really?

Chuck: Yeah. I had the world's oldest living State Supreme Court judge, the guy who sent Dr. Spock up. What made me think about it was that the reason those things were seen as pornographic was totally contextual. I did nudes in bathrooms, where there were toilets and sinks, where bodily functions happen—

Eric: Right.

Chuck: —and therefore the nude now became—

Eric: —too physical.

Chuck: Yeah.

Eric: Too real.

Chuck: You talked at the beginning of our conversation about the stream of piss in the Bacon painting. Well, when the judge asked why these paintings were pornographic, the opposing lawyers pointed to a painting of a fully clothed man in a bathroom. The space between his legs happened to be yellow, and they said that the yellow space, which was actually light coming between his legs, was urine. Then they pointed to the tiles on the wall of the bathroom, each one of which was a little abstract painting, not unlike what I'm doing in my paintings now. I had made small abstract expressionist paintings on each of the tiles. The lawyers for the state would point to the tiles and say, "This is a penis, this is a vagina, this is…" They only saw those things because of the context of the bathroom.

Bill: It's almost hard to believe.

Eric: Not at all in today's climate.

Bill: No, not today's climate, but that they would even be looking for that stuff.

Chuck: The judge broke up. He thought this was the funniest thing he'd ever seen: that these guys would sue, that they were busily finding penises, that they had spent weeks researching where they all were, so that they could point them out to the judge. The judge threw the whole thing out. [In 1969, Close, then an instructor at the University of Massachusetts (Amherst), was exhibiting his paintings of explicit nudes on the corridor walls of the Student Union. The University ordered their removal based on grounds of obscenity. Close argued that his First and Fourteenth Amendment rights were being violated. The United States District Court directed reinstatement of the exhibition for the balance of the time remaining in the original exhibition schedule. The university officials appealed the decision. In overturning the decision, the Federal Appellate Court drew an analogy between visual speech and pure speech stating, "There are words that are not regarded as obscene, in the constitutional sense, that nevertheless need not be permitted in every context. Words that might be properly employed in a term paper about D.H. Lawrence's *Lady Chatterly's Lover,* or in a novel submitted in a creative writing course, take on a very different coloration if they are bellowed over a loudspeaker at a campus rally or appear prominently on a sign posted on a campus tree."]

Eric: That's wild.

Chuck: It's also interesting that my friend Mark Greenwold was blackballed by Lucy Lippard when he had a show at Phyllis's [Kind] years ago in which a painting showed domestic violence taking place in a kitchen. A woman was being stabbed with a pair of sewing scissors. [In response to the gallery's press release, written by Greenwold's art historian wife, for his 1979 show that featured only one painting, *Sewing Room (for Barbara),* 1975–79, Lippard wrote an undated (c. March 1979) letter to Phyllis Kind. In it she stated, "I was appalled to see the announcement for Mark Greenwold's show and wonder how you, as a woman, can show work that so blatantly and even naturally reflects the kind of violence against women that is rampant in this country during these times of economic depression and rightwing backlash… I and many others I know have no intention of visiting the gallery while this bit of painful sensationalism is hanging, and… it gives me pause on many other levels concerning the role art does or does not play in society."]

Eric: I think I saw this painting. The figures are sort of out of scale, right?

Chuck: Yes, right.

Eric: Yeah, I remember that painting. Weird, tilted planes of perspective. I'll never forget that painting either.

Chuck: Lucy, who never saw the painting, advised people in the Village Voice to boycott the show, to not even see it, and made a rather bizarre leap to assuming that if you make a painting in which there is sexual content and violence, you are in some way advocating the violence rather than the opposite, which sounds like the case of the guy about whom you're talking who was trying to work out issues of abuse.

Eric: It's like if you speak it, you have to do it. If you say it, if you show it, you have to do it.

Chuck: It's a prejudice we extend to painting that we don't extend to film or the novel, because you can make a movie that's violent, and no one says it's pro-violence.

Eric: Well, they do now. I mean, that whole issue is being debated, especially in relation to TV and films. I think violence in novels is physically different than in paintings. I was actually talking to my students about this earlier. I was wondering out loud whether you can paint any subject, or whether there are experiences that can't be painted, that the medium of painting is too limited to get at, or that change by being painted. I was thinking of how, when you read a description of something that is, for instance, violent, you are reading words rather than seeing a picture, so you create your own mental picture, and it is different from anyone else's. The violence exists within a narrative that moves as your eyes move across the page, and then you turn the page, and it changes, and you go from that violent act to something else. Even though you can be affected by the description of the violence, somehow it doesn't hold you in the way that a painting freezes it. A picture monumentalizes it, and it becomes a totally different kind of thing.

Chuck: I wonder if it also isn't a question of the painting being out in public. You think about pornography. Pornography is meant to be experienced singly and alone: either alone in a home looking at a porno magazine, holding it in your lap, or reading a book that describes—

Eric: —right, the intimate—

Chuck: —or in a darkened theater where you might be in the same room with a bunch of other people, but you're all watching it alone in the dark; whereas when you are standing in a room looking at a painting, and standing next to you is someone else who is looking at it also, it becomes too intimate.

Eric: I had a show at Dartmouth of some monoprints that I had done, and they produced a beautiful catalog with four scholarly essays on the work, one of which was written by this woman Carol Zemel. She wrote a feminist interpretation of the work and a critical one at that, and I don't understand why they had to put it in my catalog. It actually pissed me off that they included her essay. *[laughter]* Couldn't they just have had her publish it someplace else? She can express her thoughts, but—you know. Anyway, her take was that, precisely because of their scale and their publicness, the monoprints return you to the intimate voyeurism of the nineteenth century: that thing of holding it in your lap, privately looking into this world of sexuality and tension when you're not being scrutinized. Whereas, when I blow the monoprint up and make a big painting out of it, it creates a shared experience with other people as you were saying, and therefore you become self-conscious about your voyeurism, you can't experience

it in the same way. The painting becomes critical of the voyeuristic stance whereas the mono-print doesn't, which I don't agree with, but it is an interesting distinction she's trying to make.

[Carol Zemel's essay "Private Pleasures: Fischl's Monotypes" was one of four essays included in the catalog accompanying the exhibition *Scenes and Sequences: Recent Monotypes by Eric Fischl* at the Hood Art Museum at Dartmouth College in 1990. Zemel's essay is a feminist critique taking Fischl to task on a number of issues regarding his representation of women. She states, "For all its gratification, this is a much different experience than the participatory demands of the paintings, whose raking perspectives and spatial intrusions—protruding beds, terrace planters—engage the viewer as a responsible witness-participant. The monotypes unfold before us as a closed and separate realm, leaving the viewer comfortably detached and our voyeurism undisturbed. The book begins and ends, as it were, with images of a nude woman reading in a windowed bedroom. Appropriately titled *Dream*, these views into a heavily curtained interior proclaim a conventional site of sexual fantasy: the reading/daydreaming woman, whose body and imagination are laid out for us to possess. In the present context, she is also an objectified companion for the book's reader, and so frames the touristic sequences and erotic imaginings within. Thus, if the oil paintings problematized the viewer's spectatorial participation in contemporary sexual games and fantasies, the monotypes in contrast leave the viewer's position seemingly intact. We watch the pictured realm of fantasy as if our particular and socially constructed positions were universal and natural, which of course, they are not."]

Chuck: Well, in a way, I think one of the things that made my big portraits off-putting was that the heads are so large, the experience is the equivalent of standing much too close to someone.

Eric: Yeah, they invade your space.

Chuck: They invade your space; on some level, they make the experience too intimate to have in public.

Eric: Yeah, especially because you're not doing portraits of obviously famous people. They are not like a monumentalizing of Napoleon or Lenin—

Chuck: —or Mao—

Eric: —or something like that where the people are supposed to be revered and to totally inhabit your space because they're "the guys." Your portraits are of strangers, persons unfamiliar to the viewer, whose likenesses—

Chuck: Now you know more about them than you ever wanted to know.

Eric: Right. At that scale your gaze becomes critical. You begin to sit there and look at creases and pimples and cracks and nostrils. You do the whole thing, and all of a sudden you're investigating—

Chuck: One of the things that I discovered when I did the Polaroid nudes and the Polaroid flowers, both of which were really huge—I am obviously not the first person to deal with this—was flowers as a kind of sexual orifice. I found the Polaroids of the flowers far sexier than the Polaroids of the nudes, and I came to the strange conclusion that maybe since flowers are meant to entice insects, maybe insects are more discriminating than humans. It's harder to entice an insect than it is a person.

Eric: Do you mean that insects are less seducible?

Chuck: Maybe bugs are more careful than people about who they have sex with.

Eric: The thing is, the sex of the human is not necessarily the seductive part. It's not just the vagina to which we respond when we're attracted to a woman. Different cultures eroticize different parts of the body. For instance, the underarm hair for the Japanese is a big deal, or maybe the breasts or the belly button become the most erotic thing, with the vagina being the place you finish.

Chuck: The book Rizzoli did on me couldn't be printed in Japan because of the pubic hair. Yet in Japan they sell these incredible comic books that show golden showers and all kinds of other stuff. They are not at all prudish.

Bill: I will never forget the Jeff Koons show, the one with his wife. There were busloads of Japanese tourists there the day I was there, most in their sixties, and the women would stand in front of these huge pricks, sort of smiling and laughing, and their husbands would be taking pictures of just a part of the painting with their wives reaching toward certain areas. It was the ultimate tourist attraction.

Eric: First of all, there is a difference between eroticism and sexuality. Sexuality is a form of identification, self-identification; it's part of your psychology and emotional make-up. It's about identity. Whereas eroticism is about sensation, pleasure, fantasy, and things like that. It seems that, in order to generate eroticism, you can—again, it's like the cat, it's not the thing itself, it's the things you can make out of it, the things that remind you of it, like flowers. I lament that I'm not an erotic artist. I don't know whether it's a strictly personal problem or whether it's a cultural one that I inherited, but that kind of unabashed pleasure of the erotic life is something that I can't quite free myself up to.

Chuck: Well, it seems that what you do is more transgressive than overtly sexual, don't you think?

Eric: Transgressive in that it's about boundaries?

Chuck: Yes.

Eric: And questioning where those boundaries are?

Chuck: Right.

Eric: Yeah, exactly. That's well put. Yeah, but it's within the context of sexuality: sexual desire, sexual violation. What are the boundaries? Is what I want what they want? Is there a consensus here? It's true. I don't know. Maybe in my artistic evolution I'll get to the point where I can just paint a Bouguereau and let it go at that. And then shoot myself. [Adolphe-William Bouguereau (1825–1908), a French academic painter who, although immensely successful during his own lifetime, was viewed as an opponent of all progressive ideas. He painted portraits of photographic verisimilitude, slick and sentimental religious works, and coyly erotic nudes.]

Chuck: I would like to get to other issues. One of the things that has been discussed in all of the conversations with the painters, because I like to demystify the process a little bit, is how works get made and what working methods are used, how things actually get onto the canvas. I've been very interested in the kind of collage technique that you used to build those complicated images, the kind of tracing paper things that you do. Can you talk a little bit about how you construct one of those?

Eric: Well, the glassine paper—I don't even use it now—was actually my introduction to how to construct a picture, to create a narrative. What I discovered is that the way my creative mind works is by association. If I see a chair, the kind of questions I ask myself about the chair are not formal questions about the shape of the chair or the light and shadow of the chair, but are practical questions. Where is this chair? Is it in a room? Is it outside? Are there other chairs in the room? Is there a table that goes with this chair? Is there someone sitting in the chair? Is he standing next to the chair? Is he nowhere near the chair? You know. And then things occur to me and I begin to answer those questions. Yes, there's a table there. The chair is, in fact, next to the table. There is a person there. The person is not on the chair. The

person is standing next to the chair. The person is under the table. Why is the person under the table? You know, who would be under a table? Is it an adult under the table? If it's an adult under the table, what makes an adult go under a table?

Chuck: *Uh huh.*

Eric: Obviously, it's not entirely the same thing that makes a kid go under a table, so I begin to weigh those things. With the glassines I was actually doing that. I would put a piece of paper up, and I would say, "Okay, it's an adult standing next to the…" I would look at that. If it wasn't interesting, I'd take the adult away, and I'd make it sitting down, put on another one, and work it. What I found was that this process clarified my own way of constructing a narrative, and when I went into paintings, I used this same process. The difference is that no one could see the layers, the overlays.

Chuck: *Well, you did that a little with the separate panels.*

Eric: Part of the modernist thrust has to do with the image being transparent so that the process can be revealed, either through the painterliness, which shows the way the decisions were made, or the construction of the thing, which makes you aware of the surface, makes you aware of the scale, and those kinds of things. This is an idea in which I have willingly participated. It seemed a legitimate part of art making to have the audience both absorbed in the illusion and thrown back on the magic, the technique of creating the image. Collage was, to my mind, as radical a discovery to modernism as perspective was to the Renaissance. What perspective did to the Renaissance was give the mathematical solution to the way we see, illusionistically. It's a kind of abstraction. There was no happenstance there. Well, what the collage does is similar. It becomes a metaphor for the way we think rather than for the way we see; the way we think about things and then make that thought process visual. I think I discovered how natural that way of thinking was. When I was doing those paintings using the different panels, my thinking was that I wanted the audience to participate in the construction of a scene. I wanted to bring them into the creative process in more depth than the rectangle itself would allow with all the decisions buried underneath the final resolution. I thought that by using several panels, they could see the first thought, what was added to the second thought, that something was added to the third thought, and so on. You know, there's an idea in science of an elegant solution being the highest form of scientific thinking; that an incredibly complex thing can be expressed simply—$e=mc^2$ is the most elegant solution in physics. Simply put, it describes the entire working of the world. I stopped using the panels because the rectangle offers the same elegant solution to a visual problem. It creates a way of seeing that is not exactly the world, but in fact you take as the world.

Chuck: *From scale shifts, however, you created a much more crowded space as in the multi-figured pieces and the India paintings. That also is a product of the collage thinking, and made me think of Asian art and the Asian perspective.*

Eric: Non-hierarchical.

Chuck: *And non-preferential in some way, as in a Chinese scroll painting, or a Japanese piece; a bigger figure doesn't necessarily mean that it seems closer to you than a smaller figure would.*

Eric: It just means that it's more important.

Chuck: *Yes. There is a discomforting aspect to those crowded paintings, in which everything didn't have its own space. I thought it was very interesting.*

Eric: I was playing around with that sort of composition precisely for those reasons. It was a way of trying to reenergize a content with which I was familiar. How was I going to make subject matter with which I was very familiar more interesting to me? What could I change? What would help me turn a corner?

Chuck: *It seemed to reengage you. There's the look of change—this year's subject matter as opposed to last year's subject matter—or there's real change for the purposes of growth. It seemed to reestablish a sense of urgency that may have gotten lost as something became habitual.*

Eric: Right.

Chuck: *Fuck it up a little bit.*

Eric: I was thinking about that when I was looking at your current paintings, as opposed to your airbrush paintings. In the airbrush paintings, in order for the process to break down and become paint, you had to go up very, very close, almost microscopically close to the surface, to see how that was done. Whereas with your current paintings, the audience is met very quickly with the way it's constructed, almost simultaneously to the image, but from a far greater distance. The intimacy of the surface comes much farther out to meet you, which is a fantastic shift, and it's also a totally new energized way of doing it. Do you feel that? Do you at all understand it in those terms?

Chuck: *On one level, I was always decorating a flat surface, distributing paint on a flat surface. The question was whether or not the viewer saw the surface first or saw the image, and then went back and forth. These have a much more insistent flat reading that warps into the other, and then back.*

Eric: The image can be revealed, or the paint revealed to make the image.

Chuck: *They've always been big and kind of aggressive, especially the ones with white backgrounds, the early ones. The white background agreed with the wall. That pushed the figure ahead of the wall and made it come into the room with you and made them seem aggressive. The minute they had a color in the background, they became a window in the wall, they were like the Jolly Green Giant outside a house looking through a window. That made them seem less aggressive, because they didn't come into the room with you. There have been some other changes along the way that have influenced the way we address the painting and a proper viewing.*

Eric: Well, do you think these have a more traditional sense, a more traditional function as art, in that they reassert the idea of the painting as a window?

Chuck: *Yeah, but with the early color paintings, for which I built a full color world by superimposing three one-color paintings on top of each other, all the colors were built in a very similar way to the way these are, but those colors were superimposed on top of each other and disappeared. Here, the colors are spread out next to each other and mix in your eye and mix in your mind really. I couldn't have made these color decisions had I not spent so many years making a complicated color out of three simple colors. It's really the experience of that—*

Eric: Frankly, I was completely amazed at your color sensibility when I saw these paintings. I mean, if someone had asked me before whether I thought you had a color sensibility, I would have said, "No way." *[laughter]* Maybe a literal color sensibility, flesh looks like flesh or something like that, but when I see these—

Chuck: Before the flesh was flesh colored, it was red, and it was purple, and then it finally got to flesh color, so it was artificial before it was natural. When you look at the initial stages of one of these paintings, I do sort of a fauve painting first—the underpainting looks kind of like a fauve thing—and then I sort of "tame the wild beasts" with the color that goes on top of it, but that's more a case of pushing. It's more interesting to move from one color to another color than it is from a white background to a color.

Eric: Also more complicated, I would think.

Chuck: Yeah.

Eric: With one color painted on top of another, you arrive at these weird colors in between the final ones, but they're not from decisions that you are making, they're things that occur because of the overlay, whereas here you first have to see and break down more color than actually is in the photograph, and then you have to invent that, and then you have to shift relationships by mixing values and hues and—

Chuck: The other thing I like about these is that there's no drawing other than the grid, so at the same time that I'm building the color world, I'm also having to put English on the stroke to give it a diagonal nature or make it contract, simply because I have to build the shape and the structure at the same time that I'm arriving at the color. That's sort of interesting too, because they end up having their own vocabulary.

• • • •

Eric: I don't really have a solid response to [my painting] because it was done and shown at the same time as April's, and everybody talked about April's painting *[laughter]*, so I kind of looked at mine like, "Well, what's wrong with it?" I mean, I've had my portrait done twice, but I don't actually have any idea how people see me, I have no sense of that. Part of it is that I don't know how I see myself, so I can't imagine that somebody else sees me in any other way, you know, which I'm sure I'm wrong about. You know, I just don't know, so it's always a surprise to me. Plus, I find it embarrassing to have somebody else see me.

Chuck: You know, it's funny. I have never painted people who see themselves clearly, who present a specific persona, with the exceptions maybe of Lucas and Cindy, but she is so self-effacing that she becomes someone other than herself. I would have a hell of a time painting Julian [Schnabel] because he's so busily presenting himself in a bombastic—

Eric: There's no place for you in there.

Chuck: There's no room for me.

Eric: You either accept it or reject it.

◆

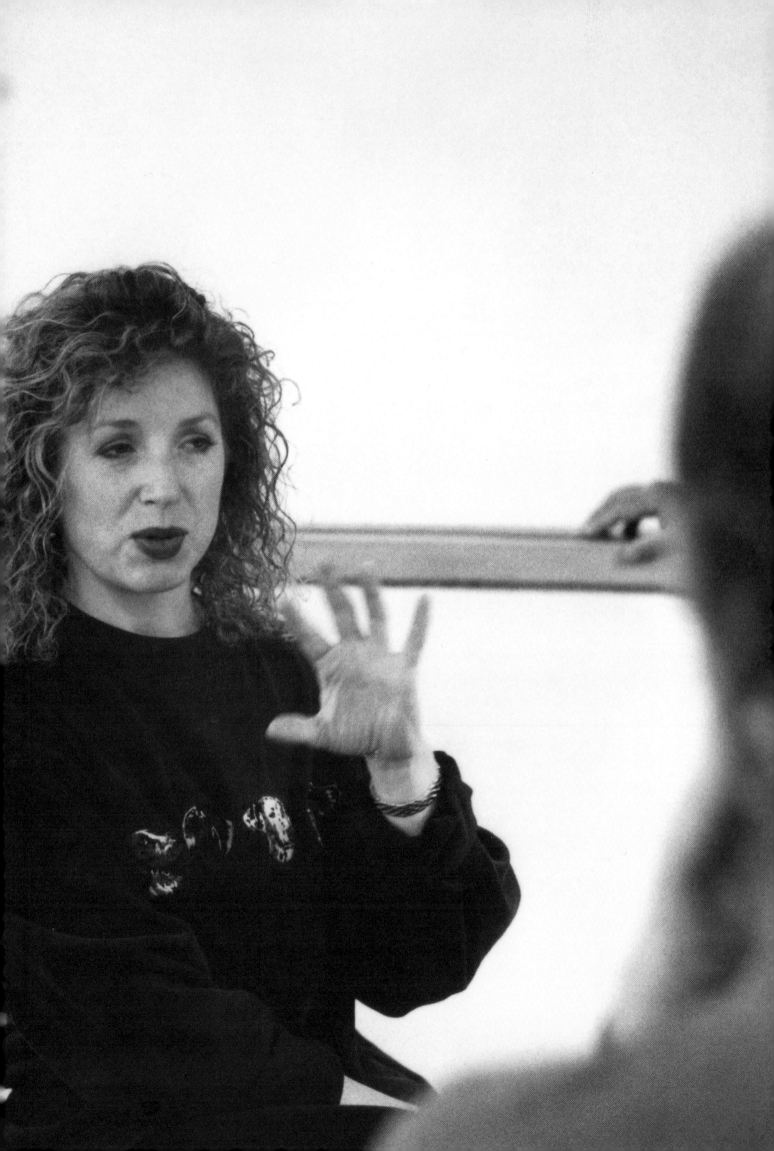

April Gornik

New York City, March 16, 1994

Chuck Close: I've known a lot of the people I've painted better than I know you. One of the things I find interesting is painting people with whom I am personally involved as well as people with whom I'm involved through their work.

April Gornik: Do you find a difference between painting them? Do they come out differently?

Chuck: I think sometimes they do. I probably have more of an arms-length distance with the people I don't know as well, whereas with those I know really well, the paintings end up looking more like them than the photographs do. Somehow, everything that I know about them gets in there.

April: You add character lines.

Chuck: Without realizing it. I try not to editorialize, but sometimes I can't help it. Alex [Katz] thought I had captured his rage somehow. So, what's lurking underneath your surface, April?

April: Where's my shrink?

Bill Bartman: The painting is the shrink.

Chuck: Not only that, but I've painted Eric [Fischl] too, so feel free to analyze Eric through his painting as well.

April: Oh, may I? That would be easier. To one's own self one is always going to be more confused. That's for sure. I think that my surface doesn't show a lot of the stuff that goes on with me, but I'm not really sure what my surface looks like. I'm not a person who has a clear sense of what I give off. For instance, I've been with a group of people and gotten really irritated at someone but not said a thing, and afterwards a friend would say something like, "My god, you really iced that person. You gave him such a look," and I would think, "Oh, it showed that much?"

Chuck: I should be looking for a sign that you're angry at me.

April: I don't know. Do you really think you can tell much about people from their faces?

Chuck: I think that a person's face is ultimately a road map of his life. If he has laughed his whole life, he is going to have laugh lines, but if he has frowned his whole life, he's going to have furrows. Other than that, there's not much. I look at people I know really well and then remember that I did the painting, but when I see you now, I see the painting much more—

April: Because you have a longer experience with those you know well.

Chuck: *Plus, it's more recent.*

April: We've done less hanging around talking.

Chuck: *When I look at you now, I'm looking for all the things that have changed, like a different hair color or whatever.*

April: Let's see what has changed: a few new lines, all laugh lines of course.

Chuck: *I don't know if you know that one of the learning disabilities I have is my inability to recognize faces. I have a terrible time. I never know whom anyone is. I can spend a whole evening staring across a dinner table at someone, riveted by everything that they are saying, examining everything about them, see them on the street the next day, and not have any recollection of having seen them before. I think that's ultimately why I end up scrutinizing a photograph over and over. It's already flat, and it's easier to remember something flat.*

April: Maybe you're not remembering the face. Maybe what you take away from that is the course your eyes took over the face rather than an image.

Chuck: *I don't know. It's awful. Also, I have to keep seeing people all the time, even those I know well, to reinforce it. Otherwise, I won't recognize someone with whom I've lived for years.*

April: Really?

Chuck: *Yes.*

April: Wow. That's quite an excuse. I have the exact opposite problem. I remember absolutely everybody's face but nobody's name.

Chuck: *I don't remember the names either. Try getting along in the world when you can't remember who anybody is, their name, address, or telephone number. You can't look the person up in the phone book because you can't remember their name. You don't know where they live because you don't remember an address. If I were the ayatollah, everyone would have to wear a name tag printed in very big print: "Hi my name is ___," sort of like at a convention.*

April: "Hello my name is ___." I'm sorry, but I have a fashion restriction against that.

Chuck: *I'd really rather their names be tattooed on their foreheads—something that would be permanent.*

April: I think your paintings reveal about as much about you as mine do about me. I mean, neither of us is really very revealing. Eric reveals a shit load of stuff about himself, a giant amount of information, if you look even a little hard.

• • • •

Chuck: *When was your first show?*

April: 1981.

Chuck: *I was telling Alex that I really appreciated the fact that he had sort of kicked open the door for an intelligent figuration or representational painting that wasn't backwards looking, that wasn't retardataire, that wasn't rooted in all sorts of shop-worn realist traditions, and so forth. I think he really managed to make a thoroughly modern painting.*

April: I think so too, with a little bit of thanks to the pop tradition, but he went beyond it into his own little realm. I don't think it's anybody else's.

Chuck: I don't know what kind of work you used to make. How did you find entrance into the work that you're currently doing? Painting is always dead. Every few minutes they pronounce painting dead. Figurature or representational painting is always sort of suspect too.

April: Well, painting was so dead when I started painting that I actually painted with house paint and glued together pieces of wood to make rectangles on which to paint. I had an aversion to painting on canvas stretched on wood. It just seemed so terribly traditional. If I look at my leap into landscape painting—to me it seems like a leap—with a broader perspective, I have to say that there were intimations going on before the leap. I did minimalist hard-edged color paintings when I was in school; I got into a really bastardized conceptual art thing during which I was taking photographs, and reading a lot of Claude Levi-Strauss and Marx, and trying to make remarks about who I was. I didn't know then, so how can I explain it to you now? I was searching and trying to do the right thing.

Chuck: Where did you go to school before Nova Scotia?

April: The Cleveland Institute, and then I transferred up to the Nova Scotia College of Art and Design. It was such a hotbed of conceptual art activity then. I transferred up there because I decided Cleveland was too boring and too dull, and I needed more stimulation. I very impetuously threw together some slides and a hastily and sloppily written application in order to get into the school. I sent it up, and, of course, they loved it because they were into that kind of rebellious stuff. "Oh yes, come right on up." So I finished my last year there, and I guess in a similar spirit of the rebelliousness that took me there, within a semester I started to reject all the things that they were doing. It was "No, no, a thousand times no" to everything that was going on. There was a point at which I thought trying to make art that illustrated methods of cultural analysis like structuralism, or historical analysis like Marxism, so that the art would seem smarter than it was. It was so stupid, so unsmart that I kind of threw it away. I started to investigate things in a more poetic vein. I really just floated for about a year or so. I was interested in the idea of making objects that had light in them or on them, or had a reference to light. I was using all kinds of scraps of metal, anything that came up. I allowed myself to use house paint in my studio. As long as it wasn't real oil paint, canvas, and material like that, I would use it.

Chuck: We make all of these funny rules for ourselves.

April: Oh, I had thousands.

Chuck: As if anybody else cared, especially in school.

April: Nobody gave a shit. I was living in Nova Scotia, it was 1977, and there wasn't a soul around. I was out of school. I was waitressing. I was just hanging by myself. I mean, I had met Eric, so I was still kind of vaguely connected to some of the faculty who were friends of mine, but as far as learning what I was doing, I didn't have a clue. I was working in my studio one day, and I got an image in my head that I felt like making. It had been a long time since that had happened to me—maybe never—so I took pieces of one by fours and glued them together; I cut them off and made a rectangle; I drew out this image; I painted it in; I stepped back; and it was a landscape. I looked at it, and basically my first thought was, "A landscape, oh man. This is really bad. The first thing that comes to mind that I really want to do in my life and it's a landscape." It was the most *retardataire,* the most black-sheep genre of art history, a bad idea.

Chuck: It may have been even dumber than painting portraits. It's right in there. It's a tossup.

April: It's less taught in art history classes than portraits.

Chuck: I'm not big on dead fish and other kinds of still life either. They're all pretty stupid.

April: Anyway, I thought, "Now what do I do?" But I didn't have to figure it out because I was in Nova Scotia, and there was no one around, so I made some more of them. I stuck to my principle of not using canvas. Finally, I started using sheets of plywood so I wouldn't have to glue one by fours together. You know, artists' minds don't work the way other people's work. Right away, the paintings started to have more light, more space. I started doing these things that were at the furthest end of the spectrum from what I could have been doing. When I moved to New York, I tried to paint interiors because I thought, "I just can't paint landscapes in New York, it's too embarrassing." I started painting interiors, and I made myself do that for three or four months. I was the most unhappy person. I was unhappy because I was living in New York and I had no money whatsoever. I was waitressing and killing myself just to survive, plus I was making myself paint things that I hated. Finally, I started painting things that I liked, which were landscapes again. They just kind of evolved. The first people I bravely invited into my studio after living in New York for about a year were more than sympathetic. The *New Image* show at the Whitney had just opened. Some of them were actually enthusiastic about the work, and I started to think, "Well, I can do this." Now, of course, we're back to the conceptual thing.

Chuck: I think people are starved for painting again.

April: Do you think that just because I've been saying this?

Chuck: No. Young artists seem to be really interested.

April: I knew it would come around. It always does, but you just don't know when.

Chuck: I've lived long enough for painting to have been declared dead about five times. When I came up, painting was dead too. Nobody was interested in it. Everybody wanted sculpture. Nothing could have been further out of it. Painting was way out of it, and representational painting and portraits were gone.

April: I remember your work from school. There was a guy who was in some of my classes who was obsessed with your work. He was doing portraits painted with pencil eraser tips and stuff. He made me address your work early on more than I would have otherwise. To me it's amazing that painting could be dead again so soon. There's just a ten or twelve-year gap. I opened up a Canadian art magazine that featured a lot of American art, and there were artists who were making childish scrawl, childish handwriting art. I thought, "I just can't take much more of this revisionist junk that's going on." Then I thought, "Don't be such an old fogy. They have to go through it in their own way. Let the kids get through this stage. Then they'll go back to painting." I've been saying to people for about a year now that painting has to be coming back any second. It's just too thin out there. I mean, there's not enough air to breathe as far as I'm concerned. Going out to galleries is like going to a high altitude.

Chuck: When there is a show of paintings, it seems to get more attention than expected.

April: Everyone is talking about Lucian Freud, for instance. How did you like it?

Chuck: Actually, I was underwhelmed by the show. I think the paintings that he does best are really small. There were a few early paintings in the show. The period that I think is most interesting is the

middle period in which they're thick but still quite modest in scale and when it seemed to me he real-
ly handled the whole rectangle. Now that they've gotten big, the figures are all gloppy and clunky, and
the backgrounds are so splashed in.

<div align="center">• • • •</div>

Chuck: There was a Freud retrospective in Washington about seven or eight years ago. I was real-
ly blown away by that show. He's done larger scale paintings since then. I think he's an interesting
painter, and I liked the show. I just prefer his earlier work. The other thing is that he seems to have
gotten just a little formulaic. All the figures are so clotted.

April: His palette is entirely formulaic. Absolutely.

Chuck: If the thickness of the paint is because of struggle, doesn't he get any part of a painting
right to begin with? It's as if he has to get the surface up before he can make the painting.

April: I think a lot of paintings were seriously overpainted in "the emperor's new clothes"
fashion. Very few people actually mentioned it, but I think there was a huge amount of over-
painting going on in that show. I love the most recent ones though. I love the one of the big back.

Chuck: I think he's really interesting. I think it's funny that Robert Hughes, in the last twenty years,
has pronounced three different people the world's greatest living realist.

April: Have you ever been one of them?

Chuck: No, I was never one of them. They were Lucien Freud, Balthus, and Lopez-Garcia. He has
written articles saying that each of them is the world's greatest realist.

April: Let's have a paint off: get them in the same room, and have them tear each other
apart. I had a secret ambition for the Freud show. A couple of months before it opened in
New York—Eric had already seen it in London—I said, in a fit of aggravation, "I'm making a pre-
diction right now that with the advent of the Freud show the art world is going to turn around
again and painting is not going to be dead anymore. People are going to be looking at painting
and wanting to be looking at painting." I really want it to succeed for the crazy reason that I
made this bold prediction.

Chuck: Since you mentioned it, where do you think the art world is today?

April: At best it's in a healthy pluralistic state of confusion that allows for a lot of different
things to be seen; at worst we're back to something that is going to narrow itself down.

Chuck: I like the lack of focus.

April: I do too.

Chuck: I think it is rather like the seventies, which was a decade that I liked for the fact that a lot
of different things went on at the same time.

April: I think pluralism is entirely healthy. The idea of the neo-expressionist boys' club hap-
pening again really doesn't interest me at all. It's just too stifling when that happens. Not that
there wasn't some exciting painting happening and it wasn't all boys, but there's a kind of atti-
tude the art world gets into when that's happening that annoys me enormously. The critics
seem more powerful, and they're given more to work with, because they have the illusion that
they're living on the top of a heap at a certain point. I just think that's really unhealthy. I think

the recent winnowing out of the high prices was good. I've suffered like everybody else, maybe less than some people, but I still think it's a good thing. What's your take on it?

Chuck: I think in the long run that it could be a healthy thing for the art world once everything settles down. I think that for the young artists, after a period of raised expectations that the art world owes them a living, and a rather handsome one at that, all they have to do is make the right moves. I think it's a lot easier coming up when you assume nothing is going to happen, and then you are pleasantly surprised when it does.

April: I'm just realizing now that, when I talk about how much I like a pluralist state of affairs, obviously I have a vested interest in it myself. My work has always been idiosyncratic, and it doesn't look as if it's going to go in a more mainstream direction, so I feel that pluralism gives me the room to be appreciated. If things get narrow, I'm afraid of being pushed out.

Chuck: Absolutely. Arne [Glimcher] was lamenting the death of the connoisseur. He said that in the old days collectors would come to town from Chicago, for instance, go to ten galleries, and say, "Show me interesting work, show me interesting drawings." The galleries would bring out stuff to show them, and before they went back to Chicago they may have bought work by those people. They defined themselves by the work that they assembled, and there were these great personal collections. These people explored their own interests and tastes. Unfortunately, during a very focused time when everything seemed to clearly define who the art stars were, I think buyers were shopping with a hit list. They would go to a gallery and say, "I want to see so and so's work," and that's the only stuff they would look at. Then they would go to the next gallery and look at the next person's work. Everyone was after the work of the same eight or ten people. The list may have changed a little. One year's list was slightly different from the next year's. People who fell out of the mainstream, or were idiosyncratic, or were doing something that was out of phase or favor at that particular moment just totally fell by the wayside. I think it's true that the healthier the art world, the more (as far as artists are concerned) pluralistic it is.

• • • •

Chuck: I try to demystify the working process a little bit. Would you—could you—talk a little bit about your working method? How do you end up making what you make and—

April: How do I end up with the image or—

Chuck: Yeah, the whole thing.

April: Well, as I said, when I first started doing landscapes my inclination was to paint them with found paint, like house paint. I first painted them on boards, and then I switched to plywood, and then they quickly grew to be the size that they are (around six by eight feet), because I really like to go into the space physically. I like to be able to literally move into the work in a certain way. Eric once said, "Oh, you have to see Arizona." People had been telling me about the desert for years, because a lot of the images that I was cooking up were desert images that I hadn't actually seen.

Chuck: That you were cooking up?

April: Yeah, that I was inventing. Then we went out to Arizona in 1980 or '81, and when I saw

the landscape there I realized that I was looking at something more amazing or as amazing as anything that I'd invented, and I started taking photographs. That's when I started to work from photographs as well as from my imagination and from dreams that I had. I had a lot of landscape dreams when I first started painting them. It was as if the old floodgates of the subconscious—

Chuck: Isn't it amazing how, when you start doing something, you start seeing that stuff everywhere?

April: Oh, it's fantastic.

Chuck: When I'm painting black and white, the world becomes black and white.

April: Yeah.

Chuck: When I'm painting in color, all of sudden I start seeing color everywhere—

April: Yeah.

Chuck:—and I hadn't seen it at all when I was doing black and white.

April: I know. It's the weirdest thing.

Chuck: And people start sending you postcards of landscapes—

April: Yeah.

Chuck: —that look like yours.

April: Right. One of the best compliments is when someone says, "Oh, I was driving back from such and such a place, and I 'saw' one of your paintings. Let me tell you exactly what it looked like, because I think you'll want to paint this." They have the impression that, if they describe it succinctly enough, I'll actually be able to have their experience of what they think my work is like. It's a nice circle.

Bill: Do people ever ask you to paint their own land?

Chuck: A commissioned portrait of their land?

April: Just this summer it happened a couple of times. I actually went to look at a piece of land because I thought, "Why not, I should see if it's really amazing." I took some photographs, and I told the dealer who had been approached by the landowner that if I made a painting of that land, and it turned out to be a painting that we both liked, she could buy it, but I wouldn't do it on a commission because therein lies madness.

Chuck: Yes. [laughter] Tell me about it.

April: People will tell you that they want something, but they have no idea that you can't see into their heads and do the things that they're imagining. Then they are disappointed.

Chuck: Well, I'm sure people are as proprietary—no pun intended—about their property as they are about their faces.

Bill: Or their dogs.

Chuck: Yeah, Bill Wegman wanted me to paint his dogs. Can you imagine opening that door?

April: Anyway, when I started working more from photographs—

Chuck: What percentage of the works are out of your head, and what percentage are based on photographs, or are they a little of both?

April: Well, they are a little of both. Even when they're really from a photograph, I always alter the image in a very important way. Sometimes I'll have a photograph, and I'll use a little tiny corner of it, some light situation that's happening. I will suddenly see a painting and then draw it out.

Chuck: Maybe an edge where an object meets the sky or something? But you don't paint that exact situation.

April: No. It could be something that the photograph reminds me of, or it could be a tiny piece of the photograph, the rest of which is wrong for what I want to make, and then I'll just kind of continue from there. I don't feel any hesitation about taking over a found photograph either, you know. I believe that it's my image, and someone else just accidentally spotted it.

Chuck: Did you see The Lightning Field *[referring to Walter de Maria's land sculpture] when you were out there?*

April: No. I wish I had, but we're probably going to go to Santa Fe at New Year's, and maybe we'll get over there and drive around. I've never seen New Mexico. I've only seen Arizona, and I hear it's different but equally spectacular and magnificent, so I want to check it out. Monument Valley is my favorite place out there. It's like the Ryoan-ji, the famous Zen rock garden, only blown into this immeasurable size which, when you look at it, somehow collapses back to the size of art in your imagination. It's so wondrous that the place exists. I can't tell you. It's my favorite spot. Do you think of your work in terms of landscape at all?

Chuck Well, I did initially. When I did the Big Nude *before I started the portraits, I was trying to make every piece of the painting equally important, but there are hot spots, especially the genitalia, to which people gravitate. It was hard to make a kneecap as interesting as any other part. The way that I was able to force myself to do that was to treat the piece as if it were a landscape. When you're walking through the landscape, each step is part of the trip. You may have your eyes on the mountain in the distance, but you have to navigate the terrain, and so I began to think in Brobdingnalian terms—a kind of* Gulliver's Travels *of what it would be like if a little person crawled across the surface of a face not even knowing what it was that they were seeing or what they were on. You know, they would stumble over some beard stubble and fall into a nostril and have to crawl out of it or whatever.*

April: Right, right.

Chuck: It helped to be able to disassociate the parts from the whole and look at each piece as a separate experience, a separate unit to be dealt with. I often lost track of what part of the face I was actually working on. The features that we normally think are important, the eyes and nose and mouth, became no more important than an earlobe, a piece of cheek, a shoulder, or whatever. So I did think of them as landscapes. I always thought of them in some way as landscape surfaces.

April: I was really curious, because I think that when I look at your working methods, the way that your work accumulates, in some way in my mind's eye I experience it literally as an accumulation. When Eric is painting a figure, there's a very obvious hierarchy. One thing is more important than another. When I'm painting, I always feel I have to stay keyed-up, in terms of attention and concentration, so that even when I'm painting a section that's far away from the main event, as it were, the whole painting stays keyed up at the same level so that I don't lapse. It's not really about a hierarchy in the same way, which I find incredibly satisfying. Maybe it's more Oriental or something.

Chuck: My other interest in landscape comes from studying geology when I was a student. I loved mapping, and there's a mapping aspect to what I do. I love reading topographic maps and figuring out where things are. I love driving on the highways, going up the Taconic Parkway; I love the Northway

north of Albany up towards Lake Placid where my kids go to camp. I love the cuts of the highway through mountains where you see the strata, and I love to follow the strata and see it dip into the ground and then re-emerge two or three miles later, and maybe what was below is now on top because it was folded over. I think that stuff is so incredible. We have a primal relationship to the land, the "earth mother" kind of thing. I think your work hinges on that. It has to do with its nonspecific qualities, with the fact that it's not readily identifiable as any particular piece of landscape.

April: Right. Although there are people who come into a show and say, "I can't believe you've been to Winginaga, Wisconsin. I grew up there. When were you there?" "I'm sorry. I was never..." The way people possess the work and make it specific to themselves is what's so nice for me.

Chuck That's right. You know, one of the great advantages of representational painting is that instead of just bringing art baggage to look at the work, viewers bring their life experiences. Everybody has looked at faces. Everyone has experienced landscapes. They are possessive of experiences that are personal. You know, "This must be my landscape you're talking about."

• • • •

Chuck: How about resistance? I always thought that at the Olympics there should be a set of scores for what you accomplished and another set of scores for the degree of difficulty.

April: You think that they should do it for artists?

Chuck: Yeah.

April: To us?

Chuck: Right. One of the real enemies of art is ease. It gets so easy to do and so easy to get an effect, and it becomes very repetitive, very formulaic. You just sort of do it over and over. There is a need to build resistance into your work in order to keep yourself on the edge.

April: But don't you find that you do that to yourself, almost as a torture? I mean, it feels like torture, but I'm sure it's actually protective.

Chuck: What difference do you find between drawing and painting in terms of ease or difficulty?

April: Oh, it's so hugely different. Drawing is, for me, much easier. Easy is really the wrong word, but it's easier than painting, because if I treat the paper with a certain kind of respect and kind of play off of it, it gives me light. When I'm painting and dealing with liquid color of a difficult viscosity, which I think is the case with oil paints, light has to be concocted from scratch.

Chuck: It's also different because to make a drawing you have to save the white of the paper or pretty soon you won't have any white, but you can always stick more white in an oil painting.

April: I guess that's true. I'm one of those people who, when working on paper, feels a kind of—I don't know—grateful relaxation with the paper. The paper and I can interact, it will hold light. Watercolor has never terrified me. I like to do watercolors. I don't find it horrible that you can mess them up so easily. I kind of like that tension, but there's a moment in oil painting when, with the wrong move, the surface can go so dead so fast, and then you have to get back into it and bring it back to life.

Chuck: I think that's one thing that's not generally appreciated by the non-painting public.

April: Oh, absolutely.

Chuck: They don't understand the difference in physicality. It's something that we sense and feel but not something we're always aware of. I think that if the viewer has shared the experience with the painter of having made paintings or drawings, his entrance into it is different.

April: Completely different. The public isn't taught. They're taught how to read literature, but they're not taught how to look at paintings.

Chuck: Well, they're taught how to read iconography. Art history teaches iconography.

April: Right.

• • • •

Chuck: Does work flow relatively freely for you?

April: Well, I'm not the sort of artist who goes into my studio and works for three days straight and then collapses for two weeks. I'm the sort of artist who works four hours a day, every day, all the time.

Chuck: Boy, does that sound familiar.

April: I'm just not one of those romantic, driven people. I mean, I'm driven. I'm more than driven, but—

Chuck: You don't wait for the muse to strike.

April: No, no, screw that. Consequently, I'm sure there are probably days when I should just leave it alone, but I get crazed if I don't do something.

Chuck: I look back at certain paintings, and I know that they were done during really bad periods, but I can't determine the difference between the days when I was really cooking and everything was going easily.

April: I've had paintings—I swear to God—that painted themselves. I would start off just as nervous as usual and—I always do an underpainting and then work up and up and up from that—get it going and all of a sudden the thing would just take off with me behind the brush. Then there are other paintings for which I felt as if I knew the image, but three months later I would still be tearing my hair out. I wouldn't know why this was happening. It had been so clear. What happened? What went wrong? That's just as likely, and I never have a sense of when that's going to be the case. It drives me nuts. Also, it seems to me that it takes longer and longer to finish work. You were talking about how you put pebbles in your shoes to keep that little edge going? I don't even try and it happens. It seems as if it's getting harder to paint. Why should it get harder to paint? I know how to paint better, I think, but I'll start something, and I'll just get so involved in it, and—

Bill: Well, as you get older, your thoughts become more complex, and your life experience is more complex. Nothing ever seems to get easier.

Chuck: It's interesting to watch careers from that point of view when someone peaks early, and that's their best work, and then they sort of go into a period of decline, trying to keep all the balls in the air year after year, decade after decade, and still approach the work in a non-formulaic way. I think it goes back to some of the things that we were talking about before: whether one is performing in

the white hot glare of the spotlight—you know, the kind of problem that a lot of artists of the eighties had with the intense superstardom and the public waiting to see what they were going to do next.

April: I wish I'd had that problem for a couple of years, just to say I had been there.

Chuck: But it's a real problem. It could be a real problem, and I think there is a tremendous advantage idiosyncratically to be outside the mainstream.

April: Well, I've always been there.

Chuck: One can watch the slow and steady evolution of an artist's work and then, all of sudden, say, "Oh God, look at the body of work this person has produced over a long period of time." What do you think of Church, Cropsey, the Luminists?

April: I think they were really operating on a kind of pantheistic idea about the land and how it represented the grandeur of God. But, you know, it necessitated showing the diminution of man too. To do that, they always had to have the teeny-weeny Indians, the little Inca with his llama, walking up the side of the volcano. My work is actually the exact opposite of that, because it's really about scalelessness and not being specific. It's about the viewer looking at it, being able to go into it, and determining his own scale in relation to the paintings. It's a very important difference.

Chuck: I have a theory about growing up in the west, growing up surrounded by mountains. The suicide rate is much higher amongst people who live in the mountains. I think it's because they feel overwhelmed by nature. You're this insignificant little creature, surrounded by all these things that nature or God wrought, and it tends to make you feel insignificant. When you live in a city like New York, you're also surrounded by caverns, but the mountains were made by man. It's an indication that people are in charge of their own environment. They can build their own environment. That may be one reason why artists gravitate towards cities. In the mountains, if you look out your window, how can you compete with what God made? Well, those nineteenth-century guys celebrated that. I think you're right, the diminution of man and—

April: I think that's much more of a nineteenth-century notion, and I think that my notion about landscape is very uncontrollably a twentieth-century one. They felt that they didn't do the landscape justice unless they put in as many blades of grass as possible, Martin Johnson Heade being the big exception. He's the person to whom I feel the most kinship. Did you see those paintings at the Met yet? There's a show of his thunderstorm paintings. He's great. He did a painting called *Thunderstorm over Narragansett Bay*, which is a particularly nice one. It has these literally black thunderclouds and rain coming down on one side, and the water reflected is absolutely black. It's really quite radical. There are a couple of sailors trying to bring in their boats or something like that. I think he had more of a sense of abstraction in his work than any of the other artists of that period.

Chuck: What about Turner or Albert Pinkham Ryder?

April: I love Ryder, but I'm not completely crazy about Turner although I've seen some paintings that I like a lot. We were talking about making the entire surface of a painting active. In the case of Turner, I sometimes find that the whole thing is so active it loses its momentum in some way. I've been struck by a lot of his paintings, but I'm not a big Turnerphile for some reason.

Chuck: How about the impressionists? Monet's landscapes.

April: Oh well, I love those *Morning on the Seine* paintings from Giverny. I think those paintings are amazing.

Chuck: I was just in Paris, and I went to Rouen to see the cathedral. There were about twenty of the paintings there. The cathedral is really clean now. If Monet had painted it when it was clean, there would be an entirely different set of paintings.

April: Yeah, I bet.

Chuck: The building is white now. We were talking about active all-over surface.

April: Monet is a great example of all-over surface. But Turner—I feel as if he pushes you out a lot. There are little hierarchical moments that don't always build. I know that he's a good painter, but my all-time favorite painter is definitely Matisse. I know my work doesn't bear any resemblance to his work but—

Bill: You must've gone crazy during his show at the Modern.

April: I went about four times, and, luckily, two of those times were with private groups, so the museum wasn't crowded at all. I went to the Morocco Room and just stood there. The second time I went back, I thought, "Okay, I'm going to go in there, try to disassemble these paintings, and figure out how the things work. There's got to be some clue to their seamlessness. There's got to be some chink. There's got to be some flaw." I felt that if I were less smitten, if I could just allow myself to be a little colder towards them, then I could look at them in a harder way. I wanted to see if I could break them down, because I was so blown away by them, but the longer I looked, the more blown away I became, and I was so happy. I don't think anyone uses color like Matisse, and it's hard to imagine that someone else will, because it's such a perfect integration of light and form and color.

Bill: Alex [Katz] said that he has finally gotten to the point in his work where it's almost like a haiku. He knows how to do it. He can sit down and actually do a painting straight through, and he doesn't have to think about it. The process of making the painting is so easy for him that he can just paint ideas.

Chuck: One of the things that I found shocking while talking to Alex was when he said that he has trouble sustaining a painting that takes three days. For him, that's like—

Bill: He tries to do a painting every day.

April: You can translate this as hysterical laughter. Yikes!

Chuck: His whole working method is so antithetical to what I do. He does a little preparatory sketch. Then he mixes the paint that goes with that. Then he does a drawing. The drawing is pounced up onto the canvas, and then he paints it sort of wet-into-wet—all in one sitting.

Bill: He said that it's like haiku: once you learn how to compose one, you can simply sit down and write a haiku every day. He literally talks about doing a painting every day.

Chuck: That's something that I don't think nonpainters really understand. They look at the end product but don't factor in issues like whether this is the product of years of experience that is distilled and then done directly, or whether its creation required maintaining the same attitude from start to finish over a very long period of time. We don't think, for instance, that there's anything odd about a writer spending a year to write a novel and having to maintain the same attitude, the same voice, throughout—to remember when he's writing the last chapter what it felt like when he wrote the first

chapter. It is a very different working method to work for a sustained period of time and build something slowly, increasingly—to add more and more until you're eventually finished.

April: I know what you mean. It takes me two months on average to make a painting, and I feel as if I am slowly building something that will contain all that intensity and eventually generate it back to the person seeing it or living with it. I think of painting as building elaborate machines that, if working properly, will keep generating, will keep producing the same complex emotional and visceral responses that inspired me to make them and that I experienced while painting them. Active containers.

Chuck: Work habits are so interesting. When Al Held was doing what I think are some of his best paintings—the paintings like Mao *or* Ivan the Terrible, *the early geometric things with some big shapes—he found a way of working in which he repainted every square inch of every painting every day. He didn't want any old painting that hadn't been reassessed or changed to be peeking between new painting. The brilliance of this method was that if he was happy with an area of a painting that hadn't been reassessed and brought up to date, he would force himself to paint it again in the same color.*

April: No kidding.

Chuck: But as long as he was going to repaint it anyway, he might as well change the color a little bit or change an outside edge, and if he didn't like it, he could always go back and do what he did before. It forced a different kind of thinking. When he finally got what he wanted, it was all lumpy and everything, so he would sand the whole painting down and repaint the final painting on top. Isn't that interesting?

April: I had no idea that was what was going on with those. What does he do now?

Chuck: Well, I think he still does a lot of that work. I know he has to sand the paintings down. But the viewer comes in, looks at the result of the last surface, and has no idea of how it got there. That's why I think we prefer to show our work to people who have had that shared experience, who know something of what it is to build a painting as opposed to just painting it. The analogy that I like to use is of a magician performing in front of an audience of other magicians. Does the audience see the illusion or do they see the device that made the illusion?

April: The beauty of the device. Right.

Chuck: Maybe they see a little of both. That's when it really gets enjoyable.

April: I think something on a surface accumulates meaning and intensity and detail differently than something that's moving in time like a movie.

Bill: Do you guys find yourself looking at technique rather than actual paintings?

April: Well, let me start with Chuck's work. When I look at it, I'm amazed at the effect of the accumulation. It has this incredible kind of mystical balance, and I definitely am amazed by his work. By contrast, there's a lot of work out there that is just so flat.

Bill: Right. But what I'm asking is, when you see stuff you really love, does it transport you?

April: It's a little like Chuck's magician analogy. You've got to be amazed at how someone can turn the corner in one section of a painting and make the whole thing work differently. This frequently happens when I am near the end of a painting—I'll change one part and the whole thing will suddenly lock into place. You can sort of see paintings "work" when they really work, how one part can be a fulcrum on which the rest moves.

Chuck: When you read a novel, you obviously have the narrative line that's being spelled out for you, but there's also the sheer pleasure in the way the words trip off your tongue. Some people are great wordsmiths. They shove words together in a way that's physical, and you just love the way the words bump into each other.

April: Some authors have a more invisible style. Did you ever read *Blood Meridian*?

Chuck: No.

April: Cormac McCarthy. He's a very lyrical writer, and he can really craft things beautifully. He has this amazing way of using words, and he'll make up words when he needs to, but not to a fault, as opposed to someone like Robert Stone. I'm thinking of a book like *Outerbridge Reach*. The whole thing is sort of invisibly crafted, and it hits you like a sledgehammer. It's so powerful and so astonishing, yet you don't feel strain or the effort of the technique.

Chuck: Right. Some things look as if they just happened.

April: Yeah, and that's another kind of beauty and another kind of accumulation.

Chuck: Another set of choices, too.

April: Yeah, or proclivities. There must be those kinds of people. For instance, I'm the sort of person who doesn't leave a lot of false starts evident in my work. It's interesting how certain things are admired in art that are different in literature. I think we have a romantic notion about abstract expressionist paintings in which drips are left over and the struggle of the artist is apparent. You know the artist struggled because you can see the evidence. It has a certain kind of romanticism.

Bill: I just think it's so wonderful to hear people talk about this kind of stuff.

April: Well, it's nice to hear artists talk about art, because, obviously, critics can't and don't.

Bill: Well, the "critic" doesn't mean anything any more.

Chuck: What's really been wonderful about this series of conversations is how different they are from one another because I've always painted either people who I know really well or people who I'd like to get to know better. One of the things that Bill wants to do is get these books into libraries and make them available to students. I think that's their real value.

April: That'd be great. I'll never forget that show that you did at the Modern, Chuck. It was such a good show. Did you see that show guys?

Bill: Now, after this discussion, if you did the show again, you could actually have a landscape in it.

Chuck: That's right.

Bill: After today, I'll never think of a landscape as anything besides a portrait.

April: Oh, got you really confused, huh?

Bill: No, no, I'm serious. I've always thought it was a form of portraiture in a sense, because once you've frozen the person—

Chuck: And a portrait is really a landscape. We know that too.

April: Yeah, well, the way certain people do them, yeah.

◆

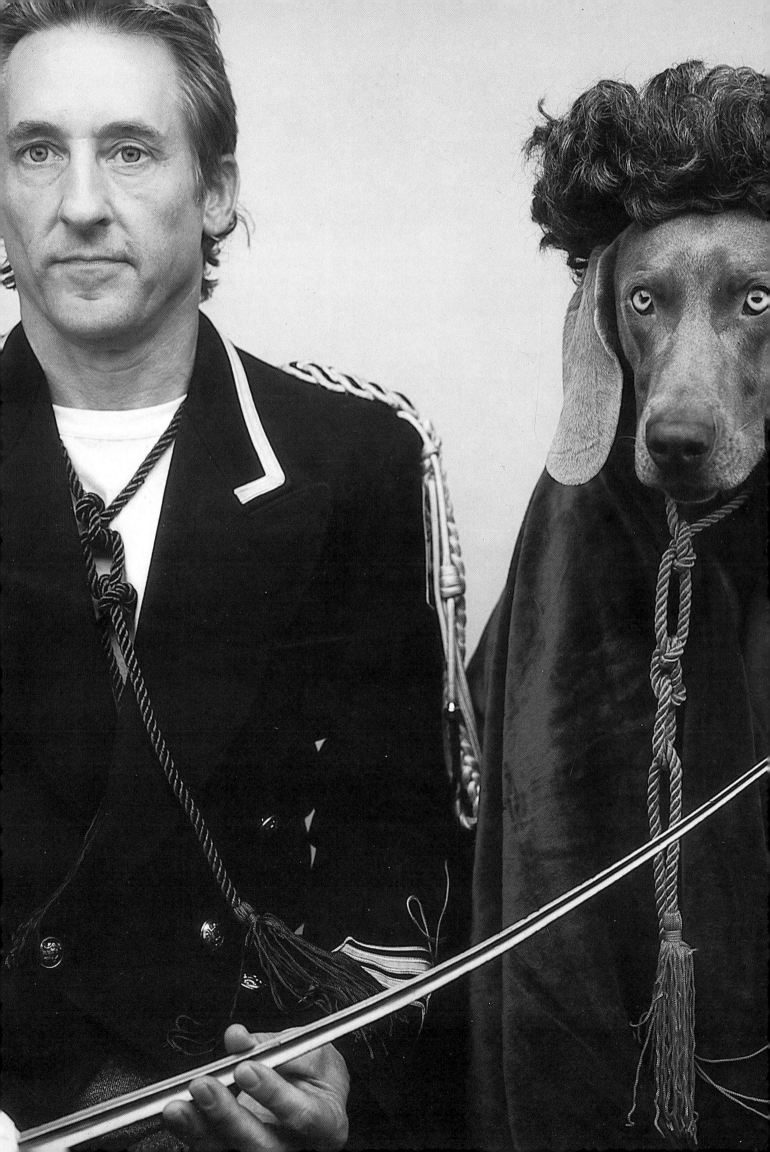

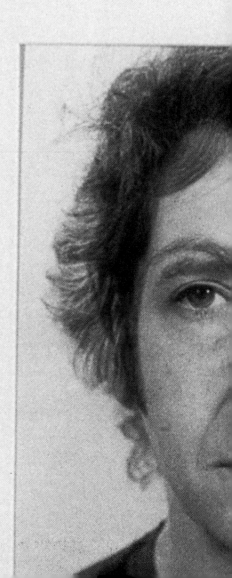

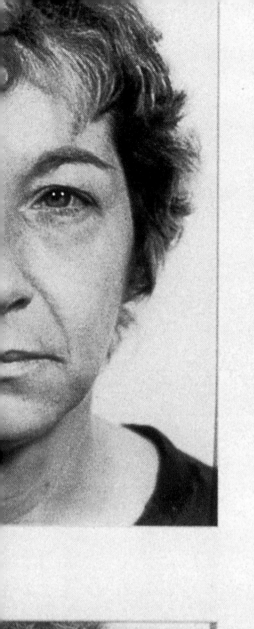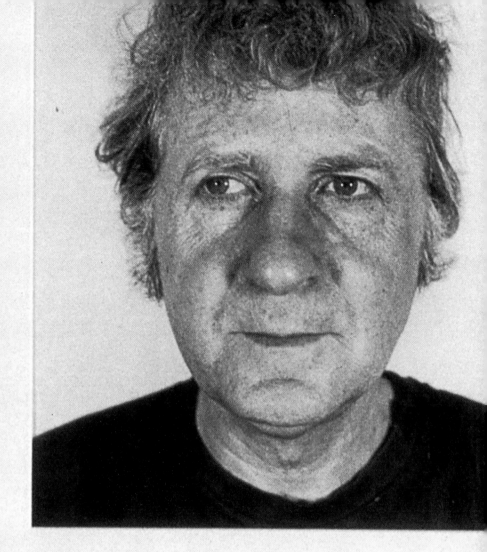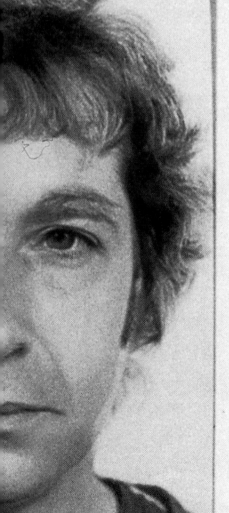

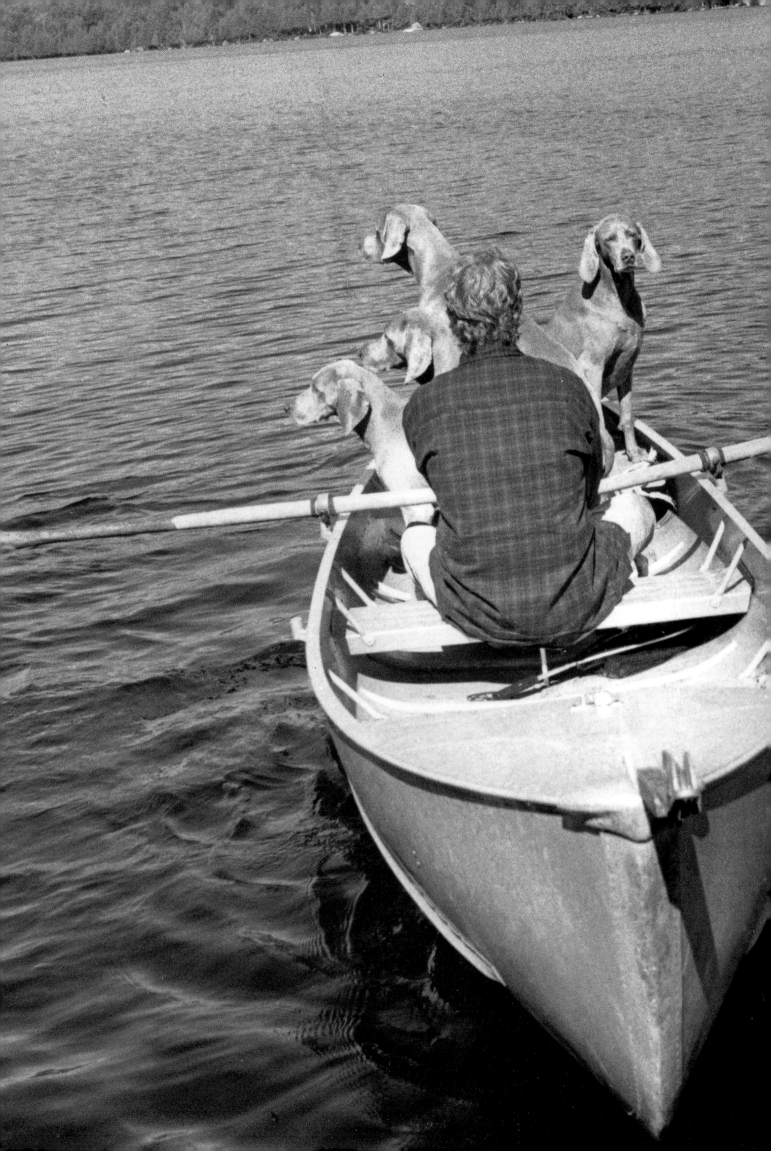

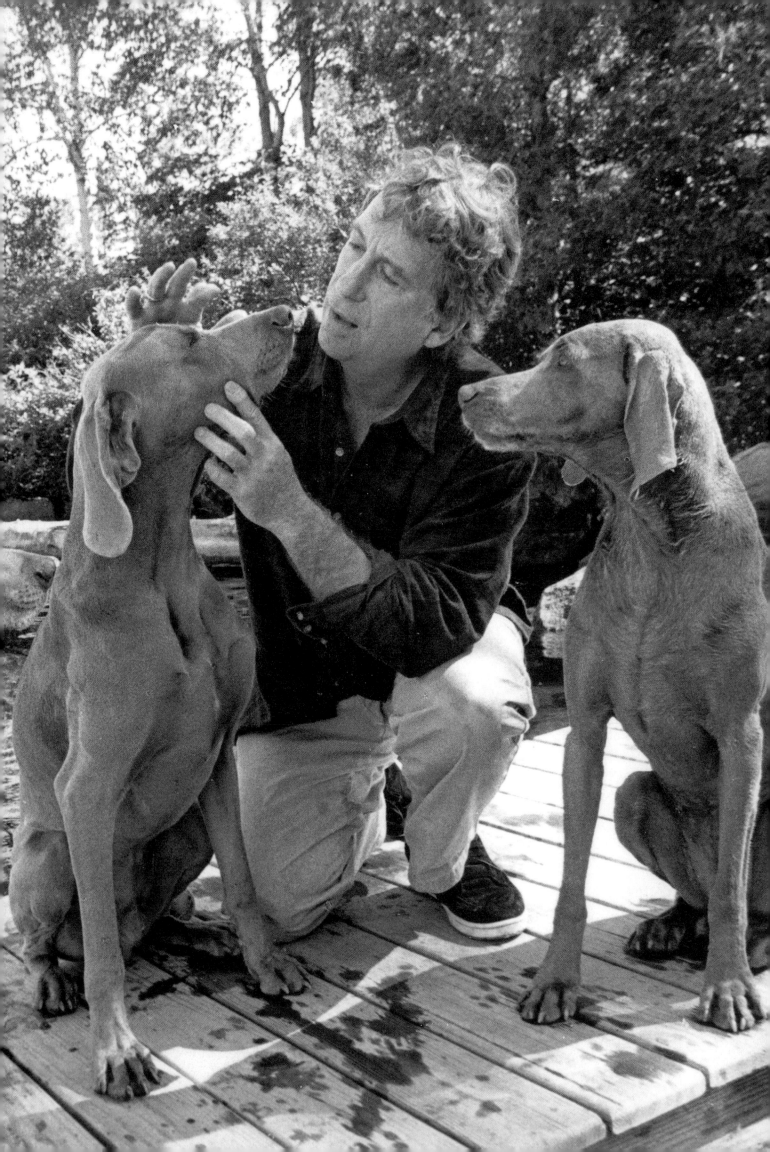

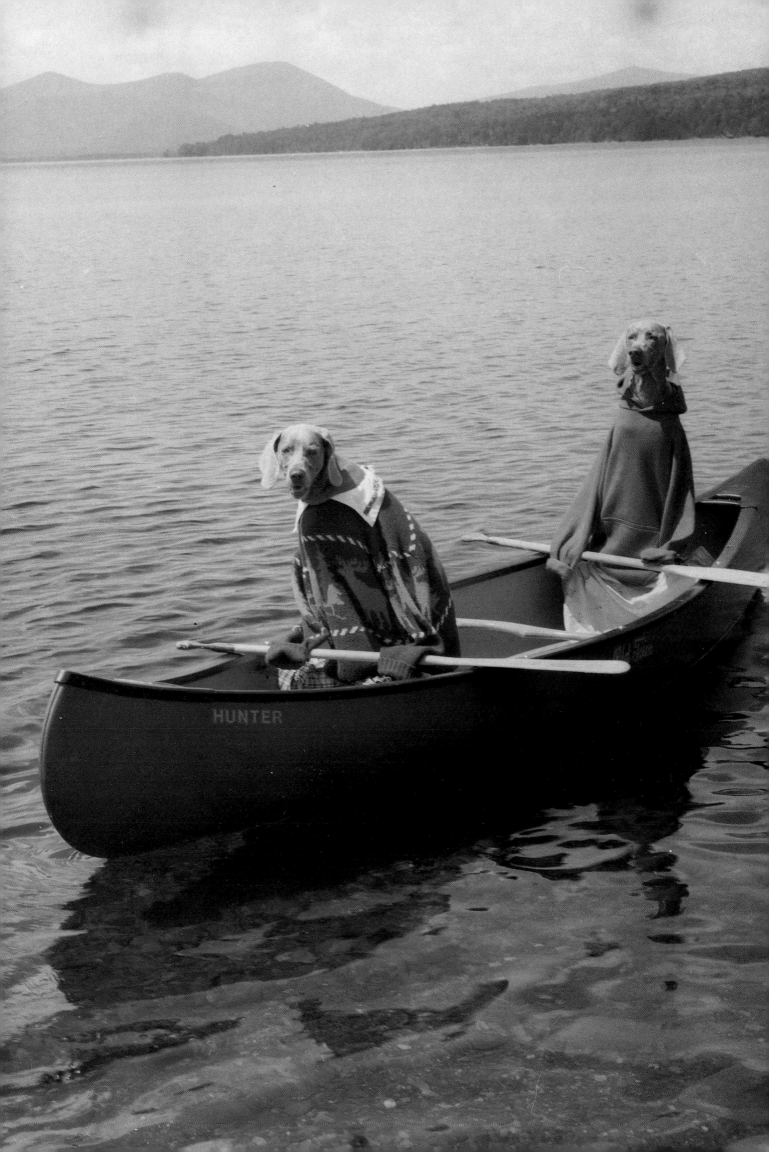

William Wegman

New York City, October, 1994

Chuck Close: I was trying to remember when I met you. We don't know each other all that well. We have had sort of parallel careers all along, mutual friends, and, of course, I've been aware of your work from the beginning. Actually, the first piece of art I bought was your work.

Bill Wegman: **Which immediately attracted me to you. Chuck Close is brilliant and perceptive, and—**

Chuck: I traded a piece with Larry Gagosian for the fake triplets made from twins.

Bill: **Right. I remember the LA County Museum bought that piece in 1971 or '72, but they didn't want it anymore because no one understood it. In fact, the critic Peter Plagens wrote about it as one person being photographed three times. The museum said, "It is too subtle for us. Can we have something a little more funny?"**

Chuck: They must have given it to Larry Gagosian because I traded him a piece for it. I had yet to buy a piece with money; the idea of buying art was, and actually still is, foreign to me.

Bill: **Yeah, it's odd, isn't it?**

Chuck: That was the first piece that I actually made some kind of arrangements to get. Then I bought a Polaroid out of your first show.

Bill: **It was a picture of Man Ray looking back.**

Chuck: Yeah.

Bill: **With glitter on it, right?**

Chuck: I bought that one first, took it home—it was all black—and it just looked like a mirror, so I traded it in for Ray Bat.

Bill: **Oh, good choice.**

Chuck: Yeah.

Bill: **My first color picture was called** *Fay Ray*; **it had a Revlon nail polish bottle in it.**

Chuck: Right.

Bill: **It was a literal use of color. I painted his toenails red and stuck the bottle there. That broke the ice. The twins picture is sort of like your basic format, isn't it? A headshot in the most—**

Chuck: I love that whole series of family pictures that you did. Was that at Sonnabend? Where did I see those?

Bill: Well, I showed at Sonnabend in '72. The first time I showed that series was in California, probably with Helene Weiner at Pomona. You don't have a background in photography, do you?

Chuck: *No.*

Bill: Maybe that's how both of us got started: just taking photographs.

Chuck: *I just took photographs because I needed them.*

Bill: Yeah, me too. I used a twin-lens camera—it was Mamiya C330—that someone told me how to use. You have to look through it in that way that gives you the upside down image. I didn't know about lighting, but I was in a studio in Santa Monica that had skylights, and that helped, along with a couple of flood lights from either side. I didn't know about the umbrella thing. My mother is still mad at me for that picture of the family combination that I took of my mother, my father, and myself. I'm in them all.

Chuck: *Those are such wonderful pieces.*

Bill: Unflattering though. My mother couldn't stand them. You know, it's just not like portrait photography.

Chuck: *I was thinking about those pieces the other day. Now that morphing and manipulation—made famous by the Michael Jackson video where the faces keep changing—is available to anyone with a hundred-dollar piece of software, anybody can morph. I was wondering whether what you were doing was morphing from you to your mother to your father or what. I wonder what that stuff looks like to someone who's grown up in this MTV age?*

Bill: Ask almost anyone. Everyone seems to know about that stuff except us, I guess.

Chuck: *Right. Well, we have such a narrow expertise. You get only the information you absolutely need to make what you want; I don't know anything about anything else. I have no general knowledge of photography.*

Bill: The best part of the family combination piece is on the back side. It's mounted on board. That's how I lined them up. I put an image down in the darkroom and traced it, then put the other negative down and traced it to line it up, so it has all these little marks—a line drawing of the three of us. Of course, you wouldn't need all those quirky little registration marks. It's like the early video that I did: all my tapes have little chalk lines on them because that's how we used to edit, like "here comes the yellow line," and then when it would hit the head you went "kush." That's how you did it.

Chuck: *That's how I did the composite Polaroids. I drew cross-hairs on people's faces, I moved the camera until I got the cross-hairs, and then I would go over and erase the cross-hairs off the person's face. And, of course, I did the big forty by eighty ones in Boston. Have you ever used that camera?*

Bill: Just once.

Chuck: *You are inside a camera, which is really a room with a lens in one end, in the dark trying to figure out where you left off with the last photograph, which appeared upside down, while in total blackness inside a camera. Being inside to see the image thrown across the room when the strobes fired was the first time I ever understood how a camera worked.*

Bill: That's amazing isn't it? It's like a camera obscura, without instructions, like saying "this

way" and "don't touch this"—

Chuck: You reminded me of that terrible Raquel Welch film, Fantastic Voyage, *in which they were shrunk down and injected—*

Bill: —into the body.

Chuck: It's like floating around inside the body. I understood how the body works.

Bill: The outside of that camera is very strange. I had Fay, who was pregnant at the time, and we had to put her on a fork lift. Fay hates machines anyway, and having her there days before she was to give birth was awful. She didn't like it.

Chuck: We'll get the Society for the Prevention of Cruelty to Animals down on you.

Bill: The most fun was taking her through the Museum of Fine Arts, Boston. I had to put her in a cage because we walked through the museum, and I took her through the Egyptian room. She looked like Cleopatra. *[laughter]*

Chuck: I had a very funny experience when I shot the nudes in the mid-eighties in the Boston Museum. I was doing a group of nudes from a painter's scaffolding on wheels. I'd shoot one section of the group, push the scaffolding down, and shoot the next section, until eventually I'd get the whole image. I didn't realize that they had closed-circuit TV in the room for the guards, and apparently, while I had the nudes, all the guards were down in the basement watching on the closed-circuit TV. When I asked for some assistance—we needed somebody outside the camera to push the dolly over—we called down and asked for a guard to come up. Next thing we knew, six guards were there. [laughter] It looked like a Mafia funeral: six guys as pallbearers pushing this scaffolding, a foot at a time, and they were all drooling over the naked people.

Bill: When did you first use that camera?

Chuck: I first used it in 1975. It took me a year after I found out it existed to get permission to use the thing. Oh, have you had trouble getting materials lately? They haven't been making the color film I want to use.

Bill: The new stuff?

Chuck: I understand you don't like it very much.

Bill: Well, it makes Fay look old, which she is. *[everyone laughs]* It's great for greens, which have never been good. Green has always looked like weird acid or something. I love the black and white because with the color I never could get Fay's whole face in focus. With the black and white you can get her eyes and nose in focus; with the color you get one or the other. Now she's at the age for her close-ups. Man Ray was nine or ten when I did the big heads. Now she's passing through that, and she's so good at it. It's just heartbreaking, Chuck. You should see her. She won't move a millimeter if I have something balanced on her nose or in her mouth. She looks right into the camera lens, and having her on my level with the camera, looking into her eyes that close is—

Chuck: It's a little like Sunset Boulevard.

Bill: —heartbreaking.

Chuck: "I'm ready for my close-up." [everyone laughs]

Bill Bartman: Remake that movie, just for Fay.

Bill: It's heartbreaking how much she likes to work; she likes to be really good, as opposed to Batty. Batty is so blasé, as if she knows she's great and so what?

Chuck: An ingenue.

Bill: I'd like to breed Batty. It was really incredibly fun to watch them at that age. When you get a dog, it's always two months old or older, and they look like postcards. When they're younger, they look like badly made toys. They look stamped, as if they're made out of cheap vinyl with pads on their feet. The eyes are so blue when they first open them.

• • • •

Bill: I did that avalanche cover with Man Ray, and I thought, "That would make a beautiful Chuck Close painting," but I was cool enough not to suggest it, knowing that wouldn't happen anyway. But I thought that picture looked like one of yours.

Chuck: Well, unfortunately I don't paint pets, although it would be great to paint a lot of hair.

Bill: Yeah.

Chuck: It would drive me crazy though.

Bill: If you got into pets, that would really be a problem wouldn't it?

Chuck: Well, hair is so labor intensive the way I used to work on it. I was looking for bald subjects. [everyone laughs]

Bill: Well, how about hairless Mexican dogs?

Chuck: I'd like you to talk about your work, about photographs. From the beginning you took photographs as documentation, right?

Bill: Yeah, in the beginning I was a painter. I got an MFA in painting, but in the late sixties when I was a grad student.

Chuck: Where did you go to school?

Bill: The University of Illinois. My roommate was Robert Cumming. He took a photo course from Art Sensibal. Do you know his photographs? Cornfields?

Chuck: Sure.

Bill: I remember arguing with Sensibal and Cumming that photography wasn't art. I hated it. And I hated the photo mentality, and I hated print making. Despised it. I was forced to take etchings and litho. I was working with scientists at the biological computer lab. The University of Illinois was a fantastic school for music, electronic music. They hooked up with electrical engineering. You know, the *Illiac Suite* was Hiller, and he worked with these people. At the university there was a guy Heinz von Foerster who gave me a grant to work with electrical engineering. I was working with scientists and composers, and then I had to go back to working on etchings and paintings, all of which I'm doing now, which is really funny. I was grandiose. I thought they were nineteenth century techniques being taught, and I thought I should be in the twentieth century. Somehow, leaving the university and being on my own got me back to being more like an artist than whatever it was I was trying to do there. Do you remember the

Art and Technology movement?

Chuck: *Oh absolutely.*

Bill: I was caught up in that, but I was very bad at it. I got so many electrical shocks trying to wire my interactive environments—

Chuck: *A lot of that art and technology stuff looked very exciting. Did you go to* Nine Evenings? *Do you remember that thing at the Armory with Billy Kluver and the Bell Labs people working with Rauschenberg and all those artists, and all that stuff?*

Bill: Sure, but I liked the minimal aspect of the work, and I didn't like the acid kaleidoscopic sort of thing, so my work in the sixties got more and more minimal. I was following work like yours and Sol LeWitt's and that group. When I just unplugged it, somehow I got around to using a camera to document some of the things. Then I realized that what I was doing was making pictures, and I started to arrange, to make my installations look better. You know, I always felt that Vito Acconci and Oppenheim really planned those things so they looked good in the pictures.

Chuck: *Right, and in that whole process they were sort of thumbing their noses at the galleries. People went out and dug ditches in the desert. Ultimately, they came back and put photo documentation on the walls of the galleries.*

Bill: They came back with collages. I thought that, first of all, I would have this purity and integrity and just throw away the other thing and make it for the picture. That was the eureka moment. You're looking at that photograph, which was the first one I took that stuck out, and none of my work followed that. Because it's so strong graphically, it just hit me in the face, like, "Yes, this is the direction in which I should be working." You know, it's like a performance, but it's so graphically centered that it works as a photograph—

Chuck: *Right*

Bill: —but it's not a snapshot or something I wandered around looking for, and it seemed to be a new way of dealing with a photograph.

Chuck: *The drawings that you were making at the same time had a tremendous economy.*

Bill: The drawings were actually two years after these photographs and videotapes and were in response to not wanting to rely on any equipment. I just wanted a number two pencil and typing paper, the simplest two-dimensional materials. In 1971, I started the drawings again, after feeling the need not to drag something into my studio, set it up, light it, you know. The videos especially were getting on my nerves. I also wanted to deal with a greater range of things than I could just drag in.

Chuck: *The other thing that strikes me and is one of the things that I love about your work is that you were the only person, with the exception of Joe Zucker, working with humor, and boy, it was such a humorless time. When we went to Max's Kansas City and sat around and talked to people, they were always so funny, and we would laugh a lot, but their work was so grim and so serious. It seemed unlikely, at that time, that anybody would dare to bring humor and visual puns into their work; I mean, it was so antithetical to that moment. I always thought that was a wonderful, risky kind of thing,*

because to be cool was everything.

Bill: I think that humor in art before that time was generally whimsy, twittering machines, and so forth. They weren't jokes so much; you didn't laugh out loud. You were amused or tickled maybe, but you didn't go, "ha ha ha." *[everyone laughs].* That was a shocking thing for me too because I wanted to be a great painter, then a great artist, and greatness had to do with seriousness. When I gave up that notion, I really knew that I was giving up something. I thought, "This is what I'm better at," not really better at, but I found something and I had to follow it. It was an incredibly interesting moment to know what you're doing, know that it's yours, and just take off from there. It didn't worry me that it didn't exist alongside other things, although in retrospect, it does. At the time, it didn't seem like anybody else's things. Other artists were making photographs and videotapes. They were, as you say, kind of humorless.

Chuck: Oh man, and—

Bill: There was nothing worse than to hear, "Hey, you want to see eleven hours of my latest video?"

Chuck: Oh I know. You could choose how long you wanted to look at a painting but not how long a video was. The biggest problem with all those videotapes was that the artists were just so amazed that their image was on the television instead of Johnny Carson's. They couldn't see their own work anymore. They thought it was incredibly interesting, which of course it almost never was. It was not interesting to anybody else in the world.

Bill: But you do have to show. I realized this right away: you have to show it to someone who doesn't know you and doesn't think you're great. You see so many students' videos in which their friend Roger is featured, and he's a real cut up, but you have to know Roger. *[everyone laughs]*

Chuck: Have you ever attempted to sweeten it with a laugh track? [laughs] I remember seeing a Woody Allen movie while I was in San Francisco, and it was as if it were a documentary. Nobody got New York humor. They didn't get Jewish references. They didn't know Yiddish. My wife and I were on the floor laughing, and everyone was turning around and looking at us.

Bill: Right.

Chuck: There is an "inside joke" aspect to the art world as well. There's a certain assumption that people know the issues, that they're bringing baggage with them to look at a work. One of the wonderful things about your work is its accessibility to all kinds of people. You are certainly respected within the art world, but all of the other people have interests without bringing any of that art-world baggage with them.

Bill: I think it is interesting that in the sixties, as we started to break through the museum and the gallery to reach a wider audience, the stuff we were doing at that time scared the shit out of everyone. No one really wanted to see it. I'm probably more well known outside the art world then in the art world. When I go to sign books, people say to me, "I didn't know that you were an artist," or "Oh, you're an artist too?" It's really happened in a—

Chuck: So maybe you were right when you said that photography isn't an art, maybe—

Bill: Yeah, that's true.

Chuck: Many people still think that. I mean, you make paintings now but—

Bill: That's art. You can frame them.

Chuck: Yeah

Bill: I always noticed that when the technicians laugh, that's a good thing in a video. If someone who sees miles and miles of stuff all day long stops and laughs, then—

Chuck: The fact that you are uncategorizable has always put you in a very good position. When I was thinking about you coming over today, I recalled something that I hadn't thought about in years. We used to play a game at Max's on the grey Formica tables late at night. We would pour salt out of the salt shaker and make a field of salt, and we would play this kind of parlor game where one person would make marks in the salt and the others would guess whose art he was making. Everybody's work is reducible to a logo-like symbol; you spread out the salt and make three or four lines this way and it's Jackson Pollock's Blue Poles, *and everyone knows it. You would barely get started when everyone at the table would yell out the name of the person. Everybody could be reduced to something, except the only person I couldn't figure out a way to represent was you. It was a "stump the band" kind of thing.*

Bill: Now anyone would just make a little dog head, and everyone would know immediately.

Chuck: Well I suppose, but back then there wasn't any identifiable image because it was an attitude more than anything else.

Bill: I hated that, when I was in graduate school, any art discussion was preceded by, "I'm working on a series of floor pieces."

Chuck: Right.

Bill: "I'm doing some corner pieces, I'm going to do a series of chicken boxes." The other thing that occurred to me is that as soon as someone saw your work as a logo, then they weren't really seeing it, they were just kind of notching it and going on. I remember really making a concerted effort not to repeat, to keep switching styles in the drawings so that you wouldn't get ready for that "Thurber look" or that fuzzy drawing look of the guy in the New Yorker that gives away the type of humor or the style of gag. It was more subversive to change so you'd have to look at it like that. The other thing is that I've always been very technologically attentive, such as when I use my black and white cameras to do what comes out of that. When I did black and white video, I'd want to switch the Polaroid camera, had to find a new way of working with that. Each format kind of gives a certain look. There's a certain look within the Polaroids and a certain look within the black and white, and by switching media back and forth it gives that strategy, I guess, of something.

Chuck: What about the videos? Is it an apocryphal story that Man Ray walked into the frame when you were doing something else?

Bill: It's true.

Chuck: It's true?!

Bill: I lived in a small house, and when I set my video up, there wasn't any place for him to go to not be in it. You know, I named him more Ray than Man, because when he was in a room he just sucked in your eyes, they just went into his soul somehow, and that really came across in the video. I was thinking that, in a way, it's like that term "space-modulator." When I first saw

him, I was thinking I would name him Man Ray. If I put the camera here, a monitor here, and the dog was here, there was this odd little circle, a closed circuit, but wherever he looked the space would be modulated. He was almost like a metronome or something that changed the circuit. It was almost as if he was a tripod: the camera was on a tripod, the monitor was on the little table, the dog was here and he could swivel like that, because he was always watching me. Wherever I am, he's doing that. It was almost as if it was all connected. That's how I first thought about using him. I had worked with video a whole year and a half before I even got a dog, so I had some attitude about it. But he really changed things. It was also very hard to work other than with him when he was present. *[laughter]* He had this great trick of getting your attention. I had these beautiful rocks from Lake Superior—they weighed about twelve pounds—and he would put one in his mouth and hover over the glass coffee table when he wanted my attention. It was as if he was threatening to drop it—

Chuck: *That's funny.*

Bill: He emitted this high frequency noise if you weren't paying attention to him. It was the highest, most annoying whine. I couldn't possibly even make it *[mimics noise]*, and he would go and do something with it.

Chuck: *It must have made it hard to have relationships with people.*

Bill: Yeah, but I loved that too because someone would come over to talk to me or do something, and they would end up looking at the dog, and I could be free to daydream. *[laughter]* Here, go talk to him.

Chuck: *I remember that, after Man Ray died, you caught a lot of shit for posing people doing the same things that your dogs had done.*

Bill: Yeah.

Chuck: *It's really interesting the way we think about images of people as opposed to images of animals. Of course, people get far more upset if an animal is hurt than if a person is hurt. I mean people are always worried about animals being hurt in the making of a movie, but they don't care how many extras died in—*

Bill: But imagine if an animal was crushed in a Richard Serra piece. *[laughter]* A mouse, a rat.

Chuck: *He'd be finished. What a funny thought.*

Bill: I used to get more animal rights stuff, and now they all want me to do some benefit for them. Poor Eve, my friend Eve, loved to have her picture taken. In between Man Ray and Fay Ray I used Hester, who was a great model, born to pose. Some are like that. They just love the camera and, whether the camera likes them or not, they just want to do it. She was great. I took some; I put some in that book. I think they were pretty good, but one of the reasons that you can easily photograph a dog and not a person is that dogs don't pose, so to speak, although I found out that Fay actually does. I photographed Ed Ruscha because he had the same eyes as Fay did.

Chuck: *I used that photograph in the show I did at the Modern. Maybe we ought to get it over with and ask you what your feelings were about my painting you, about being on the other side of the*

camera. I mean, you've photographed yourself a lot, and videotaped yourself tons. But I—

Bill: I was flattered and excited. I had no idea what you were going to do because I hadn't seen that kind of donut, hot-dog style, so it was really surprising. I heard about the picture before I ever saw it. About twelve people told me they had seen it and how great it was.

Chuck: Wow.

Bill: Then I think I may have seen it at the Whitney.

Chuck: Well, I do think of the subject almost as the client, even though no one I ever painted has owned his own piece. Until a painting is really finished, however, I'm reluctant to have the subject come in and see the painting. Other people will come in and see the painting in progress, but it's no problem. I guess if I found out that you or whomever I was painting hated it while I was half way through, it would really fuck things up.

Bill: The first thing I thought was how did you think of putting those things in there, like martini glasses, and—

Chuck: The whiskey bottles.

Bill: All kinds of liquor things. I used to be a really heavy drinker.

Chuck: It just creeps in, I don't know.

Bill: It's probably in my nose and broken blood vessels from that binge in 1978. I hate photographing myself or being photographed. For some reason, when I was in my twenties I never thought about what I looked like. I was just there. I wasn't handsome or not handsome, tall or short, or anything. It was not even Bill Wegman, or whatever. I was just there. Then at a certain age, like my late thirties, I started to angle a different way, and then I started to have a problem with it. Now my least favorite people are photographers. I'm always having to be photographed. They are always getting low to be down by the dogs, so I'm having this pin head with gigantic nostrils. It's just so unflattering, so I'm always trying to get lower than the dogs.

• • • •

Chuck: What about your return to painting?

Bill: Well, that's something that I did really sheepishly. The first painting I did in Maine was on the back of a store-bought canvas so I could turn it to the wall, and I painted—

Chuck: You mean you literally painted on the back?

Bill: On the back, the inside. I painted telephone poles with the wires cut; a tractor ran over it. I don't even know why I painted that, but I didn't want anyone to know I was painting. I didn't want anyone to call me up.

Chuck: So what was on the front of the canvas?

Bill: Nothing. I still have that painting. It's a stupid canvas, it's the back, and not really a painting, you know. Every night I was having dreams that I was painting, not sleeping dreams, but just painting when I was asleep. I would imagine what the paintings would look like, so I decided I had to start painting to see what they would look like. After the first year, someone said I put art history in a blender *[makes blender noise]*: Picasso-looking things, cartoon things, and all about art-student size. That's the hardest size to paint.

Chuck: Right.

Bill: Eighteen by twenty-four.

Chuck: Practical art, station-wagon-sized art. Art that you can fit in your station wagon.

Bill: Yeah, it's really hard because you have to have something going on there other than a big wash of colors. I was driving myself crazy learning how to paint; I realized that I had completely forgotten how to paint and didn't have a clue. Oddly enough, I had a gallery where I could show while I learned! In those first two years, '85 and '86, my paintings were painted in twenty different styles, and they were really bad, but there were a couple of funny ones that stuck out. Then I kind of found a niche, something that I could do, and it was pretty much like working on a found object. But I made the object that I found. I would work on these muzak abstractions, ignore them for a while, then say, "Look what I found," and start painting on it again. I started dreaming about almost an archaeology of images; I would put down some images and let them settle in, then add another veil of images. Then it became really slow, then I could wipe some out, almost like—if there was a film of it you could see a hundred different paintings. I felt that was really where I should be when I was painting, because I have photography, which is instant, and if I don't like it I can throw it away or do another one, but this was something where one must constantly change and adjust so I used my eye and my mind, and I got a whole different sense of time in which to create the work. A lot of the images come from the encyclopedia, out-of-date ones, so I never really know what I'm going to paint. I don't know when I start what it's going to be like.

Chuck: Do you paint in bursts, then stop and photograph for a while, or do you do both simultaneously?

Bill: Well, they can be simultaneous, but it tends to be more like months of painting, and then, especially with movies and things that I'm doing now where I have to edit every day, I don't really have time to do any painting. When the dogs are in a phase, at about ten years old, I really will be concentrating on them. I have my prime time players, they're ripe. They're positioned right now, and they're so ripe, and they won't be here in five years. I can't say I'm really going to concentrate on Fay in five years, because she'll be fifteen. What a funny set of problems. It is really odd isn't it? It's unlike the problems of any other artists in a way. It's not just that they live to be ten or fifteen years old, it's that when they're two years old, they look a certain way, and when they're seven years old, they look another way. You get these short little cycles with which to work, and I'm interested in that. I think of getting amazing things and that I'm making a legacy for Fay like I did for Man Ray: that's like a commitment to her, I want her to have this.

Chuck: It's like a second child. You don't want her album of photographs to be slimmer than that of the first child so that she thinks that you don't love her as much.

Bill: Oh, they're much fatter.

Chuck: We had single dogs, standard poodles, one after another, and they thought they were people, you know. When a dog would come up to smell her ass in the park, she'd be like, "What are you

doing?" They didn't relate to other dogs. But poodles are sort of like that.

Bill: Fay was in a kennel for six months before I got her, so she's very dog related. She really is nice with other dogs, but Batty isn't at all. She's fine with her breed, with her siblings, but with anything other than a grey dog—*[everyone laughs]* I take her to the dog runs in the dog parks, and she won't play with any of them. She foams at the mouth, she stays over by me, and it's pathetic. Fay is out socializing: "Hi, I'm Fay Ray."

Bill Bartman: Giving autographs.

Bill: Yeah, but I'm really just a dog. Sniff my butt.

Chuck: Well, in New York City the dog is the greatest single social tool.

Bill: Yeah, you can go up and talk to anybody with a dog.

Chuck: Absolutely. No one talks to anybody they don't know in New York unless they have a dog. You see some really sad people using their dogs that way.

Bill: Yeah, what's strange is that the dog doesn't seem to mind. If you're a bank robber, he'll like you as much as if you're the head of the Humane Society, I guess. Someone let me use their apartment in France, in Paris, and there was a husky there, and the husky would only let me go in two rooms. He didn't say anything, but he would meet me and block the entrance, and I didn't know enough about huskies to say, "I'm going by now," so I just stayed in those two rooms.

Chuck: Well, I hope one of those rooms was the bathroom.

Bill: Yeah, the bathroom, the hallway, and the bedroom. I couldn't go into the kitchen to get anything or into the other living rooms. Learn how to communicate with huskies.

Chuck: Well, speaking of communication, I find that when I take Polaroids, because I don't shoot every day, it's really great to have somebody around who does shoot every day. John, or whoever the Polaroid technicians have been over the years, really has been the level head in the room who reminds me that I didn't close the shutter down, or—

Bill: Yeah, I've always worked with other people there. The first person was Joanne Verberg.

Chuck: Yeah, that's right, mine too.

Bill: I used to take a friend, Betsy Connors, and she used to help, because especially when I'm working with a dog I sometimes have to be up there. For instance, in one of my more well-known pictures, *Dusted,* flour is coming down. I can't even remember who took that photograph, whether it was John or somebody else, but I was up on the ladder shaking the bag of flour, and someone else clicked it just at the right moment. Usually I take it, but now when I'm next to the camera, Fay will look right into the lens. She knows that this bull's eye is where she's going. So when I say "ready Fay"—*[everyone laughs]* When the camera is ready, John says, "Ready Bill," and I see Fay kind of purse her lips. *[laughter].* If you don't believe me, come and watch. John will go [makes a camera like noise] with the camera, say, "Ready Bill," or I'll ask, "Ready John?" and he'll say, "Ready Bill," and then Fay is just there. She looks over, click, a big Pavlovian blast of light comes out—

Chuck: Yeah, the strobes fire, and the dogs don't even blink, right?

Bill: No, we aim the strobes at them, but it's off to the side. It certainly gives them the "act

of God" thing, they know that something really has gone by. That's why it is so weird to do this film in which there is no big action like that. It's just continuous. The camera is on and it's rolling, but where is the moment, you know, where's the big light?

Chuck: *Yeah.*

Bill: It's really hard to direct without that.

Chuck: *Talk a little about the film.*

Bill: Well, I tried to do a story. I've done video before, but this is an attempt to connect a narrative using these dog caricatures, the Hardlys, in *The Adventures of the Hardly Boys.*

Chuck: *We all got the pun: they're all girls so they're "Hardly boys."*

Bill: I wrote a story. It's a real mystery, and they catch criminals. I'm working on a book version of it with a Polaroid camera. It's difficult taking it on location, setting it up. I need seven or ten people helping. But the film had twenty-five people helping, and there's no moment when the shot is over, it's just a sequence. Getting four dogs to do four different things simultaneously is excruciatingly difficult. It's also hard in photography but you can just get that lucky moment in which they do it and it implies what is meant to be.

Chuck: *Right.*

Bill: The narrative moment can be like the one in my book *Cinderella.* Fay looks so evil as the stepmother because I caught her at that moment when her eyes are a little glazed over. I could repeat it, but maybe I could never get as good of a shot as I happened to get then.

Chuck: *Are you tempted to do it with lots of cuts, or are you trying to do it in one long scene?*

Bill: Oh, I try to get as long a scene as I can, but it ends up being cut until it's no good anymore.

Chuck: *Were you shooting this in the country?*

Bill: Yeah, in the country and out at locations. The photography is kind of dignified with the dogs; Fay knows where the lens is, and I don't use food because that makes them kind of disrespectful and they look drooly, and I don't need it. However, I was smearing cheese over books and things like that to get them to look as if they were reading. I can get them to look; I'll throw a little pebble into the book, the dog will look like that, and I'll snap it. You'll think, "God, she's really reading that book." But in a film, she goes, "Okay, keep throwing the pebble," so I was buying things like fox urine and grass scent, and I was making little things that made lots of noise when they needed to look for a long time.

Chuck: *Do you use any sound when you're shooting?*

Bill: No, because I'm always bellowing through tubes and things. That was one of the funniest things, tube talk: to throw my voice, talking through these long conduits. *[Changes voice to mimic tube talk]* "Batty," and she would look up there. It would only work for a while, because eventually they would look back at you. "You going to talk through that tube again?" They figure it out.

Chuck: *Well, you know all those Walt Disney true-life adventures with animals that we grew up with? Disney had absolutely no interest in anything being accurate, and he got animals to pretend to be human. They shot all that true-life adventure film footage as silent film, and then they had people*

fake animal sounds. None of them had been to Alaska to learn what kind of sound a walrus really made, so it's some Hollywood guy's notion of what a walrus sounds like. We all grew up thinking that was what a walrus sounded like, and it was all wrong.

Bill: I was on a plane and watched *Speed* without any sound, and then in my hotel I watched *The Fugitive* without sound. I watched these two action films without sound, and they were really kind of bland.

Bill Bartman: **Once you start working with sound, you're much more aware of how essential it is in movies.**

Chuck: You wouldn't spring for three bucks for the headset on a plane? [laughter]

Bill Bartman: **Chuck talks often about how his paintings and photographs are a frozen moment in time.**

Chuck: Trying to make something that you spend as many as twelve or fourteen months working on not seem terribly labored and overworked can be difficult. The fact that the image itself is taken in a hundredth of a second means that there is still some freshness, some frozen moment, no matter how long it actually takes to resolve the painting.

Bill Bartman: **Does it ever seem absurd to be working on something that long?**

Chuck: Oh, yeah, it does. I don't worry about likeness because the painting looks more like the person than the photograph does. I have never quite figured out why that happens, but it must be that since I have so much time working on it I'm putting in a kind of nuanced inflection rather than making an absolutely direct translation. They almost always end up looking more like the person. The one exception was the painting of Joel Shapiro. I think he looks less like himself.

Bill: That is really curious, isn't it? I wonder if it has something to do with the fact that we don't stop people for $\frac{1}{25}$th of a second. And maybe there is some kind of softening when you translate, no matter how precise you think you are. What do you think of my painting, the painting you did of me?

Chuck: I did the two versions of you. The little one looks to me like a clown painting. It's probably the silliest painting that I've ever made, and I've been making some pretty silly paintings. It looks to me like a kind of Italian restaurant painting, not something made by a supposedly sophisticated painter. You might as well have had one of those big rubber noses on or something. Also, there's this sort of truism that people begin to look like their dogs and their dogs begin to look like them. When you see somebody walking down the street with their dog, the dog and the person always go together. You don't know who owns whom: does the dog own the person or the person own the dog? I thought there was something strangely dog-like [laughter] about the portrait.

Bill Bartman: **The ears.**

Chuck: There's that wonderful drawing that you did on top of a photograph—

Bill: Yeah.

Chuck: —that I love.

Bill: The Ray/Cat one, when I turn the dog into a cat.

Chuck: Yeah, and I thought something like that ended up happening. I don't know whether you see that.

Bill: I did a lot of those things, but that was the one that jumps out because it's clear. In a way,

that's what you do, too. You alter a photograph. How do you choose which photograph to do?

Chuck: I usually scan the photograph very closely. I don't use a magnifying glass, but I look at it in pieces, and I imagine what it might feel like to make a painting from that photograph. One photograph is always more appropriate than the others. It may not be the best likeness, and it certainly isn't going to be the most flattering. Then, with the way I'm working now with the incremental pieces, I start by laying a grid. I have various sized grids drawn on pieces of acetate, and I slide those grids around on top of the photographs. Some of them are diagonal grids, some are horizontal/vertical grids, some are very coarse grids, and some are quite fine. I try two or three photographs that I like and see how the increments fall: do they fall on top of the eyeball, or slice an eyeball in two, or go down the side of a face? That's how I determine what size the painting will be and whether it has the diagonal or the horizontal/vertical axis. They tell me what to paint, and it really lets me off the hook. You know, a long time ago I found that the format is the frame of the camera. It's the same proportion as the painting so the composition has never been an issue. Then and now, the way that they're broken up is almost automatic. I found it quite liberating not to have to worry a great deal about how to do it. The paintings make themselves. I just have to show up.

• • • •

Chuck: Your books seem to have a tremendous cross-over appeal. It's like when you can get a song on both the country and western charts and the pop charts at the same time. They don't know whether to put your books in the art section of the bookstore or the children's section.

Bill: Children or dogs.

Bill Bartman: There's a kind of sophisticated humor that goes right over the heads of a lot of children that's for the grownup who's reading the book to the child. I mean, it's kind of amazing that—

Bill: I haven't really had to change anything. I just took the things that I was doing and followed through. I never had to say, "Ages seven through ten would probably like it if I used this photo." *[laughter]* I guess my audience is changing, because I'm not really quite sure who it is. It used to be mostly art students. I always loved to go to the Art Institute of Chicago. They seemed to really get my work, and that was the main place we'd go. There were other places, other pockets, but now these dog people come to my shows and children—

Bill Bartman: It was a very interesting audience the day I went to your show at the Whitney. It was such a mix, it was one of the most diverse groups of people I have ever seen there in my life.

Bill: I think I may have lost the university audience. I was at Cornell, and a student came up to me and said, "Mr. Wegman, Mr. Wegman, you're my mother's favorite artist." *[laughter]* I kind of really sunk when she said that.

Chuck: Yeah, when someone who's middle-aged says, "I've been a fan of yours all my life," [laughter] it's depressing. My daughter Maggie was born in 1984. She was six in 1990 when I took her, at least three times, to see your retrospective at the Whitney. Every time, we had to sit through all the videos all over again. Many of them I had seen myself years ago, but it was really great to see them through the eyes of a kid. She has the typically post-MTV short attention span for anything, but I've never seen her have such patience. You could not drag her away.

Bill: Why do you think that was? To what parts did she respond?

Chuck: *I don't know. It wasn't just the dog videos.*

Bill: The hardest audience are eleven-year-old boys. They ask questions like, "How much money do you make?"

Chuck: *Well, that's what the art students ask too.*

Bill: Yeah, I guess I'm wrong about eleven-year-old boys.

<p style="text-align:center">• • • •</p>

Bill Bartman: What about telling us a little bit about portraiture. Do you see yourself as doing portraits within the tradition of portraiture?

Bill: I never knew what to think about it. I never thought of myself as a photographer, so when I took someone's picture, I never thought that I was taking a photo of someone. I was making a piece. I feel stupid talking about it. I wasn't trying to capture someone but maybe you are, Chuck.

Chuck: *I never thought I was a portrait artist either. I always called them "heads." I refused to call them portraits.*

Bill: I never wanted to catch that moment, when I first did the twins and those things. I needed the image to be exactly the same so I could register for the next one, if I was doing overlapping things. One of the things that I did with the twins was to photograph the same expression. I made them do perky looks or something like that. Then I made little notes that I drew right on their heads where their expressions were really different, like between their eyes or their dimple or something that really stuck out on identical twins as non-identical things. I did a lot of stuff like that.

Chuck: *When I look at the twins/triplets piece that I've had for twenty years or so, and I look at it a lot, I imagine which one of the twins I would like the best, or with which one I would be friends, or which one was more attractive. The triplet, the fake person, I sometimes think cancels out the things that I like about the other two, and then sometimes I think, "Well, he's made a more attractive person than either one of them."*

Bill: It's true. I thought that maybe it was more profound, but really it's make-up. It darkens their features slightly so they're more pronounced. They were kind of plain, very, very plain, almost with a mid-western look, and this gave them a little bit of Hollywood or something.

Chuck: *One of them looks sad.*

Bill: You've looked at this picture a lot more than I have.

Chuck: *Probably.*

Bill: I don't have it up, and I haven't seen it since 1970 except when I'm flipping through a book. I haven't had the chance you have had to contemplate it as portraiture.

Chuck: *Well, it's in our living room. I have shelves installed similar to the Modern show. I have tons of photographs. The living room is all portraits.*

Bill: Did you do that installation after you did the Modern show?

Chuck: *Yeah, I had shelves put into our living room. I have always leaned stuff against the walls. I*

hate to pound nails in the wall, because once I put a piece on the wall it disappears. Lot's of times it's just there, it becomes too close, but if you keep moving it around and putting it next to different pieces, it is always different. It's true that once the twins piece went in with all those other portraits, it became more of a portrait. Yours and the painting by Frida Kalho were the only two animals in the Modern portrait show—she with the monkey, and you—but I would have been happy to put just a single dog picture in. I didn't feel I needed a face. This was a funny thing about that show. I brought all the work up and did that salon style against the wall, and I put the Frida Kalho up with the mirror. Of course, everybody who went into the exhibition looked in the mirror, which put their portrait into the show as well. Sometimes I would sit in there and watch people marching around looking down at the faces and then confront their own. They always pose. The funniest of all was that there was the portrait of Holly Solomon by Neil Winokur, and it happened to be right next to the mirror. When Holly came up to the mirror, she looked at herself in the mirror and then looked at her portrait, and she looked at herself in the mirror and then she looked at the portrait. It was like watching her confront the picture of Dorian Gray. What had happened to her face in the years since Neil had photographed her?

Bill: She probably hated Neil's photo and now she likes it. That is one of the sad things about photography, isn't it? I remember having those sad thoughts as I took long drives back from Maine. I would look at a bridge up ahead and think, "By the time I get to that bridge, I'll be older." Then there'd be another bridge.

Bill Bartman: Aging is also magnified tremendously when you have dogs because their life span is so much shorter than ours. It is sad. When you put pictures up on a wall, they ossify.

Bill: Some of the Man Ray pictures are like that. When I see a picture like *Dusted* or something that's in these books, it's like an emblem. Then I go through some old half-inch reel-to-reel video, and I see him in something that wasn't artwork or didn't really work out, and I see how he really was.

◆

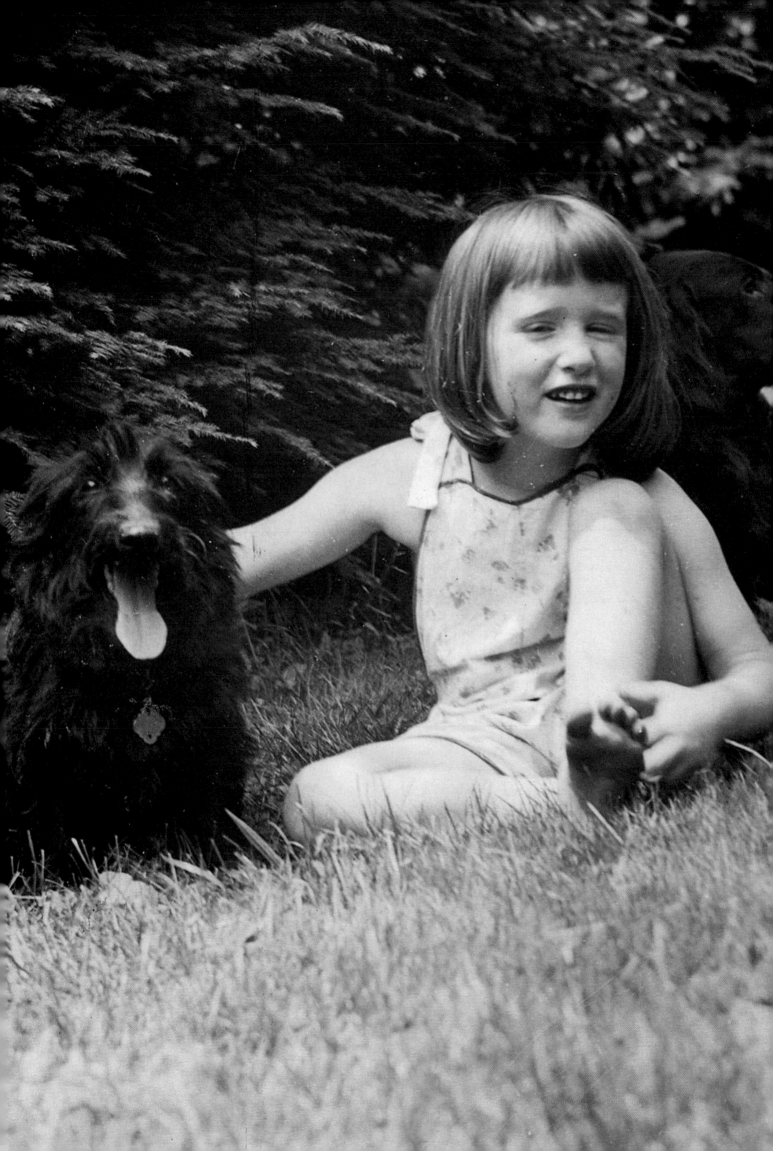

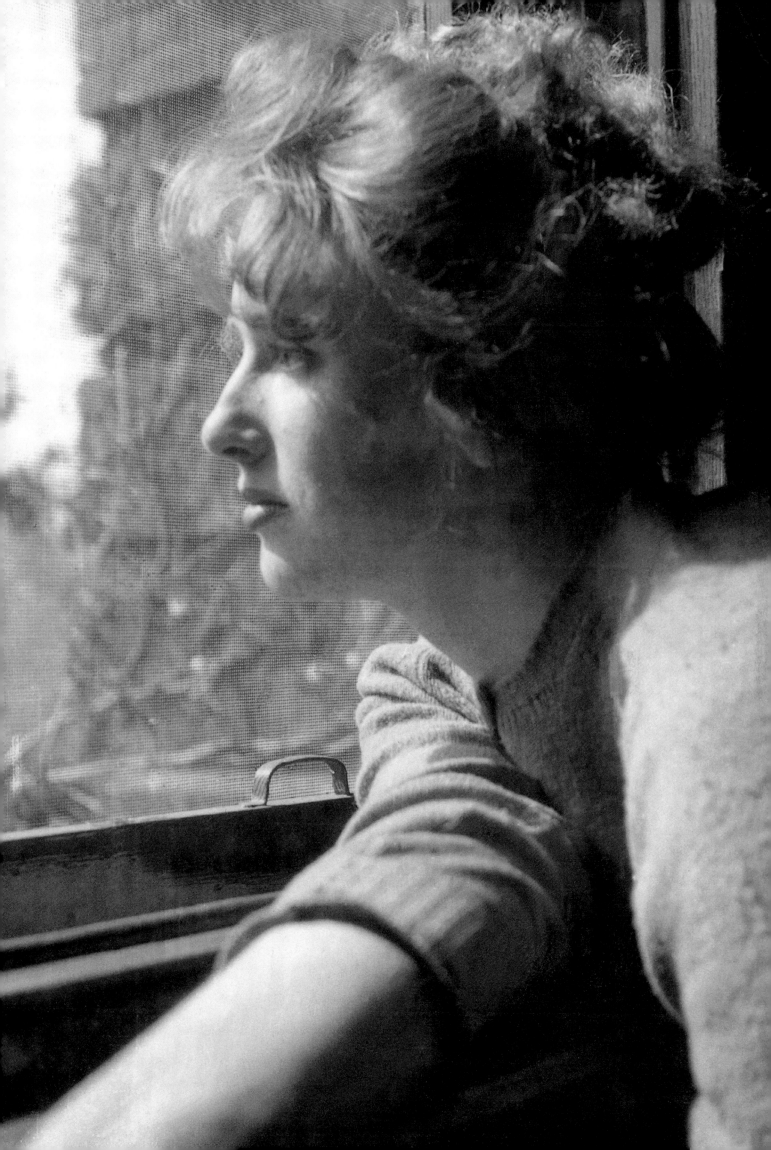

Janet Fish

New York City, April 7, 1995

Chuck Close: We were talking with Alex yesterday about the time when he was teaching at Yale, and I asked him whether or not he had been able to judge anything about our futures by the way we were as students. He said that you were a real surprise.

Janet Fish: I was really quiet at the time.

Chuck: We were talking about how everyone ended up doing something different from what they had been doing at Yale.

Janet: I like that. Sometimes I show slides of what people were doing then compared to now, because it was so different. Students hang on to what they're doing at the moment. They think that's it.

Chuck: We were also talking about how none of us were doing anything at Yale that we could have brought to New York and shown, as opposed to later generations that became very proficient at making something that was showable in New York, came to town, and started showing it. I think the fact that, as a generation, we had time to find out who we were after we were out of graduate school—

Janet: I expected to take a long time. The generation before us also didn't achieve that kind of youthful success.

Chuck: We weren't expecting it because—

Janet: —we hadn't seen it as a possibility.

Chuck: In what year did you start showing in New York?

Janet: Let me see. I was in a couple of co-op galleries.

Chuck: You were in Mercer Street.

Janet: I was in 55 Mercer. I'm trying to remember when I showed at Kornblee. It was sometime around 1970. I got to New York around 1965 and kind of struggled along.

Chuck: Yeah, you got here a couple of years before I did, because I taught for a couple of years. It was '67 when I got here.

Janet: It was kind of nice to be in co-op galleries first because everybody helped each other, and it was a good way to get to know a lot of people.

Chuck: I don't know if there is a comparable co-op gallery today.

preceding pages:

Majorska Vodka (detail), 1971, oil on canvas, 60 × 48 inches. Collection AT&T. Photo courtesy DC Moore Gallery, New York.

With dog Sheba in Bermuda, circa 1948.

At Smith College, 1960.

Janet painting in her studio on Prince Street, New York circa 1971.

Studio in Vermont.

Box of Four Red Apples (detail), 1969–70, oil on canvas, 30 × 40 inches. Photo courtesy DC Moore Gallery, New York.

Three Vases, Three Bowls (detail), 1994, oil on canvas, 50 × 50 inches. Photo courtesy DC Moore Gallery, New York.

With Charles Parness, New York, 1996.

Photographed by Marilyn Minter In Chuck Close's studio, 1995.

Janet: Now people send their slides and apply to get into 55 Mercer Street as if it were a gallery. For a while, they were trying to put people together so that they could make their own gallery, but the people didn't want to do that. We just took a crummy space and cleaned it up.

Chuck: *Were you a founding member?*

Janet: Not of 55 but of Hours Gallery, which lasted only a year. Then the other people started 55 towards the middle of the year that Hours crashed, and some of us went over to 55.

Chuck: *Everybody who was in the gallery was a participant?*

Janet: Well yes, we all helped clean the space, do the wiring, paint the walls, pay the rent.

Chuck: *There was no director. You took turns sitting at the desk.*

Janet: Everyone had their month, and we had meetings during which people would go bananas. I remember one time when this woman had her nose to my nose and she was screaming at me. I said, "Don't get hysterical," and she said, gulping air, "I'm not hysterical." It was roach heaven there. I remember sitting there watching my show one time, and the roaches came walking across singing a little song.

Chuck: *So for the month that your show was up—*

Janet: You watched it. You sat it.

Chuck: *What a horrible thing to do.*

Janet: We would trade with each other sometimes.

Chuck: *What do you think the difference is between that kind of co-op scene and the alternative spaces of today, and what do you think the options are for a young artist today?*

Janet: I think the co-op galleries were really just a group of friends whose work was really different. There wasn't an attitude. We were just people who were working and who wanted to show others our stuff.

Chuck: *Alex was saying yesterday that he didn't realize that you were ambitious in the way that you ended up being.*

Janet: That's because I didn't talk.

Chuck: *He was really surprised when he saw the vacuum-wrapped vegetables.*

Janet: I showed some at 55 Mercer, and I showed some at Hours. By the time I got to Kornblee, I think I was showing bottles.

Chuck: *He thought they were ambitious pieces to make. We were talking about them in the light of a non-reactionary form of representational painting that wasn't backward looking or retrograde in the sense of trying to find a kind of modernist use of imagery.*

Janet: That's the problem with representational work now. The only people anyone ever thinks of are the retrograde types. There are others out there, but they're not getting much play.

Chuck: *I remember Jack Beal once criticized me in print for not having any books on artists before 1945. Jack always felt that being a realist was some kind of "us against them" moral crusade. He thought that Frank Stella was the devil or something. It's true that I don't have a lot of books on Velasquez and the history of portrait painting and that I was really interested in trying to make art today. I was much more interested in work that was being made today than I was in the art of the past, although, over the years, I have become much more interested in the history and traditions of portraiture. I now spend a lot more time than I used to looking at old stuff at the Met or the National*

Gallery, but at the time it was true that I was interested in art made after 1945, and I was interested in trying to figure out a reason to make a portrait. I was wondering whether you had similar feelings, or whether you felt more connected to the traditions of still life.

Janet: It wasn't so much that. I had attended Smith College, and the whole area, including Mount Holyoke, Amherst, and UMass in the fifties and sixties was dominated aesthetically by Smith College professor Leonard Baskin, the sculptor/printmaker. Then I attended Yale. I learned a formula at Yale and learned how to make an abstract painting. We learned push and pull. It's not that I necessarily rejected that, but I had my arguments with it. I felt that if I was going to be an artist, I had to do something for which I personally had a reason, because I'm the one who spends my time at it. I felt that, in this case, not only did I know the formulas, but using them didn't mean anything to me. I was just arranging paint. I had an education, but I felt it was all words, and I wanted to drop the words and get out of myself. I started painting things at which I was looking. I wanted to see what would happen. Also, no one had really taught me how to do that. I went at it in that way and tried to find out what was there and in what I was interested. At that point, I sort of took a reductive approach. I kept taking things out, and taking things out, and then I started putting things back in.

Chuck: Actually, they're anything but reductive now.

Janet: I know, I know. Now I'm going for excess.

Chuck: I think that's true for me also. I think it's hard for people to know about a certain time unless they lived through it. The "Old Testament version" of our history assumes that so and so begat so and so who begat so and so, that kind of linear straight-line thing as if nothing influenced anything, nothing came in from a tangent or whatever.

Janet: It's not real.

Chuck: It's not real. I was making representational painting, but the things that influenced people who were involved with minimal concerns or process stuff were in the air. Ideas such as paring stuff away, getting rid of stuff, and trying to impose limitations that would allow one to move or change or whatever were not the sole property of the minimal artist or the process group. Representational painters for generations had tried to pare down their work or simplify, from Whistler to Sheeler to Hopper and, of course, the pop artists. Alex Katz is a good example of a contemporary artist who reduced the elements in his figurative paintings. In the late sixties, composers such as Philip Glass and Steve Reich, filmmakers like Michael Snow or Paul Sharits, the concrete poets, and certain novelists all seemed to feel the need to purge their work of the unnecessary, the decorative, the emotional, and the virtuoso performance and search for the simpler, "flat-footed," unadorned, and unflashy essence.

Janet: I started using the glasses as a form of grid. I could really understand that kind of grid, working in a serial kind of way. All of those ideas were there, and I think we all played with them. Another idea was finding other ways of organizing information than that whole art-historical way, which used to be taken as the word, that one thing led to another. In fact it seems not to have ever been true. I once heard a really great lecture based on a letter from some academician to Degas. The two were good friends, and the guy had visited Degas's studio and left him a note about what he didn't like in a painting and what he did like. Apparently, Degas

paid attention to it. If there were instant art history, they wouldn't have been friends. They would have been enemies.

Chuck: *That's the wonderful thing about the Eva Hesse catalog from the Yale show. Did you see it?*

Janet: It's a great catalog. You must get it.

Chuck: *Did you know Eva?*

Janet: Yeah.

Chuck: *Of course, she was very close to Sol LeWitt and Mel Bochner and lots of friends, but what's so wonderful about this catalog is that it's full of her diary entries and her other writings in which she says who she ate dinner with, who was in her studio, who was looking at her work, whose work she was looking at, and whose work really turned her on. It wasn't that very narrow group of which it now seems she would have been part, and, of course, she was married to Tom Doyle, whose work was extremely different from hers.*

Janet: That's interesting to me because what I've always liked about New York was that you could visit studios and begin to relate to what someone was doing by seeing the process. I think there is a kind of fascism in art. When I go to a school, it seems as if all the students who are painting realistically sign up to talk to me.

Chuck: *When I'm on a jury, the stuff on which I'm the hardest is the stuff that resembles mine. I look much more favorably on stuff that is abstract or whatever. I think that when people know who is on the jury, they assume who voted for them and who voted against them.*

Janet: They do, and they're wrong.

Chuck: *They would be wrong. They would absolutely be wrong.*

Janet: I know people who, if they know who's on the jury, will select work that they think relates to the jury member, sometimes in really dumb ways, like pictures of fish *[long and loud laugh]*. It kind of narrows the discourse when it's going like that. Also, it seems to me that if you want to move at all, you have to talk to someone who thinks differently, or otherwise you will just happily go along with the same thing.

• • • •

Bill Bartman: *OK, I'm going to talk about the painting. Was Janet one of the people who you painted because of her work, because of your friendship, or both?*

Chuck: *I didn't paint anyone whose work I didn't like. I was friendlier with some more than others. For all of them, the work had to speak to me as well. It was a celebration of the art world as a kind of family with which I was trying to deal. Sometimes the subjects were people with whom I also happened to be close friends, and sometimes the relationship was through the work, but Janet is an old friend. I've known Janet since 1962, I guess.*

Janet: A ridiculous amount of time.

Chuck: *We left Yale in '64. You were there before I got there.*

Janet: I was there before you. I went there in '60, '62.

Chuck: *I was there from 1962 to 1964.*

Janet: Then I stayed a year in New Haven, and then we were in the same building for a while.

Bill: *Talk a little about the process of being painted and seeing the painting.*

Janet: Well, Chuck has done a number of versions of it. The first time I posed, it was on a really cold day. I had a red nose, my freckles were showing, and my hair was wild. I came out looking like an insane person. Actually, he took some other photographs another time, and I kind of steeled myself to not look wonderful. So when I saw this big painting that he had done, I thought, "Oh, I can live with that." Really, I didn't expect to look as I would wish to look. As a teenager, I would probably have preferred to look like Gina Lollabrigida, but it didn't happen. It's hard to see yourself.

Bill: *When you came to be photographed, did you actually come dressed for the picture?*

Janet: For this one, [*referring to image with the earrings*] I brought props. I brought two pairs of glasses and two pairs of earrings, and Chuck picked the wildest of both.

Chuck: *You had those dangling—*

Janet: The dinosaur earrings and the glasses with the things on them.

Chuck: *The glasses reminded me of my grandmother, who wore glasses like that without any degree of irony.*

Janet: Then you sort of sit there smiling and then holding it, dropping your smile and then holding it.

Chuck: *With the Polaroid, at least you have a chance to see what's going on.*

Janet: Right. I thought that was really interesting. It gives an instant result.

Chuck: *You have a chance to lobby if you don't like something.*

Janet: Right. You let me take the one I wanted, and I thought, "Well, he will grab the one that he wants, and then I will take one."

Bill: *At the time that you took the* Polaroids, *had you yet admitted to being a portrait artist?*

Chuck: *You know, it was gradual. I had never thought of myself as a photographer either, and it wasn't until I started doing Polaroids that I had photographs left over that I wasn't going to use to make a painting. I realized, "Well, if I have photographs that I'm not going to use for a painting, then they must be photographs; therefore, I must be a photographer." These are things that you gradually learn to accept. Early on when I was painting the continuous tone things, the ones people think look just like photographs, everyone was always worried about wrinkles and zits.*

Janet: Oh yeah, because they were all there.

Chuck: *This recent incremental approach is a relatively painless process for the sitter.*

Janet: I like the way you push the lights and the darks so it really kind of jumps. I thought it was as nice a painting as I'd seen, and I liked it.

Chuck: *Alex was talking yesterday about posing. He definitely thought that he was giving me "a Chuck Close."*

Janet: Oh, he did?

Chuck: *He thought he knew what they looked like, and he was going to give me that. The thing that I thought was interesting was that when he painted himself, he painted himself with an arm's-length distance, almost as if he were painting something far removed, and he thought that somehow my picture captured the rage underneath the surface.*

Janet: Well, there is certainly a feral snarl in that picture. The first time I saw it, I started to laugh.

Chuck: Do you think that I exposed anything lurking beneath the surface with you?

Janet: I don't know. It's always hard. I've never done any self-portraits because I could never look myself in the eye. I thought you had a kind of sparkle that I liked, that jump, and the way things moved very fast. That is something that I feel involved with in painting, so I think I was relating to that a lot.

Chuck: What I like about the big black and white painting I did of you is its kind of formal issues of photography: the straight hair hanging lent itself to being broken down in the grid to a kind of beaded curtain, or jewels, or crystal chandeliers, or something like that. You never know when you take a photograph how it's directly going to translate. When I made the decisions, laying the plastic grids on top of the photograph in order to see how it would break up, what the scale of the painting should be, how large the grid across the picture would be, the thing that interested me was trying to capture with the strong darks and lights this kind of sparkly, almost liquid effect.

Janet: My first reaction was that I felt the kind of things that came up in the painting were the kind of things with which I was involved in painting, particularly at that time. So when I saw the picture, rather than relating to it from a more vain point of view, that was what I really liked in it. In that sense, I felt that it was really a picture of me, as well as your painting.

Chuck: I don't consciously try to do anything to bring it in. The only case in which I did something conscious like that was with the concentric grid portrait of Lucas that emanated from the third eye, which was a definite attempt to comment on his Svengali-type mind control, the fact that if someone elected him Ayatollah, he would absolutely run the world without any problem. However, I do think that some of that stuff creeps in.

Janet: It's sort of unconscious, but it seems that in your new paintings the unconscious element is more visible. That is my take on it. The last one I saw was of Chamberlain. It was wild.

Chuck: The paintings of John turned out to be more sculptural, almost as if they related to his crushed car bodies or something.

Janet: Yes.

Chuck: I wasn't really trying to do that either.

Janet: Well, it just means that a little hidden thinking is going on. I think that there is a linear train of thought as well as another kind of thinking that is always happening. Sometimes you see it more than at other times. Every now and then I try to remember to let some of that back in: get out of it, get reasonable, and then let it back.

Bill: I think this is a really interesting issue about which we haven't talked with anyone else: whether, consciously or unconsciously, you put these things into the work.

Janet: Your process has changed a bit, and it seems to encourage this. I love those early paintings that look like photographs from a distance but when you get up close you see the painting. This process doesn't seem as rational. Maybe it is.

Chuck: It is interesting that the earlier work seemed more programmatic. Critics often wrote of those early black and white pictures that they were coldly mechanical, that they were just a direct translation from one medium to another, as if there is a direct translation from a photograph to a painting. A painting is made in such a different way than a photograph. To me, you have to try to understand something in one language really well in order to be able to translate. If you're going to translate from German to

English, you can't do a direct one-to-one translation; you have to understand the idiom said in one language in order to translate it into the other. A painting isn't made, it has to be built. I think the basic misunderstanding was that the early paintings were not as coldly mechanical as they looked, and these are not as free as they look. Probably people think these represent a real break, in terms of expression or freedom, but, in fact, they feel very much like the others felt to make, and the paintings have always been far more intuitive than anyone thought. A process narrows things down enough so that you can really focus your attention on something, and then there is a great deal of room for responding in an almost unconscious way. I don't sit around and think, "Now, what color should I use after I use those others?" Something just occurs to me, and I don't want to do the same thing that I did in the previous square.

Janet: Well, you've had all these years of working through this kind of process, working in layers, so now you've broken the whole thing up, and it's a more difficult thing. I don't think you could have done those paintings years ago, do you?

Chuck: I don't think I could have done them without having done the three-color paintings.

Janet: It seems very much like a playing with that whole process.

Chuck: Your paintings have exploded in color in the last few years too.

Janet: They seem to have, yeah, and I'm aware now that I can play more with the marks. I'm freer with it, and it's just from doing it for so long.

Chuck: Do you think that because you have recently started painting a lot more in Vermont—

Janet: Because I paint a lot, I'm relating a lot to what I'm seeing there. The light in Vermont and the light in New York are really different. If I were to move to Tulsa, Oklahoma, I would have a whole different painting again.

Chuck: Even the recent paintings that were made in New York—your studio used to be my studio and that kind of grimy, grungy, dark New York light that comes through those old windows is hardly the light that you have—

Janet: I'm aware that it's a more muted light. I always used to say that I painted what I saw but chose to see what I wanted. I used to sit on the subway and change things from red to green just by changing my focus and pushing the color. That happens all the time. I've selected things, and I've chosen to see them that way, and I suppose I have been really pushing the color range.

Chuck: I find myself using colors that I haven't used since I was in college. There are little pieces of painting that remind me of what I was ripping off from deKooning. I found myself using those colors but hopefully using them in a different way.

Janet: Well, we came out of that. You must never deny your roots. I used to think that the ones in which you could see the pores when you got up close were really pretty expressionistic. That's what I loved about the paintings. One time you were hanging in the Whitney on one wall, and Alfred Leslie was on the other. Leslie's painting sort of came together from a distance, but the viewer had to get up close to yours. That was the thing: for yours the viewer stood back, then walked close, and then started in the other direction with Leslie.

Chuck: Yeah, I guess we do deny our roots in order to move on, and you have too.

Janet: You have to say "no."

Chuck: "If I don't get rid of all the gods or all the people whom I love, I'll never be me." Then you get to a point later on when you can kind of nostalgically bring that stuff back in, but you have such a different reason to use it that it's not the same.

Janet: Also, I think that saying "no" is as much of a trap as saying "yes." Instead of just embracing something totally, you're saying no to it totally. In the end, you need to take stuff from here and take stuff from there.

Chuck: Do you think that there is something different about those of us who came up in the late sixties and seventies in such an unfocused, pluralistic decade and those from other generations?

Janet: I'm very glad to have actually come up during that time. I'm glad for the diversity. I'm glad that when we were at Yale, they really didn't know who they were; Yale was in a process of change. I think we were very lucky. It made us argue things out. It made us interact a lot more and have to think things through more. I think we were fortunate to not have a really strong god there. I feel now that there is a crunching in and a taking away of possibilities that is really unfortunate, and I think it's very academic to have a line of reason and to follow it. All the art schools are producing the same thing; they're all arguing the same arguments. These people may come out of this, fight back, and come up with something in a few years. I'm sure they will. It's the true essence of academy to me. I think we were at a point where Yale had been an academy with Albers, but it didn't know what it was becoming, and we were just plain lucky. I think that was why it was so lively. So many people went on to be artists, and I think it's because of that.

Chuck: When I went to Norfolk for the first time for Yale summer school, someone said, "You thirty-five students from around the country, all hot shots at whatever school you've been, have come together in this program to battle it out. If two of you, ten years from now, are still making art, you will have defied the odds. The odds are that only two out of thirty-five will succeed," and we all looked around trying to figure out which two would be the ones. "It's going to be me, but who else?" That probably is pretty true, but it wasn't true for us.

Janet: It wasn't true for us, and personally, I always knew that I was going to be an artist although nobody else did. Some of it was the intelligence of the group of people who were there, but there are a lot of intelligent people.

Bill: Was that the summer that Vija Celmins was there too?

Chuck: Vija was there. Vija, Brice Marden, David Novros.

Janet: Quite a list when you think of it, quite a list over a cluster of years at Yale.

••••

Chuck: Your mother was a painter, right? Weren't there a bunch of others in your family too?

Janet: My grandfather was a painter. He was an impressionist painter and my mother was—

Chuck: You actually grew up in Bermuda, but your family was from the Hudson River Valley.

Janet: Connecticut. Lyme, Connecticut was where my mother grew up.

Chuck: Nothing could be further from my experience than having a painter in the family. I've always thought that one of the real advantages of having been poor white trash was that if you did anything at all, you were a success. If you stayed out of jail, you were a success.

Janet: I felt that in a sense I was a success because the artists we knew weren't rich and famous, although my uncle hung out with Calder a little bit. Most of the people led a life in art without stardom.

Chuck: *It was bohemian.*

Janet: It was a bohemian lifestyle. When I was a teenager, I worked for a sculptor in Bermuda who was a pure bohemian. She said that money always came from somewhere, and it always did for her. She was always saved in the nick of time until the very end. She lived an interesting but very poor life. I've certainly known a lot of people like that. Sometimes when you're having a major anxiety attack, it's nice to remember that. I'm very capable of immense anxiety.

Chuck: *You're one of the most nervous people I know, especially when it comes to finances or career stuff.*

Janet: It's because of my first experience with coming to New York when nobody would give me a job, and I kept trying to find work. Of course, I wouldn't take a full-time job. I was making it hard. I couldn't type, I couldn't spell, and they didn't give women teaching jobs at that time. I probably would have been a terrible teacher at that point anyway, because I didn't really like to talk in front of people. It was rough, so in the back of my head there is the thought that, if I have a bad time, there had better be something there to support me because I won't get a job. It's hard to get rid of that attitude.

Chuck: *These certainly are troubled times.*

Janet: I'm not as troubled as some people I know, because I knew it was coming.

Chuck: *There's a great epithet on a tombstone somewhere in New Hampshire. Underneath the guy's name and when he was born and died, it said, "I Told You I Wasn't Feeling Well."*

Janet: Under mine it will say, "I Knew It Was Coming."

Chuck: *Well, even if you do predict the worst, you're covered.*

Janet: Then you can be happy for the best: a negative approach, but it works.

Bill: *None of that shows up in your work.*

Chuck: *I thought the greatest scam that you came up with was painting liquor bottles. A truck backed up to the building one day, and—what was it, Schenley Liquors?*

Janet: Let me see, at that point it could have been Tanqueray—

Chuck: *She got cases of booze in all the sizes: half pints, pints, quarts—*

Janet: The mama, papa, and baby bottles.

Chuck: *—just in case she might want to paint them. What a deal.*

Janet: I know, and when I did Heublien, I got all their keystone brands. The day after the party I had for the opening, I realized that people had been walking around with bottles of booze as if it were Coca-Cola, and they were under chairs and things. Nobody was used to hard liquor in that quantity.

Chuck: *You know, artists have always used painting landscapes as an excuse to write off a trip to the Bahamas, which I know you're not above doing, but that's probably the best. One of the truisms about art is that when nobody's interested in your work, you have lots of time to make it. When everybody is interested in your work, you don't have any time because there are so many people who want you for boards,*

juries, teaching, committees, and interviews like this that there is no time to paint. I've always found that, when I show new work, if I already had a painting working, the next day I could go right back to work, but if the show opened and the paint was still wet, then you go back to that empty studio and sit there.

• • • •

Janet: Also, there is a level of ambition in urban areas that doesn't really exist for better or worse in Vermont. I think maybe people are better off for not being driven by ambition, but it's there, and if you are that kind of person, you have to go and compete in a sense, be a part of it. I'm happier when I'm working, but I also know that I need to see what other people are doing.

Bill: *Do you feel more of that when you go to shows or to other people's studios?*

Janet: Well, when you go to shows, if you're in a bad mood, you can walk in and out, but when you go to studios, you are forced to relate. You talk to the person. You look at their work. You become involved with what they are involved with. I like going to studios. I also like going to shows. I have seen Richard Estes work forever now. There's a whole bunch of people like that whose work I've seen for years. I've seen your work for years.

Chuck: *In all of these years, I doubt whether either of us has missed a show of the other or, for that matter, an opening.*

• • • •

Chuck: *Most people fail because they're chasing the art world, they're always trying to jump on the bandwagon as it's pulling out of town; whereas, if you do something because it has some urgency for you, you're actually in the best position to be there, the firstest with the mostest, when people react against whatever there has been too much of.*

Bill: *Also, the work then has a strong reason for existing. For me, all art, no matter what it is, needs to have that underpinning of truth—*

Guest: *If it looks like somebody's truth—that's my criteria—then it's compelling and nobody knows why. It's resonating. I can't explain.*

Bill: *Then it's interesting. I don't have to like the actual pieces, but there needs to be something about the stuff that just has to exist.*

Guest: *Someone once said this, and I don't know if it's true: "Everybody, when they start, does it for the fame, but sooner or later, they get to the place where they do it for the work."*

Chuck: *There was no chance of fame when we were getting started.*

Janet: We did it for the work. There was never anything in my head other than that it was for the work. Fame just wasn't the issue. Sometimes when someone makes a statement like that, they're talking about themselves.

Guest: *I can't remember who it was. I just wondered if it was true.*

Janet: It's true for some people. It seems like a foolish way to go. It's sort of like going into art to make money. There's more money in other places. There's more fame in the movies.

Chuck: *That's why I always assumed that no one was doing something in order to rip people off. If you were going to be a con-artist, any profession would be a better one to go into than this one.*

Guest: Most of the artists I know are really pretty smart. They could actually be on Wall Street or something.

Janet: If they wanted to put the time and their lives into something else, they probably could.

Bill: When I taught college, I always told kids that the only reason for wanting to become an actor was that there was absolutely nothing else on earth that they could possibly wake in the morning and do, because if you don't want to do it that much then it is just too awful, and there is too much rejection.

Chuck: On the other hand, artists do live better than other people. I mean, you can live on a poverty income as an artist and travel and go away for the summer. It's always amazed me.

Guest: It's like there is an underground network.

Janet: It's also because your head is loose enough to say that you can do it. You know, it's something that you can do. A lot of other people could do that too, but they're locked into the notion that they've got to have this and they've got to have that.

Guest: I do think that you have to be compulsive about it. You have no choice. You need your fix.

Janet: I always liked the way van Gogh lived in poverty: winter in Paris, summer in Arles.

Guest: I love it: Gauguin going off to the South Seas.

Chuck: Do you want to hear a phenomenal thing? What do you think Gauguin looked like when he got off the boat in Tahiti? This is so wonderful. He was wearing a Stetson hat, a fringed buckskin jacket, cowboy boots, and he was carrying a Winchester rifle.

Janet: That's wonderful.

Chuck: He had just seen Buffalo Bill at the Paris World's Fair. That's what Gauguin thought you had to look like if you were going to go to the New World, the new frontier, so he sent off a mail order and got all this stuff. Isn't it crazy that he saw Buffalo Bill Cody at the Paris World's Fair?

Guest: Didn't you always know that you were going to come here to New York, Janet?

Janet: No. I did by the time I was through Yale, and I figured that I was going to be miserable somewhere, so it might as well be in New York.

Chuck: Where they make an art of being miserable. I grew up in Washington State, and I didn't know anyone who was an artist. I didn't know you could be one. It's a total accident that I ended up where I am. If it hadn't been for the Bay of Pigs and the Cuban Missile Crisis, I would never have gone to graduate school. Had I never gone to graduate school, I would have stayed in Seattle, and I don't know what I would have done. It's all an amazing kind of accident. I grew up in Everett, a small mill-town north of Seattle. A lot of people I went to high school with are retired now. They all went into the army or went into the police, and they all have Winnebagos, and they go camping, and they have grandchildren older than my children. I went to a reunion, and nobody had left the town. Almost everyone worked for the same mill for which their mother and father had worked. I don't know what made me realize that there was something else out there and that I should go and do it. They talk about it as "God's country" and all that shit. It rains 250 days a year. To me, that's not "God's country." I don't know, but I think I just needed to get the hell out of there too. To paraphrase Gertrude Stein, "The minute that I discovered that there was a there there, I wanted to be there."

◆

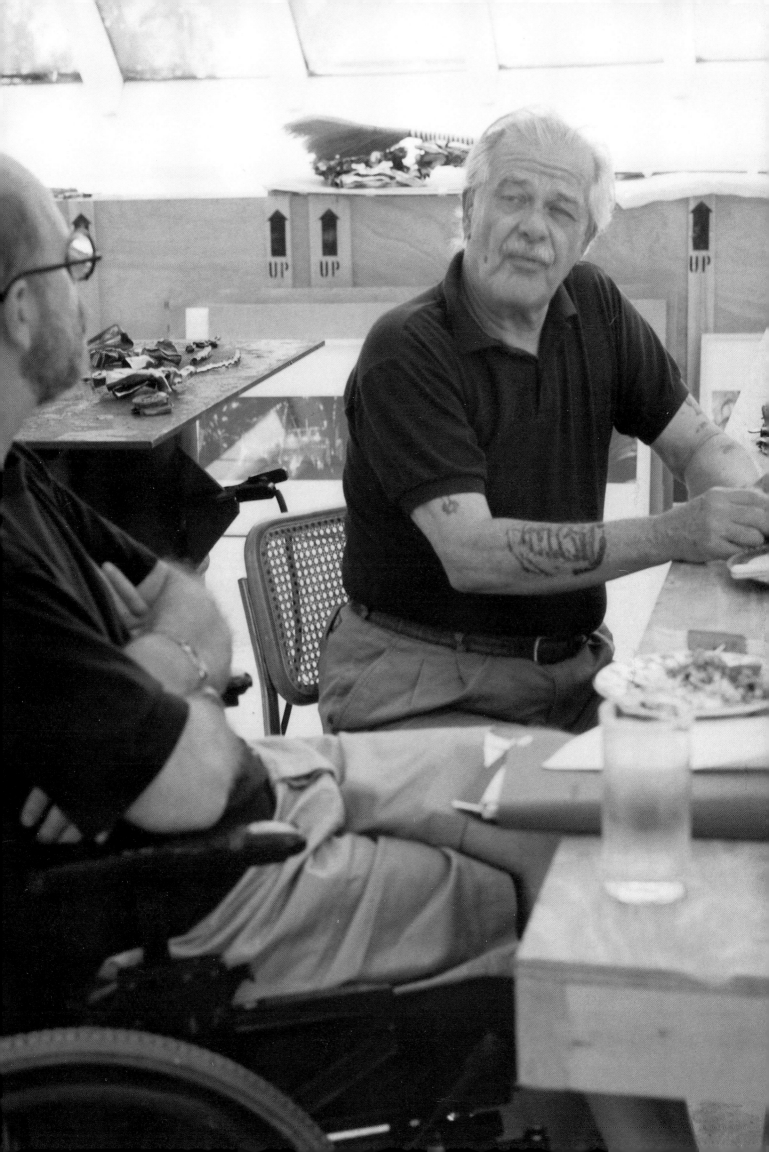

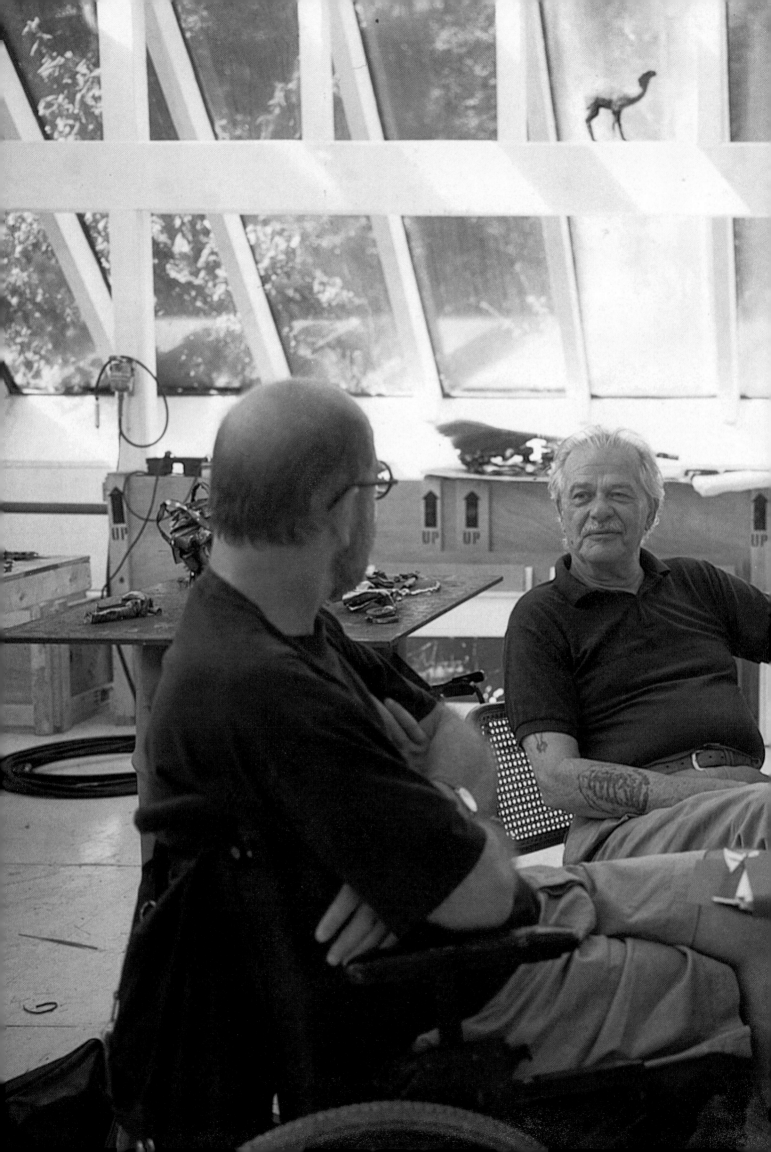

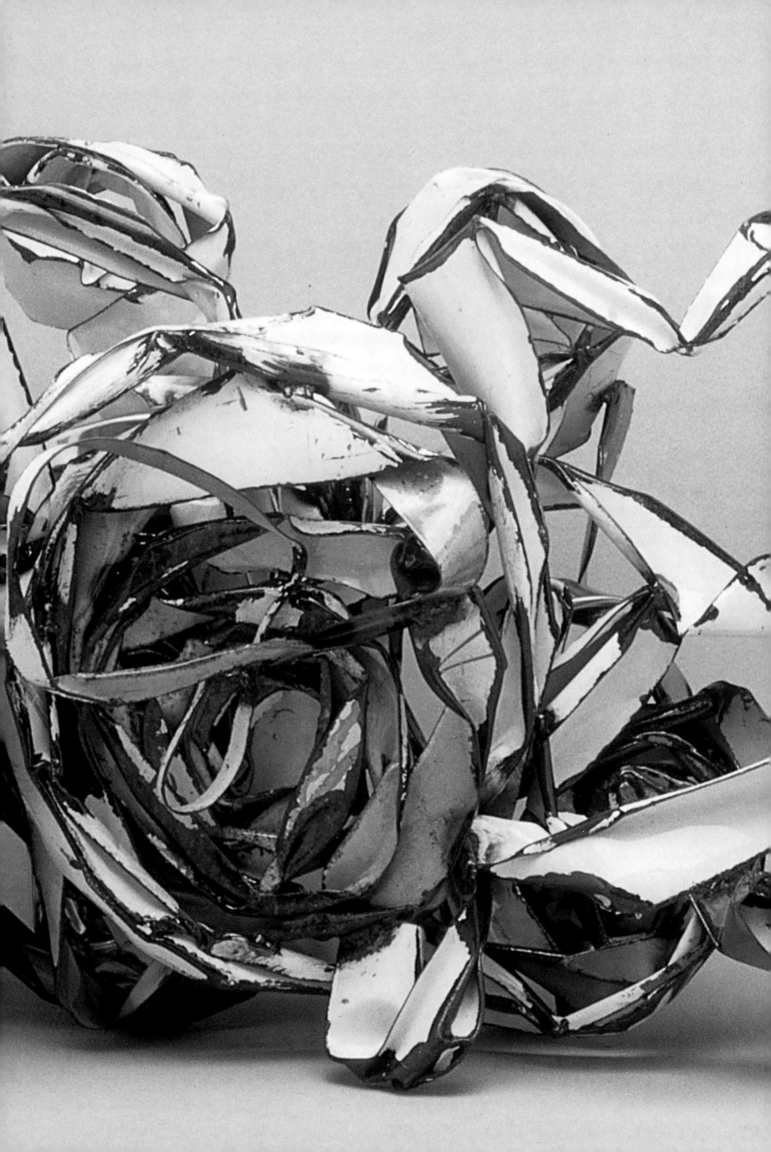

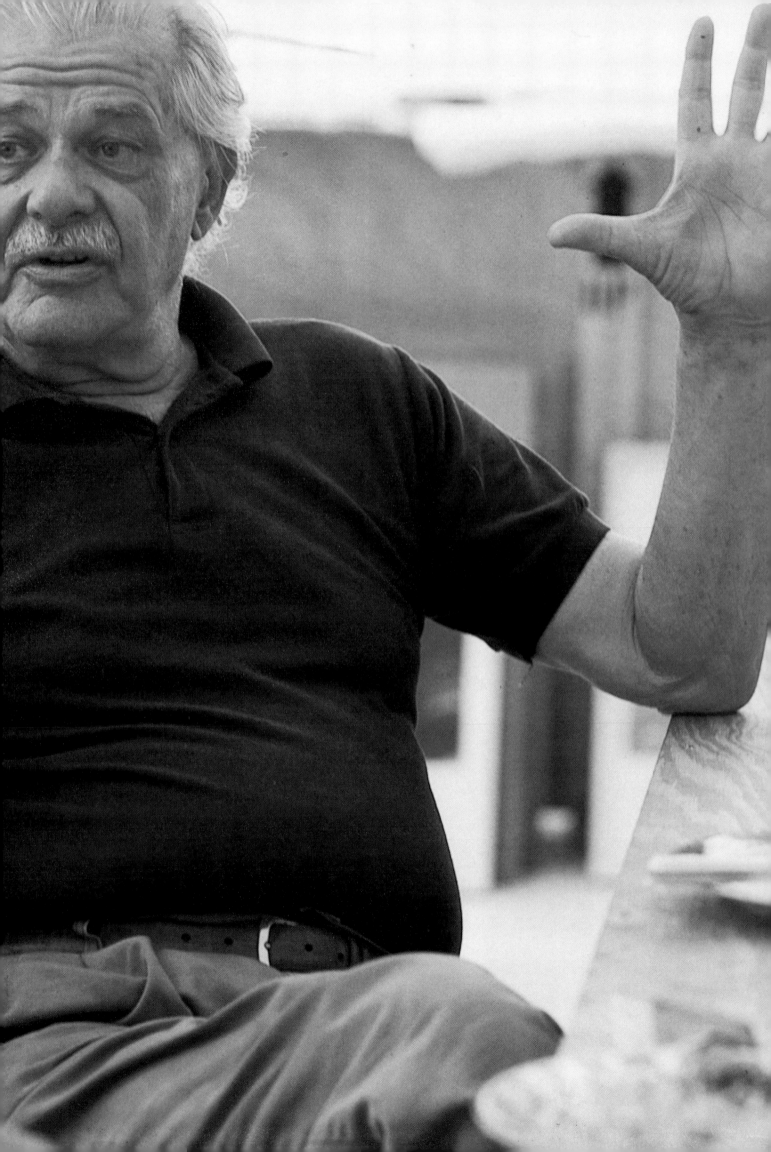

John Chamberlain

East Hampton, New York (Chamberlain's house/studio), July 19, 1995

John Chamberlain: So, what's up?

Chuck Close: Well, nothing much. These sessions are really supposed to be like lunch conversations, but lately they've become too much like interviews, so feel free to ask questions back. I'm running a question by you right now. Rochester, Indiana.

John: Ugh. It's in the north central part of Indiana, which is in the central part of the United States, and the United States is in the Western Hemisphere, and—

Chuck: —and you were—

John: Earth, universe.

Chuck: It's not a part of the earth or the universe in which I'd want to live, and I don't think you wanted to live there very much either.

John: Well, I didn't want to live there, but it turns out that my family plotted the town in 1830. It's a farm town, the county seat of Fulton County, and it has a magnificent courthouse, a terrific courthouse. It's a beautiful building, and I knew that it was a beautiful building when I was only ten years old. When I was ten or eleven, we used to catch pigeons and sell them to people for a dime.

Chuck: What did they want them for?

John: In 1930 or '32, something like that—

Chuck: You could make a million in New York selling pigeons. What did people want a pigeon for?

John: Oh, in the thirties they wanted to eat them.

Chuck: Oh, depression squab.

John: Yeah, depression squab, correcto. Let's see, what else do I know about that town. Well, my grandfather plotted it around 1830 or '32, and they opened Chamberlain's Tavern or Inn or whatever at Ninth and Main. That was the first time, as far as I know, that our family entered the restaurant business.

Chuck: Well, you come from, as you describe it, a long line of saloonkeepers, many, many generations of saloonkeepers.

John: About six.

preceding pages:

God's Chalk (detail), 1988, painted and chromium-plated steel, 16½ × 37½ × 14½ inches. Photo courtesy PaceWildenstein, New York.

Jeau Ronomeau (detail), 1993, painted steel, 10 × 16 × 9½ inches. Photo courtesy PaceWildenstein, New York.

With Chuck in John's studio, East Hampton, New York, 1995. Photo: Bill Zules.

Spell Sideways (detail), 1996, painted steel, 19¾ × 28½ × 15¾ inches. Photo courtesy PaceWildenstein, New York.

Lillith Full Moon (detail) 1967–68, galvanized metal, 70 × 75¾ × 68½ inches. Photo courtesy PaceWildenstein, New York.

Talking to Chuck, July, 1995. Photos: Bill Zules.

Chuck: And you actually have a restaurant out on Shelter Island with, I suppose, a liquor license.

John: Yeah, right, that's true.

Chuck: But you're off the sauce.

John: Oh yeah. I think it is funny that once you quit eating, smoking, and drinking, you buy a restaurant.

Chuck: I read an interview in which you said something interesting about the relationship between a saloon and Black Mountain: that they both had a built-in audience, a built-in clubby quality.

John: Well, I never had much of a social life until I came to New York, and then I noticed that if people wanted to be out and be social, they went to a bar. If they didn't, they stayed at home, because you didn't go to people's homes without an invitation.

Chuck: Yeah, a formal invitation.

• • • •

Chuck: Especially for an art community, places like the Cedar Bar and later, of course, Mickey's joints, all of Mickey's various joints, were really important.

John: Some good times were had at Dylan's and the Ninth Circle.

Chuck: Yep, the Ninth Circle and, of course, at Max's, where one of your sculptures used to sit in the front area. It was one of the galvanized ones, wasn't it?

John: Actually, there was a color one there before that, but all the waitresses complained because they kept snagging their stockings on it or something. Then there was a galvanized one, and then there was a foam sculpture.

Chuck: Watching every night as people came into Max's and the coats started to get piled on the sculpture always reminded me of one of those African nkisi n'kondi sculptures into which people kept driving more nails, because your sculpture would grow until it was a fifteen-foot-high pile of coats, and then it would shrink as the coats were removed when people would leave.

John: That's not bad, but there was no thought in it. All of my sculptures are like the pile of coats, or the way the bed looks in the morning, or like a pile of laundry. They are not a hell of a lot different from those things.

Bill Bartman: Would you explain what the Ninth Circle was, for us younger people?

John: Well, the Ninth Circle was Mickey's place before he had Max's Kansas City. He sort of liked me and a few other guys and wanted us around all the time, and that sort of thing.

Chuck: So, he let people trade art for their tabs. In Max's he had your piece, he had a Judd along the wall, and there was, of course, the Flavin in the back room. By all definitions, you were a rather strange kid growing up in Rochester, and the strangest thing that I heard was that you invented radar when you were eight or nine years old.

John: Naw, it wasn't radar.

Chuck: It was sort of like radar. Tell me what it was.

John: Well, I learned to fly before I learned to drive. I made a lot of airplane models, but I couldn't figure out navigation. My memory of it is that it was like a color TV set, but you saw

a map, and wherever you saw the red dot on the map was where you were. What I didn't do is go backwards and find out the three-point coordinates that you have to send out. They do that now, and it's called OMNI, but it is from land-based signals. They also do it with a GPS [Global Positioning System], which bounces off the satellites.

Chuck: How does a kid get interested in this? You wanted to be an engineer initially, right?

John: Well, I was thinking along those lines. When I was ten or eleven, I wrote this little poem about all the methods of travel that I knew. It had roller skates, a two-wheel scooter, and a crate. Remember the crate?

Chuck: Oh yeah.

John: The crate scooter.

Chuck: Made out of skates and—

John: It also had roller skates, you know, before skate boards, and a bicycle, a tricycle, a blimp with wheels, a kayak—I'm sure there were some more. I think I wanted to fly the airplane. I guess it was that business of leaving more than anything else, but flying was still pretty new. I occasionally gave myself an "A" in airplane models. I would figure out how to make a retractable landing gear, or something.

Chuck: When you got a model then, it was nothing like the models now. You usually got a box with a block of balsa wood in it.

John: You had to carve things. The parts were like the parts you would use if you were going to build a real airplane, even though it wasn't as complicated as they are now, but similar, it was still similar. You had to make all the wing shapes. They were all numbered, and you had to put them in the right line, and blah, blah, blah. I could do all of this, and I could figure out other things, like making a part work from another place, but I could never paper it. My Aunt Charlene had to paper. The irony of that is that later, the airplane that I had learned to fly cracked up. It was a little plane called a Curtis Wright Fisher. It had a fuselage that looked like a cigar, with two open seats up in the nose, an overhead wing, and an engine on top of the wing that faced aft with a wooden propeller. I'm sure that if it did eighty miles an hour it was straining. Anyway, someone cracked it up, and I helped the guy put it back together. I was a worker for this guy putting it back together, and I ended up doping the canvas, which was the job that I couldn't do on the models. *[laughter]* I was the doper. It was my first experience with dope. *[laughter]*

Chuck: And it had a similar effect, I expect.

John: I have a great soft spot for that airplane. It was a 1931 Curtis Wright Fisher, and it might have been the forerunner of something like the PBY, which was an excellent aircraft in World War II. But to continue, when I was twelve, I discovered Schubert, and that sort of canceled it.

Chuck: There probably weren't too many people listening to Schubert then.

John: Well, every time I heard him I broke down and cried. It was later that I figured out that it probably was just the recognition of a certain ability to measure loneliness.

Chuck: Uh huh. You had a desire to get the hell out of Rochester very early. What made you feel that way? I was a terrible student, I couldn't memorize anything, I wasn't athletic, I couldn't hit a ball,

I couldn't run. The only thing that ever made me feel special was that I could pick up a pencil and make a drawing, or I could build something, and it was into that that I retreated. You described your-self as being alone or lonely.

John: I kept running around, I kept going, looking. If you wanted to get laid, it was best to stay in art school.

Chuck: That's why I went to art school. I thought that was the best reason to go to art school. If you wanted to use drugs and you wanted to get laid, you went to art school. Certainly the Republicans weren't doing that.

John: I'm glad I joined the Navy in 1943 though. After boot camp they ask you what school you want to go to. For some reason I said music school. Well, I almost made it, but I wasn't far enough along in my musical education. Had I known how to read music faster and better, who knows what might have happened?

Bill: You'd be making music boxes.

Chuck: I remember you telling me once that the reason you went into the navy was—

John: —to stay out of jail.

Chuck: You were in jail, right? You were on your way to California to become a movie star or some-thing. Were you in Nevada or someplace like that, someplace almost to LA?

John: Blythe, California. There's a place to go to jail!

Chuck: As I remember, you didn't have any money, and you weren't doing very well at begging for food—

John: Or getting a job.

Chuck: —so you decided to go to a restaurant, eat the food first, and then tell them you didn't have any money. What happened?

John: That's when we went to jail.

Chuck: And then?

John: Then we went back to Phoenix, and I saw the sign that said, "Join the Navy," and I thought, "Well, that will get me to California."

Chuck: Next stop: San Diego and the navy.

John: Yeah.

Chuck: How many years did you spend in the navy?

John: A little under three.

Chuck: That was during the war.

John: It was '43 to '46. It was the right war, except I hear now that conservatives like Phil Gramm are accusing Bob Dole of not being a really good conservative because he fought against the Germans.

Chuck: Although we weren't in the second world war for the right reasons either, there certainly were great reasons to be there, but I don't think many people were very concerned about freeing the concentration camps.

Bill: Actually, they weren't really publicized in the United States.

Chuck: Artschwager was telling us that he was in the first group of Americans to go into Dachau. He had to debrief Goebbels, and Goering, and Speer.

Bill: Was he a translator?

Chuck: No, he was in intelligence.

Bill: He spoke German?

Chuck: I don't know, I guess.

John: Artschwager was in intelligence? *[laughter]* How did he ever become an artist?

Chuck: He was a late bloomer.

John: Hmm.

Bill: He did cabinetry first. He was making cabinets for his brother. He had a company that made cabinets, and from that he got ideas for art.

• • • •

Chuck: I hate to admit this, but I used to paint to quiz shows. First I listened to soap operas while I painted, then I got tired of the soap operas and switched to quiz shows. I would listen to all the quiz shows. At that time, there were lots of them on all the channels. There was Hollywood Squares and all that stuff, and obviously they listened to each other. The guys who wrote the questions must have listened to each other's shows, because when an answer would break through, it would quickly make it to all three networks, all the different quiz shows. For many, many years there were only five answers to art questions on quiz shows. They were: Michelangelo, Leonardo, Rembrandt, van Gogh, and Picasso. Those were the only five answers. No one else ever came up. Then one day—

John: They never came up with America's most revered, favorite artist?

Chuck: Not Andrew Wyeth, no.

John: That isn't who I was thinking about.

Bill: Norman Rockwell?

Chuck: Norman Rockwell?

John: No, he's second.

Bill: Gosh.

Chuck: LeRoy Neiman?

John: The greatest American artist?

Bill: Jackson Pollock?

John: Walt Disney.

Chuck: Oh. Well, the sixth answer was Warhol.

Bill: Oh.

John: The one that, for sheer entertainment, I liked the best was *The Gong Show*.

Bill: It was like performance art.

Chuck: I thought The Gong Show *was like getting reviewed; it was like having an exhibition.*

John: It was terrific, you know, like "The Unknown Comic." Notice that his career was over as soon as he took the bag off his head.

• • • •

Chuck: You studied hairdressing on the GI Bill, right?

John: Well, that was another thing, figuring out where you might make money and get laid at the same time.

Chuck: Uh huh.

John: Wrong!

Chuck: Because all the other hairdressers were gay, you figured—

John: Naw. I think I just scared everybody to death.

Chuck: I don't know that I'd want to see you coming at me with a pair of scissors. [laughter]

John: Actually, it turns out that I was very good at it, but that's only ten percent of the job. Ninety percent of the job is getting along with everybody.

Chuck: Schmoozing, listening to their problems. You were in Chicago when you were a hairdresser?

John: Yes, I was there also. I was a hairdresser while I went to the Art Institute of Chicago.

Chuck: You were studying art and supporting yourself.

John: Yeah, I had a bunch of part-time jobs then. Hairdressing was good. You could work three days a week because there wasn't much business, and I refused to work in any place that didn't have a Jewish clientele.

Chuck: If art isn't a job, and I don't think it is, then anything you do that you want to do and for which you get paid to do it, is like dying and going to heaven as far as I'm concerned. It sure is a miracle when you think about it.

John: I don't know. I never died and went to heaven, and if it's such a great deal, why aren't more people doing it?

• • • •

Chuck: In the fifties, during the Eisenhower era, I worked for the Office of Civil Defense Mobilization. I helped make a billboard about a fallout shelter. I designed fallout shelters. We had to make an animated film on how to survive inside a fallout shelter.

John: That kept you busy.

Chuck: They used to say that what you had to do was open the door to your fallout shelter, put a plate outside, and go back into your fallout shelter. After an hour, you would go out, pick up your plate, bring it back in, and measure the radiation on the plate. I did this animated thing, but they said that I made it too happy. I made the radiation look like snow, and it looked like Christmas. The odd thing was that they wanted to make the fallout shelters look like homes, so they had fake windows with criss-cross tie-back curtains and a photo mural back there. It was so bizarre. It was a crazy time.

• • • •

Chuck: Our other big obsession as a country is violence. One of the things that always confused me was why work like yours was constantly described as being about violence. I never saw it in Pollock or de Kooning. I never thought it was violent.

John: You notice that no one really cares about de Kooning's abstract paintings *Gotham News, Easter Monday,* or *Excavation.* No, they always point to his paintings of women. In other words, you have to have an object in order to relate. You see, nobody has this trouble when it comes to music.

Chuck: *Well, they deal with Pollock as violent too, but for me it's like a doily on the back on my grandmother's chair. It's hardly anything. It's so lyric, it might as well be crocheted.*

John: Yeah.

Chuck: *You know what I mean? How do you feel about the way your work has been dealt with critically?*

John: Well, as I said it's like the way your bed looks in the morning. I can show you. There are a couple of shapes that look just like this. It's interesting to me, much more interesting than when things are laid out just right, never been used, no fingerprints. I guess they think that if something is crumpled up, then there's something violent about it.

Chuck: *Yeah, I don't get that. It must be the association with automobile wrecks, or something like that.*

John: Well, that wasn't my idea.

Chuck: *I know, beause you made such a—*

John: No, no, when something is just abstract like music is, they can deal with it, but when it's visual, they don't know what to do with it. "Who is that? What is that?" In other words, it can't just be itself. It has to *be* something else. Vision hasn't caught up to hearing for some reason, in terms of mental perception. Wait. Listen to the music. It's going in the ear. What is it? It is certain notes that, when put together, either form chords or a melody or a harmony that satisfies your sympathetic nervous system. Colors and shapes do that too. So, you see one by one sense, and you see the other by another sense. Humans, for me, haven't caught up to the ear with the eye. This is lagging. The eye is lagging behind the ear in terms of perceptions, in terms of perceptive values.

Bill: *I think it's more. Young children can see things before they're taught how to look at things. We're taught how not to look at things. We're taught to censor things or compare them to other things.*

John: Everybody understands when Picasso says he learned how to draw like an adult when he was little, then had to spend the rest of his life trying to learn how to draw like a kid. Yet, when Twombly comes by, they say, "Oh what's that? It looks like a bunch of scratches." But they were happy with Keith Haring. It was pretty clear.

Bill: *I think a lot of it has to do with—*

John: You see, it was the clarity: not only does it have to be clear to you, but—

Chuck: *The other thing about your work, besides the fact that for me it's very inaccurately described as being about violence and has that stupid association with car wrecks—*

John: Well, I don't think that's being done much anymore.

Chuck: *Well, I'm keeping it alive by bringing it up again.* [laughter]

John: Okay.

Chuck: *The other thing is that people just associate your work, I think, with one relatively narrow piece of it, although it's been evolving and changing all along. I was writing down the various things*

that I can remember that you have done. You made paintings that we don't usually think of. You put paint on and sandblasted the paint off down through the—

John: I made it look like giraffe skin.

Chuck: You made the wonderful foam rubber pieces, which I love, the galvanized things, the couches, which I love, stainless things, the Plexiglas pieces, paper bags, cigarette packages, foil, and something else I can't read here. What the hell is that?

John: I always thought you were supposed to do a certain number of different things. That's why in '66 I stopped using this particular kind of material. That's when I started using the foam. I tried the foam, and I thought "That was a good idea," and I did it for a while. No money came. "Ugh. They'll never last."

Chuck: At first, people defaced them and carved their initials and stuff into them.

John: A friend of mine actually said that he thought It was interesting for people to carve their initials; it was very American to carve your initials into something that had a very low life span.

Chuck: Yeah, people were really worried about that stuff.

John: What were they worried about? Whether it would last? I mean, it only takes you four and a half seconds to either get it or never get it. Anyway, I moved on to melting plastic boxes, but I didn't know how to color them. Then I came across this idea of putting them in Larry Bell's vacuum coater. Well, that was all right except that it cost too much. No money from that, but the idea was there if I could have done it. Each shot cost like two grand, and you know, in 1970, geez, that was a lot of money.

Chuck: Every time you put it in this machine it was—

John: It cost two grand to fire a—

Chuck: Larry Bell was putting it on plain, flat sheets of well-cleaned glass. You were trying to get it to stick to warped, fucked-up—

John: Yeah, that helped, but you needed to go in again, and turn it around. Well, I couldn't do that, and it had to be very clean. It was no good if—

Chuck: That sort of ruled you out right there.

John: My first experience with trying to get people to work for me was like, "Would you clean this?" They would work on it for a little while, and then they'd get bored and say, "I don't want to do this any longer." The pieces I made then were actually too large to do this. I should have done much smaller ones, but I didn't. It was too expensive to keep going into the third and fourth stages of something in order to find out whether it would work, which is really what you have to do, but there was no money to do this. Those boxes cost money. I took them to East Los Angeles, where the oven is. Of course, paper bags were too small, too common, but they were something you could relate to. Everybody blows up a brown paper bag and goes POP! Well, I didn't pop it as much as I did slow motion, articulate wadding. Well, that wasn't interesting either, even though I watercolored it and, in order to give it weight and stability, poured resin down all the creases. I thought that was an engineering feat of the century. Anyway, for me it was.

Chuck: Remember the bags that Alex Hay made? Those big bags?

John: Yeah, but he made a bag, that looked like a bag. Mine was a bag that looked like something else, but you still knew it was paper. The reason I put the resin down the creases was to maintain the paper. If you make it in bronze, then it's bronze, it is not paper. Then I made these big bags of aluminum foil. I would pull the bag in and crunch it down, and it looked like a big popcorn ball, but that didn't go over either. This was during a seven-year period of doing what I thought was my job, which is what I'm trying to get to. This was my job. Everytime I did these things, I appeared at my dealer's. It was the time when all your hair changes, all your skin changes, all your cell tissues change, and also, I always felt that it took seven years to figure out each studio you had, and then it was time to move on. So I did this, and every time I made these different kinds of sculpture, that great humanitarian Leo Castelli never understood an eyedropper's worth of any of it, you know.

John: You are writing. I wrote a book too. How about the—

Chuck: *Sure, absolutely, the films.*

John: I made a couple of films. Actually, I had a film career but it was too much, it was too much. I'm afraid to say that it was too much effort, but it might have been that. I think there were too many people to deal with.

Chuck: *Collaborative.*

John: I would stand around and wait for everybody in a collaborative effort. "When are you going to catch up?" But out of that movie, *The Secret Life of Hernando Cortez,* came three other movies that would have been terrific.

Chuck: *Well, you actually did make one.*

John: One actually still exists.

Chuck: *Yeah.*

John: I have it copyrighted so I can take this chance to talk about it because this is the time to talk about things I am probably never going to do. It's *The Secret Life of William Shakespeare,* and Bill, as he is known, or Will, is having a writer's block. It's halfway through his career and he's having this awful writer's block. His best friend, who is the village idiot and looks like a matinee idol. He's one of those young guys, a young stud, and everybody talks in front of him, so he and Will have all these conversations about what he heard. At night, Will's old characters come out like in that Christmas story. What's the name? Scrooge? Like the Old Christmas, the New Christmas, they all come out and talk to him. "What's the matter Bill, you can't write? You did okay by me," and they go through the thing. The other characteristic was that everybody in the movie had to speak in American cliché, which is the language of this country. My wife Lorraine was sitting in Jimmy Day's on Bedford Street once and all these guys who were sitting on a banquette started doing clichés, like an avalanche after a while, and she said it was the funniest goddamn thing she had ever seen, so I know that it works, you see? But I wouldn't know who to cast, and the costumer in that one *[looking at the poster of Hernando Cortez]* is dead now, Tyger Morris.

Chuck: *Oh yeah.*

John: She was great. I liked old Tyger.

• • • •

Chuck: Okay, so humor me and tell me some stories about Black Mountain. You were there right at the end, right?

John: Yeah, but that was a good place.

Chuck: Yeah.

John: It was a terrific place.

Chuck: You went there from the Art Institute of Chicago?

John: Yeah, a friend told me to go there. We went there together, actually. We all piled into my old Hudson and went down there in 1955. It was the poets' regime then.

Chuck: Yeah. Most of the people you talk about are the poets.

John: Well, I learned a lot from the poets then. That was a very valuable time, actually. That was the time when I really decided that I was good at assembly and collage, and the whole attitude came from trying to figure out poetry. I didn't know anything about poetry, so I started by putting words together and trying to make the poem that way. I still do the same thing. I was trying to make drawings with a pen, a brush, and ink. I had a hard time trying to figure out how to deal with the edge of the paper, so that a drawing didn't look as if it was squished inside that particular space, so I put a roll down on the floor as though it was one big piece of paper, and just made marks anywhere, and took them apart. Then, for some reason, each piece of paper had a mark going off the edge, and that somehow cured that dribble in my mind.

Chuck: Uh huh. To not respect the edge, in other words?

John: What?

Chuck: In other words, when you drew from then on, you didn't respect the edge in the same way.

John: Well, I did respect the edge.

Chuck: But you didn't respect it as a barrier.

John: Right. It was not a barrier. Anyway, I was doing these brush and ink drawings, not thinking anything of it, just doing something to keep my wrist flexible or whatever, but then Olson comes up with this guy named Ernest Fenollosa.

Chuck: Olson, the poet?

John: Olson, the poet. Charles Olson. Fenollosa was a teacher of English in China in about 1900, and he wrote this thing about how poetry and the ideogram should have a certain connection. The ideogram was a drawing of something, and it wasn't anything else. He was trying to be exact, and he didn't feel as if English was exact, in that sense. Ezra Pound found this essay ,and Olson said that everybody had to read it, so, for some reason, I went to his class. You had to take what you were working on, so everybody showed up with the three poems they had written that week, and I showed up with about four of these drawings. It was the first time anybody remembered that Charles Olson was at a loss for words.

Chuck: Was there much cross fertilization, generally?

John: No, Black Mountain was the kind of place where you could pick up something just bywalking down the road. You would see something or somebody would say something as

you passed, or you would observe a bunch of other people's dumb actions the night before, or remember something that was left over from drinking at Ma Peak's Bar.

Chuck: Had Buckminster Fuller and all those guys already left by that time?

John: Well, the painting people had left. Josef Albers was the head honcho before Olson.

Chuck: Rauschenberg and Twombley and all those guys were there during Albers?

John: That was another regime. It started with short story writers and let's see, 1948 or 1949 was when they had the biggest number of students, probably about ninety of them. When I got there, there were five. Actually, there were more faculty than students. Somewhere along there in '56, a bunch of people came thinking that there was just a big sex pot going on. They came to get laid, I guess.

Chuck: Not that the rest of you were against that?

John: Oh no. Many things were going on. I took Elaine de Kooning there. Ah, a new me. All's fair in love and war, you know.

Bill: We have an obligatory question.

Chuck: Oh yeah. I forgot about that. We ask everybody to say something about my having painted them, what you think of the painting, or some comment.

John: Oh that. First of all, I was very flattered that you asked, and secondly, I was glad to do it, and thirdly, I was never disappointed.

Chuck: Oh. I thought you looked very "matinee idolish" myself, but you do in real life also.

John: As long as you don't go below the nipples, you're all right.

Chuck: Oh, you know what I didn't tell you? I didn't remind you of the first time we met. The first time we met, which was in '68 or '69, I was going to a party in the building on the corner of Wooster and Broome, where Brooke Alexander is now. There was a party there, and you were the unofficial bouncer at the door.

John: Oh really?

Chuck: You threw Richard Serra and me down an entire flight of stairs. I know how Richard feels about you because I heard him toast you at an opening, and he said that he thought you were America's greatest living sculptor. I thought that was a very nice thing for Richard to say about any other sculptor, and, obviously, I don't hold it against you either.

John: I don't remember that.

Chuck: I don't hold it against you because I knew you wouldn't even remember.

◆

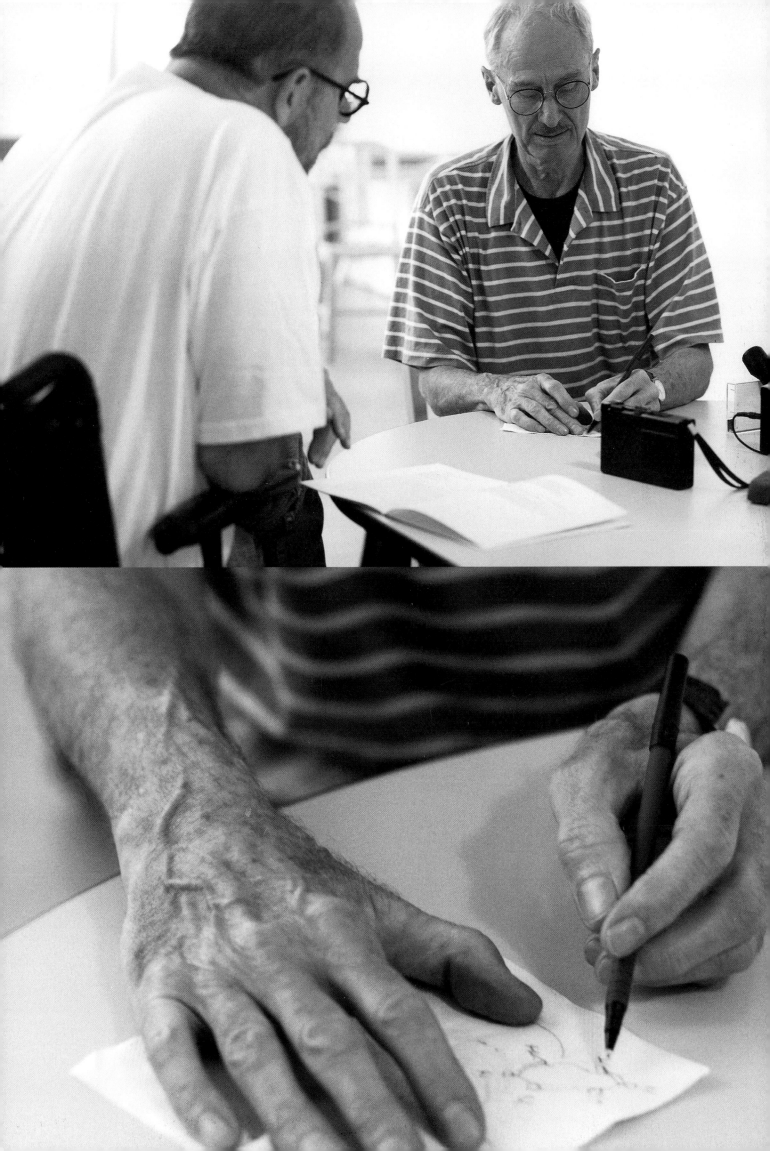

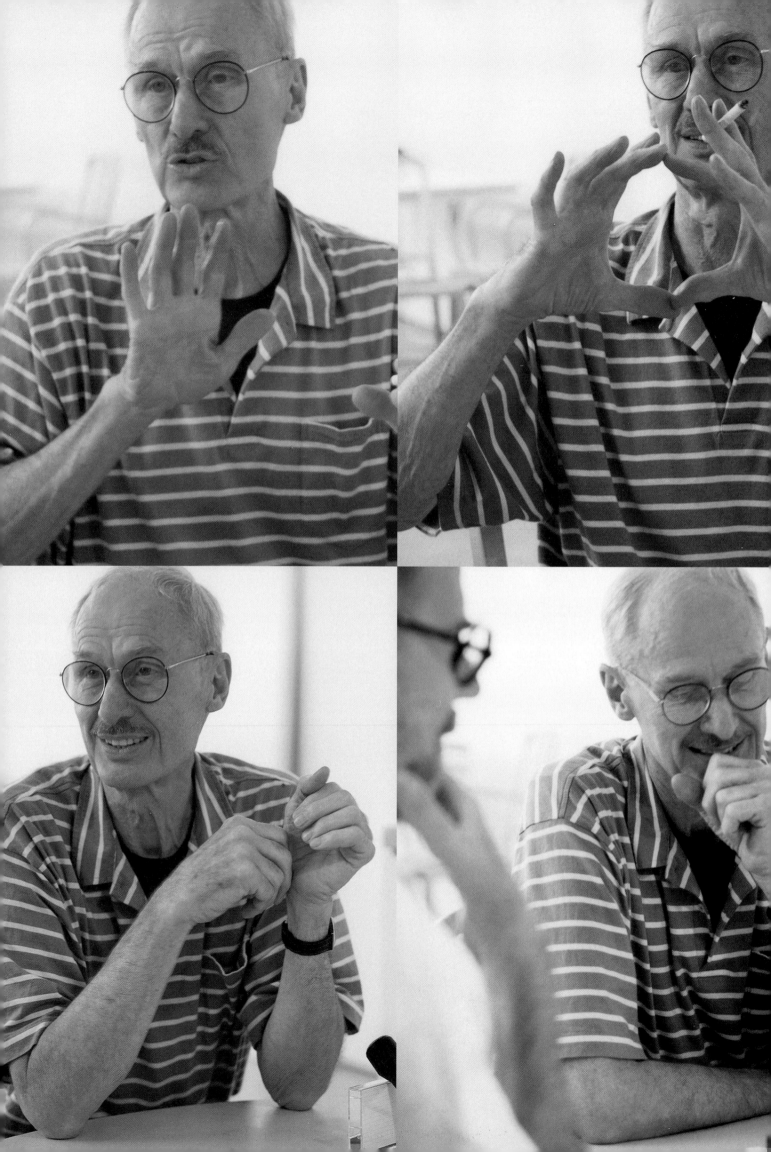

Richard Artschwager

New York City, May 9, 1995

Chuck Close: Speaking of being a late bloomer, the first show listed in your bio is a group show at Leo's [Castelli] in '64. Where were you before that?

Richard Artschwager: Where was I? Well, I was in a group show in the fall of '63, which was put up in a matter of days. I had an appointment with Leo that same week. I showed up for the appointment, but the gallery was closed. Leo opened the door and said, "Oh, I'm sorry, our President is dead."

Chuck: Oh god.

Bill Bartman: You're kidding.

Chuck: Wow.

Bill: Everybody asks the question, "Where were you?"

Chuck: Is that where you first heard it?

Richard: No, no. It was just the way he said it. It stuck in my mind. It was sort of an apocalyptic statement.

Chuck: I was a graduate student at Yale when Kennedy was shot.

Bill: I was in class. It was the beginning of my senior year in high school.

Chuck: If you don't mind me asking, how old were you in 1963?

Richard: Either forty or just on the way to forty. I was born in '23, and my birthday is the day after Christmas, so I was almost ready to roll over and turn forty.

Chuck: In today's generation that would be considered a late bloomer, because if you haven't had a major career by the time you're thirty—

Bill: Thirty? Twenty-five!

Chuck: Twenty-five. That's the age of the people in the Whitney Biennial this year. It was pretty shocking to me to learn their ages. I remember seeing your first show at Leo's in '65.

Richard: It would have been '65, yes.

Chuck: I don't think I saw the group show.

Richard: The group show was in '64. Four people were in it: myself, Alex Hay, Christo, and Robert Watts.

Chuck: *What ever happened to Alex Hay? I loved his work.*

Richard: I think he was more involved in dance then. There was an interdisciplinary explosion, and a lot of good material emerged at the turn of that decade.

Chuck: *What did you have in the show?*

Richard: I had just one piece, *Table and Chair.* It was later titled *Beyond Realism* and shown at Pace. I figure that title either came from Fred Mueller or from Ivan Karp, both of whom were interested in my work at the time. I know there was also sculpture in that show. Christo had a store front—the "mom and pop" store front. The preceding fall, Warhol was in a group show.

Chuck: *Was Christo's piece the one with the paper on the window?*

Richard: Yeah, it was papered up, and they were fighting, squabbling behind this fake door.

Chuck: *Who was responsible for you going with Leo?*

Richard: Oh, that was Ivan's doing. I sent a letter with photos in the spring, and I got a letter back saying, "Come back in the fall." I sent out eighteen more or less identical letters both to galleries and museums. I got a postcard from Alicia Legg, and then I got this letter from Ivan, and that was it. Those were the only responses.

Bill: *I've known Ivan since 1968, and he still personally looks at every set of slides that comes in. I feel as if he's a used car salesman. He deals with art as if it's still a commodity. He's got so much stuff for sale there.*

Chuck: *Were you doing cabinet work prior to that?*

Richard: I made furniture because I had decided that if, number one, I was going to be an artist, then number two, I had better figure out a way to make a living.

Chuck: *Were those two mutually exclusive?*

Richard: No question. The question didn't even arise. I was already on in years. It was the summer of '48 when I made the decision. I was prompted by my wife of that time Elfriede who said, "You don't have the temperament to be a scientist. You shouldn't be a scientist. You have the temperament of an artist. You should be an artist." I looked at her and said, "Yeah, okay," and so it was.

Bill: *You were a scientist?*

Richard: It was a toss of the coin. I was supposed to be a scientist. I took a trip to Pasadena and met with a man who was an old friend of my father's. I'm blowing names off. You know, Alzheimer's is the only thing I'm afraid of being nailed by. I felt then as if I was really in over my head. My mental set was fine, but the guys who were there working on their doctorates at Cal Tech were so cool. I had been out of it. I'd been in the army. In a way, becoming an artist was a cop-out.

Chuck: *So your wife convinced you that you would make a better artist than a scientist.*

Richard: First of all, I continued schooling. I wasn't done with school yet. I had another semester to go, so maybe it was '47. We went to Ithaca, and she got a job as an instructor in the language department. I had to finish my degree, because I felt that I ought to.

Chuck: *Was this engineering?*

Richard: No, it was biology, with a major in chemistry and a minor in math. In other words, a prep in the physical sciences would give me the surest power base for making advances in biology. Our feeling was, "Don't take a teaching job, because that will interfere with the main thing, which is to do the art, and don't take a commercial art job, because that will interfere also."

Chuck: *In other words, you didn't want to be doing, as a job, the same thing you were trying to do when you left your job. Is that why you felt a commercial art job would interfere with your art career?*

Richard: Your focus or attention is drawn into teaching or into commercial art, but that attention is what must be saved for the art, so you must do something else, something that's different.

Chuck: *So you made furniture.*

Richard: You go for a trade because people in trade can fail to show up for work on Thursday, and they don't have to say why. A trade seemed like a nice thing. If I was going to drop out, I might as well really drop out.

Chuck: *Did you teach yourself how to make furniture, or did you study it?*

Richard: My brother-in-law and I did it together. He was working on a Ph.D. at Columbia, and we knew we had to do something. I had worked as a photographer, a job I grabbed out of the paper. The requirements were that you have a two-lens reflex and a car. I had both of those things, so I got the job. It was hard work. I would sometimes do ten or eleven sittings a day: two bucks per shot.

Chuck: *Two bucks a shot? And what were you shooting?*

Richard: Babies. *[laughter]* It was a tie-in with the Stork Diaper Service. They would get the listing, and the photo outfit would go out—

Chuck: *Oh. Once someone ordered diapers, the diaper service figured they wanted pictures.*

Richard: The customer would receive a free five-by-seven photograph when she subscribed to the Stork Diaper Service. I would take a bunch of photos, but the salesperson would take only one five-by-seven and go in and beat 'em up. *[laughter]* I was self-taught. My brother-in-law took early retirement from teaching literature at the University of Arizona so that he could go back to building furniture, which he really liked to do.

Chuck: *While you were making furniture, were your first pieces paintings, or were you making sculpture?*

Richard: At that time I must have been going to art school with one of the émigrés, the French purist Ozenfant, who had a school on the other side of Gramercy Park between Third and Second down about Twentieth Street, I think.

Bill: *We've just interviewed Dorothea, and it's interesting that both of you began by being interested in science and math.*

Richard: I didn't know that about Dorothea.

Bill: *I didn't know that about Dorothea either. That interview was sort of shocking to me, because I had a completely different vision of what the underpinnings of her work were.*

Richard: In my case, there was really a break. I went from the world of the objective to the world of the subjective. These are two very different—I would now call them—bodies of

knowledge or modes of knowing. I think scientists mostly think that art is healthy, therapeutic, and a great ornament to life, but not a serious business, not a grown-up pursuit.

Chuck: I never found anything at all therapeutic about it. That's why I go to therapy.

Bill: Most mathematicians who are real mathematicians, for instance, Einstein, consider themselves artists in a way.

Chuck: When you really break through at the top end of math, it isn't about arithmetic and nuts and bolts stuff. It's very creative. I obviously never got that far.

Richard: It's about making something that wasn't there before.

Chuck: Anyhow, I'd just gotten out of graduate school in '65 when I saw your first show. I went to Europe, and then I moved to New York in '67, the same year you had your second show. I'd just like to say, early in this interview, how important your work was to me in many, many ways. You sort of built paintings, especially with the Celotex and its hairy texture. Half of my work is black and white, and I'm sure your black and white work got into my head in some way and made an impression, and obviously, the grisaille paintings with their level of mixing artificiality with reality had an influence on me because they were black and white and because of the insistent texture of the Celotex. I was trying to make work that was a departure from what I had made before, which had been abstract, and I was looking for an intelligent kind of figuration that wasn't backward looking, that wasn't reactionary, or retardare. For me, you really kicked open an important door for modernist figuration and representation that was intelligent, forward looking, advanced, difficult, rigorous, and all of those things.

Richard: But it was never a trap for you.

Chuck: Well, there are so many things about artificiality. I care a lot about marks on a surface, and that whole notion of artificiality when you used Formica that had a wood grain and lately painted faux wood grain—How we read things in the work has been incredibly important to me, and I wanted you to know just how important that has always been to me.

Bill: That's one of the reasons Chuck painted you. He never wanted to forget how important you have been to him.

Chuck: Plus, I have always loved sculpture more than painting.

Richard: I love to hear that. One wants to count for something, and that's a way to count for something: to find a different way of seeing, which was what I was looking for or, as you put it, kick—I love that—kick the door open. I value that as much as anything.

Chuck: When someone kicks the door open, the rest of us can go through that door a lot easier. It is an important thing.

Richard: Well, oneself gets to go through the door too—have your cake and eat it too.

Bill: Have you ever said this to Richard before?

Richard: Yes he has. In a bar. At the Spring Street Bar.

Bill: That's what we're trying to recreate here.

Chuck: Yeah, these conversations are the nineties version of sitting at the bar, I guess. I think I was always more interested in sculpture than I was in painting. My favorite artists tended to be sculptors. Your use of a table almost as a sign for a table and all of those things was incredibly important. I remember how oddly you fit into the Primary Structures show. Here was this idiosyncratic personal

vision stuck into the Primary Structures *show, which I thought was very interesting. You certainly made it interesting for a lot of sculptors as well.*

Richard: I think it was a piece of good luck that I was more or less stuck in my workshop and decided to let some art happen there. It pretty much started with a chair. There are two ways to make a chair. One is to form a chair in your mind and then build it. The other way is to take an existing chair and copy it. I thought I would do both. On the radio a while back I heard Yogi Berra being quoted as saying, "When you come to a fork in the road, what do you do? Answer: Take it." And it all came together because of the materials I knew about, and I had the good sense to not compromise but to push to extremes. The chair is the chair of the mind, like a lower case "h," and the model is a very particular chair, the mahogany Victorian chair with red plush upholstery. The latter is jammed into the former. This has helped me to understand painting too, I think.

Chuck: *Right.*

Richard: Uh, it's like benzene. There's something that happens in organic chemistry that's like what happens in painting when you see what's there and what isn't there. It takes both to make a painting work, but they are incompatible, so they must alternate in our perceptions, maybe very fast. Now, back to benzene, and it looks like this:

Chuck: *Uh huh.*

Richard: There's another version of this, which is to double bond this, single bond, double, single, double. Which is it?

Chuck *I don't know.*

Richard: It's both. This is Linus Pauling's thing. It resonates between the two. How fast does it resonate? Is it a chair or is it an image of a chair?, and little afterthoughts like that, plus the shadow under the chair is in the same plane, so image is forced and then the structure is forced and then you have what was the object to begin with, or the dilemma, an absolute dilemma wherein both are right, but each is unstable. That also tells you about paintings, why paintings can continue to be interesting. We know now that they have existed for thirty thousand years. Why do they continue to be interesting?

Chuck: *Some people don't think they still are.*

Richard: I know. Painting's dead.

Chuck: *Right. Well, you made those wonderful symbols of paintings with the Formica for the image and the Formica for the frame.*

Richard: Yeah, this is all spin-off from those.

Chuck: *Did you first use Formica for the frames of paintings?*

Richard: No.

Chuck: *You used to do those wonderful metal frames, too, that gave a certain object-status to the frame that said, "Everything inside of this is a painting."*

Richard: But Chuck simply blew away the frame, or pretty much the space around the face. I mean, the painting is going to make you come even closer, and you want to be this close, and you want to be—

Chuck: You know, everyone has regrets, and one of my big regrets is that, very early on, I didn't buy two of your paintings when I first saw them. One was a little painting of the Capitol, and the other was George Washington's head. They were three hundred dollars each. At the time, I was making three thousand dollars a year and paying two thousand a year in rent. I wanted to buy either or both of those paintings so badly. I would visit the paintings as if they were mine, and I was trying to raise the money to buy one of them.

Richard: I think I would have given it to you.

Bill: The thing about Ivan is that although he is such a wheeler-dealer, there was about a ten-year period during which I always owed him money. I would pay about twenty-five dollars a month.

Chuck: My problem was that I was trying to raise the money first. I should have just taken it and figured out how to pay for it later.

Bill: Patterson [Sims] taught me that I could do that. To this day, I'm paying fifteen different galleries as little as fifty dollars to two hundred dollars a month for artwork. I don't take it until I have completely paid for it.

Chuck: Oh, I do have a wonderful little painting of yours for which we traded, and it is one of my greatest pleasures to own it. I have one of those with three lines. When did you start making the lozenge-shaped blip work? It must have been '67 or '68, or something like that. I had a blip on my wall before I moved, so it had to have been around then.

Richard: That would be about right. I did the punctuation pieces first. That was in '66. They hung on the wall and were meant to be in common space—the same space that you and I are in. That lay dormant for a while, until I took a job at UC Davis for a semester. This was the time for a long look, and I decided to take my painting apart and see what was there. There were maybe half a dozen kinds of basic marks. I tried these together in different ways. It didn't go anywhere. I took a page in a notebook, and put a ballpoint dot right in the middle. Drawing done: good visibility because of little competition. I went into some magazines to punctuate various places and events, this time with a felt marker: accidental or intentional lengthening of the mark, which gave a time lapse and orientation. I made some marks that were physical, painted wood stuck on wall, made some clusters that reminded me of Bart van der Leck who made paintings, black dashes on a white ground, just a very few to make, for instance, a cat.

Chuck: Oh yeah, right. We'll have to look up who that was.

Richard: I'd seen that, and I decided to make something in the same space as the punctuation was. I had to settle on a size, so from this format I arrived at not smaller or bigger than a bread box or a loaf of bread but the size of a loaf of bread. I made a bunch of those out of one-by-four or one-by-three light-weight pine and gave them that shape. I used double-faced tape, which had just shown up. I had seen pieces done by a Swedish artist, Oyvind Fahlström, who had components in the painting that were like arms and legs and were movable or would be fastened on one end and the viewer could actively participate. I made about a bushel of these. I actually had a bushel basket. I filled a bushel basket and painted them black. At Davis there is a studio or exhibition space that was like a floating crap game. Either faculty or students could put up art. You could put up some art, and then, after a while, take it down. So I

took a wall there, and I started putting these things up. There were clusters, spread over twenty feet of wall. I took some down. A good friend of mine had been watching me and she said, "Why don't you take down some more?" So I took down some more and then I got to a single and went out and starting installing them in the hall, out the door of the building, and that was the trigger.

Chuck: *Pretty soon, these things were showing up all over the world.*

Richard: I wouldn't say it went down the drain, but—

Chuck: *I thought the same thing but I didn't ask.*

Richard: I had the woodworking business.

Chuck: *Then you began to make the blips. I had a peel-and-stick black vinyl blip. You made those things out of that material that looked like air-conditioner filter stuff.*

Richard: Contradicting was a formula from the beginning. If you look at a Matisse painting, for instance the one of the piano lesson, and you stare at it, you get nothing. If you move a little bit, then that's a more natural way of looking, and the whole thing becomes hyperreal. With the Seurat, that was done so systematically and so consciously that it almost didn't work.

Chuck: *You know, I have to tell you a funny story about when you started making the blips out of different thicknesses and different kinds of materials. One day I was walking up Greene Street from Canal Street, and lying in the gutter was a black rubber blip that was about eight inches long and about a half inch thick—a perfect lozenge-shaped blip lying in the street. I thought, "Oh, Richard has been here." I wanted to lean over, pick it up, and take it home, but I thought, "No, I'd better not because this is the distribution piece. This is all over the place." I walked further up Greene Street, and there was another one—*

Richard: Oh really?

Chuck: *—and another one, and then there were five or six of them. Then I got to the Houston Street end of Greene Street and there was a truck sitting there, and it was piled ten feet high with these things. They were obviously some kind of industrial by-product that had been stamped out and was scrap being taken somewhere else. Obviously it wasn't your work at all, but I had thought that it was. I thought it was wonderful that you had taken this shape and, just as Yves Klein took that blue and removed it from the palette so that no one else could ever use that blue without thinking "Yves Klein," you had taken this shape and made it so much yours, that even when someone saw something else in that shape, they assumed it was yours.*

Richard: I didn't arrive at it that way. It was under foot in my life just as in yours, but I had to get to it by another path.

Chuck: *Did you have people go out and distribute the blips? I remember seeing them in Seattle, and again in Tokyo, on the sides of buildings.*

Richard: Tokyo I don't know about, but Seattle, yes. I think that Lucy Lippard asked me to participate in something in Seattle, but I couldn't go to Seattle, so I sent the blips. Also, when doing those in New York or other cities, it was smarter to go with someone who could keep an eye out on things. This was done rather quickly with stencils and someone had to watch to make sure that no one was looking. You've got to have a collaborator. Torreano worked along with me in the Whitney Annual that time.

Chuck: If you look at the titles of your shows: Box *at Dwan Gallery, then* Primary Structures *at the Jewish Museum,* Art in Process *at Finch Gallery,* Photographic Image *at the Guggenheim,* Cool Art, *let's see,* New Medium Methods, When Attitudes Become Form, *great show,* Aspects of New Realism, *the Information Show Lucy Lippard did in Seattle,* Pop Art Redefined, Soft Art, Art By Telephone, Walls, Information. *When you look at a list like that, you realize how difficult it is to categorize work that could have been in that many different kinds of shows, with that many different titles. It really is amazing, the uncategorizableness of what you do and the breadth of it.*

Bill: That's why so many people have been influenced by his work. That's why you've pushed open so many doors for so many different people who do such different work, because—

Richard: It seems more like one door. Either that, or else I'm the whore of the art world.

Bill: No, no. I mean many people have found something in your work, something that they could continue.

Chuck: Can you talk a little bit about the reoccurring imagery that's been in your work for all of these years and that resurfaces here and there: the wood grain and all of that sort of stuff? Why do some of these kinds of imagery fascinate you, and how do you continue to find new urgency with them, year in and year out? What can you say about what really seizes you as an image that has mileage in it, so that you can keep shuffling your deck?

Richard: Maybe it starts with the beginning of the day: "What am I going to do today?" "I'll do what I did yesterday. I'll just do what I did yesterday."

Chuck: I have a similar approach. It's nice not to have to reinvent the wheel every single day of your life.

Richard: Well, maybe you could turn it in a different direction. I felt trapped by the blips because I thought they really covered the ground, no pun intended. How could I get out of that? In a way, you mark time, and you still do what you did yesterday. I have a five-foot shelf that is filled with notebooks. Sometimes I just open a notebook and draw something. I worked in one room for about ten years. It was really a good room in which to work. It had been a bedroom. Eventually, I emptied the contents of that room into my notebooks. My mother taught me the elements of drawing. You first draw from the model things that have edges rather than surfaces. If you could see your retina, then that would be easier, but it's not that bad, and soon you get the hang of it. She also told me in so many words, "Watch the edges." It is still, for me, a very trippy thing to do. That's how you make the jump from where you can grab something that you imagine or you receive something with all your senses to putting it on something flat. Everybody who learns to draw crosses over into that. If you want to draw a horse, you draw the torso, and then you draw the shoulders, and then you draw the ass end, and these are manifolds. The oval means a three-dimensional thing that's easily understood or a box, you sketch in a figure, and if you do an oval, the top of a glass, you've got a glass there, and the top of a glass, it's not that, it's that and what is that? Well, you have to look down to see what it is. You keep yourself in the same position. In other words, you project what you're doing naturally and if you would shut up and see what's on your retina, the retina on your eye, which is an oval and—

Chuck: It's funny too, because when you teach a system for drawing a glass in perspective, the minute a person learns that system, they stop looking at the object. They no longer look at the specifics of that particular glass, they just use this imprinted, pre-recorded—

Richard: —generic—

Chuck: —system for how to do it. I was taught that way and it was a stupid way to teach, because it really truncated one's experience. Having this kind of overlay stopped the looking process somehow. There's nothing more repetitious than being an artist.

Richard: A lot of it is just keeping your eyes open. That's the way I got out of the blip thing; I just drew what was in the room. "I've had my coffee, I've been to the bathroom, so I'll draw something that could maybe be made more substantial." One morning I didn't know where to go, so I thumbed back through a notebook. There was a piece of interior, and there was also one a few pages back, so I thought, "I'll start with that." I made a list of the things that were in this drawing. There were entities that you could separate out: a door, a rug, a table, and so on. I wrote those six words at the top of a fresh page in the notebook and that's what I started with. "I don't have to look at anything, I'll just draw those six things in the context of one another"—not putting that in so many words—"to jump-start myself." Then I came up with a drawing that was different from the source and thought, "Fine, now what will I do?" "Well, I'll just use the same set of instructions," and then I ended up doing that fifty or a hundred times.

Chuck: It's a wonderful series. The variations are incredible.

Richard: There's one constant, which is the black spot, and the context is what—

Chuck: If you limit yourself to only what's in that room, you really have to get moving to make it interesting.

Richard: It's also liberating, because when you start with the word, you can then start with one of the objects, and the others have to relate to that somehow. There are a thousand different ways to do that, because the paths that can lead from that are determining each one of them. If you do a second thing, it can determine the third thing, and so, that way, it's a universe of the six objects, but their context is of one another instead of the whole world with the black spot, it's kind of the opposite of that, but it isn't. It's nothing that had occurred to me, I had to serendipitously find it by trying to jump-start the day and get going.

Chuck: That's actually not very different from when you used to take a photograph of a building being blown up or something like that, just accept that, and then start making a series of paintings.

Richard: It's similar because you're taking the image, which from the start was a cruddy, small, inaccurate image—it's like a weakened virus: you can do things with it because not everything is determined—but you can get off the track. The object is to get off the track, and that happens to work very well with small newsprint reproductions.

Chuck: You change in order to keep going. You build objects for a while, then you draw for a while, and then you make paintings for a while. Or do you do them all at once?

Richard: More like one at a time, sometimes for short spells. It's better that way.

Chuck: I'm good at working within limitations. You were saying how liberating narrowing the focus is; that what it would seem to do is limit your options, so that they would seem to get narrower and more claustrophobic; but in fact it always opens things up.

Richard: That's the way it seems to happen.

Chuck: *One of the nice things about being an artist is that it can be constantly gratifying, as long as you—*

Richard: It's a great gig.

Chuck: *It really is, and to do what you want to do and get paid for it is an absolute miracle, don't you think? I know a lot of people my age who have had very little critical or financial success, and they have been making art for as long as I've been making art. In any other field, they would be considered failures because the standard of measurement is financial success or fame.*

Richard: Well, some of that crept into the art society too.

Chuck: *You used to be able to do all the galleries that showed contemporary art in an afternoon. You could see everything, you were part of a community in which you knew virtually every other person making art. You could very easily see everything that anyone who called themselves an artist was making, very easily, but it's a different world today for a young artist getting started.*

Richard: Things are pretty tough.

Chuck: *Yeah, but you've kept all the balls in the air for a long time. It's a long time to keep engaged, keep it fresh, keep it moving. What do you think of the art world today?*

Richard: Quick answer: anarchy. It took me a while to find out that that is really the state of affairs.

Chuck: *You were talking a little while ago about luck, that you do what you do and, if you're lucky, the art world happens to be interested in it, and, for a moment at least, you're in sync with the art world. Your paths cross. Later, you go out of phase again, and then later, if you're lucky, your paths will cross again and the art world will see real urgency in what you are doing, and if you live long enough, maybe that will happen yet again.*

Richard: I've been out of phase a lot.

Chuck: *Yeah, but in the eighties, a lot of young artists tried to find a strategy to fit into what the art world wanted, and in a sense ended up chasing that notion, but they were always a few steps behind. You're a perfect example of someone who just kept moving. Your work has been in and out of phase with the art world several times, and it continues to have real urgency for a lot of other people. Many young artists continually keep rediscovering your work. Another artist who is being discovered by kids is H.C. Westermann. They had no idea this guy existed, and he's been dead now for how long? It's like new work for them.*

Richard: They gave him a show at the Whitney, and then he dropped dead.

Chuck: *Yeah. Let that be a lesson to us.*

Richard: Super fanatical, disgustingly fanatical pieces, undertakings, laminated toilet, plywood.

Chuck: *You know what I was thinking of in relation to your work? His faux knotty pine piece made from the clear pine box. He cut the knots out of other wood and then inlaid the knots into the box to make a fake knotty pine box. Do you know that piece?*

Richard: No.

Chuck: *It's a wonderful piece. Coming to the art world from the navy, from an entirely different point of view, informed his work in such a different way. Boy, talk about somebody who came from left field.*

Bill: Let's talk a little bit about the paintings and drawings that Chuck did of you. They are almost thirty years apart.

Richard: I got a call from a lady at the Metropolitan about this drawing. Kathy had sold it. It was a bummer because I didn't have it. I don't have it.

Chuck: Yeah, well that's divorce.

Richard: It just brings to mind a whole catalog of sins and stupidities that I've inflicted on other people and myself.

Chuck: Almost everyone with whom I ever traded doesn't have the work. It became the roof on the house, the car that they needed—

Richard: You see, I always thought that was okay.

Chuck: I remember that I gave a piece to someone, then they needed a down payment on a house, and the piece went into the down payment of the house. Then they got divorced, and I said, "Well, I'll give you another piece," and then another marriage, and then that piece ended up being sold for the same thing. It's fine though. It's a life that keeps on. Your hair has gotten lighter.

Richard: Yes, oh yes, and there is less of it, too.

Chuck: You still have more hair than you're supposed to, as far as I'm concerned. I want to know why Joe Zucker has always called you "the parson."

Richard: The parson?

Chuck: Yeah.

Richard: Oh, he might be thinking about Doc Holliday or—the parson? I would have thought the undertaker.

Chuck: I'd like to talk about your paintings a bit. Let me just ask you a question while you're here. When you paint on the Celotex, how do you do that? Do you size it? Do you seal it with something?

Richard: This is a subject that—just to digress—this subject has come up a lot of times over the years and I used to talk about it, but I'd lose the person's attention within the first three minutes, and I could ramble on about anything, so that—

Chuck: The physicality of the paintings seems so important.

Richard: Well, the ground is important in that it's flexible, maybe even more flexible than canvas because it doesn't have threads running all the way through. It's fiber, it's sugar cane fiber.

Chuck: I didn't know that is what it is made of. Sugar cane fiber.

Richard: It was a case of finding a use for waste material. Somebody made a lot of money on it; it was a worthwhile thing to do.

Chuck: So you've been involved with recycling all these years, in a user-friendly pro-environmental approach.

Richard: It pre-dates Rachel Carson. It's paper, it gets sized at the factory, and the medium is acrylic polymer water emulsion. If you don't let it get too brittle, you are painting on a surface that is a complex schism. Canvas is a complex schism. You're not starting with nothing.

Chuck: It's something with an insistent surface too. Something that you either fight or go with.

Richard: Canvas has a north-south-east-west grid. This pattern is used by painters when they use a palette knife to scrape the paint, hitting the high spots, because the palette knife will

not dig into the deep spots. It leaves a thin residue of paint on the high spots and leaves the low spots filled in, which makes a color and makes a pattern. Then you put on some thick paint, and the thick paint obliterates the grid, departs from the grid. It's also true of drawing, but the given with drawing is not north-south-east-west, it's random, hills and valleys. Even with a glazed paper, there is fine tooth and there's coarse tooth.

Chuck: *Right.*

Richard: So you want to keep the tooth because you are consciously acknowledging and using this given. It's all water-based, and I draw with charcoal. I wanted something that had the characteristics and strength of drawing—the full power of drawing. If you look at a piece of newsprint under magnification, you begin to get some expression. If you were drawing with charcoal and charcoal paper, you would use a range, from drawing line to line with the thumb lightly passed over it, to taking the charcoal and the surface and anchoring it in the high spots and taking it away from the low spots, and then you have a—

Chuck: *A natural halftone.*

Richard: A brilliant surface, or a natural halftone, as you say, or you rub it and you get a—is it called a *sgraffito* when you get a kind of a fault—so you have a range with drawing that's a lot like the range with painting.

Chuck: *Let me just ask one question. You are talking about the north-south axis of the grid of canvas. Are the kind of swirly patterns in a lot of these paintings in some way connected to the fact that there is not a standard direction to the fibers of the solotex?*

Richard: No. Celotex, which is paper, is made out of a slurry and then concentrated, not with a screen, but with rollers, and there is a random spread of the fibers, and they lock into each other like magnets. Paper patterns.

Chuck: *Like paper does too.*

Richard: Yeah. Sugar cane fiber is a very coarse fiber, and if you beat it, not to death, but if you beat it sort of part way, you can get a range from here to maybe out to here [*indicates with hands*]. What you're talking about is an embossment. I've been able to go beyond that to get embossment. I tried to make this myself using fiberglass but with no success. It would be like Celotex under magnification but with real organzation, with a repeat pattern that would look like the brushstrokes of a fifties de Kooning.

Chuck: *Or the background of* Starry Night *by—*

Richard: That would be the other one, where you have swirls, like the van Gogh *Starry Night*. I've used those two kinds. I've used a couple of other kinds, but I haven't run out of options with these.

Chuck: *What interests me is the resistance of painting on something that has got some texture. There's some drag, the brush drags. It's a little bit like putting rocks in your shoes: you're going to run differently because they're there. It keeps you from just slipping the paint on, is that correct?*

Richard: It's more possible to do things if you have a little resistance or drag. There are more options in the kind of drawing that happens. You can be guided by the surface if you hit it light, or you can re-arrange the surface if you don't, so you can have both of those working. If you're

guided by the surface, then there is a kind of repeat that runs through the thing, it cycles through it, a little bit like the ghost echo that you get if you work a grid and you do one square at a time. You're embedded within the square, and it's kind of like taking a virus and weakening it so that you have more room for yourself. Salk had more room to play with polio because he took the virus and poisoned it, weakened it, so that it would be less stubborn in a way.

Chuck: This stuff clearly addresses interesting issues. Any time you have a recognizable image, people stop at the level of iconography. The thing that really interests me about your paintings is how the drag, the resistance, influenced the way the images were built. If they were reproduced, they might look the same, but as a physical experience, they are entirely different.

Richard: Absolutely.

Chuck: It's not something that people write about because they are so iconographically oriented.

Richard: Also, they know about [Walter] Benjamin's *The Work of Art in the Age of Mechanical Reproduction*, and they believe that's the story, so half of the art historical landscape is fucked.

Chuck: Yeah.

Richard: They leave room for the rest of us.

Chuck: I'm really glad you said that. I think that's really true.

Richard: I really had a chance to see [Kasimir] Malevich in Holland. When I actually looked at a bunch of them, not just the white square at the Modern, to see that the substance of the paint was what makes those paintings—

Chuck: Right. To say that it's just a white square is to totally miss the point.

Bill: The Robert Ryman show was a revelation.

Chuck: Absolutely. Yeah.

Richard: Ryman has always known what he's doing.

Chuck: The notion that he was a "Johnny One Note" because everything was all white, "Oiy, you're making another white painting," was ridiculous. The tremendous range that he had in that show was unbelievable, as opposed to say the Twombly show, which I found unbelievably repetitious and boring. I think what you said about [Walter] Benjamin is really interesting. Have you ever read Ivins's book? He was the former print curator at the Met, and he wrote an incredible book about looking at prints. Did you ever read it?

Richard: No.

Chuck: It's brilliant because he talks about pictorial syntax, and one of the examples that he uses in this book was the discovery of the sculpture Laocoon. It was discovered pre-photography. When it was first discovered, it went into the Vatican's collection, and people from all over the world heard about this sculpture and wanted to know what it looked like, so print-makers from all over the world flocked to Rome. They all made etchings of what Laocoon looked like, and, of course, they didn't see each other's prints, but they all had exactly the same source. Each print-maker found a different way to draw this sculpture. Some of them used dots, some of them used cross-hatched lines, some drew outside, outline things, some of them modeled it, and—

Richard: This is the *Laocoon* with the two sons and the serpent? I'm working on one on that very subject matter.

Chuck: No kidding. Well, you've got to see this. I'll see if I can find the book and get it to you, because independently they all found a different way of drawing this thing. The brilliance of Ivins' book is that he is actually able to talk about pictorial syntax in the same way that a writer would tell a story. A writer's choice of words influences what you come away with as an experience. In this case the constant is this piece of sculpture, but each artist brings something different to it, a different hand, a different touch, a different interpretation. It's really such good reading. He's one of the few people who writes about art in the way that people who have had the shared experience of making art think about art. It's not only what you're making, it's how you choose to make it. The thing about this Ivins is that he really takes on Benjamin, from the point of view that the invention of reproducible imagery has changed art in a way rather than killed certain aspects of art. If you're interested in debunking Benjamin, I would really recommend Ivins. I'll see if I can find it. It's out of print, but maybe I can. What Prints Mean *by William Ivins.*

• • • •

Richard: *[Looking through Chuck's Baden-Baden catalog]* Is that the eight-foot nude?

Chuck: Yes, that was in the show. It was the first time it had ever been exhibited.

Richard: Where was this? Berlin?

Chuck: It was in Baden-Baden, and then it went to Munich and Paris. I didn't love being in Germany, though.

Richard: I'm a collector of souvenirs. One of my souvenirs is a death certificate for Robert Lye. He was in Hitler's cabinet. He was the leader of the strength through joy movement. I lifted his death certificate from the files when I was there. I worked there until the end of the war. I couldn't get transferred back to the States because I didn't have enough points, so I worked in Frankfurt at the former headquarters of the I.T. Farben Industry, which was then Eisenhower's headquarters. I saw that the death certificate had been duplicated. There were six copies, all signed by this doctor who was a medic in the Marine Corps. Anyway, I just took one.

Chuck: What were you doing for the army?

Richard: I had basic training in artillery at Fort Bragg, and I went through field artillery school in Oklahoma. Then I went to the intelligence school at what is now called Camp David. There wasn't an OSS. It was just strictly military intelligence, the army, and I went through that training and was shipped over to join an infantry division.

Bill: Was this after Normandy?

Richard: Oh yeah. I didn't get in until the latter part of the Battle of the Bulge. I had a great uncle who starved to death in Leningrad during the siege—he was lucky—and a first cousin who was on the other side in the Battle of the Bulge. I hadn't seen him since he was five years old when my father took us over for a summer to visit the farm. My cousin was in an SS Division, and I was on the other side.

Chuck: Wow.

Richard: We figure we were maybe ten miles away from one another, maybe less, on opposing sides of the line.

Chuck: *You had been that close to each other?*

Richard: Yeah.

Chuck: *Wow.*

Bill: *It's amazing how different things affect our lives.*

Richard: But he knew what was going on.

Chuck: *How long did you stay after the war was over?*

Richard: My division had gone back, but I hadn't been in the service long enough —

Chuck: *—to get discharged?*

Richard: Yeah. There were friends of mine around. One in particular, who had done the course with me at the intelligence school, said, "Do you want to come to Frankfurt?" I replied, "Sure," so then I joined the G2 section for the European theater. Basically, I had an office job, did some career work, and took a field marshal who had been an occupation commander to Oslo to stand trial. Then I had a run down to Vienna, met some people there, and got transferred to Vienna. I was Vienna CIC for about a year, at least a year.

Chuck: *I was in Vienna too, in the sixties.*

Richard: Yeah?

Chuck: *Were collections open in Vienna, or did they put everything away?*

Richard: There was a spa in Wiesbaden that had a bunch of paintings stacked up. One of them was the Manet barmaid with the mirror. Did I get to see any collections? The answer to the question is no. That was '45, and I was in Vienna in the winter of '45.

• • • •

Richard: My father had sent me and my sister to Munich for the winter of 1932. I think he just wanted to get rid of us. [laughter] So my sister and I both went to school that winter, and my mother did too. She went to the academy.

Bill: *Your mother was an artist?*

Richard: Yes.

Chuck: *I didn't know that.*

Richard: She had two kids, and my father worked for the government and didn't make much money. Basically, she was a mom and a housewife, but she painted throughout her life. About one out of every ten of her works was good.

Bill: *Do you have any of her work?*

Richard: My oldest daughter is sitting on most of it. I was hopping around too much. It's not good for me to have a lot of anything, so I have only a few pieces.

Bill: *It would be interesting to see it.*

Richard: She liked Oskar Kokoschka and Lovis Corinth.

Chuck: *I'm always amazed when I run into an artist who had any exposure to art as a child. The fact that your mother even knew who Lovis Corinth was is shocking to me. Now that I know that your mother was an artist and your father was a scientist—*

Richard: He wrote his doctoral thesis on the definitive anatomy of the potato.

Chuck: *Well, what else do we need to say?*

Bill: *We still haven't gotten a reaction to the goddamn painting.*

Richard: Which painting?

Bill: *The painting of you, by Chuck.*

Richard: Well, let's get it out.

Bill: *It's right here.*

Chuck: *You don't really have to say anything.*

Bill: *I'm interested in knowing what you thought when you saw it finished.*

Richard: I remember being posed for this. You paid some attention to the tilt of the head. Maybe I have too much objectivity, but I can really be outside of myself.

Chuck: *The painting is actually more pale than it reproduces.*

Richard: Yes.

Chuck: *It's a very pale, very washed-out kind of image.*

Richard: The right way to do a portrait is to make the portrait address the person to whom it is looking: one on one, directly; the eyes are the windows of the soul; the mutual presence of oneself; the viewer and the portrait. Whichever. I'm not going to be the portrait. I'm just going to be the self. I said earlier that your paintings address one in wraparound. You blow away the frame. It's not an issue. It is a presence that, if it works, is not going to tolerate only the eyes being the windows of the soul, although it also needs that. *[Looking at a reproduction of his portrait]* So you have eyes, this is looking at me, and I can't say that this is looking at me and this is looking at me, but in fact, I'm looking at it, as I'm looking at your thumb in your mouth. I need this to operate in a time frame, so paintings in general have to work in the instant, because that's what it is. It's a still, but they are in a time frame no matter how. So, to get specific, the ear is looking at me, the hair is looking at me. Your high contrast eyeballs appear wherever you happen to make them, but it happens that most of them are in the hair, except the hair being all, I mean, in a chemical way, categorize as eyeballs is all of the piece, the eye part goes into periphery. But what it boils down to is these depart and they come back, especially this white one here. When you look at it, it kind of goes away and then it comes back. It's a special case for painting in general, but there has to be an address and that address includes my hand. You can't do an exact equivalent of that, but it sort of boils down to the same thing. I mean, there's this event, and after a bit there's this event, which is not unlike having folded your arms down, and then you've done this, and this and moved your head. It doesn't hold still. I mean, a totally different event—very crisp, hard-edged—could be made by using high resolution film and so on. You get to the last thing that pervades the whole painting. I'm always interested in the time frame that paintings are in, and whether some of our contemporaries have tried to make paintings that are one shot, or instant, but then they fail at that, intentionally, because there are ripples that come off of that, causing people to get into arguments, or they did about twenty or thirty years ago. For instance, are Frank Stella's paintings generated from

the literal support, from the outside, or as John Coplin has argued are they generated from the center and work outward, but sort of helplessly reaching out for what happens in a painting, which is more than one thing at a time, and those things being absolutely contradictory as, you know, eyeball to eyeball, this instant, and then the eyeballs are all over the place. Of course, they are not eyeballs, but they are that which is unaddressed by your—

Chuck: Someone said that these paintings depict the way a fly must see with all of their eyeballs: that kind of fractured thing. When something moves through their field of vision, they don't really see anything, they just see movement across all these eyeballs, which is a kind of interesting way of seeing a fractured, elusive image.

Bill: That's a completely different way of talking about the painting than anybody else has talked about the painting. It has varied from Alex Katz saying that you're the only person who has really caught his rage, to women talking about their earrings. I don't remember exactly what Dorothea said. She didn't think that the painting really looked like her. She thought it seemed so stern. You caught a quality of her that I found in a taxi ride with her. She was much more like the painting than the way she was in person here. Here she was laughing and smiling, and then all of a sudden, she got sort of serious and stern.

Richard: **But he took the picture.**

Chuck: Well, we present ourselves to each other. One of the reasons why I didn't paint Dorothea smiling, why I really don't paint anybody smiling of whom you could speak, is that when you're presenting yourself to people, you hold your face in the way in which you want to be seen. My mother smiled all the time, and only when she thought no one was looking, or she thought no one else was in the room would her face go slack. It still had all the laugh lines from the way she forced her face into a smile, every waking minute that she had someone looking at her, but the real her was when she didn't have that mask on for everybody else. I thought the same thing was true of Dorothea. We never think photographs look like we actually look.

◆

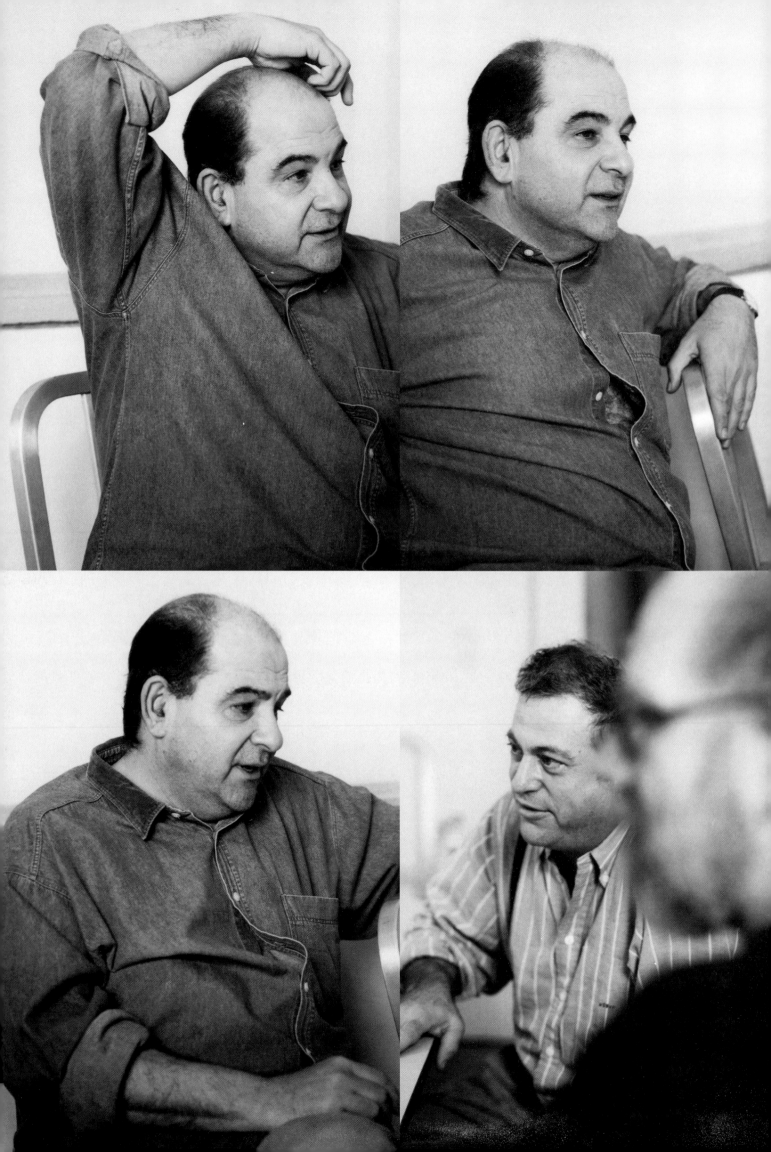

Joel Shapiro

preceding pages:

Untitled (detail), 1989–90, bronze, edition 1/4, 58¾ × 46¼ × 27 inches. Photo courtesy PaceWildenstein, New York.

Untitled, 1973–74, cast iron, 3 × 1¼ × 1¼ inches. Photo: Geoffrey Clements, courtesy Paula Cooper Gallery, New York.

In Chuck Close's studio, 1995, New York. Photo: Bill Zules.

Untitled (detail), 1972, balsa wood, bass wood and bronze, 4 pieces. Photo courtesy Paula Cooper Gallery, New York.

In India, 1965.

Untitled, 1973–74, cast iron, 5½ × 6¾ × 5 inches. Photo courtesy Paula Cooper Gallery, New York.

For the Dead and Surviving Children, 1993, bronze, figure: 24 feet; house: 8 feet. United States Holocaust Memorial Museum, Washington, D.C. Photo courtesy PaceWildenstein, New York.

Untitled, 1995, cast bronze, 66½ × 37 × 26 inches, Photo courtesy PaceWildenstein, New York.

Untitled, 1969–70, mixed media, 59 × 596 (overall) × 5 inches (each unit). Photo courtesy Paula Cooper Gallery, New York.

Deatil of previous piece.

With Chuck Close and Bill Bartman in Chuck's studio, 1995. Photos: Bill Zules.

New York City, April 13, 1995

Chuck Close: There are a lot of parallels between our careers. We started showing at about the same time, and we were in a lot of the same shows.

Joel Shapiro: **Right.**

Chuck: I remember seeing the first show you had at Paula's, which had the shelf pieces. That was in 1970. [Shapiro's shelf pieces were exhibited at the Paula Cooper Gallery, March 8–April 1, 1970. Robert Pincus-Witten, in his review in the May 1970 *Artforum*, said, "The shelves are unabashedly what shelves are meant to be—supports and display units—although their effect is altered by the height at which they are affixed to the wall—slightly too high for comfortable viewing."]

Joel: **It was 1969, maybe 1970.**

Chuck: Let's see if I can remember what was on the shelves. There were lead, rubber, concrete, and stone.

Joel: **The shelves were the same, but the material on each shelf was different.**

Chuck: There was the short bar and the long bar of lead and aluminum, or lead and whatever it was. Was it 75 lbs?

Joel: **That was another piece.**

Chuck: Was it in that section?

Joel: **Yeah. It was seventy-five pounds of magnesium and seventy-five pounds of lead.**

Chuck: Yeah, the lead was maybe a couple of inches long.

Joel: **Right. It was my attempt at the theatrical: elevate the magnesium via the dense lead.**

[Jeremy Gilbert-Rolfe's review of Shapiro's piece *75 lbs.* in the December 1973 issue of *Artforum* discusses the piece with both a formal description and a contextual analysis. He said: "*75 lbs.* indicates the extent to which material differences, and by extension materiality as such, are able to function visually, and in a way that goes beyond the 'purely' visual. *75 lbs.* works by pointing out what is quantitatively demonstrable about lead and magnesium, i.e., one is a heavier metal than the other, which is obviously apparent to our visual apprehension…*75 lbs.* relates Shapiro's work to Richard Serra's, particularly to Serra's use of materiality in a work such as *Roll Bar.* Similarly to the lead's levitation of the magnesium in Shapiro's piece, *Roll Bar* turns the physical properties of heavy metal against themselves, depicting weightlessness in a context of explicit materiality."]

Chuck: I read somewhere that you studied art at a very early age. How young were you?

Joel: **Young.**

Chuck: Yeah. So was I. I started studying when I was about eight.

Joel: I didn't pursue it. My mother made sculpture and took classes, but she was a scientist. She had some real talent, but I distinctly recall destroying all of her sculpture as a kid.

Chuck: *Her sculptures?*

Joel: Yeah, my sister and I. We had a pretty loose, progressive upbringing. After the war, my parents moved to Sunnyside. Sylvia and I grew up together.

Chuck: *Sylvia Mangold?* [Sylvia Mangold explores the deception of the flat picture plane. In the 1960s, she painted quasi-representational images of floor patterns combined with measuring devices such as rulers. In the 1970s, she framed her landscape paintings with drawings of masking tape, calling into question the nature of reality and perception.]

Joel: Yeah, in the same town. There was a local art teacher named Max Schwartzberg, who was a German expressionist refugee, and he used to teach a class in our basement, so I studied with him. I took ceramics with somebody else and took classes at the Modern when I was a young teenager. I never pursued art because my father was a physician, and there was a lot of pressure.

Bill Bartman: *To be a doctor?*

Joel: Well, yeah, of course.

Bill: *You're one of the few artists to whom we've talked who actually grew up in the New York area.*

Chuck: *I know. You may be the only one, other than—*

Bill: *Alex [Katz] and Paul Cadmus.*

Joel: Is Paul Cadmus a New Yorker?

Chuck: *Yeah.*

Joel: I didn't know that. It's a big trip across the East River. Don't ever think that Queens is the same thing as Manhattan, because it's not.

Chuck: *Did your family take you to the Modern and stuff?*

Joel: Yeah, yeah, sure.

Chuck: *Believe me, that's a very different childhood experience from growing up in Seattle.*

Joel: My parents always took me to the Modern and the Met, but I was much more interested in the Museum of Natural History or the planetarium. I knew, even in high school, that I was a better artist than my friends who had already declared themselves to be artists, but I didn't decide to pursue art until I was twenty years old. Then I joined the Peace Corps.

Chuck: *Yeah.*

Bill: *That's really interesting. Where did you end up in the Peace Corps?*

Joel: I ended up in India, South India, from 1965 through 1967. [The Peace Corps was officially established in March 1961 under executive order of President John F. Kennedy. In his book *Come As You Are: The Peace Corps Story,* Redmond Coates describes the assignment Shapiro and others took. "The first two groups of [Peace Corps] volunteers, known as India I and India II, came from varied backgrounds, some urban, some rural; almost all had college degrees. A few had been out in the 'real world' for a while and had earned a living before joining the Peace Corps. Most had not. Still, it was possible for this disparate, scattered, eclectic but basically privileged potpourri of young Americans to do something quite spectacular, for a while, in an enigmatic, alien culture where the poverty and hunger were staggering." Jeremy Gilbert-Rolfe specifically discusses, in an exhibition review of the impact of Shapiro's work, the impact that Shapiro's time in India had on his working process. "Shapiro spent two years in India, an experience that seems to have affected his feeling for animal forms. But the animal sculpture that

he makes also throws light on his need to personally manipulate the materials he employs, to make them stand for his own activity in a way that is very direct."]

Chuck: Did you work on physical projects like digging trenches for water or sewage, and stuff like that?

Joel: Yeah. We used to dig latrines and build smokeless stoves. The women of the village had serious glaucoma problems because they cooked inside over smoking fires, so we tried to build stoves, made of cow dung and straw, that had apertures for fire but drew smoke out of the room.

Chuck: A guy from Queens showing people how to dig a ditch in India is pretty interesting.

Joel: Yeah, but I was fortunate. I trained for the Peace Corps at UC Davis, which was an interesting school at the time, so I hung out with art students. I was sure that, as soon as I got beyond my own culture, I would pursue art. I just didn't quite know how to do it.

Chuck: Uh-huh.

Joel: You know, it all falls into line.

• • • •

Joel: I worked at the Jewish Museum for a while.

Chuck: Was Brice [Marden] a guard there then?

Joel: Brice had been there.

Chuck: They should do a show of former guards from the art museums. Sol LeWitt and Robert Ryman were guards at MoMA.

Joel: Kynaston [McShine] hired me.

Chuck: When Kynaston was at the Jewish Museum, they were still doing great shows. Brice was a guard during the Jasper Johns show.

Joel: Yeah. When I was there, it was near the end of the interesting shows. They had a three-person show; there was the Yves Klein show.

Chuck: Yes, I remember it very well.

Joel: It was a fabulous show; it was a really instrumental show. Then the museum became much more conservative. I think that the theological seminary put the screws on them and said, "Deal with Jewishness."

Chuck: Yeah.

Joel: "Don't deal with the modernism of Jewishness as a possible Jewish condition." I think maybe they'll go back to modernism, become more enlightened.

Chuck: Yeah. Were you around when they did the Primary Structures *show?* [Curated by Kynaston McShine, the *Primary Structures* show included work by Carl Andre, Dan Flavin, Sol LeWitt, Donald Judd, Robert Morris, and Robert Smithson. In his review of the exhibition in the June 1966 *Arts* magazine, Mel Bochner explains: "What these artists hold in common is the attitude that Art—from the root artificial—is unreal, constructed, invented, predetermined, intellectual, make-believe, objective, contrived, useless. Their work is dumb in the sense that it does not 'speak to you,' yet subversive in that it points to the probable end of all Renaissance values."]

Joel: No, I wasn't. The first show I saw in New York really puzzled me. It must have been Bob Morris's grey boxes at the Green Gallery. I remember going to that. I remember going to

that and going to World House. [Robert Morris's 1966 show at the Green Gallery, *Polemics and Cubes*, consisted of grey boxes. David Antin's review in the April 1966 issue of *ARTnews* describes the pieces as "large grey volumes with ambiguous shapes that lack overt iconography and resist interpretation. These minimal grey boxes rise from the floor, press against the walls, and otherwise dominate their surrounding space."]

Chuck: When we started going to galleries, we would go to every gallery that showed art. We were indiscriminate, because you could do them all in an afternoon.

Joel: Yeah. World House would have surrealism, Giacometti, and great European stuff. Paula Cooper worked at World. I think that was the first gallery at which she worked.

Chuck: As an art school student, were you, as were so many people of our generation, a junior abstract expressionist, or did you skip over that?

Joel: Well, I really skipped it. I did some of that beforehand.

••••

Chuck: A lot of us seemed to find what could be considered as a more mature voice and a personal vision and emerged in the late sixties and early seventies. Certainly, if you were young, receptive, and knew what you were looking at, you were working out some minimalist concerns with a lot of self-imposed limitations, a lot of concerns with materiality. You would get a material that no one else used and try to find a way to—

Joel: Manipulate it and find some method of self-expression.

Chuck: That's right. If you believed in process, and gave yourself over to a process, you believed you would be free.

Joel: I think that to some extent it worked, but the main thing was a correspondent stripping away of precepts, or preconceived notions of making art, with some allegiance to minimalism as a new set of conditions.

Chuck: Neither of us made things that were really minimal, although I think it was a major formative experience.

Joel: Yeah, it was a reductivist mode; but I think it was political too. I mean, you no longer had a belief in received information. I think minimalism was attractive because it was so reduced, and it had a certain structure, at least in language. I don't think it necessarily did in the work, and that was a great situation to synthesize and from which to react.

Chuck: Yeah.

Joel: And find out how empty it might be.

Chuck: Didn't you get a lot of shit for not being a pure minimalist in your work?

Joel: I did, yeah. Oh, yeah. I remember that I showed at Paula's the piece with the bird, the coffin, and the boat. That was a great start. I had been in India for two years and looked at a lot of architecture and sculpture. India had a kind of chronological vista in which you could see things from the eighth century to the fourteenth century and how they had evolved. I mean, process art was actually the beginning of a reaction to minimalism.

Chuck: Right.

Joel: And it was about the insertion of self into the work.

Chuck: There was a self-conscious effort on the part of a lot of artists to move away from it. I remember when I was helping Richard Serra build his early prop pieces. We built The House of Cards—*that two-ton prop piece of four plates. I was on the inside of that thing with a rope tied around my waist, which was threaded through a block and tackle on the ceiling. As the plates were raised, I'd fit them together. When I was finished, they pulled me out of the piece. The very last words that Richard said before the plates were lifted were, "Let's get Carl Andre up off the floor."*

Joel: Sounds wild!

Chuck: The idea was to encourage the viewer to walk around the sculpture. It was also a very conscious effort on his part to put distance between himself and the prevailing—

Joel: Yeah, I think that's what everyone did. I think that's what young artists always do. That's the nature of the—

Chuck: For me, the most perverse twist that you gave that distancing was to fly in the face of the conventional wisdom of the moment, which dictated that all sculptors be very macho and really into tonnage. You know, "Let's move the whole lot of shit around." You know, big. Only you and Richard Tuttle were doing things that could be missed. One could open a door, look in, and say, "Was there a show in here? No, I don't think it's up yet," and close the door. One could miss the show. You did it with tiny little structures, which went very much against the grain of that macho tonnage, and Tuttle did it with little wires. He could carry an entire exhibition in his pocket, which I think he did in Germany with Attitudes Become Form. *I think he took the entire exhibition in his pocket and then installed it.* [In his review in *Artforum*, May 1974, James Collins said, "The size of the gallery showing Shapiro's lilliputian sculptures is about 3500 square feet with about 17-foot ceilings. Showing only five tiny things, two on the floor and three on the wall—that's about 1200 cubic feet per sculpture—the size of an apartment. Unless you're a dedicated Minimalist looking for less, or you've got great eyesight, you could be in and out of the gallery without knowing the show was on—as a friend of mine did."]

Joel: Yeah, at that point, I was much more interested in size—size as projection of thought. A piece had to be only big enough for my own recognition.

Bill: I love that little chair. [Much of Shapiro's work attempts to resolve inherent contradictions of scale, medium, or experience, either worldly or metaphyiscal.]

Joel: I've made a great change in scale. Now I have to go uptown and see these godzillas that are total insanity—twenty-two feet of massive bronze. It's the total reverse of what I did twenty or twenty-five years ago.

Chuck: Yeah.

Joel: That was important. I felt that was how I could insist on myself. After all, there was no need to make my work larger. In fact, if that chair were large, it would be meaningless. Its whole character and the impression it gives is surprising, because when shown on a floor like this, it really does condense space in some way that is unexpected.

Bill: It's funny how, when you see that piece installed, you can't look at anything else in the room except it, because it's so uniquely scaled that it sort of pulls you into it.

Chuck: When your retrospective opened at the Whitney and that piece was on the floor with thousands of people standing around, if you looked down, you saw this small chair in a forest of people.

••••

Chuck: I think that at that point, abstract expressionism had been used by the federal government as an example of our freedom and had been exhibited all over the world by the USIA. [During the Cold War, American abstract expressionism was touted as symbolizing political and civil freedoms, in contrast to the repressive social realism of the USSR. The link between the American government and the emerging art was established and strengthened by the Museum of Modern Art's international program.)

Joel: It was politically determined. Its drive, breadth, and scale had a lot to do with winning the war. Regardless of how depressing it can be, the work is driven by optimism and a certain euphoria.

Chuck: Yeah, which is interesting, because there appears to be no political content in that work.

Joel: Well, I always felt that way, but then I remember having a discussion—I forget to whom I was talking, but it was at Max's—about politics and form. I kept insisting that politics were manifest in the form and that all form was conditioned politically. I still believe that. You can scream, rant, and rave, but if there's not some transformation into a form, it's nothing. It's just someone else's anger. I think the form was conditioned politically, but I don't think it was ever dealt with, because the concept is much too complicated for the art world at large, which is virtually incapable—I shouldn't say this—of dealing with anything substantial, anything with real substance. It seems so superficial and glib.

Chuck: When you went to Max's, another political issue was where you sat. Did you sit up front with Smithson, Dorothea, and Mel Bochner, or did you sit in the back with Andy [Warhol] and Brice Marden?

Joel: I sat at the front.

Chuck: Under the Donald Judd sculpture. I sat up front too.

Joel: I sat up front. You know, that reminds me that Smithson came to a show of mine at the Clocktower.

Chuck: I was just going to talk to you about your 1973 solo show at the Clocktower. [The Clocktower building houses the Institute for Art and Urban Resources, an alternative art space.]

Joel: Smithson looked at the work and asked how I could do the work. I thought he meant what psychological state allowed me to work. I was touched. I took him very seriously. I felt more comfortable at Max's after that exhibition.

Chuck: One way to look at Smithson's work is to see it as being very political.

Joel: Oh, I think that you can understand work by analysis of the form. Structure is political, form is political. You can't make big paintings and thrust yourself into them without a very broad context that allows that to happen. It's a complicated bunch of factors.

••••

Chuck: You were among the first artists to return to bronze, which was considered a totally suspect medium.

Joel: It was verboten.

Chuck: It was accompanied by so much art historical baggage. What was your first cast bronze piece?

Joel: Well, I began to cast work in iron. I chose iron because it is fundamental. Also, it was

elemental. It was a single element. I chose iron, not steel, because steel was an amalgam of metals and therefore impure. I had this notion of purity. Iron was fundamental, and you could not reduce it beyond its elemental state. That appealed to me.

Chuck: I made black and white paintings with black paint so that I would use the least amount of paint necessary.

Joel: Right, exactly. We were so modest.

Chuck: I made color paintings with only red, yellow, and blue.

Joel: That was the sort of climate in which you could function with a more reduced belief structure. Of course, it was all a construct. When did I first cast in bronze? The first bronze piece I did was a bird. I think it was in 1973. I had been casting in iron, which was difficult. It casts well, but that's it. The cast surface is great, but once you penetrate it, you end up with a repellent bright reflective surface. I was interested in the romance of bronze, the possibility of bronze.

Chuck: Were the first houses that you did in bronze done about that time?

Joel: The first houses were iron.

Chuck: But the first ones in bronze?

Joel: They were done in 1973.

Chuck: The first houses were hollow and made of boards, right?

Joel: No, they were cast from thick boards expediently joined together. The form was crude.

Chuck: The first solid house was a bronze piece?

Joel: I showed that four-part piece at Paula's with a bird, bridge, boat, and coffin. The bird was cast in bronze, the rest was made out of wood. The piece was about the temporal. The sculpture was dramatic. Was I really feeling these things? I think I was, so I put it in the work. It went against the prevailing rational climate. The bridge, which was an image of change, was made out of sticks of balsa wood. At some point, I just said, "Fuck it," and carved the bridge from a block of iron, which I later exhibited at the Clocktower.

Chuck: And it was big.

Joel: Well, I pushed the size up a degree so that it no longer could be read as a "model." The whole idea of removing material to arrive at the form was a means of insistence.

• • • •

Chuck: Maybe you can talk for a minute about how you saw your position within the art world. You were taken very seriously, very early in your career, by all the best critics. All of the heavy-weight people weighed in very early on your work.

Joel: Roz Krauss wrote the catalog for a show of mine in 1976 at the Museum of Contemporary Art in Chicago. It was very serious. It was all about reduction of size and psychological space. Well, I sort of took it all in, but my sense of self was still sort of tentative. I don't think I became grandiose. I was too occupied with ordinary problems.

Chuck: But it must have been scary, because the art world is a fickle place. It giveth and it taketh away.

• • • •

Chuck: I know you've said that the mix of people was very important to you: people like Elizabeth [Murray]; I know you were friends with Joe Zucker; and Jennifer [Bartlett]; and—

Joel: Well, I had met Jon Borofsky. Jennifer and Elizabeth were good friends of mine.

Chuck: Did you do the summer house in South Hampton with Jennifer, Elizabeth, Joe Zucker, and—

Joel: I went out to visit.

Chuck: Yeah, so did I.

Joel: I had rented Alan Shields's house in Shelter Island for two weeks that summer. Paula had the house next door. I went to South Hampton a few times. Ivy was three or four years old. I was in the midst of a divorce. There was a lot of crossed allegiances, and it was hard for me, but I did go and visit.

Chuck: Was your wife Amy part of the women's group?

Joel: Yeah, absolutely. Sure she was.

Chuck: So when your marriage ended, it ended like a ton of bricks.

Joel: I was basically booted out of the house. I was perplexed and hurt but happy to be free. I joined a men's group, which actually gave me some insight. It was helpful. It was difficult, and I was not mature.

Chuck: Mine is one of the only marriages that actually survived that period.

Joel: Remarkable!

Chuck: In our building on Prince Street, all the men moved out. I was the male mascot for a feminist co-op, and I was the only one who knew how to run the furnace and would go down there where the rats were. The women's movement stopped where rats—

Joel: —began.

Chuck: And the furnace. They were not going into the basement, that's for sure.

Joel: Well, it was a very serious issue, and very disruptive, and it questioned perceived boundaries.

• • • •

Bill: I love these wooden pieces [looking at the 1995 PaceWildenstein Gallery catalog Joel Shapiro: Painted Wood Sculpture and Drawings].

Joel: Oh yeah, they're lively.

Chuck: What interested me about the wooden pieces is how the scale changed from the early maquette stage to the finished piece. I mean, you weren't using real four by fours or six by sixes or whatever, but you had to make something that stood for the qualities of that maquette. I think the wonderful thing about the pieces is that they look as if they just happened, although one knows that they didn't.

Joel: Yeah, they're pretty well crafted, so they look fresh.

Chuck: Yeah.

Joel: Well, my assistant Ichiro and I have worked together for a number of years. It's very

tough, because when you have to make—only an artist would see this—something that measures six inches by six inches by three feet out of wood, you can't just buy any piece of wood. It would crack, it would—

Chuck: Twist.

Joel: It would twist and turn. It's hopeless. You have to build it out of wood and build it carefully. During that building, it can easily turn into a piece of furniture—there's a really narrow line. It has to be well built.

Chuck: It was interesting when you talked about not only using paint for a metaphor for every other association that you can have for the color, for lighting the piece or whatever, but for disguising the process of how the pieces were built, because now you're 180 degrees from originally wanting to show the process. You've come full circle.

Joel: No, I don't think that's exactly true. I'm always interested in the process being revealed.

Chuck: But it doesn't have to hit one over the head.

Joel: If you are not in touch with it, you lose it, you wouldn't even know where to paint the piece, so I think it's understanding the genesis of the work. The mahogany was a problem. I ran out of the wood with which I like to work.

Chuck: I love this piece. This piece has the most human qualities in it. It has a stand, it is like Charlie Chaplin moving, or some movie star moving. I think it's really—

Joel: A piece that evolved over time.

Chuck: Maybe it's because I'm in a wheelchair and use prosthetics and orthotic devices, but he seems to be propped up.

Joel: Oh, that one with the big projections.

Chuck: It's almost as if there are crutches.

Joel: Oh, I think they do function as crutches. I think that's a reasonable statement. That one?

Chuck: Yeah. And I read this little stub down here almost as an—

Joel: —an amputation.

Chuck: Yeah. And, of course, as a dick for anybody—

Joel: —who'd like to have one.

Chuck: But also, I begin to read—am I crazy? Is this a post-rehabilitation spin that I'm putting on all of these pieces?

Joel: No, I think it's a legitimate interpretation. The fact is that this piece in wood can't exist without support. I mean, Ichiro and I could have tried to figure it out, and spent six months on it, but I don't know if there is any way you could have conceivably balanced this piece. What I was interested in doing in these pieces—let me see this, there's one piece that's the most obvious. Yeah, this piece. I built that piece when I was just sick of bronze. I mean, I can't tell you, Chuck, what a pain in the ass it is. I have Patrick Strzebec at the foundry two days a week, and I go there every other week, and I hate it. I mean, you have to will the work to be what you want. There's a constant struggle trying to reduce other people's personal input into the work

in order to retain your own character in the work. It's a real battle, so when I went back to bronze casting, I approached it very differently. It would not be farmed out to another person; it was something over which I would retain control and do in the way I wanted. Anyway, I was really fed up. I had a piece in the studio, and I put it on a big platform. What I wanted to do was invert the piece, subvert the piece, so the floor became perpendicular to it, so that it really became a kind of inversion. I always wanted to make pieces that would stand alone, but they don't. You can't defy gravity—you use crutches and props. Ichiro and I, he is Japanese, refer to the props as "kuroko," the boy in Kabuki who is dressed in black, holding things up onstage, but who you are not supposed to notice.

• • • •

Bill: At some point, did you have a lot of pressure to make work that looked like "Joel Shapiro" work?

Joel: Well, I think there is always a lot of internal pressure to change and evolve, but there were moments when I thought that I couldn't access any other aspect of myself to do, for instance, those coffins. You know, I've always thought that my work affords an opportunity for negative manifestations. The way I work, the creation, the finding of the image, is in itself more important than—you know, it's a way of being closer to my potential. Yeah, there is a lot of pressure to make a bronze that's freestanding, that's classical. There is a lot of interest in that; and market.

Chuck: It's true, but you can always do what you want to do.

Joel: Arne doesn't interfere with one's work. He really is responsive if your need is strong enough.

Chuck: He has never told me that he didn't like something I was doing until years later. He is always open to whatever I want to do. He never tries to pressure me to do something else. Years later, he'll say, "You know, that piece," or "that body of work was not my favorite," but he never says it while I am making it.

Joel: He's told me, too, that he didn't like certain pieces. But, to be quite frank, he's so convincing when he really likes something that you can usually tell.

Chuck: Speaking of liking things, we have to do the obligatory, "How do you feel about my having painted you?"

Joel: Oh, I like the painting. I think I was very nervous though.

Chuck: You always called it "Chairman Joel."

Joel: I know. I look very stern. I like it. I think it's interesting. I wish I had been more relaxed when I posed, but it's tough for me to do because I'm self-conscious.

Bill: What did your wife Ellen think about the painting?

Joel: You'll have to ask her.

Chuck: I have to paint Ellen, too.

Joel: I have learned not to speak for her.

Chuck: Well, those of us who lived through the first women's movement learned.

Joel: We learned, certainly, but I clearly didn't learn enough. I really learned a lot though because Ellen has been quite demanding and also not ideological. A lot of those marriages would have dissolved anyway. Maybe it was just a rapid distillation. I like the painting, it's kind of surprising. I think I was very stern looking, but that's okay. They're great paintings.

Chuck: Why, thank you.

Joel: I shouldn't say this, because it sounds awkward, but your current work is more empathic than your earlier work.

Chuck: Well, if you say you like the new work, does that mean you didn't like the old work?

Joel: No, but I do think our work evolves, and I think good artists get better. It's not like mathematics, with which you crap out at age nineteen or twenty.

Chuck: Well, if you look at late de Kooning, late Picasso, late Matisse, you see something really kind of wonderful.

Joel: Late Giacometti.

Chuck: Late Giacometti, yeah.

Bill: When I went to Paul's [Cadmus] show and saw his most recent drawings—he's ninety years old, and he still draws everyday—there were some wonderful drawings that I liked a lot.

Chuck: And he's still finding room for pictorial invention.

Joel: Right. Age is a great opportunity for the work to get better.

Bill: Cadmus told this wonderful story about how The Ship's In *hung behind the secretary of the navy's desk for ten years, until they realized that it had drunken sailors, prostitutes and men, and gay prostitutes, and then they moved it to a dark billiard room.*

Joel: It shows you how rare it is for someone to really look at something.

◆

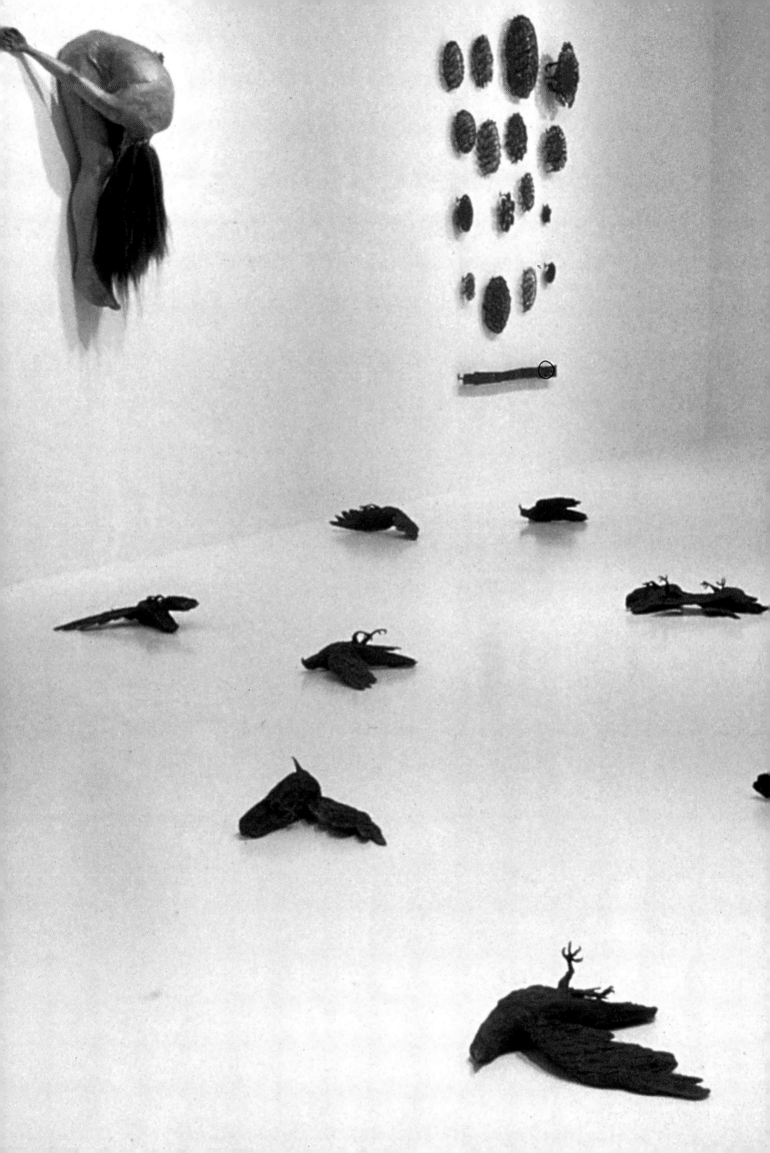

SHE CAME IN A BODY THROUGH A HOLE

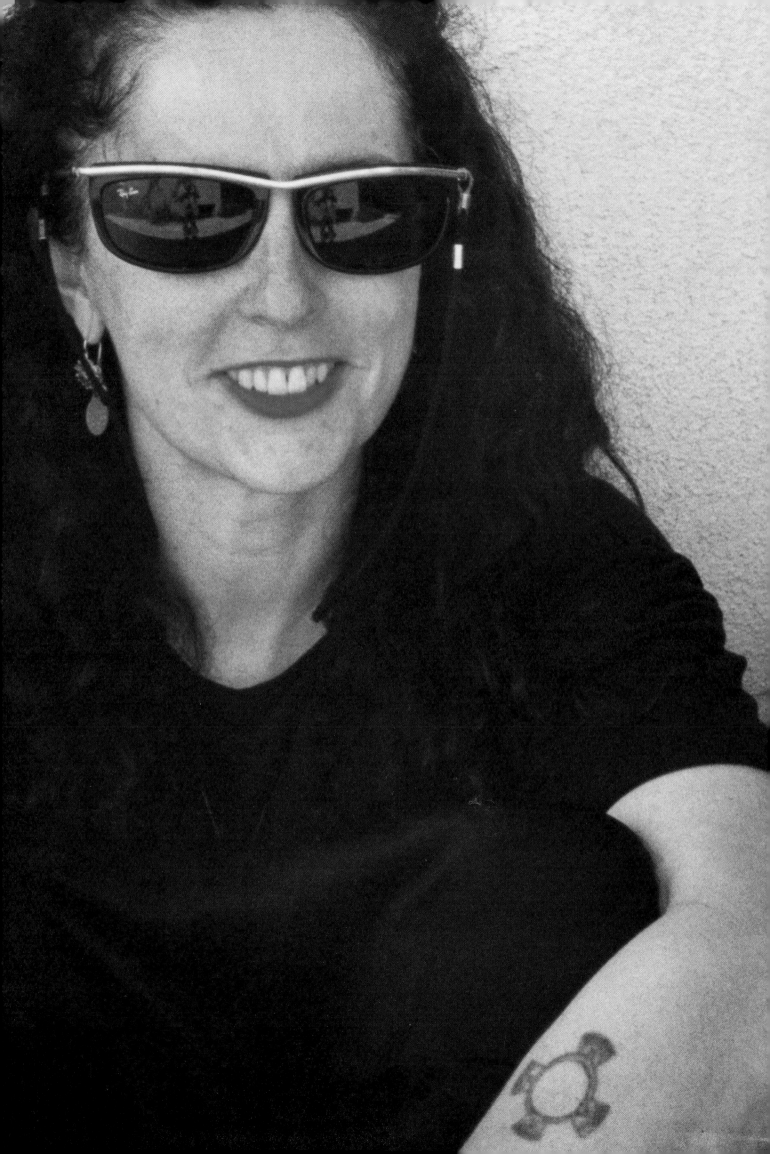

Kiki Smith

New York City, April 15, 1994

Bill Bartman: Here we are on April 15, 1994 with Chuck Close and Kiki Smith. It's tax day with Chuck and Kiki. Why don't we start with the painting, since at some point we always talk about the painting. What was it like being painted?

Kiki Smith: I don't know. I wasn't there, because you paint from photographs. I was wondering whether you ever make paintings from people sitting. Have you ever done that?

Chuck Close: Not since I was in school.

Kiki: How come?

Chuck: I don't want them around.

Kiki: Really? Lots of people make portraits because they like having the subjects around. They like snooping into their lives and knowing everything about them. It's a way of getting to know people.

Chuck: Well, there are a couple of practical reasons for not having subjects around. I do things that take a long time. It's not like a quick sketch. The first advantage of working from a photograph is that no matter how long I work on it, there is an immediacy to the photograph. It's a frozen moment in time. It has some immediacy even though it's dealt with over an extended period of time. I've made the analogy that it's a little bit like the way a poem cuts across time. It's very much not about time. The painting is made over a kind of novelistic time frame, but no matter how long I work on it, it hopefully still contains that frozen moment.

Kiki: Fresh.

Chuck: The most practical reason for working with a photograph is that when models come over again and again, their hair grows longer, they cut it off, they gain weight, they lose weight, they're happy, they're sad, they're awake, they're asleep, and the painting becomes the mean average of all of those things, which doesn't interest me.

Kiki: I met a woman who is the head of Whitechapel in London, and she's been modeling for this guy for sixteen years. She goes every Monday.

Chuck: For Lucien Freud?

Kiki: Not Freud, but it was one of those guys. I thought it was really interesting. I was totally jealous of her. It was like a meditation.

preceding pages:

Jersey Crows (detail) , 1995, silicon bronze, 6¼ × 17½ × 11 to 16 × 19½ × 23 inches, Installation view, PaceWildenstein Gallery, New York.

Kiki, one year old, Nuremburg, Germany.

Modeling paper dress at Sophie VDT fashion show.

Through a Hole, version 1 (detail), 1995, silicon bronze, 16 units, 6 to 20 inches, 60 inches diameter. Photo: Ellen Page Wilson, courtesy PaceWildenstein Gallery, New York.

At Watts Towers, Los Angeles, 1973. Photo: Edmund Teske.

Ice Man, 1995, polyester resin and fiberglass, 82 × 30 × 11¼ inches. Photo: Ellen Page Wilson, courtesy PaceWildenstein Gallery, New York.

Working on an edition at Sueño U.L.A.E. (Universal Limited Art Editions), West Islip, New York, 1991. Photo: Jo Fielder.

In Santa Fe, New Mexico, 1994. Photo: Dwight Hackett.

Chuck: At least you would know what you were doing every Monday.

Kiki: Instead of going to therapy, you could just go and sit there. I thought it was really great.

Chuck: We could make this into a therapy session. Do you want to lie down?

Bill: Maybe we could do this every Monday.

Kiki: Go and talk to Chuck.

Bill: Conversations with Chuck.

Kiki: I thought it was really interesting. I started trying to make self-portraits about two years ago, when I was in hotel rooms. I thought that when I was traveling, I was wasting my time and not getting any art work done.

Chuck: You and Morley Safer. He works in his hotel rooms.

Kiki: Thanks for making that comparison. I love you too. When I was younger, I couldn't stand looking at details of things. It made me sick to look at details, but now I really like looking at all the spots, at that part of getting older. As you get older, your face becomes more interesting. There is more to look at or something.

Chuck: I've had a lot of trouble painting young people because there's just not enough information. I'm doing a painting now of Paul Cadmus who is ninety-two years old, and I painted my wife's grandmother who is ninety now, so she was in her eighties when I painted her. I think a person's face is a road map of their life experiences.

• • • •

Chuck: I know that your mother came to visit your painting a lot.

Kiki: Yeah.

Chuck: Maybe it's easier to get along with your painting than it is to get along with you. [laughter]

Kiki: I'm sure that may be true. It's certainly louder than I am.

Chuck: I was touched by the fact that she seemed to get so much pleasure out of it.

Kiki: She loved it. I totally loved it too. As a kid I never thought that I could be an artist. I thought, "Oh, I can be like the Mona Lisa. I can be someone who is the subject."

Chuck: Someone who was in the art world, but not an artist.

Kiki: As a girl, I didn't think I could be an artist; it didn't really occur to me. I thought perhaps someone could paint a picture of me, and when you did, I thought, "Oh no."

Chuck: Even with a father who was an artist [sculptor Tony Smith], it didn't occur to you that this was something that a woman could do? Because all of his friends were men?

Kiki: He had women friends too.

Chuck: Women artist friends?

Kiki: Some, but not as many as men artist friends.

Chuck: It was a very male generation. I love what's happened to the art world. When I went to school, half the students were women, but the assumption was that the men would go on to have art careers. I have juried a lot of shows and given grants away and stuff, and I think that, without making any effort to ensure that women are getting their share of grants or whatever, if you just judge on the basis of quality, half of the superior work ends up being by women. People think it's about a quota, but I've never seen that to be necessary, especially when I look at the art world today, particularly my

generation which has women like Elizabeth Murray, Janet Fish, and Nancy Graves. Apparently, when you saw the nude that I did in the sixties, you told—

Kiki: I loved it because of the stretch marks.

Chuck: I loved your comment. You said that it was early "body art" because of the flaws.

Kiki: That was the first time that anyone had painted stretch marks like that, and it was in a big public forum. I thought that was incredible.

Chuck: I'd never seen that woman without her clothes on until she came to be photographed, and I thought it was great. There was so much more to paint.

Kiki: More to paint.

Chuck: She was worried that I would find her somehow flawed, but it was the best news ever when I got to see her. I was sorry that none of your tattoos ended up in your picture.

Kiki: I've got two new ones. Little dots.

Chuck: My photographs have more information than most people could ever absorb. A lot of people have used the Gulliver's Travels *analogy, that it's like a Brobdingnagian world with these little Lilliputians crawling all over the body of the giant. Some of those really big Polaroids have all the detail: body hair and skin texture.*

Kiki: It's as if you're taking a thing that's mechanically made, rendering it back to the body, and by doing so putting your own body energy back into the world. What's the difference between leaving them as photographs and painting them?

Chuck: I haven't had the desire to make them into paintings.

Kiki: Who were the people?

Chuck: You know, I couldn't get my friends to take their clothes off. All my friends are too old and they sag too much. There are hang nails and little cuts on his fingers [looking at Mark II]

Kiki: You see that he has lousy cuticles. I've been casting people who are a lot younger than me, and it's boring now. It's boring making figures of twenty-year-olds because I'm not twenty years old, and I don't want to make art about twenty-year-olds.

• • • •

Chuck: We have not been long-time friends. The important thing for me is to have some important connectiveness, some kind of relationship. It's been fun getting to know those people I haven't known or with whom I don't have a long history of friendship but already felt as if I knew through their work— I had a dialogue with their work. That's certainly true of your work. I've been a big fan of your work for a long time. It's been an important relationship to me even before I knew you personally.

Kiki: It's funny that one feels that affinity with the work of others.

Chuck: Art is the other family. It's all family and friends. I consider the art world family to be almost as important as my real family. It gives me a sense of belonging to something larger than myself.

Kiki: Through my father I knew artists, but I didn't really know that much about their work. It wasn't until I went to college that I looked at Barney Newman's work in a book and tried to see what it meant externally to people in the world. I didn't know anything about representational art until I went to college. I didn't really consider representational art. I always

thought that people who came from the Mid-west had to struggle to get here and didn't have any artists in their families. I always had big romances about that.

Chuck: *Do you think you were driven to representational art on some level because it was so different from your father's work?*

Kiki: Yes, because it was different, and also because it was popular. You didn't have to know anything.

Chuck: *You mean people could come to it without baggage.*

Kiki: It was populist. If you make things, especially bodies or faces, you don't have to know anything special about them. Everybody has equal experience with them, very different, but equal experience.

Chuck: *What about all the formal invention and stuff that you bring to the work as well?*

Kiki: That's like home entertainment. That's like secret things that amuse you or something like that. I never talk about them in public when I talk about my work. I always talk about what it means emotionally or some other thing. The formal thing is my own personal secret. Also, I'm not abstract, I don't really understand that. I'm very happy living with abstract things, but I am not abstract. I wish that I could make abstract art. I like abstract art much better in some respects, but I can't make it.

Chuck: *I like it so much, and I respect those people, my heros, so much. I think they do it better than I could ever do it.*

Kiki: Yeah, you're kind of floating in and out. You're just holding ground by a thread at the moment.

Chuck: *Well, that's interesting. I feel as if I'm hanging by a thread on many levels. I think I was, in a sense, driven to make representational painting because I love that other stuff so much, and I couldn't get it out of my work. I couldn't get my influences out of my work, so I pushed myself somewhere where no one else's answers were applicable, and I had to solve my own problems.*

Kiki: You kind of made your own territory.

Chuck: *So did you.*

Kiki: I don't think my art has very much to do with art. Maybe how it functions and the use of different materials does, but its impetus isn't from art. Lots of it is rehashing stuff that others have already made or that I saw in museums, so I guess it is about art but not in the sense of current concerns or themes. It just comes out of life, my life.

Chuck: *You mentioned that you wished you could but are not equipped to make abstract art. I know we both have a lot of learning disabilities, and we can talk about that if you want. We've had a lot of laughs over lunch comparing our childhood experiences of trying to get through school. I cannot remember things that are in three dimensions because they move, or I move around them, and they're elusive. I have to get everything made in two dimensions and then I can remember it. That's why I ended up being a painter. I never understood sculpture, and I would love to be able to make sculpture, but if you move your head a quarter of an inch, everything changes.*

Kiki: I don't understand painting. When I first met you, you said that you didn't ever recognize people's faces, so every time I saw you, I would reintroduce myself to you because I always thought, "He isn't going to remember who I am."

Chuck: If I were the Ayatollah, everybody would be forced to wear name tags and maybe a little short resume.

Kiki: Maybe I should continue doing that. I was thinking that making portraits was a funny—

Chuck: That's true. Even people with whom I lived I don't recognize on the street, but once I have reduced someone to a flat surface—

Kiki: Than you can?

Chuck: Then I can remember them much better.

Kiki: That's a weird thing.

Chuck: I'm sure that I ended up doing what I'm doing largely to compensate for those defects and to try to really commit the images of people who mattered to me to memory in a very personal way.

Kiki: It's very concrete. It's also like a devotion, taking that time with someone.

Chuck: Absolutely. I feel as if I'm lighting a candle to the person every day that I work on them. It's a real homage and devotion.

Kiki: That's weird. I was realizing the other day that I will go to see someone's show, and I'll remember where a piece was that I liked, but I have no recollection of what it was. You were saying that you remember architecturally every place you've been, and I pretty much do that too, but I can't remember what's there. I remember what part of the room something's in, but what was there I never have any remembrance of.

Chuck: I collect art magazines, so I have all the art magazines from the beginning of time, and I can pick up a magazine and tell you that there is a particular painting on the lower left hand corner of a certain page and open it to that page, yet I can't remember the person's name or the title of the painting.

Kiki: My father was like that too. We kept all the *New York Times, Wall Street Journals*, daily magazines, and newspapers.

Chuck: Your basement was full of these?

Kiki: Yes, and we moved them from one house to the next. For thirty years we kept all of them. He would do that too. He would say, "Go to the basement, look three piles down in the corner, and find the recipe in the middle of May, Sunday section.

Chuck: Yet I don't know what year this is.

Kiki: I love all this shit.

Chuck: You know, I still forget which is my right hand. I salute the flag by putting my hand over my heart. In the old days in grade school, you had to get up and pledge allegiance, and you used the right hand to do that. That is how I remembered.

Kiki: That's funny. I was in Ireland recently, and I looked at the *Book of Kells*. I was thinking about all those people writing out manuscripts. It's sort of the way you are working—like paying attention, like acute paying attention.

Chuck: And having something to do everyday.

Kiki: It's sort of like knitting too: you can be a little bit brain dead while you're doing it. It's like being really aware and really out of it at the same time.

Chuck: It's like what people used to call women's work: like knitting, crocheting, quilting. You knit every day, and eventually you have a sweater.

Kiki: And it turns into a big thing. It's like small particles—

Chuck: I don't know how to do big things. I break them down into the smallest parts. Do you do the same thing?

Kiki: Yeah, because I can't make big sculptures. I can only do them by making individual elements.

Chuck: You told me that you're often frustrated by how to do things too, but you do so many different kinds of things.

Kiki: I don't understand how things are physically put together at all.

Chuck: Yet physicality is so important in your work.

Kiki: Yeah, but it's a different version. When I was younger, a friend and I were in the same class, and he said that no one was going to pay attention to me or any of the women I knew because our art work was made too poorly. I made everything out of cardboard because I didn't have money, and it really made me mad, so for a couple of years I tried to make everything out of concrete or bronze or something that was really sturdy and strong and wouldn't fall apart. I found that when I made something that broke into bits, I really wanted it. I made a ceramic piece that I put together with crazy glue, and I decided that from then on I would make things as precarious as possible, and really do it aggressively, really push it. I think my work is still like that. Now I lose that sometimes, but a lot of times it's just that, and it can't be stopped.

Chuck: Even the most recent pieces that are made of sturdy materials were in a precarious state at one point. The meat heads and stuff like that were—

Kiki: Nodding.

Chuck: I mean, you could freeze it and make it in bronze, but there was a point where—

Kiki: It was rotting and the flies were swarming. I like that.

Chuck: You've made a kind of frozen sperm out of glass.

Kiki: They say the sperm count is down fifty per cent in males in America, and alligators' penises are half the size that they are supposed to be—

Chuck: Not just alligators.

Kiki: —from DDT. The DDT turns into something else, and it screws up their sperm count. It's been down for the last fifty years. You're half the man you used to be.

Chuck: Are you going to redo your sperm pieces as miniatures?

• • • •

Bill: Do you see anything subliminal, or reflecting your work, in Chuck's painting of you?

Kiki: Although he used it in other paintings, I always liked the flowers, the flower eyes. They are in the paintings of other people too, but when I saw them in mine, I thought, "Well, that's because I'm really into flowers."

Chuck: I thought about it immediately after I finished the four-leafed clover kind of eye. I thought, "Oh my God, I'm just commenting on…" I immediately recognized it, but I didn't predetermine it.

Kiki: Didn't think about it? That I love.

Bill: Alex Katz said that Chuck is the only person who really caught his rage that was underneath the surface. Is there anything in your painting that's psychologically revealing about you?

Kiki: No. That's why I like it. It's like this very hippy flower power thing. I really like that. It's something with which I really identify.

Chuck: Well, there is a kind of psychedelic aspect to the paintings. Someone said that they look like Vasarely on acid. I'm certainly a child of the sixties.

Kiki: I love them. Actually, I love the ones before these too, but I must admit that when you had that show at the Museum of Modern Art, I wasn't sitting at home thinking about you too much.

Chuck: You weren't?

Kiki: I wasn't thinking of you in my future, no, but when I saw that show I wanted to write you a letter, because it just blew me away: for instance, that portrait of Elizabeth Murray and all the portraits inside. I think it was the first time I had ever thought about portraiture, because I didn't always like portraiture. I like to look at it, but have never liked it for myself because when I was making my work, I thought that if you made it specific, people could say, "Oh, that's happening to that particular person, but it couldn't happen to me." I wanted the work to be more general as a whole so that you could see that you could possibly be in that situation. I never made specific people, but when I saw the show it really blew me away, and I felt curious about you because that painting was so incredible.

Chuck: You know, I think that artists don't tell each other enough. Sometimes I would like to tell someone how much I liked their show.

Kiki: Well, yeah. I thought, "I can't just write to Chuck." I felt that I couldn't go around writing letters to famous artists. Then someone said that you had just gotten in a wheelchair, and then there was a lot of hoopla piling up around that show.

Chuck: Well, I'm glad you liked that aspect of the show, because I didn't want to put my own paintings in the show. They wanted me to do something, so I put them outside to sort of explain who I was. For me, the pleasure of doing the show was building an exhibition in a similar way to the way that I build a painting: building incremental parts and putting them together to make something larger than the sum of the parts. Also, the show celebrated the different ways various people have found to make portraits.

Kiki: It was really amazing that they were so different. There are so many different possibilities of what to see in people's faces. It doesn't matter what you're doing if you can really make it live.

Chuck: I thought this show celebrated idiosyncratic personal vision because of the common denominator of similar imagery. It celebrated the different way people have found to get this stuff down. It was a great experience, plus it was a great experience to sort of raid the cultural ice box and go down in the basement.

• • • •

Chuck: What I'm trying to do is to have some reason to get up in the morning, some place to go, something to do, some ritualized activity that is calming and soothing.

Kiki: Doing what I'm doing makes me feel safe. It gives me something to do all day long. I almost wish that I could live in a nunnery. I like that they share all their money. If you're a nun and give all your money to your convent, then they support you with what you need back. Nuns live a long time. That's the problem. There isn't enough money coming in for the older ones.

Chuck: Things like the Book of Kells *were done by people who had lots of time to work.*

Kiki: A monastic life.

Chuck: *We're sort of monastic, but here you are with assistants. I have the same issue. I became an artist largely to be in a room by myself, and now I'm in a room with a bunch of people, or at least they're around. How do you find that?*

Kiki: I really like the company of it and the feeling that it's not just on me. That's delusional thinking, but I pretend that it's not just on me, that I have this group with which I'm working.

Chuck: *Artists are very good at deluding themselves.*

Kiki: When I work at a foundry, I love it because I go to work every morning at eight o'clock and work until five, and it makes me feel really safe.

Chuck: *Don't you feel that you get energy from everybody around you? They're all busy.*

Kiki: You get everybody's good ideas and get to take credit for all of them. Also, when I come home in the evening at about eleven, I have to work another hour by myself, or otherwise I feel that I'm being robbed of my secret. I can't draw with other people around. I need to be sewing or doing something like that by myself every day, but I love having assistants around. Also, it's much better for traveling because you're not alone. I think it's a good thing. I think a lot of artists get nutty being by themselves all the time. They can be really out of it. That's the bad thing about the art world. It kind of fosters self-importance and isolation. I have friends who stopped being artists because they couldn't hack the isolation of it.

Chuck: *Do you go around to studios?*

Kiki: Sometimes, if people ask me. I don't go much of anywhere though. I mostly try to stay at home and work when I'm at home.

Chuck: *But you're on the road all the time.*

Kiki: So when I go home, I like to stay at home. I'm one of those people who doesn't go out of their houses. I go out in my neighborhood. I don't really go anywhere. I don't do much of anything when I'm home because of working. I go out to eat dinner or something, but I don't have a very active life I guess. I shouldn't say that though because it sounds better if I say I'm going to interesting places.

• • • •

Kiki: In the general scheme of things, I prefer art to be in public collections. If you make figures or anything like that, they take up so much space. I've had some of my sculptures in the house, and they scare me. Every time I walk into the house, I see this big figure standing there. It's the Virgin Mary, and it gives me the creeps.

Chuck: *When I was in Baden Baden, I went to Kolmar to see Grunewald's Isenheim altar piece. It was the most unbelievable painting. I had no idea that it was something like twenty feet across. Think about people coming in from the outside world, which must have been very bleak and dark-ages-like into a cathedral with this incredible series of images. You would keep opening the doors, and there would be different images. Now they have them all in an "exploded plan" view so that you can see them all at once, but to come from the cold cruel world into this space and see these absolutely incredible images must have been mind blowing to those people. It still is. It still is to the MTV generation, which is so used to seeing images. It must have been extraordinary. You would love these. Have you ever seen them?*

Kiki: Actually, I was looking at a big book of it the other day.

Chuck: *It was in a hospital setting. The chapel was part of a hospital. The patients had St. some-body's fire.*

Kiki: Elmo's?

Bill: *That was a movie.*

Chuck: *St. Sebastian's fire, which was a plague that caused people's bodies to burn. Everybody went to see the altar piece. They even had beds for those people who walk so that they could see the altar piece as well. He painted decaying flesh from experience, especially the flesh of the legs that eventually become gangrenous. He painted gangrene in the most beautiful, impossible colors. It must have been incredible for those patients to see images that looked like them. I thought a lot about you, about the way you portray something that's not particularly beautiful in a beautiful way, the dichotomy between how lovingly these passages of decaying flesh were painted and how gruesome the imagery ultimately was.*

Kiki: What I always liked in northern things was that they were very specific. If you look at French medieval things, they're always really general. All the sculptures are totally generalized, like idealized people, but German and all those northern things are very specific in the paint-ing of concrete physical beings. I love that they're so into that.

Chuck: *I just saw a print of a contemporary of Grünewald's. He did a print of a doctor examining a urine specimen.*

Kiki: Wow, that's great. Gee, it makes my blood boil. I was in Vienna at Josephina Museum, which is all seventeenth-century Italian anatomical. There's also the Pathological Museum, which is a beautiful round building, full of wax figures depicting diseases. I used to really like diseases before they got a little too close in my real life through people with AIDS and dying. It was more interesting to me when I was younger, because it was about viruses that go between being alive and being dead. They have both attributes or something, and they can go back and forth.

Chuck: *Have you seen the medical sculptures in Florence, the wax figures?*

Kiki: No, but that's what they have in Vienna too.

Chuck: *They're incredible. There's a Boticelli-like woman with real hair, and her eyes are open.*

Kiki: Yeah, they're all classical.

Chuck: *Her guts are ripped open, and the intestines are lying out.*

Kiki: I love them.

Chuck: *They're incredible things, but in a beautiful package.*

Kiki: It's very classical. Women have pearls around their necks.

Chuck: *They reminded me of Andres Serrano's corpse photographs.*

Kiki: Aha, because they're very aestheticized.

Chuck: *I thought the scariest of all of Serrano's was the woman's hands. You knew that she was dead, but they were the most beautiful hands you'd ever seen. I found that much more troubling and difficult to look at—*

Kiki: —than seeing cut up bodies and stuff. There was that death show at the New Museum a couple of years ago. I think there was a German artist who had a picture of a woman who was very beautiful lying dead. She had had an autopsy. They were sewing up her stomach. She was totally beautiful and calm and dead at the same time, but that's a big romance too.

Chuck: You told me that you made death masks of your sister and your father, and that you found out recently that your father had made one—

Kiki: No. When I was a kid, when you came in our front door we had my grandmother's death mask in the hallway. When my father died, my sister and I thought that we should make a death mask of him because there was one of my grandmother, and we thought that since he had done it, we could do it too. Then my aunt told us that he didn't do it at all, that he had gotten somebody else to do it. We were furious. Then my sister died, so I made one of her because we had done my father's mask together. The thing that is really incredible about it is that I have them all on a shelf at home. I cast their faces and their hands. On the shelf I have my grandmother's, who died twenty or twenty-five years before I was born, so I never met her, and my sister's, and they have the exact same profile. It was really amazing because you could see the genes flying through the generations. I just cast my face because I was making a latex mask for something. I carried it to Germany to show it for a set design thing that I'm making, and I looked at it, and then I looked at it sideways too, and it was the same. I started crying my eyes out because it was like seeing a death mask of myself. It was slight so there are no ears. It's not like a whole head. It's like this little shallow thing.

Chuck: An artist just came to do me for a piece that he is doing, and he made an extra cast for me. I'll show you.

Kiki: Wow.

Chuck: When he started to pull the beard and nose hairs out, I wished that I had been dead!

Kiki: Did he put alchemate on your face?

Chuck: He put Vaseline on it.

Kiki: Then what's the stuff that he put on like gunky or like plaster. Oooo, your head's so big.

Chuck: You can see the hairs stuck in the—

Kiki: Oh, you've got nothing there, only three, four, five, fifteen little hairs.

Chuck: There are many that didn't come through in the cast believe me.

Kiki: Wow, it's like an egg shape too. That's really a wonderful shape. Now he put plaster gauze on you.

Chuck: Yes.

Kiki: I can see it on the nose. Wow. What's the person going to do with it? Do you like being cast now?

Chuck: Yeah.

Kiki: So now we'll get you with your clothes off and do a whole body, six and something feet of you.

Chuck: I always wanted to be a rock star so I could have a plaster cast of my penis.

Kiki: Well, that can always happen too. Wow, look at that. It's beautiful how it makes this big lozenge shape.

Chuck: I never realized that my nose was that big. It's a big nose. I hope the same thing happens with my penis. [laughter]

Kiki: Look at it sideways. That's nice but strange. Seeing this cast of my face really made me incredibly upset because, although I've cast my head tons of times, it was my whole head. To

see it in the same shape as the death masks upset me. Then I did this one. A friend called me and said that a friend of his had just died of AIDS. He asked if I would make a death mask of him. I thought, "Oh God." The funeral parlors often asked me if I would like to go into the business of it because people would like to have death masks made; that was sort of a traditional thing to do. I told this guy that I didn't really want to do it but that I would tell him how to do it, but then I thought, "Oh, I never do anything for other people, I'll do it." It was really interesting casting someone you didn't know, because the other people were my sister and my father. I really loved them. You love people's bodies just as much as you love their personalities, and when they're dead, you really identify with that shape or something like that. So it was different. Although it was someone who I didn't know at all, it was a little like doing work: when you do it, you talk to them and tell them, or their friend, what you're doing.

Chuck: Have you worked with cadavers?

Kiki: A little bit while going into schools and stuff, and sometimes people have snuck me into schools, but I'm not into it anymore, although I don't mind looking.

Chuck: Didn't the meat pieces come out of the experience of—

Kiki: Yeah, yeah. Actually, my favorite thing was when they would cut off all the flesh and stuff and put it into plastic bags. The thing that was incredible was that there were these dark green plastic bags on the floor, all of somebody's fat and flesh in a pile on the floor.

Chuck: Ooooo, ooooo.

Kiki: And the body was lying on a table.

Bill: Was this at a medical school?

Kiki: Yeah, and the body just lying on the table. In one way, it was nice because the body was skinned down.

Chuck: Some of us would make a bigger pile of fat than others.

Kiki: That's what I liked, because we're thin under our fat. I mean, under the fat there is muscle. Actually, it was strange to see that we're not just this fat. We're also this other thing. The fat is just a layer of you. It was really amazing. It was really like chicken fat. It was just like fat. It was yellow fat, and the flesh was pretty thick, I mean the skin part. It was really amazing. I was thinking that when my mother dies, I might try to skip an autopsy and just go into the freezer for a couple of days. But don't their souls kind of hover around? Souls take awhile to get out. I don't think that all the people in these colleges really chose for their bodies to be there. The students are sort of learning pretty crude methods of chopping. It's the first body that they get to chop up, and it's pretty rough.

Chuck: What if your body parts are going to be used by somebody else?

Kiki: I don't know. I guess that's okay, but I don't want somebody cutting my insides out. If I were sick, I'd probably do it in a second, but if you think about it, there is an integrity to your body. The students are all holding some person's brain and passing it around in class to see what a brain looks like. That's really interesting and super fascinating and stuff, but I didn't know then what it meant. We were in the British Museum last week and a curator let us into the back rooms. I was picking up all these parts of mummy bodies, and then I thought that I didn't want to touch them. Then my camera stopped working. So I took it as a sign. I don't know

what it means. If your body is preserved, what's you? In 1971 they found and now are showing hundreds of bodies of Caucasian people that they found in Western China all naturally mummified because they had been in the desert.

• • • •

Chuck: I think the idea of being an artist is screaming out like a child, "I am here, I am somebody, pay attention to me," and having a desire for immortality in the sense that one leaves residue suggesting that he or she was here. I think the really important relationships live only as long as people live who can recount them, as long as there are people who knew you. When they're gone, there's no evidence that you were here.

Kiki: It's scary. I've been reading Egyptian cosmologists and stuff. It's really weird that we can only go back a couple of thousand years. That's all we know about basically but there were thousands of years before that, and we don't seem to have any idea what the human race was up to in a really concrete way. I love that Peter Greenaway film. It was one of my favorite films. It was about people who were pulled out of the Seine during the French Revolution, under what circumstance they were pulled out, and how many generations it takes until knowledge of an individual disappears. I know practically nothing about my mother's family because she doesn't talk about them. I know a little about my father's family, but when they're dead, I'll have no more access to this history.

Chuck: I always used to deny the connection between my work and the history of portraiture. It's pretty bizarre, I suppose, but I needed an arm's-length distance.

Kiki: Because it's a heavy history.

Chuck: Whenever I go to a museum, I realize when I'm leaving that I spent all the time in front of portraits. It's how we end up knowing about ourselves and how we try to figure out what it was like to have been someone else.

Bill: You learn a lot about yourself and the history of that period from those paintings and what is going on in those people's faces and eyes.

Kiki: The interesting thing about Chuck's paintings is that they take away the attributes of things, because the portraits are constructed from objects. You take away the subject's entire body. You have their heads, but you take away everything else.

Chuck: Can we talk a little bit about the fact that so many artists are dyslexic and have learning disabilities? So many artists are left-handed and a lot of other things like that. I know that you had some similar struggles when you were a kid and that it affected, of course, your sense of self worth.

Kiki: I thought that the big difference between me and you was that you ended up going to Yale and I ended up going to trade school.

Chuck: It was a total accident.

Kiki: I went to trade school in Newark.

Chuck: I went to a junior college that had to take me because I was a taxpayer's child. I had no entrance requirements. I took no SATs. That's how I got into college. I could never have gotten into a college with SAT requirements.

Kiki: I didn't take SATs either. I never took them. That is why I went to art school. If I could get into art school, then I could go to university and take university classes, which were more interesting to me.

Chuck: *We always had to prove ourselves to people. The assumptions are that you are dumb, lazy, a shirker and a malingerer, or whatever. I used art all the way through school to show the teacher that I was interested in the course. I couldn't remember the names and dates, so I'd make a twenty-foot-long mural of the Lewis and Clark trail and schlepp it into class to show the teacher that I cared. Art saved my life all the way through school. It was the only place where I felt special. It was the only thing that I did that my friends couldn't do. I wasn't an athlete, and I wasn't a good student.*

Kiki: I don't really have any kind of talent. I really don't know how to draw or anything like that so I never could do that. When I was a kid, I didn't know how to draw.

Chuck: *But your work is all about drawing.*

Kiki: But I couldn't do it. I worked in a bar, and one day a guy with whom I had been in school came in. I had always been in the lowest group all the way through lower school and high school. I practically flunked out of high school. I really hated to go to school. One thing I realized was the economics of school. I grew up in an upper-middle-class town. I realized that everyone else in the lowest group were either immigrants, blacks, Italian, or working class people. All of the working class people were being trained to be working class people. I was in there too.

Chuck: *They told me I should go to body and fender school. That's what my high school advisor said. "Don't take college preparatory courses. You'll never get into college. Go to a trade."*

Kiki: Well, that's what I did, and I saw this guy and realized that, because I'd gone into art, I had escaped being like one of the dumb people. He was still stuck in that. We were supposed to be punished and stupid our entire lives. We were supposed to act stupid and polite to those people who were smarter. Being in art was really great because it didn't matter what college anyone went to. To some extent people care about that but it's more in their social lives. An artist can come from anything. I always think that art saved my life.

Chuck: *Yeah, me too.*

Kiki: It saved my life as a grown-up more than as a kid, because I didn't really have any particular ability in art.

Chuck: *The wonderful thing about being an artist is that even if you're not particularly valued by society in the time in which you live, you may be significant to the future. When we look back at Florence in the sixteen hundreds, we don't know who the mayor was, we don't know who any of the important people were at the time. What we know about that culture we know because of the artists, so ultimately we end up having much more importance than we ever felt in our lives.*

Kiki: The thing that's really great is that I have a really good sense of direction.

Chuck: *Me too.*

Kiki: I remember things. Last year I went to Washington state to where my grandmother's house had been. I hadn't been there since I was five years old, but I knew where it was, I knew what it looked like, I knew what the inside looked like. I remembered everything. I remember things visually. I can't read a lot of times. I can spell it out to you, but I can't tell you what it says. I remember things visually.

Chuck: I can draw a floor plan of every house I was ever in from kindergarten on. I remember what was behind the wall, if there was a staircase going up.

Kiki: That's a big deal I think. I always amaze people. Friends of mine will say, "Well, this is like something or other." I'll look at it and realize that they don't know how to pay attention to details, the physical, how something's made, what it's made of. They have no sensitivity to that. Being left-handed also has a real advantage during a stroke because it means your brain is less compartmentalized, and if you have a stroke you lose less information. Most of the artists I know are left-handed. I realize that I go all around the world not paying attention. I don't like paying attention that much. To lots of things I don't like paying attention—

Chuck: It drives my wife crazy.

Kiki:—but I always get wherever I'm supposed to be. It all works out for me, all the time.

Chuck: That sounds like the way you approach your work. You don't preplan it. You just do it, and it all works out.

Bill: One of things that is repeated again and again in the various interviews is that you, Chuck, work intuitively. People don't believe me. They look at me as if I'm out of my mind because your work looks so systematic that they don't have a clue what I'm talking about.

Chuck: Well, a system liberates me from the big problems, from those things that overwhelm me, so that I'm free, within the very narrow confines of what I have left, to be open and intuitive and do it one way or the other.

Kiki: That's like people who make religious paintings. That's very frustrating to me. I always think that if I could just make religious paintings for the rest of my life, I wouldn't have to think about what they're supposed to be about. I mean, you can play in that a lot.

Chuck: Well, limitations that used to be imposed by other people, patrons or the Pope, we now have to impose on ourselves.

Kiki: And, actually, there were a lot.

Chuck: When you look at Arnolfini Wedding, the painting was not great because of all that stuff that was in there. It's a miracle that it was great in spite of all that shit in there. If we had to put a donor in the lower left-hand corner of every painting that we made—

Kiki: I love that you said that you begin with really broad strokes and then make it more and more specific. I was thinking about how other people like having assistants, letting other people make decisions, how you can go in any direction, but once you go in a direction, it gets more and more specific and gets really fine. At a certain point it gets either really right or really wrong. My assistant sometimes says, "Let's make something together." Then I'll have to redo the part she made because it's not mine, because it's not enough mine. Someone else would look, and they wouldn't see any difference, but to me it's this enormous crevice or something. It's unbearable. It's similar to what you said: there's a large possibility and then it gets very precise.

◆

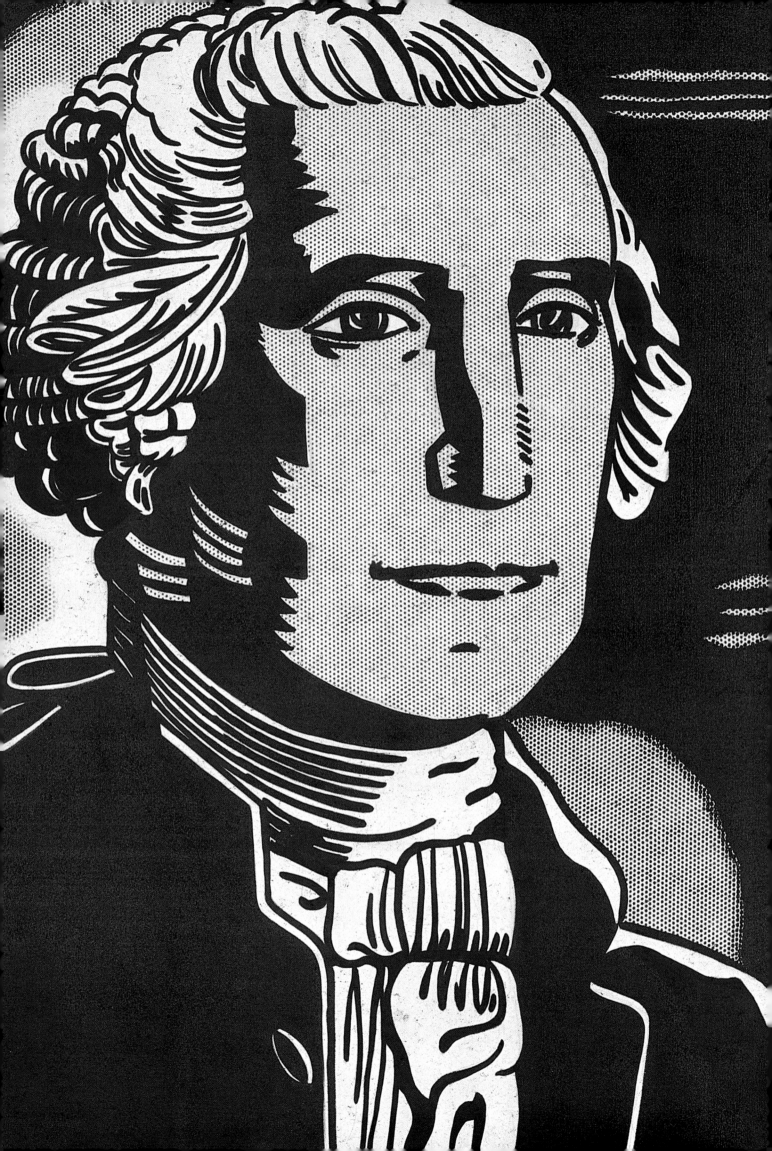

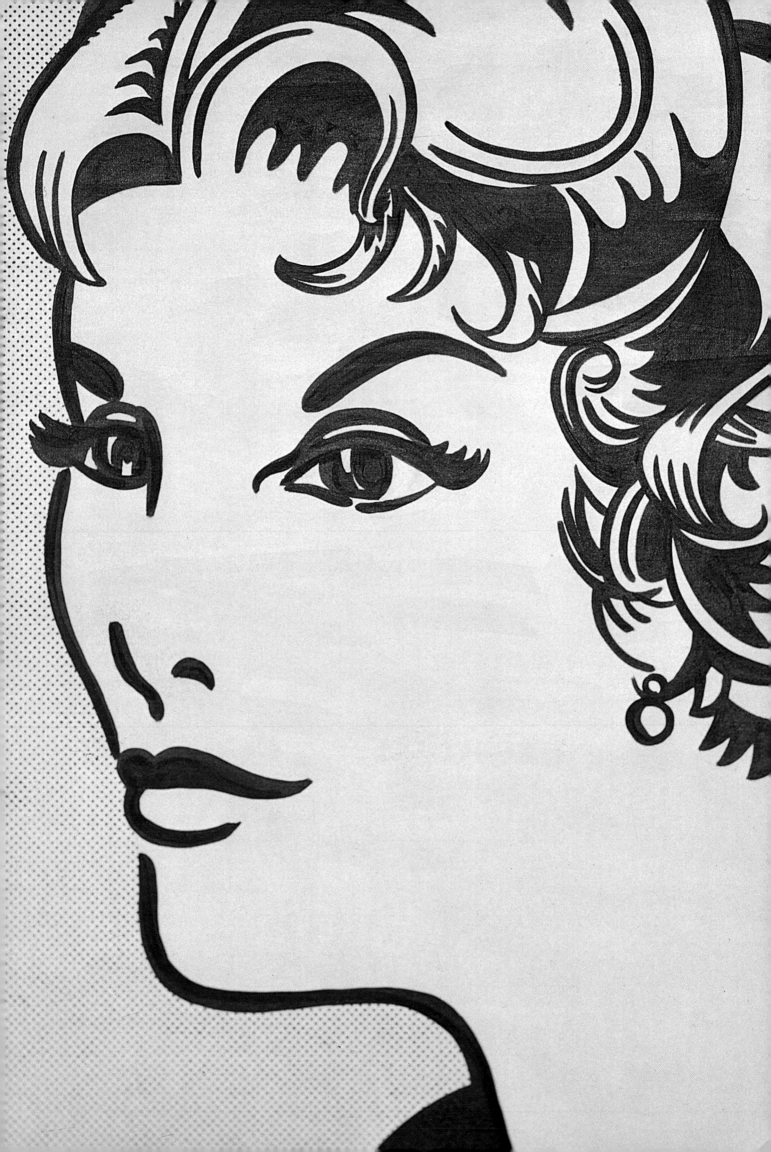

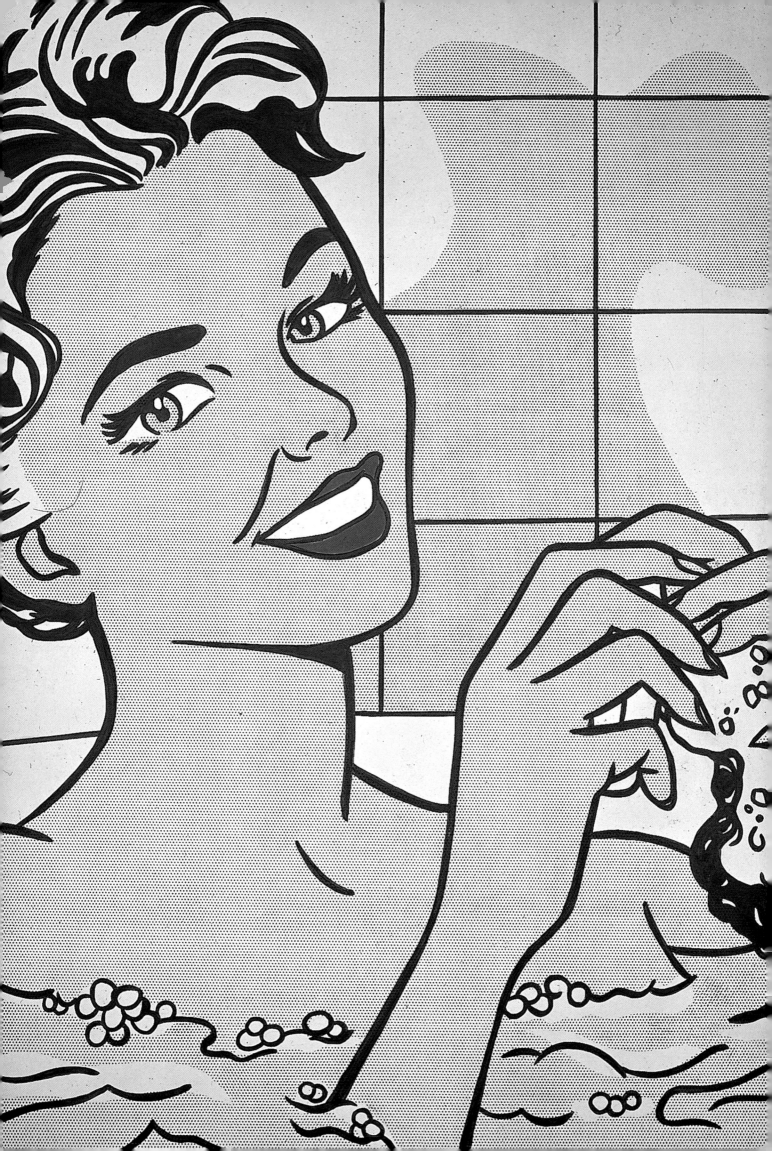

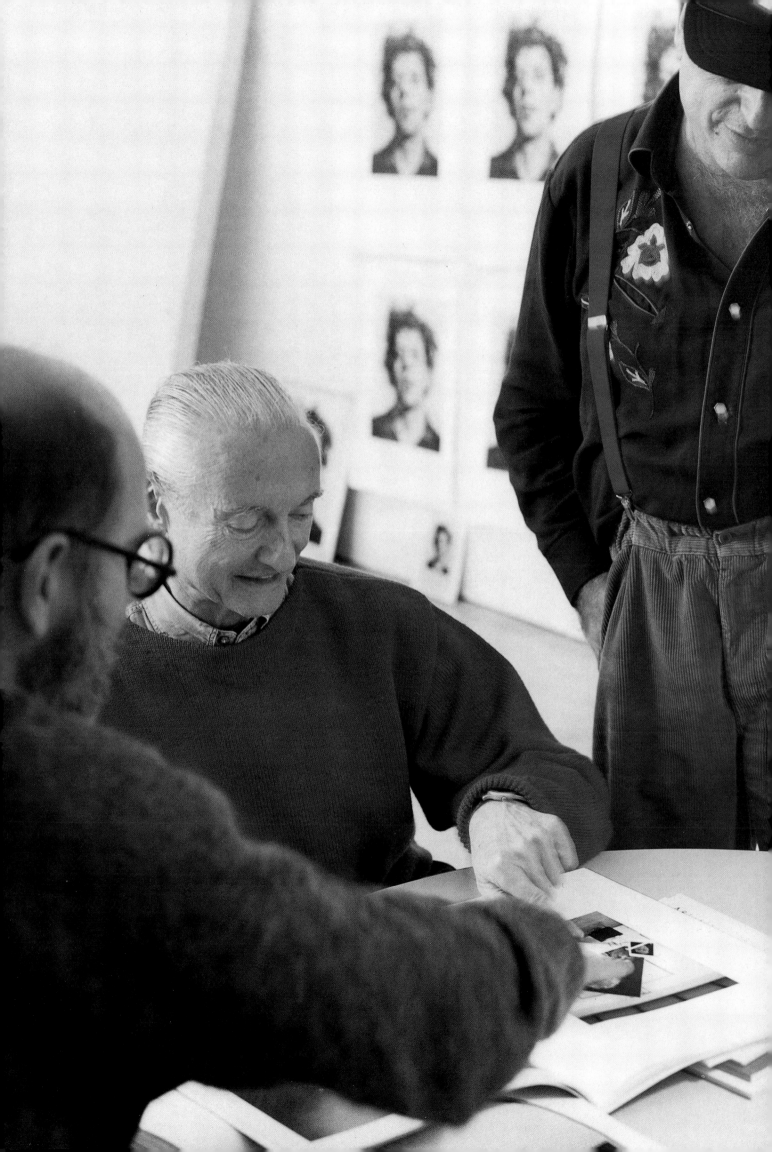

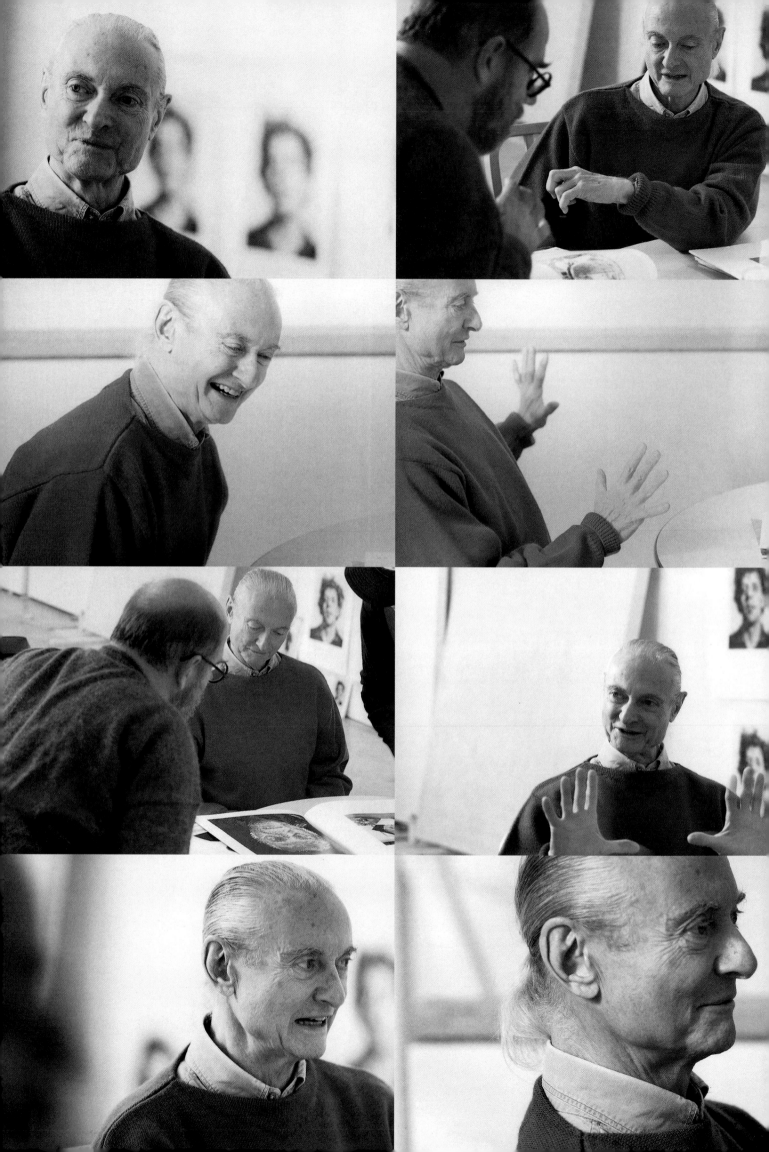

Roy Lichtenstein

New York City, October 23, 1995

Chuck Close: I think that you are the quintessential New York artist, and as we know, there are very few native-born New York artists.

Roy Lichtenstein: Yes, that's true. It's just amazing. Larry Rivers is one. I was born in New York, and then I left and went to college at Ohio State in Columbus. There really wasn't a New York art world of which I was aware. I went to the Art Students League for one summer in 1939 or 1940, I'm not sure which, but I knew absolutely nothing about the art scene.

Chuck: Didn't you go to museums as a kid?

Roy: Yes, I did. I went to museums a lot, but in those days nobody knew much about art except people who were definitely in art. It wasn't like now. Abstraction wasn't taken for granted as a possible way of painting. You lived in your folks' house, and they had their still life by some unknown after somebody else, and that was art. That I became interested in art is sort of amazing to me. I could draw things, but that doesn't really mean a lot, so it is kind of mysterious to me why I decided to go into it. I didn't know of a New York School at the time, so although I didn't really like it, there was nothing wrong with going to Ohio, and I thought it would be nice to get out of New York and see another part of the world.

Chuck: Right, but there is a very different view of the art world in the Mid-west. They are very enamored of those artists we would consider the minor masters and have some suspicion of the mainstream. They like artists like [Charles] Burchfield better than—

Roy: Yes, I know. It's funny. They like Braque instead of Picasso and that sort of thing. *[laughter]*

Chuck: When I was a kid, there weren't any baseball teams west of the Mississippi, so everybody rooted for the Dodgers because you root for the people who are behind: the underdogs. Nobody rooted for the Yankees.

Roy: Yeah, because it was obvious that they were going to win the pennant.

Chuck: You have occasionally mentioned that you saw art only through art magazines.

Roy: But I think there was only *ARTnews*. Well, there was also *American Artist*, but that was another story.

Chuck: Yeah, it still is. [laughter]

preceding pages:

Girl with Beach Ball II (detail), 1977, oil on magna on canvas, 60 × 50 inches. Photo courtesy Leo Castelli Gallery, New York.

Composition I (detail), 1964, oil and magna on canvas, 68 × 58 inches. Photo courtesy Leo Castelli Gallery, New York.

George Washington, 1962, oil on canvas, 51 × 38 inches. Photo courtesy Leo Castelli Gallery, New York.

Head, Yellow and Black (detail), 1962, magna on canvas, 48 × 48 inches. Photo courtesy Leo Castelli Gallery, New York.

Girl in Bath (detail), 1963, magna on canvas, 68 × 68 inches. Photo courtesy Leo Castelli Gallery, New York.

Reflections II (detail), 1988, oil on magna on canvas, 70 × 86 inches. Photo courtesy Leo Castelli Gallery, New York.

With Chuck Close in his studio, October 13, 1995. Photo: Bill Zules.

Magnifying Glass (detail), 1963, oil on canvas, 16 × 16 inches, Photo courtesy Leo Castelli Gallery, New York.

Portrait of Madame Cezanne (detail), 1962, magna on canvas. Photo courtesy Leo Castelli Gallery, New York.

In Chuck Close's studio. Photos: Bill Zules.

Roy: We had some fairly forward looking people in Ohio. I remember a Pollock painting came out, and we were kind of willing to understand it.

Chuck: *I saw my first Pollock when I was about thirteen, and it outraged me. I saw it at the Seattle Art Museum, and I was furious. It didn't look like art. "Who the hell is this guy?" I thought. Within days, I had dripped paint over all of my canvases.*

Roy: I know.

Chuck: But I didn't know what color to use. Having seen only black and white reproductions, I didn't know what color a de Kooning might be. That may be why I paint so many black and white paintings now.

Roy: We saw almost everything in magazines, or on slides, or something like that. While on the jury for various things, like the New York State Arts Awards, I realized that, if you don't know the art, and you first see a slide of it, and then see the original, it's so different. The scale and everything is different. You've projected so much onto that slide. If you don't really know what a painting looks like, and you see it reproduced, you can project everything you know onto that reproduction, but when you see the original, it's a completely different thing. In other words, in order to understand a reproduction, you really have to have seen similar work.

Chuck: *I remember looking at reproductions of Kurt Schwitters' work in art history classes. They were intimate little things that looked forty feet large in reproduction. How can you make a decision from that distortion. The same holds true for a [Joseph] Cornell box.*

Roy: Even if they tell you the size, it doesn't do it, yeah.

• • • •

Chuck: *Diane Waldman [curator of your retrospective exhibit at the Guggenheim Museum, NY] said that you arrived at abstract expressionism remarkably late.*

Roy: Oh yeah, I'll say. 1957 to 1960.

Chuck: *That wasn't late in academia. I mean, it was still being taught. It was the official art.*

Roy: I've always said that it doesn't make any difference in which style you are painting. There are more fundamental things than style. But there was an assumption with expressionism in my work that perhaps the subject matter was derived from Manet or Ingres or that color areas were being used to make a painting in some ways look like a Cezanne or a van Gogh. I wouldn't have said, "This is the style that must be used," or anything like that. In a sense you really ought to invent your own style, but you can't invent it by sitting there. There is no way to make yourself invent something, but you should be open to it. When I look back, it was abstract expressionism with which I was dealing.

Chuck: *Who was your biggest hero?*

Roy: de Kooning, I guess.

Chuck: *de Kooning. One was either a de Kooning fan or a Pollock fan. I think it really came down to choosing sides, to whether or not you looked towards Europe, because de Kooning was much more a cubist and much more a European kind of painter than Pollock.*

Roy: Yeah, he was, and I guess his work was more understandable, but the Pollock work that looked so tough at that time looks very beautiful now.

Chuck: I said it looked like the doilies that my grandmother had on the back of her couch. They have that kind of skein-like lyrical form, and they don't look violent at all.

Roy: No, the metallic paint, cigarette butts, and other things in it seemed really tough at the time. I liked it for that reason. Now it looks quite tame. de Kooning's work looks the same. I've always liked de Kooning.

Chuck: You were talking about art history class. Did you diagram paintings in art history class in the same way that you ended up doing in the diagram paintings? [laughter]

Roy: No, they were diagrammed, but I never really believed in that.

Chuck: They still teach that shit. I always thought it was very funny.

Roy: What about all the other marks in the picture? What do they mean? *[laughter]* It's only this outline, and why are no two the same? Erle Loran, who had done a book on Cezanne, which had the diagrams of Madame Cezanne, objected to the fact that I had used his work. I didn't really want to be mean to him, but the idea that Cezanne, who had said, "The outline escapes me," was being diagrammed with this heavy black line was kind of amusing. [In his book *Cezanne's Compositions: Analysis of His Form with Diagrams and Photographs of His Motifs*, University of California Press, 1947, Erle Loran analyzes Cezanne's paintings according to categories such as: static picture plane, dynamic picture plane, overlapping planes, volumes moving in space, dimensional movement, rising and falling movement, linear rhythm or movement, and tension between planes. He created diagrams, with heavy outlines, to illustrate his definitions of these categories. In addressing *Portrait of Madame Cezanne* in particular, Loran states: "There are qualities of dynamic tension in this portrait of Madame Cezanne that cannot be explained on human or literary grounds. Consequently, it seems advisable to study it with an eye to the axial tipping that contributed so much to the dramatic quality of the landscape previously analyzed, for in this portrait there is a majestic quality having little if anything to do with the human character of the sitter."]

Chuck: I have to tell you a funny story. I think that, when you look back a decade or two or three or four, it's really hard to remember how radical something was when you first saw it. When I was a graduate student at Yale in 1962, I came down for your first show at Leo's. It was one of those wonderful experiences when something didn't look like art, and it really irritated me the way Pollock had irritated me. I thought, "Gee, what could be more 'out of it' than something that has to do with commercial art?"—I had also wanted to be a commercial artist at one point—but at the same time it really grabbed me by the balls. I ended up buying a little print of the woman with the yellow hair. There was no word bubble with it. It was five dollars unsigned, or ten dollars signed. I went all the way, and got the ten dollar signed one. That was about one quarter of my weekly earnings, so it represented quite a commitment.

Roy: Thank you. That was very nice of you.

Chuck: I took it back to Yale, which was probably the premier art school in the country, and I got such shit from everybody. You were really kind of the antichrist.

Roy: Yeah I know. I realized that. Because I made a very fast change from abstract expressionism—only I thought I was an abstract expressionist—to this, I understood how it could be seen. I took the work seriously, of course, but I wondered how it would be received by people I knew or by people coming from the same place. As an art teacher from the Mid-west, I'd go to the Cedar Bar and see if I could find [Franz] Kline, look at him, and hope that maybe someone would introduce us. I always felt completely outside the picture anyway, and having failed to succeed—I was already thirty-eight in '61, so I was getting along—

Chuck: It was time to get your career in order. You would be finished now if you hadn't had something happen by then.

Roy: Yeah. I guess my age allowed me to change. There was really no risk involved. The idea of defining everything was not part of what I was doing. I would see delicious passages in works, and I'd try to make a brushstroke like that. Doing that had taken up fifteen years of my life, so I tried to do the same thing but in this strange style.

Chuck: I was really interested in the system to which you were exposed in Ohio of drawing in the dark. How did that work?

Roy: There was a completely dark room, which is actually hard to make. The students stood at desks with large pieces of newsprint, fifty pages or something like that, and a big hunk of charcoal. At the back of the room was a projector with a revolving aperture. It would flash a slide on the wall every tenth of a second. You would see the slide, flash, and then you would be in total darkness, and you would get a very strong after-image. [Ohio State professor Hoyt L. Sherman's unified perception theory described in his book *Drawing by Seeing* focused on the totality of the image rather than the individual parts. By using a tachistoscope, Sherman developed his "flash room" in which he required his students to draw the image they saw flashed before them.]

Chuck: It sort of burns into the retina.

Roy: And it shifts. In fact, funny things happen. You look at a wall that you know is nearer and it gets smaller, it does funny things. Anyway, you can't look at only part of your own after-image. Even though it shifts, you always see the whole after-image. Whatever there is of it, you see. The idea is, now that you've got a total picture in your mind that you can't get rid of, to sense where the marks ought to be. You can't really see them so you have to sense one from the other, and you're getting a visual kinesthetic sense of position. The idea wasn't to draw it exactly or anything like that, but to try to draw it.

Chuck: Without looking.

Roy: You couldn't see anything. You could feel where the paper was, but you couldn't see it. The slides started with just a few marks, and then as the course progressed, they got more complicated: the values changes, some of them were in color, and other things.

Chuck: What were the slides like? What were they showing?

Roy: Well, just a mark, say a big mark and a little mark, and then they'd be in different values, and then there would be a number of marks. Then they were in color, and you would translate from color to value, and then they would flash set-ups in the room: chairs hanging from the ceiling, people, and—

Chuck: You mean they were real?

Roy: They were real, but you'd get the same kind of image. It's not that you could draw all of that in any detail but you could respond to it. You would only do this for fifteen minutes a day, and then you would go and draw but try to draw with the same sense in you. You'd try all kinds of things like drawing under a sheet of paper so you couldn't see what you were doing, anything to reinforce the visual-kinesthetic and your response to it. Some people drew pretty amazing things that way. I don't know that anyone understood it or used it, but I think it had an effect. The professor was interested not so much in creating artists as in what you do with mass education and what you tell someone to do that makes sense. That's very hard, I think.

• • • •

Chuck: There's a prejudice that I hear all the time. People will ask me, "Can you really draw?" and I'll say, "What do mean?" and they will say, "Well you copy photographs. Can you really draw?" They have the idea that if you're drawing from something that's already flat, then you're not using your eyes. You must have gotten that a great deal.

Roy: Yes.

Chuck: Not only were you drawing from—

Roy: It looks like the same thing.

Chuck: It looks like the same thing.

Roy: I love that idea for that reason. *[laughter]* I mean, it was uninventive, it was fake, it was copied, it didn't have any redeeming features whatsoever. But are you asking me if I can I draw?

Chuck: No, I know that you can.

Roy: Drawing to me means that you can make a mark that relates to another mark, irrespective of the subject or anything else. There is always a level at which you can't draw. I mean, I can't draw like Raphael. Maybe I could if I studied it or tried, although I doubt it, but I don't think that has a lot to do with art.

Chuck: So many people think drawing from photographs is cheating. I once had a class of little kids who were about seven years old, and those little kids were saying, "Well, you cheat. You draw from photographs. Can you really draw?" So I did a drawing of Mickey Mouse, and they applauded!

Roy: Oh yeah? *[laughter]*

Chuck: They could appreciate the fact that I could draw Mickey Mouse, so perhaps you have a leg up because you were drawing something that people knew and cared about.

Roy: I can almost draw Mickey Mouse. *[laughter]* I also have an idea that art really comes from two-dimensional references, that when the teacher shows you how the shadows fall on an object, he thinks he saw that in nature and that's why he knows how to draw it, but if we really drew only by looking at nature, without any reference to other art, we'd be drawing like children. The only thing that makes you understand what is taken for drawing in this civilization at this time is a norm that comes from drawing, not from observing nature. I don't mean that no one ever observes nature and finds something new in it, because then there would never be any progress, but I think that ninety percent of drawing is drawing like someone else, and that one is influenced by the whole history of art of which one is aware. Why do all Japanese drawings look Japanese? It isn't because they are trying to make a Japanese drawing. It's because they are drawing. I'm talking about the ones in history.

Chuck: There are a bunch of conventions and traditions that we've accepted. The idea of perspective is just a set of conventions into which we bought.

Roy: Yeah, right. Perspective isn't terribly useful unless you have architecture. If you are drawing a group of people, you don't really decide where the vanishing point is.

Chuck: Uccello tried to put the spears on the ground in a perspective grid of the battle. [Battle of San Romano, 1445, National Gallery, London]

Roy: And they look very awkward. I look at perspective as a symbol for seeing things from one point of view. However, rendering perspective doesn't necessarily mean that you are seeing

things from one point of view; it could be a symbol of that rather individual Byzantine way.

Chuck: You did mechanical drafting at one time too.

Roy: That's right. I never did commercial art, but I took engineering drawing. In fact, I took a lot of it because the war was on. I knew I'd be drafted, and I wanted to be able to do something.

Chuck: Something besides stand up and take the bullets.

Roy: Right, so I did time in the army, and then I worked for architects and did various other things that required mechanical drawing.

Chuck: I worked for the Corps of Engineers. I got the job by submitting a friend's drawing, and once they hired me they couldn't get rid of me. They soon knew they couldn't trust me to do the important drawings because I would screw them up, so they had me doing caricatures of people until the summer was over and I could go back to school. I enjoyed reading in your Guggenheim retrospective catalog that at one point when you were in the army, they had you doing—

Roy: Bill Mauldin cartoons. Yeah, the colonel liked to decorate his house with them. That was my job. There was a war on, and I was in there making cartoons. "Ah, that looks nice. Get a tacky frame for him and put it up in his house."

Chuck: So there are a lot of Roy Lichtenstein Bill Mauldins around somewhere?

Roy: Somewhere.

Chuck: Yeah, that's funny.

Roy: I think that, just as an art form, making other people's art might be a step beyond copying from photographs or cartoons or something, and I think that should be your next step since you mentioned it. That's okay, you can cancel that idea.

Chuck: Well, it's already art too, so that the way you do brushstrokes is what you are about. You make a brushstroke in a very different way than the original brushstroke was made.

Roy: That's true.

Chuck: Actually, I think that's one of the funny things about the way you work. I love how the Benday dots really were content, and how in that wonderful painting of the magnifying glass the dots are simply bigger inside the frame of the glass. [Magnifying Glass, 1963, private collection, Italy]

Roy: It really teaches you a lot.

Chuck: The other one I love is the old reweaving thing where there is a hole and then the hole disappears. You could really make the mark content, and it is a very interesting comment on why art works. [Like New, 1962, Collection of Robert and Jane Rosenblum, NY.]

Roy: I can see it in your work, of course, because the mark that is supposed to symbolize a highlight or a shadow is itself a decorative thing; it could be a painting.

Chuck: Well, I think that's why your work was so important to me. In fact, when Diane Waldman said that you were conjoining a real image with an abstract style, that had real urgency for me: the idea that it was so clearly the marks on the surface at the same time as it was the image.

Roy: Cartoons sort of do that, except that they've invented a lot of things like explosions and signals like a blast, very beautiful things that have no existence in nature. Cartoonists are telling a story in the composition. Their real purpose is to tell the story, not to make strong drawings from an art viewpoint. The style that they have, partly because of the economics of

how things are printed, is to make lines around the figures and to use flat colors: things that are easy to print. Recent cartoons are almost impossible for someone over the age of eighteen to read. There is so much going on in them. There is no limit to the technique, and there are lurid colors, and they can modulate the colors.

Chuck: Cartoons were made for their economy and simplicity. There was a system in the printing process to drop a tone in or whatever, and the mileage they got out of that stuff was incredible. You have said, "I want my paintings to look programmed; I want to hide the record of my hand," which is also something that I wanted to do. I was trying to make my work look like photographs in order to get my hand out of there, because I had all of these habits that were associated with other people's work. I was trying to purge de Kooning, purge [Hans] Hofmann and all of those people.

Roy: Not that one didn't know that you had to be original, but that wasn't drummed into us in particular. I mean, we'd draw from models, but today people are so aware that art has to be original—and it does—that it must be almost impossible to get through art school. You need to have a lack of awareness for a while during this learning period.

Chuck: And run through a lot of different people's work too, I think: be Cezanne for a while, be—

Roy: Otherwise, how are you going to learn?

Chuck: There's an awful lot of pressure to find a mature style very quickly.

Roy: Yeah, yeah. But it is good to be aware of how much of what you're doing is simply because you want it to *appear to be art* to people.

Chuck: I remember going into Stable Gallery in the early sixties—that was such an incredible period—and seeing Warhol's Boxes *and the things stacked up: the Brillo boxes, the Heinz ketchup bottles, and all that. It looked like a supermarket warehouse. It didn't look like an art gallery.*

Roy: Yeah, I remember that.

Chuck: It was really shocking. It didn't look like art. It was an incredible time.

Roy: Then there was the person who had designed the real Brillo boxes who objected or something or other. I don't remember what his role was. He designed the box, but he was also an "artist." He was in the news a little bit.

• • • •

Chuck: When you were at Rutgers, at Douglass College, there was an incredible batch of people there. [Lichtenstein was an assistant professor of art at Douglass College from 1960 to 1964.]

Roy: George Segal was getting his masters there, and Samaras had been there the year before. He wasn't there when I was there, but Bob Whitman was, and the Fluxus group [George Brecht, Geoffrey Hendricks, Dick and Alison Higgins, and George Maciunas] was there.

Chuck: There were also others whose work was shown in the early pop shows, such as Robert Watts, who I always thought was a very interesting artist.

Roy: I have quite a few pieces of Bob Watts's work because Dorothy was sort of the manager of the Biancini Gallery, and she had a lot of pop art. She had the supermarket show up, but I think they carried Bob Watts, or at least I know they had a Bob Watts show.

Chuck: Remember when Sidney Janis rented the ground floor for that show? There were about forty artists in the show. Were you teaching then?

Roy: Yes. It was just total luck. I was teaching up in [State University of New York at] Oswego, and a friend on the staff had Reggie Neal come up, and Reggie hired both of us. I think that, because he wasn't too interested in the Fluxus influence, he—

Chuck: —wanted someone who still made things.

Roy: I was actually still painting, and I think that's the real reason I was hired.

Chuck: It got you out of Oswego.

Roy: Yeah, it sure did. *[laughter]*

Chuck: So what were you teaching?

Roy: Oh, drawing, design, and all of that stuff.

Chuck: Were you teaching "The Academy," teaching abstract expressionism?

Roy: Pretty much. I wasn't trying to make the students into abstract expressionists, but that was the umbrella under which I worked.

• • • •

Bill Bartman: Have you kept any of your work that was completely different from—

Roy: You mean pre-pop things? I have the largest collection of those *[laughter]* in the world. I took them off the stretchers and made big portfolios of them. They're hanging down inside a giant portfolio, but many of them were too big or too whatever.

Chuck: I was noticing that half of your early print of the [ten] dollar bill is an expressionist dollar bill. [Ten Dollar Bill, 1956, lithograph, edition of twenty-five.]

Roy: It's really cubist-expressionist. It fortuitously looked like pop art to people.

Chuck: It's actually here in your catalog. There are pieces that look as if you found the proto-Benday dot by— What did you use to make the dollar bill print half tones?

Roy: Because it's a lithograph, I don't think it could have been frottage. I don't remember now how I did it, but I might have used inked fabric or something like that. I was trying to make it look like the engraving. I think it was some kind of fabric that I could somehow ink on and stamp on.

Chuck: It really did presage your use of the Benday dot by quite a while. When you actually did begin making the dots, you used some kind of primitive grill. How did you make those things?

Roy: Well, the first thing I used was a plastic dog brush with regular tynes. I dipped it in, stuck it on, and then I'd move it. *[laughter]* Next I used a thin piece of aluminum. I put a piece of graph paper over it and drilled holes, but they didn't come out. It's very hard to drill precisely at the intersection, so it's kind of messy, but I used it. It wasn't very big either, so I would—

Chuck: —you would roll paint on it, and you'd shove the paint through the holes. Now I know that what I need is a dog brush. I can put a lot of dots on at one time. This is going to change my life, Roy. [laughter]

Roy: The stencil is okay with black paint, but if you put red on it, oxidation occurs and the metal will turn it blackish before you can get started. Therefore, it had to be painted with a

white enamel, cleaned in the shower each time it was used and then repainted. You had to do this everytime, so I thought of just using perforated paper and throwing it away. It's really easy, and it's baked in. Now we have it down, but then it was trial and error.

• • • •

Chuck: **Gene Swenson quoted you as saying that you wanted to make art that was despicable.** [In his seminal interview with Gene Swenson, "What is Pop Art?: Answers from Eight Painters," *ARTnews*, November, 1963, Lichtenstein commented that he wanted to make his paintings so despicable that no one would hang them. Lichtenstein discussed that he chose commercial art as his subject because he thought everyone hated commercial art.]

Roy: I hate that quote. People keep bringing it up.

Chuck: I know, and I'm bringing it up one more time. For someone who wanted to make despicable art, you certainly made an awful lot of art that wasn't. The thing that grabbed me was what you said that you were against. You were "anti-contemplative, anti-nuance, anti-getting away from the tyranny of the rectangle, anti-movement and light, anti-mystery, anti-paint quality, anti-Zen, and anti-all those brilliant ideas of preceding movements, which everybody understands so thoroughly." I love that quote because I've always thought that the choice not to do something was much more important than the choice to do something. The choice not to do something pushes you somewhere else. Ad Reinhardt was extremely important for me because he said—

Roy: Oh, he said brilliant things—

Chuck: —against this and against that. But it programs change and makes you move someplace; it keeps you from being stuck.

Roy: I'm not anti-Zen in the sense that I don't like the religion. I meant the beauty of it, whatever they considered "Zenish" at the time.

Chuck: Some artists were actually running off to Zen Buddist monasteries. Can you talk a little bit more about that thinking? Were you, in essence, purging your work?

Roy: Except for the strength of painting—the structure, not the design—I felt that everything was a mannerism of some kind, and I'm sure this is now true of my work too.

Bill: Wow, you were so brave to have put all those early works in [the Guggenheim catalog]. Most people destroyed all of their—

Roy: Well, I wouldn't have necessarily put them in but— *[laughter]*

Guest: Thank god for art historians.

Chuck: You notice they're not hanging at the Guggenheim.

Roy: They're not in the show except in Germany where they put the early work in. I think it helps in a certain way. Everybody says, "Oh! You know how you used to have to prove you could draw before you did an abstraction, because otherwise nobody would believe that you were an artist?" I had to prove I could push paint around, that I was actually an artist, because you couldn't tell from the cartoon things.

Chuck: Who was particularly important to you when you were a student, Roy? The art world broke down into the surrealist branch and the expressionist branch, and we all bought into the expressionist branch.

Roy: Um hum. I always thought that Picasso's *Demoiselles d'Avignion* [1907] was both earlier and wilder than Duchamp's *Nude Descending the Staircase* [1912]. Picasso had the structure,

the power, and the innovation without believing he was anti-art. I've always tried to do constructive art. I don't mean Duchamp wasn't doing that, I just mean he had that ironic element, the ironic part that I saw as an influence.

Chuck: When artists tried to use art as a criticism of society, that was really—

Roy: I thought that was reaching.

Chuck: Yeah. Do you think you would have drawn cartoons if you hadn't had kids?

Roy: That's hard to say because I was drawing them before, and then the kids would ask me to draw Donald Duck, and I would draw a more conventional Donald Duck, and maybe the act of doing that had an effect.

Chuck: I've always had to draw for my kids to entertain them.

• • • •

Chuck: Maybe we can talk a little bit about what it was like when you first took your work to Leo [Castelli], the role Ivan [Karp] played in all of that, and the fact that Warhol took his work there at the same time.

Roy: Well, let me see. [Allan] Kaprow made an appointment with Ivan. I had taken my work around to galleries a lot. You didn't really need an appointment then because nobody was doing anything anyway. There was usually somebody at a desk pretending they were working, but there was never anyone in the gallery. Most of them would look at your work, and I would always have mine with me. Anyway, I had this appointment, and Ivan was immediately taken with my work. Ivan had written pop novels, and he was ready for it, and I also think Oldenburg had already shown his early things, so it wasn't completely mysterious. I thought, however, that no one would really take to this work except Castelli or maybe Green Gallery. I also didn't really care that much anymore. When you're kind of insecure, the gallery is extremely important, but I really thought I had done something, so it didn't make any difference. Anyway, Ivan was immediately interested in the work and he wanted Leo to take it, so he removed some of the pieces that he thought were a little more tentative and put them somewhere. Leo came out, and he was very polite, interested in puzzles, and he wanted me to leave the work there. I thought that was a nice idea and—

Chuck: You had brought it strapped to the top of your station-wagon: station-wagon-sized art.

Roy: They were not huge. I came back in about three weeks, and that's when I saw Andy's work—Nancy and Dick Tracy. Mine were extremely similar to those but a little rough here and there.

Chuck: But rough in a different way.

Roy: Yes, he was doing certain things to be artful, and I was trying to make work that looked like cartoons. Rosenquist's work was there too, and I guess Leo felt that there was some sort of movement going on because none of us knew each other at all.

Bill: It's really interesting that you were all doing similar work but none of you knew each other.

Roy: Yeah, it's amazing, isn't it?

Chuck: How important were Rauschenberg and Johns in your thinking?

Roy: Well, they were more important indirectly than directly. I knew of their work, but I didn't associate it with mine. I didn't even associate it with Oldenburg. I thought, "It's cartoons, hum," and then I realized that something had given me this idea. If I had done it three years earlier, I wouldn't have understood it.

Chuck: I was thinking about the two paintings that Rauschenberg had made, Factum One and Factum Two. I saw those paintings when he initially showed them, and they looked identical. I was shocked that two abstract expressionist paintings could be the same. Now when you see them—

Roy: —they're not that similar. [Rauschenberg described his thought process by saying: "I painted two paintings, Factum I and Factum II, with the idea that I'd just make them as much alike as I could without measuring. The point was to see what the difference could be between the emotional content of one and the other. I couldn't tell the difference after I painted them!" Lawrence Alloway defined Rauschenberg's intention as that of the "investigation between spontaneity and accident in making a work of art."]

Chuck: They're so far apart that it's surprising we ever thought they looked the same. Not long after that, you did portraits of Ivan Karp and Kaprow, and they were literally the same.

Roy: Yes they were. I used a stencil. I had this idea of doing everybody, but I got bored with the idea. It would have been good, however, to have done a few more.

Chuck: That's the thing. If you had assistants then, you could have done more, but without them we get too bored, and we move on.

Roy: Yeah. I know. I always wonder how much of this I would do without assistants to whom I can say, "Gee, I don't know, let's get rid of the red dots, and we'll put in diagonals." If I had to do it—

Chuck: You'd learn to love those red dots. The art world was so small then. You could see every work by a living artist in half a day. There were about a half-dozen galleries. If you didn't get shown by one of those few, you were finished.

Roy: And practically nobody was shown.

Chuck: I love your early black and white paintings, the economy and the invention of the black and white. Of course, it's perfectly fine to make black and white art. I love the list here [referring to the Guggenheim catalog] of all the things that you made paintings of '61 to '63: twine, Cezanne, coffee cups. It's as if Cezanne is just in there as part of—

Roy: —the inventory.

Chuck: Coffee cups, curtains, electric cords, engagement rings, flower arrangements, golf balls, magnifying glasses, Mondrian, Picasso, refrigerator, roller skates, sneakers, etcetera. George Washington, he's an object. Did you know Picasso's Bather with a Beach Ball? I mean, I love it when catalogs are done later and things like this are juxtaposed with yours. [Girl with Ball, 1961, Museum of Modern Art]

Guest: Do they still run that Pocono ad for Mount Airy Lodge in the Sunday New York Times Travel section? You saw it around for years and years and years.

Roy: They changed the image, but then it came back.

Chuck: [singing] "Beautiful Mount Airy Lodge." I think that your cover for the Whitney's [1978] Art about Art catalog was probably one of the greatest comments on art. I was thinking that the difference between Johns's appropriation of imagery and yours is that Johns picked objects of which there is no specific example. For instance, there is no one flag, or one target, or one map. They are generic

things, so there is tremendous latitude in the number of concentric circles he uses for a target, whether it's black and white, or whether it's something else. Similarly, there are many different kinds of maps, there are many different kinds of flags that had forty-eight or fifty stars, or whatever. You appropriate something specific.

Roy: Maybe. I'm not sure. I never thought of that.

Chuck: Well, this is probably not a good example of it, but I mean that the reason you can't leave off the "s" in compositions in the notebook paintings is that it refers to a specific thing. [Composition I, 1964]

Roy: Yeah, exactly, right.

Chuck: I was wondering whether or not you see yourself as a post-modern artist, having appropriated early and often, or whether you see yourself as tagged onto the end of a long tradition of modernism.

Roy: I guess the idea of post-modernism came after I started. I think my work is post-modern in the sense that I would define modern art as a search for the meaning of art through getting rid of the subject, reducing art to elements that are only art. Modernism is saying that art is only relationships, positions, color positions, or whatever, and that it doesn't need subject matter. Of course, it has subject matter because an Albers doesn't look like a Pollock, and because they have content. I think modernism, and I may be totally wrong, is kind of a search for form. I think art is… isssssssss… I think art is—that's a great way to start a sentence, don't you think? *[laughter]*

Chuck: And we're all sitting on the edge of our seats.

Roy: I don't want to give it away. *[laughter]* It think art entails two kinds of perception: one from which form is made and one that says something new about the nature of perception, or how one sees things. Obviously, Cezanne saw in nature or art a form that was different from the form seen by Watteau. They were seeing nature in different ways. I guess post-modernism deals with things other than a search for form. You may assume form to begin with, but it is searching for something else. Boy, that's a great definition.

Chuck: It seems to me that it's sort of an artificial line: everything before this is modern, everything after is post-modern. In fact, there are clearly many things that happen in a modern era that are attributed to a post-modern spirit. I guess it's clearer when you look at architecture. Post-modern architects can take freely from the past. They can take a porch from one style and—But appropriation seems to be such a big part of the post-modern spirit, as well as a kind of ironic stance with maybe a little cynicism thrown in. Your work had always seemed much more earnest.

Roy: Humor is also a part of post-modernism, even in architecture. Something is meant to be funny in a way, but it also has a function. I think that in order to make the split between modern and post-modern you have to define modern and post-modern, and they are not easy to define.

Chuck: Do you see yourself as a hinge between these two?

Roy: My work is obviously not a search for form, if that is the way you want to define modernism. I don't know if anyone defines it in that way other than me, but that's how I think it's different from post-modernism. I see a progression through history through things, Byzantine, Egyptian, one thing at a time: this is a king, this is a servant, and so forth; the

Renaissance composing collections of things in an attempt to be seen from a single viewpoint. The Renaissance integrated figure with ground. That's meaningful. In Byzantine work, the ground was goldleaf or something; they weren't terribly interested in the ground, it was the figure that was important. When you get to Pollock, you can't really tell the difference between figure and ground.

••••

Chuck: What did it feel like to actually put back into your work a stroke that had identity as "the artist's hand" after all that time? [During the 1980s Lichtenstein introduced gestural brushwork into his paintings in works such as *Laöcoon*, 1988 and *Reflections II*, 1988.]

Roy: Like the good old days. I did like it. I mean, those things are not exactly free because even the brush strokes I do are pretty thought out, but it was nice. Even the surface quality and everything else became interesting—all of the stuff I had been trying not to do—but I thought it would be interesting to show real ones with fake ones.

Chuck: I remember when Malcolm Morley did the South African racetrack painting that he x-ed out. He x-ed out the painting with a great X, a big drippy painterly X. He'd finished the painting, and he found that he couldn't just walk up to it and make the X, so he painted a bunch of Xs on acetate and put them on the painting until he found the one he wanted. Then he gridded it off—

Roy: He's so methodical.

Chuck: —and he painted that X by hand, a little bit at a time, making it look like—

Roy: I thought it was so bold to just take a painting and X it. [*Racetrack, South Africa*, 1970]

Chuck: In these paintings, these late paintings of yours, in which you combine the real brush strokes and the fake brush strokes—how do you keep them from being self-conscious?

Roy: Probably they are totally self-conscious. [*laughter*] I think I even did things like collage brushstrokes on paper to see how the color and the strokes would look.

Bill: Do you have anything to say about Chuck's paintings of you?

Chuck: Well, now that I don't smear people's zits all over the canvas, vanity doesn't enter into the reaction quite as much.

Roy: You weren't trying to capture my age and appearance, which I appreciated. It is amazing how, if you blow something up and look at it, it doesn't look like anything at all, but when you see it from a distance, it's very convincing. The tonality of the whole thing is very beautiful, but you can always go back and add something or other. It's pretty amazing how far your work can be from an image of someone and yet be recognizable. That's not what I love about your painting as painting, but it's an interesting side quality. I think your work is actually completely intuitive. [*Looking at the Pace Gallery catalog*] Is this underpainting something you do first?

Chuck: I paint a sort of fauve painting underneath so I can push the painting from someplace to someplace else. Roy, we'll let you go so you can continue with your day. Thank you very much.

Roy: Great to see you. Thank you. This was fun.

◆

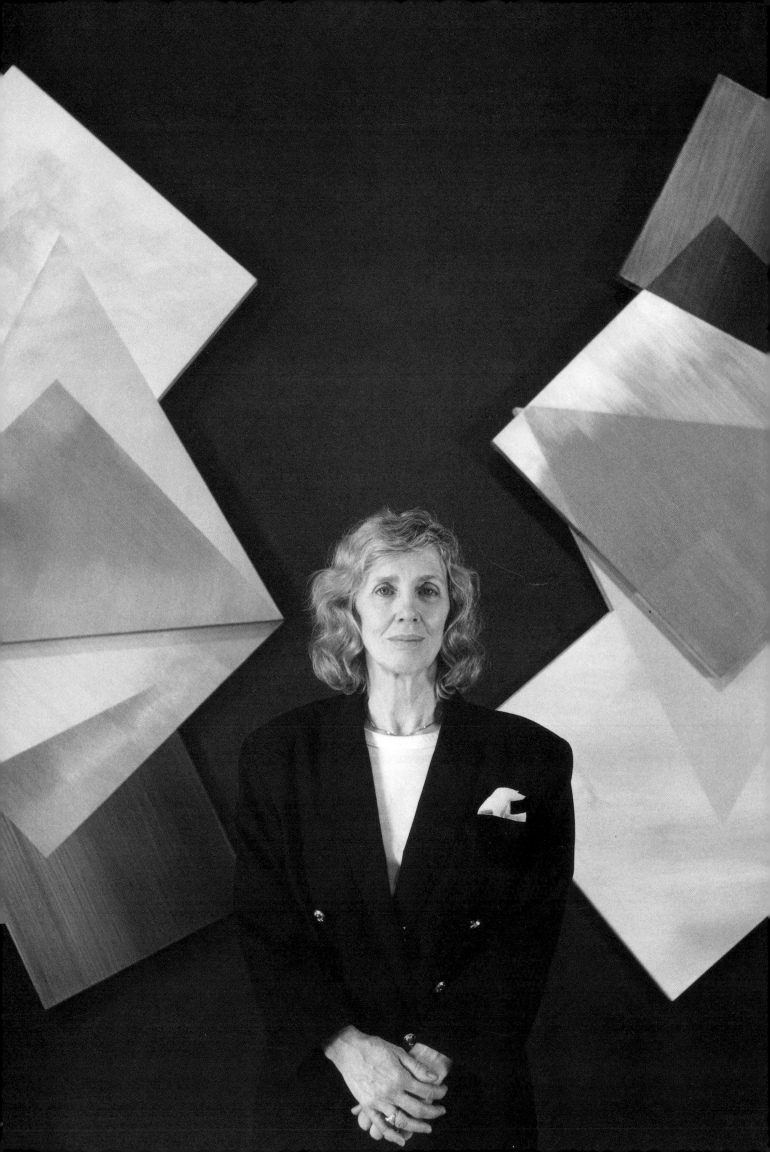

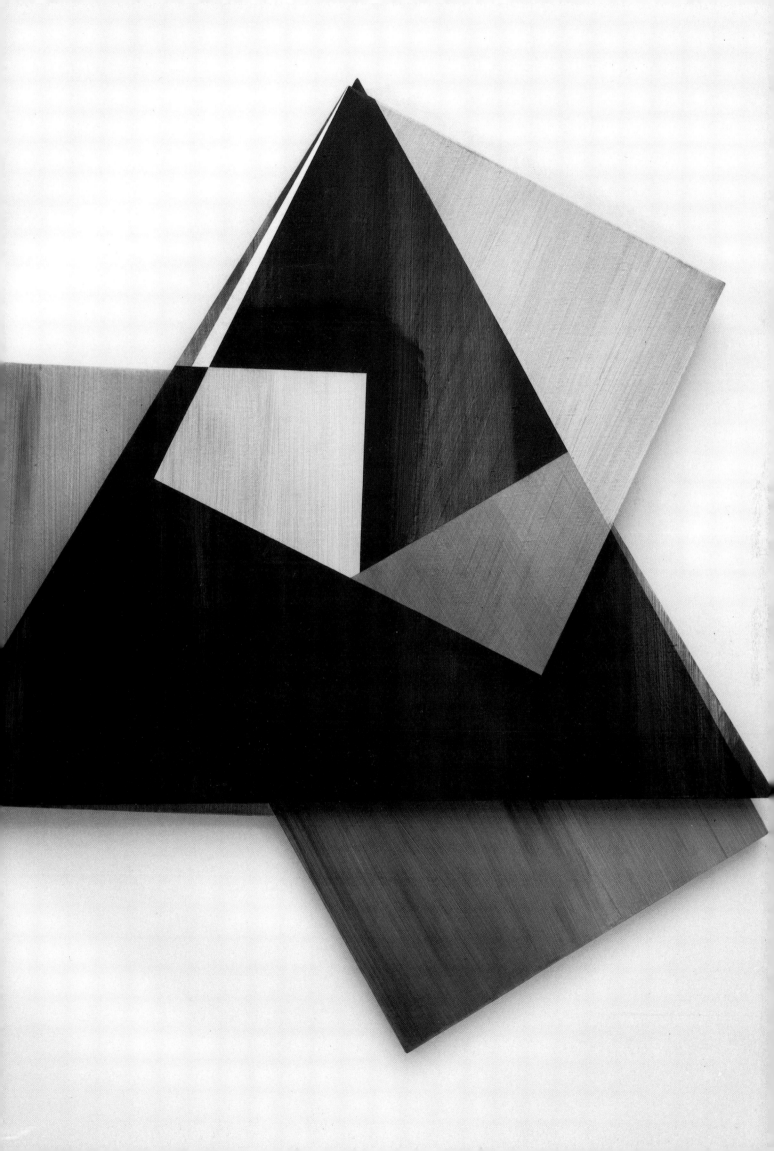

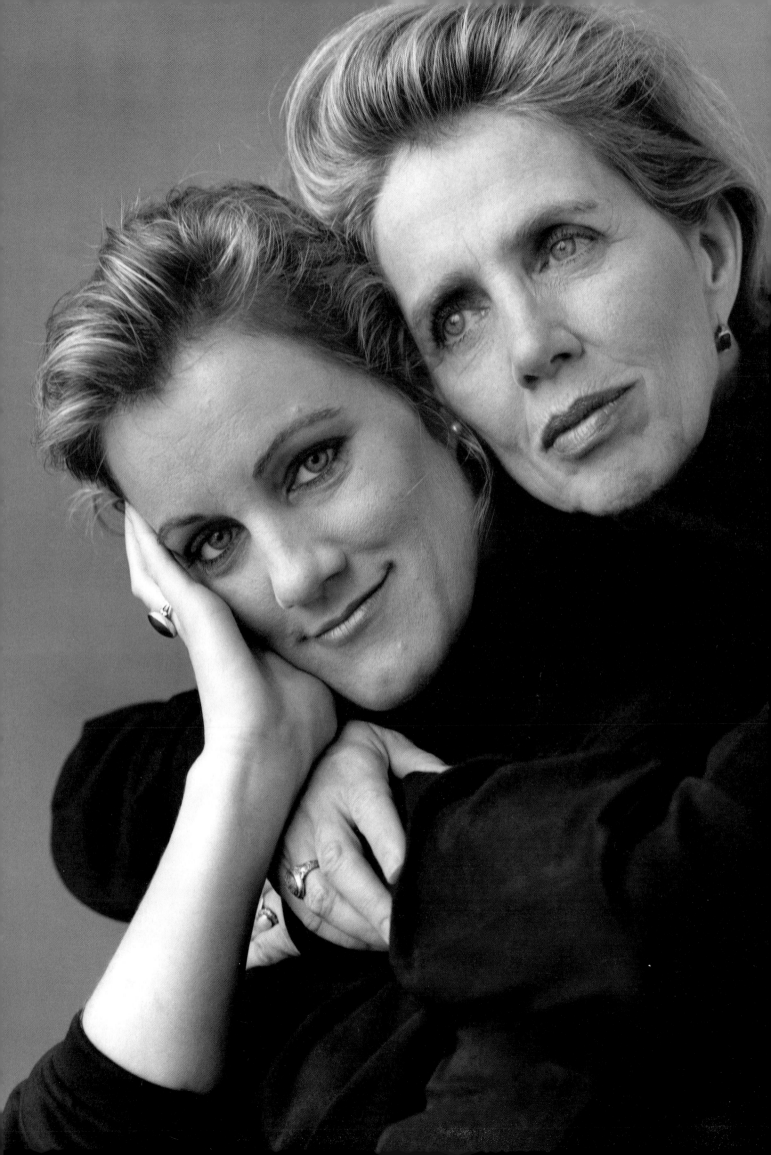

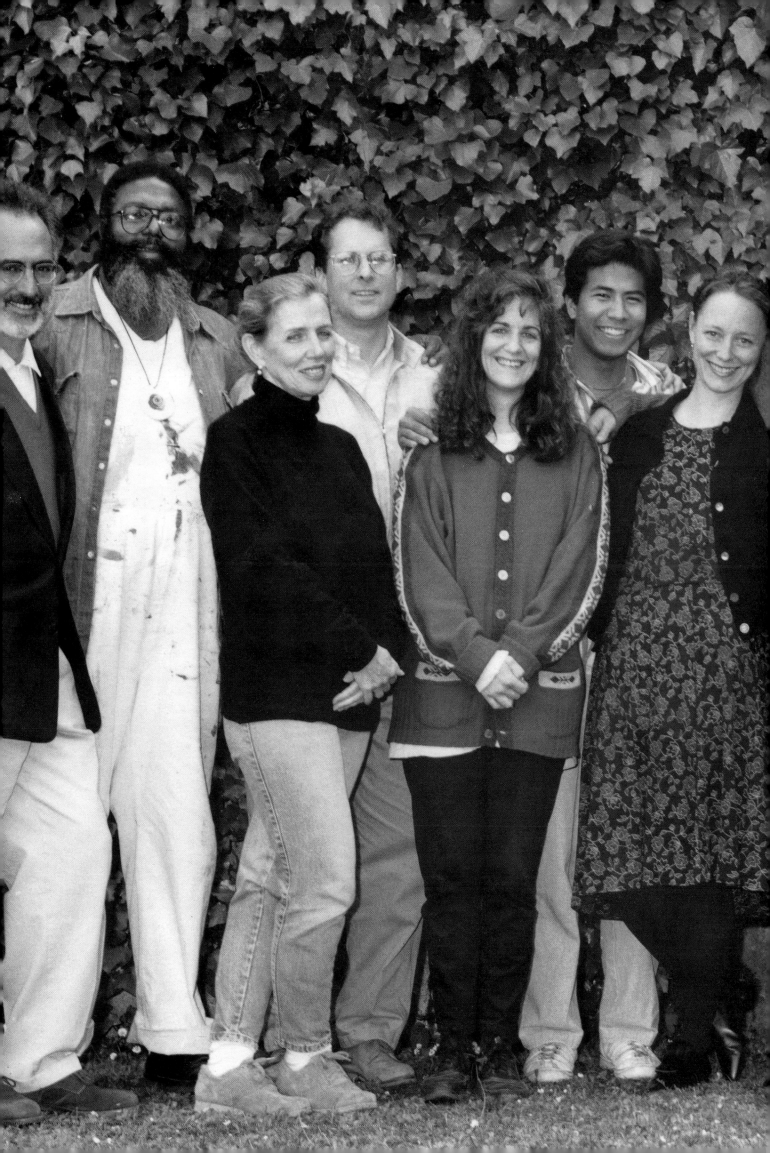

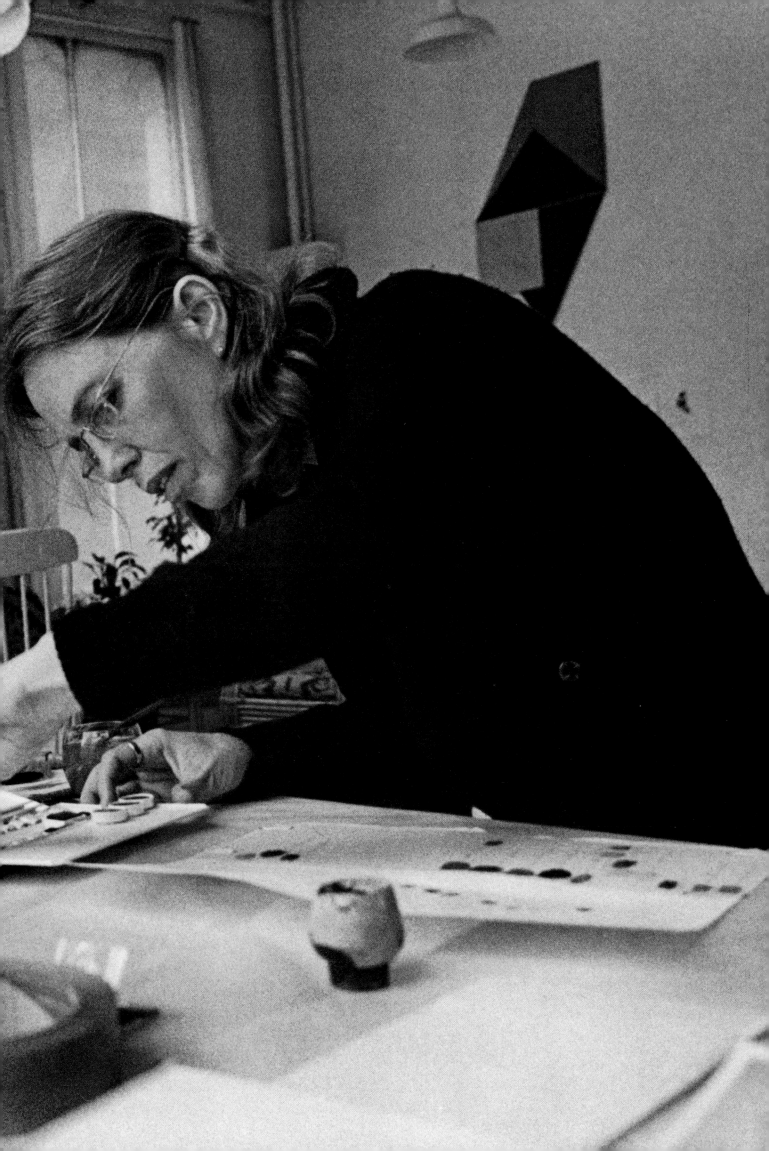

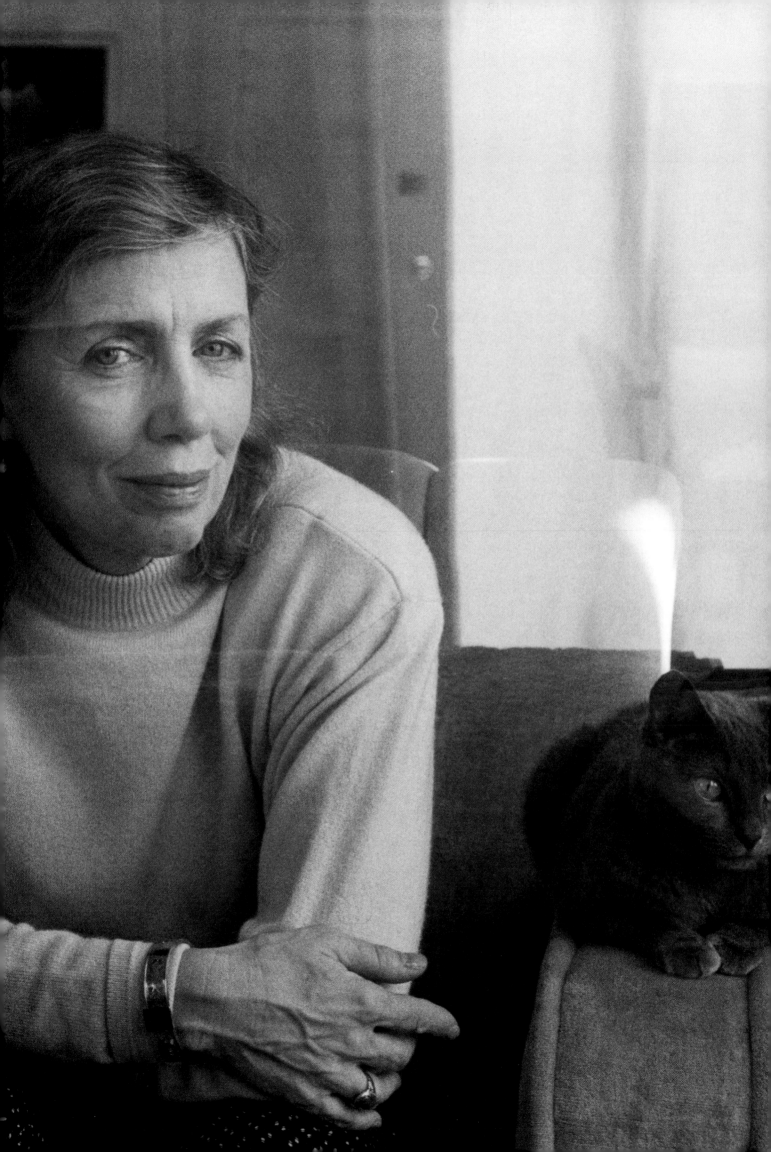

Dorothea Rockburne

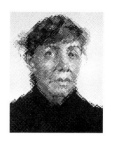

New York City, May 12, 1995

Chuck Close: I guess we've known each other for close to thirty years. We met around 1968 when we were both showing at Bykert Gallery. I know some of the things that happened once you came to New York, and I know that you were born and raised in Montreal. Your bio lists Black Mountain under education, so I thought maybe you could talk a little about what happened to you before you went to Black Mountain. I know about your interest in math and other things. Was art a part of your life early on?

Dorothea Rockburne: Well, I was sick as a child. It was very cold in Montreal. It was twenty degrees below zero during the day, and it got colder at night. If you had a car, which we did, you had to go into the garage, put a gadget on the motor to heat it, and run like hell back into the house. Then you waited half an hour before you could even start the car. It was very cold. I had asthma, which had a tendency to turn into bronchitis and then pneumonia and then double pneumonia. I spent most of the first eight years of my life in and out of bed, which meant that I was very isolated. Chuck and I are both quite dyslexic, and it's amazing that we made this date, isn't it?

Chuck: Yeah, right. We've made lunch appointments that—

Dorothea: I often make two dates for the same time and write them down in different places.

Chuck: We once had a lunch date, and I went to Jerry's. I was sitting in the booth waiting for Dorothea to come, and she didn't come. Finally, she came in with another woman. I thought she had brought along someone else for lunch, but the two of them sat down at another booth. I thought our appointment was for that day, and Dorothea thought it was for another day.

Dorothea: We joined you, didn't we?

Chuck: Yes. Two dyslexics trying to make a date to have lunch. Actually, I was very sickly as a kid, too, so it's something with which I identify. Art is the thing for the housebound.

Dorothea: Everybody I know who is an artist, and everybody I've taught who has had any real potential, had a warped childhood in one way or another. My sister, who is older than I am, was supposed to read to me. Naturally, she hated it, so instead, she taught me to read. This, of course, was a blessing in disguise, one child teaching another, because dyslexics have a difficult time learning to read through the normal channels. So there I was, dyslexic, but reading

by four years of age. I just spent my time in bed reading, and thinking, and trying not to be sick. It defined part of my personality then when I was very young; I'm a complete rebel, but because I'm kind of quiet it doesn't exactly show. When I was a kid, I went to Ecole des Beaux Arts de Montreal on Saturdays. It was academic and concentrated on various older techniques: fresco, egg tempera, silver point drawing, grinding our own pigments. In other words, it was three hundred years behind the times, and I loved it. I was very interested in obeying all the rules and learning. I learned a great deal. However, when I went to the Montreal Museum School, that all changed and I became very rebellious. Arthur Lismer was the director, and he also taught. I know we just love Canadian art history, but there was a group of Canadian artists called the "Group of Seven," and Tom Thompson headed it. He was a not very good latter-day sort of impressionist. Arthur Lismer was part of the "Group of Seven."

Chuck: A kind of Canadian version of American impressionism. American impressionists are bad enough. I can't imagine what a Canadian would do. You don't have a hell of a lot of light up there to deal with, either.

Dorothea: Well, actually, the winter light is beautiful. The moonlight on the snow makes the night bright with light.

Chuck: Oh. But in most northern cultures such as Scandinavia, there's not a lot of color. I mean, there is a lot of light and dark, but not a lot of color.

Dorothea: I don't find much color in American art, either. I think there is a puritan sensibility here, and artists don't use color.

Chuck: When I was growing up in Seattle, the influence of Morris Graves and Mark Tobey and Asian art was strong, and there was that kind of northwest grey mystic sensibility. There's supposed to be no color. I wasn't interested in Asian culture. I was interested in Europe and in New York. I wanted to use color straight out of the tube.

Dorothea: Thank God.

Chuck: Nothing could be more offensive than color to the sensibility that was so ingrained out there. Did you feel that you were working against the grain or that your sensibilities were different?

Dorothea: In a certain way, the Montreal Museum School had more rigid rules than Ecole des Beaux Art because the rules were unspoken. For instance, there was the first time I ever used tar. We were asked to make a big painting, and they expected, you know, Poussin or something like that, which they would have considered radical. I got a mop and some tar and put the tar on paper on the floor and almost got expelled. I also remember taking a drawing class with Arthur Lismer. He told me to use perspective in the drawings. He said that the way I was drawing the figure made the figure look like a map. I was fifteen, and I said, "Yes, I know, that's what I'm trying to do." Having studied perspective in depth at Ecole des Beaux Arts, I was trying to understand flatness in the contemporary sense. I was looking at Picasso. I was looking at Matisse. I was looking at Renaissance art for the first time, because there was some in the Montreal Museum, but the things that they admired were really bland.

Chuck: Was there a corresponding growing interest in things mathematical at that time?

Dorothea: No, my schooling was horrendous. I mean, it was very good academically, but in terms of human things, it was just absolutely horrible. I had a teacher who was a nightmare in, I think, the sixth grade. Everybody was afraid of her. They had corporal punishment and things like that.

Chuck: *Oh, yeah. Boy, did I get beaten.*

Dorothea: Yeah, and this was grade school. She explained some word problems, as they were called. They were really beginning algebra. She walked around and looked over everybody's shoulder to see what they were doing. She stopped at my desk, and I thought, "Oh, hell," and then she said, "Don't tell me there's somebody in this class who gets it," or words to that effect. I just about dropped dead. I remember liking the problems. Once it got into the abstract, I began to understand it.

Chuck: *We have talked many times about the similarities of many of our experiences being dyslexic or learning disabled as kids. Nobody really knew about learning disabilities then; they had never heard the term dyslexia until relatively recently.*

Dorothea: I just learned the term about ten years ago.

Chuck: *We were just pigeonholed as dumb, or shirkers, or whiners, or lazy.*

Dorothea: I didn't get that because I was so rebellious. It was war, and it started very early. Either I faked it, or I actually learned to be very smart. I was almost ostracized for that. My sister and my brother put a sign on my door that said, "Genius at Work." That sort of reputation follows me around. People are a little bit afraid of me because they think I'm so smart, but I'm not. I mean, I know smart people, and I know where I stand in relation to them.

Bill Bartman: *Some of it has to do with your name, Dorothea. It sounds so formal and intimidating. It is really interesting to meet you after talking on the phone two or three times. Chuck's picture is sort of—*

Dorothea: Serious. And I'm actually always cracking up.

Chuck: *I know. I heard that you said you didn't think it looked like you, and I think the reason is that you're usually smiling.*

Dorothea: I don't smile in the mirror.

Chuck: *Even though we talk all the time, and I am never concerned about what I'm going to ask you or what we're going to talk about, the idea of doing something slightly more formal like this taped conversation scares me because of the things that bring you the most pleasure like quantum mechanics.*

Dorothea: I barely know it. But, you're right, I love it. I have to study all the time. I work and work at trying to understand it. In a way, it explains creation, and, to me, it's visual. I know it sounds like a big jump, but quantum physics let me understand Michelangelo's intention in the Sistine Chapel in a way I didn't before.

Chuck: *I always think, "How could you be learning-disabled and get that stuff?" As that teacher said, "Finally, somebody got it," and that the somebody was you is so antithetical to my experiences as a learning-disabled student. I wonder how it manifested itself, whether you were driven to greater strength in the remaining things that you could do because of the deficits in the things that you couldn't do.*

Dorothea: Well, I don't know if you've noticed this about me, Chuck, but socially in groups I can be very uneasy. Have you noticed that? Of course, it depends on the situation and who the people are. At Black Mountain, for instance, there was a kind of boys' club. Most artists, and especially the writers, were all in one kind of group in a way, and I was not a part of their activities. But neither were Bob Rauschenberg and Cy Twombly. Naturally, Bob and Cy and I became fast friends partly because we comprised the total photography class! I'm on several art association boards in New York City and often at board meetings I can't understand the political undercurrents of what is being said in the group. Do you experience that same dynamic in groups?

Chuck: *Yes, I understand what you're saying, except that you were always at Max's sitting there with—*

Dorothea: Ah! Max's Kansas City. That was such an interesting time. The discussions about theory were fascinating, though sometimes volatile. I was informed but very shy. The guys wouldn't let the few women participants talk. They'd interrupt or shout one down. I was at Max's, and I'll tell you why I was at Max's. This was a point in my life when I was completely unhappy. In retrospect, most of my unhappiness was due to the women's issues of the day. This was the late sixties, early seventies. I was the sole support of my daughter, and I was in a relationship. I woke up crying, and I went to bed crying, because I was working so hard and everybody was saying, "Run faster." It was a nightmare. I couldn't understand what was wrong because I kept thinking that by being a better person and doing more, I could make everything right.

Chuck: *Yeah. And you were a single mother raising a child.*

Dorothea: I went to get a physical checkup because I wasn't feeling well, and even though I ate a lot, I kept losing weight. My doctor advised me to go to a therapist. I didn't have any time or money, but he set me up with a therapist who was a genius. I mean, he was great. He told me I had to go to Max's and talk with people when I was there. You know, my former husband had been a motorcycle and car racer, and I had stopped driving because I saw so many people blown up. My therapist made me take driving lessons and drive, and he made me go to Max's. I'd go to my appointment, and our whole session would be about how those guys at Max's were really talking nonsense and didn't know philosophy, how they were using philosophy as a found object without understanding its previous social history. My therapist just kept making me talk. He said, "You've got your assignment for the week. You have to go to Max's Kansas City, and you've got to say at least ten sentences."

Chuck: *Well, talk is good.*

Dorothea: I learned.

Chuck: *You scared the hell out of me.*

Dorothea: I learned to talk. Isn't that interesting?

Chuck: *Yeah. But no one was as intimidating as Smithson.*

Dorothea: I remember having two fights at Max's, and one was with Smithson. The other was with Carl Andre. Smithson was telling me how gallery art was over; that for an artist the days of having a studio were finished.

Chuck: *But all those guys found a way to drag themselves back and put their work in the gallery.*

Dorothea: That's right. That's exactly right. I don't think they meant to be dishonest, but they said one thing, swept away by enthusiasm, and did another.

Chuck: *They went out and dug ditches in the desert, but they were going to haul something back, at least photographic evidence. They all wanted patrons, that's what they were interested in. They didn't want to have collectors as much as they wanted patrons.*

Dorothea: That's correct. And I wanted to make objects at a time when the big thing was not to make objects.

Chuck: *Absolutely.*

Dorothea: I felt that, because of my childhood, a visual, philosophical object had formed inside of me, and unless I got that object out of my head and into the outside world, I would go absolutely crazy. All of my life, in my work, I've been trying to define the nature of the object. To this day I don't know. Mathematicians consider an equation to be an object.

Chuck: *And they consider certain equations more elegant objects.*

Dorothea: Oh, absolutely. I love the terms in higher mathematics: dominant and passive and aggressive. These social values are all applied to the letters within the equation. There are lots of things that I can't understand. I can't read novels because I can't understand what's going on, or maybe I'm just not interested. My mind wanders.

Chuck: *The storyline, right.*

Dorothea: You understand.

Chuck: *Absolutely. I can't remember the names of the characters.*

Dorothea: I can't remember the names. I cannot follow a storyline. I remember playing games as a child, and I couldn't follow the rules because I didn't understand the way in which people were integrating with each other through dumb rules instead of making better rules. They all seemed to have a code, and I was not privy to it.

Chuck: *When somebody says dyslexia, they think it's inverted letters and—*

Dorothea: It's a standard thing with dyslexic people. They can read technical books, and they can't—

Chuck: *But I can't read technical books either. I get all my information through my ears. I don't get anything from reading. I was looking at a book this morning that contained an interview with you, and you were discussing how, early in your life, you got a book on Pascal—*

Dorothea: Right, in grade school.

Chuck: *There is no way I could have understood it. Maybe if Pascal had been in classic comic book form, I might possibly have had some idea what the hell he was talking about. I've literally never read anything like that. I relate to your work in a totally visual, totally formal way, even though I know that there's an inherent underlying system and rigorous underpinnings that I intuit. There must be. I never look at titles. I don't care what anybody names their pieces.*

Dorothea: Titles are important to me in my work; I title things before I paint them. I don't want life to interrupt or any chance that my focus will change within the work that I'm painting. I'm afraid that I'll lose track and therefore lose the work and have to begin again. It happened once, years ago. It was necessary to begin again in order to complete my thinking

process. By titling first, I always know exactly what I'm aiming for. Consequently, I never paint something and title it afterwards. Never.

Chuck: *So, tell me about what happens to someone like you when, at a young age, Pascal comes into their life. What happens?*

Dorothea: Well, the first thing that interested me about Pascal was his philosophy, because I grew up in a Catholic province. I'm not a Catholic, but I grew up with Catholicism all around me. The philosophy of *Les Penses* is interesting and prompted me to read other things by him. He believed that the path to God was through learning and belief, not just blind belief. He thought that doubt was not to be feared but to be welcomed. Good art attitude, right? Eventually, I read a biography of him, and I became even more interested because he was very sick. He died fairly young. I came across a book of his equations somewhere, I think maybe it was at Black Mountain, and suddenly the whole world came alive. I couldn't solve the equations—his equations are really dense—but I could intuit what he was trying to do. I think he was trying to invent a mathematics that would describe creation. And, just on the gossip level, he was very rebellious, incredibly politically rebellious. He had a press that published antipapal and antigovernment tracts. It was a complete printing outfit that he moved every evening, and they could never find him.

Chuck: *You're making it sound so exciting.*

Dorothea: Wait until I get to the end; that was really interesting. He published a book called *The Provincial Letters*; that's the name of one of my paintings, which is hysterically funny. It debates social values. Rob Storr wrote an essay about my Pascal paintings. He's read Pascal and understood what I was after, the rebelliousness. I mean, talk about rebelling. Pascal then became very sick and became very religious. He was involved in a kind of weird Protestantism. I can't remember which branch. He had a belt of spikes around his body so that when he moved, the spikes impaled him. He was found with this belt on him when he died. His sister was part of this Protestantism, and he then joined it. Before this epiphany, he had been a real playboy and, I suspect, a gay man. There's every indication of that. Everything he stood for in the strong part of his life was something that I admired, his ultimate belief in a grand creativity. I'm talking about the way the world, or the universe, is wired in a big sense.

Chuck: *Saul Ostrow called and said that he thinks you are the most spiritual person—*

Dorothea: I hate that word. They only use that word with women. You know, men are strong, women are spiritual. I hate it, even though I was part of the art and spirituality exhibition of Maurice Tuchman.

Chuck: *Don't you think he just means you are interested in the unknown?*

Dorothea: I think it means an interest in things that are not concrete, and they're always assigned to women. When I say I don't know what comprises an object, I mean, who is to say whether air is an object. I don't think that what I'm concerned with is not concrete. One turning point for me was when I went to the American Academy in Rome in 1991. I was always interested in math and art and in somehow fusing them together. When I was there I looked at ancient Roman art and at the Renaissance, and I realized that every artist has always been interested in math and art. No big news there.

Chuck: Right.

Dorothea: When I went to the American Academy in Rome in 1991, I went on all the trips with the scholars. I began to experience time before clocks; the way time was measured. I realized that the Pantheon is a calendar.

Chuck: Right.

Dorothea: I went to a site called Torre di Roccabruna. Close to my name; don't you love it? It is beside the Villa Adriana, but down a privately-owned road. We were there with a picnic dinner at sunset on the day of the summer solstice. This is a Roman astronomy tower with two openings on opposite walls. The light came in from both sides at the moment of sunset. It formed a perfect "X" from sunlight in the center of the room at the moment of sunset with the light going out the opposite openings.

Chuck: Ooohh.

Dorothea: I know. And then I saw a seventeenth-century sky chart and there were things that you could recognize like the sun and the earth and so on, but there was also the path of Pluto, and Pluto wasn't discovered until 1929. The sky chart was a fresco that covered the walls and which was curved at the point where the walls and ceiling met. It just turned me around and, even though you weren't supposed to, I took several photographs of this sky chart when the guard's back was turned. I would show this photo to people who knew more about astronomy than I did and ask, "Isn't this the path of Pluto?" Then, about two years ago, I found out that Pluto had come close to the earth at that time. I belong to a group of "naked eyes astronomers." They're fun. The group is about understanding astronomy in the real sense of the word—the way the universe is recreating itself all the time, what quasars are doing, what the concept of the black hole is about. When I study the movement of the nighttime sky from summer to winter, I can experience an ancient knowledge. The implosion and chaos theories begin to make sense. I think that that is what artists do; they try to understand the nature of creation. By the way, just for the record, I don't believe that the Big Bang, or Big Bangs, started from a speck or from strings. I believe there was a void that folded over on itself. To me, not an astronomer, what remains gives that indication.

Bill: I'm going to send you Jane Roberts's books, because the basic premise of these books is that time isn't really linear.

Dorothea: Time is not linear.

Bill: And Einstein proved it.

Dorothea: Yes.

Bill: And there are people who can't deal with that. Artists have the ability to create a reality that nobody else can see besides—

Dorothea: —or to perceive a reality, not create a reality. It's perception.

Bill:—to perceive a reality that's just as real as what we call reality. Jane Roberts talks a lot about this kind of stuff. You're the only people I've ever heard talk about some of these things. I usually don't even mention some of this stuff because the idea that you live your life with time not being linear just freaks people out.

Chuck: It freaks me out. I can barely live in a world that is linear. One foot in front of the other—

Dorothea: Well, you see Chuck, one of the things that's always so interesting to me about your dyslexia, for instance, is that you integrate with people. You know vast numbers of people. You have vast numbers of friendships that you keep up with.

Chuck: But I think that's because I'm trying to glean information from everyone. Really, I'm interviewing everybody. I don't get information—

Dorothea:—in the normal way.

Chuck: First hand, yes. So I ask, "Hey, what is this? What's going on here? So tell me about this. Show me."

Dorothea: See, for me reading Pascal's equations was such an eye opener, even though I can't just sit down and dash off the answer to his equations. I have a mathematics calculator, I have a lot of shortcuts, but I still can't do his equations. The math language is different from today's. If I don't get it right, I don't care, because I'm not a mathematician, and I don't have to solve it. I just do it sort of for fun. I feel as if I know Einstein, and I don't know the next-door neighbors in my building.

Chuck: Another change that came out of your stay in Rome is working directly on the wall. That's really changed so many aspects of your work, the physicality of the work—

Dorothea: I went to Rome with the explicit idea of not working, because Kahn had gone to the American Academy in Rome for two years and not worked.

Chuck: Louis Kahn?

Dorothea: Yeah. He'd been at the American Academy for two years and hadn't worked. Story has it he just looked at things and lay on his bed, but when he returned to America he was "Louis Kahn." The first time I went to Rome was in 1985 for six weeks. I went with all kinds of deadlines, worked the whole time, and barely saw Rome. The second time I went, I said, "I've been working like hell all my life and I'm not going to work these next four months. I'm going to be a tourist." So I went on many trips with the art historians. The American Academy can obtain permission to go into places where nobody else can go. I had never thought of Rome as a city of painting. It had always seemed to me to be the city of baroque architecture and ancient architecture.

Chuck: And sculpture.

Dorothea: Right, but never a city of painting. Everywhere I went, I saw early "Gorkys," only they were done by the Romans, or the beginning of Picasso on walls that were all pre-Christian or early Christian. Did you go to Nero's Golden House?

Chuck: No.

Dorothea: Nero's Golden House is across from the Coliseum. The dining room was probably fifty feet high and one hundred feet across, and had an octagonal center. While the diners were eating, they were on this octagonal platform that was turning around.

Chuck: Oh my god!

Dorothea: On top of it was a golden ceiling that, at the end of the meal, opened up, and flower petals rained down on the diners.

Chuck: Those guys knew how to live.

Bill: Well, he knew how to live.

Dorothea: It really blew me away. In each of the four corners of the room were nymphaeum, which are waterfalls where nymphs were said to dwell, that cooled the air in the room for the diners. It turns out that, according to the scholars, while he was supposed to live on the Palatine Hill, he burned it down, because he didn't think it was a fitting way for a caesar to live and he wanted to build another house, so he built a huge palace. The Coliseum wasn't there at that time. That area was a marble-lined lake adjacent to his palace. There was something in all of this that told me about what a small—

Chuck: You know they flooded the Coliseum and used it for boat races.

Dorothea: Well, Nero did that; he used the lake for boat races, too. Of course, when he died, nobody wanted to ever think about him again, so it was forgotten for centuries. What was made clear to me, especially having been to Egypt, is the magnificence of the human spirit and how intertwined we are—you know, how intertwined we all are on a—I hate this term—cosmic level. I think I'd like to talk about my interest in music; it's all in this same relationship.

Chuck: Were you interested in music early on?

Dorothea: When I was a child, my parents gave me Mozart's "Eine Kleine Nachtmusik." Mozart helped me to get healthy. From Mozart I learned to breathe. Recently I went to hear a concert by somebody named Krystian Zimmerman. He's Polish and rather young. By that I mean probably forty. I don't mean to jump around, but I'm also very interested in the physicist Richard Feynman.

Chuck: In who?

Dorothea: Richard Feynman, the physicist. He's dead now. He died of cancer, as did most of the Los Alamos physicists who worked on the Manhattan Project. His books are hilarious; he was the person who brought to physics the fact that light moves both by particles and by waves. He aroused my curiosity about wave and particle theory. Sound exists in waves, and Zimmerman's playing allowed me to experience music in a different way. Here was a man, a great pianist, absolutely perfect, and he was playing a very difficult program, and a program that didn't interest me when I read it. He started out with Webern, next to Sibelius my least favorite composer. He began to play and absolutely transformed me through the waves he was transmitting to the audience. He was playing the piano, allowing the sound waves to go completely through his body, to circulate in his body, and vibrate through his hands into the next note. I thought, "Damn, I've never seen that before," and somehow, I understood more about curves by hearing this concert. He then played a very difficult Bach partita. He then played another Bach piece after intermission, and ended with Chopin, the work that contains the funeral march. All of this music is, in a way, so common and yet so uncommon. Maybe I never understood music before, in the same way, and it's the same as making art, of course.

Bill: Even John Cage and other contemporary musicians are very interested in math and mathematical theory.

Dorothea: Mozart, Mozart, Mozart! A lifetime of listening! In 1985 I finished a diptych called *Mozart and Mozart Upside Down and Backwards* with one section consisting of several shaped and joined layered canvases presented in a straightforward way, and the second section consisting of the same shapes and images but upside down and backwards, in every direction, because that's how Mozart worked. I think Mozart was dyslexic because you don't do things upside down and backwards unless you're dyslexic.

Chuck: That's some of my favorite stuff of yours, actually. The first works with which you went public in New York in the late sixties and early seventies were pieces that were incredibly influential. They really extended for a lot of us the notion of process and the real engagement with the physicality of making something. I am thinking of the early oil and paper pieces that you did at Bykert, nailing them to the wall. I remember a funny thing that happened with a piece of yours that came back from an exhibition. It was made of ordinary brown wrapping paper, and they assumed the piece was inside, so they wrote "Dorothea Rockburne, c/o Bykert Gallery" on the outside of your piece. The delivery guy brought it, and it wasn't in a crate, it wasn't packaged, it was just a roll of paper. He handed it to Klaus [Kertess]. How startling it was at that time to see art that was of humble materials and so minimal; how little there was going on, yet how transcendent it really was. Can you talk a little about that work and how it relates to what you're doing today?

Dorothea: When I stopped doing post-student work, I did some work on creased metal. I don't know if you've ever seen that work, but it was a real pain in the neck to do. I had a zillion jobs at once and a kid in school. We lived on Chambers Street, and, naturally, Christine was going to school on 89th Street. Guess who took her and picked her up and all that stuff? I literally lived on four hours of sleep a night and lots of math. That was how I lived and painted. I lived in a walk-up loft, so getting the metal panels up there was difficult, and those panels were painted in heat-activated industrial wrinkle finish. I was trying to think about topology because that's what I was doing in the math, and there was some point at which I was trying to teach Christine new math. Although I had studied set theory at Black Mountain, this gave me a chance to review and rethink it. I had always visualized it. I never expected to be exhibiting my work because women had a hell of a hard time showing, so I ditched the metal panels, which were permanent but cumbersome and expensive to do. I started working with large sheets of paper, rolls really, chipboard, and crude oil.

Chuck: And as a material, certainly at that time, metal panels were kind of macho; there was a macho tonnage sensibility.

Dorothea: Not to this stuff. It was great. It's called pig iron, and it is very thin. It wasn't macho at all. But then I started working with materials from the hardware store across the street, the crude oil and brown paper work that you're referring to. Later I did get other paper that would hold up better. I think it was Bee paper, which is an art paper company. I was constantly trying to define for myself what an object is and how it exists. I'd go into a gallery and there would be all of these individual artworks by the same artist, and I couldn't understand— perhaps the dyslexia, I don't know—I couldn't understand why these objects were separated—this was before artists were working in series. They all seemed to be the same object in

a way, but separated and spread out. One of the first wall works that I did in 1970 or so was *Set*. It has a plus sign on the wall in graphite between the two paper sections, and everyone thought it was a cross. It wasn't, it was a plus sign. It was saying, "This plus this makes one object," with different parts to the object. I feel now as I did then. Part of the reason I glaze instead of mixing paint is that for me art exists in a series of different tensile sheets, a series of one sheet on top of another, or sheets that interpenetrate each other. With crude oil and linseed oil, staining was a way of interpenetrating, making a liquid sheet that penetrated another physical sheet or remained as a sheet itself, as in a pool of oil. I was beginning to try to understand the equation for general relativity. It took a long time, and there was no one I could talk to about it. It was just me and the books. I finally understood it when computers came in and someone showed me the program.

Chuck: *You just wouldn't give up until you figured it out.*

Dorothea: Exactly. I'm totally persistent. One of the ways in which I rebel is with this dogged persistence. Somewhere along the line, I think it was 1975, the window on set theory closed. It wasn't in any of the math magazines to which I subscribed. I couldn't find it anywhere. I haunted the Strand Bookstore for new copies of math books that might come in—mathematicians brought in review copies and sold the. You can still get the best math books there. Barnes and Noble and other shops didn't carry them. There was no set theory anywhere, and I realized it was because nobody could do it. After a point, no one could do the number crunching. Even though computers existed, you had to buy computer time, and so it just closed. At this point, I had wandered around Europe a lot, and I felt that I wanted to go back to my Ecole des Beaux Arts origins. I became very involved in mannerism, looking at mannerist art in Europe, particularly in Florence. I was visiting Florence frequently at this time since I exhibited there. I began to use the topological geometric shapes that had formed the *Golden Section* paintings. These paintings are a continuous piece of canvas that, while maintaining it's integrity as a whole, is cut and folded and glued to form specific geometric configurations following topological principals. Once glued, they were hung on the wall with Velcro that was applied to the wall and to the back of the painting. Paintings hung in this way almost become part of the wall because the shapes tend to integrate the wall into the work—kind of a forerunner of my work now. Around 1982, I had stretchers made in the golden section shapes, and I began to stretch the canvas using the same previous shapes but painting the canvases in a rather classical way using gold leaf and glazing techniques and layering the shaped canvases. I was trying then, as I am now, to bring tradition to the point of paradox, as the Mannerists had done. I was trying to be completely rebellious, I think, in my way. German neo-expressionism was riding high, so I had to go in exactly the opposite direction.

Chuck: *There's a perverse strain that runs through all of us.*

Dorothea: Yes, that's certainly true. A little bit later I came across the Mandelbrot equation for chaos. He discovered it in 1981. I didn't find it until somewhere around 1989 or 1990 when it began to be published. I didn't know what to do with it because it was clear to me that if you followed it, if you graphed it into what then was becoming fractal information, it looked

like tie-dye, which did not interest me at all. Fractals didn't interest me per se. I thought about it for a long time, and then I went to Rome and realized that Mandelbrot was also dealing with a facet of the concept of the nature of creation, and this could probably also be applied to the way the planets were formed and exist, stars, and certainly the electromagnetic field, which was beginning to interest me a great deal since that is what scientists at the time were trying to plumb it in terms of gravity. I began to take a lot of license with the Mandelbrot equation. Instead of working the equation the normal way, I exchanged the letters directly into designated curves. I then created energy centers by allowing the beautiful quality of light that the Lasceau paint permits to enter illuminated areas designated as circles that in turn became the originating focus of the various curves. The equation was worked in the space with large curves.

Chuck: So, how do you feel about the time in the late sixties when everybody was driven to purge their work of everybody else's? People tried to get a material that nobody else would use and one that wouldn't have historical baggage that the viewer would bring to looking at something. It really didn't matter what particular corner you backed yourself into, you were just going to be alone there.

Dorothea: I still feel that way. Not backed into a corner, far from it, but alone in what I'm doing, but not unappreciated.

Chuck: It wasn't necessary that all footnotes be in place to understand work, because I think what we were looking for was a way to get to a point where we could function intuitively without simply demonstrating what it was we were trying to do as a kind of illustration of a principle or illustration of what a material would do. Most people are not going to come to your work with a knowledge of set theory.

Dorothea: They shouldn't. You don't have to know the chemical content of water to swim in it.

Chuck: I don't find it necessary. There's an internal logic into which you buy as a kind of leap of faith—"Yes, this must be operating here"—but I never found it particularly necessary.

Dorothea: I do sit all summer long and do equations for the hell of it. I mean, it is exciting.

Chuck: People get turned off to math because arithmetic is nuts and bolts, and most of us break down right there. We never get to the creative part of math, which operates in another hemisphere of the brain. For those of us who operate almost entirely in that other hemisphere, it's nice to know that you don't have to. I mean, they always said that Einstein couldn't balance his checkbook. The actual nuts and bolts of arithmetic were uninteresting to him.

Dorothea: His mind wandered. Mine does, too. I'm amazed at the mistakes that I make in balancing my own checkbook, and I don't care. But, as you know, when you're doing higher mathematics, you don't have to be accurate. Accuracy isn't part of it; it's the general flow. If you don't know what to do with a certain aspect of an equation that looks good but that you can't use, you bracket it, and maybe you'll pull it in later. All that kind of stuff is so exciting. There was a certain point in the late seventies when I decided to work with curves. Do you remember the *Vellum Curve* drawings? The thing that motivated me was a geometry book dating from around 1920, written by the Indian mathematician T.E. Rowe. Somebody gave me a copy of it because it does algebra through folding, and I was folding a lot. It includes the "Witch of

Agnesi," which was the last curve ever invented algebraically. The fact that it was called the "Witch of Agnesi" and was invented by a woman motivated me to try to learn this aspect of geometry, which I didn't know. A friend volunteered as a math tutor for six months, because I wanted to be the next woman to invent a curve. On a realistic level, I knew that I could never do it, but on a fun, art, love level, I wanted the journey. It was great.

Chuck: *A witch in waiting, right?*

Dorothea: A witch in waiting, exactly.

Chuck: *Sitting here listening to you made me think that there's theoretical math, and there's practical math. I'm just guessing, but I bet the first ships were made by people who just wanted to get from here to there through the water. Then they discovered that certain ships with certain shapes move through the water better than others. Somewhere along the line, they said, "Um, we could make the curve this way and it will cut through the water better, keep the ship higher out of the water," and somehow that evolved into the standard ship curves. But it would seem to be—correct me if I'm wrong—that when theory follows practice, in a sense you're being pushed somewhere rather like banging around in a dark room until you hit a wall, and then banging around until you hit another wall. There's a real reason why those shapes evolved. It's because boats are supposed to be doing something that keeps them from being arbitrary. I'm trying to say there's a kind of intuit authenticity about your work, as well, because it's not decorative, it's not just making a curve that your arm wants to make because your arm is so long and attached at the shoulder and it is the easiest curve for your arm to make, but a very specific curve that you needed to make, even if it wasn't the most natural thing. People look at my paintings, and they begin to intuit that there's a system, then they want me to define the system, but I can't because the system is only there for me to function within.*

Dorothea: I don't know about you, but I adjust everything along the way. I'm not following any rules. People want rules, but I don't have any rules. I follow the logic of discovery.

Chuck: *So structure exists to be negated.*

Dorothea: Or to be improved upon, or challenged.

Chuck: *Speaking of doing shows at which we know nothing's going to sell, let's talk about Bykert.*

Dorothea: When I did those installation shows on set theory, I expected the work to go up on the walls and go in the garbage afterward since the work consisted of rolls of paper interacting to form an idea. No one bought work anyway, and I loved the experience of walking into the Bykert Gallery and being surrounded by my ideas, of seeing thought made visual.

Chuck: *The fight Klaus constantly had with himself was that he didn't want to be a merchant; he wanted to be a talent scout. He got bored the minute anything sold. Ultimately, and perhaps ironically, he got out of the gallery business just as the gallery was becoming successful.*

Dorothea: Klaus was great and so was Bykert, even with all its faults. I did a show called the *Domain of the Variable* in which chip board was painted white on one side with the same paint as the wall paint. A line was drawn along the wall and the chip board was, in some instances, glued with a beige contact cement to the wall and then ripped down so that the wall transferred to the board and the board was fragmentally still glued to the wall, and both the

line and the board and part of the wall lay on the floor. It ripped half the wall out! That work also employed thick transparent cup grease which had an odor and was partially smeared on the wall. As the work went up, Klaus never said a word. He was wonderful.

Chuck: We could talk about the problems of being a woman artist. Were you involved in the early seventies when the first women's movement hit like a ton of bricks in the art world?

Dorothea: I benefited from it, but I am a truly unpolitical person. I'm a philosophical person, and it was very much a political movement that was defined by actions and activations. I once was a part of a consciousness-raising group.

Chuck: That's what I was going to ask. Was this one that Leslie went to a couple of times? Was it SoHo-based?

Dorothea: No, I don't think Leslie was in it. Lucy Lippard was part of it. So was Betsy Baker and Alanna Heiss. It didn't last very long. We met perhaps eight times and that was that. There was some need to communicate the difficulties that we were having simply on the basis of being women. It wasn't the way I'd heard other groups described: "Why doesn't he take down the garbage or do the dishes?" or whatever. We didn't discuss that.

Chuck: We were just talking the other night with some people who also went through one of those experiences. I think it probably had much more of an effect on men at the time than on women. I think men were the ultimate beneficiaries of the women's movement in many ways.

Dorothea: You're one of the few men who thinks that way. I realize now in retrospect that one of the differences between our little group and what I had heard from other people was that we hardly ever met. I was working, working, working. I mean, I barely had time to sleep, let alone go to a group, so I never went. Maybe I was a snob. I was never interested in the problems. Those were not the problems I was living. But the thing that this group was talking about—if they were talking about anything—was that they had all hit the glass ceiling. Now I realize, as a woman, just exactly what the glass ceiling is. And it's there.

Chuck: You bet.

Dorothea: And it's in spades. And it's awful.

Chuck: I know that for someone of her reputation, even with a woman dealer, Elizabeth Murray's work sells for a fraction of that of any man in that gallery.

Dorothea: That's the way the glass ceiling works. I think Elizabeth is a wonderful artist. I love her work. It's just terrific. But that's one way it works. Another way it works is that there is a certain correlation between how new and how attractive you are. Lynda Benglis is another artist who has been totally rebellious in her work all the way along, who dared to try to make work that was beautiful at a time when people were only using the ugly aesthetic, who has been an influence on other artists, and who has been completely ignored as far as I can tell.

Chuck: Absolutely.

Dorothea: If she were a man, she would be in a completely different place, she and Elizabeth Murray. Elizabeth had a retrospective at the Whitney, but by now, she certainly should've had one at the Modern and be known in Europe, which she isn't, as should I. I haven't even had a retrospective at the Whitney; I don't mean that it's a lesser museum, but usually an artist can start

there first or the Guggenheim, and then go on. I've been completely ignored. It hurts, and it makes me angry. It's my life's work and my passion. I've walked through fire to do it, and it's deserving.

Chuck: Aside from the politics of the glass ceiling and those very real problems and the lack of attention, what do you think the up side of being a woman artist can be?

Dorothea: That's hard to define. In a certain way, I think that's a very difficult question.

Chuck: Aside from the difficulties of women in our culture, women in the art culture, what do you think being a woman has brought to your work?

Dorothea: The difficulty is that we want to be recognized. I want recognition for what I'm doing because that's the only way I can share it with other people. One of the real troublesome areas is with critics. We want criticism, good criticism. Look at my work and criticize it. Often critics do not pick up the sexuality in my work, because the vernacular of criticism is often geared towards male sexuality and nineteenth-century values of heroism, or they're trying to deal with my work in terms of mathematics and physics, which is no way to deal with it anyway. That gets into linear thinking. Deal with my brains, okay, but deal with my brand of heroism too, please. Not all, by any means, but most critics don't get it, they do not get it. It's in your portrait, though. I see it in the portrait that you did. I can't recognize my own face, but I recognize a certain womanly way that I am that's in that picture.

Bill: I was a little frightened about meeting you based on your portrait and our phone conversations, because you were so rushed.

Dorothea: The story of my life is sort of hell right now.

Bill: My life is like that, too. I was intimidated by the portrait in a way that I've never been intimidated by your work. Judy Pfaff said the other day that once someone has written something about you, whether it's saying that your work relates to math or anything else, you can't ever get rid of it unless you change 180 degrees.

Dorothea: No.

Bill: Judy said that basically critics always write about how colorful and cheery and happy her work is. She would react against it and do very dark pieces that had no color in them at all, and they still wrote about it that way.

Dorothea: But that is such a misunderstanding.

Chuck: Maybe other artists look at work differently because they've had that shared experience of also having been around. The fraternity of shared experience makes more possible than it does for critics or—

Dorothea: I find that to be true. You know, your painting of Lucas affected me deeply. That painting contains a sensuality that would not generally be interpreted that way. I mean, critically it wouldn't be talked about in that way, but to me, it's really there in fullness.

Chuck: I have this problem of people writing about my work prior to my being in the hospital and after my being in the hospital as being two totally separate bodies of work, and not being able to see the common threads.

Dorothea: I know. When you first showed the portrait of Elizabeth at the Museum of Modern Art, I remember thinking, "What do I think of it?" Didn't I think this and didn't I feel

that? It had to do with that divide, and it quite frankly surprised me, because the strokes were different—the doughnuts. I had to search for the continuity, but then—Bingo!—your intention resonated. I loved it.

Dorothea: To go back to the mathematics tutor friend who was helping me with curves, I was doing homework every night and all day Saturday and Sunday, and I cut out my social life from January to June. At the end of the time, I threw the whole thing out and only saw the solution to perhaps finding a new curve in terms of a physical material approach. I bought vellum and drew the golden section. Picture the transparent vellum in an open form, a square joined to the golden section rectangle, which in turn makes a very long rectangle, which is then divided horizontally, vertically, and diagonally. I drew a circle in colored pencil five-eighths of an inch wide in the square and an ellipse in the rectangle. The vellum was then cut and folded and glued so that various curve configurations occurred through the transparent layers of the vellum. I'm convinced that the golden section, the golden mean, plays a part in everything. Did you know that the universe has an up and down and that it has a shape? That shape is not perceivable yet because even with Hubble we can't see far enough. I'm convinced that the shape of the universe is based on the golden section. The *Vellum Curve* drawings are golden section. I did it topologically, and I never did invent a new curve. It was a continuation of the invention of shapes from the *Golden Section* paintings, or let me say, discovery, because the reason my work has been varied is that it's a process of discovery and learning.

Bill: You're trying to solve a problem.

Dorothea: Teaching myself, I'm teaching myself all the time. Richard Feynman called himself an explorer. So am I, reaching for a new continent of experience, standing on the edge of the next knowledge.

Bill: You're trying to solve a problem to which there is no answer.

◆

Truth was asked that she display her breasts to confirm her sex during a meeting that she might have been a man masquerading as a woman.

SHE SAW HIM DISAPPEAR
THEY ASKED HER T
ONLY TO DISCO

Y THE RIVER.
TELL WHAT HAPPENED,
NT HER MEMORY.

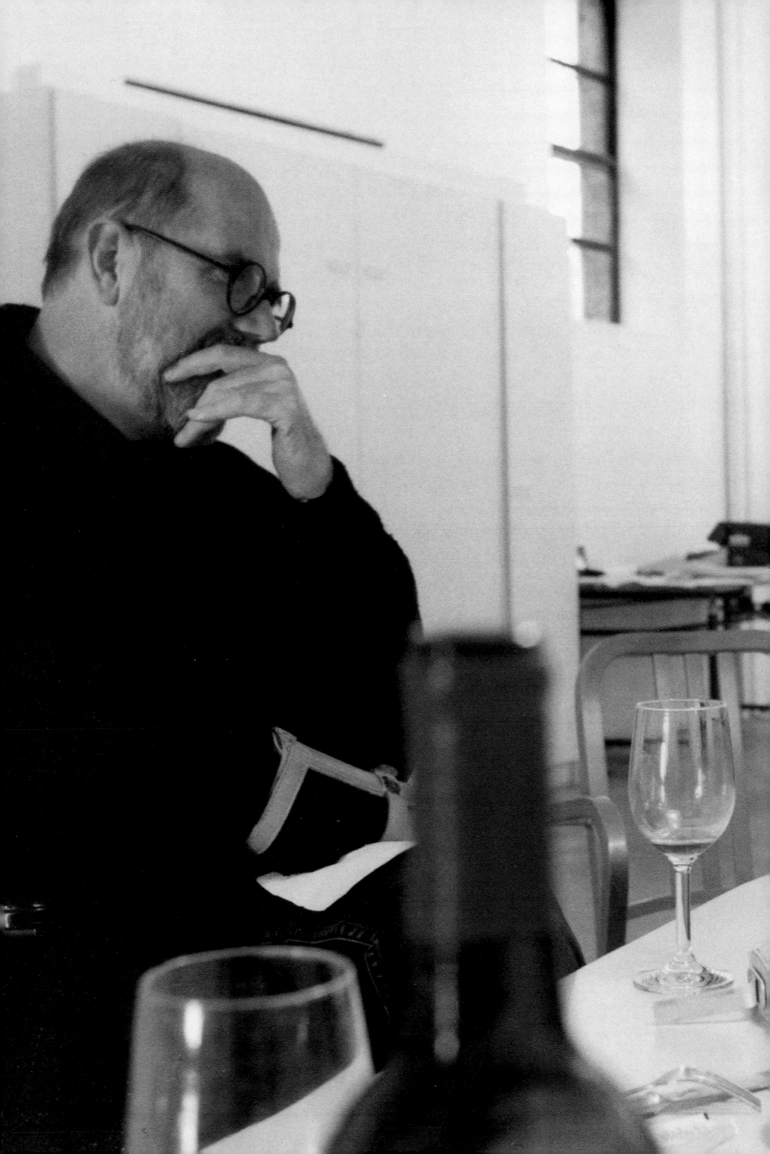

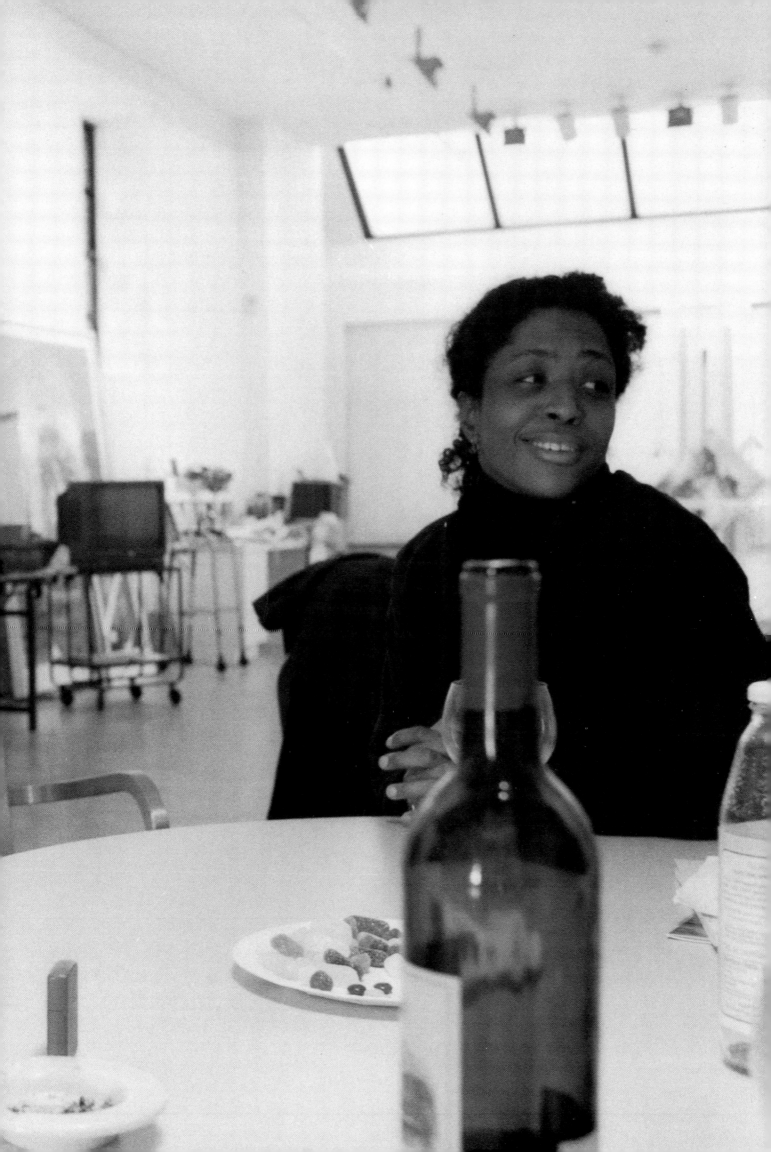

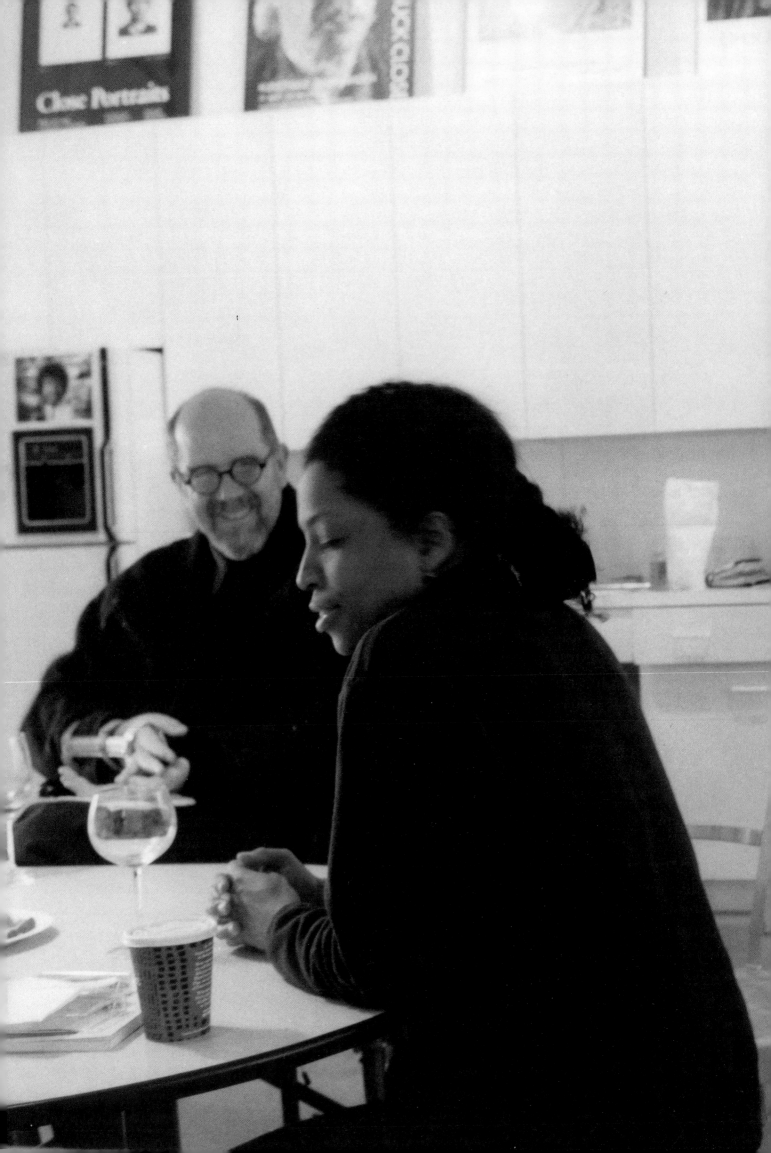

Lorna Simpson

New York City, December 12, 1995

Chuck Close: **The idea of this book is to interview the subjects of my paintings, some of whom I've known for thirty years or more, and others, like you, who I haven't known for very long. Ideally, during these conversations, we just forget that all of this recording is going on and pretend that we are just having lunch together.**

Lorna Simpson: **Oh, I don't get lunch?**

Chuck: **You get lunch.** *[laughter]* **Anyway, we're on and we're rolling. I think I've seen most of your shows in New York: the Philip Morris Whitney one, the Modern one, the black male show, the Whitney Biennial, and your gallery shows. The reason that I wanted to paint you, besides the fact that I have found you really interesting and charming and wonderful when we've juried shows and done other things together, was that your work really speaks to me, and in a way that I wouldn't necessarily have expected as a white man. You may have noticed that I'm a white man.** [*Standing in the Water*, The Whitney Museum of American Art at Philip Morris, NY, 1994; *Lorna Simpson: Projects 23*, Museum of Modern Art, NY, 1990; *Black Male: Representations of Masculinity in Contemporary Art*, Whitney Museum of American Art, NY, 1994; 1991 *Biennial Exhibition*, Whitney Museum of American Art, NY, 1991.]

Lorna: **No, I didn't notice.** *[laughter]*

Chuck: **I feel as if I have to speak for my race and my sex whenever I talk. I find it interesting that I sometimes feel excluded by so much of the art that is gender-based or race-based. One of the things that I think is so wonderful about your work is the way in which I relate to it. You just put it out, you make it available, you don't proselytize.**

Lorna: **Well, in some ways, the way that I try to fashion the work is to leave it open. Since so much of it is about the construction of identity or the construction of race and sexuality and gender, it has to be left open in terms of the viewer, because I don't want to put any parameters on what those things are, or suggest how they should be for a person. It's more about construction. Therefore, when people come to the work, there is, or there should be, a certain openness about it.**

Chuck: **Yeah. I read one quote where you said that you weren't interested in black and white, you were interested in grey. It is an interesting idea that halfway between black and white is grey, but we're not a society that's very interested in grey right now—**

preceding pages:

Wigs (detail), 1994, installation of fifty waterless lithographs on felt, 98 × 265 feet overall. Photo courtesy Sean Kelly Gallery, New York.

Waterbearer, 1986, gelatin silver print and plastic letters, 41¾ × 2¼ inches. Photo courtesy Sean Kelley Gallery, New York.

In Chuck Close's studio, 1995. Photos: Leslie Ernst.

Lorna: True.

Chuck: —or in finding commonality or shared experience in our humanness, or whatever it is that we are about.

Lorna: Well, I think that we live in a world that is filled with all sorts of racist, sexist, homophobic constructions, societal constructions, which people feel the need to live by. I wish I could say that it was a more generous and more open place to live, but at the same time there is a lot of polarization between groups, and everyone protects their own particular territory at the expense of the greater whole.

Chuck: I think it is the generosity and the openness of your work that attracts me. You really make it available to everybody.

Bill Bartman: I find most work, whether it's Jewish work, or black work, or Indian work, or whatever, to be so exclusive, so exclusionary. When I worked in theater it was like that too. When you did a play about a particular subject, you already agreed with its premise. You never invited people in to have a discussion, but that to me is the most important thing about art.

Chuck: Then there is the assumption of the work. Why should we assume that everybody should see the earth in the white European male way? Yet that's the normal way that everything else is looked at.

Bill: I think artists who are really good strive to make something that has some universal qualities in it that allow people to interpret it in any way.

Lorna: Well, I think that there are many assumptions and expectations as to what is "ethnically specific" as opposed to what is "universal." It all depends on where you've been, or where you come from. At the same time, the art world has a very convenient way of cubbyholing artists, particularly artists of color. In terms of what the work is about, sure there are aspects of it that have universal qualities. In terms of my own work, while some of the subject matter is very particular to an experience of either an African American female or male, at the same time a lot of the things that go on do speak about the nature of memory, constructions of language, and narrative.

Chuck: Absolutely.

Lorna: They are about living in America.

Chuck: It must be an incredible burden to feel as if you must speak for your—

Lorna: Having my voice in my work is a privilege. Making art is kind of a privileged activity, but through it I speak only for myself.

Chuck: But no one likes to be pigeon-holed. I don't like to be pigeon-holed as a photo-realist for god's sake, and that's a lot worse than—[laughter] Your work is also very formal. Is there a part of you that just wishes you could make the decisions totally on formal grounds?

Lorna: No, I've never desired that. In terms of process, I like having several layers of engaging how the viewer is going to perceive the work. I'm seduced by imagery, kind of photographic imagery, and that's why I have a tendency to work in that area. I like playing with the notion of photography or representation.

Chuck: So much art has been about the body, and you gave us the body in a very different way from some of the other artists. First of all, you turned your back to the world, and then you had stand-

ins like shoes and wigs, and now they're really absent all together, which is pretty interesting. Do you want to talk about that a little bit?

Lorna: In the work where the figure's face is not revealed, it is meant to engage a desire or expectation that the viewer may have in regard to a portrait, that reveals the face and an entry to be able to "read" a psychological state of the person portrayed. I then replaced that physical information with text. A few years later, I used surrogates for the body and then worked without the figure entirely, but this shift came after seeing a survey of my work at the Museum of Contemporary Art in Chicago. It provided me with a very methodological view of how I went from one thing to the next, and I realized, in terms of process, that I could not work in that manner anymore.

Chuck: It's scary to see your work pass before your eyes like that.

Lorna: I felt that I had explored many areas. I felt that artistically I needed to break a certain kind of formulaic way of working and invent another one, one that actually was a formula of exclusion: no more figures, maybe no more text for a while. That kind of got me to the work that I'm doing now.

Chuck: I've always thought that one moves forward more in one's work by choosing not to do something than by choosing to do something.

Lorna: Yeah.

Chuck: It is in that way that Ad Reinhardt was such an important person to me. Even though my work is not like his, he made the choice not to do something a positive decision.

Lorna: Which is hard, but it's good to be nervous.

Chuck: Oh yeah, but when you give up things that you do well, or things that you like to do, or things that people have identified with your work, and you go out there and do something else, that can really be scary.

Lorna: It makes me more nervous, in terms of my relationship to the work, when I know that it is time to figure out different ways of working. In terms of the audience, I think they are a secondary thought. I would show my work to someone, and they'd say, "Wow, this is much different," and I'd say, "Yeah, no kidding."

Chuck: You started off as a photography student at the School of Visual Arts. I used to teach in the photography department there.

Lorna: Really?

Chuck: Well, I started teaching there in '67. It was the only time I ever taught photography students rather than painting students.

Lorna: Did you hate them?

Chuck: No, they were really very interesting kids. They were all grappling with commercial work versus "fine art" photography, whether they wanted to take photographs, or how they were going to survive. Painters cannot survive by making paintings in a commercial way but most photographers can. I read somewhere that you became really disenchanted about the so-called—

Lorna: —the documentary.

Chuck: —truth of photography, its uses, and how it's been misused.

Lorna: I went to undergraduate school at a moment in the late seventies when, in New York, in terms of education, the California school of conceptual art was completely left out of the curriculum. I was kind of coming into my own, thinking, "This doesn't make any sense," and as I became more interested in film and taking film courses at Visual Arts, I began looking at Jean-Luc Godard and looking at underground documentary films out of the sixties. There were conversations about critiquing, uses of imagery, and construction of film, which was not present in the photography classes. Film class was the only environment where conversations were taking place about the structure of things and how a medium that we take for granted is put together and interpreted. [Godard (b. 1930) was raised in Paris and studied ethnology at the Sorbonne. Godard is one of the most influential figures from the "New Wave" cinema of the 1960s. In his film Breathless (1959), he experimented with narrative structure and combined elements from various genres—detective, suspense, and comedic. He was one of the first directors to make films that referenced other films.]

Chuck: *Well, photo documentation in the sixties was really a startling use of photography. All of a sudden there was another way for photography to exist in art, different from any way in which it had been used before. Art made out of the studio, earthworks, etcetera, wouldn't be seen unless people went out and dug in the desert, came back, and sold the photographs in a gallery. I guess in one of these pieces, they were talking about—I don't know if you said this or somebody else did—the way black women had been portrayed in National Geographic.*

Lorna: I think it was actually from a catalog, *For the Sake of the Viewer.* There are essays by Beryl Wright and Saidiya Hartman. Hartman compares the way that I engage portraiture by not giving up the identity of the subject and by shifting the viewer's gaze as a response to ethnographic photography's relationship to the viewer's gaze and the racist implications that are imposed on the sitter. The function of my work was that the photograph not reveal anything specific about the identity of the person before you, except your own ideas or assumptions about this concealed identity.

Chuck: *In some of the photographs the models are wearing a kind of white gown-dress thing, whatever that is, which is really very nondescript and very hard to read, but in various reviews people have called it a hospital gown.*

Lorna: Right, or a slip, *[laughter]* or a nightgown.

Chuck: *All of those things have other associations that aren't really there.*

Lorna: Yeah, it has to do with the gesture or the way the model is posed. Dressing the figure in feminine clothes was a funny place to start. I don't know what year it was, but maybe five or seven years later, I decided to make the figure more androgynous. Playing on my own work, rather than having the figure with this little neckline, it wore more tailored men's suits, but it was almost in the same poses. Because of the clothing and the gesture, the viewer didn't know whether the figure was male or female. It's a funny thing to, at a certain point, play on my own work or the use of feminine clothing.

Chuck: *Not only do you turn your body away from the camera, but you turn—*

Lorna: It's not me, it's not me!

Chuck: *I know, but you turn your subject away from the camera; you turned a mask, an African mask,*

away from the camera, which I thought was really a brilliant deconstruction of something that—I mean, the idea of such a simple thing making the viewer feel like a participant, which is a very big aspect of your work, was brilliant. It really worked incredibly well, changing the focus from the gaze to the participant—

Lorna: —back to the viewer. I think I try to do that on several levels: in terms of the scale of the figures, they're either life-size or a little larger than life; and, talking about construction of identity or African American identity, rather than looking at the African mask for its formal qualities instead of in terms of participation in a particular culture, or a particular event, a dance or a performance, one talks about questions of participation or questions of closeness. I thought that was a good way to talk about that piece, because it drops all assumptions about how one constructs a cultural identity, and in particular, an African American identity.

Guest: When a viewer comes to your work, he has to sort of take on that construction to a certain extent. I think that if there is a universal quality, if there is a cross-over, that's where it happens. Even if you have the actual mask turned away, it sort of presents itself to the viewer as if the viewer was stepping into that mask, and when your figures are turned away from us, it's as if we're getting in line.

Lorna: Oh right. *[laughter]*

Guest: Do you know what I'm saying?

Lorna: Yeah, yeah.

Guest: Maybe this is just completely again reading into this.

Lorna: But it does mirror a back to back. In comparing the documentary work to the roots of my own work, I think I was always interested in working with the viewers, but I wanted to force them away from the tools that they normally use to interpret a topic, look at a photograph, or derive meaning. I wanted to switch their expectations. The viewer expects to see a face and to get some kind of emotional reading from the face. There is a strong desire by the viewer to have that, so once you eliminate that, the viewer, on a certain level, thinks, "Why are you showing me this?" and then the possibility of a "message," or an emotional reading, or a situation that you don't actually see opens up to the viewer, and he thinks, "Oh, so the piece isn't about this, it's about something else." I'm always either pulling the rug out from under the viewer in a certain way, or getting the viewer to interpret the work in a completely different way than he might normally.

Chuck: Oh, I see. Actually, I think the whole idea of what people expect when they see a portrait is probably the one area in visual communication in which even the most sophisticated person enters through a life experience rather than through their art baggage. We've spent so much time looking at ourselves and at other people, and we have such strong feelings about how people should be represented that, if you mess with it at all, we get very upset.

Lorna: The viewers don't like it, but it's a nice way to seduce them.

Chuck: Absolutely, but people really want to have a psychological reading. For years I put those faces out there, and I called them heads or whatever. I tried to keep an arm's length distance, but people were always trying to figure out—

Lorna: —what the emotional state was.

Chuck: Yeah. Of course, the minute I went into the hospital, the assumption became that they are

now even more emotional than they ever were. I'm not sure that they are, but people would like to believe that they are. I think it's interesting that you've been able to get so much mileage out of the stand-ins you've used for people: the wigs, the shoes. Also, the fact that the wigs were so political is interesting.

Lorna: Right. The history of wigs.

Chuck: The history of women, the history of ethnic—that incredible thing about hair being sold as European hair. I never knew that. They required that wig hair be European.

Lorna: Well, it's sold for its texture, the buying and selling of "European textured hair."

Chuck: "Guaranteed European hair." None of that—

Lorna: None of that South American stuff, or Chinese stuff.

Guest: When you've used these artifacts, they remind me of evidential photography.

Lorna: Um hum.

Guest: When you've taken a certain artifact from a crime, or a particular event, or whatever, it's framed to be read in a particular way.

Lorna: And isolated.

Guest: And isolated. It seems as if your work has been partially drawn, or at least has knowledge within it, of traces of, if not an actual crime, the constructions about which we were talking.

Lorna: True, true.

Chuck: However, there is always so much breathing room for other interpretations. What was the name of the water piece that you did?

Lorna: *Standing in the Water.*

Chuck: Standing in the Water, which is shoes on—

Lorna: —on felt.

Chuck: —felt, silk-screened water on felt, and video images also. There are references to walking on water and—

Lorna: —bathing, like from the very mundane to the—

Chuck: —to christening to—

Lorna: Actually, I wanted to stay away from religious rituals. I wanted to stay away from that.

Chuck: I know, but I mean—

Lorna: It's very mundane. My intention was to kind of be very mundane events to very political events that take place in water, or common experiences in water, but I was trying to avoid that religious thing.

Chuck: I know you were, but what stuck in my mind was that although you were avoiding it, it was like saying, "Don't think about elephants": the minute you say that, it's all you can think about.

Lorna: Yeah, it's nothing but elephants.

Chuck: You may not have wanted to do that, but you haven't excluded it as a possibility.

Lorna: That was not my intention in terms of the reading of the piece, but people do associate it with religious rituals.

Chuck: When one editorializes, and one proselytizes, and one propagandizes, one makes sure that there's only one interpretation.

Lorna: True.

Chuck: It's banged over your head, and if you haven't gotten it yet, you're hit again, and just when you're picking yourself up off the ground, you're hit one more time just to make sure that you got the point. So even something that you didn't want isn't excluded—

Lorna: I guess.

Chuck: —which I think is nice. Did you do a piece with water that directly refers to Sarah Bartmann?

Lorna: Yes, I did. It's called *Unavailable for Comment*, but it has another kind of water in it.

Chuck: Okay, tell me about her.

Lorna: Sarah Bartmann? Sarah Bartmann was a black woman from South Africa who ended up in Paris as part of a kind of circus or curiosity act, which was based on her body. It was based on racist European constructions of African identity and it used her body as a vehicle of demonstration and exposed her as an exotic creature from Africa. She toured in exhibitions in Europe, mainly in Paris, and she died in Paris. At the time of her death, her buttocks and her vagina and different parts of her body were dissected and placed in the Museum of Man, which is where they are today. *Unavailable for Comment* is about the return of Sarah Bartmann to the Museum of Man to collect her body parts. It's just a very short thing in French about her return, and the disruption of the day-to-day routine of the museum. She was used for many things, and her image was used over and over, but she's more well-known in Europe than she is here.

Chuck: She was called the Hottentot Venus. That's an incredible story: the use of body parts in that way.

• • • •

Guest: Lorna, you've seen Chuck's work over the years. What have been some of the things that have drawn you to his work?

Lorna: In terms of your work, Chuck, I think over the years in which I've encountered it, even when I was a very young person going to museums—

Chuck: We've already established that you were a child then. [laughter]

Lorna: Come on. I'm giving you my development as an artist. They are portraits, but they're not portraits in terms of personality, which, speaking of my first encounter of seeing them, is what attracted me to them. They were these monumental objects that were segmented. They had this curious kind of volume and flatness at the same time, and although they were individuals who I could recognize, or if I didn't know them I knew their names, they had nothing to do with any kind of emotional presence. Maybe it was the qualities and the volume of the head and in some ways, the way that their faces looked. I wasn't interested in them in terms of who the individuals were or the personalities of the individuals, so they had this kind of very funny edge, especially seeing them in museum settings with other portraits. They always stood out. Also, their scale kind of draws you in, and at the same time they're always receding from you at a certain point. I mean, the further away from them you are, the more you're attracted to them and want to enter them, but they kind of recede as you come closer to them. There is a kind of elusiveness about them.

Chuck: So how do you feel about the painting? I wanted to do a portrait.

Guest: Do you think that the image of you is detached in some way, or—

Lorna: Yeah, what was funny was that, while shooting it, I kept saying to John Ruter at

Polaroid, "John, come on, come on, put on a different lens. *[laughter]* Give me that beauty lens, come on." I'm very self-conscious, which is another thing that might speak to my own work and the reason why I don't use faces. I'm so self-conscious about it. When I came here to the studio with my girlfriend Donna—we were passing by—it was quite amazing to see this unfinished huge head of mine from the door, but it is quite beautiful since it kind of looks like me and then it doesn't look like me. I like it.

Chuck: *Yeah, well it looks like a lot of big circles too. [laughter] They're not as unforgiving as they used to be, when a zit or a mole or something was evident, but they're still not flattering.*

Lorna: Right. I do have an ego. I would have liked it to be a little more flattering. I'm teasing, I'm teasing.

Chuck: *Actually, I was very upset that it didn't come out as beautiful as you. I must be softening in my old age, because I never cared before if the subject liked them.*

Lorna: In terms of photography, even with photographs of myself, when I look at pictures, they never look like me to me. That's just my own kind of idiosyncrasy. It's jarring. But in terms of looking, when I saw it in here in the studio, it looked quite beautiful.

Chuck: *I must say that I had real misgivings about asking you, because you are someone who clearly has trouble presenting herself. Do you know what I mean? You are reluctant to present an image, period, let alone an image of yourself. I felt as if it was an invasion to ask you.*

Lorna: No, because in some ways it's not about personality. It wasn't someone just taking my portrait. I have posed for other artists. Dawoud Bey takes Polaroids, and he made a portrait of me. I mean, I'll do it from time to time, but I especially like yours; it's disturbing. It's not about me, per se.

• • • •

Guest: *I wanted to ask you just a quick question: What is the most common misreading of your work?*
Chuck: *That's a good question. I wish I'd asked that.*
Bill: *We can put your name on anything you want, Chuck.*
Lorna: Well, this doesn't happen all the time, and sometimes it's appropriate, sometimes it's inappropriate, and I think it happens more with people who read materials from maybe five or seven years ago. The wig piece to which you referred has many different wigs. It's kind of a historical look at the function of cross-dressing, from a very personal thing to a kind of political thing: pretending to be white and escaping slavery. It's about cross-dressing in the forties in Los Angeles. Unfortunately, when it's written about the response has been," Oh, how black women wear their hair," but the piece is really not about that. There's a lot more going on, but when people take a very surface approach, it's like, "Oh, I read the material from ten years ago on her work on the body or the black female and then they don't read the text to draw a conclusion of what the work is actually about. That's really easy to notice in a review, and I think, "Oh, so you didn't read the piece."

Chuck: *You know, in general, I really can't stand going into galleries and reading text on the walls. That's a prejudice of mine. However, yours is the one exception to that rule because the text always*

does something else to the image than what I thought it was going to do. It's always off, it's always skewed. It always causes me to think differently. I don't usually want to know what the title of the painting is or anything like that. I don't need that to look at it, but when text actually changes the way you see something, then it's a functioning part of the art and not just—

Lorna: —additive.

Chuck: *It's not a burden. For me, yours is the most intelligent use of text of anyone's.*

Lorna: Well thanks.

Chuck: *Your work now is getting sexy.*

Lorna: Oh, that's because the subject is sex. *[laughter]* The work now is still about photography. *Public Sex* is a series of landscapes and interiors that deal with public sex. When you encounter those photographs, which are kind of large scale, somewhat like a mural, your expectation is, "Oh, they're beautiful landscapes. What is she doing now?" They are romanticized, and they participate in that kind of history of photography about the landscape and that sort of beauty, but in talking about seduction in terms of the way those sort of images and their scale are supposed to draw you into this environment, the text defines what am I drawing you into.

Chuck: *They are really wonderful pieces. The work has always been beautiful, and it is very seductive, but it is never a gratuitious thing because it's like baiting the trap in a way.*

Lorna: It's true.

Chuck: *For me, that's a good example of text really changing things. I can't remember having an experience in a gallery in which I'm looking at work and, because of the text, feeling so differently about what I'm looking at as with those landscape pieces.*

Lorna: I think in some ways that's because there are no clues. It's a funny experience to present these images. When I am in the room, I overhear people who are walking into the gallery say, "Okay, so where's the Lorna Simpson show?" "Well, you're standing in it," and then they have to read the text. I really don't provide the viewer with any clue.

Chuck: *I know.*

Lorna: Except perhaps the nature of the photographs. You have a park. You have a city park. A hotel room. If one used "outlawed" places, places where you would have sex in public, one might still continue. People write things in the guest book like, "What about an elevator? You forgot the elevator." It's a cliché place.

Bill: *Catch them on an airplane.*

Lorna: There's only so much wall space, you know. My choice of different places was based on those clichés.

Chuck: *Yeah, absolutely, and the office piece has to do with power as well: your secretarial position, versus the power of the employer.*

Lorna: True, but you know, especially with that particular piece, I wanted to write it in such a way that you do not know who is speaking, especially in terms of gender. I mean, you kind of get a sense that, if you're working that late, you might be of a certain age at which you're trying to work late in order to get up the ladder or whatever, but I wanted to leave it open so that it didn't seem like, "Okay, this is the boss and the secretary." I mean, in some ways it

could be two men who are both brokers; you have no idea.

Chuck: I went through all of those possible arrangements, which I thought was really interesting.

Lorna: That's kind of what I wanted the viewer to do. It's about the architecture of the space and trying to negotiate it, or the environment.

Chuck: That's exactly the thought process I had. Is this someone in a position of power? Is it someone who works for him or her? Are these two co-workers? Are they the same sex? Are they different sexes? I went through all of those questions while reading the text. It was amazing that you left it open enough for the viewer to get to all of that.

Lorna: That was a fun piece to do, especially because I was somewhat tired of the gallery world in New York and had been doing work over the past three years with which audiences in New York weren't familiar. It's very abrasively different for New York audiences. For me, it's a continuation of things that I've been doing, but it was a nice opportunity to be back in New York and show something completely different.

• • • •

Chuck: Whose work interests you, especially work that has to do with the body?

Lorna: It's funny, but I think work that interests me is work that is nothing like mine. *[laughter]*

Chuck: I realized as soon as I asked that how much I would hate *to be asked that question.*

Lorna: That's why I do my work, because I don't like the work anybody else is doing. *[laughter]*

Chuck: You're right.

Lorna: The egotistical artist rears her ugly head.

Chuck: I chose to do what I do because everybody else did what I like better than I could.

Lorna: Exactly. That's why I don't paint. *[laughter]* Really. I remember taking a painting course in college and then visiting friends of mine who were a couple of years older, who were in studio classes, and I was just amazed. I just stood there. I was in shock. I mean, I had been laboring over this shit for hours, days, and they were just like, swish, swish, swish, done.

Chuck: Your pieces often have an object status which is closer to painting than to traditional photography.

Lorna: That's true in terms of its formal qualities and the way that it's put down, especially in terms of the way the figure is sometimes positioned.

Chuck: The physical aspects of it also contribute to that assessment. For instance, the way ink sits on felt, and stuff like that, is very different from photography.

Lorna: True. I think that after a certain point, I got bored with photographs behind a frame: going to the lab, going to framer. I mean, that whole process seemed a necessity for the material that had nothing to do with the image. I like dissecting the image, and part of the framing is very important in terms of the way that I wanted to crop the images and present them, but other than that, I got really tired of it. It was nice to find another material and another form that was more immediate, and with which you didn't need the Plexiglas.

••••

Guest: So you moved from Brooklyn to Queens?

Lorna: In 1968 we moved from Brooklyn to Queens and then I grew up in Hollis, Queens, a working class, black community.

Guest: Did you go to school there? High school?

Lorna: Well, I actually went to the High School of Art and Design in Manhattan. I was an only child so my parents took me to theater, I took dance lessons, I took ballet lessons, I was tutored in French, I was tutored in math. They spent a lot of time on me.

Chuck: I'm an only child too.

Lorna: It was a little bit more attention that one could bear. *[laughter]* Then they said, "Oh, you're taking art when you go to college. What do you mean you're taking art?" I'm like, "Oh please, you sat me through *Hair* when I was seven years old. You'd better be sure I'm gonna be an artist."

Chuck: Yeah, you should do it but you shouldn't get too interested in it. Study ballet, but don't be too good.

••••

Chuck: I remember the fifties and Eisenhower, and the fifties when it seemed pre-civil rights everything, when the world seemed so polarized, but I can't remember anytime that seemed as polarized as right now. I think it's as polarized between the sexes as it's probably been in my lifetime. I was curious since your work is so much about presenting something without an editorial spin so that people don't see it one way or the other but can have totally different views of the same stuff depending on what they bring to it, how you see the Rodney King trial and the O.J. Simpson trial. People saw these same events in such radically different terms. How can we be one society when people see everything in totally diametrically opposed ways?

Lorna: You know, if one had lived through the turn of the century in this country, or knew the history of oppression—the way in which this country developed—it is clear to me that one would have a different perspective about race, class, and privilege than those who have for generations enjoyed the privileges of the development and expansion of this country. What is ridiculous is that, instead of talking about constructions of race, privilege, and the exclusion of the poor from basic rights that everyone should have access to and be protected by, the focus is on an athlete who is accused of killing his wife. That is kind of absurd.

Chuck: Yeah.

Lorna: It's really unfortunate. I was in Brooklyn—I can't remember what I was doing—but I was on the street when the O.J. verdict was given and people cheered. There was an office building where people with shirts and ties worked; there was an installation of a bank of videos; and everybody in shirts and ties was watching it. People on the street were listening in their cars or on radios that they had. They all cheered. It was kind of incredible to me, because in some ways, I don't see—

Chuck: It became an "us against them" thing whether it was supposed to or not.

Lorna: True, but O.J. Simpson isn't exactly your average guy.

Bill: He also spent his entire life not being black.

Chuck: I'm as black as O.J. Simpson is. This guy has hardly been black.

Lorna: Well, it's not so much that. It has to do with class. It's something to do with class. It's something to do with being able to buy enough talent and enough tests so that you can question everything that's brought forth. But the idea that he is a victim is absurd. Okay, as a person, I believe he did it and got away with it, but that's my own personal opinion. I believe that based on my own use of logic, not any kind of law or anything that they brought into the courtroom. It's unfortunate that he becomes a hero, because basically he's beaten his wife, he beat the woman before she died. It's the same thing with Mike Tyson. You rape someone, you have to go to jail. The idea that his status as an athlete supersedes everything else is absurd. In terms of politics within the black community, I think the black community is having to deal with the idea that it is not monolithic, it has never been monolithic.

Chuck: I think I'm really surprised at how monolithic it seemed in the reaction to the verdict.

Lorna: But it never was monolithic. Even during the sixties with Martin Luther King, Malcolm X, or the Nation of Islam, even then it was divided. It's never been monolithic. It's just that each group sees itself as monolithic to a particular cause, so given the seventies and eighties, for some reason, in the minds of people it has established itself as this monolithic thing.

Guest: It's indicative of the overall culture not being able to deal with issues of class.

Lorna: I think so, but it's also part *not* dealing, America *not* dealing with race. For instance, the Rodney King situation and the way that was handled: the beating of that man, a kind of average person minding his own business. The frequency of that situation caused such a furor in LA, but the repercussions throughout the country set up the thing for O. J. standing in as a victim of racial bias. What's unfortunate is that the Rodney King situation (and that of other individuals) isn't really dealt with. What's unfortunate is that the Rodney King thing happened, and then it wasn't dealt with very well or at all, in terms of the LA police force, and in terms of what you were just saying you saw in Cincinnati.

Chuck: Every person who lives in LA, white or black, fears the police. They are the most feared police force. It's true. White people don't want to be pulled over by the cops.

Bill: But it's different.

Lorna: It's different because if you're in the right community, if you're in a wealthy community and you're riding around, it's not a problem—even myself, living in La Jolla. If you have the wrong demeanor, in the wrong neighborhood, if you're gay, and you're in the other neighborhood, they suspect that something is wrong. If there are two men in a car and they suspect something is going on between them, they will pull them over. Or if you're tailed, coming from a gay bar and going someplace else, they can be difficult. I've gone to hotels when I've had different projects. I remember in Seattle, in particular, the front desk clerk said, "Applications are over there," but I was really checking in. "Do you want to call the manager?" And that's—

Guest: —that's a very particular experience.

Chuck: I'm not surprised in Seattle.

Bill: **That's still going on?**

Guest: **It's still going on, and, in fact, I think it's getting worse.**

Lorna: Oh, I think it's getting much worse.

Chuck: **You know, I was just in Cincinnati last year. Cincinnati is a real southern city, although you don't think of it in that way.**

Lorna: Oh god, don't say this. I've got to go there next week.

Chuck: **Oh, I think you should rethink your trip. We went, and first of all, it's right across the state line from Kentucky and Tennessee. There was a mall, and in the parking lot there were a bunch of antique dealers, a flea market. Everybody had booths, and one booth was a white supremacist booth. They were selling jam, and they were selling—**

Lorna: —and they were selling white supremacy.

Chuck: **They were handing out their stuff. That was last year in Cincinnati.**

Lorna: It's coming to task. It's coming to a point, I think, at which issues are getting so skirted, and the idea that O.J. is becoming a galvanizing force within the black community to talk about race is a ridiculous place to start.

◆

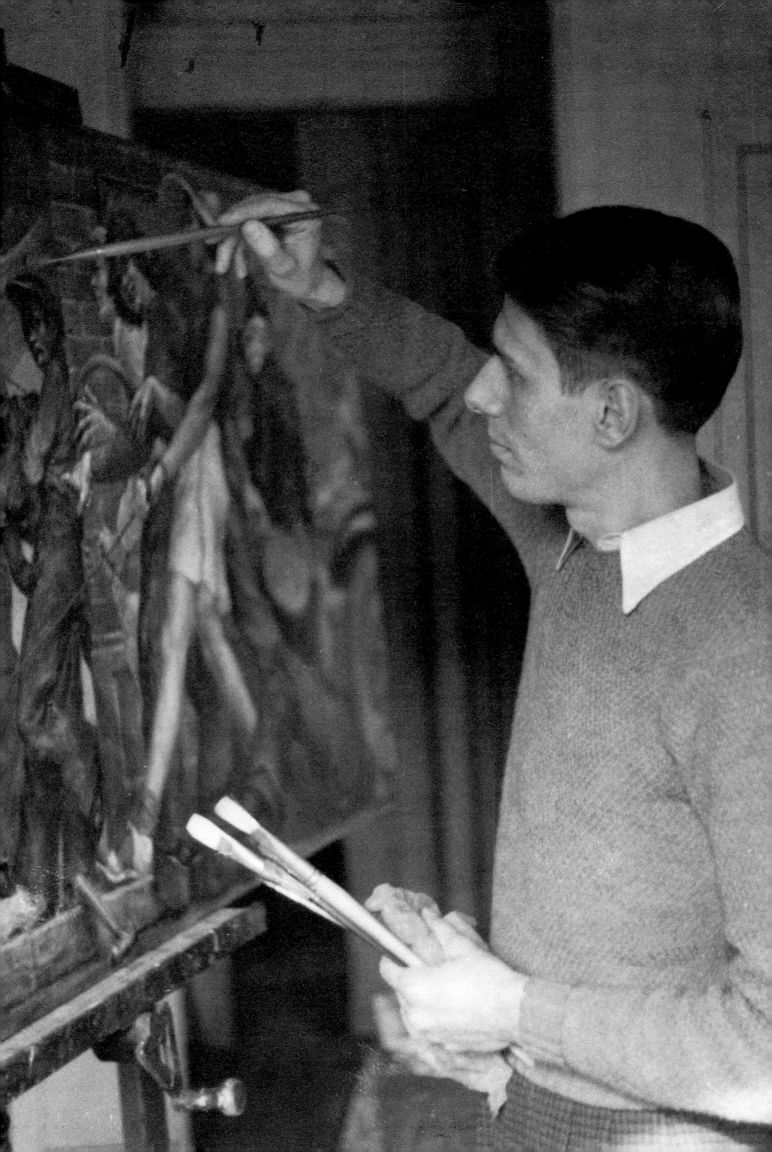

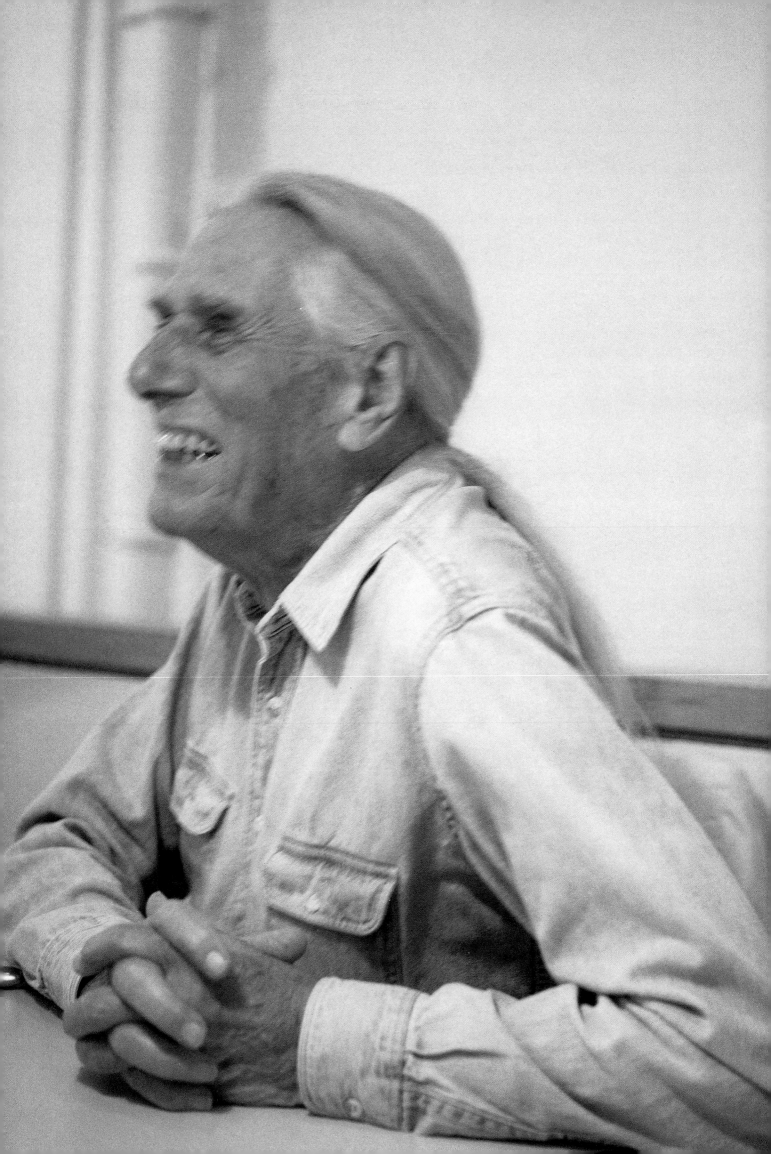

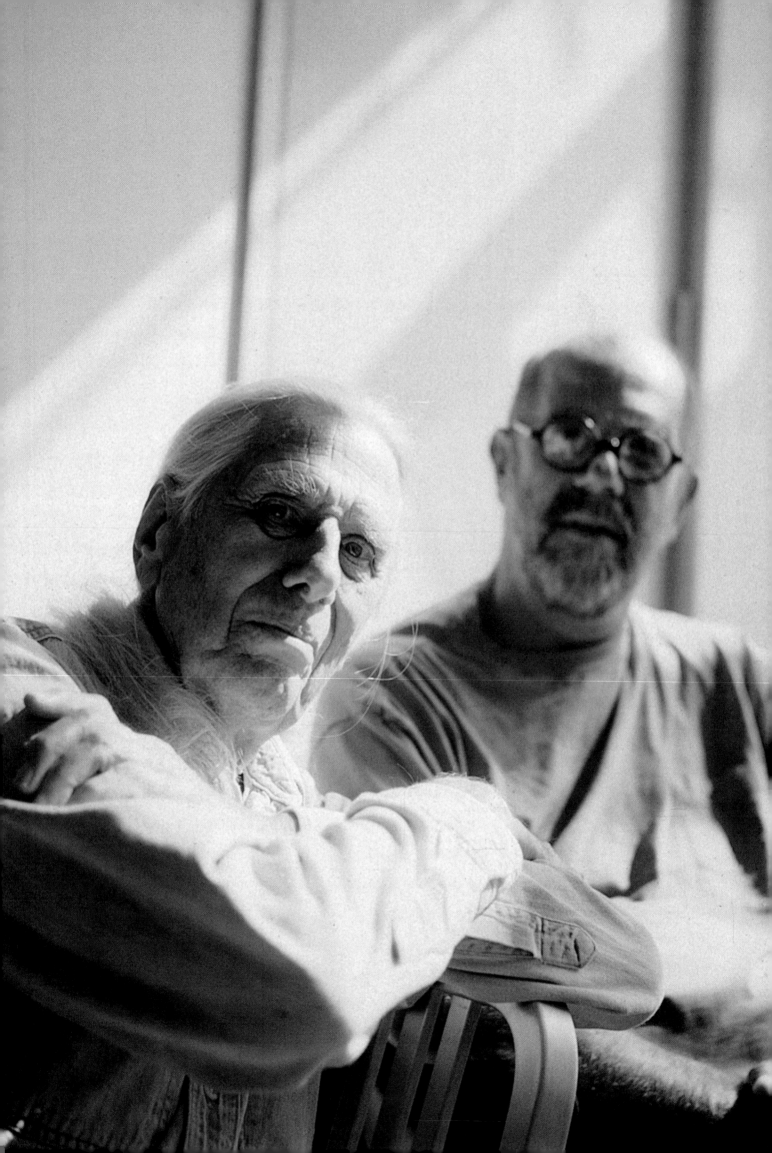

Paul Cadmus

New York City, September 14, 1994

Paul Cadmus: Perhaps it would be good to begin with a quote from Goethe: "Art exists to be seen and not to be talked about, except perhaps in its presence."

Chuck Close: The last time we met—I wish we had had a tape recorder then—you were talking about your early childhood experiences and about your life in New York, and you said something about your mother—

Paul: —being neurotic.

Chuck: Yeah, your mother being phobic about you and your school. You were saying that your mother was quite neurotic and that she didn't want you to take public transportation to school. You had to live close enough to walk to school.

Paul: She didn't want me to take public transportation because it was so dangerous, and I was never to accept a lift from anyone in a car. If anyone offered to give me a ride from 103rd Street to the academy at 109th Street, I had to refuse because I might be "abducted and strapped to a bed and abused." I think there had been something in the paper about that having happened to someone, so my mother was sure it would happen to me too. My mother was quite neurotic in many ways. She didn't want to only bring up her children, she wanted to be an artist, and she was good too. Both of my parents studied at the National Academy of Design when they were young. In fact, they studied with one of the art teachers with whom I later studied. Actually, it was planned that I would be an artist ever since I was a child. I mean, it was planned by my parents or, at least, by my mother. My mother cared more. My father was a Sunday painter. He wanted to be a full-time painter, but he had to support two brats, my sister and myself—I guess we weren't as bratty as lots of children—so he worked in a lithography shop most of his life. When I was fourteen, I dropped out of high school to go to art school, which was my mother's desire as well as mine, but my father would rather have had me go to college and get an education. We lived at 152nd Street and Convent Avenue at the time. It was really a very nice apartment for us. We were very poor. I was born in a tenement on 103rd Street and Amsterdam Avenue. I liked 152nd Street, but my mother thought it was too far from the National Academy of Design, which was at 109th Street and Amsterdam

Avenue. I would have had to take the elevated train, and the elevated train used to go around a curve at about 110th Street that she thought was a very dangerous curve. My mother never rode on the subway in her life. When we went on a trolley car from somewhere downtown, we would get off at the foot of the hill at 125th Street, walk up the hill, and take the trolley again at the top because my mother was afraid the trolley would slide down the hill. So we moved back down to 103rd Street into the same building in which I was born. It was infested with bedbugs and cockroaches.

Chuck: What year was that?

Paul: I was fourteen at the time. I was born in December 1904, so it would have been 1918. I think that's when I began to study at the National Academy of Design, which I thought was a wonderful school in those days, and it cost almost nothing. I think it was only about twenty-something dollars a semester. Before that, it had even been free for artists.

Chuck: With whom did you study there?

Paul: I studied with several academicians: George W. Maynard, who did nymphs in the waves; Charles C. Curran, who did girls on tops of hills with wind blowing their white skirts, not too far up but just blowing their skirts; and Francis C. Jones, who was also a portrait painter and still life painter. I didn't study with Hawthorne, who was also teaching during the end of my stay there. I studied at the academy for six or seven years.

Chuck: It's interesting that your parents had that ambition for you.

Paul: I don't know if that was my father's ambition for me, but it was sort of accepted that I probably had the ability for it. I may not have had the ability for anything else, I don't know. My sister would say, "When Paulie grows up, he's going to be a policeman, and I'm going to be an artist." It didn't work out that way, although she did good work too, but I wasn't a policeman. I don't really remember my childhood very well. Most people do. I remember almost nothing until I went to art school.

Chuck: I know. I don't understand how people can have incredible recall from their childhoods. There's just nothing there. I don't know what to do to dredge it up. I've been in therapy for years. You'd think that, if I was going to remember something, I would have remembered it by now.

Paul: I remember little incidences here and there: my sister tripping me, or me tripping her. I don't even remember anymore which one it was.

Chuck: After you told me about your mother's admonition not to take rides from strangers, you told me about the only thing your father ever told you about sex. Do you remember that?

Paul: He gave me a little booklet. It said that if you were at a swimming pool, and a girl didn't want to go swimming or didn't want to dive or anything, you mustn't press her because it was probably her time of the month.

Chuck: That was it for sex, huh?

Paul: I'm terribly afraid of the religious right, aren't you?

Chuck: Oh, absolutely, and the kind of censorship that's happening in the art world right now. You were just telling me that—

Paul: Officially-sanctioned art has always been a mess. Our government is so stingy, compared to what European nations give to their artists. It's a measly amount, but it's important to the few who get it.

Bill Bartman: It's very important to the people who get it. Unfortunately, they have yet to realize that artists are real people with real world concerns, not just beings sitting in an ivory tower somewhere; but that is not the information that gets out.

Chuck: Over your long career, you have used subject matter that was difficult for some people.

Paul: All along, I mean, ever since *The Fleet's In!* in 1934. It was my first appearance in public.

Chuck: The Fleet's In! Was that originally commissioned?

Paul: It was the PWAP [Public Works of Art Projects]. [In response to the Depression, then President Roosevelt waged a war against poverty in the thirties by allocating more than three billion dollars for the purpose of creating employment opportunities. The Works Progress Administration (WPA) was one of the first such programs. Thousands of workers built or renovated hundreds of schools and colleges, laid thousands of miles of highway, and provided health services. The WPA was such a success that it became the model for other programs. In 1935, the Federal Arts Project (FAP) replaced the Public Works of Art Projects, both of which were often used interchangeably with WPA. The FAP was established for the purpose of employing artists and craftsmen to decorate public buildings and to help "establish a new way of national thinking about art and even new ways of seeing." Over fifty-three hundred artists, working as easel and mural painters, sculptors, graphic artists, and photographers benefitted from the patronage of Roosevelt's administration.]

Chuck: WPA, yeah, but how did the navy end up owning the painting?

Paul: They sequestered it. It was the WPA, the dole of those days. We were paid only twenty-something dollars a week or thirty-something a week, I can't be sure, but even in those days you could live very decently on that as far as I was concerned. In fact, I used to save five dollars of it and put it in the bank. [In 1934, Secretary of the Navy Swanson ordered *The Fleet's In!* to be removed from the Corcoran Gallery of Art in Washington, D.C. because he felt it was an untrue and sordid representation of naval sailors. Retired Admiral Hugh Rodman agreed, saying that it was an "insult to enlisted men." This censorship caused Cadmus to be labeled an "enfant terrible" who claimed that he painted what he observed and interpreted as freedom and lack of inhibition on the part of the sailors. The Whitney Museum of American Art exhibited *The Fleet's In!* and two other sailor paintings in *Collection in Context: Paul Cadmus, the Sailor Trilogy,* June–September 1996. The title of Grace Glueck's review in the *New York Times,* "Paul Cadmus, a Mapplethorpe for His Times," reinforced the "enfant terrible" label to the present day.]

Bill: Did the government get to keep all the paintings made under the WPA?

Paul: They supposedly kept all the paintings made by artists on the project. I was only on the project for a very short time. I think it was near the end of the project. I only did two paintings: *The Fleet's In!* and *Greenwich Village Cafeteria.*

Chuck: So they got these wonderful paintings. What did they do with them?

Paul: Well, a lot of them were just sold as junk. A great many of them appeared on Canal Street in those furniture junk shops. Do you remember those?

Chuck: Yeah.

Paul: They were rather entertaining shops. I'm sorry they're gone.

Chuck: I understand that they would take the canvases off of stretchers and sell them to rag merchants for drop clothes. As far as its reception went, The Fleet's In!, *for its time, was certainly as difficult as anything that Andres Serrano has come up with.* [In 1989, Senators Jesse Helms and Alfonse D'Amato, along with certain religious groups, attacked the work of Andres Serrano, specifically *Piss Christ,* calling it blasphemous and obscene.]

Paul: It didn't seem difficult at all, and I don't think it would have been difficult if the admirals hadn't made a fuss.

Bill: *It probably was an accurate depiction of what was going on.*

Paul: I thought it was. You never can be sure. I thought it was. It was what I had been looking at for a long time from Riverside Drive.

Bill: *It probably would have been more accurate now, and they really couldn't have said anything about it. It's such an odd thing that you can be gay, but you can't say anything about it.*

Chuck: *And the kind of heterosexual activities occurring—look at Tailhook. It's certainly not something—*

Paul: —of which they should be proud. Actually, *The Fleet's In!* wasn't objected to because of the homosexuality. That was irrelevant. That had nothing to do with it. They objected to the fact that the sailors were drunken and consorting with loose women.

Bill: *They didn't even notice the loose men.*

Paul: There was only one loose man, one marine being loosed.

Chuck: *You kept it at ten per cent of the population.*

Paul: I tried to, because I don't think the whole world is homosexual by any means.

Bill: *It's funny that that wasn't their objection.*

Paul: There was a little bit of comment about it in some of the newspapers, but that wasn't what the admirals complained about.

Chuck: *The painting just recently resurfaced. You didn't know its whereabouts for a long time?*

Paul: It eventually turned up. It had been sequestered by the assistant secretary of the navy under Roosevelt. He had it for quite a while, and then he gave it to a place called the Alibi Club. It didn't belong to them, it belonged to the public, but they put it in a republican club in Washington called the Alibi Club. I think only a few influential Republicans belonged to the club. It was a very limited club. The painting was there for a great many years hanging over a fireplace and being enjoyed by the members until, finally, a fuss was made by some people who were interested in getting my work out into the public. They threatened to sue, and finally they got it for the Naval Historical Museum which, by this time, welcomed it because the behavior depicted in the painting was no longer considered such bad behavior.

Chuck: *Talking about the WPA, when we think about the artists who were supported during that period, we often think of the people who later became the abstract expressionists. Was there a quota for how much work had to be figurative and how much abstract?*

Paul: I don't think so. Every artist who had a certain amount of credibility could get in. I knew so many, but I've forgotten the names of practically all of them. If you look at the resumes of those who were around during that time, you will find that a lot of them had been on the WPA. After the project folded, they put me into another project in 1936 and '37, the Treasury Relief Art Project, designing murals for public buildings. I made small-scale sketches for a mural for the Port Washington [New York] Post Office. They were rejected because it was thought that they were not flattering to the community. I showed a lot of fat people running to the

train, and I showed golfers who shouldn't be playing golf—a poor caddy and an overstuffed golfer. They were not approved, but the woman who ran the program thought that they would be good easel paintings, so I was given a job doing half-scale paintings. I think I made four or five panels for that project. It's called *Aspects of Suburban Life: Polo Spill, Golf, Main Street, and Public Dock.*

Bill: Do you know where they are now?

Paul: One is in a private collection. It had been returned to me from the billiard room of the American Embassy in Ottawa, because they decided at some point that it was not fit to be in a billiard room. Actually, the only thing to which they objected was that in the *Main Street* panel there were some girls coming around the corner, and there was a boy scratching his crotch. That was not fit to be in a billiard room in an American Embassy.

Bill: No one scratches his crotch in a billiard room, God forbid.

Paul: Anyway, it was returned to me, and I sold it. The others eventually got into the Smithsonian collection. It's nice to be there.

Chuck: Was there ever any sense that the government had gotten such a good deal on those paintings that the artists should have their work returned to them or share in—

Paul: I don't think there was. You know, I would go to a bookstore on Canal and see very good paintings by fellow artists. There was a Jared French painting there called *Chess Game.* It looked as if it were Stalin playing chess with someone else, although it wasn't exactly political. In any case, it was on a wall there for quite a while, and it was priced at thirty-five dollars. We didn't think that we could afford to buy it at the time. We used to walk around and see what paintings were up. Eventually, that piece was sold for a good price at Sotheby's. After that project ended, there was another government project designing commissions for post offices. In 1938, I got a commission for *Pocahontas and John Smith* in Richmond, Virginia. There was even trouble with that, because I had an Indian wearing a loincloth of fox skins, and the head of the fox skin reminded people of a penis. It was just the head of the fox. So that had to be changed. I had to turn it into a fox fur without any head.

Bill: Was that one actually done?

Paul: It was actually done, yes.

Bill: Does it still exist as a mural?

Paul: The building was eventually destroyed. They removed the mural. I think the painting is now in Philadelphia. How it got there I don't know. That was the end of my connection with the government. I've never had any other help from the government.

Chuck: The idea of living longer than a post office and having your work moved is amazing. You think of these places as being there forever.

Paul: I've lived longer than hotels.

Chuck: Maybe you can fill us in about the time between when you were at the academy and when you went on WPA. What was it like to survive as a young artist at that time?

Paul: Well, I lived with my family until I was about nineteen or twenty, I guess. While my mother was still alive, I lived with her and my father. I began exhibiting etchings before I was

twenty. I became a member of the Brooklyn Society of Etchers, which was the big etching society in those days, and I got some money by selling prints and things like that, but it wasn't enough to live on. For a year and a half I worked in an advertising agency as a layout man. I earned quite a lot of money at that job and saved enough to go to Europe. That was about 1931. I spent two years in Europe and came back with no money.

Chuck: *Where did you live in Europe?*

Paul: I lived in Mallorca with Jared French for about two years, just painting, traveling around Europe, and going to museums. Because I was trained at the National Academy of Design, I never thought of composing a picture or making up something that was not right in front of me. I suppose it was the influence of my friend Jared French that persuaded me to paint something that wasn't directly from life. When I was in Europe, I studied Renaissance art, and I've never gotten away from it. I never wanted to. Very limited I am, terribly limited. There's very little that I like.

Chuck: *A better way of putting that is to say you're "focused."*

Paul: Some people would say that I'm focused on the wrong thing. This is a very good thing. Tom Stoppard said: "Skill without imagination is craftsmanship and gives us many useful objects such as wickerwork picnic baskets; imagination without skill gives us modern art." Your work has craftsmanship and imagination, but a lot of modern art does not have craftsmanship. I don't know whether you will admit that or not, but your work has plenty of imagination, rather unlicensed imagination, I think.

Chuck: *Did you see yourself as pitted against modernism?*

Paul: No, I didn't pay any attention to that as long as I could get along. It didn't interest me. I don't think of you as a modern artist. I just think of you as an artist.

Chuck: *The whole "realist versus abstraction" thing is about the most boring issue that I can think of, and obviously, I don't think that you're closer to God because you make a certain kind of art. I never wanted to do what I wanted to do because I was against something else.*

Paul: I never reacted that way.

Chuck: *I think a lot of people who work figuratively are almost driven to it out of incredible dislike and suspicion—a couple of whom will have to remain nameless.*

Paul: **Too bad. Clement Greenberg wouldn't have let them remain nameless.** [Greenberg (1909–1994) was an art critic and author who was influential in popularizing the Abstract Expressionist Movement in the 1940s and 1950s, especially championing the work of Jackson Pollock. He wrote for the periodicals *The Nation* and *New Leader* and authored *Art and Culture: Critical Essays,* and a biography of Joan Miro.]

Chuck: *Clement Greenberg, by the end of his life, said that Andrew Wyeth was a better painter than Jasper Johns or Rauschenberg.*

Paul: He didn't really, did he?

Chuck: *Yeah.*

Paul: I knew that he said artists were dumb and stupid people; that we were all terrible bores.

Chuck: *I think his exact quote was: "Andrew Wyeth was a greater painter than Jasper Johns, Rauschenberg, or anyone in the last five Whitney Biennials." That pretty much covered the waterfront.*

Paul: He was awful about those people who had been his friends. Franz Kline said that Arshile Gorky was a violent anti-Semite. I hadn't known that, but I read somewhere that he said those things.

Chuck: *I know a lot of people with whom you were friendly, but were you also friendly with people whose work was unlike yours.*

Paul: I don't think so. I think we were very limited. I've never been a great group person. I did have a few friends who happened to be at the same gallery that I was or with whom I had gone to school, but, as far as I know, none of them became abstract artists. I have nothing against abstract art except that I think some of it is merely decoration, and I'm not interested in anything except the human being. You deal almost entirely with human beings, don't you?

Chuck: *I care more about them than anything else too, but bad figurative painting is sometimes harder to look at than bad abstract work; or maybe it's a toss-up.*

Paul: Most of it is dismissible too, I think. I just dismiss decoration, because I can't pay attention to it for very long. I think it's handsome. I mean, I love it as a background. I enjoy wallpaper very much.

Chuck: *A bad abstract painting makes a better backdrop for cocktail chit-chat than a figurative painting. A bad figurative painting sticks out like a sore thumb.*

Paul: A bad figurative painting is not only tasteless, it is usually kitschy. It's embarrassing. It's more embarrassing than a bad abstract painting, which doesn't inspire conversation. You talk about the hostess. You don't talk about the painting that is behind her. You don't look at it really. It's good background, that's all.

Chuck: *None of us are responsible for those people who come after us and who are encouraged by us, but you are really a hero to many people who are involved with figuration. You are someone who was doing such interesting work so early, work that seemed to have something to do with the social issues of society, not just portraits of college presidents or things like that. I mean, you really kicked the door open for a lot people to a kind of intelligent figuration.*

Paul: As you said, most figurative art is worse than most abstract art. Art should give pleasure. That's from a quote I saw in my book last night. As he grew older, Thomas Mann said again and again: "An artist is one who seeks to divert, give pleasure. He is always more *jongleur* than *philosophe.*" I feel more and more that way.

Chuck: *Where is the guy who started this conversation by saying how uneducated he was?*

Paul: I read. I read.

Chuck: *You'll have to translate the French for me, because I don't—*

Paul: It means that as an artist gets older, he gets to be more of a juggler than a philosopher. That's a compliment. My younger work, I guess, deals more with problems of the day, but I became more and more a juggler as I grew older. You've got to juggle with what you've got left, I suppose.

Bill: *Do you paint everyday?*

Paul: Oh, no, by no means, not anymore. I try to draw as much as I can. I only do about one

painting a year, and I really don't want to repeat what I've done before, if I can help it. I try not to. My tendency is to paint fairly normal domestic scenes. You were talking about art imitating, and I have another quote. Oskar Kokoschka spoke of Egon Schiele as "Schiele, that pornographer."

Chuck: When I was on a Fulbright, I studied at the Academy of Fine Arts in Vienna. The two most distinguished students they ever had were Adolf Hitler and Egon Schiele.

Paul: What a combination.

Chuck: Schiele only lasted for about two weeks before they tossed him out on his ear. If Hitler had been a more successful architect, maybe we wouldn't have had World War II. Maybe he could have just designed fascist architecture.

Paul: Instead of those awful nudes. I like [Gustav] Klimt even better than Schiele.

Chuck: I loved Klimt. My Fulbright was to study Klimt and Schiele. I did it for pragmatic reasons: I wanted to live in Vienna because it was centrally located in Europe, and I wanted to travel every month. If you're going to study in Vienna, who do you say you want to study? The only people are Klimt and Schiele. I felt some obligation, after having taken the money, to actually look at their work. I was working abstractly at the time, and seeing their work didn't have great urgency for me, but I spent a lot of time looking at it. I only recently realized the relationship between the marks that I'm making now and Klimt's work, especially his dresses.

Paul: And the backgrounds. There is a great connection. That and the Ravenna mosaics. [Ravenna houses some of the most spectacular mosaics, including S. Vitale, c. A.D. 547, and Sant'Apollinare in Classe, c. A.D. 533–49.]

Chuck: Which I've never seen. My wife and kids just went this spring, but I've never been to Ravenna.

[Close subsequently spent the spring of 1996 in residence at the American Academy in Rome and went to visit the mosaics in Ravenna.]

Paul: I consider them icons. I love those things. I also feel that way about your pieces. You will certainly love the Ravenna mosaics too. I think all beginners should study and look at the art of the past. I believe in an academic training no matter what you become later on. It didn't hurt a lot of abstract artists to have an academic training. Grunewald's Isenheim altarpiece is my favorite northern painting. And southern, Piero della Francesca—

Chuck: Piero's right up there, but I guess my favorites are Giotto's frescos at the Arena Chapel in Padua [1305–6]. As an environment, as a wall-to-wall wraparound experience, they are incredible. They're so intact and complete. They totally engulf you; that's probably part of the reason why I prefer them to some of the other works.

Paul: What engulfed me even more than Piero is [Luca] Signorelli's fresco *Damned Consigned to Hell* [1499–1504] in the Cathedral of Orvieto. You're very close to the works. The Giottos are much farther off, higher up. I was thinking the other day the about definition of art. I was considering that all good art is magic, or magical, and therefore all good artists are magicians. True magicians are very rare. Most art nowadays is done by people who imitate successful magicians. The main thing about Chuck's kind of magic is that he exposes his magic. He's like a magician who saws a lady in half, but you see how he does it. I mean, he shows you how to do it, but no one else can do it.

Chuck: No one else is stupid enough to do it, that's all. I think you're right about magic, and I think this is why artists like to have other artists look at what they do. The shared experience of having made

illusions makes another artist an interesting member of the audience. When you have an exhibition and artists come to it, it is like a magician performing for an audience filled with magicians. They see both the illusion the magician has conjured and some of the devices used to make the illusion.

Paul: I think, according to my notion, that Piero is the greatest magician of all. Do you think Giotto was the greatest of all magicians?

Chuck: No, I think Vermeer was the greatest magician of all. Speaking of which, I just did an interview with Kiki Smith for Bomb *magazine, and in it she talks about stealing from the old masters. I said, "Why doesn't your work look like everyone else's who is appropriating?" She said, "Because I'm appropriating from different people than my colleagues."*

Paul: A person who has a basic originality, no matter how much he copies or is influenced by something else, doesn't lose his originality. I believe in being influenced by other artists. It doesn't hurt an original artist at all. It's like classic ballet. Tradition is very important, I think. I'm sure it is in your work.

Chuck: I had trouble admitting it, I think.

Paul: Really?

Chuck: Yeah.

Paul: Have or had?

Chuck: Had. I used to refer to my paintings as heads. I didn't think they were portraits. I didn't think that I was connected to the portrait painting of the past. I just recently realized that whenever I go to a museum, the work that I stand in front of, or sit in front of, is invariably portraits. I'm clearly much more connected to those conventions or traditions than I've ever acknowledged in public. I suppose that my generation was trying to make our work look unlike anybody else's. We were driven to purge our work of all influences. One was supposed to have sprung full blown out of thin air complete with personal vision.

Paul: I have another quote—I don't know who said it—about museums and looking at art: "Sheep may safely gaze." I think that many people go to museums as sheep, don't you?

Chuck: Do you prefer your work to be in public collections where everyone has access to it?

Paul: I think it's nice. I like people to see it. There are so few of mine. I'm not prolific.

Chuck: That's another way in which you're a hero. You're a hero to those people who are not prolific, who show remarkable restraint in flooding the art world with their work.

Paul: Is it restraint or constipation?

Chuck: Well, I prefer to think of it as restraint.

Bill: Vija [Celmins] used the word constipation.

Paul: Well, perfectionists never do produce a great deal.

Chuck: Do you think that you put rocks in your shoes to make things more difficult?

Paul: No, I think I'm lazy. That slows the process down.

Chuck: I'm lazy too, and that's why I think I came up with a process that required me to work every day. I work every day so that I don't have to think about waiting for the muse or waiting for lightning to strike.

Paul: The muse isn't hanging over our shoulders all the time depending on us. We just hope that he, or she, or whatever it is will come. In the meantime, we can just practice doing our scales, etcetera.

Chuck: *You've chosen working methods that require certain of those craft issues about which we were talking.*

Paul: Craft and imagination are a wonderful combination. That's what I find so lacking. Anyone who can buy a tube of paint is an artist nowadays, and they don't consider it a hobby. They consider it creative. I think it was much better in the Victorian days when people thought that their watercolors and their albums were a hobby, a talent like tinkling on the piano, rather than that they were geniuses right out of the box.

Bill: *I think, ultimately, that things don't last that can't stand the test of time.*

Paul: But such large quantities are produced. I think one of the greatest enemies of all artists, really of all people living nowadays, is diffusion. I mean, we're subjected to so much.

Chuck: *That's where the narrowness or focus comes in. The ability to cut out all of that other stuff is very important.*

Paul: You have to limit yourself. I don't limit myself enough by putting aside things that shouldn't impinge.

Chuck: *A friend of mine said that he thought it was important to have enough craft in your paintings so that they aren't thrown away, so that a museum won't deaccession your work. If they're out of favor but have enough craft, they'll put them in the basement.*

Paul: That's a very good thought.

Chuck: *He called it "built-in antique value." People keep things that seem to have skill and into which a lot of time has been put. I don't really care how much time goes into a work. I don't think a work is more valuable because a lot of time went into it, but if you've got a six-month idea, you had better spend six months doing it.*

Paul: Poussin said, when he was dying, "I have neglected nothing," and very few artists can say that nowadays.

Chuck: *I think he neglected a few things. I'm not a big Poussin fan.*

Paul: I neglect things all the time, but one should try not to. For instance, when I do a big area that is just sky, I try not to neglect it just because it's a big area. I try not to just squish it on.

Chuck: *That's really why I started using a grid. I would have to give the same exact amount of attention to the background as I did to a nose or an eyeball. The wonderful thing for someone like me is that there is a celebratory aspect to finishing every little piece, so I don't have to wait for completion to feel as if I've been rewarded. Where do you find your reward? Do you actually enjoy the activity, the physicality of pushing the paint around?*

Paul: I don't enjoy all aspects of the work. I don't enjoy it until I begin to work on the panel. I enjoy making preparatory drawings, but until I'm actually painting, I don't get great pleasure out of it. I don't get any pleasure from making the panel, transferring the drawing to it, or the early stages.

Chuck: Work methods and that sort of thing are seldom talked about. I haven't done egg tempera since I was in college. It seemed such an unforgiving medium, and it's not something that one would think of being used by someone who was chasing pleasure.

Paul: It's not voluptuous.

Chuck: It's not like oil paint. It's not gushy and wonderful.

Paul: However, the actual surface is rather sensual. It's like an eggshell.

Chuck: Yeah, it's wonderful. The final surface is wonderful, but making it—

Paul: You can't wallow in it. Of course, all of my limitations leave out geniuses who can do *anything*. If you're a genius, you can get away with anything. I think, perhaps, there's about one every twenty years.

Chuck: Do you care to speculate on geniuses produced by the last twenty or forty years?

Paul: No, no. The last one I can think of is [Georges] Seurat.

Chuck: He certainly is a genius for me too.

Paul: There may be others about whom I don't know. I knew Hopper. He was impossible in many ways. He was quite a grand old codger. He said terrible things. I shouldn't quote him. When he went to Mexico, I asked him if he enjoyed the Mexicans, enjoyed the people there, and he said, "A bunch of gorillas." He said all sorts of peculiar things. I asked, "Do you rent your place when you go away?" and he replied, "Oh no, I wouldn't want anybody to see the books I read." He and his wife shared an apartment on the top floor of Washington Square North. In the middle of the apartment he painted a line, and she was not allowed to cross that line in the daytime. I think he adored her, actually. They slept in a double bed and everything like that, but in the daytime he didn't want her. She was kind of bubbly and frivolous, and he was very sober and solemn and, I guess, meditative. Maybe she did, sometimes, get across in the daytime. I don't know.

Bill: Maybe she snuck across for a quickie.

Paul: We once had to go and look at her paintings too. I mean, he didn't show his paintings. There was never any of his work there to see; when he finished a painting it would go to the gallery. One time we were asked to look at her paintings, and she brought out one after another. She had a painting of pears, and she said, "E. Hopper"—she always called him E. Hopper when she spoke to him—"E. Hopper said that they don't have any body, that they're like balloons, but I want them to fly. I want them to be like balloons."

Chuck: That's one way to take criticism well. Just turn it around and make it a compliment.

Paul: I have no idea where he lived before he moved to Washington Square North. He was a fairly successful commercial illustrator. I remember another thing that Mrs. Hopper said. It was in the 1940s, I guess. They had been married for a long time, and she always posed for his pictures. All of the women in his pictures were Mrs. Hopper. He changed her around, and used her as he wanted. He did a burlesque thing that had a stripteaser prancing across the stage. "I posed for that," she said, "and me, a virgin."

Guest: There was a drawing like that in the show I did at the Whitney.

Paul: She was fun, though she could sometimes be too much.

Bill: You talk about Hopper as if you knew him fairly well.

Paul: Well, we'd go to tea there once in a while.

Bill: Do you feel that you had a professional relationship with him? I mean, did you look at each other's work?

Paul: I don't think he disrespected my work as much as he disrespected most people's work. I think he had no use for anyone else's work.

Bill: Did you talk about work with one another?

Paul: No. He never talked about his work.

Guest: He wasn't a great draftsman.

Paul: He wasn't a great draftsman, but he was an adequate draftsman. I don't think he cared very much. There was a great deal of abstraction in his work. He considered himself almost an abstract artist, I think.

◆

Artists' works

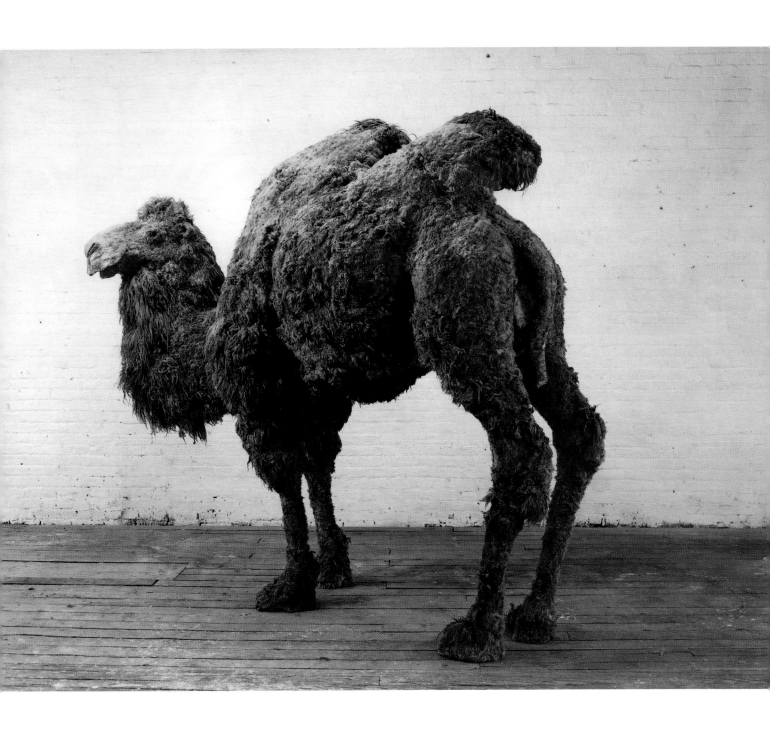

Nancy Graves
Mongolian Bactrian, 1969, wood, steel, burlap, polyurethane, skin, wax, oil paint, 96 x 126 x 48 inches

Collection Neue Gallerie-Sammlung Ludwig, Aachen, Germany

Richard Serra
One Ton Prop (House of Cards), 1969, lead antimony, 4 plates, 48 x 48 x 1 inches each.

Collection the Museum of Modern Art, New York

Philip Glass
Music in Similar Motion, 1969, page from original manuscript

Joe Zucker
100-Foot-Long Piece, 1968–69, mixed media, 8 x 55 feet Installed in studio

Robert Israel
Act III, Scene 1 of Leos Janácek's *Kátyă Kabanová*, 1991, Metropolitan Opera, New York.

Mark Greenwold
Sewing Room (for Barbara), 1975–79, oil on canvas, 22½ x 28½ inches

Lucas Samaras
Sittings 8 x 10, 1978–80, Poloroid Polacolor II photograph, 8 x 10 inches, unique

Alex Katz
Ada in the Sun, 1994, oil on canvas, 48⅛ x 36 inches.

Cindy Sherman
Untitled, 1983, color photograph, 68 x 45 inches

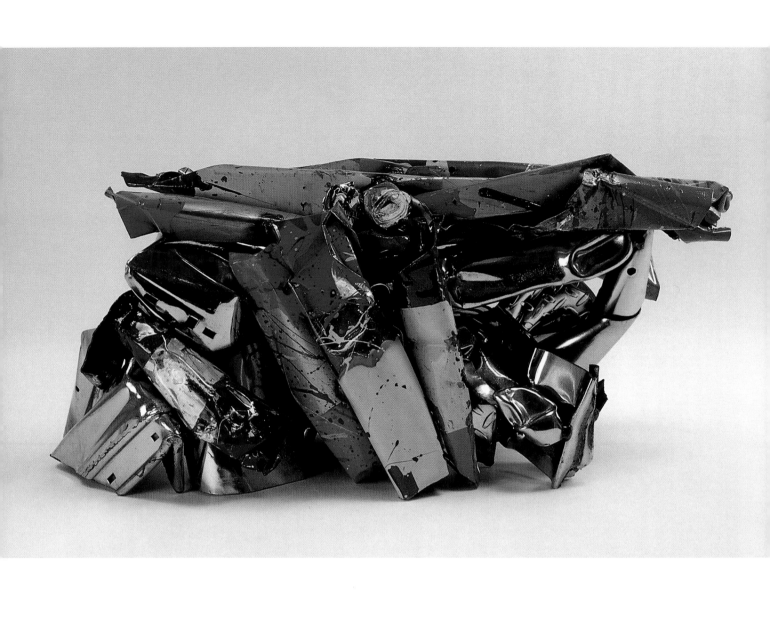

John Chamberlain
God's Chalk, 1988, painted and chromium-plated steel, 16½ x 37½ x 14½ inches

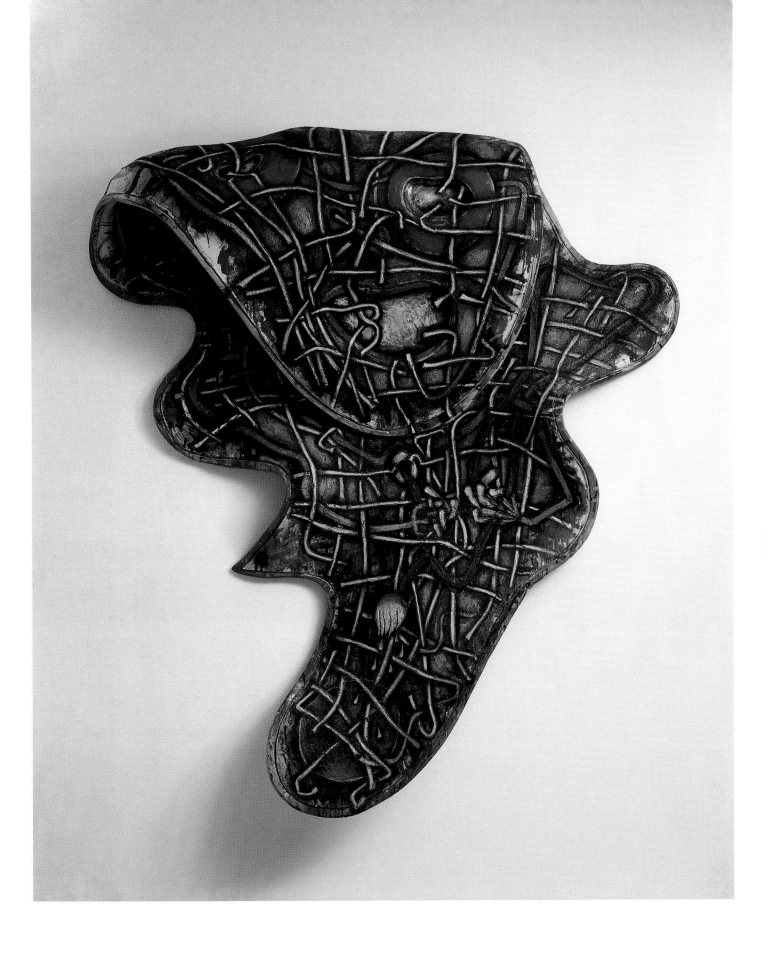

Elizabeth Murray
Specs, 1991, oil on canvas on plywood, 92¾ x 81⅞ x 16 inches

Collection Susanne Feld Hilberry and Richard Kandarian

Eric Fischl
Bad Boy, 66 x 96 inches, oil on canvas, 1981

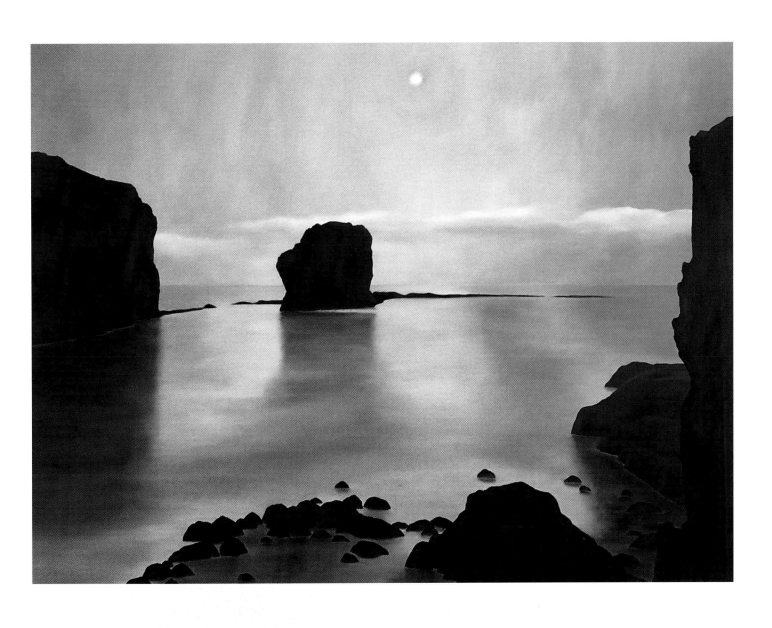

April Gornik
Moon Bay, 1996, oil on linen, 72 x 96 inches

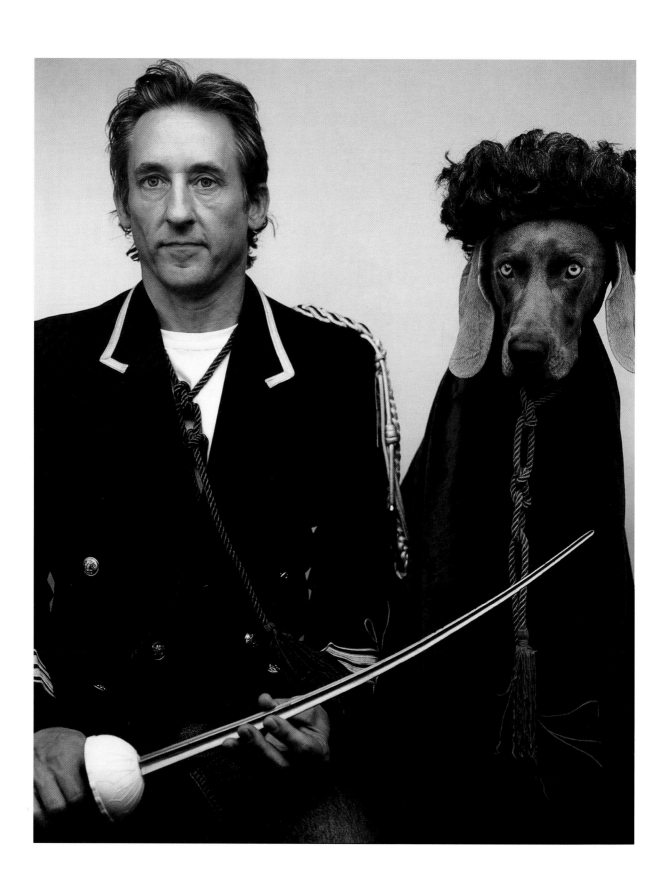

William Wegman,
Leading Roles (Fay and Ed Ruscha), 1987, unique Polacolor ER, 20 x 24 inches

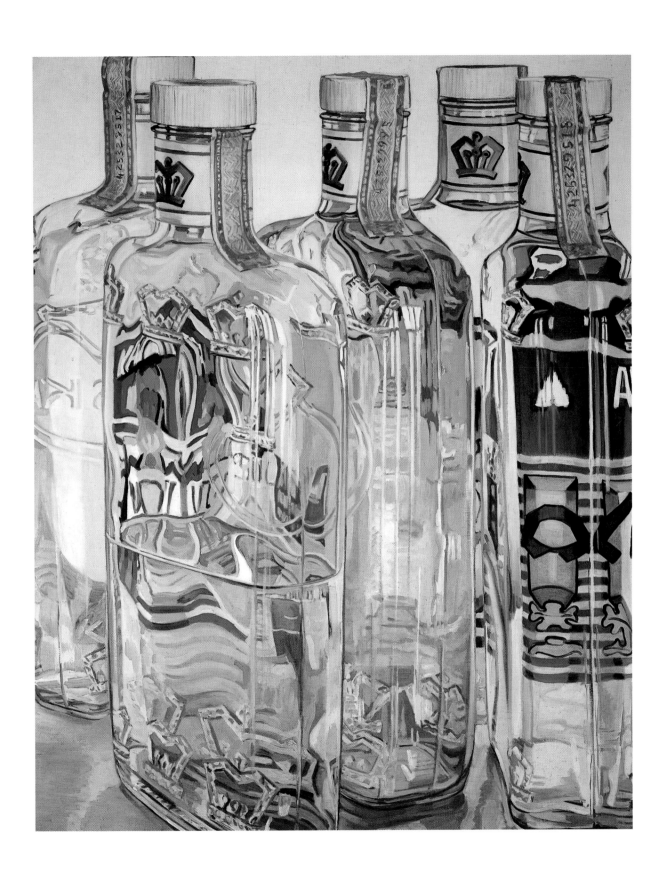

Janet Fish
Majorska Vodka, 1971, oil on canvas, 60 x 48 inches

Judy Pfaff
N.Y.C.B.C.E, 1984, mixed media installation. Installation view, 1984 Biennial Exhibition, Whitney Museum of American Art

Joel Shapiro
Untitled, 1989–1990, bronze edition 1/4, 58¾ x 46¼ x 27 inches

Richard Artschwager
Untitled, wood, 1994, 56 x 63 x 22 inches

Kiki Smith
Jersey Crows, 1995, silicon bronze, 6¼ x 17½ x 11 to 16 x 19½ x 23½ inches, Installation view (PaceWildenstein Gallery, Greene Street).

Roy Lichtenstein
Girl With Beach Ball II, 1977, oil and magna on canvas, 60 x 50 inches

Dorothea Rockburne
Northern Sky, 1993, fresco secco—Lascau Aquaryl, Berol pencils and artstix on gesso and matt medium surface on a wall,
30 x 30 feet, Sony Installation

Lorna Simpson
Wigs, 1994, installation of fifty waterless lithographs on felt, 98 x 265 feet overall

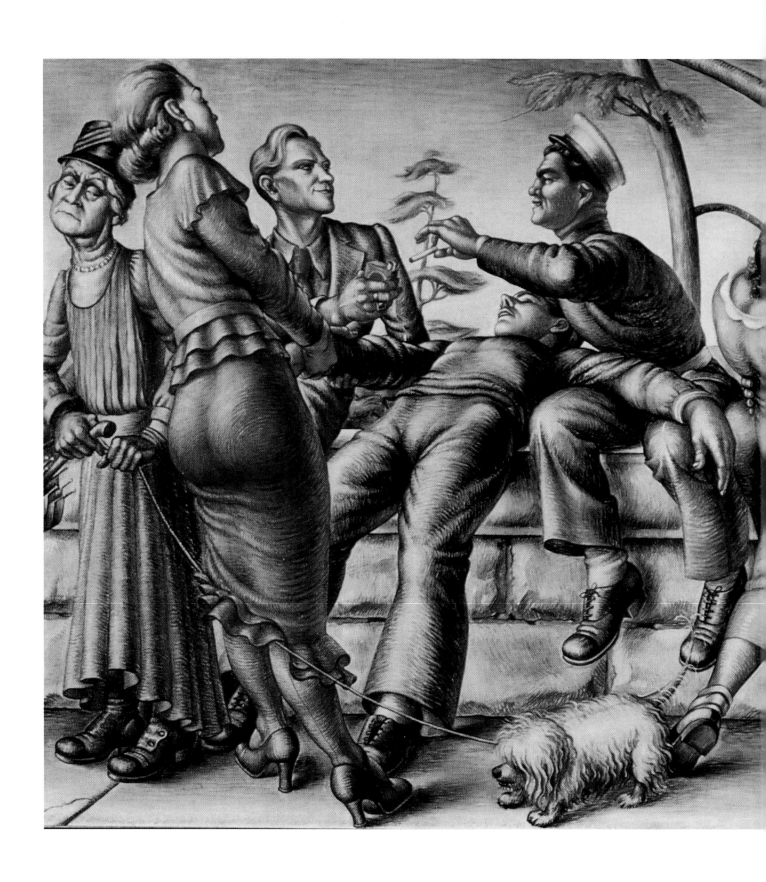

Paul Cadmus
The Fleet's in!, 1934, oil on canvas, 30 x 60 inches

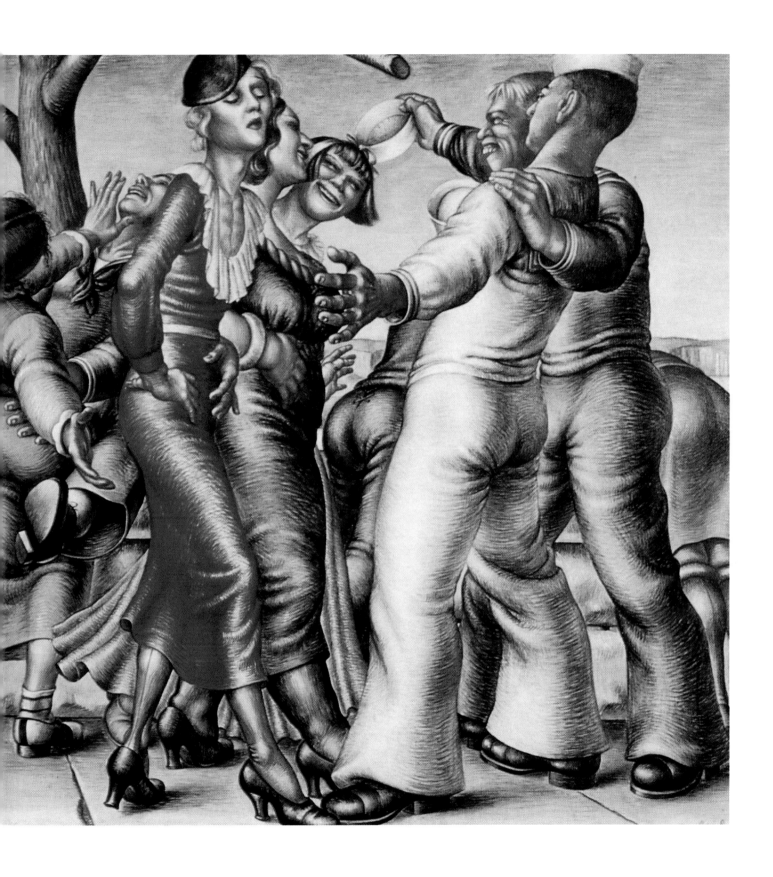

Credits

Artists' projects

Nancy Graves. *Mongolian Bactrian,* 1969, wood, steel, burlap, polyurethane, skin, wax, oil paint, 96 x 126 x 48 inches. Neue Gallerie-Sammlung Ludwig, Aachen, Germany. Photo: Peter Moore

Richard Serra. *One Ton Prop (House of Cards),* 1969, lead antimony, 4 plates, 48 x 48 x 1 inches each. The Museum of Modern Art, New York. Gift of the Grinstein family, Photo courtesy PaceWildenstein, New York

Philip Glass. *Music in Similar Motion,* 1969, page from original manuscript. Courtesy Dunvagen Music Publishers, Inc. New York. Photo: Adam Reich.

Joe Zucker. *100-Foot-Long Piece,* 1968–69, mixed media, 8 x 55 feet. Installed in studio. Photo: Jim Strong.

Robert Israel. Act III, Scene I of Leos Janácek's *Kátya Kabanová,* 1991, Metropolitan Opera, New York. Photo: Winnie Klotz.

Mark Greenwold. *Sewing Room (for Barbara),* 1975–79, oil on canvas, 22-1/2 x 28-1/2 inches. Photo courtesy Phyllis Kind Gallery, New York.

Lucas Samaras. *Sittings 8 x 10,* 1978–80, Polaroid Polacolor II photograph on paper, 8 x 10 inches, unique. Photo courtesy PaceWildensteinMacGill, New York.

Alex Katz. *Ada in the Sun,* 1994, oil on canvas, 48-1/8 x 36 inches. Courtesy Marlborough Gallery, New York.

Cindy Sherman. *Untitled,* 1983, color photograph, 68 x 45 inches. Photo courtesy Metro Pictures, New York.

Elizabeth Murray. *Specs,* 1991, oil on canvas on plywood, 92-3/4 x 81-7/8 x 16 inches. Collection Susanne Field Hilberry and Richard Kandarian. Photo courtesy Susanne Hilberry Gallery, Birmingham, Michigan.

Judy Pfaff. *N.Y.C.B.C.E.,* 1984, mixed media installation. Installation view, 1984 Biennial Exhibition, Whitney Museum of American Art. Photo courtesy Holly Solomon Gallery, New York.

Eric Fischl. *Bad Boy,* 1981, oil on canvas, 66 x 96 inches. Photo courtesy Mary Boone Gallery, New York.

April Gornik. *Moon Bay,* 1996, oil on linen, 72 x 96 inches. Photo courtesy Edward Thorp Gallery, New York.

William Wegman. *Leading Roles (Fay and Ed Ruscha),* 1987, unique Polacolor ER, 20 x 24 inches. Copyright William Wegman, 1987. Photo courtesy PaceWildensteinMacGill, New York.

Janet Fish. *Majorska Vodka,* 1971, oil on canvas, 60 x 48 inches. Collection AT&T. Photo courtesy DC Moore Gallery.

John Chamberlain. *God's Chalk,* 1988, painted and chromium-plated steel, 16-1/2 x 37-1/2 x 14-1/2 inches. Photo courtesy PaceWildenstein, New York.

Joel Shapiro. *Untitled* (detail), 1989–1990, bronze edition 1/4, 58-3/4 x 46-1/4 x 27 inches. Photo courtesy PaceWildenstein, New York.

Richard Artschwager. *Untitled,* 1994, wood, 56 x 63 x 22 inches. Photo courtesy Mary Boone Gallery, New York.

Kiki Smith. *Jersey Crows,* 1995, silicon bronze, 6-1/4 x 17-1/2 x 11 to 16 x 19-1/2 x 23 inches. Installation view (PaceWildenstein Gallery, Greene Street). Photo courtesy PaceWildenstein, New York.

Roy Lichtenstein. *Girl With Beach Ball II,* 1977, oil and magna on canvas, 60 x 50 inches. Photo courtesy Leo Castelli Gallery, New York.

Dorothea Rockburne. *Northern Sky,* 1993, fresco secco— Lascau Aquaryl, Berol pencils and artstix on gesso and matte medium surface on a wall, 30 x 30 feet, Sony Installation. Photo courtesy Andre Emmerich Gallery, New York.

Lorna Simpson. *Wigs,* 1994, installation of fifty waterless lithographs on felt, 98 x 265 feet overall. Photo courtesy Sean Kelly Gallery, New York.

Paul Cadmus. *The Fleet's In!,* 1934, oil on canvas, 30 x 60 inches. Photo courtesy DC Moore Gallery, New York.

Chuck Close's paintings

Nancy, 1968, acrylic on canvas, 108 x 84 inches. Collection Milwaukee Art Museum, Milwaukee. Gift of Herbert H. Kohl Charities, Inc. Photo courtesy PaceWildenstein, New York.

Richard, 1969, acrylic on canvas, 108 x 84 inches. Ludwig Collection, Aachen, West Germany. Photo: Kenneth Lester, courtesy PaceWildenstein, New York.

Phil, 1969, acrylic on canvas, 108 x 84 inches. Collection the Whitney Museum of American Art, New York. Purchase, with funds from Mrs. Robert M. Benjamin. 69.102.

Joe, 1969, acrylic on canvas, 108 x 84 inches. Collection Osaka City Museum of Modern Art, Osaka, Japan. Photo: Bill Jacobson, courtesy PaceWildenstein, New York.

Bob, 1970, acrylic on canvas, 108 x 84 inches. Collection Australian National Gallery, Canberra. Photo courtesy PaceWildenstein, New York.

Leslie, 1973, watercolor on paper on canvas, 72-1/2 inches x 57 inches. Private collection, New York. Photo courtesy PaceWildenstein, New York.

Klaus, 1976, watercolor on paper, 80 x 58 inches. Collection Sydney and Frances Lewis, Richmond, Virginia. Photo: Bevan Davies, courtesy PaceWildenstein, New York.

Mark, 1979, acrylic on canvas, 108 x 84 inches. Private collection, New York. Photo: Ellen Page Wilson, courtesy PaceWildenstein, New York.

Georgia, 1982, pulp paper collage on canvas, 48 x 38 inches. Private collection, New York. Photo: Ellen Page Wilson, courtesy PaceWildenstein, New York.

Arne, 1983, pulp paper on canvas, 24-1/4 x 20-1/4 inches. Private collection, New York. Photo: Ellen Page Wilson, courtesy PaceWildenstein, New York.

Lucas II, 1987, oil on canvas, 36 x 30 inches. Collection Jon and Mary Shirley, Seattle. Photo: Bill Jacobson, courtesy PaceWildenstein, New York.

Alex, 1987, oil on canvas, 100-1/4 x 84 inches. Collection the Toledo Museum of Art, gift of the Apollo Society. Photo courtesy PaceWildenstein, New York.

Cindy, 1988, oil on canvas, 102 x 84 inches. Collection Camille and Paul Oliver-Hoffman. Photo courtesy PaceWildenstein, New York.

Elizabeth, 1989, oil on canvas, 72 x 60 inches. Collection the Museum of Modern Art, New York. Fractional gift of an anonymous donor to The Museum of Modern Art. Photograph © The Museum of Modern Art, New York.

Judy, 1989–90, oil on canvas, 72 x 60 inches. Collection Modern Art Museum of Fort Worth. Gift of Anne Burnett Tandy in Memory of Ollie Lake Burnett, by exchange. Photo: Bill Jacobson, courtesy PaceWildenstein, New York.

Eric, 1990, oil on canvas, 100 x 84 inches. G.U.C. Collection, Deerfield, Illinois. Photo courtesy PaceWildenstein, New York.

April, 1990–91, oil on canvas, 100 x 84 inches. The Eli and Edythe L. Broad Collection. Photo courtesy PaceWildenstein, New York.

Bill, 1990, oil on canvas, 72 x 60 inches. Private collection, New York. Photo courtesy PaceWildenstein, New York.

Janet, 1992, oil on canvas 100 x 84 inches. Collection the Albright-Knox Art Gallery, Buffalo, New York. Photo: Bill Jacobson, courtesy PaceWildenstein, New York.

John, 1992, oil on canvas, Photo: Bill Jacobson, 100 x 84 inches. Collection Michael and Judy Ovitz, Los Angeles. Photo: Bill Jacobson, courtesy PaceWildenstein, New York.

Richard (Artschwager), 1992, oil on canvas, 72 x 60 inches. Private collection, Los Angeles. Photo: Bill Jacobson, courtesy PaceWildenstein, New York.

Joel, 1993, oil on canvas, 102 x 84 inches. Private collection, New York. Photo: Bill Jacobson, courtesy PaceWildenstein, New York.

Kiki, 1993, oil on canvas, 100 x 84 inches. Collection Walker Art Center, Minneapolis. Gift of Judy and Kenneth Dayton, 1994. Photo: Ellen Page Wilson, courtesy PaceWildenstein, New York.

Roy I, 1994, oil on canvas, 102 x 84 inches. Private collection, Los Angeles. Photo: Ellen Page Wilson, courtesy PaceWildenstein, New York.

Dorothea, 1995, oil on canvas, 102 x 84 inches. Collection The Museum of Modern Art, New York. Promised gift of Robert F. and Anna Marie Shapiro; Vincent D'Aquila and Harry Soviak Bequest, Vassilis Cromwell Voglis Bequest, and the Lauder Foundation Fund. Photo: Ellen Page Wilson.

Lorna, 1995, oil on canvas, 102 x 84 inches. Private collection, San Francisco. Photo: Ellen Page Wilson, courtesy PaceWildenstein, New York.

Paul II, 1996, oil on canvas, 30 x 24 inches. Private collection, Los Angeles. Photo: Ellen Page Wilson, courtesy PaceWildenstein, New York.

Self-Portrait, 1997, oil on canvas, 102 x 84 inches. Private collection, New York. Photo: Ellen Page Wilson, courtesy PaceWildenstein, New York.

overleaf: Photo: Bill Zules